Directory of Art Libraries and Visual Resource Collections in North America

Directory of Art Libraries and Visual Resource Collections in North America

Compiled For The Art Libraries
Society Of North America (ARLIS/NA)

By

Judith A. Hoffberg
and
Stanley W. Hess

Neal-Schuman Publishers, Inc.

Published by Neal-Schuman Publishers, Inc.
64 University Place, New York, New York 10003

Distributed exclusively by ABC–Clio, Inc.
Riviera Campus, 2040 A.P.S., Box 4397,
Santa Barbara, California 93103; European
distribution: Clio Press, Ltd., Hinksey Hill,
Oxford OX15BE, England.

International Standard Book Number: 0-918212-05-7
Library of Congress Catalog Card Number: 78-61628

CONTENTS

FOREWORD

It is entirely appropriate that the person responsible for the formation of the Art Libraries Society of North America (ARLIS/NA) should be one of the compilers of this *Directory of Art Libraries and Visual Resource Collections in North America.* Judith A. Hoffberg has devoted many long hours to the service of art librarianship. In 1972, she visited Great Britain and observed the activities of the four-year-old Art Libraries Society, an organization of art librarians in the United Kingdom. At a gathering of about a dozen art librarians from the United States and Canada attending the 1972 American Library Association convention in Chicago, she proposed the formation of an organization of art librarians modeled after the Art Libraries Society in the United Kingdom. A subsequent organization meeting was held in New York City in January 1973, and over eighty interested librarians attended. The new organization they founded was called the Art Libraries Society of North America (ARLIS/NA). Ms. Hoffberg was the Society's first Chairman, its first Executive Secretary, and its first Newsletter Editor.

Once founded, the Society grew rapidly. Today there are about 1,000 memberships, both personal and institutional. The membership is drawn from a rich assortment of art professions: mostly art librarians from museum, public, and college and university libraries, as well as an increasing number of visual resource curators who work in slide, photograph, video, and other multimedia collections. It also includes a number of art publishers and book dealers. From its beginning, ARLIS/NA has been an international society, with charter members from Canada as well as the United States, and an affiliation with ARLIS in the United Kingdom. ARLIS/NA is now the largest association of art librarians in the world.

The communication of an art library point of view is one of the chief functions of the Society. This is achieved through its participation in the Council of National Library Associations, the U.S. IFLA Committee, and the Subject Analysis Committee of the Cataloging and Classification Section of the American Library Association. ARLIS/NA is also a sponsor of the Repertoire International de la Litterature de l'Art (RILA), and is affiliated with the College Art Association of North America.

Annual conferences have been held by the Society every year since 1973 to provide a forum for the membership with speakers on a variety of subjects, and a number of workshops. Since November 1972, a bimonthly newsletter has provided a means of communication among the Society's far-flung membership. The *ARLIS/NA Newsletter* carries news of the activities of the Society's working committees and local chapters, book reviews, notices of new publications, and a variety of articles on the visual arts and art librarianship. The Society also publishes an annual membership directory.

In addition to the *Newsletter* and the annual *Directory of Members*, the Society has published *Standards for Staffing Art Libraries,* the culmination of two-and-a-half years of work by the ARLIS/NA Standards Committee. The Society also published *A Guide to Art Resources in Los Angeles,* compiled by the Southern California Chapter. Other local chapters of ARLIS/NA have produced guides to collections, local newsletters, and checklists of exhibition catalogs. One of the most notable is the *Annual Checklist of New York City Museum and Gallery Exhibition Publications* produced by the New York Chapter, and the subsequent establishment of a permanent archive of New York exhibition catalogs at the Fashion Institute of Technology in New York City. Another important local publication was issued by the Museum of Fine Arts in Boston, the *Guide to New England Art Museum Libraries,* by Nancy Allen, an ARLIS/NA member.

The publication of the *Directory of Art Libraries and Visual Resource Collections in North America* has been a goal of the Society since 1973. It is the first commercial publication of the Society, and we are grateful to Neal-Schuman Publishers for their assistance in this venture. Although the existence of art libraries has been recorded generally by the *American Library Directory* since 1923, this directory will provide much more detailed information about the holdings and services of all art libraries than has been given previously, especially those which are departments of large library systems. For

the first time, the holdings and services of visual resource collections in art will be covered in depth, along with art libraries. Stanley Hess, the Photograph and Slide Librarian at the Cleveland Museum of Art, deserves special thanks for his work in compiling this much needed information.

The Society hopes that this directory will be the first of many regularly updated editions. We welcome additions and suggestions for future editions.

KATHARINE M. RATZENBERGER
Chairman, ARLIS/NA
and

Assistant Librarian
Library of the National Collection
of Fine Arts & the National Portrait
Gallery, Smithsonian Institution
May 1978

PREFACE

Directory of Art Libraries and Visual Resource Collections in North America is intended as a reference and research tool. The descriptions of collections and services provided by institutions throughout the United States and Canada are designed to aid faculty, curators, librarians, scholars, students, researchers, and the general public in locating and using both print and nonprint materials in the fine arts.

The Directory includes approximately 1300 listings, representing libraries, museums, galleries, art schools, colleges and universities. The editors have excluded institutions such as film libraries and historical societies, as these sources are indexed in existing or forthcoming directories. The majority of entries have been derived from questionnaire responses, correspondence, and other contacts with the editors and/or project volunteers across the continent. However, because questionnaire response was less than anticipated, even with three separate mailings through the course of the spring, summer and fall of 1977, the visual resource listings include a number of entries for institutions which did not respond to the information request but are known to have important collections. These entries are marked with an asterisk (*). Even so, the editors recognize that the content and coverage of the Directory is far from complete. It is hoped that any future revision of the Directory will receive greater cooperation from colleagues, and thereby correct some of these deficiencies.

DIRECTORY OF ART LIBRARIES

General Arrangement

The Directory is organized alphabetically, by state or province, and then by institution. The code preceding each citation consists of the letters AL (art library) and a number. In this volume all indexes refer to these codes rather than to page numbers. Each citation includes the name of the institution, the name of the library, the most current address and telephone number, and the name of the librarian. The hours of service are indicated, but visitors are encouraged to verify this information, particularly during the summer or on a holiday, or between semesters for academic libraries.

Information Details

Circulation: Those who may borrow materials are noted. Also includes limitations of service and an indication of open or closed stacks.
Reference Service: The availability of reference service for patrons or by telephone and letter to outside users and other libraries is noted.
Reprographic Services: A "Yes" indicates the availability of either a coin-operated photocopy machine or copies made by the staff. The lack of photocopy facilities or any special restrictions are noted.
Interlibrary Loan: Indicates the library's membership in the National Interlibrary Loan System or any other system.
Networks/Consortia: Notes the library's membership in formal or informal groups involved in cooperative sharing on the local, regional, or national level.
Publications: Indicates publications such as bibliographies, newletters, and orientation handbooks generated by the library for public or in-house use.
Information Sources: Cites books and articles written about the library or its collections in the professional literature.
Special Programs: Notes the availability or periodic scheduling of group and individual tours, lectures, bibliographic instruction, and intern programs.
Cataloged Volumes: The approximate number of volumes in the arts collection was requested, but oftentimes a library has included its total volumes.
Serial Titles: Indicates the number of titles received and union lists which include the serial holdings.
Holdings: Includes quantitative information on ver-

tical files, sales and auction catalogs, exhibition catalogs, microforms, and other items such as student research papers.

Subjects: Lists areas included in collections—art, architecture, decorative arts, classical archaeology, film & video, graphics, photography, music, theatre, dance.

Special Collections: May include broad topics which involve a generalized scope of a specialized subject, or may include definitive titled collections which have distinctive subject matter and scope.

Subject Index

Special collections are indexed under more than 500 subject categories immediately following the listings of art libraries.

Acknowledgements

The editor wishes to personally thank publishers John Vincent Neal and Patricia Glass Schuman for their faith and warm friendship; Leslie Coleman for typing and editing assistance; and Lindy Narver, who applied intelligence and patience to a most difficult editorial task. Above all, sincere gratitude is expressed to those colleagues who provided time and/or information toward the completion of this project.

JUDITH A. HOFFBERG
May 1978

DIRECTORY OF VISUAL RESOURCE COLLECTIONS

General Arrangement

The Directory is organized alphabetically by state or province and then by institution. The code preceding each citation consists of the letters VR (visual resource) and a number. In this volume, all indexes refer to these codes rather than to page numbers. Each citation includes the name of the institution, the visual resource collection, the address, and telephone number. Further administrative information is included when provided. The indication of administrative or supervisory personnel and titles, when given, are those provided by the responding institution or visual resource collection. In a limited number of cases the supervisor's title was not provided although the questionnaire was returned. For these individuals, the title "Person in Charge" was assigned. To give users and librarians an additional scale of comparison, the number of other professional staff members is given. This will indicate to users a rough measurement of the size, variety, and quality of collection and services. Many institutions provide public services. The hours at which these are available are indicated. When in doubt about hours or services, etc., users are encouraged to call or write in advance for clarification or further information.

Circulation Policy

Circulation policies of the reporting institutions vary considerably from one institution and/or department to another. Users planning to visit a new collection are generally encouraged to find out in advance what the circulation policy is for any given collection. This suggestion is especially important for those persons who intend to use academic collections not associated with their own places of employment or research.

The information provided on circulation policies is presented according to media. Many collections have restricted use policies, especially those collections serving teaching situations in colleges, universities, and art schools. Some collections do provide public services on an unrestricted or moderately restricted basis. Public services are most often found in museum and public libraries and to some extent in the large central academic libraries. Because of the great cost of maintaining collections and services, many of these institutions which provide public services underwrite the cost by charging a fee, which users should be prepared to encounter when asking to use the collection.

Collections and Collection Emphases

This section is intended to provide the users with an overall view of the collections and their primary art historical emphases. The information is provided by media: films, photographs, slides, etc., and by collection size and the visual resource classification scheme of each. The principal schemes used for classification and organizing collections are those developed by the visual resource collections of the

Fogg Art Museum at Harvard University, The Photograph and Slide Library, Metropolitan Museum of Art, New York, and the automated system developed by Simons and Tansey at the University of California at Santa Cruz. Numerous other systems were also reported but lacked numbers to indicate any trend of system design or change.

Collection emphases are indicated according to art form: architecture, sculpture, painting, graphic arts, and decorative arts. Collection emphases are then indicated by broad cultural designations based upon a minimum content of 3% per category, with the exception of several very large collections, such as the Columbia University Slide Collection, where all collection emphases are listed.

Subscriptions and Unique Collections

To provide users of the Directory with additional information with which to evaluate collections as well as to locate research tools of special interest, a section has been included based upon major non-book visual resource reference tools which are or have been available for purchase through subscription programs. It is the intent of these sections to identify special collections regarded as essential to in-depth research and study in a number of areas of art historical exploration. The survey questionnaire included the following subscriptions in its query: Wayne Andrews, American Committee of South Asian Art, Asian Art Photographic Distribution, James Austin, Berenson Archives, Carnegie Set, Chinese National Palace Museum Photographic Archives, Courtauld Institute Photography Survey of Private Collections, Decimal Index of the Art of the Low Countries, Gernsheim Collection, Princeton Index, University Colour Slide Scheme (Courtauld Institute, London). To this list the respondents to the questionnaire were encouraged to list additional subscription series known to them.

In addition to the subscriptions listed above, information was sought to identify special collections which were possibly unique or rare in the field of visual resource collections. The response to this question has brought to light many resources of special interest to scholars and researchers. Users will be able to identify and locate these collections by using the subject index at the end of the volume.

Services

The concluding section of the entry citation deals with services provided by institutions in the way of photographs and slides and their availability for purchase, duplication, or rental. This section is intended primarily for VR Curators and Librarians seeking acquisition sources in building their collections and also for researchers and publishers seeking illustrative materials for use in their studies or publications. If individuals wish to take their own photographs or slides, they must inquire within the institutions involved to obtain permission. No attempt was made by this survey to solicit information regarding private photography of collections. In all cases involving publication, users must obtain permission from the institutions and abide by their regulations and fees.

Indexes

Immediately following the institutional listings are three classified indexes. The first, "Index to Collection Emphases," groups institutional names, by state, under an alphabetical arrangement of art forms in combination with historical emphases, e.g., Architecture—African, Architecture—Ancient, etc. The "Index to Subscription Series" lists institutions according to their available subscription programs. The last classified list provides a "Subject Index To Special Collections." With all indexes, the parenthetical codes following the institutional name indicate the media of specific collections.

Acknowledgements

The success of the Directory is due in large measure to the volunteer assistance of individuals in nearly every state and province in the United States and Canada. Without their cooperation and advice this project would be much the poorer. Judith A. Hoffberg joins with me in extending heartfelt thanks to the following persons and their institutions and colleagues who responded to our request for assistance:

Betty Alley, Peter Anthony, Rosann M. Auchstetter, Linda F. Bell, William C. Bunce, Barbara Burlison, Norine D. Cashman, Elizabeth L. Chiego, Helen Chillman, Ann S. Coates, Sarah S. Daniels, Lynn Davis, John A. Day, Dawn M. Donaldson, Phyllis Durham, Ann Fenhagen, Eleanor Fink, Eileen Fry, Emily B. Gadd, Louise Henning, Alice T. Holcomb, Sheila J. Johnson, Wendy Knight, M. Anne McArthur, Kathryn McKenney, Janet Meneley, Joan L. Muller, D. John Murchie, Joan H. Nilsson, Margaret P. Nolan, Linda J. Owen, Glenda M. Rhodes, Verna Ford Ritchie, Alice Rydieski, Nancy S. Schuller, Gillian M. Scott, Courtney Ann Shaw, Susan Shearer, Clinton A. Sheffield, Dianne Smith, Mary Snyder, Jeannette Squires, Elsie H. Straight, Carol Ulrich, Mary Ann Traylor, Olivia Watson, Dustin Wees, Elizabeth T. Woodin.

In addition to the above, the following are singled out for their advice and contributions towards the design of the questionnaire used to solicit information for the visual resource section of the Directory: Norine D. Cashman, Dawn M. Donaldson, P. Eileen Fry, Margaret P. Nolan, and Carol T. Ulrich.

The editor wishes to express his special thanks for their advice and support of the Directory project. Also I wish to thank Marjorie J. Henderson for her many hours devoted to typing the index to the visual resource section.

And above all I wish to acknowledge and thank my co-editor, Judith A. Hoffberg, who as Executive Secretary of ARLIS/NA at the onset of this project, invited my participation in this undertaking over 18 months ago; and John Vincent Neal of Neal-Schuman Publishers, New York, whose support and advice through all has been unfailing; and the Executive Board of ARLIS/NA, who together with the Publishers, have sponsored and underwritten the costs of the publication. And finally I wish to thank The Cleveland Museum of Art for its support of my project. I extend my apology to anyone whose name I have inadvertently omitted, for I am sure there are numerous individuals whose contributions have gone unrecorded.

STANLEY W. HESS
May 1978

Part One
DIRECTORY OF ART LIBRARIES

Alabama

AL 1
BIRMINGHAM MUSEUM OF ART LIBRARY
2000 Eighth Ave N, Birmingham, AL 35203
Tel: 205-254-2565
Dir: David Farmer

Museum Founded: 1951
Hours: Mon, Tues, Wed, Fri, Sat 10-5
 Thurs 10-9
 Sun 2-6
Circulation: Restricted; limited public with permission (open
 stacks)
Reprographic Services: No
Interlibrary Loan: No
Networks/Consortia: No
Cataloged Volumes: 1,000
Serial Titles: 5
Subjects: Art, decorative arts, architecture, classical archae-
 ology

AL 2
BLOUNT COUNTY MEMORIAL MUSEUM LIBRARY
204 Second St N, Oneonta, AL 35121
Tel: 205-274-2153
Museum Chairman: Amilea Porter

Museum Founded: 1970
Hours: Mon-Sun 2-4
Circulation: Students (open stacks)
Reference Service: In person, mail (when postage is provided)
Reprographic Services: No
Interlibrary Loan: No
Networks/Consortia: No
Publications: Quarterly bulletin
Special Programs: Group tours of historical sites
Special Collections:
Thomas Alva Edison Collection
Collection of patents, posters, phonograph records, bulbs,
 books, slides, china, stamps, dolls & other memorabilia.
Photograph Collection
Framed prints of historical photographs.

AL 3
CULLMAN COUNTY PUBLIC LIBRARY
200 Clark St, Cullman, AL 35055
Tel: 205-734-2720
Libn: Bettina P Higdon

Public library Founded: 1928
Hours: Mon, Tues, Wed, Fri 9-5:30
 Thurs 9-9
 Sat 9-4
Circulation: Public (open stacks)
Reference Service: In person, telephone, mail
Reprographic Services: Yes
Interlibrary Loan: NILS; state loan system
Networks/Consortia: No
Special Programs: Group & individual tours
Card Catalog
Cataloged Volumes: 47,600
Serial Titles: 35
Holdings: 12 vertical file drawers; 45 volumes periodicals
Subjects: Art, decorative arts, architecture, film & video,
 graphics, music, theatre, dance

Special Collections: Books, periodicals & related material on
 Alabama & the South

AL 4
MONTGOMERY MUSEUM OF FINE ARTS LIBRARY
440 S McDonough St, Montgomery, AL 36111
Tel: 205-834-3490
Libn: Elizabeth Brown

Museum Founded: 1930
Hours: Tues, Wed, Fri, Sat 10-5
 Thurs 10-10
 Sun 1-6
Circulation: Restricted to museum staff & members
Reference Service: In person, telephone, mail
Reprographic Services: Yes
Interlibrary Loan: Yes; catalog exchange program with 200
 museums
Networks/Consortia: No
Publications: Newsletter, special catalogs
Special Programs: Group tours
Card Catalog
Subjects: Art, decorative arts, architecture, photography

AL 5
UNIVERSITY OF ALABAMA IN BIRMINGHAM
Mervyn H Sterne Library, University College
University Station, Birmingham, AL 35294
Tel: 205-934-2253
Libn: Paul Spence

Academic
Hours: Mon-Fri 7:45-10:30
 Sat 9-5
 Sun 1-9
Circulation: Students, researchers, faculty/staff (open stacks)
Reference Service: In person
Reprographic Services: Yes
Interlibrary Loan: NILS
Networks/Consortia: No
Publications: Orientation handbook
Special Programs: Group tours
Card Catalog
Cataloged Volumes: 3,000 (art)
Serial Titles: 44
Holdings: 100 sales & auction catalogs; 100 exhibition cata-
 logs; microforms
Subjects: Art, decorative arts, architecture, classical archae-
 ology, film & video, graphics, photography, music, theatre,
 dance

AL 6
UNIVERSITY OF ALABAMA IN HUNTSVILLE
LIBRARY
Box 1247, Huntsville, AL 35807
Tel: 205-895-6540; 6526
Dirs: Elizabeth B Pollard & John Warren

Academic Founded: 1950; autonomous university 1969
Hours: Mon-Fri 8-10
 Sat-Sun 12-6
Circulation: Public (open stacks) (Fee for those not in UAH)
Reference Service: In person, telephone, mail
Reprographic Services: Yes
Interlibrary Loan: NILS (Robert Wheeler, Interlibrary Loan
 Dept, Univ of Alabama in Huntsville)

Networks/Consortia: No
Publications: Orientation handbook; bibliographies
Special Programs: Group & individual tours; bibliographic
 instruction; single lectures; undergraduate
Card Catalog
Cataloged Volumes: 4,172
Serial Titles: 52
Holdings: 1,200 microforms
Subjects: Art, decorative arts, architecture, classical archae-
 ology, graphics

Alaska

AL 7
FAIRBANKS NORTH STAR BOROUGH PUBLIC
 LIBRARY & REGIONAL CENTER
1215 Cowles St, Fairbanks, AK 99701
Tel: 907-452-5178
Lib Dir: Marvin E Smith

Public Library Founded: 1909
Hours: Mon-Wed 10-9
 Thurs & Fri 10-6
 Sat & Sun 1-5
Circulation: Public (open stacks)
Reference Service: In person, telephone, mail
Reprographic Services: Library materials only
Interlibrary Loan: Pacific Northwest Bibliographic Center
Networks/Consortia: No
Publications: Bibliographies; publication of local literary &
 artistic events
Special Programs: Group tours; film presentations; informal
 intern program
Card Catalog
Cataloged Volumes: 43,545 (34,144 titles)
Serial Titles: 399 (University of Alaska Union List of Serial
 Holdings)
Holdings: 8 vertical file drawers; 58 microforms; Newsbank;
 Phonefiche
Subjects: Art, architecture, classical archaeology, dance,
 decorative arts, film & video, graphics, music, photog-
 raphy, theatre
Special Collections: Alaskan collection includes 4,000
 volumes

AL 8
THE SHELDON MUSEUM & CULTURAL CENTER
 LIBRARY
Box 236, Haines, AK 99827
Tel: 907-766-2128
Curator: Elisabeth S Hakkinen

Museum Founded: 1927; 1975
Hours: Mon-Sun 2-4
Reference Service: In person only
Reprographic Services: No
Interlibrary Loan: No
Networks/Consortia: No
Publications: Newsletter; book catalog
Special Programs: Group & individual tours; single lectures
Cataloged Volumes: 300
Subjects: Ethnology & anthropology of Alaska

AL 9
UNIVERSITY OF ALASKA, FAIRBANKS
Elmer E Rasmuson Library

Fairbanks, AK 99701
Tel: 907-479-7224
Dir of Libs: H T Ryberg

Academic Founded: 1917
Hours: Mon-Thurs 7:30-10
 Fri 7:30-6
 Sat 1-6
 Sun 1-8 (semester sessions)
 Mon-Fri 8-5 (semester breaks)
Circulation: Students, researchers, faculty/staff; periodicals
 do not circulate (open stacks)
Reference Service: In person, telephone, mail
Reprographic Services: Yes
Interlibrary Loan: NILS; Pacific Northwest Bibliographic
 Center (University of Washington, Seattle, WA; Carol
 Crosby, ILL, same address as above)
Networks/Consortia: No
Publications: Orientation handbook; acquisitions list (Skinner
 Collection); Elmer E Rasmuson Occasional Papers;
 Library Skills Workbook (self-directed course); in-house
 periodical index (Union List of Serials; University of
 Alaska, Fairbanks, Holdings)
Special Programs: Individual tours; bibliographic instruction;
 single lectures; self-directed course in library skills
Card Catalog
Cataloged Volumes: 423,910
Serial Titles: 2,250
Holdings: 20 vertical file drawers; 202,941 microforms
Subjects: Art, architecture, dance, decorative arts, film &
 video, graphics, music, photography, theatre
Special Collections:
Skinner Collection
Twenty thousand volumes pertaining to Alaska & polar
 regions, including Arctic & Antarctic

Arizona

AL 10
AMERIND FOUNDATION, INC.
Research Library
Box 248, Dragoon, AZ 85609
Tel: 602-586-3003
Dir: Charles C Di Peso

Museum Founded: 1962
Circulation: Restricted to appointments by research scholars
 (open stacks)
Reprographic Services: Yes; limited
Interlibrary Loan: NILS
Networks/Consortia: No
Special Programs: Group & individual tours
Card Catalog
Cataloged Volumes: 20,000
Serial Titles: 350
Holdings: 25 vertical file drawers; 385 cards, 352 reels,
 4,000 prints; 500 bound periodical volumes; 10,000 slides
Subjects: Classical archaeology, anthropology, ethnohistory
 of the American Southwest & Mexico
Special Collections:
El Archivo de Hidalgo de Parral, 1631–1821 (microfilm)
Colonial Period of New Spain Collection
Records of the period from the area of Northern Mexico
 known as Nueva Vizcaya.

AL 11
ARIZONA STATE UNIVERSITY
Charles Trumbull Hayden Library
Tempe, AZ 85281
Tel: 602-965-3606
University Libn: Dr Donald W Koepp

Academic Founded: 1966
Hours: Mon-Thurs 7-12
 Fri 7-5
 Sat 9-5
 Sun 12-12
Circulation: Public (open stacks)
Reference Service: In person, telephone, mail
Reprographic Services: Yes
Interlibrary Loan: NILS; Center for Research Libraries
Networks/Consortia: OCLC
Publications: Bibliographies
Special Programs: Group & individual tours; bibliographic
 instruction; single lectures
Cataloged Volumes: 1,280,000 total; 36,000 art
Serial Titles: 380 art-related (National Union Catalog)
Subjects: Art, architecture, dance, decorative arts, film &
 video, graphics, music, photography, theatre

AL 12
CASA GRANDE PUBLIC LIBRARY
405 E Sixth St, Casa Grande, AZ 85222
Tel: 602-836-7242
Dir: David Snider

Public Library
Hours: Mon-Thurs 10-8
 Fri 10-5
 Sat 9-5
 Sun 1-5
Circulation: Public (open stacks)
Reference Service: In person, telephone
Reprographic Services: Yes
Interlibrary Loan: NILS
Networks/Consortia: No
Special Programs: Group & individual tours; intern program
Cataloged Volumes: 23,000 (21,000 titles)
Holdings: 3 vertical file drawers; 94 microfilms of local news-
 paper from 1912–1974
Subjects: Art, architecture, dance, decorative arts, film &
 video, music, photography, theatre

AL 13
GLENDALE COMMUNITY COLLEGE
Instructional Materials Center
6000 W Olive Ave, Glendale, AZ 85302
Tel: 602-934-2211, Exts 242; 239
Dir: Jean Staten

Academic Founded: 1965
Hours: Mon-Thurs 7-9:50
 Fri 7-4:20
Circulation: Public (open stacks except for periodicals &
 media section)
Reference Service: In person, telephone
Reprographic Services: Yes
Interlibrary Loan: State & Public Library
Networks/Consortia: State Library Department Network
 (under federal grant)
Publications: Orientation handbook; bibliographies; acqui-
 sitions list; brochures; in-house periodical index (Glen-

dale Community College Instructional Materials Center
 Periodicals, Newspapers & Indexes)
Special Programs: Group & individual tours; bibliographic
 instruction; single lectures
Cataloged Volumes: 60,919 (56,448 titles)
Serial Titles: Intermountain Union List of Serials; MCCCD
 Union List
Holdings: 24 vertical file drawers; 8,152 microfiche; 4,274
 microfilms
Subjects: Art, architecture, classical archaeology, dance,
 decorative arts, film & video, graphics, music, photog-
 raphy, theatre

AL 14
HEARD MUSEUM OF ANTHROPOLOGY &
 PRIMITIVE ART
Heard Museum Library
22 E Monte Vista Rd, Phoenix, AZ 85004
Tel: 602-252-8848
Volunteer Libn: Carol Ruppé

Museum Founded: 1929
Hours: Mon-Fri 10-5
Circulation: Faculty/staff (open stacks)
Reference Service: In person, telephone, mail
Reprographic Services: No
Interlibrary Loan: No
Networks/Consortia: No
Special Programs: Individual tours; bibliographic instruction
Cataloged Volumes: 4,800 (4,300 titles)
Serial Titles: 86 (Intermountain Union List of Serials)
Holdings: 8 vertical file drawers; 1 file drawer of exhibition
 catalogs
Subjects: Art, architecture, classical archaeology, decorative
 arts
Special Collections: Anthropology, Native American Indian
 Arts & Crafts; Primitive Art

AL 15
MESA PUBLIC LIBRARY
59 E First St, Mesa, AZ 85201
Tel: 602-834-2207
Dir: Clarence M Dial

Public Library Founded: 1910
Hours: Mon-Thurs 9-9:30
 Fri-Sat 9:30-5:30
Circulation: Public (open stacks)
Reference Service: In person, telephone
Reprographic Services: Yes
Interlibrary Loan: NILS
Networks/Consortia: No
Special Programs: Group & individual tours
Card Catalog
Cataloged Volumes: 109,622
Holdings: 9 vertical file drawers

AL 16
NORTHERN ARIZONA UNIVERSITY LIBRARIES
Flagstaff, AZ 86011
Tel: 602-523-2171
Dir: Dr Robert E Kemper

Academic
Hours: Mon-Thurs 7:30-11
 Fri 7:30-6
 Sat 8-6
 Sun 1-11

Circulation: Public (open stacks)
Reference Service: In person only
Reprographic Services: Yes
Interlibrary Loan: NILS
Networks/Consortia: OCLC
Publications: Orientation handbook; bibliographies; special catalogs; in-house periodical index (Northern Arizona University Periodical Holdings List)
Special Programs: Group & individual tours; bibliographic instruction; single lectures
Cataloged Volumes: 241,786
Serial Titles: 3,000 (Intermountain Union List of Serials)
Holdings: 279,061 microforms
Subjects: Art, architecture, classical archaeology, dance, decorative arts, film & video, graphics, music, photography, theatre
Special Collection:
Arizoniana
The economic & social history of Northern Arizona.

AL 17
PHOENIX ART MUSEUM
Research Library
1625 N Central Ave, Phoenix, AZ 85004
Tel: 602-257-1222
Libn: Shirley Haskin

Museum Founded: 1972 (museum founded 1959)
Hours: Tues-Fri 10-5
Circulation: Restricted use (open stacks except for rare books & magazines)
Reference Service: In person, telephone, mail
Reprographic Services: Yes; limited
Interlibrary Loan: Local libraries
Networks/Consortia: No
Special Programs: Group & individual tours, single lectures, research training program for docents
Card Catalog
Cataloged Volumes: 5,000
Serial Titles: 42 (Intermountain Union List of Serials)
Holdings: 48 vertical file drawers; 3,800 sales & auction catalogs; 20 file drawers of exhibition catalogs; 2,300 one man show catalogs
Subjects: Art, architecture, decorative arts, graphics
Special Collections:
Lansing Egyptology Collection
Orme Lewis Collection
Collection of Rembrandt print catalogs from 1721. Contains rare works of first Gersaint catalog & the Rovinski set.

AL 18
PHOENIX PUBLIC LIBRARY
Fine Arts & Recreation Department
12 E McDowell, Phoenix, AZ 85004
Tel: 602-262-6451
Libn: MaryLou Sutherland

Public Library
Hours: Mon-Thurs 10-9
 Fri-Sat 10-6
 Sun 2-6
Circulation: Public (open stacks)
Reference Service: In person, telephone, mail
Reprographic Services: Yes
Interlibrary Loan: NILS; Channel Arizona Information Network
Networks/Consortia: No

Card Catalog
Holdings: 8 vertical file drawers; some exhibition catalogs
Subjects: Art, architecture, decorative arts, film & video, graphics, photography, music, theatre, dance

AL 19
PIMA COMMUNITY COLLEGE LEARNING RESOURCE CENTER
West Campus Learning Resource Center
2202 W Anklam Rd, Tucson, AZ 85709
Tel: 602-884-6821
Coordinator of Lib Services: Margaret Holleman

Academic Founded: 1971
Hours: 7-10 during academic semesters
Circulation: Public (open stacks)
Reference Service: In person
Reprographic Services: Yes
Interlibrary Loan: NILS
Networks/Consortia: No
Publications: Orientation handbook; bibliographies; acquisitions list; newsletter; in-house periodical index
Special Programs: Group & individual tours; bibliographic instruction; single lectures; self-paced workbook on library skills; intern program
Card Catalog
Cataloged Volumes: 70,000 (55,000 titles)
Serial Titles: 1,300
Holdings: 12 vertical file drawers; 186,100 microforms; 10,000 AV materials
Subjects: Art, architecture, classical archaeology, dance, decorative arts, film & video, graphics, music, photography, theatre
Special Collections: Spanish-language collection includes 8,000 items

AL 20
SAFFORD CITY—GRAHAM COUNTY LIBRARY
808 Eighth Ave, Safford, AZ 85546
Tel: 602-428-1531
Libn: Starla Cathcart

Public Library Founded: 1962
Hours: Mon-Thurs 11-8
 Fri & Sat 12-4 (during winter)
Circulation: Public (county residents; open stacks except for rare materials)
Reference Service: In person
Interlibrary Loan: NILS (Rose Lawhorn, ILL Clerk, same address as above)
Networks/Consortia: No
Special Programs: Group & individual tours
Card Catalog
Holdings: 5 vertical file drawers
Subjects: Art, architecture, classical archaeology, dance, decorative arts, film & video, graphics, music, photography

AL 21
TUCSON MUSEUM OF ART LIBRARY
235 W Alameda, Tucson, AZ 85701
Tel: 602-623-4881
Libn: Dorcas Worsley

Museum Founded: 1974
Hours: Mon-Fri 10-3
Circulation: Researchers, faculty/staff, museum members (open stacks)
Reference Services: In person, telephone, mail

Reprographic Services: Yes
Interlibrary Loan: Local libraries; University of Arizona; Tucson Public Library
Networks/Consortia: No
Publications: Orientation brochure; bibliographies
Special Programs: Group & individual tours; bibliographic instruction; intern program
Card Catalog
Cataloged Volumes: 3,100
Serial Titles: 10
Holdings: 30 vertical file drawers; sales & auction catalogs; exhibition catalogs
Subjects: Art, architecture, classical archaeology, decorative arts, photography, pre-Columbian
Special Collections:
Frederick R Pleasant Collection
Rare and unusual items relating to primitive, Oceanic, African, pre-Columbian, Mexican, Meso-American & South American materials
Slides
14,239 slides on pre-Columbian, Africa, Oceania & primitive arts
Vertical File Collection
Arizona, Tucson artists & galleries, & art organizations

AL 22
TUCSON PUBLIC LIBRARY
Fine Arts Room
200 S Sixth Ave, Tucson, AZ 85701
Tel: 602-4393
Libn: Janet Lombard

Public Library Founded: 1901
Hours: Mon-Thurs 9-9
 Fri-Sat 9-5
 Sun 1-5
Circulation: Public (open stacks)
Reference Service: In person, telephone, mail
Reprographic Services: Yes
Interlibrary Loan: NILS; Channeled Arizona Information Network (Tucson Public Library, Box 27470, Tucson AZ 85726)
Networks/Consortia: Pima Regional Library Service
Special Programs: Group & individual tours; intern program
Card Catalog
Cataloged Volumes: 16,000
Serial Titles: 153 (National Union Catalog; Intermountain Union List of Serials)
Holdings: 4 vertical file drawers; sales & auction catalogs, exhibition catalogs; microforms
Subjects: Art, architecture, classical archaeology, decorative arts, film & video, graphics, photography, music, theatre, dance, crafts, antiques, rodeo, Indian arts & crafts

AL 23
UNIVERSITY OF ARIZONA
Center for Creative Photography
843 E University, Tucson, AZ 85719
Tel: 602-884-4636
Libn: Terence R Pitts (temporary)

Museum Founded: 1975
Circulation: Public; rare books, manuscripts & photographs do not circulate (open stacks)
Reference Service: In person, telephone, mail
Reprographic Services: Yes
Interlibrary Loan: NILS (Interlibrary loan, University of Arizona Library, Tucson, AZ 85719)

Networks/Consortia: No
Special Programs: Group & individual tours, single lectures
Card Catalog
Cataloged Volumes: 3,000
Serial Titles: 35-40
Holdings: 10 vertical file drawers
Subject: Photography

AL 24
UNIVERSITY OF ARIZONA
College of Architecture Library
Tucson, AZ 85721
Tel: 602-884-2498
Libn: S W Gresham

Academic Founded: 1965
Hours: Mon-Fri 9-5
 Sun-Thurs 7-10
 Sat 9-12; 1-4
Circulation: Students, faculty/staff, architects (open stacks)
Reference Service: In person
Reprographic Services: Yes
Interlibrary Loan: NILS
Networks/Consortia: No
Card Catalog
Cataloged Volumes: 8,800
Serial Titles: 100
Subjects: Art, architecture, decorative arts, photography, building technology, city planning

AL 25
UNIVERSITY OF ARIZONA
University Library—Reference
Tucson, AZ 85721
Tel: 602-884-1719
Libn: Rebecca Boone

Academic
Circulation: Students, researchers, faculty/staff, restricted use by state residents (open stacks)
Reference Service: In person, telephone, mail
Reprographic Services: Yes
Interlibrary Loan: NILS; Center for Research Libraries (Susan Spaulding, University Library, Tucson, AZ 85721)
Networks/Consortia: No
Publications: Orientation handbook; bibliographies; newsletter; in-house periodical index (Visible Index)
Special Programs: Group & individual tours, bibliographic instruction, single lectures, tape tours
Card Catalog
Cataloged Volumes: 33,000 (25,500 titles)
Serial Titles: 200 (Intermountain Union List of Serials)
Holdings: 11 vertical file drawers; sales & auction catalogs
Subjects: Art, architecture, decorative arts, graphics, music
Special Collection: Rare books of Arizoniana

AL 26
WILLIAMS PUBLIC LIBRARY
113 S First St, Williams, AZ 86046
Libn: Betty Cole

Public Library Founded: 1895
Hours: Tues-Sat 3-6; 7-9
Circulation: Restricted to property owners (open stacks)
Reference Service: In person
Reprographic Services: No

Interlibrary Loan: No
Networks/Consortia: No
Card Catalog
Cataloged Volumes: 5,000
Subjects: Art, decorative arts

Arkansas

AL 27
UNIVERSITY OF ARKANSAS
Fine Arts Library
University of Arkansas, FA-103, Fayetteville, AR 72701
Tel: 501-575-4708
Libn: Eloise E McDonald

Academic Founded: 1951
Hours: Mon-Thurs 8-10
 Fri 8-5
 Sat 9-1
 Sun 6-10
Circulation: Students, faculty/staff (open stacks)
Reference Service: In person, telephone, mail
Reprographic Services: Yes
Interlibrary Loan: NILS; state & regional systems (Joan
 Roberts, ILL Librarian, Mullins Library, Univ of
 Arkansas, Fayetteville, AR 72701)
Networks/Consortia: No
Special Programs: Group & individual tours; single lectures
Card Catalog
Cataloged Volumes: 27,000
Serial Titles: 145 (Arkansas Union List)
Subjects: Art, decorative arts, architecture, classical archae-
 ology, graphics, photography, music

AL 28
UNIVERSITY OF CENTRAL ARKANSAS
Torreyson Library
Conway, AR 72032
Tel: 501-329-2931, Ext 449
Dir: Jerrel K Moore

Academic Founded: 1908
Hours: Mon-Thurs 8-11
 Fri 8-5
 Sat 8:30-4
 Sun 1-10
Circulation: Students, faculty/staff (open stacks)
Reference Service: In person
Reprographic Services: Yes
Interlibrary Loan: NILS (contact Mr Hardin, ILL Dept,
 sam address as above)
Networks/Consortia: Amigos Bibliographic Council, OCLC
Special Programs: Group & individual tours, bibliographic
 instruction; single lectures
Card Catalog
Cataloged Volumes: 260,000
Serial Titles: 2,160 (Arkansas Union List of Periodicals)
Holdings: 50 vertical file drawers; 415,000 microforms
Subjects: Art, decorative arts, architecture, classical archae-
 ology, film & video, graphics, photography, music, theatre,
 dance

California

AL 29
ACADEMY OF MOTION PICTURE ARTS & SCIENCES
Margaret Herrick Library
8949 Wilshire Blvd, Beverly Hills, CA 90211
Tel: 213-278-4313
Libn: Mildred Simpson

Non-Profit Association Founded: 1927
Hours: Mon, Tues, Thurs & Fri 9-5 (open stacks for books
 & periodicals)
Reference Service: In person, telephone, mail
Reprographic Services: Yes; restricted to published scripts
Interlibrary Loan: NILS
Networks/Consortia: Film & Television Study Center, Inc.
Special Programs: Group tours
Card Catalog
Cataloged Volumes: 11,700
Serial Titles: 140
Holdings: 900 vertical file drawers
Subjects: Film & video

AL 30
ARCADIA PUBLIC LIBRARY
20 W Duarte Rd, Arcadia, CA 91006
Tel: 213-446-7111
Lib Dir: Richard Miller

Public Library
Hours: Mon-Thurs 9:30-9
 Fri & Sat 9:30-5:30
Circulation: Public (open stacks)
Reference Service: In person, telephone
Reprographic Services: No
Interlibrary Loan: NILS
Networks/Consortia: No
Special Programs: Group & individual tours
Cataloged Volumes: 120,000 (110,000 titles)
Serial Titles: 120
Holdings: 10 vertical file drawers
Subjects: Art, architecture, classical archaeology, dance,
 decorative arts, film & video, graphics, music,
 photography, theatre
Special Collection: Christmas decorations

AL 31
THE FRANCIS BACON FOUNDATION, INC
The Francis Bacon Library
655 N Dartmouth Ave, Claremont, CA 91711
Tel: 714-624-6305
Libn: Elizabeth S Wrigley

Rare book research library Founded: 1938
Hours: Mon-Fri 9-4:30
Circulation: Restricted to use in library (open stacks)
Reference Service: Telephone, mail
Reprographic Services: Yes
Interlibrary Loan: NILS; Southern California Interlibrary
 Loan (Honnold Library, Claremont Colleges, Claremont,
 CA 91711)
Networks/Consortia: Cooperating libraries in Claremont
Publications: Bibliographies; special catalogs
Information Sources: Firman, Joseph. "Scholars Like This
 Library," *Pomona Progress Bulletin,* Feb 26, 1966; Smith,
 Jack. "An Encounter with Six Ladies," *Los Angeles Times,*
 Nov 15, 1973; Information Bulletin 4. *Libraries in
 Claremont,* 1976, Claremont Colleges

Special Programs: Group & individual tours
Card Catalog
Cataloged Volumes: 10,000
Serial Titles: 36 (National Union Catalog of Manuscripts; National Historical Publications Record Commission)
Holdings: 3 vertical file drawers; 2 sales & auction catalogs
Subjects: Art, architecture
Special Collections:
Arensberg Archives
Francis Bacon Collection
Emblem Literature
E S Wrigley Collection
Art, architecture books, pictures & engravings of his period; 16th & 17th century volumes of woodcuts & engravings; correspondence with 20th century artists.

AL 32
BERKELEY PUBLIC LIBRARY
Art & Music Department
2090 Kittredge St, Berkeley, CA 94704
Tel: 415-644-6785
Libn: Bruce A Munly

Public Library Founded: 1960
Hours: Mon-Thurs 9-9
 Sat 9-6
 Sun 1-5
Circulation: Public (open stacks; restriction on reference & rare books)
Reference Service: In person, telephone, mail
Reprographic Services: Yes; limited to 5 photocopied pages
Interlibrary Loan: NILS; CA State Library Interloan Service
Networks/Consortia: Berkeley-Oakland Service System; Bay Area Reference Center
Special Programs: Group & individual tours
Card Catalog
Cataloged Volumes: 16,000
Serial Titles: 104
Subjects: Art, decorative arts, architecture, graphics, photography, music, dance, costume

AL 33
BEVERLY HILLS PUBLIC LIBRARY
Art Research Library
444 N Rexford Dr, Beverly Hills, CA 90210
Tel: 213-550-4720
Libn: Nicholas Cellini

Public Library Founded: 1974
Hours: Mon, Wed, Fri 10-6
 Tues, Thurs 10-9
Circulation: (open stacks restricted to library use)
Reference Service: Telephone, mail
Reprographic Services: Yes
Interlibrary Loan: Metropolitan Cooperative Loan System
Networks/Consortia: No
Card Catalog
Cataloged Volumes: 10,000
Serial Titles: 35
Holdings: 40 vertical file drawers; 500 sales & auction catalogs; 3,000 exhibition catalogs; 5,000 theatre & dance photos
Subjects: Art, decorative arts, film & video, graphics, photography, theatre, dance
Special Collection:
Dorothi Bock Pierre Collection
Collection of rare & limited editions of books, photographs, programs & periodicals relating to dance & theatre.

AL 34
BRUGGEMEYER MEMORIAL LIBRARY
318 S Ramona Ave, Monterey Park, CA 91754
Tel: 213-573-1412
Libn: Colin Lucas

Public Library
Hours: Mon-Thurs 10-9
 Fri 10-6
 Sat 10-5
 Sun 1-5 (closed Sun during summer)
Circulation: Public (open stacks)
Reference Service: In person, telephone, mail
Reprographic Services: Yes
Interlibrary Loan: Metropolitan Cooperative Library District; Southern California Interlibrary Loan
Networks/Consortia: Metropolitan Cooperative Library District
Publications: In-house periodical index
Special Programs: Group & individual tours; intern program
Cataloged Volumes: 125,000 volumes (not exclusively art)
Serial Titles: 400
Holdings: 2,100 microfilms
Subjects: Art, architecture, classical archaeology, dance, decorative arts, film & video, graphics, music, photography, theatre

AL 35
CABOT'S OLD INDIAN PUEBLO MUSEUM LIBRARY
67-616 E Desert View, Desert Hot Springs, CA 92240
Tel: 714-329-7610
Curator: C H Eyraud

Museum Founded: 1969
Hours: Wed-Mon 9:30-5
Circulation: Restricted to museum (open stacks)
Reference Service: In person, telephone
Reprographic Services: No
Interlibrary Loan: No
Networks/Consortia: No
Special Programs: Group & individual tours
Holdings: 50 vertical file drawers
Subjects: Art, architecture, history

AL 36
CALIFORNIA COLLEGE OF ARTS & CRAFTS
Meyer Library
Broadway & College, Oakland, CA 94618
Tel: 415-653-8118, Ext 32
Libn: Robert L Harper

Art School Founded: 1907
Hours: Mon-Thurs 8-7
 Fri 8-5
 Mon-Fri 8-5 (summer)
Circulation: Public (open stacks)
Reference Service: Telephone, mail
Reprographic Services: Yes
Interlibrary Loan: No
Networks/Consortia: Union of Independent Colleges of Art
Publications: Acquisitions list
Special Programs: Group tours; single lectures
Card Catalog
Cataloged Volumes: 25,300 (25,100 titles)
Serial Titles: 225
Holdings: 29 vertical file drawers

Subjects: Art, decorative arts, architecture, film & video, graphics, photography, music, theatre, dance
Special Collection:
Jo Sinel Collection
Father of American Industrial Design (1889–1975). Collection of two- & three-dimensional industrial & commercial design materials, package design & models. Includes copies of books designed, paintings & slides.

AL 37
CALIFORNIA INSTITUTE OF THE ARTS LIBRARY
24700 McBean Pkwy, Valencia, CA 91355
Tel: 805-255-1050, Exts 225; 241
Libn: Elizabeth Armstrong

Art School Founded: 1968
Hours: Mon-Thurs 9-10
 Fri 9-5
 Sat-Sun 11-5
Circulation: Students, faculty/staff; restricted use of reference, periodicals, permanent reserve (open stacks except for permanent & faculty reserves, film & slide library)
Reference Service: Telephone, mail
Reprographic Services: No
Interlibrary Loan: NILS; Total Interlibrary Exchange
Networks/Consortia: Black Gold Cooperative Library System
Publications: Orientation handbook; in-house periodical list
Special Programs: Group & individual tours; bibliographic instruction; single lectures
Card Catalog; also periodical index
Cataloged Volumes: 73,061 (30,252 titles)
Serial Titles: 515 (247 continuations)
Holdings: Vertical files; 5134 exhibition catalogs; 5264 microfilm reels, 2100 fiche
Subjects: Art, decorative arts, architecture, classical archaeology, film & video, graphics, photography, music, theatre, dance
Special Collection: Art of the 20th century

AL 38
CALIFORNIA STATE UNIVERSITY OF LONG BEACH
California State University Library
1250 Bellflower Blvd, Long Beach, CA 90840
Tel: 213-498-4023
Libn: Henry J DuBois

Academic Founded: 1949
Hours: 7:30-12 (during regular sessions)
Circulation: Students, faculty/staff (open stacks, except for rare books)
Reference Service: In person, telephone, mail
Reprographic Services: Yes
Interlibrary Loan: NILS; Intersegmental Lending & Borrowing Service
Networks/Consortia: Libraries of Orange County Network
Publications: Orientation handbook, bibliographies, newsletter
Special Programs: Group & individual tours; bibliographic instruction; single lectures
Card Catalog
Cataloged Volumes: 25,800
Serial Titles: 90 (California State University & Colleges Union List of Periodicals)
Holdings: 36 vertical file drawers
Subjects: Art, decorative arts, architecture, video, graphics, music

AL 39
CALIFORNIA STATE UNIVERSITY OF SACRAMENTO
Humanities Reference Department
6000 J St, Sacramento, CA 95819
Tel: 916-454-6218
Libn: Eugene Salmon

Academic Founded: 1947
 (became subject divisional 1959)
Hours: Mon-Thurs 8-11
 Fri 8-5
 Sat 9-5
 Sun 1-9
Circulation: Students, faculty/staff (open stacks; restricted use of periodicals, reference books, special collections)
Reference Service: In person, telephone, mail
Reprographic Services: Yes
Interlibrary Loan: NILS; Mountain Valley Loan System
Networks/Consortia: No
Special Programs: Group tours; single lectures; video cassette tours of library
Publications: Periodicals list
Card Catalog
Cataloged Volumes: 473,877 (297,991 titles)
Serial Titles: California State Univ & College Union List of Periodicals
Holdings: 18 vertical file drawers
Subjects: Art, decorative arts, architecture, classical archaeology, film & video, graphics, photography, music, theatre, dance

AL 40
CLAREMONT COLLEGES
Hunnold & Denison Libraries
Claremont, CA 91711
Tel: 714-626-8511, Ext 2221

Academic
Hours: Mon-Fri 8-11
 Sat-Sun 12-5
Circulation: Students, faculty/staff (open stacks)
Reference Service: In person
Reprographic Services: Yes
Interlibrary Loan: NILS
Networks/Consortia: No
Card Catalog
Subjects: Art, decorative arts, architecture, classical archaeology, film & video, graphics, photography, music, theatre, dance

AL 41
COSUMNES RIVER COLLEGE
Learning Resource Center
8401 Center Pkwy, Sacramento, CA 95823
Tel: 916-421-1000, Ext 249
Asst Dean, Learning Resources: Terry Kastanis

Academic Founded: 1970
Hours: Mon-Thurs 7:30-9:30
 Fri 7:30-4
 Sat 11-3
Circulation: Students, faculty/staff (open stacks)
Reference Service: In person, telephone, mail
Reprographic Services: Yes
Interlibrary Loan: Mountain Valley Library System
Networks/Consortia: Television Consortium of Valley Colleges

Publications: Orientation handbook; bibliographies; acquisitions list; newsletter; in-house periodical index (Cosumnes River College Periodicals Holdings)

Special Programs: Group & individual tours; bibliographic instruction; single lectures; Learning Resource Center Skills course (on slides & tape)

Cataloged Volumes: 54,467 (45,000 titles)

Serial Titles: 878 (California Union List of Periodicals)

Holdings: 24 vertical file drawers; 1,738 microform titles

Subjects: Art, architecture, classical archaeology, dance, decorative arts, film & video, graphics, music, photography, theatre

Special Collections:

American West Collection

Collection of five Western printing items & general Western Americana.

Environmental Design Portfolios

Third World Materials

AL 42
CRAFT & FOLK ART MUSEUM
5814 Wilshire Blvd, Los Angeles, CA 90036
Tel: 213-937-5544
Libn: Joan M. Benedetti

Museum Founded: 1975

Hours: Wed 11-5, or by appointment

Circulation: Faculty/staff (open stacks, public use only with librarian present)

Reference Service: In person

Reprographic Services: Yes

Interlibrary Loan: No

Networks/Consortia: No

Publications: Newsletter

Card Catalog

Cataloged Volumes: 300

Serial Titles: 10

Holdings: 2 vertical file drawers; 100 exhibition catalogs, 2,000 slides

Subjects: Art, decorative arts, architecture, international folk art & crafts

AL 43
E B CROCKER ART GALLERY LIBRARY
216 O St, Sacramento, CA 95814
Tel: 916-336-3677
Dir: Richard V West

Museum Founded: 1885

Hours: Tues 2-10
 Wed-Sun 10-5

Circulation: Researchers, staff, docents; restricted to use within museum

Reference Service: Telephone, mail

Reprographic Services: Yes; written permission necessary for publication

Interlibrary Loan: No

Networks/Consortia: No

Publications: Newsletter; special catalogs

Special Programs: Group tours; single lectures

Card Catalog

Cataloged Volumes: 500 (525 in process)

Holdings: 300 exhibition catalogs

Subjects: Art, decorative arts, architecture, graphics

Special Collections: Books, catalogs, monographs, ephemera on the Old Masters; books about James M Whistler; manuscript material of art historian and curator N S Trivas

AL 44
FINE ARTS GALLERY OF SAN DIEGO
Art Reference Library
Box 2107, San Diego, CA 92112
Tel: 714-232-7931, Ext 28
Libn: Nancy J Andrews

Museum Founded: 1926

Hours: Tues-Thurs 9:30-12:30
 Fri 12:30-4:30
 Sat 10-12:30; 1:30-4:30

Circulation: Restricted to members & students (open stacks)

Reference Services: In person, mail to libraries

Reprographic Services: No

Interlibrary Loan: No

Networks/Consortia: No

Card Catalog

Cataloged Volumes: 6,847

Holdings: 10,000 sales & auction catalogs; 12,500 exhibition catalogs

Subjects: Art, decorative arts, architecture

AL 45
FINE ARTS MUSEUMS OF SAN FRANCISCO LIBRARY
M H de Young Memorial Museum
Golden Gate Park, San Francisco, CA 94118
Tel: 415-558-2887
Libn: Jane Nelson

Museum Founded: 1955

Circulation: Restricted to use by faculty/staff of museum

Reference Service: Limited to telephone & mail which cannot be answered elsewhere

Reprographic Services: Yes

Interlibrary Loan: No

Networks/Consortia: No

Card Catalog

Cataloged Volumes: 20,000

Serial Titles: 46

Holdings: c 5,000 sales & auction catalogs; 6,000 exhibition catalogs

Subjects: Art, decorative arts, architecture, classical archaeology, graphics, Africa, Oceania, American Indian, pre-Columbian

Special Collection:

Achenbach Foundation for Graphic Arts

3,500 books on graphic arts.

AL 46
FULLERTON PUBLIC LIBRARY
353 W Commonwealth Ave, Fullerton, CA 92632
Tel: 714-871-9440
City Libn: Jean Nelson

Public Library

Hours: Mon-Fri 9-9
 Sat 9-6
 Sun 1-5

Circulation: Public (open stacks)

Reference Service: In person, telephone, mail

Reprographic Services: No

Interlibrary Loan: American Library Association Interlibrary Loan Code

Networks/Consortia: Santiago Library System; Libraries of Orange County Network

Publications: In-house periodical index

Special Programs: Group & individual tours; bibliographic instruction; bookmobile

Cataloged Volumes: 187,000
Serial Titles: 524 (California Union List of Periodicals)
Holdings: 30 vertical file drawers; 8,700 microfiche
Subjects: Art, architecture, classical archaeology, dance, decorative arts, film & video, graphics, music, photography, theatre

AL 47
THE GAMBLE HOUSE
Greene & Greene Library
4 Westmoreland, Pasadena, CA 91103
Tel: 213-793-3334
Curator: Randell L Makinson

Museum Founded: 1968
Hours: Mon-Fri 1-4
Circulation: Restricted to within library (open stacks)
Reference Service: In person only
Reprographic Services: Yes
Interlibrary Loan: Avery Architecture Library—Columbia University; Documents Collection, College of Environmental Design
Networks/Consortia: (see above)
Cataloged Volumes: 400 (390 titles)
Serial Titles: 3
Holdings: 4 vertical file drawers; 1,000 microforms; 400 slides of architecture; 200 boxes of information regarding Greene & Greene client homes
Special Collection:
Greene & Greene Collection
Information & examples of architecture, Tiffany, arts & crafts movement, period craftsmen; Greene & Greene pottery & photographs.

AL 48
THE J PAUL GETTY MUSEUM LIBRARY—PHOTO ARCHIVES
17985 Pacific Coast Hwy, Malibu, CA 90265
Tel: 213-459-2306
Libn: Katherine Jones

Museum Founded: 1953
Hours: Tues-Fri 10-5 (by appointment)
Circulation: Faculty/staff (open stacks)
Reference Service: In person (limited), mail
Reprographic Services: Yes
Interlibrary Loan: NILS
Networks/Consortia: No
Special Programs: Group & individual tours, library school intern program
Card Catalog
Cataloged Volumes: 25,000
Serial Titles: 59
Holdings: 3 vertical file drawers; 400 reels of microfilm
Subjects: Greek & Roman art, European Old Master paintings, French decorative art

AL 49
GLENDALE PUBLIC LIBRARY
Brand Library
1601 W Mountain St, Glendale, CA 91201
Tel: 213-956-2051
Libn: Jane Hagan

Public Library Founded: 1956
Hours: Tues 12-9
 Wed 12-6
 Thurs 12-9

Fri-Sat 12-6
Sun 1-5 (mid Sept-June)
Closed Mon
Circulation: Public (open stacks)
Reference Service: In person, telephone
Reprographic Services: No
Interlibrary Loan: No
Networks/Consortia: Metropolitan Cooperative Library System cards honored
Publications: In-house periodical index
Special Programs: Bibliographic instruction; monthly art exhibits; concerts; art & music oriented lectures; dance program
Card Catalog
Cataloged Volumes: 31,355
Serial Titles: 80
Holdings: 15 vertical file drawers; 20,000 phonograph records; 1,000 cassettes; 2,000 exhibition catalogs
Subjects: Art, architecture, crafts, decorative arts, graphics, music, photography
Special Collections:
Dieterle Collection
Mounted clippings & illustrations of art historical periods & artists.
Edwards Collection
Scrapbooks of illustrations from 19th & early 20th century magazines. Examples of well-known illustrators.
Photography Journal Collection
Early 20th century European & American journals.

AL 50
HUMBOLDT STATE UNIVERSITY LIBRARY
Arcata, CA 95521
Tel: 707-826-3416
Art Bibliographer: Lucy L Butcher

Academic Founded: 1913
Hours: Mon-Thurs 7:30-12
 Fri 7:30-6
 Sat & Sun 11-5
Circulation: Public (open stacks)
Reference Service: In person, telephone, mail
Reprographic Services: Yes
Interlibrary Loan: NILS; California State Universities & Colleges Interlibrary Loan System (Betty Jain, Interlibrary Loan)
Networks/Consortia: North State Cooperative Library Service
Publications: In-house periodical index (Humboldt State University Periodical List)
Special Programs: Group & individual tours; single lectures
Serial Titles: 2,500 (California State Universities & Colleges Union List of Periodicals)
Subjects: Art, architecture, classical archaeology, dance, decorative arts, film & video, graphics, music, photography, theatre

AL 51
HENRY E HUNTINGTON LIBRARY & ART GALLERY
Art Reference Library
1151 Oxford Rd, San Marino, CA 91108
Tel: 213-792-6141
Curator: Robert R Wark

Museum Founded: 1934
Hours: 8:30-11:45; 1-4:20

Circulation: Restricted to British art scholars (open stacks)
Reference Service: In person
Reprographic Services: Yes
Interlibrary Loan: No
Networks/Consortia: No
Card Catalog
Cataloged Volumes: 12,000
Holdings: 25 vertical file drawers; 5000 exhibition catalogs
Subjects: Art, decorative arts, architecture
Special Collection: Photographic archive of British paintings.

AL 52
JR ARTS CENTER IN BARNSDALL PARK
Center Library
4814 Hollywood Blvd, Los Angeles, CA 90027
Tel: 213-666-1093
Dir: Claire Isaacs

Art School Founded: 1967
Hours: Mon-Fri 9-5
Circulation: Restricted to faculty/staff for classroom resources
Reprographic Services: No
Interlibrary Loan: No
Networks/Consortia: No
Cataloged Volumes: 1,500-2,000
Subjects: Art, decorative arts, architecture, film & video, graphics, photography, natural history
Special Collection: Picture books on natural history.

AL 53
LA JOLLA MUSEUM OF CONTEMPORARY ART
 LIBRARY
700 Prospect St, La Jolla, CA 92037
Tel: 714-454-0183
Libn: Gail Richardson

Museum Founded: 1940
Hours: 10-4
Reference Service: In person
Reprographic Services: No
Interlibrary Loan: NILS
Networks/Consortia: No
Card Catalog
Cataloged Volumes: 2,000
Holdings: 12 vertical file drawers; file boxes; 40 artists, 82 subject, 88 museums, 40 foreign galleries & museums
Subjects: Art, architecture, graphics, photography

AL 54
LIBRARY ASSOCIATION OF LA JOLLA
Atheneum Music & Arts Library
1008 Wall St, La Jolla, CA 92037
Tel: 714-454-5872
Libn: Lynn Neumann

Private Library Founded: 1899
Hours: Tues-Sat 10-5:30
Circulation: Restricted to members only (open stacks)
Reference Service: In person, telephone, mail
Reprographic Services: No
Interlibrary Loan: No
Networks/Consortia: No
Special Programs: Group & individual tours
Card Catalog
Cataloged Volumes: 11,700
Serial Titles: 47

Holdings: Limited vertical file
Subjects: Art, decorative arts, architecture, graphics, photography, music, theatre, dance

AL 55
LONG BEACH PUBLIC LIBRARY
Performing Arts Department
101 Pacific Ave, Long Beach, CA 90802
Tel: 213-436-9225
Libn: Natalee Collier

Public Library
Hours: Mon-Thurs 10-9
 Fri-Sat 10-5:30
 Sun 1:30-5
Circulation: Public (open stacks; restrictions on sheet music)
Reference Service: In person, telephone
Reprographic Services: Yes
Interlibrary Loan: NILS
Networks/Consortia: No
Publications: Film catalogs, in-house periodical index
Special Programs: Group tours; intern program
Card Catalog
Cataloged Volumes: 32,801
Serial Titles: 61 (National Union Catalog)
Holdings: 276 vertical file drawers
Subjects: Art, decorative arts, architecture, classical archaeology, film & video, graphics, photography, music, theatre, dance
Special Collection: Extensive, indexed sheet music collection; 20,000 records

AL 56
LOS ANGELES COUNTY MUSEUM OF ART
Art Research Library
5905 Wilshire Blvd, Los Angeles, CA 90036
Tel: 213-937-4250, Ext 219
Libn: Eleanor C Hartman

Museum Founded: 1965
Hours: Tues-Fri 10-4:30
Circulation: Faculty/staff (open stacks, restrictions on special collections)
Reference Service: In person
Reprographic Services: Yes; no photographs or microfilm
Interlibrary Loan: NILS
Networks/Consortia: No
Special Programs: Intern program
Card Catalog
Cataloged Volumes: 54,000
Serial Titles: 1,582 (Union List of Periodicals in Southern California Libraries)
Holdings: 80 vertical file drawers; 15,000 sales & auction catalogs; 5,500 exhibition catalogs; 19,230 microforms
Subjects: Art, decorative arts, architecture, classical archaeology, film & video, graphics, photography, music, theatre
Special Collections: Art of India; Renaissance & Baroque art; 19th & 20th century paintings, textiles, costumes

AL 57
LOS ANGELES PUBLIC LIBRARY
Art, Music & Recreation Department
630 W Fifth St, Los Angeles, CA 90071
Tel: 213-626-7461, Ext 257
Libn: Katherine E Grant

Public Library Founded: 1872

Hours: Mon 10-9
 Tues-Sat 10-5:30
Circulation: Public (3/5 of collection in closed stacks)
Reference Service: In person, telephone, mail
Reprographic Services: Yes
Interlibrary Loan: NILS; Southern California Interlibrary
 Loan
Networks/Consortia: No
Special Programs: Group tours; bibliographic instruction;
 intern program
Card Catalog
Cataloged Volumes: 175,000
Holdings: 95 vertical file drawers; sales & auction catalogs;
 microforms
Subjects: Art, decorative arts, architecture, film & video,
 graphics, photography, music, dance, recreation

AL 58
METRO GOLDWYN MAYER STUDIO
Research Dept Library
10202 Washington Blvd, Culver City, CA 90230
Tel: 213-836-3000, Ext 1474; 1475
Head: James J Earle

Motion Picture & Television Studio Founded: 1929
Circulation: Public; fee charged (open stacks)
Reference Service: In person, telephone, mail
Reprographic Services: Yes
Interlibrary Loan: Informal agreements with other motion
 picture research departments
Networks/Consortia: No
Publications: Magazine analytic file
Special Programs: Group tours for library students; intern
 program
Holdings: 550 vertical file drawers
Subjects: Art, architecture, classical archaeology, costume,
 dance, decorative arts, graphics, music, photography,
 theatre
Special Collections: Pictorial coverage on all subjects.

AL 59
MILLS COLLEGE LIBRARY
Oakland, CA 94613
Tel: 415-632-2700, Ext 260
Libn: Laura L Blomquist

Academic
Hours: Mon-Thurs 8:30-10
 Fri 8:30-5
 Sat 12-5
 Sun 1-10
Circulation: Students, faculty/staff; researchers may use re-
 sources in-house (stacks open to Mills-users only)
Reference Service: In person, telephone, mail
Reprographic Services: Yes
Interlibrary Loan: NILS; Stanford University Interlibrary
 Loan
Networks/Consortia: California Library Authority for
 Systems & Services
Publications: Bibliographies; in-house periodical index
Special Programs: Group & individual tours; bibliographic
 instruction; single lectures
Serial Titles: (National Union Catalog)
Subjects: Art, architecture, classical archaeology, dance,
 decorative arts, graphics, music, photography, theatre,
Special Collection:
Albert M Bender Collection
Historical collection of graphic arts & original book illus-

trations. Extensive collection of fine bindings & books on
the history & technique of bookbinding. Early-printed
treatises on perspective, color theory, architecture &
artists' lives. Extensive collection relating to dance &
dancers from the 16th-20th centuries.

AL 60
MONROVIA PUBLIC LIBRARY
Audio-Visual Department
321 S Myrtle Ave, Monrovia, CA 91016
Tel: 213-358-0174
City Libn: John Lustig

Public Library
Hours: Mon, Tues & Wed 10-9
 Thurs, Fri & Sat 10-6
Circulation: Public (open stacks)
Reference Service: In person, telephone
Reprographic Services: Yes
Interlibrary Loan: Southern California Interlibrary Loan;
 Metropolitan Cooperative Library System
Networks/Consortia: Southern California Answering Net-
 work
Publications: Bibliographies, in-house periodical index
 (Index of Monrovia Periodical Holdings)
Serial Titles: (Union List of Periodicals for the Metropolitan
 Cooperative Library System; San Gabriel Community
 College Library Cooperative)
Subjects: Art, architecture, classical archaeology, dance,
 decorative arts, film & video, music, photography, theatre

AL 61
MOUNT SAINT MARY'S COLLEGE
Charles Willard Coe Memorial Library
12001 Chalon Rd, Los Angeles, CA 90049
Tel: 213-476-2237, Ext 233
Head Libn: Deirdre D Ford

Academic Founded: 1925
Hours: Mon-Thurs 8-9
 Fri 8-5
 Sat 1-5
 Sun 6-9
Circulation: Public (open stacks)
Reference Service: Yes
Reprographic Services: Yes
Interlibrary Loan: NILS; Southern California Interlibrary
 Loans
Networks/Consortia: OCLC
Publications: In-house periodical index
Special Programs: Individual tours; bibliographic instruction
Cataloged Volumes: 124,017 (92,400 titles)
Serial Titles: 638
Holdings: 12 vertical file drawers; 293 microform titles
Subjects: Art, decorative arts, music, photography, theatre

AL 62
OAKLAND MUSEUM
Art Department Library
1000 Oak St, Oakland, CA 94607
Tel: 415-273-3005
Acting Art Libn: Odette Mayers

Museum Founded: 1916; 1969
Hours: Tues-Fri 8:30-12; 1-5
Circulation: Faculty/staff; material available to public for
 in-house use (closed stacks)

Reference Service: In person, telephone, mail
Reprographic Services: No
Interlibrary Loan: No
Networks/Consortia: No
Special Programs: Group & individual tours by special
 request
Cataloged Volumes: 2,500
Serial Titles: 30
Holdings: 100 vertical file drawers; 2,000 microforms; 2,500
 exhibition catalogs; 500 binders
Subjects: Art, architecture, decorative arts, graphics, photog-
 graphy
Special Collections: Archives of California Art; American
 Art; Western Art

AL 63
OAKLAND PUBIC LIBRARY
Fine Arts Department
125 14 St, Oakland, CA 94612
Tel: 415-273-3176
Libn: Richard Colvig

Public Library Founded: 1868
Hours: Mon 12:30-9
 Tues-Thurs 9-9
 Fri-Sat 9-5:30
Circulation: Public (open stacks)
Reference Service: Telephone, mail
Reprographic Services: Yes
Interlibrary Loan: NILS; East Bay Information Center
Networks/Consortia: Bay Area Reference Center; Berkeley/
 Oakland Service System
Publications: Subject booklists
Information Sources: Novotny, Ann. *Picture Sources 3,*
 Special Libraries Assn, 1975; Pavlakis, Christopher.
 American Music Handbook, Macmillan, 1974
Special Programs: Intern program
Card Catalog
Cataloged Volumes: 18,000
Serial Titles: 90 (Union List of Serials in San Francisco &
 Bay Region Libraries)
Holdings: 8 vertical file drawers; 1,600 exhibition catalogs;
 California Artist Biography file
Subjects: Art, decorative arts, architecture, film & video,
 graphics, photography, music, theatre, dance, arms, cos-
 tume, fashion, sports, recreation
Special Collection: Fine arts pictures, original prints, World
 War I & II posters, costume index, local architectural
 periodicals prior to 1929 index, Art Deco Movement col-
 lection

AL 64
ONTARIO CITY LIBRARY
215 East C St, Ontario, CA 91764
Tel: 714-984-2758

Public Library Founded: 1885
Hours: Mon-Thurs 9:30-9
 Fri & Sat 8-5
 Sun 1-5
Circulation: Public (open stacks)
Reference Service: Yes
Reprographic Services: Yes
Interlibrary Loan: NILS; Inland Library System; Sirculs
 Network
Networks/Consortia: Inland Library System; Sirculs
 Network

Publications: Orientation handbook; bibliographies
Special Programs: Group & individual tours; bibliographic
 instruction; single lectures; intern program
Cataloged Volumes: 175,876 (148,617 titles)
Serial Titles: 652 (Inland Library System Union List of
 Serials; California State Union List of Serials)
Holdings: 63,054 vertical file drawers; 4,675 microforms
Subjects: Art, architecture, dance, decorative arts, graphics,
 music, photography, theatre
Special Collections:
Braille & Talking Book Collection
Model Colony Local History Collection
Books, pamphlets & artifacts relating to the history of
 Ontario.

AL 65
OTIS ART INSTITUTE LIBRARY
627 S Carondelet St, Los Angeles, CA 90057
Tel: 213-387-5288
Libn: Joan Hugo

Art School Founded: 1954
Hours: Mon-Thurs 8:30-7
 Fri 8:30-5
Circulation: Students, faculty/staff (open stacks)
Reference Service: In person
Reprographic Services: No
Interlibrary Loan: No
Networks/Consortia: No
Publications: Orientation handbook, acquisitions list
Special Programs: Orientation workshop for student workers
Card Catalog
Cataloged Volumes: 24,000 (15,000 titles)
Serial Titles: 350
Holdings: 21 vertical file drawers; 54 drawers of exhibition
 catalogs; also posters & maps
Subjects: Art, decorative arts, architecture, film & video,
 graphics, photography, music
Special Collection: Illustrated books of artists' lives & works,
 artists' books

AL 66
PALOMAR COMMUNITY COLLEGE
Fine Arts Library
W Mission Rd, San Marcos, CA 92128
Tel: 714-744-1150, Ext 277
Reference Libn: Judy Cater

Academic Founded: 1947; 1968
Hours: Mon-Thurs 7:30-8:50
 Fri 7:30-4
 Sat 10-2
Circulation: Public (open stacks)
Reference Service: In person, telephone, mail
Reprographic Services: Yes
Interlibrary Loan: NILS; San Diego County Interlibrary
 Loan; California State Library System
Networks/Consortia: San Diego Metro; Sierra Regional
 Library System, San Diego County
Publications: Bibliographies; in-house periodical index
Special Programs: Group & individual tours; bibliographic
 instruction
Cataloged Volumes: 10,000
Serial Titles: 101
Holdings: 9 vertical file drawers; microforms; music scores;
 art tapes; sheet music; phonograph records
Subjects: Art, architecture, classical archaeology, crafts,
 decorative arts, graphics, music, photography

AL 67
PALOS VERDES LIBRARY DISTRICT
Audio-Visual Department
650 Deep Valley Dr, Palo Verdes Peninsula, CA 90274
Tel: 213-377-9584, Exts 37; 38; 39
Supervisor: J R Clifford

Public Library Founded: 1926
Hours: Mon-Fri 10-9
 Sat 10-6
 Sun 1-5
Circulation: Public (open stacks)
Reference Service: In person, telephone, mail
Reprographic Services: Yes
Interlibrary Loan: NILS
Networks/Consortia: Metropolitan Cooperative Library System; Public Library Film Circuit; Southern California Film Circuit
Publications: Bibliographies; special catalogs; book catalog; in-house periodical list; 16mm film catalog
Information Source: Brown, James. *New Media in Public Libraries,* Jeffrey Norton Publisher/Gaylord 1976
Special Programs: Group & individual tours; bibliographic instruction; single lectures; library skills; intern program
Card Catalog
Cataloged Volumes: 221,632 (92,225 titles)
Serial Titles: 507 (California State Union List)
Holdings: 52 vertical file drawers; 9,370 microforms
Subjects: Art, decorative arts, architecture, classical archaeology, film & video, graphics, photography, music, theatre, dance

AL 68
PASADENA PUBLIC LIBRARY
Fine Arts Division
285 E Walnut St, Pasadena, CA 91101
Tel: 213-577-4049
Fine Arts Coordinator: Josephine M Pletscher

Public Library Founded: 1927 (fine arts division)
Hours: Mon-Thurs 9-9
 Fri & Sat 9-6
 Sun 1-5
Circulation: Public (open stacks except for rare materials & back issues of periodicals)
Reference Service: In person, telephone, mail
Reprographic Services: Yes
Interlibrary Loan: NILS; Metropolitan Cooperative Library System; Southern California Interlibrary Loan System
Networks/Consortia: Southern California Answering Network
Publications: Special catalogs; bibliographies; in-house periodical index (Pasadena Public Library Currently Received Periodicals)
Special Programs: Group tours; single lectures; intern program
Cataloged Volumes: 23,326
Serial Titles: 115 (Metropolitan Cooperative Library System & San Gabriel Community Library Cooperative Union List of Periodicals; California Union List of Periodicals)
Holdings: 68 vertical file drawers; 6 Princeton files of sales & auction catalogs; 13 Princeton files of exhibition catalogs; records; cassettes
Subjects: Art, architecture, classical archaeology, dance, decorative arts, film & video, graphics, music, photography

Special Collections:
Architecture Collection
Scrapbooks relating to California architecture & architects.
Coffin Fun Art Books

AL 69
PLACER COUNTY MUSEUM LIBRARY
1273 High St, Auburn, CA 95603
Tel: 916-885-9570
Curator: Cevera Ingraham

Museum Founded: 1948
Hours: Mon-Fri 10-4
 Sat-Sun 10-5
Circulation: Public
Reference Service: In person, telephone, mail
Reprographic Services: Yes
Interlibrary Loan: No
Networks/Consortia: No
Special Programs: Group & individual tours
Card Catalog
Subjects: Art, photography

AL 70
POMONA PUBLIC LIBRARY
Reference, Interlibrary Loan, Special Collections & Audio-Visual
625 S Garey Ave, Pomona, CA 91766
Tel: 714-620-2033
City Libn: Halbert Watson

Public Library Founded: 1887
Hours: Mon-Thurs 10-9
 Fri & Sat 10-5
Circulation: Public (open stacks)
Reference Service: In person, telephone, mail
Reprographic Services: Yes
Interlibrary Loan: NILS; Southern California Interlibrary Loan
Networks/Consortia: Metropolitan Cooperative Library Systems; Southern California Answering Network
Publications: Bibliographies; in-house periodical index
Special Programs: Group & individual tours; single lectures; intern program
Holdings: 61 vertical file drawers (special collections); 250 microforms (special collections)
Subjects: Art, graphics, photography
Special Collections: Photographs of the Southwest United States

AL 71
PRESIDIO OF MONTEREY MUSEUM LIBRARY
Presidio of Monterey, Bldg S-113, Monterey, CA 93940
Tel: 408-242-8547
Curator: Margaret B Adams

Museum Founded: 1965
Hours: Thurs-Mon 9-12:30; 1:30-4
Circulation: Restricted to museum
Reprographic Services: No
Interlibrary Loan: No
Networks/Consortia: No
Special Programs: Group & individual tours; bibliographic instruction; single lectures
Card Catalog
Cataloged Volumes: 150
Holdings: 3 vertical file drawers
Subjects: Archaeology of California

AL 72
RICHMOND ART CENTER LIBRARY
25 St & Barrett Ave, Richmond, CA 94804
Tel: 415-234-2397
Dir: Ernie Kim

Art School–Museum Founded: 1936
Circulation: Restricted to member students & faculty/staff
Reprographic Services: No
Interlibrary Loan: No
Networks/Consortia: No
Publications: Orientation handbook; newsletter; special catalogs
Special Programs: Group & individual tours; workshops & seminars by artists
Card Catalog
Cataloged Volumes: 300 (60 titled art works)
Holdings: Sales & auction catalogs
Subjects: Art, decorative arts
Special Collection: 19th century European artists, contemporary paintings

AL 73
THE ROBERT GORE RIFKIND COLLECTION
9454 Wilshire Blvd, Beverly Hills, CA 90212
Tel: 213-278-0970
Asst Curator: Karen Reed

Private Collection Founded: 1970
Hours: By appointment only
Circulation: No (closed stacks)
Reference Service: No
Reprographic Services: No
Interlibrary Loan: No
Networks/Consortia: No
Publications: Special catalogs; in-house periodical index
Information Source: Reed, O P Jr. *German Expressionist Art: The Robert Gore Rifkind Collection,* Frederick S Wight Art Gallery, 1977
Cataloged Volumes: 3,000
Holdings: 500-1,000 sales & auction catalogs; 200 exhibition catalogs; illustrated books; periodicals
Subjects: Art, architecture, dance, decorative arts, graphics, music, oil painting, sculpture, theatre

AL 74
SAN DIEGO PUBLIC LIBRARY
Art, Music & Recreation Section
820 E St, San Diego, CA 92101
Tel: 714-236-5810
Libn: Barbara A Tuthill

Public Library Founded: 1954
Hours: Mon-Thurs 10-9
 Fri-Sat 9:30-5:30
Circulation: Public (open stacks)
Reference Service: In person, telephone, mail
Reprographic Services: Yes
Interlibrary Loan: NILS; Metropolitan Cooperative Library System
Networks/Consortia: Sierra Regional Library System
Publications: Acquisitions list
Special Programs: Group tours
Card Catalog
Cataloged Volumes: 52,000
Serial Titles: 250

Subjects: Art, decorative arts, architecture, film & video, graphics, photography, music, theatre, dance
Special Collection: 1,500 volumes on Oriental art

AL 75
SAN FRANCISCO ART INSTITUTE
Anne Bremer Memorial Library
800 Chestnut St, San Francisco, CA 94133
Tel: 415-771-7020, Ext 59

Art School Founded: 1871
Hours: Mon-Thurs 9-8 (fall & spring)
 Fri 9-5 (fall & spring)
 Mon-Thurs 9-5 (summer)
Circulation: Students, researchers, faculty/staff (open stacks; rare, archival & artists' books non-circulating)
Reference Service: In person, telephone, mail
Reprographic Services: Yes
Interlibrary Loan: No
Networks/Consortia: No
Special Programs: Group tours
Card Catalog
Cataloged Volumes: 19,610 (13,287 titles)
Serial Titles: 233
Holdings: 8 vertical file drawers; 1976 exhibition catalogs
Subjects: Art, decorative arts, architecture, classical archaeology, film & video, graphics, photography, music, theatre, dance
Special Collection: San Francisco Art Institute Archives

AL 76
SAN FRANCISCO MARITIME MUSEUM
J Porter Shaw Library
Foot of Polk St, San Francisco, CA 94109
Tel: 415-673-0700
Libn: David Hull

Museum Founded: 1952
Hours: Mon-Fri 10-5
Circulation: Faculty/staff; other museums
Reference Service: Telephone
Reprographic Services: Yes
Interlibrary Loan: No
Networks/Consortia: No
Publications: Newsletter; in-house periodical index
Special Programs: Individual tours, bibliographic instruction
Card Catalog
Cataloged Volumes: 6,000 (5,000 titles)
Serial Titles: 94
Holdings: 1,020 collections; 800 maps
Subjects: Art, graphics, photography, ship plans
Special Collections: Maritime history; marine artists & photographers

AL 77
SAN FRANCISCO MUSEUM OF MODERN ART
Louise Sloss Ackerman Fine Arts Library
McAllister & Van Ness, San Francisco, CA 94102
Tel: 415-863-8800
Libn: Eugenie Candau

Museum Founded: 1935
Hours: Mon-Wed 1-5
Circulation: Public (open stacks for monographs & current periodicals only)
Reference Service: Telephone, mail
Reprographic Services: Yes

Interlibrary Loan: No
Networks/Consortia: Bay Area Reference Service of San
 Francisco Public Library
Special Programs: Group & individual tours; bibliographic
 instruction
Card Catalog
Cataloged Volumes: 5,000
Serial Titles: 100
Holdings: 108 vertical file drawers; 40,000 exhibition cata-
 logs; vertical file ephemera
Subjects: Art, decorative arts, architecture, film & video,
 graphics, photography
Special Collection: Art & artists of the 20th century

AL 78
SAN FRANCISCO PUBLIC LIBRARY
Art & Music Department
Civic Center, San Francisco, CA 94102
Tel: 415-558-3687
Libn: Mary Ashe

Public Library Founded: 1879
Hours: Mon-Thurs 9-9
 Fri-Sat 9-6
Circulation: Public (open stacks)
Reference Service: Telephone, mail
Reprographic Services: Yes
Interlibrary Loan: NILS
Networks/Consortia: No
Publications: Union List of Periodicals
Special Programs: Group tours
Card Catalog
Cataloged Volumes: 40,000
Serial Titles: 900 (National Union Catalog)
Holdings: 35 vertical file drawers; picture file with 1,000
 items
Subjects: Art, architecture, decorative arts, film & video,
 graphics, photography, music, theatre, dance

AL 79
SAN MARINO PUBLIC LIBRARY
1890 Huntington Dr, San Marino, CA 91108
Tel: 213-282-8484
Libn: Lois Ann Dienes

Public Library Founded: 1932
Hours: Mon-Thurs 9-9
 Fri-Sat 9-6
Circulation: Public (open stacks)
Reference Service: In person, telephone
Reprographic Services: Yes
Interlibrary Loan: NILS
Networks/Consortia: Metropolitan Cooperative Library
 System
Card Catalog
Cataloged Volumes: 83,000

AL 80
SANTA BARBARA PUBLIC LIBRARY
Art & Music Division
Box 1019, Santa Barbara, CA 93102
Tel: 805-962-7653
Libn: Linda Gaede

Public Library Founded: 1930 (library founded 1917)
Hours: Mon-Thurs 10-9
 Fri-Sat 10-5:30
 Sun 1-5

Circulation: Public (open stacks; closed reference area)
Reference Service: In person, telephone, mail
Reprographic Services: Limited quantities
Interlibrary Loan: NILS
Networks/Consortia: Black Gold Cooperative Library
 System
Card Catalog: Phonograph records only; microfilm catalog
Holdings: 130 vertical file drawers; sales & auction cata-
 logs; exhibition catalogs
Subjects: Art, decorative arts, architecture, film & video,
 graphics, photography, music

AL 81
NORTON SIMON MUSEUM LIBRARY
411 W Colorado Blvd, Pasadena, CA 91105
Tel: 213-449-6840
Libn: Amy R Navratil

Museum Founded: 1924
Hours: By appointment only
Circulation: Staff (open stacks)
Reference Service: No
Reprographic Services: Yes
Interlibrary Loan: No
Networks/Consortia: No
Cataloged Volumes: 4,000
Serial Titles: 30
Holdings: 21,200 sales & auction catalogs on microfiche;
 7,500 exhibition catalogs
Subjects: Art, graphics
Special Collections:
Blue Four Galka Scheyer Archives
Letters, monographs & exhibition catalogs on Klee, Kan-
 dinsky, Feininger & Jawlensky.
Knoedler Library
British, French, German, Swiss, Dutch, Belgian & American
 sales & auction catalogs from the 19th century to present.
 Museum publications & exhibition catalogs from US &
 Western European institutions including material from
 18th & 19th century Paris Salons.

AL 82
STANFORD UNIVERSITY ART LIBRARY
102 Cummings Art Bldg, Stanford, CA 94305
Tel: 415-497-3408
Libn: Alexander D Ross

Academic Founded: 1969
Hours: Mon-Thurs 8-10
 Fri 8-5
 Sat 9-5
 Sun 1-10
 Mon-Fri 8-5 (summer)
Circulation: Faculty/staff (for one-week loans; open stacks to
 Stanford & Berkeley faculty/staff & graduate students)
Reference Service: In person, telephone, mail
Reprographic Services: Yes
Interlibrary Loan: NILS (Interlibrary Loan, Stanford
 University Library)
Networks/Consortia: UC/Berkeley-Stanford Research
 Library Cooperative Program
Special Programs: Group & individual tours; bibliographic
 instruction; single lectures
Card Catalog
Cataloged Volumes: 90,000
Serial Titles: 505 (Stanford Union List of Serials)
Subjects: Art, decorative arts, architecture, classical archae-
 ology, graphics, photography

AL 83
UNIVERSITY OF CALIFORNIA AT DAVIS
Art Department Library
Davis, CA 95616
Tel: 916-752-3138
Libn: Barbara D Hoermann

Academic Founded: 1966
Hours: Mon-Fri 8-12; 1-5
Circulation: Public (open stacks)
Reference Service: In person
Reprographic Services: No
Interlibrary Loan: No
Networks/Consortia: No
Card Catalog
Serial Titles: 30
Holdings: 700 exhibition catalogs; 27 microforms
Subjects: Art, architecture, classical archaeology, graphics,
 photography

AL 84
UNIVERSITY OF CALIFORNIA AT DAVIS
The General Library
Davis, CA 95616
Tel: 916-752-2110
University Libn: Bernard Kreissman

Academic Founded: 1908
Hours: Mon-Thurs 8-12
 Fri 8-11
 Sat 10-6
 Sun 11-12
 Open for undergraduate study 24 hours, daily
Circulation: Public (open stacks)
Reference Service: In person, telephone, mail
Reprographic Services: Yes
Interlibrary Loan: NILS; US Dept of Agriculture Docu-
 ments Delivery System
Networks/Consortia: Tri System (includes Mountain-Valley
 Library System, North Bay Cooperative Library System,
 North State Cooperative Library System); Sierra
 Libraries Information Consortium; Northern Regional
 Library System
Publications: Orientation handbook; bibliographies; acqui-
 sitions list; newsletter; special catalogs; library informa-
 tion leaflets; in-house periodical index
Special Programs: Group tours; bibliographic instruction;
 single lectures; cassette tape tours
Card Catalog
Cataloged Volumes: 24,500 classified in fine arts
Serial Titles: 201 (National Union Catalog; University of
 California Union List of Serials & New Serial Titles)
Holdings: 2,700 major auction house catalogs; 300 exhibition
 catalogs including Chadwyck-Healy Art Exhibition cata-
 logs in microformat
Subjects: Art, architecture, dance, decorative arts, film &
 video, graphics, music, photography, theatre
Special Collections: Baird Archive of California Art;
 Performing Arts Collection (Donald Kunitz, Head,
 Shields Library, Dept of Special Collections)

AL 85
UNIVERSITY OF CALIFORNIA, BERKELEY
General Library
Berkeley, CA 94720
Tel: 415-642-5338; 6657
Art History/Classics Libn: Susan V Craig

Academic Founded: 1872
Hours: Mon-Thurs 8-10
 Fri 8-5
 Sat 9-5
 Sun 1-5
 During academic year
Circulation: Public (closed stacks except for faculty,
 graduate students & research cardholders)
Reference Service: In person, telephone, mail
Reprographic Services: Yes
Interlibrary Loan: NILS (Interlibrary Loan, Lending
 Division)
Special Programs: Group & individual tours
Cataloged Volumes: 56,800 art
Holdings: 10,000 exhibition catalogs (uncataloged)
Subjects: Art, architecture, classical archaeology, dance,
 decorative arts, film & video, graphics, music, photog-
 raphy, theatre
Special Collection:
Bancroft Library
Collection of rare books, manuscripts, illuminated manu-
 script facsimiles & Western Americana material.

AL 86
UNIVERSITY OF CALIFORNIA, IRVINE
University Library
Box 19557, Irvine, CA 92713
Tel: 714-833-5228
University Libn: John E Smith
Art Bibliographer: Marion Buzzard

Academic Founded: 1965
Circulation: Public (open stacks)
Reference Service: In person, telephone, mail
Reprographic Services: Yes
Interlibrary Loan: NILS; University of California Inter-
 library Loan System (Yvonne Wilson)
Networks/Consortia: Libraries of Orange County Network
Publications: Orientation handbook; bibliographies; news-
 letter; in-house periodical index
Special Programs: Group & individual tours; bibliographic
 instruction; single lectures
Cataloged Volumes: 782,822
Serial Titles: 11,851 (National Union Catalog; University
 of California Union List of Serials)
Subjects: Art, architecture, classical archaeology, dance,
 decorative arts, film & video, graphics, music, photog-
 raphy, theatre
Special Collection: Dance

AL 87
UNIVERSITY OF CALIFORNIA, LOS ANGELES
Elmer Belt Library of Vinciana
405 Hilgard Ave, Los Angeles, CA 90024
Tel: 213-825-3817; 4927
Libn: Joyce Pellerano Ludmer

Academic Founded: 1961
Hours: Mon-Fri 9-5
Reference Service: In person, telephone, mail
Reprographic Services: Yes
Interlibrary Loan: No
Networks/Consortia: No
Information Source: Finger, Francis L. *Catalog of the
 Incunabula in the Elmer Belt Library of Vinciana,* 1971
Publications: Leonardo da Vinci Periodical Index
Special Programs: Group & individual tours; bibliographic
 instruction; single lectures; intern program

Card Catalog
Cataloged Volumes: 7,500
Serial Titles: 2
Subjects: Art, architecture, classical archaeology, graphics, theatre
Special Collection: Emphasis on Leonardo da Vinci & Italian Renaissance

AL 88

UNIVERSITY OF CALIFORNIA, LOS ANGELES

UCLA Art Library, Dickson Art Center
405 Hilgard Ave, Los Angeles, CA 90024
Tel: 213-825-3817
Libn: Joyce Pellerano Ludmer

Academic Founded: 1952
Hours: Mon-Thurs 8-10
 Sat 9-5
 Sun 1-9
Circulation: (Open stacks)
Reference Service: In person, telephone, mail
Reprographic Services: Yes
Interlibrary Loan: NILS (Reference Dept, UCLA University Research Library)
Networks/Consortia: No
Special Programs: Group & individual tours; bibliographic instruction; single lectures; special lectures
Card catalog; book catalog
Cataloged Volumes: 53,706
Serial Titles: 882 (836 uncataloged serials)
Holdings: Sales & auction catalogs; exhibition catalogs; 893 microforms; 48,366 pamphlets
Subjects: Art, decorative arts, architecture, classical archaeology, film & video, graphics, photography
Special Collections:
Princeton Index of Christian Art
Iconographic index of all media before 1400, with photographic, bibliographic & subject files. Includes the *Decimal Index of Art of the Low Countries* (DIAL) & *Index of Jewish Art.*

AL 89

UNIVERSITY OF CALIFORNIA, SANTA BARBARA

Arts Library
Santa Barbara, CA 93106
Tel: 805-961-2766; 3613
Libn: William R Treese

Academic
Hours: Mon-Thurs 9-11
 Fri-Sat 9-6
 Sun 2-11
Circulation: Public; restricted use of exhibition catalogs, periodicals, phonorecords (open stacks)
Reference Service: Telephone, mail
Reprographic Services: Yes
Interlibrary Loan: NILS (Barbara Silver, ILL Librarian, Main Library, Univ of California, Santa Barbara, CA 93106)
Networks/Consortia: Black Gold Cooperative Library System; Total Interlibrary Exchange
Publications: Bibliographies; acquisitions list; special catalogs; in-house serial list (UCSB)
Information Sources: Smith, Virginia Carlson & William R Treese. "A Computerized Approach to Art Exhibition Catalogs," *Library Trends,* Jan 1975, p 471-81; *UCSB Catalogs Collection of the Arts Library, University of California at Santa Barbara,* Somerset House, 1977

Special Programs: Group & individual tours; bibliographic instruction; single lectures
Card Catalog
Cataloged Volumes: 110,000
Serial Titles: 450 (UC Union List of Serials)
Holdings: 20 vertical file drawers; 10,000 sales & auction catalogs; 21,000 exhibition catalogs; 10,647 microforms; 22,000 phonorecords
Subjects: Art, decorative arts, architecture, classical archaeology, graphics, music
Special Collection: Art exhibition catalog collection

AL 90

UNIVERSITY OF SOUTHERN CALIFORNIA

Architecture & Fine Arts Library
Watt Hall, University Park, Los Angeles, CA 90007
Tel: 213-741-2798
Libn: Alson Clark

Academic Founded: 1925
Hours: Mon-Thurs 8:30-10 (Sept-May)
 Fri 8:30-5 (Sept-May)
 Sat 12-5 (Sept-May)
 Sun 1-8 (Sept-May)
 Mon-Fri 8:30-5 (summer)
Circulation: Students, faculty/staff (open stacks)
Reference Service: In person, telephone, mail
Reprographic Services: Yes
Interlibrary Loan: NILS; UCLA & CALTECH (Interlibrary Loan, Reference Dept, Doheny Library, University Park, Los Angeles, CA 90007)
Networks/Consortia: California Interlibrary Loan Network; Southern California Interlibrary Loan
Publications: Guide to use of library
Special Programs: Group & individual tours; bibliographic instruction; intern program
Card Catalog
Cataloged Volumes: 32,000
Serial Titles: 160 (National Union Catalog)
Holdings: 48 vertical file drawers; 1,000 exhibition catalogs; 100 reels microfilms; 3 drawers of fiche
Subjects: Art, decorative arts, architecture, graphics, photography

AL 91

UNIVERSITY OF THE PACIFIC

Holt-Atherton Center for Western Studies
3600 Pacific Ave, Stockton, CA 95211
Tel: 209-946-2404
Dir: Dr Walter Payne

Academic Founded: 1957
Hours: Mon-Fri 8:30-5
 Weekends by appointment
Circulation: Restricted to some manuscript collections
Reference Service: Telephone, mail
Reprographic Services: Yes; except some manuscript collections
Interlibrary Loan: NILS (Irving Martin Library, Univ of Pacific)
Networks/Consortia: 49-99 Cooperative Library System (Northern California)
Publications: Orientation handbook; bibliographies; acquisitions; newsletter; special catalogs; in-house periodical index; quarterly journal, *The Pacific Historian*
Special Programs: Group & individual tours; bibliographic instruction; single lectures

Card Catalog
Cataloged Volumes: 50,000
Serial Titles: 40 (National Union Catalog)
Holdings: 24 vertical file drawers; 2 sales & auction catalogs; 5
 exhibition catalogs
Subjects: Art, photography, Western Americana
Special Collection:
Stuart Library of Western Americana
Collection of rare first edition Western books in history, art,
 literature, belles-lettres.

AL 92
VENTURA COUNTY HISTORICAL MUSEUM
Historical Library
100 E Main, Ventura, CA 93001
Tel: 805-648-6131; Exts 2701; 2702
Libn: Lee Harris

Museum Founded: 1931 (Museum); 1977 (Library)
Hours: Tues-Sat 10-5
Circulation: No
Reference Service: Telephone, mail
Reprographic Services: Yes
Interlibrary Loan: No
Networks/Consortia: Black Gold Cooperative Library
Publications: Newsletter
Special Programs: Group tours
Cataloged Volumes: 1,800
Serial Titles: 20
Holdings: 6 vertical file drawers
Subjects: History of California & Ventura County
Special Collections:
Charles F Outland
Historical materials dealing with California, Southern Cal-
 ifornia & Ventura County.

AL 93
WOODBURY UNIVERSITY LIBRARY
1027 Wilshire Blvd, Los Angeles, CA 19745
Tel: 213-482-9269
Dir: Everett L Moore

Academic Founded: 1884
Hours: Mon-Fri 7:15-10:30
Circulation: Students, faculty/staff (open stacks)
Reference Service: In person
Reprographic Services: Yes; photocopy only
Interlibrary Loan: No
Networks/Consortia: No
Publications: Orientation handbook, acquisitions list
Special Programs: Group & individual tours
Card Catalog
Cataloged Volumes: 40,000
Serial Titles: 425
Holdings: 8 vertical file drawers; 1,500 microforms
Subjects: Art, decorative arts, architecture

Colorado

AL 94
AURARIA LIBRARIES
11 & Lawrence Sts, Denver, CO 80204
Tel: 303-629-2805
Dir of Libs: Donald E Riggs

Academic

Hours: Mon-Thurs 7:30-10
 Fri 7:30-5
 Sat 9-4
 Sun 2-6
Circulation: Public (open stacks)
Reference Service: In person, telephone
Reprographic Services: Yes
Interlibrary Loan: NILS
Networks/Consortia: No
Publications: Orientation handbook; bibliographies; acquisi-
 tions list; in-house periodical card catalog
Special Programs: Group & individual tours; bibliographic
 instruction; single lectures
Cataloged Volumes: 350,000
Serial Titles: 1,200
Subjects: Art, architecture, graphics, music, photography,
 theatre

AL 95
COLORADO HISTORICAL SOCIETY
Documentary Resources Department
1300 Broadway, Denver, CO 80203
Tel: 303-892-2305
Curator: Dr. Maxine Benson

Historical Society Founded: 1879
Hours: Mon-Fri 9-5
Reference Service: In person, telephone, mail
Reprographic Services: Yes
Interlibrary Loan: No
Networks/Consortia: No
Publications: Bibliographies
Special Programs: Group tours; informal intern program
Card Catalog
Cataloged Volumes: 40,000
Serial Titles: 300
Holdings: 100 vertical file drawers; 26,000 microforms
Subjects: Architecture, photography

AL 96
COLORADO SPRINGS FINE ARTS CENTER
LIBRARY
30 W Dale St, Colorado Springs, CO 80903
Tel: 303-634-5581, Ext 22
Libn: Elsa Reich

Museum Founded: 1936
Hours: Tues-Sat 10-5
 Closed Mon
Circulation: Students, faculty/staff, members of museum
 (open stacks)
Reference Service: In person, telephone
Interlibrary Loan: NILS
Networks/Consortia: No
Publications: Bibliographies; acquisitions list; in-house periodi-
 cal index
Special Programs: Group & individual tours; bibliographic
 lectures
Card Catalog
Cataloged Volumes: 15,000
Serial Titles: 100
Holdings: Sales & auction catalogs; exhibition catalogs
Subjects: Art, decorative arts, architecture, classical archae-
 ology, film & video, graphics, photography, theatre, dance
Special Collections: Collection of art, archaeology & eth-
 nology of the American Southwest; ancient & modern;
 Latin American art

AL 97
DENVER PUBLIC LIBRARY
Western History Department
1357 Broadway, Denver, CO 80203
Tel: 303-573 5152, Ext 265
Head: Eleanor M. Gehres

Public Library Founded: 1934
Hours: Mon-Thurs 10-9
 Fri & Sat 10-5:30
Circulation: No (closed stacks)
Reference Service: In person, telephone, mail
Reprographic Services: Yes
Interlibrary Loan: NILS (Frances Bucy, Interlibrary Loan)
Networks/Consortia: Yes
Publications: Special catalogs; in-house periodical index
 (Western History General Index); book catalog
Information Sources: "Western History Department, Denver
 Public Library," *Great Plains Journal,* v 11, no 2, Spring
 1972, pp 101-115
Special Programs: Group & individual tours; single lectures;
 informal intern program with University of Denver
Serial Titles: 10 (National Union Catalog)
Holdings: 5 vertical file drawers; 5,000 microforms; minimal
 sales, auction & exhibition catalogs; 500 items of original
 art
Subjects: Art, architecture, classical archaeology, dance,
 decorative arts, film & video, graphics, music, photog-
 raphy, theatre
Special Collections:
Western History Collection
Collection of material illustrating the development of the
 American West, including original art & prints, architec-
 tural drawings & photographs & the Frederic Remington
 Manuscript Collection.

AL 98
GRAND COUNTY MUSEUM LIBRARY
Box 168, Hot Sulphur Springs, CO 80451
Libn: Ida Sheriff

Museum Founded: 1939; reorganized 1975
Hours: Mon-Fri 12-4 or 5 (during summer)
 By appointment during winter
Circulation: No
Reference Service: No
Reprographic Services: Copies of photos only
Interlibrary Loan: No
Networks/Consortia: No
Publications: Newsletter
Card Catalog
Holdings: 6 vertical file drawers
Subjects: Photography

AL 99
GREELEY PUBLIC LIBRARY
City Complex Bldg, Greeley, CO 80631
Tel: 303-353-6123, Ext 271
Libn: Esther Fromm

Public Library Founded: 1888
Hours: Mon-Thurs 9-9
 Fri & Sat 9-6
Circulation: Public (open stacks except for some out-of-print
 materials)

Reference Service: In person, telephone, mail
Reprographic Services: Yes
Interlibrary Loan: Bibliographic Center; High Plains System
 (Bibliographic Center for Research, Rocky Mountain
 Region, Inc, 1357 Broadway, Denver, CO 80203)
Networks/Consortia: No
Publications: Bibliographies, acquisitions list
Special Programs: Group tours; story hour
Cataloged Volumes: 97,000 general collection (90,000 titles)
Subjects: Art, architecture, classical archaeology, decorative
 arts, music, photography

AL 100
NORTHEASTERN JUNIOR COLLEGE
Learning Resource Center
Sterling, CO 80751
Tel: 303-522-6600
Dir: Joan L Weber

Academic Founded: 1941
Hours: Mon-Thurs 8-10
 Fri 8-4
 Sat 1-5
 Sun 4-10
Circulation: Public (open stacks)
Reference Service: In person, telephone, mail
Reprographic Services: Yes
Interlibrary Loan: High Plains Region in Colorado
Networks/Consortia: No
Special Programs: Group & individual tours; bibliographic
 instruction; single lectures
Cataloged Volumes: 60,000
Serial Titles: 500
Holdings: 16 vertical file drawers; 5,000 microforms
Subjects: Art, classical archaeology, dance, film & video,
 graphics, music, photography, theatre

AL 101
UNIVERSITY OF COLORADO
Art & Architecture Library
University of Colorado Libraries, Boulder Campus,
 Boulder, CO 80302
Tel: 303-492-7955

Academic Founded: 1966
Hours: Mon-Thurs 8-11
 Fri 8-5
 Sat 9:30-5:30
 Sun 1-11
Circulation: Public; restricted use of periodicals (open
 stacks)
Reference Service: In person
Interlibrary Loan: NILS
Networks/Consortia: No
Special Programs: Group tours; bibliographic instruction
Card Catalog
Cataloged Volumes: 44,440
Serial Titles: 276
Subjects: Art, decorative arts, architecture, graphics, pho-
 tography

AL 102
UNIVERSITY OF DENVER
Penrose Library
Denver, CO 80208
Libn: Morris Schertz

Academic　　　Founded: 1864
Circulation: Students, faculty/staff (open stacks)
Reference Service: Telephone
Reprographic Services: Yes
Interlibrary Loan: NILS
Networks/Consortia: Colorado Academic Research Libraries
Publications: Orientation handbook; bibliographies; acquisitions list; special catalogs; in-house periodical index (University of Denver Periodicals & Serials)
Special Programs: Group & individual tours; bibliographic instruction; single lectures; slide/tape show; cassette tour; intern program
Cataloged Volumes: 688,030
Serial Titles: 5,000 (National Union Catalog; Colorado Academic Research Libraries Union List of Serials)
Holdings: 246,155 microforms
Subjects: Art, dance, decorative arts, film & video, graphics, music, photography, theatre

AL 103
UNIVERSITY OF NORTHERN COLORADO
James A Michener Library
Greeley, CO 80631
Tel: 303-351-2601

Academic
Circulation: Public (open stacks; periodicals restricted)
Reference Service: Telephone, mail
Reprographic Services: Yes
Interlibrary Loan: NILS (Lucy Schweers, Interlibrary Loan Offices, Univ of Northern Colorado)
Networks/Consortia: No
Publications: Orientation handbook; periodical index
Special Programs: Group tours at teacher's request
Card Catalog
Subjects: Art, decorative arts, architecture, classical archaeology, film & video, graphics, photography, theatre, dance

Connecticut

AL 104
LYMAN ALLYN MUSEUM LIBRARY
100 Mohegan Ave, New London, CT 06320
Tel: 203-442-2545
Libn: Marianne Dinsmore

Museum　　　Founded: 1926
Hours: Tues-Sat 1-5
　　　　Sun 2-5
Circulation: (open stacks)
Reference Service: In person
Reprographic Services: No
Interlibrary Loan: NILS
Networks/Consortia: No
Publications: Orientation handbook; special catalogs
Special Programs: Group & individual tours; single lectures
Card Catalog
Cataloged Volumes: 6,583
Serial Titles: 30 (National Union Catalog, Southeastern Connecticut Lib Assn Union List)

Holdings: 2,000 sales & auction catalogs; 2,000 exhibition catalogs
Subjects: Art, architecture, decorative arts
Special Collections: Decorative arts of New London

AL 105
BRIDGEPORT PUBLIC LIBRARY
Fine Arts Department
925 Broad St, Bridgeport, CT 06604
Tel: 203-576-7412
Head: Eva C Chattem

Public Library　　　Founded: 1881; 1971
Hours: Mon-Thurs 9-9
　　　　Fri 9-5
Circulation: Public (closed stacks except to qualified researchers)
Reference Service: In person, telephone, mail
Reprographic Services: Yes
Interlibrary Loan: Southwestern Connecticut Library System; Connecticut Interlibrary Loan Teletype System
Networks/Consortia: No
Publications: Monthly calendar; in-house periodical index (Bridgeport Public Library Union List of Serials)
Special Programs: Group & individual tours; single lectures
Cataloged Volumes: 24,644
Serial Titles: 86 (Connecticut Union List of Serials; Fairfield County Union List of Serials)
Subjects: Art, architecture, classical archaeology, dance, graphics, music, photography, theatre
Special Collections:
Milton M Klein Collection
Chinese porcelain (155 items dating from the Ming Period); 110 oil paintings; architectural drawings; sculpture; 100 original prints, engravings & etchings; 500 framed & unframed prints.

AL 106
GREENWICH LIBRARY
Fine Arts Department
101 W Putnam Ave, Greenwich, CT 06830
Tel: 203-622-7930
Fine Arts Libn: Esther Duffy

Public Library
Hours: Mon-Fri 9-9
　　　　Sat 9-5
　　　　Sun 1-5 (Oct-April)
Circulation: Public (open stacks)
Reference Service: Telephone, mail
Reprographic Services: Yes
Interlibrary Loan: NILS; Southwestern Connecticut Library System; Connecticut State Library Teletype Network
Networks/Consortia: No
Publications: Bibliographies; 40 oral histories; book catalog for fiction only; in-house periodical list (Magazines—Greenwich Library)
Special Programs: Group tours
Card Catalog
Cataloged Volumes: 200,000 (120,000 titles)
Serial Titles: 503 (Connecticut Union List of Serials; Library Group of Southwest Connecticut; Union List of Serials)
Holdings: 40 vertical file drawers
Subjects: Art, architecture, decorative arts, film & video, photography

AL 107
NEW HAVEN FREE PUBLIC LIBRARY
Art & Music Department
133 Elm St, New Haven, CT 06516
Tel: 203-562-0151, Ext 408
Art & Music Libn: Helen Worobec

Public Library Founded: 1887
Hours: Mon-Thurs 9-8
 Fri 9-6
 Sat 9-5
Circulation: Public (closed stacks)
Reference Service: In person, telephone, mail
Reprographic Services: Yes
Interlibrary Loan: Connecticut State Interlibrary Loan
Networks/Consortia: No
Special Programs: Group tours
Cataloged Volumes: 12,000
Holdings: 126 vertical file drawers of pictures
Subjects: Art, architecture, classical archaeology, dance,
 decorative arts, film & video, graphics, music, photog-
 raphy, theatre

AL 108
SAINT JOSEPH COLLEGE
Pope Pius XII Library
1678 Asylum Ave, West Hartford, CT 06117
Tel: 203-232-4571, Exts 207; 208; 209
Libn: Sr Muriel Adams

Academic Founded: 1932
Circulation: Students, researchers, faculty/staff, alumni;
 serials do not circulate (open stacks)
Reference Service: In person, telephone, mail
Reprographic Services: Yes
Interlibrary Loan: NILS
Networks/Consortia: Greater Hartford Consortium for
 Higher Education, Inc
Publications: Bibliographies; newsletter; in-house periodical
 index
Special Programs: Group & individual tours; bibliographic
 instruction; single lectures
Cataloged Volumes: 80,000
Serial Titles: 510 (Connecticut Union List)
Holdings: 24 vertical file drawers; 2,000 microforms; maps;
 government documents
Subjects: Art, dance, decorative arts, film & video, music,
 photography
Special Collection:
Curriculum Materials Center
Elementary & secondary teaching materials.

AL 109
SILVERMINE GUILD SCHOOL OF THE ARTS
LIBRARY
1037 Silvermine Rd, New Canaan, CT 06840
Tel: 203-866-0411, Ext 25
Libn: Barbara W Adams

Art School Founded: 1960
Hours: Mon-Thurs 10-2
Circulation: (Open stacks)
Reference Service: Telephone, mail
Reprographic Services: No
Interlibrary Loan: No
Networks/Consortia: No
Card Catalog
Cataloged Volumes: 3,000

Subjects: Art, decorative arts, architecture, graphics, photog-
 raphy, music, theatre

AL 110
THE STOWE DAY FOUNDATION MEMORIAL
LIBRARY
77 Forest St, Hartford, CT 06105
Tel: 203-522-9258
Libn: Joseph S Van Why

Museum Founded: 1964
Hours: Mon-Fri 9-5
Circulation: For staff & membership; interlibrary loan
Reference Service: Telephone, mail
Reprographic Services: Yes
Interlibrary Loan: NILS
Networks/Consortia: No
Publications: Bibliographies; special catalogs
Special Programs: Group & individual tours
Card Catalog
Cataloged Volumes: 15,000
Serial Titles: 10
Subjects: Art, decorative arts, architecture, 19th century
 Americana
Special Collection: 19th century drawings, decorative arts &
 architecture books
Lyman Beecher Family Collection
Papers of the Beecher family, including Harriet Beecher
 Stowe.

AL 111
UNIVERSITY OF CONNECTICUT
Magnus Wahlstrom Library
126 Park Ave, Bridgeport, CT 06602
Tel: 203-576-4740
Dean of Lib Services: Morrell D Boone

Academic Founded: 1927
Hours: Mon-Sat 8:30-11
 Sun 1-10
Circulation: Students, faculty/staff (open stacks)
Reference Service: In person only
Reprographic Services: Yes
Interlibrary Loan: NILS
Networks/Consortia: New England Library Information
 Network
Publications: In-house periodical index (Library Group of
 Southwestern Connecticut Union List of Serials)
Cataloged Volumes: 270,000
Serial Titles: 2,600
Holdings: 50 vertical file drawers; 300,000 microforms
Subjects: Art, architecture, classical archaeology, dance,
 decorative arts, film & video, graphics, music, photography,
 sculpture, theatre
Special Collections:
Davis-Lincoln Collection
Pictures, books, pamphlets, clippings & ephemera.
McKew-Parr Voyages of Discovery
Books, manuscripts, ephemera.

AL 112
UNIVERSITY OF HARTFORD
Anne Bunce Cheney Library
200 Bloomfield Ave, West Hartford, CT 06117
Tel: 203-243-4397
Libn: Jean J Miller

Academic Founded: 1964
Circulation: Public (open stacks)
Reference Service: Telephone, mail
Reprographic Services: Yes
Interlibrary Loan: NILS; Connecticard (Phyllis Burger, Mortensen Library, Univ of Hartford)
Networks/Consortia: OCLC (through New England Library Information Network & Greater Hartford Consortium for High Education)
Publications: In-house periodical list (University of Hartford Holdings List)
Special Programs: Individual tours; bibliographic instruction
Card Catalog; also periodical index
Cataloged Volumes: 9,815
Serial Titles: 85 (Connecticut Union List of Serials)
Holdings: 26 vertical file drawers; 36 drawers of mounted reproductions
Subjects: Art, decorative arts, architecture, film & video, graphics, photography

AL 113
WADSWORTH ATHENEUM
Auerbach Art Library
600 Main St, Hartford, CT 06103
Tel: 203-278-2670, Ext 257
Libn: Elizabeth G Hoke

Museum Founded: 1934
Reference Service: Telephone, mail
Reprographic Services: Yes
Interlibrary Loan: NILS
Networks/Consortia: No
Publications: In-house periodical index (WA Bulletin Index)
Special Programs: Intern program
Card Catalog
Cataloged Volumes: 15,000
Serial Titles: 160 (Connecticut State Libraries List of Serials)
Holdings: 80 vertical file drawers; 50 shelves of sales & auction catalogs
Subjects: Art, architecture, decorative arts, dance, film & video, graphics, photography
Special Collections: Museology; art education

AL 114
WESLEYAN UNIVERSITY
The Art Library, Davison Art Center
High St, Middletown, CT 06457
Tel: 203-347-9411, Ext 697
Libn: Richard H Wood

Academic Founded: 1950
Hours: Mon-Fri 9-5; 7-10
 Sat 12-4
 Sun 12-10
 Mon-Fri 9-5 (summer)
Circulation: Public (open stacks; some books restricted)
Reference Service: In person, telephone, mail
Reprographic Services: No
Interlibrary Loan: NILS (W J Dillon, Olin Library, Wesleyan University)
Networks/Consortia: No
Card Catalog
Cataloged Volumes: 12,500 (10,000 titles)
Serial Titles: 125 (National Union Catalog)
Subjects: Art, decorative arts, architecture, classical archaeology, film & video, graphics, photography

AL 115
WESTPORT PUBLIC LIBRARY
Art & Music Room
Westport, CT 06880
Tel: 203-227-8411, Ext 34
Libn: Thelma Gordon

Public Library
Hours: Mon, Thurs 9-9
 Tues, Wed, Fri 9-6
 Sun 1-5
Circulation: Public (open stacks)
Reference Service: In person, telephone
Reprographic Services: No
Interlibrary Loan: State of Connecticut
Networks/Consortia: No
Card Catalog
Cataloged Volumes: 15,000

AL 116
YALE CENTER FOR BRITISH ART
Reference Library
Box 2120, Yale Station, New Haven, CT 06520
Tel: 203-432-4098
Libn: Jaylyn Olivo

Academic Founded: 1977
Hours: Tues-Fri 10-4:30
Circulation: Restricted to staff members for in-house use (open stacks)
Reference Service: In person, telephone, mail
Reprographic Services: Yes
Special Programs: Group tours; bibliographic instruction
Card Catalog
Cataloged Volumes: 7,500
Serial Titles: 130 (National Union Catalog; Union Shelf List of Research Libraries Group)
Subjects: Art, history of British art

AL 117
YALE UNIVERSITY
Art & Architecture Library
180 York St, Box 1605A, New Haven, CT 06520
Tel: 203-436-2055
Libn: Nancy Lambert

Academic
Hours: Mon-Thurs 8:30-11
 Fri 8:30-5
 Sat 11-6
 Sun 2-11
Circulation: Students, faculty/staff restricted to one book overnight (open stacks)
Reference Service: In person, mail
Reprographic Services: Yes; except for fragile materials
Interlibrary Loan: NILS; loan to Research Libraries Group (Interlibrary loan office, Yale University Library)
Networks/Consortia: Research Libraries Group
Special Programs: Group & individual tours
Card Catalog
Cataloged Volumes: 65,000
Serial Titles: 455
Holdings: 145 vertical file drawers; 8,500 (unclassified titles) exhibition titles
Subjects: Art, decorative arts, architecture, graphics, photography
Special Collections:
Faber Birren Collection on Color

Decimal Index to the Art of the Low Countries (DIAL)
I Tatti Archive (Berenson Collection)
Photographs of Italian paintings.
Illustrated Bartsch
Photographs of prints indexed in Adam Bartsch's *Le Peintre-Graveur.*
Meeks Collection
File of student papers on Connecticut & New Haven architecture.
Rose Collection
Photographs of New England churches, correspondence & research used in preparation of Harold Wickliffe Rose's *Colonial Houses of Worship in America.*
Scrapbooks of Joseph Albers, Annie Albers, Paul Rudolph

Delaware

AL 118
DELAWARE ART MUSEUM LIBRARY
2301 Kentmore Pkwy, Wilmington, DE 19806
Tel: 302-571-9590
Libn: Phyllis J Nixon

Museum Founded: 1912
Hours: Mon-Fri 10-4:30
Circulation: Faculty/staff (open stacks)
Reference Service: Telephone
Reprographic Services: Yes
Interlibrary Loan: NILS
Networks/Consortia: Council of Historical Libraries in Delaware
Publications: Periodical index
Special Programs: Group & individual tours; bibliographic instruction; intern program
Card Catalog
Cataloged Volumes: 20,000
Serial Titles: 139
Holdings: 60 vertical file drawers; 7 shelves sales & auction catalogs
Subjects: Art, architecture, decorative arts, classical archaeology, graphics, photography
Special Collections: Archival materials of Gayle Hoskins, Frank Schoonover, Stanley Arthurs, Jerome Myers, Albert Lindsay
Bancroft Pre-Raphaelite Library
Collection of materials on Pre-Raphaelites, especially D G Rossetti.
Collection of Illustrated Books
Includes N C Wyeth's, Frank Schoonover's & Gayle Hoskin's works.
Howard Pyle Collection
Books & stories written or illustrated by Pyle; part of his personal library. Includes a clipping file on pupils of Howard Pyle.
John Sloan Memorial Library
The artist's personal library & related materials.

AL 119
HENRY FRANCIS DUPONT WINTERTHUR MUSEUM
Henry Francis du Pont Winterthur Museum Libraries, Joseph Downs Manuscript & Microfilm Collection
Winterthur, DE 19735
Tel: 302-656-8591
Libn: Beatrice K Taylor

Museum Founded: 1955 (manuscript collection)
Hours: Mon-Fri 8:30-4:30
Reference Service: Telephone, mail
Reprographic Services: Yes; must have permission for publication
Interlibrary Loan: No
Networks/Consortia: No
Publications: In-house periodical index
Special Programs: Group tours
Card Catalog: Name cards only
Holdings: 48,000 vertical file drawers; 612 reels of microfilms of auction & exhibition catalogs; 2,471 reels of microforms; 1,121 photostats
Subjects: Art, decorative arts, architecture, graphics, photography, music, theatre, dance
Special Collections:
The Edward Deming Memorial Shaker Collection
Furniture Collections
R W Symonds papers on English furniture, business papers & glass plate negatives of Gustav Stickley, furniture craftsman; research notebooks, diaries, letters, manuscript of Irving W Lyon for his book, *Colonial Furniture in New England.*
Stanley B Ineson Collection
Correspondence & photographs pertaining to silverware.
Thelma Seeds Mendsen Card Collection
Greeting cards, postcards & trade cards collection.
Pewter Collections
The notes & scrapbooks of Percy E Raymond, research papers, manuscript & photographs for Leslie I Laughlin's *Pewter in America.*
C W Unger & William B Pennebaker Watermark Collections
Mrs William R Waldron Collection
Paper dolls, toy books & games collection.

AL 120
HENRY FRANCIS DUPONT WINTERTHUR MUSEUM
Printed Book & Periodical Library
Winterthur, DE 19735
Tel: 302-656-8591
Libn: Eleanor Thompson

Museum Founded: 1969
Hours: Mon-Fri 8:30-4:30
Circulation: Students, faculty/staff (open stacks)
Reference Service: In person, telephone, mail
Reprographic Services: Yes; permission for publication purposes
Interlibrary Loan: No
Networks/Consortia: No
Publications: Orientation handbook; printed catalog of the collection
Special Programs: Group & individual tours; bibliographic instruction (prior arrangements necessary)
Card Catalog
Serial Titles: 337 (National Union Catalog)
Holdings: 15 vertical file drawers
Subjects: Art, decorative arts, architecture, classical archaeology, graphics, photography, music, theatre, dance
Special Collections: Waldron Phoenix Belknap, Jr Research Library of American Painting

AL 121
HENRY FRANCIS DUPONT WINTERTHUR MUSEUM
Winterthur Estate Archives
Winterthur, DE 19735

Tel: 302-656-8591
Libn: Barbara Hearn

Museum Founded: 1969
Hours: Mon-Fri 8:30-4:30
Reference Service: Telephone, mail
Reprographic Services: Restricted to staff use
Interlibrary Loan: No
Networks/Consortia: No
Publications: Guides; in-house periodical index (Registers & Inventories)
Special Programs: Group & individual tours
Card Catalog
Cataloged Volumes: 13,000 cu ft
Holdings: 214 vertical file drawers, 180 document boxes
Subjects: Art, decorative arts, architecture, photography, music, theatre

AL 122
HENRY FRANCIS DUPONT WINTERTHUR MUSEUM
Winterthur Museum Libraries
Winterthur, DE 19735
Tel: 302-656-3591, Ext 227
Libn: Frank H Sommer

Museum Founded: 1951
Hours: Mon-Fri 8:30-4:30
Circulation: Students, faculty/staff for research (open stacks, restricted circulation)
Reference Service: In person, telephone, mail
Reprographic Services: Yes; permission for publication
Interlibrary Loan: No
Networks/Consortia: Council of Historical Libraries of Delaware
Publications: Orientation handbook; acquisitions list; newsletter; special catalogs; periodical index; book catalog
Special Programs: Group & individual tours; bibliographic instruction; single lectures
Card Catalog
Cataloged Volumes: 60,000
Serial Titles: 337
Holdings: 15 vertical file drawers
Subjects: Art, decorative arts, architecture, classical archaeology, graphics, photography, music, theatre, dance
Special Collections:
W P Belknap, Jr Research Library of American Painting
Collection of books, periodicals, photographs, slides, manuscripts, microfilm, prints on history of early American painting.

AL 123
UNIVERSITY OF DELAWARE
Morris Library
Newark, DE 19711
Tel: 302-738-2965
Dir of Libs: Dr John M Dawson

Academic Founded: 1834
Hours: Mon-Thurs 8-11:30
 Fri 8-10
 Sat 9-5
 Sun 1-11:30
Circulation: Students, researchers, faculty/staff (open stacks)
Reference Service: In person only
Reprographic Services: Yes
Interlibrary Loan: NILS (Interlibrary Loan Section, Reference Department)

Networks/Consortia: Pennsylvania Area Library Network
Publications: Orientation handbook; bibliographies; in-house periodical index
Special Programs: individual tours; bibliographic instruction; single lectures
Cataloged Volumes: 1,067,964—total collection
Serial Titles: 11,544—total collection (National Union Catalog)
Holdings: 366,838 microforms—total collection
Subjects: Art, classical archaeology, dance, music, photography, theatre

AL 124
WESLEY COLLEGE
Parker Library
College Sq, Dover, DE 19901
Tel: 302-674-4000, Ext 213
Libn: Paul B Lawless

Academic Founded: 1873
Hours: Mon-Thurs 8:30-10:30
 Fri 8:30-4:30
 Sat 11-2
 Sun 1:30-4:30; 7-10
Circulation: Students, researchers, faculty/staff (open stacks)
Reference Service
Reprographic Services: Yes
Interlibrary Loan: NILS
Networks/Consortia: No
Publications: Orientation handbook; acquisitions list
Special Programs: Group tours
Card Catalog
Cataloged Volumes: 40,000
Serial Titles: 318
Holdings: 12 vertical file drawers
Subjects: Art, decorative arts, architecture, classical archaeology, graphics, photography, music, theatre, dance

District of Columbia

AL 125
AMERICAN INSTITUTE OF ARCHITECTS LIBRARY
1735 New York Ave NW, Washington, DC 20006
Tel: 202-785-7293
Libn: Susan C Holton

Professional Association
Hours: Tues-Fri 8:30-5
Circulation: Staff, AIA members (open stacks with some restricted areas)
Reference Service: In person, telephone, mail
Reprographic Services: No
Interlibrary Loan: Government agencies only
Networks/Consortia: No
Publications: Bibliographies; acquisitions list
Special Programs: Group & individual tours; bibliographic instruction
Cataloged Volumes: 20,000
Serial Titles: 400
Holdings: 40 vertical file drawers; 120 microfilms
Subjects: Architecture, urban planning
Special Collection:
Richard Morris Hunt Collection of Drawings

AL 126
**ARCHIVES OF AMERICAN ART—SMITHSONIAN
 INSTITUTION**
Eighth & F Sts, FA-PG Bldg, Washington, DC 20560
Tel: 202-381-6174
Dir: William E Woolfenden

Archives, Manuscripts Repository Founded: 1954
Hours: Mon-Fri 9-5
Circulation: Researchers; restricted to microfilm
Reference Service: Telephone, mail
Reprographic Services: Yes
Interlibrary Loan: NILS—microfilm only (Archives of Amer-
 ican Art, Midwest Area Office, 5200 Woodward Ave,
 Detroit, MI 48202)
Networks/Consortia: No
Publications: *Journal: Checklist of the Collection*
Card Catalog
Cataloged Papers: 4,500 boxes; 3,012 collections of papers
Holdings: 20,000 sales & auction catalogs on microfilm;
 14,000 exhibition catalogs on microfilm; 3,900 rolls 35mm
 microfilm; 1,500 oral history inteviews
Subjects: Art, decorative arts, graphics, photography

AL 127
CATHOLIC UNIVERSITY
Fine Arts Council Library
Catholic University, Washington, DC 20016
Tel: 202-635-5777
Dir: Chris Wilkinson

Academic Founded: 1964
Hours: Mon-Fri 10-3
Circulation: Undergraduates; others with permission (open
 stacks)
Reprographic Services: No
Interlibrary Loan: No
Networks/Consortia: No
Cataloged Volumes: 120
Subjects: Art, film & video, graphics, photography

AL 128
CORCORAN GALLERY OF ART
Curatorial Library
17 St & New York Ave NW, Washington, DC 20006
Tel: 202-638-3211, Exts 32; 34; 35
Asst Curator of Collections: Linda C Simmons

Museum Founded: 1869 (open to public in 1874)
Hours: Mon-Fri 9-5 (Gallery hours)
Circulation: Restricted to use in the library (open stacks)
Reference Service: Telephone, mail; time limits
Reprographic Services: Yes; staff approval of material
Interlibrary Loan: NILS
Networks/Consortia: No
Card Catalog
Cataloged Volumes: 12,000 (11,900 titles)
Serial Titles: 18
Holdings: 44 vertical file drawers; 400 sales & auction cata-
 logs; 2,500 exhibition catalogs
Subjects: Art, decorative arts, architecture, graphics, photog-
 raphy
Special Collection:
Corcoran Gallery of Art Archives

AL 129
**DAUGHTERS OF THE AMERICAN REVOLUTION
 MUSEUM**

Museum Reference Library
1776 D St NW, Washington, DC 20006
Tel: 202-628-1776, Ext 236
Curator: Jean T Federico

Museum Founded: 1970
Hours: Mon-Fri 9-4
Circulation: (open stacks)
Reference Service: Telephone, mail
Reprographic Services: No
Interlibrary Loan: No
Networks/Consortia: No
Publications: Special catalogs
Card Catalog
Cataloged Volumes: 1,000
Holdings: 2 drawers of sales & auction catalogs; 3 drawers
 of exhibition catalogs
Subjects: Art, decorative arts

AL 130
DISTRICT OF COLUMBIA PUBLIC LIBRARY
Martin Luther King Memorial Library—Art Division
901 G St NW, Washington, DC 20007
Tel: 202-727-1291; 1238
Chief, Art Division: Lois Kent Stiles

Public Library
Circulation: Public; VF material & periodicals do not circulate
 (open stacks except for back issues of periodicals)
Reference Service: In person, telephone, mail
Reprographic Services: Yes
Interlibrary Loan: NILS; Metro Area Interlibrary Loan
 System
Networks/Consortia: Metro Area
Publications: Orientation handbook; bibliographies; news-
 letter; in-house periodical index (Martin Luther King
 Memorial Library Periodical Holdings)
Special Programs: Group & individual tours; bibliographic
 instruction; single lectures; annual historical print ex-
 hibition
Cataloged Volumes: 43,101 circulating; 5,289 reference
Serial Titles: 120 (Metropolitan Area Guide to Serials)
Holdings: 50 vertical file drawers; sales & auction catalogs
Subjects: Art, decorative arts, architecture, graphics, photog-
 raphy

AL 131
**DUMBARTON OAKS RESEARCH LİBRARY &
 COLLECTION**
Center for Byzantine Studies
1703 32 St NW, Washington, DC 20007
Tel: 202-232-3101, Ext 219
Libn: Irene Vaslef

Academic Founded: 1940
Hours: Mon-Fri 9-5
Circulation: Researchers, faculty/staff; restricted to use in
 library (open stacks)
Reference Service: In person, telephone, mail
Reprographic Services: Yes
Interlibrary Loan: NILS (Annettli B McFadden, ILL Asst)
Networks/Consortia: OCLC through Consortium of the
 University of the Washington Metropolitan Area
Special Programs: Group & Individual tours; single lectures;
 intern program
Card Catalog
Cataloged Volumes: 85,000
Serial Titles: 1,200
Subjects: Art, architecture, classical archaeology

AL 132
FREER GALLERY OF ART LIBRARY
12 & Jefferson Dr SW, Washington, DC 20560
Tel: 202-381-5332
Libn: Priscilla P Smith

Museum Founded: 1923
Hours: Mon-Fri 10-4:30
Reference Service: Telephone, mail
Reprographic Services: Yes
Interlibrary Loan: No
Networks/Consortia: No
Card Catalog
Cataloged Volumes: 24,000 (12,000 titles)
Serial Titles: 100
Subjects: Art, decorative arts, architecture, arts of the Near
 & Far East
Special Collection: Correspondence of C L Freer, Whistler,
 Abbott Thayer, Thomas Dewing, Dwight Tyron, Frederick
 Church, Gari Melchers

AL 133
GEORGETOWN UNIVERSITY
Lauinger Library, Special Collections Division
Washington, DC 20057
Tel: 202-625-3230
Special Collections Libn: George M Barringer

Academic Founded: 1789
Hours: Mon-Fri 9-5
Reference Service: In person, telephone, mail
Reprographic Services: Yes
Interlibrary Loan: No
Networks/Consortia: DC Consoritum
Publications: Special catalogs; in-house periodical index
 (DC Union List of Serials)
Card Catalog
Cataloged Volumes: 30,000+ (22,000 titles)
Holdings: 5 vertical file drawers; 3,000 sales & auction cata-
 logs; 3,500 linear feet of manuscripts; 12,000 uncata-
 loged titles; 150,000 photographs
Subjects: American history, astronomy (to 1850), English &
 American literature, film & video, foreign affairs, political
 science, US railroads
Special Collections: Over 125 manuscript collections; 22 rare
 book collections; 1 photographic collection

AL 134
HIRSHHORN MUSEUM & SCULPTURE GARDEN
 LIBRARY
Eighth & Independence Ave SW, Washington, DC 20560
Tel: 202-381-6702
Libn: Anna Brooke

Museum Founded: 1974
Hours: Mon-Fri 10-5
Circulation: Staff; open to scholars by appointment (open
 stacks)
Reference Service: In person, telephone
Reprographic Services: Yes
Interlibrary Loan: NILS
Networks/Consortia: No
Publications: Acquisitions list
Card Catalog
Cataloged Volumes: 4,048
Serial Titles: 50
Holdings: 30 vertical file drawers; 2,000 sales & auction
 catalogs; exhibition catalogs; 83 microforms

Subjects: Art, emphasis on modern painting and sculpture

AL 135
HISTORIC AMERICAN ENGINEERING NATIONAL
 PARK SERVICE
1100 L St NW, Rm 5125, Washington, DC 20240
Tel: 202-523-5460
Records Asst: Isabel T Hill

Government Agency Founded: 1969
Hours: Mon-Fri 7:45-4:15
Circulation: (open stacks)
Reference Service: No
Reprographic Services: Yes; only through Library of Congress
Interlibrary Loan: No
Networks/Consortia: No
Card Catalog
Cataloged Volumes: 300
Holdings: Housed in Library of Congress
Subjects: Architecture, engineering & industrial technology

AL 136
LIBRARY OF CONGRESS
Prints and Photographs Division
110 Second St SE, Washington, DC 20540
Tel: 202-426-6394
Asst Chief: Dale K Haworth

Federal Library Founded: 1800
Hours: Mon-Fri 8:30-5
Circulation: No (closed stacks)
Reference Service: In person, telephone, mail
Reprographic Services: Yes
Interlibrary Loan: NILS
Networks/Consortia: OCLC; CONSER; MARC; SCORPIO
Publications: Orientation handbook; bibliographies; acquisi-
 tions list; newsletter; special cataogs; Library of
 Congress Publications in Print, Spring 1978; partial book
 catalog; in-house periodical index
Special Programs: Group & individual tours; intern program
Cataloged Volumes: 260,859 (1976)
Serial Titles: 3,500 (National Union Catalog)
Subjects: Art, architecture, classical archaeology, decorative
 arts, film & video, graphics, photography

AL 137
MUSEUM OF AFRICAN ART LIBRARY
318 East NE, Washington, DC·20002
Tel: 202-547-7424
Libn: Father Robert Meyers

Museum Founded: 1964
Hours: Mon-Fri, by appointment only
Circulation: Faculty/staff; limited to use in museum
Reference Service: Telephone, mail
Reprographic Services: No
Interlibrary Loan: No
Networks/Consortia: No
Special Programs: Museum internship workshops
Card Catalog
Cataloged Volumes: 4,000
Serial Titles: 3-6
Holdings: 6-10 vertical file drawers; 100 sales & auction
 catalogs; 100 exhibition catalogs; 25-35 maps
Subjects: Art, decorative arts, architecture, classical archae-
 ology, photography, music, theatre, dance

AL 138
NATIONAL ARCHIVES & RECORD SERVICE
Audiovisual Archives Division
Eighth & Pennsylvania Ave NW, Washington, DC 20408
Tel: 202-523-3010
Dir: James W Moore

Archives Founded: 1934
Hours: Mon-Fri 8:45-5:15
Circulation: No
Reference Service: In person, telephone, mail
Reprographic Services: Yes; copies available for purchase;
 Federal regulation restrictions
Interlibrary Loan: NILS
Networks/Consortia: No
Publications: Orientation handbook; special catalogs; select
 lists; preliminary inventories; guides
Special Programs: Group & individual tours; "Films at the
 Archives"; orientation program to motion picture holdings
 of the Archives; intern program

AL 139
NATIONAL ENDOWMENT FOR THE ARTS
Arts Library
2401 E St NW, Rm 1256, Washington, DC 20506
Tel: 202-634-7640
Libn: Mary P Morrison

Federal Agency Special Library Founded: 1971
Hours: Mon-Fri 9-5:30
Circulation: Restricted to staff use (open stacks)
Reference Service
Reprographic Services: Yes
Interlibrary Loan: NILS
Networks/Consortia: No
Publications: Acquisitions list
Special Programs: Individual tours
Card Catalog
Cataloged Volumes: 2,200 (2,000 titles)
Serial Titles: 225
Holdings: 9 vertical file drawers; 200 exhibition catalogs
Subjects: Art, decorative arts, architecture, film & video,
 graphics, photography, music, theatre, dance, arts manage-
 ment

AL 140
NATIONAL GALLERY OF ART LIBRARY
Sixth & Constitution NW, Washington, DC 20565
Tel: 202-737-4215, Ext 337
Chief Libn: J M Edelstein

Museum Founded: 1941
Hours: Tues-Fri 10-5:30
Circulation: Faculty/staff; in-house use for staff & visiting
 scholars
Reference Service: Telephone, mail
Reprographic Services: Restrictions on rare & fragile
 materials, folios
Interlibrary Loan: NILS (Thomas F J McGill, Jr, ILL Libn)
Networks/Consortia: No
Special Programs: Group & individual tours; bibliographic
 instruction; intern program
Card Catalog
Cataloged Volumes: 64,375 (48,225 titles)
Serial Titles: 450 (National Union Catalog)
Holdings: 100 vertical file drawers
Subjects: Art, architecture, decorative arts, graphic, photog-
 raphy

Special Collections: Leonardo da Vinci; illuminated manu-
 scripts; modern European & American art; sales catalogs;
 artist monographs

AL 141
NATIONAL GEOGRAPHIC SOCIETY
Illustrations Library
17 & M Sts NW, Washington, DC 20036
Tel: 202-857-7492
Libn: L Fern Dame

Publishing Organization Founded: 1919
Hours: Mon-Fri 8:30-5
Circulation: Staff; outside requests require permission
Reference Service: Yes; staff only
Reprographic Services: Yes; restricted
Interlibrary Loan: No
Networks/Consortia: No
Publications: Thesaurus; in-house periodical index (Illustra-
 tions Library Subject Catalog)
Special Programs: Group & individual tours; appointment only
Card Catalog
Holdings: 250,000 color transparencies (35mm); 450 black &
 white photographs; 8,500 paintings
Subjects: Art, photography

AL 142
NATIONAL TRUST FOR HISTORIC PRESERVATION
LIBRARY
740-748 Jackson Place NW, Washington, DC 22312
Tel: 202-638-5200; Ext 280
Libn: Brigid Rapp

National Clearinghouse Founded: 1949
Hours: Mon-Fri 9-5
Circulation: Faculty/staff (open stacks)
Reference Service: Telephone, mail
Reprographic Services: Yes
Interlibrary Loan: No
Networks/Consortia: No
Publications: Bibliographies; acquisitions list; directories;
 news articles; information sheets
Card Catalog
Cataloged Volumes: 6,000
Serial Titles: 62
Holdings: 196 vertical file drawers; limited sales & auction
 catalogs; limited exhibition catalogs; limited microforms
Subjects: Decorative arts, architecture

AL 143
THE PHILLIPS COLLECTION
1600 21 St NW, Washington, DC 20009
Tel: 202-387-2151
Asst Curator: Kevin Grogan

Museum Founded: 1921
Hours: Tues-Fri 10-5
Circulation: Researchers, faculty/staff (open stacks)
Reference Service: Mail
Reprographic Services: Limited to pamphlets & exhibition
 catalogs
Interlibrary Loan: No
Networks/Consortia: No
Publications: Orientation handbook; special catalogs; exhibi-
 tion catalogs
Information Source: Phillips, Marjorie. *Duncan Phillips &
 His Collection,* Atlantic-Little-Brown, 1970
Special Programs: Group & individual tours; intern program

Card Catalog
Cataloged Volumes: 5,000 (in process)
Serial Titles: 30
Subjects: Art, decorative arts, architecture, graphics, photography

AL 144
SMITHSONIAN INSTITUTION
Library of the National Collection of Fine Arts & the
National Portrait Gallery
Eighth St NW, Washington, DC 20560
Tel: 202-381-5118; 5853
Libn: William B Walker

Museum Founded: 1930
Circulation: Faculty/staff; undergraduates need letter of introduction (open stacks; for staff)
Reference Service: Telephone, mail
Reprographic Services: Yes
Interlibrary Loan: NILS
Networks/Consortia: Federal Library Network, OCLC
(cataloging)
Information Source: Walker, William B. "Notes on the Scope
and Collections of the NCFA/NPG Library," Special Lib
Assn, Museum Division. *Bulletin*, Spring 1968, p 5-14
Special Programs: Group & individual tours; bibliographic
instruction; by appointment, publication exchange with
institutions
Card Catalog
Cataloged Volumes: 28,000
Serial Titles: 900
Holdings: 290 vertical file drawers; several thousand sales &
auction catalogs; several thousand exhibition catalogs;
several hundred microforms
Subjects: Art, decorative arts, architecture, graphics (emphasis
on 20th century American painting, sculpture, graphic arts;
American & English portraiture)
Special Collection:
Ferdinand Perret Library
Art pictures & clippings compiled by Perret in Los Angeles
from 1920-45. Includes California art & artists' files.

AL 145
TEXTILE MUSEUM
Arthur D Jenkins Library
2320 S St NW, Washington, DC 20016
Tel: 202-667-0441
Libn: Katherine T Freshley

Museum Founded: 1926
Hours: Wed-Fri 10-5
Circulation: (open stacks)
Reference Service: In person, telephone
Reprographic Services: Yes
Interlibrary Loan: No
Networks/Consortia: No
Publications: Newsletter; in-house periodical index
Special Programs: Group & individual tours; intern program
Card Catalog
Cataloged Volumes: 7,000
Serial Titles: 80
Holdings: 3 drawers sales & auction catalogs; exhibition
catalogs
Subjects: Decorative arts, anthropology, archaeology relating
to textile collection

AL 146
UNIVERSITY OF THE DISTRICT OF COLUMBIA
Fine Arts Library

916 G St NW, Washington, DC 20001
Tel: 202-727-2668
Fine Arts Libn: Barbara Quinnam

Academic Founded: 1975
Hours: 9-7
Circulation: Students, faculty/staff (open stacks)
Reference Service: In person, telephone
Reprographic Services: 15 page maximum
Interlibrary Loan: NILS (Frances Churchill, 724 Ninth St
NW, Washington, DC 20001)
Networks/Consortia: No
Special Programs: Group & individual tours
Card Catalog: Book catalog
Cataloged Volumes: 3,000
Subjects: Art, architecture, graphics, music, theatre

Florida

AL 147
CUMMER GALLERY OF ART
829 Riverside Ave, Jacksonville, FL 32204
Tel: 904-356-6857

Museum Founded: 1958
Hours: Tues-Fri 10-4
 Sat 12-5
 Sun 2-5
Circulation: No (open stacks, by appointment only)
Reference Service: No
Reprographic Services: Yes
Interlibrary Loan: No
Networks/Consortia: No
Publications: Newsletter; special catalogs
Cataloged Volumes: 3,000
Serial Titles: 20
Holdings: 400 sales & auction catalogs; 600 exhibition
catalogs
Subjects: Art, decorative arts, architecture, classical archaeology, graphics, photography

AL 148
DUNEDIN PUBLIC LIBRARY
233 Douglas Ave, Dunedin, FL 33528
Tel: 813-733-4115
Dir: Sydniciel Shinn

Public Library Founded: 1895
Circulation: Public (open stacks)
Reference Service: In person, telephone, mail
Reprographic Services: Yes
Interlibrary Loan: Florida State Interlibrary Loan
Networks/Consortia: No
Publications: Bibliographies; acquisitions list; in-house
periodical index
Special Programs: Group tours; bibliographic instruction
Card Catalog
Cataloged Volumes: 41,000 (35,000 titles)
Serial Titles: 150 (Florida Union List of Serials)
Holdings: 8 vertical file drawers; sales & auction catalogs
Subjects: Art, decorative arts, architecture, classical archaeology, film & video, graphics, photography, music,
theatre, dance

AL 149
FLORIDA GULF COAST ART CENTER LIBRARY
222 Ponce de Leon, Bellair-Clearwater, FL 33516
Tel: 813-584-8634
Libn: Marion Davis

Art School/Gallery Founded: 1948
Hours: Tues-Sat 10-4
 Sun 3-5
 Closed Mon
Circulation: Art center members (open stacks except for rare
 books & back issues of periodicals)
Reference Service: In person, telephone, mail
Reprographic Services: No
Interlibrary Loan: No
Networks/Consortia: No
Publications: Orientation handbook
Special Programs: Group & individual tours; intern program
Cataloged Volumes: 2,900 (2,783 titles)
Holdings: 8 vertical file drawers; 1 shelf sales & auction cata-
 logs; 1 shelf exhibition catalogs
Subjects: Art, architecture, classical archaeology, dance,
 decorative arts, graphics, music, photography, sculpture,
 theatre
Special Collections: First editions & rare books (79 in excel-
 lent condition)

AL 150
FLORIDA SOUTHERN COLLEGE
Roux Library
Lakeland, FL 33802
Tel: 813-683-5521, Ext 211
Dir: Larry Stallings

Academic Founded: 1885
Hours: Mon-Thurs 8-10
 Fri 8-5
 Sat 1-5
 Sun 2-10
Circulation: Students, faculty/staff (open stacks)
Reference Service: In person, telephone, mail
Reprographic Services: Yes
Interlibrary Loan: No
Networks/Consortia: Associated Mid-Florida Colleges
Publications: Orientation handbook
Special Programs: Group tours; bibliographic instruction
Card Catalog
Cataloged Volumes: 150,000
Serial Titles: 750
Holdings: 18 vertical file drawers; 5,800 microform units
Subjects: Art, architecture, graphics, photography, music,
 theatre, dance

AL 151
CONNI GORDON ART SCHOOL LIBRARY
530 Lincoln Rd, Miami Beach, FL 33139
Tel: 305-532-1001
Dir: Conni Gordon

Art School Founded: 1956
Hours: Mon-Fri 10-5
Circulation: Students, faculty/staff (open stacks)
Reference Service: In person
Reprographic Services: No
Interlibrary Loan: No
Networks/Consortia: No
Publications: Special catalogs; in-house periodical index
 (Conni Gordon Art Books)

Special Programs: Single lectures
Card Catalog
Cataloged Volumes: 16
Subjects: Art

AL 152
GULF COAST COMMUNITY COLLEGE
Learning Resource Center
5230 W Hwy 98, Panama City, FL 32401
Tel: 904-769-1551, Ext 210
Dean: Charles Bond
Libn: Margaret Barefield

Academic Founded: 1957
Hours: Mon-Thurs 7-9
 Fri 7-4
Circulation: Public (open stacks)
Reference Service: In person only
Reprographic Services: Yes
Interlibrary Loan: Florida State Library (R A Gray Bldg,
 Tallahassee, FL 32304)
Networks/Consortia: No
Publications: Orientation handbook
Cataloged Volumes: 45,000
Serial Titles: 777 (Florida Union List of Serials; University
 of West Florida Union List of Serials)
Holdings: 24 vertical file drawers; 367 microform titles
Subjects: General collection for 2 year undergraduate program

AL 153
JACKSONVILLE ART MUSEUM LIBRARY
4160 Boulevard Center Dr, Jacksonville, FL 32207
Tel: 904-398-8336
Libn: Julia Schlegel

Museum Founded: 1948
Hours: Mon-Fri 10-4
Circulation: No (closed stacks)
Reference Service: No
Reprographic Services: No
Interlibrary Loan: No
Networks/Consortia: No
Special Programs: Art classes
Cataloged Volumes: 650
Subjects: Art, architecture, decorative arts
Special Collections:
Koger Collection of Oriental Art

AL 154
JACKSONVILLE PUBLIC LIBRARY
Art & Music Department
122 N Ocean St, Jacksonville, FL 32202
Tel: 904-633-3748
Chief, Art & Music Department: Jeff Driggers

Public Library Founded: 1965
Circulation: Public (open stacks)
Reference Service: In person, telephone, mail
Reprographic Services: Yes
Interlibrary Loan: NILS; Florida Interlibrary Loan Network
Networks/Consortia: Southeastern Library Network
Publications: In-house periodical index
Special Programs: Group tours
Cataloged Volumes: 60,000 (40,000 titles)
Serial Titles: 94
Holdings: 29 vertical file drawers
Subjects: Art, architecture, decorative arts, dance, film &

video, graphics, music, photography, sports, theatre
Special Collection:
Delius Collection
Letters, scores, clippings & pictures pertaining to English
composer Frederick Delius who lived in Florida from
1884-5.

AL 155
KEY WEST ART & HISTORICAL SOCIETY
E Martello Gallery & Museum
S Roosevelt Blvd, Key West, FL 33040
Tel: 305-296-3913
Curator: Louise V White

Museum & Art Gallery Founded: 1947
Hours: Mon-Fri 9:30-5
Circulation: No
Reference Service: No
Reprographic Services: No
Interlibrary Loan: No
Networks/Consortia: No
Publications: Special catalogs for members
Subjects: Local history

AL 156
MIAMI BEACH PUBLIC LIBRARY
2100 Collins Ave, Miami Beach, FL 33139
Tel: 305-673-7535
Libn: Oscar C Everhart

Public Library Founded: 1927
Hours: Mon-Wed 10-9
 Thurs-Sat 10-5:30
Circulation: Public (open stacks)
Reference Service: Telephone, mail
Reprographic Services: Yes
Interlibrary Loan: NILS
Networks/Consortia: No
Special Programs: Lectures; musical programs; book reviews;
 book clubs
Card Catalog
Cataloged Volumes: 180,000
Holdings: 19 vertical file drawers
Subjects: Art, decorative arts, architecture, photography,
 music, theatre, dance

AL 157
MUSEUM OF FINE ARTS LIBRARY
255 Beach Drive N, Saint Petersburg, FL 33701
Tel: 813-896-2667
Dir: Lee Malone

Museum Founded: 1961
Hours: Tues-Sat 10-5
 Sun 1-5
Circulation: Restricted to use within library (open stacks)
Reference Service: In person, telephone
Reprographic Services: No
Interlibrary Loan: NILS
Networks/Consortia: No
Publications: Newsletter; special catalogs
Special Programs: Group tours; single lectures
Card Catalog
Cataloged Volumes: 5,000
Holdings: 12 vertical file drawers; sales & auction catalogs;
 exhibition catalogs; microforms
Subjects: Art, decorative arts, architecture, classical archae-
 ology, film & video, graphics, photography

AL 158
NORTH FLORIDA JUNIOR COLLEGE LIBRARY
Turner Davis Dr, Madison, FL 32340
Tel: 904-973-2288, Ext 52
Dir of Lib: Lu Sands

Academic Founded: 1958
Hours: Mon-Fri 8-9
Circulation: Public (open stacks)
Reference Service: In person, telephone, mail
Reprographic Services: Yes
Interlibrary Loan: NILS; statewide interlibrary loan networks
Networks/Consortia: No
Publications: Orientation handbook; bibliographies; in-house
 periodical index
Special Programs: Group & individual tours; bibliographic
 instruction
Serial Titles: (Florida List of Serials)
Subjects: Art, architecture, decorative arts, dance, film &
 video, graphics, music, photography, theatre

AL 159
PIONEER FLORIDA MUSEUM ASSOCIATION
LIBRARY
Box 335, Dade City, FL 33525
Tel: 904-567-0262
Curator: John Hermann

Museum
Hours: Tues-Sat 1-5
 Sun 2-5
Circulation: Restricted to use in museum
Reprographic Services: No
Interlibrary Loan: No
Networks/Consortia: No
Cataloged Volumes: 80-90

AL 160
RINGLING MUSEUM OF ART
Art Research Library
Box 1838, Sarasota, FL 33578
Tel: 813-355-5101, Ext 31
Libn: Valentine L Schmidt

Museum Founded: 1950
Hours: Mon-Fri 9-4:30
Circulation: (open stacks for books & periodicals)
Reference Service: In person, telephone, mail
Reprographic Services: Yes
Interlibrary Loan: No
Networks/Consortia: No
Publications: Special catalogs; in-house periodical holdings
Information Source: Schmidt, V L. *Florida Libraries*, v 21, no
 3, Sept 1970
Special Programs: Group & individual tours; bibliographic
 instruction; single lectures
Card Catalog
Cataloged Volumes: 7,500 (7,000 titles)
Serial Titles: 50 (Florida Union List of Serials)
Holdings: 16 vertical file drawers; 90 drawers of sales &
 auction catalogs; 20,000 exhibition catalogs
Subjects: Art, decorative arts, architecture, graphics, photog-
 raphy, theatre
Special Collection: 16-18th century rare books on iconography,
 biography, emblematics

AL 161
RINGLING SCHOOL OF ART

Ringling School of Art Library
1191 27 St, Sarasota, FL 33580
Tel: 813-351-1437
Head Libn: Elsie H. Straight

Art School Founded: 1932
Hours: Mon-Fri 8:45-9
Circulation: Public (open stacks except for rare books &
 plates)
Reference Service: In person, telephone, mail
Reprographic Services: No
Interlibrary Loan: NILS
Networks/Consortia: No
Publications: Orientation handbook
Special Programs: Group tours
Cataloged Volumes: 7,500 (7,340 titles)
Serial Titles: 88
Holdings: 4 vertical file drawers; 150 sales & auction catalogs;
 500 exhibition catalogs
Subjects: Art, architecture, decorative arts, film & video,
 graphics, photography
Special Collections: Interior design; graphic arts

AL 162
SANTA FE COMMUNITY COLLEGE LIBRARY
3000 NW 83 St, Gainesville, FL 32602
Tel: 904-377-5161, Ext 315
Coordinator: Jean L Thomas

Academic Founded: 1967
Hours: Mon-Thurs 7:45-10
 Fri 7:45-5
 Sat 9-5
Circulation: Students, faculty/staff, Santa Fe-sponsored
 public & researchers (open stacks)
Reference Service: In person, telephone, mail
Reprographic Services: Yes
Interlibrary Loan: NILS; Santa Fe Regional Library; State
 Library of Florida
Networks/Consortia: No
Publications: Orientation handbook; bibliographies; acquisi-
 tions list; in-house periodical index (Magazine Catalog)
Special Programs: Group & individual tours; bibliographic
 instruction; single lectures; non-credit course in use of
 library
Cataloged Volumes: 33,000 (general collection)
Serial Titles: 400 (Florida Union List of Serials)
Holdings: 10 vertical file drawers; 6,500 microfilms; 20 sales
 & auction catalogs; 7,000 art slides; 100 records
Subjects: Art, architecture, decorative arts, classical archae-
 ology, dance, film & video, graphics, music, photography,
 theatre

AL 163
TAMPA PUBLIC LIBRARY
Fine Arts Department
900 N Ashley St, Tampa, FL 33602
Tel: 813-223-8863; 8864
Libn: Robert Barnes

Public Library
Hours: Mon-Thurs 9-9
 Fri 9-6
 Sat 9-5
 Sun 1-5 (Oct-May)
Circulation: Public (open stacks)
Reference Service: Telephone, mail
Reprographic Services: Yes

Interlibrary Loan: NILS; Florida Library Information Network
Networks/Consortia: SOLINET
Publications: In-house periodical index (Tampa-Hillsborough
 Public Library System)
Special Programs: Group & individual tours; intern program
Card Catalog
Cataloged Volumes: 16,850
Serial Titles: 88 (Florida Union List of Serials)
Holdings: 24 vertical file drawers; 225 sales & auction cata-
 logs
Subjects: Art, decorative arts, architecture, film & video,
 graphics, photography, music, theatre, dance

AL 164
TOMLINSON ADULT EDUCATION CENTER
LIBRARY
296 Mirror Lake, St Petersburg, FL 33701
Tel: 813-896-8681
Media Specialist: Martha Taylor

Academic
Hours: Mon-Fri 8-3
Circulation: Students, faculty/staff (open stacks)
Reference Service: In person only
Reprographic Services: Yes
Interlibrary Loan: No
Networks/Consortia: No
Publications: Orientation handbook
Cataloged Volumes: 240
Holdings: 3 vertical file drawers
Subjects: Art, architecture, decorative arts, graphics

AL 165
UNIVERSITY OF MIAMI
Lowe Art Museum Library
1301 Miller Dr, Coral Gables, FL 33146
Tel: 305-284-3536

Museum Founded: 1952
Hours: Mon-Fri 12-5
 Sat 10-5
 Sun 12-5
Circulation: No (open stacks)
Reference Service: No
Reprographic Services: Yes
Interlibrary Loan: No
Networks/Consortia: No
Publications: Special catalogs; book catalog
Special Programs: Group tours
Cataloged Volumes: 5,000
Subjects: Art, decorative arts, architecture, classical
 archaeology, dance, film & video, graphics, music, photog-
 raphy, theatre
Special Collection:
Kress Collection

AL 166
UNIVERSITY OF WEST FLORIDA
John C Pace Library—Special Collections
Pensacola, FL 32504
Tel: 904-476-9500, Exts 261; 262
Head, Special Collections: Marion Viccars

Academic Founded: 1967
Hours: Mon-Fri 8-4:30
Circulation: Public (open stacks)
Reference Service: In person, telephone, mail
Reprographic Services: Special cases of research only

Interlibrary Loan: NILS
Networks/Consortia: Yes
Publications: Bibliographies
Subjects: Photography
Special Collection:
History of West Florida

AL 167
VIZCAYA MUSEUM
Vizcaya Volunteer Guides Library
3251 S Miami Ave, Miami, FL 33129
Tel: 305-579-2808

Museum Founded: 1954
Circulation: Staff (open stacks)
Reference Service: No
Reprographic Services: No
Interlibrary Loan: No
Networks/Consortia: No
Publications: Special catalogs; in-house periodical index;
 book catalog
Special Programs: Group & individual tours of the museum
Cataloged Volumes: 1,325
Subjects: Art, architecture, decorative arts
Special Collection: Decorative Art of the Renaissance

Georgia

AL 168
ATLANTA COLLEGE OF ART LIBRARY
1280 Peachtree St NE, Atlanta, GA 30309
Tel: 404-892-3600, Exts 210; 212
Head Libn: Gary R Sipe

Art School
Hours: Mon-Thurs 9-8
 Fri 9-5
 Sat 10-2
Circulation: Students, faculty/staff (open stacks)
Reference Service: In person, telephone, mail
Reprographic Services: No
Interlibrary Loan: No
Networks/Consortia: University Center of Georgia (Uni-
 versity of Georgia, Athens, GA 30605)
Special Programs: Group & individual tours; bibliographic
 instruction
Cataloged Volumes: 16,000
Serial Titles: 190 (University Center of Georgia List of
 Serials)
Subjects: Art, decorative arts, architecture, film & video,
 graphics, photography

AL 169
COLQUITT-THOMAS REGIONAL LIBRARY
204 Fifth St SE, Moultrie, GA 31768
Tel: 912-985-6530; 1444
Dir: Melody J Stinson

Public Library Founded: 1907; 1952
Hours: Mon, Wed, Thurs, Fri 8:30-5:30
 Tues 8:30-8
Circulation: Public (open stacks)
Reference Service: In person, telephone, mail
Interlibrary Loan: Georgia Library Information Network
Networks/Consortia: No

Information Sources: Odom, Ellen Payne. *History of the
 Public Library of Moultrie, GA,* Moultrie-Colquitt County
 Library, 1966
Special Programs: Group & individual tours; bibliographic
 instruction; single lectures
Cataloged Volumes: 163,943
Serial Titles: 392
Holdings: 307 microfilm reels
Subjects: Art, decorative arts, music, theatre
Special Collection:
Georgiana Collection
Materials relating to Georgian history and literature, particu-
 larly local.

AL 170
COLUMBUS MUSEUM OF ARTS & SCIENCES
Museum Research Library
1252 Wynnton Rd, Columbus, GA 31906
Tel: 404-323-3617
Research Libns: Edge R Reid & John Henry III

Museum Founded: 1972
Hours: Mon-Sat 10-5
Circulation: No (open stacks)
Reference Service: In person, telephone
Reprographic Services: Yes
Interlibrary Loan: No
Networks/Consortia: No
Publications: Special catalogs
Cataloged Volumes: 1,459
Holdings: 4 vertical file drawers; limited sales & auction cata-
 logs; extensive exhibition catalogs
Subjects: Art, decorative arts, classical archaeology, graphics,
 photography
Special Collections:
Southeastern Indians & Archaeology

AL 171
DEKALB LIBRARY SYSTEM
Maud M Burrus Library—Fine Arts Department
215 Sycamore St, Decatur, GA 30032
Tel: 404-378-7569
Fine Arts Libn: Virginia J Engelland

Public Library Founded: 1925
Circulation: Public (open stacks)
Reference Service: In person, telephone, mail
Reprographic Services: No
Interlibrary Loan: NILS; Georgia State Interlibrary Loan
 System
Networks/Consortia: Georgia Library Information Network
Special Programs: Group tours
Cataloged Volumes: 4,100
Serial Titles: 22
Subjects: Art, decorative arts, architecture, classical archae-
 ology, dance, film & video, graphics, music, photography,
 theatre

AL 172
GEORGIA INSTITUTE OF TECHNOLOGY
College of Architecture Library
225 North Ave NW, Atlanta, GA 30332
Tel: 404-894-4877
Libn: Frances K Drew

Academic Founded: 1885
Hours: Mon-Sun 8-9:30
 Mon-Sun 8-8 (summer)

Circulation: Students, researchers, faculty/staff (open stacks; periodicals restricted to room use)
Reprographic Services: Yes
Interlibrary Loan: NILS; Union Catalog of the Atlanta/Athens area
Networks/Consortia: SOLINET; DELC
Publications: Acquisitions list; descriptive brochure; in-house periodical catalog (Georgia Tech Library Catalog)
Special Programs: Group & individual tours; single lectures
Card Catalog
Cataloged Volumes: 10,140 (7,500 titles)
Serial Titles: 468 (National Union Catalog)
Holdings: 151 vertical file drawers; 168 exhibition catalogs; 135 microfiche
Subjects: Art, decorative arts, architecture

AL 173
GEORGIA STATE UNIVERSITY
Arthur I & Irma L Harris Reading Room & Art Library
Arts & Music Bldg, Rm 265, University Plaza, Atlanta, GA 30303
Tel: 404-658-2973
Curator: Temme B Balser

Academic Founded: 1970
Hours: Mon-Fri 8-5
Circulation: Public (open stacks; books, catalogs, periodicals restricted to use in library)
Reference Service: Telephone, mail
Reprographic Services: Yes
Interlibrary Loan: No
Networks/Consortia: No
Special Programs: Single lectures; student intern program
Card Catalog
Serial Titles: 65-70 (National Union Catalog)
Holdings: 35-50 exhibition catalogs
Subjects: Art, decorative arts, architecture, classical archaeology, graphics, photography

AL 174
NORTH GEORGIA COLLEGE
Stewart Memorial Library
Dahlonega, GA 30533
Tel: 404-864-3391, Ext 226
Libn: Marjorie Clark

Academic Founded: 1873
Hours: Mon-Thurs 7:30-10
 Fri 7:30-5
 Sat 9-3
 Sun 2-10
Circulation: Public (open stacks)
Reference Service: Telephone, mail
Reprographic Services: Yes
Interlibrary Loan: NILS
Networks/Consortia: No
Publications: Bibliographies
Special Programs: Group & individual tours; bibliographic instruction; single lectures
Card Catalog
Cataloged Volumes: 113,015
Serial Titles: 1,200
Holdings: 21 vertical file drawers; 450 reels of microforms
Subjects: Art, decorative arts, architecture, photography, music, theatre, dance

AL 175
TELFAIR ACADEMY OF ARTS & SCIENCES, INC LIBRARY
Box 10081, Savannah, GA 31402
Tel: 912-232-1177
Libn: Kaye Kole

Museum Founded: 1886
Hours: Tues-Sat 10-4:30
 Sun 2-5
Circulation: Researchers, faculty/staff (closed stacks)
Reference Service: No
Reprographic Services: No
Interlibrary Loan: No
Networks/Consortia: No
Cataloged Volumes: 1,100
Holdings: Sales, auction & exhibition catalogs
Subjects: Art, decorative arts, architecture, graphics, photography

AL 176
UNIVERSITY OF GEORGIA—ATHENS
University of Georgia Main Library
Athens, GA 30602
Tel: 404-542-7462
Dir: Warren Boes

Academic Founded: 1801
Hours: Mon-Thurs 8-12
 Fri 8-6
 Sat 9-6
 Sun 2-12
Circulation: Public (open stacks except for special collections)
Reference Service: In person, telephone, mail
Reprographic Services: Yes
Interlibrary Loan: NILS; Association of Southeastern Research Libraries; Center for Research Libraries
Networks/Consortia: Southeastern Library Network; Georgia Library Information Network; Association of Research Libraries; Regional Depository Library for Government Documents
Publications: Orientation handbook; bibliographies; acquisitions list; newsletter; special catalogs; in-house periodical index (University of Georgia Periodical Locator)
Special Programs: Group & individual tours; bibliographic instruction; intern program
Cataloged Volumes: 1,750,000 (general collection)
Serial Titles: 29,924 in general collection (National Union Catalog; Union List of Serials; New Serial Titles; Southeastern Union List of Serials)
Holdings: 60 vertical file drawers; 1,100,000 microforms; sales & auction catalogs; exhibition catalogs (figures apply to general holdings)
Subjects: Art, decorative arts, architecture, classical archaeology, dance, film & video, graphics, music, photography, theatre
Special Collections:
Photography Collection
Rare Books and Manuscripts
Rare books, pamphlets, broadsides & manuscripts covering a range of subjects

AL 177
VALDOSTA STATE COLLEGE LIBRARY
Valdosta, GA 31601

Tel: 912-247-3228
Dir: David L Ince

Academic Founded: 1906
Hours: Mon-Thurs 7:45-11
 Fri 7:45-5
 Sat 9-5
 Sun 2-11
Circulation: Students, faculty/staff (open stacks except for
 microforms)
Reference Service: In person, telephone
Reprographic Services: Yes
Interlibrary Loan: NILS; South Georgia Associated Libraries
 (Betty Greenhaw)
Networks/Consortia: OCLC; Central Georgia Associated
 Libraries
Publications: Newsletter; in-house periodical index (Valdosta
 State College Periodical Holdings List)
Special Programs: Group & individual tours
Cataloged Volumes: 180,000 total collection (13,500 titles)
Serial Titles: 2,088 total collection (South Georgia Associ-
 ated Libraries List of Serials)
Holdings: 24 vertical file drawers (total collection); 260,754
 microform units (total collection); 300 circulating art prints;
 5-10 slide/cassette kits; several 16mm films on art-related
 subjects
Subjects: Art, decorative arts, architecture, classical archae-
 ology, dance, film & video, graphics, music, photography,
 theatre
Special Collections:
The "V" Collection of Georgiana

Hawaii

AL 178
BERNICE P BISHOP MUSUEM
Bishop Museum Library & Photo Collection
Box 6037, Honolulu, HI 96818
Tel: 808-847-3511, Exts 148; 182
Libn: Cynthia Timberlake

Museum Founded: 1889
Hours: Tues-Thurs 1-4 (open to the public)
Circulation: Faculty/staff (open stacks; restricted to museum
 staff)
Reference Service: In person
Reprographic Services: Yes; rare books, fragile materials &
 manuscripts restricted
Interlibrary Loan: No
Networks/Consortia: No
Publications: Acquisitions list
Special Programs: Group & individual tours; bibliographic
 instruction; single lectures
Card Catalog
Cataloged Volumes: 80,000
Serial Titles: 1,200
Holdings: 16 vertical file drawers; 3 drawers sales & auction
 catalogs; 950 microforms
Subjects: Art, decorative arts, architecture, classical archae-
 ology, photography, music, theatre, dance
Special Collections:
Carter Collection of Hawaiiana
Fuller Collection of Pacific Books
Rare book collection which includes maps, charts, art &
 photographs relating to early history of Pacific area.

AL 179
HONOLULU ACADEMY OF THE ARTS
Robert Allerton Library
900 S Beretania St, Honolulu, HI 96814
Tel: 808-538-3693, Ext 35
Libn: Anne T Seaman

Museum & Art School Founded: 1927
Hours: Tues-Fri 10-4
 Sat 10-3
Circulation: Restricted to use within museum by staff &
 scholars
Reference Service: Telephone, mail
Reprographic Services: Yes
Interlibrary Loan: NILS
Networks/Consortia: No
Special Programs: Group & individual tours; single lectures
Card Catalog
Cataloged Volumes: 30,000
Serial Titles: 200 (Union List of Serials in Hawaii)
Holdings: 20 vertical file drawers; 5,000 sales & auction
 catalogs; 10,000 exhibition catalogs; microfilm
Subjects: Art, decorative arts, architecture, classical archae-
 ology, graphics, photography
Special Collection:
Chinese National Palace Museum Photo Archives

AL 180
HONOLULU ACADEMY OF ARTS
Lending Collection
900 S Beretania St, Honolulu, HI 96814
Tel: 808-538-3693, Ext 56
Libn: Barbara F Hoogs

Museum & Art School Founded: 1931
 (Academy founded 1927)
Hours: Tues-Fri 1-4
 Sat 8-12
Circulation: Students, faculty/staff; restricted to educational
 use of materials (open stacks)
Reprographic Services: No
Interlibrary Loan: No
Networks/Consortia: No
Card Catalog
Cataloged Volumes: 3,400
Holdings: 63 drawers of mounted pictures; 5,000 artifacts;
 800 pamphlets
Subjects: Art, decorative arts, architecture

Idaho

AL 181
BOISE STATE UNIVERSITY LIBRARY
1910 College Blvd, Boise, ID 83725
Tel: 208-385-1204
University Libn: Timothy A Brown

Academic Founded: 1932
Hours: Mon-Thurs 7:30-11
 Fri 7:30-5
 Sat 9-5
 Sun 2-10
Circulation: Public (open stacks)
Reference Service: In person, telephone, mail
Reprographic Services: Yes

Interlibrary Loan: NILS
Networks/Consortia: No
Publications: Orientation handbook; in-house periodical index
 (Boise State University Subject List of Periodicals)
Special Programs: Group tours; single lectures
Card Catalog
Cataloged Volumes: 214,236
Serial Titles: 2,245
Holdings: 48 vertical file drawers; 12,078 microfilms;
 97,488 microfiche; 3,245 microcards
Subjects: Art, decorative arts, architecture, classical archae-
 ology, dance, film & video, graphics, music, photography,
 theatre

AL 182
UNIVERSITY OF IDAHO LIBRARY
Humanities Division
Moscow, ID 83843
Tel: 209-886-6584
Libn: Milo Nelson

Academic Founded: 1889
Hours: 8-11
Circulation: Public (open stacks)
Reference Service: In person, telephone, mail
Reprographic Services: Yes
Interlibrary Loan: NILS; Pacific Northwest Bibliographies
 Center
Networks/Consortia: Libraries of Idaho Teletype Network
Publications: Orientation handbook; bibliographies; acquisi-
 tions list; special catalog; quarterly journal; in-house
 periodical index (Linedex)
Special Programs: Group & individual tours; bibliographic
 instruction; single lectures
Card Catalog
Cataloged Volumes: 15,000 (10,000 titles)
Serial Titles: 75 (Idaho Union List of Serials)
Holdings: 2 vertical file drawers; sales & auction catalogs;
 exhibition catalog
Subjects: Art, decorative arts, architecture, film & video,
 graphics, photography, music, theatre, dance

Illinois

AL 183
THE ART INSTITUTE OF CHICAGO
Ryerson & Burnham Libraries
Michigan & Adams, Chicago, IL 60637
Tel: 312-443-3666
Libn: Daphne C Roloff, Dir

Museum Founded: 1902 Ryerson Library
 1912 Burnham Library
Hours: Mon-Sat 10:30-4 (closed Sat during summer)
Circulation: Restricted to use by members, faculty/staff,
 students of School of Art Institute of Chicago, graduate
 students with a letter
Reference Service: In person, telephone, mail
Reprographic Services: Yes
Interlibrary Loan: No
Networks/Consortia: Illinois Regional Library Council;
 Union Catalog of Art
Publications: Orientation handbook; acquisitions list; special
 catalogs; in-house periodical indexes (Index to Art Peri-
 odicals & Supplement); *Burnham Index to Architectural
 Periodicals*; descriptive catalog of Japanese & Chinese
 illustrated books in the Ryerson Library . . . ; *Surrealism &*

Its Affinities: The Mary Reynolds Collection, a bibliog-
 raphy)
Information Source: Schoneman, "The Library of the Art
 Institute of Chicago," *Chicago Art Institute Calendar*,
 v 62, no 2, March–April 1968, p 9-14
Special Programs: Group & individual tours; single lectures
Card Catalog
Cataloged Volumes: 120,000
Serial Titles: 953 (National Union Catalog)
Holdings: 207 vertical file drawers; extensive sales & auction
 catalogs; extensive exhibition catalogs; 557 reels of film;
 3 fiche; 18,460 mounted photographs of Chicago architec-
 ture
Subjects: Art, decorative arts, architecture, graphics, pho-
 tography
Special Collections: Japanese wood-block books collection;
 Reynolds collection of surrealism & its affinities
Artists' Letter Collection
Correspondence of Cassatt, O'Keefe, Sargent.
Brewster Collection
Material by and about Whistler.
Chicago Architect Collection
Papers & working drawings of Adler & Sullivan, S S Beman,
 E H Bennett, D H Burnham, W B Griffin, L H Sullivan &
 F L Wright.
Library of Fontaine
Architect to Napoleon; early imprints in theory & practice of
 architecture.

AL 184
ART INSTITUTE OF CHICAGO
School Library of Art
Columbus & Jackson Sts, Chicago, IL 60603
Tel: 312-443-3748
Acting Libn: Nadene Byrne

Art School Founded: 1971
Hours: Mon-Thurs 10-9
 Fri-Sun 10-5
Circulation: Students, faculty/staff (open stacks)
Reference Service: In person only
Reprographic Services: Yes
Interlibrary Loan: No
Networks/Consortia: Union of Independent Colleges
 Association
Publications: Orientation handbook; acquistions list; in-
 house periodical index
Special Programs: Orientation for new students & faculty
Cataloged Volumes: 9,661 (8,116 titles)
Serial Titles: 109
Holdings: 1 vertical file drawer; 1 exhibition catalog
Subjects: Art, architecture, black studies, classical archae-
 ology, dance, decorative arts, education, film & video,
 graphics, history, literature, music, philosophy,
 photography, science, theatre
Special Collection:
Paperback Film Scripts

AL 185
BURPEE ART MUSEUM
Katherine Pearman Memorial Library
737 N Main St, Rockford, IL 61103
Tel: 815-965-3131
Libn: William McGonagle

Museum Founded: 1935
Hours: Tues-Fri 12-5
 Sat-Sun 1-5

Circulation: Restricted to staff & member use in museum
Reference Service: In person, mail
Reprographic Services: Yes
Interlibrary Loan: No
Networks/Consortia: No
Publications: Newsletter; special catalogs
Special Programs: Group & individual tours; single lectures
Card Catalog
Cataloged Volumes: 600
Serial Titles: 10 (National Union Catalog)
Holdings: 6 vertical file drawers, sales & auction catalogs; exhibition catalogs
Subjects: Art, decorative arts, architecture, classical archaeology, graphics, photography

AL 186
CHICAGO PUBLIC LIBRARY
Fine Arts Divison—Art Section
78 E Washington St, Chicago, IL 60602
Tel: 312-269-2858
Head: Patricia E. Keane

Public Library Founded: 1872; 1914
Hours: Mon-Thurs 9-9
 Fri 9-6
 Sat 9-5
Circulation: Public (open stacks except for selected reference materials)
Reference Service: In person, telephone, mail
Reprographic Services: Yes
Interlibrary Loan: NILS; Illinois Library & Information Network; Chicago Public Library System (Marilyn Boria, Head, Interlibrary Loan, Chicago Public Library, 425 N Michigan, Chicago, IL 60611)
Networks/Consortia: Illinois Library & Information Network
Publications: Network brochure; in-house periodical index (The Chicago Public Library Serials List)
Information Sources: Illinois Regional Library Council, "Libraries & Information Centers in the Chicago Metropolitan Area," IRLC, 1976
Special Programs: Group & individual tours
Cataloged Volumes: 48,937 art (19,973 titles)
Serial Titles: 285 art (National Union Catalog; Union List of Serials)
Holdings: 192 vertical file drawers (including 24 pamphlets & 168 picture files); 4,239 microforms; 12 drawers exhibition catalogs (World Wide plan)
Subjects: Art, antiques, architecture, dance, decorative arts, film & video, graphics, music, photography, theatre
Special Collections:
Chicago Artists & Architecture
Chicago Stagebills
1937–present
Folk Dance Collection
26 loose leaf volumes.
Picture Collection
Over a million items of mounted pictures & clippings from secondary sources, arranged alphabetically by subject and cataloged.
Sears-Roebuck Catalogs
Contained on 80 reels of microfilm.

AL 187
RICHARD J DALEY COLLEGE
Learning Resource Center
7500 S Pulaski Rd, Chicago, IL 60652
Tel: 312-735-3000
Chairperson: Marilyn Mayer

Academic Founded: 1961
Hours: Mon-Fri 8-10
Circulation: Students, researchers, faculty/staff (open stacks)
Reference Service: In person, telephone
Reprographic Services: Yes
Interlibrary Loan: No
Networks/Consortia: No
Publications: Orientation handbook; bibliographies; acquisitions list; in-house book catalog
Special Programs: Group & individual tours; single lectures
Card Catalog
Cataloged Volumes: 35,000 (32,000 titles)
Holdings: 20 vertical file drawers; 2,000 microforms
Subjects: Art, decorative arts, architecture, classical archaeology, film & video, graphics, photography, music, theatre, dance

AL 188
EVANSTON PUBLIC LIBRARY
Art, Music & Film Department
1703 Orrington, Evanston IL 60201
Tel: 312-475-6700, Exts 58; 59
Dept Head: Linda Seckelson-Simpson

Public Library Founded: 1873
Hours: Mon-Fri 9-9
 Sat 9-6
 Sun 1-5 (Sept-May only)
Circulation: Public (open stacks)
Reference Service: In person, telephone
Reprographic Services: Yes
Interlibrary Loan: North Suburban Library System
Networks/Consortia: North Suburban Library System
Publications: Bibliographies; in-house periodical index
Special Programs: Group & individual tours; bibliographic instruction; single lectures; special exhibits
Card Catalog
Cataloged Volumes: 31,000 (fine arts subjects)
Serial Titles: 100
Holdings: 41 vertical file drawers; 216 linear feet of catalogs
Subjects: Art, architecture, ceramics, dance, decorative & minor arts, drawing, film & video, furniture, glass, graphics, interior decoration, metalwork, music, painters & painting, photography, recreation, sculpture, sports, theatre, theory teaching

AL 189
GALENA HISTORIC DISTRICT—DEPARTMENT OF CONSERVATION LIBRARY
Bouthillier St, Galena, IL 61036
Tel: 815-777-0248
Site Superintendent: Warren R Kuh

State Historical Site Founded: 1955
Hours: Mon-Sun 9-5
Circulation: Researchers; research permitted & confirmed by institution
Reference Service: No
Reprographic Services: No
Interlibrary Loan: State Interlibrary System (Springfield, IL)
Networks/Consortia: No
Publications: Site brochures
Special Programs: Group tours; intern program
Holdings: Artifact accession inventory
Subjects: Architecture, graphics, photography
Special Collections: Mississippi lead miners' region—1820–1880; U S Grant personal items & history; artifacts of 1840–1880 period

AL 190
GOVERNORS STATE UNIVERSITY
Learning Resources Center
Park Forest South, IL 60466
Tel: 312-534-5000, Ext 2321
Dean of Instructional Services: Richard J Vorwerk

Academic Founded: 1971
Hours: Mon-Fri 8:30-11
 Sat 8:30-4
Circulation: Public; restricted circulation for non-university
 members (open stacks; non-circulating documents & bound
 periodicals, media)
Reprographic Services: Yes
Interlibrary Loan: NILS
Networks/Consortia: OCLC; Illinois Regional Library
 Council; Chicago Academic Library Council
Publications: In-house periodical holding list
Special Programs: Individual tours; single lectures
Card Catalog
Subjects: Art, decorative arts, architecture, classical archae-
 ology, film & video, graphics, photography, music, theatre,
 dance
Special Collections: 19th century American folk culture;
 primitive art, Amerinidian & Mesoamerican

AL 191
HARRINGTON INSTITUTE OF INTERIOR DESIGN
Design Library
410 S. Michigan Ave, Chicago, IL 60605
Tel: 312-939-4975
Libn: Adeline Schuster

Academic Founded: 1931
Hours: Mon, Wed, Fri 8:30-5
 Tues, Thurs 8:30-9
Circulation: Public; restricted to same day use within the
 Institute
Reference Service
Reprographic Services: Yes
Interlibrary Loan: No
Networks/Consortia: Chicago Library System; Illinois
 Library & Information Network
Publications: Orientation handbook; bibliographies; acquisi-
 tions list; monthly calendar of cultural events in Chicago
 area
Special Programs: Group & individual tours; bibliographic
 instruction; single lectures
Card Catalog
Cataloged Volumes: 800 (780 titles)
Serial Titles: 38
Subjects: Art, decorative arts, architecture, classical archae-
 ology, graphics, photography
Special Collections:
Interior Design–Products Library
Manufacturers' catalogs of furnishing, lighting equipment,
 hardware, wall coverings

AL 192
ILLINOIS STATE MUSEUM LIBRARY
Decorative Arts Department & Fine Arts Department
Spring & Edwards Sts, Springfield, IL 62706
Tel: 217-782-7125
Libn, Decorative Arts: Betty Madden
Libn, Fine Arts: Robert Evans

Museum Founded: 1928

Hours: Mon-Fri 8:30-5
Circulation: Restricted to research within museum (open
 stacks)
Reference Service: Telephone, mail
Reprographic Services: Yes
Interlibrary Loan: No
Networks/Consortia: No
Publications: Newsletter; special catalogs; book catalog
Special Programs: Group & individual tours; single lectures
Card Catalog
Subjects: Art, decorative arts, architecture
Special Collection: Archives of Illinois artists

AL 193
ILLINOIS STATE UNIVERSITY
Milner Library, Humanities Department
Normal, IL 61761
Tel: 309-438-3675, Ext 267
Humanities Coordinator & Fine Arts Libn: Edward S
 Meckstroth

Academic Founded: 1857
Hours: Mon-Sat 8-11
 Sun 1-11
Circulation: Students, researchers, faculty/staff; public if
 material not available elsewhere (open stacks; restrictions
 on valuable art books)
Reference Service: In person, telephone, mail
Reprographic Services: Yes
Interlibrary Loan: NILS
Networks/Consortia: Center for Research Libraries; OCLC
Publications: Orientation handbook; bibliographies; in-house
 periodical directory
Special Programs: Group & individual tours; single lectures;
 intern program
Card Catalog
Cataloged Volumes: 20,000
Serial Titles: 375
Holdings: 1 vertical file drawer; 1,000 exhibition catalogs
Subjects: Art, decorative arts, architecture, film & video,
 graphics, photography, theatre

AL 194
MORAINE VALLEY COMMUNITY COLLEGE
Learning Resource Center
10900 S 88 Ave, Palos Hills, IL 60465
Tel: 312-974-4300, Exts 220; 221
Assoc Dean: Vicky Smith

Academic Founded: 1968
Hours: Mon-Thurs 7:30-9:30
 Fri 7:30-5
 During spring & fall
Circulation: Students, faculty/staff (open stacks)
Reference Service: In person, telephone
Reprographic Services: No
Interlibrary Loan: Suburban Library System, Illinois (125
 Tower Dr, Hinsdale, IL 60521)
Networks/Consortia: Illinois Regional Library Council;
 Northern Illinois Learning Resources Consortium
Publications: Orientation handbook; bibliographies; book
 catalog; in-house periodical index (Periodicals-Learning
 Resources Center-MVCC)
Special Programs: Group tours; bibliographic instruction;
 informal intern program
Cataloged Volumes: 95,000
Serial Titles: 669
Holdings: 42 vertical file drawers; 7,982 microfilms

Subjects: Art, architecture, film & video, graphics, music, theatre

AL 195
MUSEUM OF CONTEMPORARY ART
Education Department Library
237 E Ontario St, Chicago, IL 60611
Tel: 312-943-7755
Director of Education: Philip Yenavine

Art School Founded: 1967
Hours: Mon-Fri 10-5
Circulation: Faculty/staff; the public may use materials on a non-circulating basis within museum (open stacks)
Reprographic Services: No
Interlibrary Loan: No
Networks/Consortia: No
Publications: In-house book catalog & periodical index (vertical file card catalog)
Card Catalog
Cataloged Volumes: c 1,000
Holdings: 25 vertical file drawers
Subjects: Art, film & video, graphics, photography, performance art
Special Collection: 20th century American art

AL 196
THE NEWBERRY LIBRARY
60 W Walton St, Chicago, IL 60610
Tel: 312-943-9090
President: Lawrence W Towner

Privately-endowed Research Library Founded: 1887
Hours: Tues-Sat 9-6
Circulation: Qualified researchers (closed stacks)
Reference Service: In person, telephone, mail
Reprographic Services: Yes
Interlibrary Loan: No
Networks/Consortia: Independent Research Libraries Association
Publications: Newsletter; special catalogs; book catalog
Special Programs: Group tours; single lectures; intern program
Cataloged Volumes: 1,000,000 total collection
Serial Titles: 1,000 (National Union Catalog)
Subjects: Art, decorative arts, graphics, music
Special Collections:
Edward E Ayer Collection
Materials relating to the history of American Indians, including photographs
John M Wing Foundation
Materials relating to the history of printing, type design, book illustration & calligraphy

AL 197
NORTH CENTRAL COLLEGE LIBRARY
320 E School Ave, Naperville, IL 60540
Tel: 312-355-0597; 420-3425
Dir: Dr Glenn C Stewart

Academic Founded: 1861
Hours: Mon-Thurs 8-11
 Fri 8-5
 Sat 9-2
Circulation: Students, researchers, faculty/staff (open stacks)
Reference Service: In person
Reprographic Services: Yes

Interlibrary Loan: NILS
Networks/Consortia: LIBRAS; DuPage Library System; Suburban Library System; Illinois Library & Information Network; OCLC
Publications: In-house periodical index (LIBRAS Union List of Periodicals)
Special Programs: Group & individual tours; bibliographic instruction; single lectures
Card Catalog
Cataloged Volumes: 92,000 (84,000 titles)
Serial Titles: 760 (LIBRAS, Suburban & ILLINET Union List of Serials)
Holdings: 24 vertical file drawers; 100 units microfiche; slides
Subjects: Art, architecture, classical archaeology, film & video, music, theatre, dance
Special Collections:
Sang Jazz Collection
First edition & presentation copies of books on jazz.

AL 198
NORTHERN ILLINOIS UNIVERSITY
Founders Memorial Library, Art/Music Cluster
DeKalb, IL 60115
Tel: 815-753-1634
Libn: Gordon S Rowley

Academic Founded: 1895
Hours: Mon-Thurs 7:30-2
 Fri 7:30-10
 Sat 9-5
 Sun 1:30-2
Circulation: Students, researchers, faculty/staff; reference collection does not circulate (open stacks; restrictions on special collections & rare books)
Reference Service: In person, telephone, mail
Reprographic Services: Yes
Interlibrary Loan: NILS; Center for Research Libraries
Networks/Consortia: OCLC; Illinois Library & Information Network; Northern Illinois Library System
Publications: *NIU Libraries*; in-house periodical holdings list
Special Programs: Group & individual tours; bibliographic instruction; single lectures
Card Catalog
Cataloged Volumes: 800,000
Serial Titles: 8,400 (National Union Catalog)
Subjects: Art, decorative arts, architecture, classical archaeology, graphics, music

AL 199
PEORIA PUBLIC LIBRARY
Art & Music Department
107 NE Monroe, Peoria, IL 61602
Tel: 309-672-8847
Libn: Velma Gorsage

Public Library Founded: 1880
Hours: Mon-Thurs 9-9
 Fri-Sat 9-6
 Closed Sat (summer)
Circulation: Public (open stacks)
Reference Service: Telephone, mail
Reprographic Services: Yes
Interlibrary Loan: Illinois Valley Library System (Margareth Gibbs, Information Network Services)
Networks/Consortia: Central Illinois Cultural Affairs Consortium

Publications: Orientation handbook; bibliographies; acquisitions list; staff newsletter; special catalogs; in-house periodical catalog (Periodicals of the Peoria Public Library)
Special Programs: Group & individual tours; bibliographic instruction; single lectures
Card Catalog
Cataloged Volumes: 14,500
Serial Titles: 59
Holdings: 34 vertical file drawers; sheet music; sculpture & art reproductions; 300 recordings
Subjects: Art, decorative arts, architecture, graphics, photography, music, costume
Special Collections:
Peoriana Collection
Books, photographs, clippings on local fine arts.

AL 200
HELEN PLUM MEMORIAL LIBRARY
110 W Maple, Lombard, IL 60126
Tel: 312-627-0316
Libn: Charles Herrick

Public Library
Hours: Mon-Fri 9-9
 Sat 9-5
 Closed Sun
Circulation: Public (open stacks)
Reference Service: In person, telephone
Interlibrary Loan: NILS; DuPage Library System
Networks/Consortia: Illinois Regional Library Council
Card Catalog
Cataloged Volumes: 4,600
Serial Titles: 5
Holdings: 25 exhibition catalogs
Subjects: Art, decorative arts, architecture, film & video, graphics, photography, music, theatre, dance

AL 201
PUBLIC ART WORKSHOP
Mural Resource Center
5623 W Madison St, Chicago, IL 60644
Tel: 312-626-1713
Dir: Barbara Russum

Community Art Center Founded: 1972
Hours: Mon-Fri 10-6 (by appointment)
Circulation: (open stacks)
Reference Service: Telephone, mail
Reprographic Services: Yes
Interlibrary Loan: No
Networks/Consortia: National Murals Network
Publications: Bibliographies; Mural Resources List, in-house periodical index
Special Programs: Single lectures
Card Catalog
Cataloged Volumes: 500
Holdings: 8 drawers of new clippings, pamphlets & unpublished manuscripts
Subjects: Art, decorative arts, architecture, graphics, photography
Special Collection:
Mural Collection
Material on current mural renaissance, the great Mexican murals, New Deal art period.

AL 202
POLISH MUSEUM OF AMERICA
Library & Archives

984 N Milwaukee Ave, Chicago, IL 60622
Tel: 312-384-3352
Dir: Rev Donald Bilinski

Museum Founded: 1912
Hours: Mon-Thurs 10-4
Circulation: Public (open stacks)
Reference Service: In person, telephone
Reprographic Services: Yes
Interlibrary Loan: NILS
Networks/Consortia: No
Publications: In-house periodicals list; *Polish Museum Quarterly*
Information Source: Stefanowicz, *Historia Museum*, PRCUA, 1952
Special Programs: Group & individual tours
Card Catalog
Cataloged Volumes: 19,000
Holdings: 100 vertical file drawers; 300 reels microforms
Subjects: Art, architecture, music, theatre, dance
Special Collection: Materials of Polish origins

AL 203
QUINCY COLLEGE LIBRARY
1831 College Ave, Quincy, IL 62301
Tel: 217-222-8020, Ext 225
Libn: Rev Victor Kingery, OFM

Academic Founded: 1860
Hours: Mon-Thurs 8-11
 Fri 8-8
 Sat 12-5
 Sun 1-10
Circulation: Public (open stacks)
Reference Service: In person, telephone, mail
Reprographic Services: Yes
Interlibrary Loan: NILS
Networks/Consortia: Illinois Library & Information Network
Special Programs: Group & individual tours; bibliographic instruction
Card Catalog
Cataloged Volumes: 7,200 (7,000 titles)
Serial Titles: 50
Subjects: Art, decorative arts, architecture, classical archaeology, film & video, graphics, photography, music, theatre, dance

AL 204
ROCKFORD COLLEGE
Howard Colman Library
5050 E State St, Rockford, IL 61101
Tel: 815-226-4035-6-7
Head Libn: James Michna

Academic Founded: 1847
Hours: Mon-Thurs 8-10
 Fri 8-5
 Sat 2-5
 Sun 1-11
Circulation: Public (open stacks)
Reference Service: In person, telephone, mail
Reprographic Services: Yes
Interlibrary Loan: NILS; Illinois Library Information Network; Midwest Health Sciences Network (Joan B Surrey, Public Services Libn)
Networks/Consortia: Southern Wisconsin Associated Librarians Organization
Publications: Orientation handbook; bibliographies; in-house

periodical index (Northern Illinois Library System
Union List of Serials)
Special Programs: Group & individual tours; bibliographic
instruction; single lectures
Cataloged Volumes: 111,389 (110,000 titles)
Serial Titles: 413
Holdings: 18 vertical file drawers; 1,411 microforms
Subjects: Art, architecture, classical archaeology, dance,
decorative arts, film & video, graphics, music, photog-
raphy, theatre

AL 205
ROCKFORD PUBLIC LIBRARY

Art, Music & Literature/Audio-Visual Department
215 N Wyman, Rockford, IL 61101
Tel: 815-965-6731, Exts 55; 56; 36; 47
Libns: Genene Anderson & Ray Reinholtzen

Public Library Founded: 1873
Hours: Mon-Thurs 9-9
 Fri-Sat 9-6
Circulation: Public (open stacks; restrictions on rare materials)
Reference Service: Telephone, mail
Interlibrary Loan: NILS
Networks/Consortia: Illinois Library & Information Network
Publications: Orientation handbook; bibliographies; acquisi-
tions list; newsletter; special catalogs; consolidated peri-
odical list; in-house periodical list (Comprehensive serial
list)
Special Programs: Group & individual tours; bibliographic
instruction; single lectures
Card Catalog
Subjects: Art, decorative arts, architecture, film & video,
graphics, photography, music, theatre, dance, landscaping,
handicrafts
Special Collection: Rockfordiana

AL 206
ROOSEVELT UNIVERSITY LIBRARY

430 S Michigan Ave, Chicago, IL 60605
Tel: 312-341-3640
Dir of Libs: Adrian Jones

Academic Founded: 1946
Hours: Mon-Thurs 8-9
 Fri 8-6:30
 Sat & Sun 12-5
Circulation: Students, researchers, faculty/staff (open stacks)
Reference Service: In person, telephone, mail
Reprographic Services: Yes
Interlibrary Loan: NILS; Chicago Academic Library Council;
Illinois Library Network
Networks/Consortia: Illinois Library Network
Publications: Orientation handbook; bibliographies; acquisi-
tions list; newsletter
Special Programs: Individual tours
Cataloged Volumes: 3,343 (2,872 titles)
Serial Titles: 25 art-related
Holdings: Sales, auction & exhibition catalogs
Subjects: Art, architecture, classical archaeology, dance,
decorative arts, film & video, graphics, music, photography,
theatre
Special Collections:
Auditorium Building/Sullivan Archives
Music Library

AL 207
SANGAMON STATE UNIVERSITY

Brookens Library
Springfield, IL 62708
Tel: 217-786-6633
Dean of Library Services: Patricia Breivik

Academic Founded: 1970
Hours: Mon-Thurs 8-10
 Mon-Thurs 8-9 (summer)
 Fri 8-5
 Sat 9-5
 Sun 2-10
 Sun 2-6 (summer)
Circulation: Students; arrangements can be made for visiting
researchers (open stacks)
Reference Service: In person
Reprographic Services: Yes
Interlibrary Loan: NILS
Networks/Consortia: Conference of Directors of State Uni-
versity Librarians of Illinois; OCLC; Southern Wisconsin
Academic Librarians Organization
Publications: Orientation handbook; newsletter; "Guides to
Sources"; in-house periodical index
Information Source: Dillon, Howard, "The SSU Lib,"
Journal of Academic Librarianship, Fall 1975
Special Programs: Group & individual tours; bibliographic
instruction; single lectures; tutorials; courses
Card Catalog
Cataloged Volumes: 180,000 (150,000 titles)
Serial Titles: 3,100 (Springfield, Illinois Area Union List)
Holdings: 10 vertical file drawers; 5,000 exhibition catalogs;
300,000 microforms
Subjects: Art, decorative arts, architecture, film & video,
graphics, photography, music, theatre, dance

AL 208
SOUTHERN ILLINOIS UNIVERSITY AT EDWARDSVILLE

Lovejoy Library, Fine Arts Library
Edwardsville, IL 62026
Tel: 618-692-2000, Ext 2670
Libn: Marianne Kozlowski, Fine Arts/Music

Academic
Hours: Mon-Thurs 7:30-10
 Fri 7:30-6
 Sat 9-5
 Sun 2-7
Circulation: Students, faculty/staff (open stacks; restrictions
on special collections & rare books)
Reference Service: In person, telephone, mail
Reprographic Services: Yes
Interlibrary Loan: NILS
Networks/Consortia: Illinois Library & Information Network;
Lewis & Clark System, OCLC
Publications: Orientation handbook; in-house periodical cata-
log (Periodicals Holdings Catalog)
Special Programs: Group tours; bibliographic instruction;
single lectures
Card Catalog
Cataloged Volumes: 12,437
Serial Titles: 69 (National Union Catalog; Illinois Colleges
Union List of Serials; St Louis Metropolitan Area Union
List of Periodicals)
Holdings: 2 vertical file drawers; 255 microfiche
Subjects: Art, decorative arts, architecture, film & video,
graphics, photography

AL 209
TRITON COLLEGE
Learning Resource Center
2000 Fifth Ave, River Grove, IL 60171
Tel: 312-456-0300, Ext 214
Coordinator of Library Services: Mary Lou Lowry

Community College Founded: 1964
Hours: Mon-Fri 8-10
 Sat 8-4
Circulation: Students, faculty/staff (open stacks)
Reference Service: In person, telephone, mail
Reprographic Services: Yes
Interlibrary Loan: County & suburban
Networks/Consortia: Educational Resources Information
 Center
Publications: Acquisitions list; special catalogs; in-house
 periodical index
Special Programs: Group tours; intern program
Cataloged Volumes: 56,000
Subjects: Art, architecture, dance, decorative arts, film &
 video, graphics, music, photography, theatre

AL 210
UKRAINIAN NATIONAL MUSEUM
Research Library
2453 W Chicago Ave, Chicago, IL 60622
Tel: 312-276-6565
Libn: Dr Roman Weres

Museum
Hours: Mon-Fri 10-2 (by appointment)
 Sun 12-3
Circulation: Students, researchers, faculty/staff (open stacks)
Reference Service: In person, telephone, mail
Reprographic Services: Yes
Interlibrary Loan: NILS
Networks/Consortia: No
Publications: In-house book & periodical indexes
Special Programs: Group & individual tours
Card Catalog
Cataloged Volumes: 11,000
Holdings: 12 vertical file drawers
Subjects: Art, decorative arts, architecture, graphics, music,
 theatre, dance

AL 211
UNIVERSITY OF CHICAGO
Art Library
Chicago, IL 60637
Tel: 312-753-3439
Asst-in-Charge: Scott O Stapleton

Academic Founded: 1938
Hours: Mon-Thurs 8:30-9
 Fri 8:30-5
 Sat 9-5
 Sun 1-5
 Mon-Fri 9-5 (summer)
Circulation: Students, faculty/staff (open stacks)
Reference Service: Telephone, mail
Reprographic Services: Yes
Interlibrary Loan: NILS
Networks/Consortia: Illinois Library & Information Network
 (Interlibrary Loan Department, Joseph Regenstein Library,
 University of Chicago Library)
Special Programs: Group & individual tours; bibliographic
 instruction

Card Catalog
Cataloged Volumes: 54,000
Serial Titles: 296 (National Union Catalog)
Holdings: 7,500 vertical file drawers; 9,000 sales & auction
 catalogs
Subjects: Art, decorative arts, architecture, graphics, pho-
 tography

AL 212
UNIVERSITY OF ILLINOIS AT CHICAGO CIRCLE—
COLLEGE OF ARCHITECTURE, ART, & URBAN
SCIENCES
Architecture & Art Resource Center
Box 4348, Chicago, IL 60680
Tel: 312-996-4469
Dir: Virginia Kerr

Academic Founded: 1975
Hours: Mon-Fri 8:30-5
Circulation: (open stacks)
Reprographic Services: No
Interlibrary Loan: No
Networks/Consortia: No
Publications: Acquisitions list; handbook of procedures
Special Programs: Group & individual tours
Card Catalog
Cataloged Volumes: 825 (720 titles)
Serial Titles: 108
Holdings: 8 vertical file drawers; 435 sales & auction
 catalogs; 1,856 exhibition catalogs
Subjects: Art, decorative arts, architecture, film & video,
 graphics, photography

AL 213
UNIVERSITY OF ILLINOIS AT URBANA—
CHAMPAIGN
Ricker Library of Architecture & Art
208 Architecture Bldg, Urbana, IL 61801
Tel: 217-333-0224
Libn: Dee Wallace

Academic Founded: 1873 Architecture
 1928 Art
Hours: Mon-Thurs 8-10
 Fri 8-6
 Sat 9-5
 Sun 1-5
Circulation: Public (open stacks)
Reference Service: Telephone, mail
Reprographic Services: Yes
Interlibrary Loan: NILS
Networks/Consortia: Illinois Library & Information Network;
 Center for Research Library; Midwest Region Library
 Network
Publications: Orientation handbook; acquisitions list
Special Programs: Group & individual tours; bibliographic
 instruction; single lectures
Card Catalog
Cataloged Volumes: 36,914 (60,000 in main stacks)
Serial Titles: 447 (National Union Catalog)
Holdings: 14 vertical file drawers; 1,230 exhibition cata-
 logs; 130 microfilm, 188 microfiche, 32,065 architecture
 & art photographs/reproductions
Subjects: Art, decorative arts, architecture, film & video,
 graphics, photography, theatre

Indiana

AL 214
BALL STATE UNIVERSITY
College of Architecture & Planning Library
Architecture Bldg, Muncie, IN 47306
Tel: 317-285-4760
Libn: Marjorie H Joyner

Academic Founded: 1965
Hours: Mon 8-8
 Tues-Thurs 8-10
 Fri 8-5
 Sat-Sun 1-5
Circulation: Students, faculty/staff (open stacks)
Reference Service: In person, telephone
Reprographic Services: Yes
Interlibrary Loan: NILS (Interlibrary Loan Service, Bracken
 Library, Ball State University)
Networks/Consortia: OCLC
Publications: Acquisitions list for faculty
Card Catalog
Cataloged Volumes: 14,393
Holdings: 25 vertical file drawers
Subjects: Architecture, landscape architecture & planning

AL 215
EARLHAM COLLEGE LIBRARY
Lilly Library
Richmond, IN 47374
Tel: 317-962-6561
Libn: Evan Farber

Academic Founded: 1847
Hours: Mon-Fri 8-11
 Sat 8-5
 Sun 1-11 (during school year)
 Mon-Fri 8-5 (summer)
Circulation: Public (open stacks)
Reference Service: In person, telephone, mail
Reprographic Services: Yes
Interlibrary Loan: NILS
Networks/Consortia: Indiana Cooperative Library Services Au-
 thority; OCLC; Whitewater Area Library Services Authority
Publications: Bibliographies
Special Programs: Bibliographic instruction
Cataloged Volumes: 240,000 including documents & peri-
 odicals
Serial Titles: 1,200 (Indiana Union List of Serials)
Holdings: 3 vertical file drawers; 23,000 microforms;
 limited sales, auction & exhibition catalogs
Subjects: Liberal arts
Special Collections:
East Asian Collection
Quaker Collection

AL 216
EVANSVILLE MUSEUM OF ARTS & SCIENCES
Henry B Walker, Jr, Memorial Library
411 SE Riverside Dr, Evansville, IN 47713
Tel: 812-425-2406
Research Curator: Mrs George F Martin

Museum Founded: 1904; 1965
Hours: Tues-Fri 10-5
Circulation: Restricted to use in museum under staff super-
 vision (open stacks)
Reference Service: In person, telephone, mail; restrictions
 on lengthy inquiries

Reprographic Services: Yes
Interlibrary Loan: Evansville-Vanderburg County
Networks/Consortia: No
Publications: Special catalogs
Card Catalog
Cataloged Volumes: 3,535
Serial Titles: 41
Holdings: 13 vertical file drawers; sales & auction catalogs;
 exhibition catalogs; 9 microforms; newspapers
Subjects: Art, decorative arts, architecture, classical archae-
 ology, film, graphics, photography

AL 217
FORT WAYNE PUBLIC LIBRARY
Art & Recordings Department
900 Webster St, Fort Wayne, IN 46802
Tel: 219-424-7241, Ext 244
Libn: Helen Colchin

Public Library Founded: 1968
Hours: Mon-Fri 9-9
 Sat 9-6
Circulation: Public; reference material restricted to use within
 library (open stacks)
Reference Service: In person, telephone
Reprographic Services: Yes
Interlibrary Loan: No
Networks/Consortia: Indiana TWX Network
Publications: In-house periodical index (Union List & Subject
 Guide to Periodicals)
Special Programs: Group tours
Card Catalog
Cataloged Volumes: 11,468
Serial Titles: 154
Holdings: 7,243 pamphlets in vertical file drawers; 2,842
 framed prints; 297,315 mounted pictures; 21,540 slides;
 19,000 phonograph records; films
Subjects: Art, architecture, film & video, graphics, music

AL 218
INDIANA UNIVERSITY—PURDUE UNIVERSITY
 AT INDIANAPOLIS
Herron School of Art Library
1701 N Pennsylvania St, Indianapolis, IN 46202
Tel: 317-923-3651, Ext 32
Libn: Maudine B Williams

Art School Founded: 1970
Hours: Mon, Tues, Thurs 8-7
 Wed 8-9
 Fri 8-5
Circulation: Public (open stacks)
Reference Service: In person, telephone, mail
Reprographic Services: Yes
Interlibrary Loan: NILS
Networks/Consortia: OCLC
Special Programs: Group tours; bibliographic instruction
Card Catalog
Cataloged Volumes: 7,832 (6,566 titles)
Serial Titles: 111 (Central Serials Records; University
 Library; Indiana University—Purdue University at Indian-
 apolis)
Holdings: 36 vertical file drawers
Subjects: Art, decorative arts, architecture, classical archae-
 ology, film & video, graphics, photography

AL 219
INDIANA STATE LIBRARY

140 N Senate, Indianapolis, IN 46204
Tel: 317-633-5440
Dir: Marcella K Foote

State Library Founded: 1825
Hours: Mon-Fri 8:15-5 (summer & winter)
 Sat 8-12 (winter only)
Circulation: Public (closed stacks)
Reference Service: In person, telephone, mail
Reprographic Services: Yes
Interlibrary Loan: NILS; Indiana Teletype Network
Networks/Consortia: Indiana Cooperative Library Services
 Authority; Central Indiana Area Library Services Authority
Publications: Bibliographies; newsletter; special catalogs;
 bulletin; checklists; in-house periodical index
Special Programs: Group & individual tours; workshops;
 seminars; informal intern program
Cataloged Volumes: 879,623
Serial Titles: 40,306 (National Union Catalog; Indiana Union
 List of Serials)
Holdings: 85,921 microforms; 214,016 govt documents;
 11,061 sheet music; newspapers; talking books; braille
 cassettes
Subjects: Art. architecture, classical archaeology, dance,
 decorative arts, film & video, graphics, music, photog-
 raphy, theatre
Special Emphases: Genealogy, Indiana, Indiana Academy of
 Science, Library Science

AL 220
INDIANA UNIVERSITY
Fine Arts Library
Fine Arts Bldg, Bloomington, IN 47401
Tel: 812-337-5743
Libn: Betty Jo Irvine

Academic Founded: 1962
Hours: Varies with each semester
Circulation: Public (open stacks; restrictions on expensive
 materials)
Reference Service: In person. telephone, mail
Reprographic Services: Yes
Interlibrary Loan: NILS; State programs
Networks/Consortia: Indiana Cooperative Library Services
 Authority
Publications: Acquisitions list
Special Programs: Group & individual tours; bibliographic
 instruction; single lectures; "Research Source in Art
 History" course for graduate students; intern program
Card Catalog
Cataloged Volumes: 48,000
Serial Titles: 300 (National Union Catalog)
Holdings: 4 vertical file drawers; sales & auction catalogs;
 exhibition catalogs; 250 microforms
Subjects: Art, decorative arts, architecture, classical archae-
 ology, film & video, graphics, photography
Special Collections: African art

AL 221
MORRISSON-REEVES LIBRARY
80 N Sixth St, Richmond, IN 47374
Tel: 317-966-8291
Libn: Harriet E Bard

Public Library Founded: 1864
Hours: Mon-Thurs 9-9
 Fri & Sat 9-5:30
 Mon-Sat 8:30-5:30 (July & Aug)

Circulation: Public (open stacks)
Reference Service: In person, telephone, mail
Reprographic Services: Yes
Interlibrary Loan: NILS; Indiana Network (Interlibrary Loan)
Networks/Consortia: Indiana Cooperative Library Services
 Authority; Whitewater Valley Area Library Services
 Authority
Publications: Bibliographies
Special Programs: Group & individual tours; intern program
Cataloged Volumes: 116,932 (95,648 titles)
Serial Titles: 452 (Indiana Union List of Serials; Whitewater
 Valley Area Library Services Authority Union List of
 Periodicals)
Holdings: 40 vertical file drawers; 1,962 microforms;
 exhibition catalogs; index of local newspaper & Sunday
 Indianapolis Star Magazine
Subjects: Art, architecture, classical archaeology, dance,
 decorative arts, film & video, graphics, music, photography,
 theatre

AL 222
SOUTH BEND PUBLIC LIBRARY
Art, Music & Recreation Department
122 W Wayne St, South Bend, IN 46601
Tel: 219-288-4413, Ext 49
Head, Art & Music Dept: Nancy Hunt

Public Library
Hours: Mon-Thurs 9-9
 Fri & Sat 9-6
Circulation: Public (open stacks)
Reference Service: In person, telephone, mail
Reprographic Services: Yes
Interlibrary Loan: NILS (Margarita Corbaci, Head, Language
 Literature Department)
Networks/Consortia: Area Library Services Authority II
Publications: Bibliographies; in-house periodical index
 (Periodical Newspaper Microfilm Holdings, South Bend
 Public Library, 1975-6)
Special Programs: Group tours
Cataloged Volumes: 14,416
Holdings: 28 vertical file drawers
Subjects: Art, architecture, dance, decorative arts, graphics,
 music, photography, theatre

AL 223
UNIVERSITY OF NOTRE DAME
Architecture Library
Notre Dame, IN 46556
Tel: 219-283-6654
Libn: Geri Decker

Academic
Hours: Mon-Thurs 8-10
 Fri 8-5
 Sat 9-5
 Sun 1-10
 Mon-Fri 8-5 (summer & vacation)
Circulation: Students, faculty/staff, local architects (open
 stacks)
Reference Service: In person, telephone, mail
Reprographic Services: Yes
Interlibrary Loan: NILS(Memorial Library, University of
 Notre Dame)
Networks/Consortia: OCLC; Indiana Cooperative Library
 Services Authority
Publications: Orientation handbook
Special Programs: Group tours; single lectures

Card Catalog
Cataloged Volumes: 13,000
Serial Titles: 90 (Union List of Serials; New Serials Titles)
Holdings: 6 vertical file drawers
Subjects: Art, decorative arts, architecture

AL 224
UNIVERSITY OF NOTRE DAME
Memorial Library
Notre Dame, IN 46556
Tel: 219-283-7317
Dir: David E Sparks

Academic Founded: 1873
Hours: Mon-Sat 8-10
 Sun 1-10
Circulation: Students, faculty/staff (open stacks)
Reference Service: In person only
Reprographic services: Yes
Interlibrary Loan: NILS
Networks/Consortia: Center for Research Libraries
Publications: Orientation handbook; newsletter
Special Programs: Group tours; bibliographic instruction;
 single lectures
Cataloged Volumes: 1,277,752
Serial Titles: 12,718 (Indiana Union List)
Holdings: 80 vertical file drawers; 596,000 microforms;
 10,000 auction catalogs
Subjects: Art, architecture, classical archaeology, dance, film,
 & video, music, theatre
Special Collection:
Medieval Studies Ambrosiana Collection
Microfilm copies of 25,000 classical, medieval, Renaissance
 & modern manuscripts from the Biblioteca Ambrosiana
 of Milan; 10,000 8" x 10" photographs and 7,000 colored
 slides of manuscript illuminations.

AL 225
THE WILLARD LIBRARY OF EVANSVILLE
Thrall Art Book Collection
21 First Ave, Evansville, IN 47710
Tel: 812-425-4309
Libn: Donald E Baker

Public Library Founded: 1876
Hours: Tues-Sat 9-5:30
 Sun 1:30-5
 Closed Mon
Circulation: Public (open stacks)
Reference Service: In person, telephone, mail
Reprographic Services: Yes
Interlibrary Loan: No
Networks/Consortia: No
Special Programs: Group & individual tours; bibliographic
 instruction
Card Catalog
Cataloged Volumes: 1,200
Serial Titles: 10
Subjects: Art, decorative arts, architecture, classical archae-
 ology, film & video, graphics, photography, music, theatre,
 dance

Iowa

AL 226
BLANDEN ART GALLERY

920 Third Ave S, Fort Dodge, IA 50501
Tel: 515-573-2316
Program Supervisor: Cheryl Ann Parker

Museum Founded: 1931
Hours: Tues-Sun 1-5
Circulation: Restricted to use by faculty/staff within gallery
 (open stacks)
Reference Service: In person, telephone
Reprographic Services: No
Interlibrary Loan: No
Networks/Consortia: No
Publications: Acquisitions list; newsletter; special catalogs;
 in-house periodical index
Special Programs: Group tours; single lectures; slide & film
 series
Card Catalog
Cataloged Volumes: 792
Holdings: 3 vertical file drawers; sales & auction catalogs;
 exhibition catalogs
Subjects: Art, graphics, photography

AL 227
CHARLES CITY PUBLIC LIBRARY
Arthur Mooney Collection
301 N Jackson, Charles City, IA 50616
Tel: 515-228-5532
Libn: Anna Burnham

Public Library Founded: 1930
Hours: Mon, Tues, Thurs, Fri 12-9
 Wed 9-9
 Sat 9-5
 Sun 1-5 (during winter)
Circulation: Public; restricted to elementary children (open
 stacks; additional closed stacks for rare books)
Reference Service: In person, telephone, mail
Reprographic Services: No
Interlibrary Loan: NILS; Iowa State Interlibrary Loan
Networks/Consortia: No
Special Programs: Group & individual tours; bibliographic
 instruction
Card Catalog
Cataloged Volumes: 3,000 (2,550 titles)
Holdings: 8 microforms; 6 sales & auction catalogs; 8 exhibi-
 tion catalogs; 50 art prints; 180 art slides
Subjects: Art, architecture, decorative ars, classical archae-
 ology, film & video, photography

AL 228
CORNELL COLLEGE LIBRARY
Russell D Cole Library
Mount Vernon, IA 52314
Tel: 319-895-8811
Libn: Mary Byerly

Academic Founded: 1853
Hours: Mon-Sat 8-11
 Sun 1:30-11
Circulation: Public (open stacks)
Reference Service: Telephone
Reprographic Services: Yes
Interlibrary Loan: NILS
Networks/Consortia: Associated Colleges of the Midwest
 Periodical Bank of Periodicals; Iowa State Interlibrary
 Loan Teletype System
Publications: Bibliographies; acquisitions list; in-house peri-
 odical index

Special Programs: Group tours; bibliographic instruction; single lectures
Card Catalog
Cataloged Volumes: 96,171
Holdings: 14,225 microforms
Subjects: Art, music, theatre, dance

AL 229
DAVENPORT MUNICIPAL ART GALLERY
Art Reference Library
1737 W 12 St, Davenport, IA 52804
Tel: 314-326-7804
Libn: Gladys M Hitchings

Museum Founded: 1925
Hours: Mon, Wed, Fri 1:30-4:30
　　　　　Tues, Thurs 9:30-11:30; 1:30-4:30
　　　　　Sat 10-12; 1-4:30
Circulation: Faculty/staff; researchers & docents with permission of gallery director (open stacks)
Reference Service: In person, telephone, mail
Reprographic Services: No
Interlibrary Loan: No
Networks/Consortia: No
Publications: In-house periodical index
Special Programs: Individual tours
Card Catalog
Cataloged Volumes: 5,000
Subjects: Art, architecture, decorative arts, classical archaeology, film & video, photography

AL 230
DES MOINES ART CENTER LIBRARY
Greenwood Park, Des Moines, IA 50312
Tel: 515-277-4405, Ext 24
Libn: Peggy Buckley

Art School/Museum Founded: 1951
Hours: Tues-Sat 11-5
Circulation: No (open stacks for reference use)
Reference Service: In person, telephone, mail
Reprographic Services: Yes
Interlibrary Loan: No
Networks/Consortia: No
Cataloged Volumes: 6,800
Serial Titles: 20 (Iowa Union List of Serials)
Holdings: 22 vertical file drawers of exhibition catalogs; 3 vertical file drawers of sales & auction catalogs
Subjects: Art, architecture, decorative arts, graphics, photography
Special Collection:
Pennington Collection
Original weaving samples & notebooks.
20th century art, primarily American

AL 231
GRINNELL COLLEGE
Burling Library
Grinnell, IA 50112
Tel: 515-236-6181, Ext 681
Libn: Chris McKee

Academic
Circulation: Public (open stacks)
Reference Service: In person, telephone, mail
Reprographic Services: Yes
Interlibrary Loan: NILS; Iowa Library Information Teletype Exchange; Associated Colleges of the Midwest

Publications: Orientation handbook; acquisitions list; in-house periodical index
Special Programs: Group tours; bibliographic instruction; course in library research techniques; intern program
Cataloged Volumes: 236,420
Serial Titles: 1,284
Holdings: 41 microform titles
Subjects: Art, architecture, dance, music, theatre

AL 232
IOWA STATE UNIVERSITY
Architecture Reading Room
201 Engineering Annex, Ames, IA 50011
Tel: 515-294-7102
Supervisor: Janice M Sankot

Academic Founded: 1970
Hours: Mon, Wed, Fri 8-5
　　　　　Tues & Thurs 6-10
Circulation: Public (open stacks)
Reference Service: In person, telephone, mail
Reprographic Services: Yes
Interlibrary Loan: NILS; Center for Research Library; Iowa Library Information Teletype Exchange; Midwest Regional Library Network
Networks/Consortia: OCLC; Midwest Regional Library Network; Midamerica State University Association Network (Reference Department, Iowa State University)
Special Programs: Group & individual tours
Card Catalog: book catalog; in-house periodical index (periodicals housed in the Architecture Reading Room)
Cataloged Volumes: 2,377 (1,671 titles)
Serial Titles: 84
Holdings: 4 vertical file drawers of maps & plans
Subjects: Art, architecture, graphics
Special Collections: 120 college catalogs; 75 manufacturers' catalogs

AL 233
IOWA WESLEYAN COLLEGE
J Raymond Chadwick Library
Mt Pleasant, IA 52641
Tel: 319-385-8021, Ext 340
Dir: Helen Volkmann

Academic Founded: 1842
Hours: Mon-Thurs 8-12
　　　　　Sat 1-5
　　　　　Sun 1-12
Circulation: Public (open stacks)
Reference Service: In person, telephone, mail
Reprographic Services: Yes
Interlibrary Loan: NILS; State of Iowa; Southeast Iowa Consortium (Ted Hostetler, Reference Libn)
Networks/Consortia: Iowa Information Teletype Exchange; Southeast Iowa Academic Libraries
Publications: Orientation handbook; acquisitions list; in-house periodical index (Iowa Wesleyan Periodicals)
Special Programs: Group & individual tours; bibliographic instruction; single lectures
Cataloged Volumes: 65,000
Serial Titles: 600
Holdings: 20 vertical file drawers; 5,000 microforms
Subjects: Art, architecture, classical archaeology, dance, decorative arts, film & video, graphics, music, photography, theatre

AL 234
CHARLES H MACNIDER MUSEUM LIBRARY
303 Second St SE, Mason City, IA 50401
Tel: 515-423-9563
Dir: Richard E Leet

Museum Founded: 1966
Hours: Tues, Thurs 10-9
 Wed, Fri, Sat 10-5
 Sun 2-5
 Closed Mon
Circulation: Staff; restricted to in-house (open stacks)
Reference Service: In person, telephone, mail
Reprographic Services: No
Interlibrary Loan: No
Networks/Consortia: No
Publications: Museum newsletter; in-house periodical index
 (card file)
Special Programs: Group tours
Card Catalog
Cataloged Volumes: c 500
Holdings: 2 vertical file drawers; 2 drawers sales & auction
 catalogs; 2 drawers exhibition catalogs
Subjects: Art, decorative arts, architecture, graphics, pho-
 tography
Special Collection: American art

AL 235
MASON CITY PUBLIC LIBRARY
Art Department
225 Second St SE, Mason City, IA 50401
Tel: 515-423-7552
Dir: Lowell Wilbur

Public Library
Hours: Mon-Fri 9-9
 Sat 9-5
 Sun 3-5
Circulation: Public (open stacks)
Reference Service: In person, telephone
Reprographic Services: Yes
Interlibrary Loan: NILS; statewide interlibrary loan systems
 (North Central Regional Library, 500 College Dr, Mason
 City, IA 50401)
Networks/Consortia: No
Information Source: Barrette, Lydia. *There is No End,*
 Scarecrow Press, 1961
Special Programs: Group tours; single lectures
Card Catalog
Cataloged Volumes: 4,000
Serial Titles: 3 (National Union Catalog; Iowa Union List of
 Serials)
Holdings: 7 vertical file drawers
Subjects: Art, decorative arts, architecture, classical archae-
 ology, graphics, art education, interior design, antiques,
 art theory

AL 236
MUSCATINE ART CENTER
Research Library
1314 Mulberry Ave, Muscatine, IA 52761
Tel: 319-263-8282
Dir: Clifford Larson

Art School/Museum/Gallery Founded: 1965
Hours: Tues-Fri 11-5
 Thurs 7-9
 Sat & Sun 1-5
Circulation: Researchers, faculty/staff (open stacks)
Reference Service: In person only
Reprographic Services: No
Interlibrary Loan: No
Networks/Consortia: No
Publications: Newsletter, book catalog
Special Programs: Group & individual tours; single lectures
Card Catalog
Cataloged Volumes: 375
Holdings: 13 vertical file drawers; 40 sales & auction catalogs
Subjects: Art, decorative arts, furniture, graphics, photography
Special Collections: 19th century American graphic &
 decorative arts & furniture; contemporary art collection;
 collection of early Muscatine photographs, postcards &
 trade cards; Muscatine regional history collection

AL 237
NORWEGIAN-AMERICAN MUSEUM
Vesterheim Museum Library
502 W Water St, Decorah, IA 52101
Tel: 319-382-3856

Museum Founded: 1960
Hours: Mon-Fri 8:30-5
Circulation: No (open stacks)
Reference Service: In person, telephone
Reprographic Services: No
Interlibrary Loan: No
Networks/Consortia: No
Publications: Newsletter; special catalogs
Cataloged Volumes: 300-500
Subjects: Art, architecture, decorative arts, graphics

AL 238
SANFORD MUSEUM & PLANETARIUM
117 E Willow, Cherokee, IA 51012
Tel: 712-225-3922
Dir: Robert W Hoge

Museum Founded: 1951
Hours: Mon-Fri 9-5
 Sat-Sun 2-5
Circulation: Appointment necessary
Reference Service: Telephone, mail
Reprographic Services: No
Interlibrary Loan: Cherokee Public Library
Networks/Consortia: No
Special Programs: Group & individual tours; single lectures;
 workshops
Card Catalog
Cataloged Volumes: 2,000
Serial Titles: 3
Subjects: Art, classical archaeology

AL 239
UNIVERSITY OF IOWA
School of Art & Art History Art Library
Iowa City, IA 52242
Tel: 319-353-4440
Libn: Harlan L Sifford

Academic Founded: 1937
Hours: Mon-Thurs 8-5; 7-10
 Fri 8-5
 Sat-Sun 1-4
Circulation: Public; restricted to Iowa residents within 50 mile
 radius of school (open stacks)
Reference Service: In person, telephone, mail

Reprographic Services: Yes
Interlibrary Loan: NILS (Interlibrary Loan, University of Iowa)
Networks/Consortia: Iowa Library Information Teletype Exchange
Publications: Acquisitions list; book catalog; in-house serial index on microfiche (Serial Publications in University of Iowa Libraries)
Special Programs: Group & individual tours; bibliographic instruction; single lectures; intern program
Card Catalog
Cataloged Volumes: 45,000
Serial Titles: 225 (National Union Catalog)
Holdings: 74 vertical file drawers; sales & auction catalogs; 288 microfilm; 89 microfiche
Subjects: Art, decorative arts, architecture, classical archaeology, film & video, graphics, photography

AL 240
UNIVERSITY OF NORTHERN IOWA LIBRARY
Cedar Falls, IA 50613
Tel: 319-273-6252
Fine Arts Department Libn: Verna F Ritchie

Academic Founded: 1975 (Art & Music section)
 1876 (University of Northern Iowa Library)
Circulation: Public (open stacks)
Reference Service: In person, telephone, mail
Reprographic Services: Yes
Interlibrary Loan: NILS
Networks/Consortia: OCLC; Midwest Regional Library Network
Publications: Orientation handbook; bibliographies; acquisitions list; periodical index (List of Serials: Serial Holdings of University of Northern Iowa Library)
Special Programs: Group & individual tours; bibliographic instruction; single lectures
Card Catalog
Cataloged Volumes: 13,414 (11,900 titles)
Serial Titles: 120 (National Union Catalog)
Holdings: 8 vertical file drawers
Subjects: Art, decorative arts, architecture, graphics, photography, music

Kansas

AL 241
BETHANY COLLEGE
Wellerstedt Learning Center
Lindsborg, KS 67456
Tel: 913-227-3311, Ext 165
Libn: Dixie Lanning

Academic Founded: 1881
Hours: Mon-Thurs 7:45-10:30
 Fri 7:45-3:30
 Sat 10-12; 1-4
 Sun 2-10:30
Circulation: Public (open stacks)
Reference Service: In person only
Reprographic Services: Yes
Interlibrary Loan: NILS
Networks/Consortia: Associated Colleges of Central Kansas
Publications: In-house periodical index (Associated Colleges of Central Kansas Union List of Periodicals)
Cataloged Volumes: 2,425 (2,180 titles)

Serial Titles: 331 total; 18 art
Subjects: Art, decorative arts

AL 242
CHISHOLM TRAIL MUSEUM LIBRARY
502 N Washington, Wellington, KS 67152
Dir: Dorothea W Miller

Museum Founded: 1964
Hours: Sat-Sun 2-4 (winter)
 Tues, Wed, Thurs, Sat, Sun 2-4 (summer)
Circulation: Restricted to public use within museum (open stacks)
Reprographic Services: Yes
Interlibrary Loan: No
Networks/Consortia: No
Publications: Book catalog
Special Programs: Group & individual tours
Card Catalog
Cataloged Volumes: 300
Subjects: General coverage

AL 243
COLBY COMMUNITY COLLEGE
H F Davis Memorial Library
Colby, KS 67701
Tel: 913-462-3984, Ext 255
Dir: Ruth H Lowenthal

Academic Founded: 1964
Circulation: Public (open stacks)
Hours: Mon-Thurs 7:30-9
 Fri 7:30-4
 Sat 9-12
Circulation: Public (open stacks)
Reprographic Services: Yes
Interlibrary Loan: NILS; Kansas Information Circuit
Networks/Consortia: No
Publications: Orientation bookmarks; Western Plains Heritage Series of books
Special Programs: Group & individual tours; bibliographic instruction; single lectures; 2 credit classes
Card Catalog
Cataloged Volumes: 27,000 (26,000 titles)
Serial Titles: c 420
Holdings: 775 microfilm reels
Subjects: Art, decorative arts, architecture, photography, music, theatre, dance
Special Collection: History of the West & Northwest Kansas

AL 244
CULTURAL HERITAGE & ARTS CENTER LIBRARY
1000 Second Ave, Box 1275, Dodge City, KS 67801
Tel: 316-227-2823
Dir: Jane R Robison

Public Library/Research Center Founded: 1967
Hours: Mon-Fri 8-5
Circulation: Public (open stacks)
Reference Service: In person, telephone, mail
Reprographic Services: Yes
Interlibrary Loan: No
Networks/Consortia: No
Publications: Bibliographies; special catalogs; in-house periodical index (Reference Materials & Resources)
Special Programs: Group & individual tours; single lectures
Card Catalog
Cataloged Volumes: 9,000

Serial Titles: 100
Holdings: 10 vertical file drawers; 6 drawers microforms
Subjects: Art, dance, decorative arts, film & video, graphics,
 history, music, photography, theatre
Special Collection: The Old West Collection

AL 245
FRIENDS UNIVERSITY
Edmund Stanley Library
2100 University, Wichita, KS 67213
Tel: 316-263-9131, Ext 220
Dir: Hans E Bynagle

Academic Founded: 1898
Hours: Mon-Thurs 8-10
 Fri 8-4:30
 Sun 5-10
Circulation: Public; fee for non-university members (open
 stacks)
Reference Service: Telephone, mail
Reprographic Services: Yes
Interlibrary Loan: NILS
Networks/Consortia: No
Publications: Orientation handbook; in-house periodical index
Special Programs: Bibliographic instruction
Card Catalog
Cataloged Volumes: 70,000
Serial Titles: 500
Holdings: 20 vertical file drawers; 725 microforms
Subjects: Art, decorative arts, architecture, classical archae-
 ology, graphics, photography, music, theatre

AL 246
KANSAS STATE UNIVERSITY
Paul Weigel Library
Seaton Hall, Manhattan, KS 66506
Tel: 913-532-5968
Dir: Dorothy Leonard

Academic
Hours: Mon-Thurs 8-10
 Fri 8-5
 Sat 10-2
 Sun 2-10
Circulation: Public (open stacks)
Reference Service: In person, telephone, mail
Reprographic Services: No
Interlibrary Loan: NILS (Farrell Library, Kansas State Uni-
 versity, Manhattan, KS 66502)
Networks/Consortia: No
Publications: In-house periodical index
Special Programs: Group & individual tours
Cataloged Volumes: 22,102
Serial Titles: 172
Holdings: 20 vertical file drawers
Subjects: Art, architectural planning, architecture, graphics,
 landscape architecture, interiors

AL 247
SOUTHWESTERN COLLEGE
Memorial Library
Winfield, KS 67516
Tel: 316-221-4150, Ext 25
Dir: Daniel L Nutter

Academic Founded: 1886
Hours: Mon-Thurs 8-10
 Fri 8-4
 Sat 9-4

Sun 1-10
 Mon-Fri 9-4 (summers only)
Circulation: Public; periodicals, archival & rare materials do
 not circulate (open stacks)
Reference Service: In person, telephone, mail
Reprographic Services: Yes
Interlibrary Loan: NILS
Networks/Consortia: OCLC; On-Line Retrieval of Biblio-
 graphic Information-Timeshared; South Central Kansas
 Library System
Publications: Acquisitions list; in-house periodical index
 (Cowley County Union List of Periodicals)
Special Programs: Group & individual tours; bibliographic
 instruction; single lectures
Cataloged Volumes: 93,564 (68,805 titles)
Holdings: 12 vertical file drawers; 6,840 microforms
Subjects: Art, architecture, dance, decorative arts, music,
 theatre
Special Collection: Arthur Covey Collection

AL 248
TOPEKA PUBLIC LIBRARY
Fine Arts Division
1515 W 10 St, Topeka, KS 66604
Tel: 913-233-2040, Exts 37; 31
Libn: Robert H Daw

Public Library Founded: 1870
Hours: Mon-Fri 9-9
 Sat 9-6
 Sun 2-6
Circulation: Public (open stacks)
Reference Service: In person, telephone, mail
Reprographic Services: Yes
Interlibrary Loan: NILS
Networks/Consortia: Northeast Kansas Library System;
 Kansas Information Circuit
Publications: Orientation handbook; bibliographies; acquisi-
 tions list; special catalogs
Special Programs: Group tours; single lectures
Card Catalog
Cataloged Volumes: 30,000
Serial Titles: 90 (National Union Catalog)
Subjects: Art, decorative arts, architecture, classical archae-
 ology, film & video, graphics, photography, music, theatre,
 dance
Special Collection: European & American Art Nouveau
 Movement

AL 249
UNIVERSITY OF KANSAS
Art Library
Watson Library, Lawrence, KS 66045
Tel: 913-864-3020
Libn: Martha E Kehde

Academic Founded: 1970
Hours: Mon-Thurs 8-11
 Fri 8-5
 Sat 9-5
 Sun 2-11
Circulation: Public (open stacks; c 2,000 in closed stacks)
Reference Service: In person, telephone, mail
Reprographic Services: Yes
Interlibrary Loan: NILS; Kansas Library Interlibraries Loan
 Agreement
Networks/Consortia: OCLC
Publications: Bibliographies; acquisitions list; in-house peri-
 odical index (UKASE)

Special Programs: Group & individual tours; bibliographic instruction; single lectures; course on "Sources & Procedures of Art Historical Research"
Card Catalog
Cataloged Volumes: 30,000
Serial Titles: 600 (National Union Catalog)
Subjects: Art, decorative arts, architecture, film & video, graphics, photography
Special Collection: Chinese paintings

AL 250
WICHITA ART MUSEUM LIBRARY
619 Stackman Dr, Wichita, KS 67203
Tel: 316-264-0324
Curator of Education: Novelene Ross

Museum Founded: 1963
Hours: Tues-Fri 10-5
Circulation: Restricted use of reference library for staff, members, & public (open stacks)
Reprographic Services: No
Interlibrary Loan: No
Networks/Consortia: No
Publications: Orientation handbook; newsletter; special catalogs; exhibition brochures
Card Catalog
Cataloged Volumes: 1,834
Serial Titles: 22
Subjects: Art, decorative arts, architecture, graphics, photography, art education
Special Collection: American art

AL 251
WICHITA PUBLIC LIBRARY
Art & Music Department
223 S Main, Wichita, KS 67202
Tel: 316-262-0611, Ext 258
Art & Music Department Head: Wilma Brooks

Public Library Founded: 1876; 1967
Hours: Mon-Thurs 8:30-9
 Fri & Sat 8:30-5:30
 Sun 1-5
Circulation: Public (open stacks)
Reference Service: In person, telephone, mail
Reprographic Services: No
Interlibrary Loan: NILS
Networks/Consortia: No
Serial Titles: 66
Holdings: 18 vertical file drawers
Subjects: Art, architecture, classical archaeology, crafts, dance, decorative arts, film & video, graphics, music, photography, theatre

Kentucky

AL 252
LOUISVILLE FREE PUBLIC LIBRARY
Audio-Visual Department
Fourth & York Sts, Louisville, KY 40203
Tel: 502-583-1864; 504-4154, Ext 28
Libn: Dorothy L Day

Public Library Founded: 1949
Hours: Mon-Fri 9-6
 Sat 9-5

Circulation: Public
Reference Service: In person, telephone, mail
Reprographic Services: Yes
Interlibrary Loan: NILS
Networks/Consortia: No
Publications: Film material book catalog
Special Programs: Group & individual tours
Card Catalog
Subjects: Film & video, music

AL 253
LOUISVILLE SCHOOL OF ART LIBRARY
100 Park Rd, Anchorage, KY 40223
Tel: 502-245-8836
Libn: Kent E Metcalf

Academic/Art School Founded: 1909
Hours: Mon-Thurs 8-9
 Fri 8-5
 Sat 11-3
Circulation: Public (open stacks)
Reference Service: In person, telephone, mail
Reprographic Services: Yes
Interlibrary Loan: NILS
Networks/Consortia: Kentuckiana Metroversity
Publications: Orientation handbook; bibliographies; acquisitions list; in-house periodical index (Louisville School of Art Periodicals Received Index)
Special Programs: Group & individual tours; bibliographic instruction; single lectures
Cataloged Volumes: 7,512
Serial Titles: 44 (Kentucky Union List of Serials)
Holdings: 18 vertical file drawers
Subjects: Art, decorative arts
Special Collections: History of arts in Louisville; color; textile arts

AL 254
J B SPEED ART MUSEUM LIBRARY
2035 S Third St, Louisville, KY 40208
Tel: 502-636-2893
Libn: Frances Whitfield

Museum Founded: 1927
Hours: Tues-Fri 10-4
Circulation: Restricted to staff use
Reference Service: Telephone, mail
Reprographic Services: Yes
Interlibrary Loan: No
Networks/Consortia: No
Publications: In-house periodical index (Speed bulletin index)
Card Catalog
Cataloged Volumes: 9,732
Serial Titles: 30 (some in National Union Catalog)
Holdings: 30 vertical file drawers; 36 sales & auction catalogs; exhibition catalogs
Subjects: Art, decorative arts, architecture, classical archaeology, film & video, graphics, photography, music, theatre, dance
Special Collections: Mr Speed's Lincoln books; Weygolds' Indian collection

AL 255
UNIVERSITY OF KENTUCKY
Architecture Library
200 Pence Hall, Lexington, KY 40506

Tel: 606-258-5700
Libn: Wanda Dole

Academic Founded: 1962
Hours: Mon-Thurs 8-10
 Fri 8-5
 Sat 2-5
 Sun 3-10
 Mon, Tues, Thurs, Fri 8-5 (summer)
 Wed 8-8 (summer)
Circulation: Public; restrictions on special collections (open
 stacks)
Reference Service: In person, telephone, mail
Reprographic Services: Yes
Interlibrary Loan: NILS
Networks/Consortia: SOLINET
Publications: Orientation handbook; bibliographies; acquisi-
 tions list; in-house periodical index
Card Catalog
Cataloged Volumes: 18,177
Serial Titles: 333 (National Union Catalog)
Holdings: 6,364 vertical file drawers; 347 microforms; 25
 maps; 200 drawings
Subjects: Architecture, film & video, photography
Special Collections: Corbusier; Kentuckiana; architectural
 history

AL 256
UNIVERSITY OF KENTUCKY
Margaret I King Library
North Lexington, KY 40506
Tel: 606-257-4734
Art Libn: Karin Sandvik

Academic
Hours: Mon-Fri 8-10
 Mon-Fri 8-4 (school not in session)
Circulation: Public; periodicals & some art books restricted
 to within library (open stacks)
Reference Service: In person, telephone, mail
Reprographic Services: Yes
Interlibrary Loan: NILS
Networks/Consortia: SOLINET
Publications: Bibliographies; acquisitions list; in-house peri-
 odical index
Special Programs: Group & individual tours; bibliographic
 instruction; single lectures
Card Catalog
Cataloged Volumes: 18,871
Serial Titles: 168 (National Union Catalog)
Holdings: 9 vertical file drawers; 1,200 exhibition catalogs
Subjects: Art, decorative arts, graphics

AL 257
UNIVERSITY OF LOUISVILLE
Margaret M Bridwell Art Library
Belknap Campus, Louisville, KY 40208
Tel: 502-588-6741
Libn: Gail R Gilbert

Academic Founded: 1956
Hours: Mon-Thurs 8-10
 Fri 8-5
 Sat 9-5
 Sun 2-6
Circulation: Faculty/staff (open stacks)
Reference Service: Telephone, mail
Reprographic Services: Yes

Interlibrary Loan: NILS (Interlibrary Loan, University of
 Louisville Library)
Networks/Consortia: Kentuckiana Metroversity
Publications: Acquisitions list
Special Programs: Group tours
Card Catalog
Cataloged Volumes: 31,000
Serial Titles: 196 (National Union Catalog)
Holdings: 48 vertical file drawers; 75 reels, 400 microfiche
Subjects: Art, decorative arts, architecture, classical archae-
 ology, graphics, photography

Louisiana

AL 258
CONTEMPORARY ARTS CENTER
Artists' Resource Center of the Contemporary Arts Center
900 Camp St, New Orleans, LA 70130
Tel: 504-523-1216
Dir: Don Marshall

Exhibition & Performing Space Founded: 1976
Hours: Tues-Sat 10-5
Circulation: Printed material does not circulate
Reference Service: No
Reprographic Services: No
Interlibrary Loan: No
Networks/Consortia: No
Publications: Newsletter; special catalogs
Special Programs: Group & individual tours; single lectures;
 workshops
Subjects: Art, dance, decorative arts, film & video, graphics,
 music, photography, theatre

AL 259
GRAMBLING STATE UNIVERSITY
A C Lewis Memorial Library
Box 3, Grambling, LA 71245
Tel: 318-247-6941, Ext 220
Acting Dir: Pauline W Lee

Academic
Hours: Mon-Thurs 7-10
 Fri 8-5
 Sat 8-3
 Sun 6-10
Circulation: Public (open stacks)
Reference Service: In person, telephone, mail
Reprographic Services: Yes
Interlibrary Loan: NILS
Networks/Consortia: Trail Blazer Library System-TWX
Publications: Orientation handbook; newsletter; in-house peri-
 odical index (Periodicals Print-Out)
Special Programs: Group & individual tours; bibliographic
 instruction; single lectures; mini-courses; slide presenta-
 tions
Cataloged Volumes: 159,148 (103,861 titles)
Serial Titles: 1,064
Holdings: 116,263 microforms; 1,300 documents
Subjects: Art, architecture, dance, decorative arts, graphics,
 music, photography
Special Collection:
Afro-American Center
Books & resources relating to Black Americans of African
 ancestry.

AL 260
THE HISTORIC NEW ORLEANS COLLECTION
Research Library
533 Royal St, New Orleans, LA 70130
Tel: 504-524-1739; 523-7146
Libn: Kenneth T Urquhart

Museum
Hours: Tues-Sat 10-5
Circulation: No (closed stacks)
Reference Service: In person, telephone, mail
Reprographic Services: Yes
Interlibrary Loan: No
Networks/Consortia: No
Publications: Orientation handbook; bibliographies; special
 catalogs
Special Programs: Group & individual tours
Cataloged Volumes: 5,000
Serial Titles: 50
Holdings: 12 vertical file drawers; 118 microforms; 300 sales
 & auction catalogs
Subjects: Art, architecture, decorative arts, music, photog-
 raphy, theatre
Special Collection:
 New Orleans Architecture—Vieux Carre Survey
Architectural inventory of the Vieux Carre and other parts of
 New Orleans.

AL 261
IBERVILLE PARISH LIBRARY & CARRIAGE
HOUSE MUSEUM LIBRARY
712 Eden St, Box 736, Plaquemine, LA 70764
Tel: 504-687-4397
Parish Libn: Glenna K Lusk

Museum/Public Library Founded: 1951; 1966
Hours: Mon 8:30-8
 Tues-Thurs 8:30-6
 Fri 8:30-5
 Sat 8:30-4
Circulation: Public (open stacks)
Reference Service: In person, telephone, mail
Reprographic Services: Yes
Interlibrary Loan: NILS
Networks/Consortia: No
Publications: Bibliographies; acquisitions lists
Special Programs: Group & individual tours
Subjects: Photography

AL 262
LOUISIANA COLLEGE
Richard W Norton Memorial Library
1140 College Dr, Pineville, LA 71360
Tel: 318-487-7201
Dir: Landrum Salley

Academic Founded: 1906
Hours: Mon-Thurs 7:45-10
 Fri 7:45-5
 Sat 8:30-4
Circulation: Students, researchers, faculty/staff (open stacks)
Reference Service: In person only
Reprographic Services: Yes
Interlibrary Loan: NILS
Networks/Consortia: No
Publications: Orientation handbook; acquisitions list; in-house
 periodical index
Cataloged Volumes: 90,000 total; 6,133 art (66,000 total
 titles; 5,500 art titles)

Serial Titles: 500 total; 60 art (National Union Catalog;
 Louisiana Union Catalog)
Holdings: 15 vertical file drawers (general collection)
Subjects: Art, architecture, classical archaeology, dance,
 decorative arts, film & video, graphics, photography, theatre

AL 263
LOUISIANA STATE UNIVERSITY
Department of Architecture
105 Hill Memorial Bldg, Baton Rouge, LA 70803
Tel: 504-388-2821
Libn: Doris A Wheeler

Academic Founded: 1966
Hours: Mon-Thurs 8-10
 Fri 8-5
 Sun 7-10
Circulation: Students, researchers, faculty/staff (open stacks)
Reference Service: In person, telephone, mail
Reprographic Services: No
Interlibrary Loan: No
Networks/Consortia: No
Special Programs: Group tours for freshmen
Cataloged Volumes: 5,500
Serial Titles: 60
Holdings: 12 vertical file drawers
Subjects: Architecture, interior design, planning

AL 264
LOUISIANA STATE UNIVERSITY LIBRARY
Baton Rouge, LA 70803
Tel: 504-388-2217
Dir: George J Guidry

Academic Founded: 1860
Hours: Mon-Fri 7:15-12
 Sat 8-5
 Sun 2-12
Circulation: Students, researchers, faculty/staff (open stacks)
Reference Service: Yes
Reprographic Services: Yes
Interlibrary Loan: NILS (Jane Kleiner, Interlibrary Loan
 Department)
Networks/Consortia: Southeastern Library Network
Publications: Orientation handbook; library statistics;
 library lectures
Special Programs: Group & individual tours; bibliographic
 instruction; single lectures; intern program
Cataloged Volumes: 1,427,745 (571,709 titles)
Serial Titles: 13,954 (National Union Catalog; Union List of
 Serials; New Serial Titles)
Holdings: 80 vertical file drawers; 480,802 microforms;
 6,290 phonorecords
Subjects: Art, architecture, classical archaeology, dance,
 decorative arts, film & video, graphics, music, photography,
 theatre
Special Collections:
Archives & Manuscripts
Over 3,000,000 items relating to the lower Mississippi
 Valley region.
Jones-Lincoln Collection
Over 5,000 items, including periodicals, pamphlets & major
 Lincoln biographies.
Louisiana Rare Book Room
Extensive holdings on Louisiana.
E A McIlhenny Collection
Rare books, prints & maps relating to natural history.

Troy Middleton Collection
Material relating to military history & World War II memorabilia.

AL 265
LOYOLA UNIVERSITY, NEW ORLEANS
Main Library
6363 St Charles Ave, New Orleans, LA 70118
Tel: 504-865-3346
Libn: Joanne R Euster

Academic
Hours: Mon-Thurs 8-11
 Fri 8-9
 Sat 8-5
 Sun 2-11
 During academic year
Circulation: Students, faculty/staff (open stacks except for
 rare books & special collections)
Reference Service: Yes
Reprographic Services: Yes
Interlibrary Loan: Yes (Interlibrary Loans)
Networks/Consortia: Southeastern Library Network;
 Southeast Louisiana Library Network Cooperative
Publications: Orientation handbook; bibliographies; news-
 letter; in-house periodical index
Special Programs: Group tours; bibliographic instruction;
 single lectures
Cataloged Volumes: 250,000
Serial Titles: 1,150
Subjects: Art, architecture, classical archaeology, dance,
 decorative arts, film & video, graphics, music, photography,
 theatre
Special Collection:
Music Collection
Books, periodicals & sound recordings.

AL 266
MADISON PARISH LIBRARY
403 N Mulberry, Tallulah, LA 71282
Tel: 318-574-4308
Libn: Mabel Clair Placke

Public Library Founded: 1945
Hours: Mon-Fri 8:30-4:30 (summer)
 Mon-Fri 8:30-5 (winter)
Circulation: Public (open stacks)
Reference Service: In person, telephone
Reprographic Services: Yes
Interlibrary Loan: Trail Blazer Library System; Ouachita
 Parish Library (Monroe, LA)
Networks/Consortia: No
Special Programs: Group & individual tours
Cataloged Volumes: 21,253
Serial Titles: 60
Holdings: 6 vertical file drawers
Subjects: Art, architecture, decorative arts, music, theatre

AL 267
NEW ORLEANS PUBLIC LIBRARY
Art, Music & Recreation Divison
219 Loyola Ave, New Orleans, LA 70140
Tel: 504-586-4938
Head: Marilyn Wilkins

Public Library
Hours: Mon-Fri 9-9
 Sat 9-5

Circulation: Public (open stacks)
Reference Service: In person, telephone, mail
Reprographic Services: Yes
Interlibrary Loan: Southeast Louisiana Library Network
 Cooperative
Networks/Consortia: Louisiana State Library (16mm film
 circuit)
Publications: Bibliographies; newsletter; special catalogs;
 in-house periodical index
Special Programs: Group tours; bibliographic instruction;
 single lectures; intern program
Cataloged Volumes: 738,208
Serial Titles: 2,000
Holdings: Picture file; recordings & cassettes; sheet music;
 8 mm films
Subjects: Art, architecture, dance, decorative arts, film &
 video, graphics, music, photography, theatre
Special Collections:
Fischer Collection
Early acoustical recordings
La Hache Music Collections
Circulating recordings.
Westfeldt Art Collection
Circulating framed prints.

AL 268
NICHOLLS STATE UNIVERSITY
Polk Library
Thibodaux, LA 70301
Tel: 504-446-8111, Exts 401; 402
Dir: Dr Randall A Detro

Academic Founded: 1948
Hours: Mon-Thurs 7:30-12
 Fri 7:30-8:30
 Sat 8-12
 Sun 4-12
Circulation: Students, faculty/staff (open stacks)
Reference Service: In person only
Reprographic Services: Yes
Interlibrary Loan: NILS; Bayoulands
Networks/Consortia: Bayoulands; Louisiana–Minnesota
 Microform Network
Publications: Orientation handbook; acquisitions list; in-house
 periodical index
Special Programs: Group & individual tours; student orientation
Cataloged Volumes: 158,613 (102,200 titles)
Serial Titles: 1,346
Holdings: 18 vertical file drawers
Subjects: Art, architecture, classical archaeology, dance,
 decorative arts, film & video, graphics, music, photography,
 theatre

AL 269
THE R W NORTON ART GALLERY
Reference–Research Library
4747 Creswell Ave, Shreveport, LA 71106
Tel: 318-865-4201, Ext 29
Secretary: Jerry M Bloomer

Museum Founded: 1946
Hours: Wed, Sat 1-5
Circulation: Restricted to use within museum (open stacks)
Reference Service: In person, telephone, mail
Reprographic Services: Yes
Interlibrary Loan: No
Networks/Consortia: No
Publications: Bibliographies

Special Programs: Group & individual tours; single lectures
Card Catalog
Cataloged Volumes: 8,000 (7,000 titles)
Serial Titles: 100
Holdings: 30 vertical file drawers; 1,000 sales & auction catalogs; 500 exhibition catalogs
Subjects: Art, decorative arts, architecture, graphics, photography
Special Collections:
American & European Art Collection
History of American & European painting, sculpture, graphic & decorative arts; monographs & *catalogues raisonnés* of artists; catalogs of private collections, auction & exhibition catalogs.

AL 270
SHREVE MEMORIAL LIBRARY
400 Edwards St, Shreveport, LA 71101
Tel: 318-221-2614
Administrative Libn: Juanita Rembert

Public Library Founded: 1922
Hours: Mon-Fri 9-9
 Sat 9-6
Circulation: Public; reference books do not circulate (open stacks)
Reference Service: In person, telephone, mail
Reprographic Services: Yes
Interlibrary Loan: Green Gold Library System
Networks/Consortia: No
Card Catalog
Cataloged Volumes: 70,000
Serial Titles: 210
Holdings: 20 vertical file drawers; 10,000 microforms
Subjects: Art, architecture, classical archaeology, dance, decorative arts, film & video, graphics, music, photography, theatre

AL 271
SOUTHEASTERN LOUISIANA UNIVERSITY
Linus A Sims Memorial Library
Drawer 896, Hammond, LA 70402
Tel: 504-549-2234
Dir of Libs: F Landon Greaves

Academic Founded: 1925
Hours: Mon-Thurs 7:30-11
 Fri 7:30-5
 Sat 8-12
 Sun 2-11
Circulation: Students, researchers, faculty/staff (open stacks)
Reference Service: In person, telephone, mail
Reprographic Services: Yes
Interlibrary Loan: NILS
Networks/Consortia: Southeastern Library Network
Special Programs: Group & individual tours; bibliographic instruction; single lectures
Cataloged Volumes: 175,000
Serial Titles: 1,500
Holdings: 20 vertical file drawers; 200,000 microforms
Subjects: Art, architecture, dance, decorative arts, graphics, music, photography, theatre

AL 272
SOUTHERN UNIVERSITY
University Library/Art & Architecture Branch
Southern Branch Post Office, Baton Rouge, LA 70813
Tel: 504-771-3290
Art & Architecture Libn: Doris W Graham

Academic Founded: 1971
Hours: Mon-Fri 9-10:45 (spring & fall)
 Mon-Fri 8-5 (summer)
Circulation: Public; periodicals & reference materials do not circulate (open stacks)
Reference Service: In person, telephone, mail
Reprographic Services: Yes
Interlibrary Loan: NILS; Louisiana Numerical Register (Olga Hayward, Southern University Library)
Networks/Consortia: No
Publications: Orientation handbook; bibliographies; acquisitions list; bulletin
Special Programs: Group & individual tours; bibliographic instruction; single lectures; lecture series; intern program
Card Catalog
Cataloged Volumes: 3,833
Serial Titles: 72
Subjects: Art, architecture, building technology, classical archaeology, decorative arts, graphics, photography

AL 273
SOUTHERN UNIVERSITY LIBRARY
3050 Cooper Rd, Shreveport, LA 71107
Tel: 318-424-6552
Head Libn: Thelma Patterson

Academic Founded: 1967
Circulation: Students, faculty/staff (open stacks)
Reference Service: In person, telephone, mail
Reprographic Services: Yes
Interlibrary Loan: Green Gold Library System (400 Edwards St, Shreveport, LA 71103)
Networks/Consortia: No
Special Programs: Group & individual tours; single lectures
Serial Titles: 327
Holdings: 16 vertical file drawers; 3,092 microforms
Subjects: Art, architecture, classical archaeology, dance, decorative arts, music, photography, theatre
Special Collections: Black collection; Louisiana collection

AL 274
TULANE UNIVERSITY
Howard Tilton Memorial Library, Humanities—Fine Arts Division
700 Freret St, New Orleans, LA 70118
Tel: 504-865-6611
Fine Arts Libn: Anne McArthur

Academic Founded: 1941
Hours: Mon-Thurs 8-12:45
 Fri 8-10:45
 Sat 8-4:45
 Sun 1-12:45
 Mon-Thurs 8-9:45 (summer)
 Fri 8-5:45 (summer)
 Sat 10-4:45 (summer)
Circulation: Students, faculty/staff, subscribers; journals restricted to faculty & staff; some monographs restricted to faculty (open stacks)
Reference Service: In person, telephone, mail
Reprographic Services: Yes; approval for Rare Book Room of Latin American Library & special collections
Interlibrary Loan: NILS; Association of Southeastern Research Libraries
Networks/Consortia: SOLINET: OCLC; Center for Research Libraries; Lousiana Numerical Register–Texas Numerical Register; University Microfilms; Southeast Louisiana Library Network Cooperative

Publications: Book catalog

Information Source: *Documentation of Art,* AICARC, 1973, UNESCO

Special Programs: Group & individual tours; bibliographic instruction

Card Catalog

Cataloged Volumes: 22,936 monographs

Serial Titles: 110; 217 non-current titles (National Union Catalog; Southeastern Union List of Serials)

Holdings: 11 vertical file drawers; 140 sales & auction catalogs; 1 drawer exhibition catalogs; Carnegie Art Reference Series (2,039 photos); portrait file (2,446); circulating prints (7,580); graphic arts rental collection (219 prints)

Subjects: Art, decorative arts, architecture, graphics, photography

Special Collections: Newcomb Art Department Collection; Jay Altmayer Collection; Louisiana picture file

Latin American Library

Material & monographs on art & archaeology of Latin America. Includes Merle Green Robinson collection of 500 Mayan rubbings.

Linton-Surget Collection

Portraits & landscapes by 19th century English & American artists.

Walker Brainerd Spencer Collection

Maps, engravings & paintings pertaining to Louisiana history.

William B Wisdom Collection

Works by early 20th century Louisiana painters.

AL 275
UNIVERSITY OF NEW ORLEANS
Earl K Long Library

Lake Front, New Orleans, LA 70122

Tel: 504-283-0353

Libn: Dr Gerald J Eberle

Academic Founded: 1958

Hours: Mon-Thurs 7:45-12
 Fri 7:45-10
 Sat 9-6
 Sun 1-10

Circulation: Public (open stacks)

Reference Service: In person, telephone, mail

Reprographic Services: Yes

Interlibrary Loan: NILS; Southeast Louisiana Library Network Cooperative

Networks/Consortia: Southeastern Library Network; Greater New Orleans Microforms Cooperative

Publications: Orientation handbook; acquisitions list; newsletter; in-house periodicals index (Serials Record)

Information Sources: Tassin, Anthony G. "Automation of Acquisitions at the Earl K Long Library, University of New Orleans," The LARC Assoc, 1974

Special Programs: Group tours; bibliographic instruction; group slide/lectures

Cataloged Volumes: 614,774 (428,489 titles)

Serial Titles: 5,490 (National Union Catalog; Louisiana Union Catalog)

Holdings: 436,085 microforms, microfiche, microprints & microcards (283,977 equivalent volumes)

Subjects: Art, architecture, classical archaeology, dance, decorative arts, film & video, graphics, music, photography, theatre

Special Collections:

Crabites Collection

Materials relating to Egyptology.

Louisiana Collection

Works about Louisiana, some by Louisianans.

Wolsch Collection

Materials relating to Franklin D Roosevelt, Dwight D Eisenhower & Kennedys.

Maine

AL 276
BATH MARINE MUSEUM LIBRARY/ARCHIVES
972 Washington St, Bath, ME 04530

Tel: 207-443-6311

Asst Curator: Marion S Lilly

Museum Founded: 1964

Hours: 10-5 (May 21–Oct 22)
 (Appointment remainder of year)

Circulation: Students, researchers, faculty/staff

Reference Service: In person, telephone, mail

Reprographic Services: No

Interlibrary Loan: No

Networks/Consortia: No

Publications: Newsletter

Special Programs: Individual tours

Card Catalog

Cataloged Volumes: 5,000

Holdings: 50 vertical file drawers

Subjects: Art, decorative arts

Special Collection:

Maine Maritime History Collection

Books, photographs, paintings, models, historical documents relating to maritime history of Maine.

AL 277
BOWDOIN COLLEGE
Art Department Library

Visual Art Center, Brunswick, ME 04011

Tel: 207-725-8731, Ext 965

Art Libn: Susan D Simpson

Academic Founded: 1794; 1932

Hours: Mon-Fri 7-5; 7-12
 Sat & Sun 12-12

Circulation: Faculty (open stacks)

Reference Service: No

Reprographic Services: Yes

Interlibrary Loan: NILS (Hawthorne-Longfellow Library)

Networks/Consortia: No

Publications: Book catalog

Cataloged Volumes: 6,500

Serial Titles: 45

Holdings: 22 vertical file drawers; 500 sales & auction catalogs; 2,500 exhibition catalogs

Subjects: Art, architecture, classical archaeology, decorative arts, graphics, photography

AL 278
DYER-YORK LIBRARY & MUSEUM
371 Main St, Saco, ME 04072

Tel: 207-283-3861

Executive Dir: Barbara Bond

Museum/Public Library Founded: 1867

Hours: Mon, Wed, Fri 9-5
 Tues-Thurs 9-9
 Sat 9-12

Circulation: Public (open stacks)

Reference Service: In person, telephone, mail

Reprographic Services: No

Interlibrary Loan: Maine Library Network

Reprographic Services: No
Interlibrary Loan: Maine Library Network
Networks/Consortia: No
Publications: Bibliographies; acquisitions list; special catalogs; in-house periodical index
Special Programs: Group & individual tours
Cataloged Volumes: 55,000
Holdings: 3 vertical file drawers; 6 microforms
Subjects: Art, decorative arts, geneaology, state history
Special Collection:
Maine Historical & Genealogical Collection
Approximately 800 volumes, documents, maps, diaries & letters pertaining to York County, Maine. Antiques & paintings of local interest

AL 279
THE WILLIAM A FARNSWORTH LIBRARY & ART MUSEUM
31 Elm St, Rockland, ME 04841
Tel: 207-596-6457
Dir: Marius B Peladeau

Museum Founded: 1948
Hours: Tues-Sat 10-5
 Sun 1-5
 Mon-Sat 10-5 (June-Sept)
 Sun 1-5 (June-Sept)
 Closed Mon (Oct-May)
Reference Service: In person, telephone, mail
Reprographic Services: Yes, for artworks in collection
Interlibrary Loan: No
Networks/Consortia: No
Publications: Acquisitions list; newsletter; special catalogs
Special Programs: Group & individual tours; single lectures; film series; concerts; art exhibits
Card Catalog
Cataloged Volumes: 2,500
Serial Titles: 26
Holdings: 2,000 sales & auction catalogs; 1,500 exhibition catalogs
Subjects: Art, decorative arts, architecture, graphics, photography, Maine history
Special Collection:
American Art Collection
Art of Maine, New England from 18th century to present, including works by N C, Andrew & Jamie Wyeth.

AL 280
PENOBSCOT MARINE MUSEUM LIBRARY
Church St, Searsport, ME 04974
Tel: 207-548-6634
Libn: C G Lane

Museum Founded: 1936
Hours: Mon-Sat 9-5 (May 31-Oct 15)
 Sun 1-5
 Other times by appointment
Circulation: Within museum (open stacks to researchers with supervision)
Reference Service: In person, telephone, mail
Reprographic Services: No
Interlibrary Loan: No
Networks/Consortia: No
Publications: Bibliography
Card Catalog
Cataloged Volumes: 2,000
Subjects: Art, maritime history, ships' logs, ship construction
Special Collection:

Maritime History
Books, logs, manuscripts relating to maritime history; marine paintings & Searsport sea captain & sailor information

AL 281
PORTLAND PUBLIC LIBRARY
Art Department
619 Congress St, Portland, ME 04101
Tel: 207-773-4761, Ext 24
Libn: Judith Wentzell

Public Library Founded: 1888
Hours: Mon-Thurs 9-9
 Fri 9-6
 Sat 9-5 (closed in summer)
Circulation: Public; non-circulating special collections & reference books (open stacks; major portion is closed)
Reference Service: In person, telephone, mail
Reprographic Services: Yes
Interlibrary Loan: NILS; Maine State Interlibrary Loan System
Networks/Consortia: OCLC
Publications: Orientation handbook; in-house periodical index
Special Programs: Group tours
Card Catalog
Cataloged Volumes: 13,834
Serial Titles: 82 (Union List of Maine Serials)
Holdings: 1 vertical file drawer; exhibition catalogs; 18 drawers of picture files
Subjects: Art, decorative arts, architecture, classical archaeology, film & video, graphics, photography, music, theatre, dance, costumes
Special Collections: Maine composers sheet music collection
Press Collection
Collection of publications from the Mosher & Anthoensen Presses of Portland, Maine; and books, broadsides, prints & cards of the Cuala Press (formerly Dun Emer), Ireland.

AL 282
THE UNITED SOCIETY OF SHAKERS
The Shaker Library
Sabbathday Lake, Poland Spring, ME 04274
Tel: 207-926-4865
Dir: Dr Theodore E Johnson

Shaker Organization Library Founded: 1882
Circulation: Students, faculty/staff; restricted to members of the United Society of Shakers, Shaker Museum staff & students of the Institute for Shaker Studies
Reference Service: In person, mail
Reprographic Services: Yes
Interlibrary Loan: NILS
Networks/Consortia: No
Publications: In-house periodical index
Special Programs: Group & individual tours; bibliographic instruction; single lectures; intern program
Card Catalog
Holdings: 34 vertical file drawers; 250 microfilm reels
Subjects: Art, decorative arts, graphics, photography, music, dance

AL 283
UNIVERSITY OF MAINE
Raymond H Fogler Library
Orono, ME 04473
Tel: 207-581-7328
Dir: James C MacCampbell

Academic Founded: 1865
Hours: Sun-Sat 7:30-12
Circulation: Public; restrictions on special collections & government publications depository (open stacks)
Reference Service: In person, telephone, mail
Reprographic Services: Yes; restrictions on theses & rare books
Interlibrary Loan: NILS
Networks/Consortia: New England Library Information Network; NOSIC
Publications: Orientation handbook; bibliographies; acquisitions list; in-house periodical index
Special Programs: Group & individual tours; bibliographic instruction; single lectures
Card Catalog
Cataloged Volumes: 515,000
Subjects: Art, decorative arts, architecture, classical archaeology, film & video, graphics, photography, music, theatre, dance

Maryland

AL 284
ACADEMY OF THE ARTS
Box 605, Easton, MD 21660
Tel: 301-822-0455
Curator, Exec Sec: Linnea Hall

Arts Center Founded: 1959
Hours: Mon-Fri 9-5 (arts center)
 Mon-Fri 10-4 (gallery)
Circulation: Members (open stacks)
Reprographic Services: No
Interlibrary Loan: No
Networks/Consortia: No
Special Programs: Group & individual tours; single lectures; films; demonstrations
Card Catalog
Cataloged Volumes: 200
Holdings: Sales & auction catalogs; exhibition catalogs
Subjects: Art, decorative arts, architecture, classical archaeology, film & video, graphics, photography, music, theatre, dance

AL 285
BALTIMORE MUSEUM OF ART
Art Reference Library
Art Museum Dr, Baltimore, MD 21218
Tel: 301-396-6317
Libn: Joan Settle Robison

Museum Founded: 1929
Hours: Mon-Fri 9-5 (by appointment)
Circulation: Faculty/staff; open to the public by appointment (open stacks)
Reference Service: Telephone, mail
Reprographic Services: Yes
Interlibrary Loan: No
Networks/Consortia: No
Special Programs: Docent group tours; individual tours
Card Catalog
Cataloged Volumes: 24,000
Serial Titles: 62
Holdings: 61 vertical file drawers; sales & auction catalogs
Subjects: Art, decorative arts, architecture, graphics, photography

AL 286
ENOCH PRATT FREE LIBRARY
Fine Arts Department
400 Cathedral St, Baltimore, MD 21201
Tel: 301-396-5491
Libn: James K Dickson

Public Library Founded: 1886
Hours: Mon-Thurs 9-9
 Fri-Sat 9-5
 Sun 1-5 (winter)
Circulation: Public (open stacks for half the collection)
Reference Service: In person, telephone, mail
Reprographic Services: Yes
Interlibrary Loan: NILS
Networks/Consortia: Maryland Interlibrary Organization
Publications: Book catalog
Card Catalog
Holdings: 64 vertical file drawers
Subjects: Art, decorative arts, architecture, graphics, music, dance

AL 287
GOUCHER COLLEGE
Julia Rogers Library
Dulaney Valley Rd, Towson, MD 21204
Tel: 301-825-3300
Libn: Sarah D Jones

Academic Founded: 1885
Hours: Mon-Fri 8-10
 Sat 10-5
 Sun 12-10
Circulation: Students, faculty/staff (open stacks except for periodicals)
Reference Service
Reprographic Services: Yes
Interlibrary Loan: NILS
Networks/Consortia: Library Cooperative; Maryland Independent Colleges; Maryland Library Center for Automated Processing
Publications: In-house periodical index
Special Programs: Group tours; bibliographic instruction; single lectures
Card Catalog
Cataloged Volumes: 8,148 art (190,000 total)
Subjects: Art, decorative arts, architecture, classical archaeology, film & video, graphics, photography, music, theatre, dance

AL 288
JOHNS HOPKINS UNIVERSITY
Milton S Eisenhower Library
3400 N Charles St, Baltimore, MD 21218
Tel: 301-338-8372
Libn: David Stam

Academic Founded: 1876
Hours: Mon-Thurs 8-12
 Fri-Sat 8-10
 Sun 1-12
Circulation: Students, researchers, faculty/staff; art & reference books restricted to use within library (open stacks; special collections restricted)
Reference Service: Telephone, mail
Reprographic Services: Yes
Interlibrary Loan: NILS; Center for Research Library;

Maryland Interlibrary Organization; restrictions on fragile
& expensive art books & journals
Networks/Consortia: Middle Atlantic Research Libraries
Information Network; OCLC
Publications: Orientation handbook; bibliographies
Special Programs: Group & individual tours; bibliographic
instruction; single lectures
Card Catalog
Cataloged Volumes: 1.7 million (total library)
Serial Titles: 450 art (National Union Catalog)
Subjects: Art, decorative arts, architecture, classical archae-
ology
Special Collections: Travel prints of archaeological sites;
Evergreen collection of illustrated books; 17th century
maps & atlases
Fowler Architectural Collection
Books on architecture from Alberti to 19th century (448
items).
Alice Garrett Collection
Pictorial materials on late 19th & 20th centuries.

AL 289
LOYOLA-NOTRE DAME COLLEGE LIBRARY
200 Winston Ave, Baltimore, MD 21212
Tel: 301-532-8787
Dir: Sr Ian Stewart

Academic Founded: 1973
Hours: Mon-Thurs 8:30-12
 Fri 8:30-10
 Sat 9-5:30
 Sun 12-12
Circulation: Students, faculty/staff (open stacks)
Reference Service: Yes
Reprographic Services: Yes
Interlibrary Loan: NILS; Maryland Interlibrary Loan Organi-
zation (Elizabeth McNab)
Networks/Consortia: Maryland Library Center for Auto-
mated Processing; OCLC
Publications: Orientation handbook; bibliographies; acquisi-
tions list
Special Programs: Group & individual tours; bibliographic
instruction; single lectures
Cataloged Volumes: 172,365 total; 2,895 art (103,369 total
titles; 1,737 art titles)
Serial Titles: 1,084 total; 26 art (Maryland Library Center
for Automated Processing Union List of Serials)
Subjects: Art, architecture, classical archaeology, dance,
decorative arts, film & video, graphics, music, photography,
theatre

AL 290
MARYLAND COLLEGE OF ART & DESIGN
Art Library
10500 Georgia Ave, Silver Spring, MD 20902
Tel: 301-649-4454
Libn: Terry Kaufmann

Art School Founded: 1971
Hours: Mon-Thurs 9-10
 Fri 9-5:30
 Sat 9-1
Circulation: Students, faculty/staff (open stacks)
Reference Service: In person only
Reprographic Services: No
Interlibrary Loan: No
Networks/Consortia: No
Special Programs: Group & individual tours

Card Catalog
Cataloged Volumes: 5,000
Subjects: Art, architecture, art history, classical archaeology,
decorative arts, film & video, graphics, music, photography,
theatre

AL 291
MARYLAND COLLEGE OF ART & DESIGN
Stites Library
10500 Georgia Ave, Silver Spring, MD 20902
Tel: 301-649-4454
Libn: Kathy Kelly

Art School Founded: 1955
Hours: Mon-Fri 9:30-4
Circulation: Students, faculty/staff
Reprographic Services: No
Interlibrary Loan: No
Networks/Consortia: No
Card Catalog
Cataloged Volumes: 5,800
Holdings: 500 exhibition catalogs
Subjects: Art, graphics, photography
Special Collection:
Dr Raymond Stites Collection
Dr Stites' collection on Leonardo da Vinci.

AL 292
THE MARYLAND INSTITUTE, COLLEGE OF ART
The Decker Library
1400 Cathedral St, Baltimore, MD 21201
Tel: 301-669-9200
Libn: John Stoneham

Art School Founded: 1826
Hours: Mon-Thurs 8:30-4:30; 6-10
 Fri 8:30-4:30
 Sat 10-1
Circulation: Students, faculty/staff (open stacks)
Reference Service: Telephone, mail
Reprographic Services: Yes
Interlibrary Loan: NILS
Networks/Consortia: Union of Independent Colleges of Art;
East Coast Art Schools Consortium
Publications: Orientation handbook
Special Programs: Individual tours; single lectures
Card Catalog
Cataloged Volumes: 37,000
Serial Titles: 200
Holdings: 45 vertical file drawers
Subjects: Art, decorative arts, architecture, classical archae-
ology, film & video, graphics

AL 293
UNIVERSITY OF MARYLAND AT COLLEGE PARK
Architecture Library
College Park, MD 20742
Tel: 301-454-4316
Architecture Libn: Berna E Neal

Academic Founded: 1967
Hours: Mon-Thurs 8:30-10
 Fri 8:30-5
 Sat 1-5
 Sun 5-10
Circulation: Students, faculty/staff (open stacks)
Reference Service: In person, telephone, mail
Reprographic Services: Yes

Interlibrary Loan: NILS (McKeldin Library, same address as above)
Networks/Consortia: No
Publications: Acquisitions list
Special Programs: Group & individual tours; single lectures
Cataloged Volumes: 20,000 (15,000 titles)
Serial Titles: 140
Holdings: 25 microfilms; exhibition catalogs
Subjects: Architecture, architectural history, environmental psychology, urban design

AL 294
UNIVERSITY OF MARYLAND AT COLLEGE PARK
Art Library
Art-Sociology Bldg, College Park, MD 20742
Tel: 301-454-3036
Art Libn: Courtney Ann Shaw

Academic
Circulation: Students, faculty/staff (open stacks)
Reference Service: In person, telephone, mail
Reprographic Services: Yes
Interlibrary Loan: NILS; Interlibrary Users Association (Interlibrary Loan, McKeldin Library)
Networks/Consortia: Maryland Network
Publications: Orientation handbook; bibliographies; in-house periodical index
Special Programs: Group & individual tours; bibliographic instruction; intern program
Cataloged Volumes: 34,000
Serial Titles: 171 (National Union Catalog)
Holdings: 10 vertical file drawers; sales & auction catalogs; exhibition catalogs
Subjects: Art, architectural history, classical archaeology, decorative arts, film & video, graphics, photography, theatre design

AL 295
UNIVERSITY OF MARYLAND, BALTIMORE COUNTY, LIBRARY
5401 Wilkens Ave, Baltimore, MD 21228
Tel: 301-455-2232
Dir: Antonio R Raimo

Academic Founded: 1966
Hours: Mon-Thurs 8-11
 Fri 8-5
 Sat 10-4
 Sun 10-5
Circulation: Public (open stacks)
Reference Service: In person, telephone, mail; bibliographies restricted to university members
Reprographic Services: Yes
Interlibrary Loan: NILS; Maryland Interlibrary Organization; INBC; Interlibrary Loan Users' Association
Networks/Consortia: OCLC
Publications: Special catalogs; guides to use & policies; in-house periodical index (University of Maryland, Baltimore County Serials Holdings List)
Information Source: Time/Life. *Photography Yearbook*, 1976
Special Programs: Group & individual tours; bibliographic instruction; single lectures; self-guided tape tour
Card Catalog
Cataloged Volumes: 254,793
Holdings: 206 vertical file boxes
Subjects: Art, classical archaeology, film & video, photography, music, theatre, dance
Special Collections:
Edward Bafford Photographic Collection

Collection of photographs, including "Pavla" by Alfred Steiglitz, 5,000 labor photographs by Lewis Hine and photographic archives of the *News American*.
Edgar Merkle Collection
Collection of 19th century English graphic satire.

AL 296
THE WALTERS ART GALLERY LIBRARY
600 N Charles St, Baltimore, MD 21201
Tel: 301-547-9000
Libn: Muriel L Gers

Museum Founded: 1933
Hours: Mon 1-5
 Tues-Fri 11-5
Circulation: Faculty/staff; public by appointment only (open stacks for curatorial & educational staff)
Reference Service: Telephone, mail
Reprographic Services: Yes
Interlibrary Loan: NILS; borrow only
Networks/Consortia: No
Publications: In-house periodical index (Indexes to Journal & Bulletin of Walters Art Gallery)
Special Programs: Group tours for gallery volunteers; individual tours
Card Catalog
Cataloged Volumes: 75,000 (including bound periodicals)
Serial Titles: 500 (National Union Catalog; ULS; New Serial Titles; Union List of Serials in Delaware & Maryland)
Holdings: Several thousand sales & auction catalogs
Subjects: Art, decorative arts, architecture, classical archaeology, graphics

Massachusetts

AL 297
AMERICAN ANTIQUARIAN SOCIETY
Research Library
185 Salisbury St, Worcester, MA 01609
Tel: 617-755-5221
Dir: Marcus A McCorison

Research Library Founded: 1812
Hours: Mon-Fri 9-5
Reference Service: Telephone, mail; fee for involved questions
Reprographic Services: Yes
Interlibrary Loan: Worcester Area Cooperating Libraries
Networks/Consortia: New England Library Information Network; OCLC
Publications: Orientation handbook; bibliographies; newsletter; special catalogs; book catalog; *Proceedings of the American Antiquarian Society*
Information Sources: Bauer, Frederick E, Jr. "The American Antiquarian Society & Children's Literature," *Phaedrus*, v III, no 1, Spring 1976; Knowlton, Elliot B. "The American Antiquarian Society," *Pages,* v 1, 1976; American Antiquarian Society. *A Society's Chief Joys,* Worcester, MA: AAS, 1969; Brigham, Clarence S. *Fifty Years of Collecting Americana for the Library of the American Antiquarian Society, 1908–1958,* Worcester, MA: AAS, 1958
Special Programs: Group tours (by appointment); individual tours; bibliographic instruction
Card Catalog
Cataloged Volumes: 650,000
Serial Titles: 600 (National Union Catalog; Worcester Area Cooperating Libraries)

Holdings: 31,600 sales & auction catalogs; 2,500 exhibition catalogs; 1,500 reels of microforms
Subjects: Art, decorative arts, architecture, graphics, photography, music, theatre, American history & culture to 1877

AL 298
THE ARCHITECTS COLLABORATIVE LIBRARY
46 Brattle St, Cambridge, MA 02138
Tel: 617-868-4200, Ext 253
Libn: Anne Hartmere

Architectural Firm Founded: 1966
Hours: Mon-Fri 9-5:45
Circulation: Staff (open stacks)
Reference Service: In person, telephone, mail
Reprographic Services: Yes
Interlibrary Loan: No
Networks/Consortia: No
Publications: Orientation handbook; acquisitions list; in-house periodical index
Special Programs: Individual tours
Cataloged Volumes: 3,000
Serial Titles: 150
Holdings: 2 vertical file drawers; 6 drawers microforms; 3,000 manufacturers' catalogs (architectural & interior product samples)
Subjects: Architecture, building design & construction

AL 299
ART INSTITUTE OF BOSTON LIBRARY
700 Beacon St, Boston, MA 02115
Tel: 617-262-1223, Ext 261
Libn: Allyson Edmonston

Art School Founded: 1912
Hours: Mon-Thurs 9-9
 Fri 9-5
Circulation: Students, faculty/staff (open stacks)
Reference Service: In person only
Reprographic Services: Yes
Interlibrary Loan: NILS
Networks/Consortia: No
Publications: In-house periodical index
Special Programs: Individual tours; bibliographic instruction
Serial Titles: 33 (National Union Catalog)
Holdings: 1 vertical file drawer; 1 drawer exhibition catalogs
Subjects: Art, decorative arts, graphics, photography
Special Collection:
Illustration Morgue
10,000 illustrations covering 20th century advertisements, culled from magazines & arranged by subject.

AL 300
BOSTON ARCHITECTURAL CENTER
Alfred Shaw & Edward Durrell Stone Library
320 Newbury St, Boston, MA 02158
Tel: 617-536-9018
Libn: Susan Lewis

Architectural School Founded: 1889
Hours: Mon-Thurs 10-10
 Fri 9-5
 Sat-Sun 10-4 (closed in summer)
Circulation: Students, faculty/staff (open stacks)
Reference Service: In person
Reprographic Services: Yes
Interlibrary Loan: No
Networks/Consortia: No

Publications: Orientation handbook
Special Programs: Individual tours
Card Catalog
Cataloged Volumes: 12,000
Serial Titles: 120
Subjects: Decorative arts, architecture, graphics, photography

AL 301
BOSTON ATHENAEUM
Art Department
10½ Beacon St, Boston, MA 02108
Tel: 617-227-0270
Asst Libn: Donald C Kelley

Proprietory Library Founded: 1807
Hours: Mon-Fri 9-5:30 (Oct-May)
 Sat 9-4 (Oct-May)
Circulation: Proprietors; public; limited rental tickets available for qualified applicants (open stacks)
Reference Service: Telephone, mail; non-members must submit advance applications for long-term research projects
Reprographic Services: Yes
Interlibrary Loan: NILS
Networks/Consortia: No
Publications: Book catalog; in-house periodical catalog
Special Programs: Group & individual tours; single lectures; concerts; art gallery exhibitions
Card Catalog
Cataloged Volumes: 500,000
Subjects: Art, decorative arts, architecture, classical archaeology, photography, music, theatre, dance
Special Collections:
Boston Architectural History
Fine Arts Collection
Emphasis on American painters & sculptors pre-1950.
Gypsy Collection–Francis Hindes Groome Manuscripts
Material relating to gypsy life & culture, including letters, manuscripts & dictionaries of the Romany scholar, Francis Hindes Groome.
Topographical Print Collection
Includes the Charles E Mason Collection of over 2,000 prints of 19th century lithographic views of Boston & New England towns. Contains views of hotels, businesses & street views. Collection now includes works by 19th century Boston lithographers.

AL 302
BOSTON PUBLIC LIBRARY
Fine Arts Department
Dartmouth St, Copley Sq, Boston, MA 02117
Tel: 617-536-5400, Ext 304
Curator of the Fine Arts: Florence Connolly

Public Library Founded: 1852
Hours: Mon-Fri 9-9
 Sat 9-6
Circulation: No (closed stacks); General Library maintains a circulating collection of fine arts volumes
Reference Service: In person, telephone, mail
Reprographic Services: Yes
Interlibrary Loan: NILS (Inter-library Loans Office)
Networks/Consortia: Greater Boston Consortium of Academic & Research Libraries; Eastern Massachusetts Regional Library System
Publications: Orientation handbook; bibliographies; newsletter; special catalogs; monographic publications; in-house periodical index (Serials Currently Received in the Boston Public Library)
Special Programs: Group tours; intern program for staff only

Cataloged Volumes: 100,000
Serial Titles: 300 (National Union Catalog; Greater Boston
 Consortium List of Serials Currently Received)
Holdings: 28 vertical file drawers of ephemeral exhibition
 materials; 18 vertical file drawers of Boston architectural
 photographs & clippings; sales, auction & exhibition cata-
 logs
Subjects: Art, architecture, ancient art, classical archaeology,
 dance, decorative arts, film & video, music, theatre
Special Collections:
Boston Art Archives
Collection of exhibition & ephemeral materials relating to
 Boston & New England area artists. Indexed by artist &
 gallery.
Index to Boston Architecture
Consists of 50 catalog drawers.

AL 303
BOSTON PUBLIC LIBRARY
Print Department
Dartmouth St, Copley Sq, Boston, MA 02117
Tel: 617-536-5400, Ext 311
Keeper of Prints: Sinclair Hitchings

Public Library Founded: 1852; 1941
Hours: Mon-Fri 9-5
Circulation: No (closed stacks)
Reference Service: In person, telephone, mail
Interlibrary Loan: NILS
Special Programs: Individual tours; annual Wiggin Sym-
 posium of Prints & Printmaking
Holdings: 100,000 original prints, drawings, watercolors &
 photographs, along with a library of several thousand vol-
 umes; 2,000 sales & auction catalogs; 1,000 exhibition
 catalogs
Subjects: Graphics, photography
Special Collections:
American Collection of British Printmaking
Includes British caricature & comic art, works by Rowlandson,
 John Copley, Augustus John, etc.
American Historical Prints
Portraits & caricatures from 1750 to present.
The American West Collection
Original photographs.
Boston Pictorial Archive
Includes prints, photographs & drawings.
French, British & American Print Collection
Nineteenth century prints, including caricatures from the
 American Revolutionary War, works by Winslow Homer.
French Lithograph Collection
Prints & color lithographs of the 1890s by French artists.
The Holt Collection
European prints relating to Islam. Includes portraits, city
 views & costumes from 1600–1900.
Individual Artist Collection
Prints & drawings by Rowlandson, Goya, Daumier, Toulouse-
 Lautrec.
Modern German Prints
Extensive collection of Kathe Kollwitz prints.
Plate Collection
Includes blocks, stones & plates by artists such as Hogarth,
 Meryon, Picasso, Bellows & Eric Gill.

AL 304
BRANDEIS UNIVERSITY
Goldfarb Library
415 South St, Waltham, MA 02154
Tel: 617-647-2524

Creative Arts Libn: Robert L Evensen

Academic Founded: 1948
Hours: Mon-Thurs 8:30-12
 Fri 8:30-11
 Sat 10-5
 Sun 12-12
Circulation: Students, researchers, faculty/staff (open stacks)
Reference Service: In person, telephone, mail
Reprographic Services: Yes
Interlibrary Loan: NILS
Networks/Consortia: Boston Library Consortium
Publications: In-house periodical index (Brandeis University
 Library Serials)
Special Programs: Group & individual tours
Card Catalog
Serial Titles: 80 (National Union Catalog; Boston Library
 Consortium)
Holdings: 3,500 sales & auction catalogs
Subjects: Art, decorative arts, architecture, classical archae-
 ology, photography
Special Collections:
Bern Dibner Collection
One thousand books & pamphlets dealing with Leonardo da
 Vinci's life & work.
Benjamin H & Julia M Trustman Collection
Four thousand lithographs by Honoré Daumier

AL 305
BROCKTON ART CENTER—FULLER MEMORIAL
Library Education Department
Oak St on Upper Porter's Pond, Brockton, MA 02401
Tel: 617-588-6000
Education Coordinator: Adrienne Weinberger

Museum Founded: 1969
Circulation: Faculty/staff (open stacks)
Reference Service: Telephone, mail
Reprographic Services: Yes
Interlibrary Loan: NILS
Networks/Consortia: No
Publications: Acquisitions list; special catalogs; in-house
 periodical index
Special Programs: Group tours
Card Catalog
Cataloged Volumes: 1,400
Holdings: 8 vertical file drawers; 50 sales & auction catalogs;
 200 exhibition catalogs
Subjects: Art, decorative arts, architecture, classical archae-
 ology, film & video, photography, American art

AL 306
BROCKTON PUBLIC LIBRARY
304 Main St, Brockton, MA 02401
Tel: 617-587-2515-6
Dir: E J Webby, Jr

Public Library
Hours: Mon-Fri 9-9 (Sept-June)
 Sat 9-5 (Sept-June)
 Mon-Thurs 9-9 (July & Aug)
 Fri & Sat 9-5 (July & Aug)
Circulation: Public; reference material does not circulate;
 limit of 10 titles per patron (open stacks; restricted to
 use by teachers only)
Reference Service: In person, telephone, mail
Reprographic Services: No
Interlibrary Loan: Eastern Regional System

Networks/Consortia: No
Publications: Bibliographies; acquisitions list; in-house periodical index (Index to Brockton Enterprise)
Information Source: Massachusetts League of Women Voters. *This is Brockton*, LOWV, 1972
Special Programs: Group tours
Card Catalog
Cataloged Volumes: 200,000
Serial Titles: 250
Holdings: 10 vertical file drawers; 1,088 microforms
Subjects: Art, photography, theatre
Special Collection.
Historical Room Collection
Includes genealogical & historical material on New England region.

AL 307
CONCORD FREE PUBLIC LIBRARY
Special Collections
129 Main St, Concord, MA 01742
Tel: 617-369-5324
Lib Dir: Rose Marie Mitten

Public Library Founded: 1873
Hours: Mon-Fri 10-9
Circulation: Public; archival & photographic materials do not circulate (open stacks)
Reference Service: In person, telephone, mail
Reprographic Services: Yes
Interlibrary Loan: NILS; Eastern Massachusetts Regional Library System (Lu Ann Fiore)
Networks/Consortia: Eastern Massachusetts Regional Library System
Publications: Orientation handbook
Special Programs: Group & individual tours; bibliographic instruction
Cataloged Volumes: 175,000
Serial Titles: 283 (Eastern Massachusetts Regional Library System Union List of Serials)
Subjects: Art, architecture, classical archaeology, dance, decorative arts, film & video, graphics, music, photography, theatre
Special Collection:
Concord Authors & History
Books, manuscripts, photographs & memorabilia.

AL 308
FORBES LIBRARY
Art & Music Department
20 West St, Northampton, MA 01060
Tel: 413-584-8550
Libn: Hollee Haswell

Public Library Founded: 1894
Hours: Mon, Tues, Thurs, Fri, Sat 9-6
 Wed 9-9
Circulation: Public; older volumes & bound periodicals restricted to use in library (open stacks)
Reference Service: Telephone, mail
Reprographic Services: Yes
Interlibrary Loan: NILS; Western Massachusetts Public Library System; Hampshire Inter-library Center
Networks/Consortia: No
Publications: In-house periodical catalog
Information Source: Wikander, Lawrence E. *Disposed to Learn: The First 75 Years of the Forbes Library*, Trustees of the Forbes Library, Northampton, MA, 1972
Special Programs: Group & individual tours; bibliographic instruction; single lectures

Card Catalog
Cataloged Volumes: 15,000 (art)
Serial Titles: 43 in art (National Union Catalog; Pioneer Valley Union List of Journal & Serial Holdings)
Holdings: 16 vertical file drawers (art)
Subjects: Art, decorative arts, architecture, classical archaeology, graphics, photography, music

AL 309
ISABELLA STEWART GARDNER MUSEUM
Art Library & Archives
2 Palace Rd, Boston, MA 02115
Tel: 617-566-1401
Libn: Paula Kozol

Museum Founded: 1903
Hours: Tues 1-9:30 (closed evenings July & Aug)
 Wed-Sun 1-5:30
Circulation: Restricted to use by scholars
Interlibrary Loan: No
Publications: Special catalogs; annual report on collection; book catalog
Special Programs: Group tours
Card Catalog
Cataloged Volumes: 400
Holdings: 50 vertical file drawers; 150 exhibition catalogs; microforms
Subjects: Art, decorative arts

AL 310
HARVARD UNIVERSITY
Fine Arts Library of the Harvard College Library
Fogg Art Museum, Cambridge, MA 02138
Tel: 617-495-3373-6
Libn: Wolfgang M Freitag

Academic/Museum Founded: 1895
Hours: Mon-Thurs 9-10
 Fri-Sat 9-5
Circulation: Restricted to registered borrowers
Reference Service: In person
Reprographic Services: Yes
Networks/Consortia: Research Library Group
Publications: Orientation handbook; bibliographies; acquisitions list; book; in-house periodical catalog (Art Periodical Contents)
Special Programs: Group & individual tours; single lectures; exhibitions
Card Catalog
Cataloged Volumes: 160,000
Serial Titles: 978 (National Union Catalog; Research Library Group Union List of Serials)
Holdings: 67 vertical file drawers; 25,000 sales & auction catalogs; 22,500 microforms; archives of artists & art historians
Subjects: Art, decorative arts, architecture, classical archaeology, film & video, graphics, photography
Special Collection:
Knoedler Library on Microfiche
Collection of book jackets as original art.

AL 311
HARVARD UNIVERSITY
Frances Loeb Library, Graduate School of Design
Gund Hall, Harvard University, Cambridge, MA 02138
Tel: 617-496-2574
Libn: Angela Giral

Academic Founded: 1900

Circulation: Students, faculty/staff (open stacks; requires registration)
Reference Service: In person
Reprographic Services: Yes
Interlibrary Loan: NILS; charge for books borrowed on ILL
Networks/Consortia: Research Libraries Group
Publications: Book catalog; in-house periodical catalog
Special Programs: Group & individual tours; bibliographic instruction; single lectures
Card Catalog
Cataloged Volumes: 190,000
Serial Titles: 600 (National Union Catalog)
Holdings: 800 vertical file drawers
Subjects: Art, decorative arts, architecture, graphics, landscape architecture, city & regional planning
Special Collections: Le Corbusier Collection; Cluny Collection

AL 312
HAVERHILL PUBLIC LIBRARY
Special Collections
99 Main St, Haverhill, MA 01830
Tel: 617-373-1586

Public Library Founded: 1874
Hours: Mon-Thurs 9-9
 Fri-Sat 9-5:30 (winter)
 Mon & Thurs 9-9
 Tues, Wed, Fri & Sat 9-5 (summer)
Circulation: No (closed stacks)
Reference Service: In person, telephone, mail
Reprographic Services: Yes
Interlibrary Loan: No
Networks/Consortia: No
Publications: Special catalogs; in-house periodical index (Gale Collection Catalogue)
Special Programs: Individual tours
Cataloged Volumes: 5,600
Subjects: Art, architecture, costume, decorative arts, photography

AL 313
THE JOHN WOODMAN HIGGINS ARMORY
MUSEUM
The John Woodman Higgins Memorial Library
100 Barber Ave, Worcester, MA 01606
Tel: 617-853-6015
Registrar: Erveen C Lundberg

Museum
Hours: Tues & Thurs (by appointment)
Circulation: Restricted to research within museum
Reference Service: In person
Reprographic Services: No
Interlibrary Loan: No
Networks/Consortia: No
Publications: Newsletter; special catalogs; book catalog
Card Catalog
Cataloged Volumes: 1,025
Subjects: Art, architecture, classical archaeology, armor, arms & related artifacts
Special Collection: Books on arms & armor & fine art of the Middle Ages to the Renaissance

AL 314
MASSACHUSETTS COLLEGE OF ART LIBRARY
364 Brookline Ave, Boston, MA 02215
Tel: 617-731-2340, Ext 26
Head Libn: Benjamin Hopkins

Art School
Hours: Mon-Fri 8-5
Circulation: Yes (open stacks)
Reference Service: Yes
Reprographic Services: Yes
Interlibrary Loan: NILS
Networks/Consortia: Yes
Publications: In-house periodical index
Special Programs: Group & individual tours; bibliographic instruction; single lectures
Holdings: 2 vertical file drawers
Subjects: Art, architecture, classical archaeology, dance, decorative arts, film & video, graphics, music, photography, theatre

AL 315
MASSACHUSETTS INSTITUTE OF TECHNOLOGY
Rotch Library
77 Massachusetts Ave, Rm 7-238, Cambridge, MA 02139
Tel: 617-253-7052
Libn: Margaret DePopolo

Academic Founded: 1868
Circulation: Students, researchers, faculty/staff; room use only for visiting scholars & researchers (open stacks)
Reference Service: Telephone, mail
Reprographic Services: Yes
Interlibrary Loan: NILS (Interlibrary Loan Office, MIT Libraries, 14S-200); New England Library Information Network
Networks/Consortia: Boston Library Consortium; OCLC
Publications (internal distribution only): Orientation handbook; bibliographies; acquisitions list; in-house periodical index (Serials & Journals in MIT Libraries)
Special Programs: Group & individual tours; bibliographic instruction; single lectures
Card Catalog
Cataloged Volumes: 95,100 (excluding vertical files)
Serial Titles: 730 (National Union Catalog)
Holdings: 175 vertical file drawers; 625 microfilms; 13,950 fiche sheets; 3,240 exhibition catalogs
Subjects: Art, architecture, decorative arts, film & video, graphics, photography, urban & regional planning, urban design
Special Collections: American & European painting & sculpture of the 19th & 20th centuries; 19th century American architecture; Italian Renaissance & Baroque architecture

AL 316
MERRIMACK VALLEY TEXTILE MUSEUM
LIBRARY
800 Massachusetts Ave, North Andover, MA 01845
Tel: 617-686-0191
Libn: Helena Wright

Museum Founded: 1960
Hours: Mon-Fri 9-5
Circulation: Research library; restricted to use of materials within library (open stacks for staff only)
Reference Service: In person, telephone, mail
Reprographic Services: Yes
Interlibrary Loan: NILS
Networks/Consortia: No
Publications: Special catalogs; book & periodical catalog
Card Catalog
Cataloged Volumes: 30,000
Serial Titles: 30
Subjects: Decorative arts, architecture

Special Collections:
American Textile Industry Collection
Prints, manuscripts, textiles, on the history of the American
textile industry. Special emphasis on textile mill architecture.

AL 317
MOUNT HOLYOKE COLLEGE
Williston Memorial Library/Art Department Library
South Hadley, MA 01075
Tel: 413-538-2416
Circulation Asst: Pamela Holcomb

Academic Founded: 1837
Hours: Mon-Fri 8-10
 Sat 9-5
 Sun 2:30-10
Circulation: Faculty/staff, students (open stacks)
Reference Service: No
Reprographic Services: Yes
Interlibrary Loan: NILS (Interlibrary Loan Department)
Networks/Consortia: Hampshire Interlibrary Center, Inc.;
 New England Library Information Network
Publications: Orientation handbook; bibliographies; acquisitions list
Special Programs: Bibliographic instruction
Cataloged Volumes: 15,798
Serial Titles: (National Union Catalog; Pioneer Valley
 Union List of Serials)
Subjects: Art, architecture, classical archaeology, decorative
 arts, graphics, photography

AL 318
MUSEUM OF FINE ARTS
William Morris Hunt Library
465 Huntington Ave, Boston, MA 02115
Tel: 617-267-9300, Ext 385; 389
Libn: Nancy S Allen

Museum Founded: 1870; 1875
Hours: Tues-Fri 10-4:30
 Sat 10-1 (Sept-May)
Circulation: (Open stacks)
Reference Service: Telephone, mail
Reprographic Services: Yes; minimum charge $1
Interlibrary Loan: NILS
Networks/Consortia: Fenway Library Consortium
Special Programs: Informal intern program with Simmons
 Library School students
Card Catalog
Cataloged Volumes: 100,000
Serial Titles: 280 (National Union Catalog)
Holdings: 40,000 pamphlets
Subjects: Art, architecture, classical archaeology, decorative
 arts, graphics, music, photography

AL 319
MUSEUM OF THE AMERICAN CHINA TRADE
LIBRARY
215 Adams St, Milton, MA 02186
Tel: 617-696-1815
Assoc Dir: F R Carpenter

Museum Founded: 1971
Hours: Mon-Fri 9-5
Circulation: No (closed stacks)
Reference Service: In person, mail
Reprographic Services: No

Interlibrary Loan: No
Networks/Consortia: No
Publications: Book catalog
Cataloged Volumes: 1,000
Subjects: Decorative arts

AL 320
MUSEUM OF THE CONCORD ANTIQUARIAN
SOCIETY
Ralph Waldo Emerson Library
200 Lexington Rd, Box 146, Concord, MA 01742
Tel: 617-369-9609
Acting Dir: F A Stride

Museum Founded: 1886
Hours: Mon-Fri 10-4:30
Reference Service: In person; with written permission of the
 Emerson family
Reprographic Services: No
Interlibrary Loan: No
Networks/Consortia: No
Special Programs: Group tours
Card Catalog
Subjects: Decorative arts; emphasis of collection on all
 aspects of life in Concord, Massachusetts over a 200-year
 time span

AL 321
NEW BEDFORD FREE PUBLIC LIBRARY
Genealogy & Audiovisual Division
Box C902, New Bedford, MA 02741
Tel: 617-999-6291-2
Curator: Bruce Barnes

Public Library Founded: 1852
Circulation: Public (closed stacks)
Reference Service: In person, telephone, mail
Reprographic Services: Yes
Interlibrary Loan: Eastern Massachusetts Regional Library
 System; Boston Public Library
Networks/Consortia: No
Special Programs: Group tours
Special Collections:
Melville Whaling Room & Genealogy Room
Elephant folio, Audubon bird prints, and paintings by A
 Bierstadt, F D Millet, W Bradford and including whaling
 subjects by C W Ashly and B Russell.

AL 322
PEABODY MUSEUM OF ARCHAEOLOGY AND
ETHNOLOGY, HARVARD UNIVERSITY
Tozzer Library
21 Divinity Ave, Cambridge, MA 02138
Tel: 617-495-2253; 2292
Dir: Dr Nancy Schmidt

Academic Founded: 1866
Hours: Mon-Fri 9-5
 Sat & Sun 1-5
Circulation: Students, researchers, faculty/staff (open stacks)
Reference Service: Yes
Reprographic Services: Yes
Interlibrary Loan: NILS
Networks/Consortia: New England Library Information Network; Research Libraries Group
Publications: Acquisitions list; book catalog
Information Sources: "The Alfred M Tozzer Library of the
 Peabody Museum of Archaeology and Ethnology," *Guides*

to the Harvard Libraries, no 16, 1974; Currier, Margaret. "Anthropology Indexing at the Peabody Museum Library," *Library of Congress Information Bulletin,* vol 12, no 20, 1953; Currier, Margaret. "The Peabody Museum Library,"*Harvard Library Bulletin,* vol 3, 1949
Special Programs: Group & individual tours; single lectures
Cataloged Volumes: 119,809
Serial Titles: 1,359 (National Union Catalog; Union List of Serials; NST)
Holdings: 270 microforms; 2 films; photographs; phonograph records; slides
Subjects: Anthropology, architecture, art, dance, decorative arts, drama, music, theatre
Special Collections: Anthropology (general, biological, cultural & social); archaeology; ethnography; Mexican/ Central/South American Indian Linguistics; Primitive Art

AL 323
THE RUBEL ASIATIC RESEARCH LIBRARY
Fogg Art Museum Library, Harvard University
32 Quincy St, Cambridge, MA 02138
Tel: 617-495-2391
Curator of Oriental Art: Prof John Rosenfield
Libn: Yen-shew Lynn Chao

Academic Founded: 1927
Hours: Mon-Fri 9-5
Circulation: Students, faculty/staff, Harvard affiliates (open stacks)
Reference Service: In person
Reprographic Services: No
Interlibrary Loan: No
Networks/Consortia: No
Card Catalog
Cataloged Volumes: 12,436
Subjects: Art, architecture & archaeology of East Asia, Central Asia, India & Southeast Asia

AL 324
SALEM MARITIME NATIONAL HISTORIC SITE
Staff Library
Custom House, Derby St, Salem, MA 01970
Tel: 617-744-4323; 745-0236
Chief Interpreter: Genevieve N K Riley

Historic Site Founded: 1937
Hours: Mon-Sun 8:30-5 (except New Year's Day, Christmas, Thanksgiving)
 Library open by appointment only
Circulation: Staff
Reference Service: In person, telephone, mail; appointment necessary for staff assistance
Reprographic Services: Yes
Interlibrary Loan: No
Networks/Consortia: No
Card Catalog
Cataloged Volumes: 500
Serial Titles: 5
Subjects: Local history, maritime history, National Park Service & Salem Maritime National Historic Site administrative & research materials

AL 325
GEORGE WALTER VINCENT SMITH ART MUSEUM LIBRARY
222 State St, Springfield, MA 01103
Tel: 413-733-4214

Museum Founded: 1895
Hours: By appointment only
Circulation: (Open stacks)
Reference Service: In person (by appointment); mail
Reprographic Services: No
Interlibrary Loan: No
Networks/Consortia: No
Publications: Acquisitions list; special catalogs
Special Programs: Group tours; guest lectures
Card Catalog
Cataloged Volumes: 1,550
Serial Titles: 10
Holdings: 2 vertical file drawers; 325 sales & auction catalogs
Subjects: Art, arms & armor, classical archaeology, decorative arts, Orientalia

AL 326
SMITH COLLEGE
Hillyer Art Library
Elm St, Northampton, MA 01060
Tel: 413-584-2700, Ext 743
Art Libn: Karen J Harvey

Academic Founded: 1926
Hours: Mon-Thurs 8-11
 Fri & Sat 8-10
 Sun 2-10
Circulation: Students, faculty/staff, qualified researchers; much material non-circulating (open stacks)
Reference Service: In person only
Reprographic Services: Yes
Interlibrary Loan: NILS; Regional Five-College (Amherst, Hampshire, Mt Holyoke & University of Massachusetts)
Networks/Consortia: New England Library Information Network; Hampshire Inter-Library Center, Inc
Publications: Orientation handbook; bibliographies; acquisitions list
Special Programs: Bibliographic instruction
Cataloged Volumes: 35,500
Serial Titles: 204 (Pioneer Valley Union List of Serials)
Holdings: 6 vertical file drawers; exhibition catalogs
Subjects: Art, architecture, classical archaeology, decorative arts, film & video, graphics, photography

AL 327
SPRINGFIELD CITY LIBRARY
Art/Music Department
220 State St, Springfield, MA 01103
Tel: 413-739-3871
Libn: Karen A Dorval

Public Library Founded: 1905
Hours: Mon-Thurs 9-9
 Fri 9-6
 Sat 9-5 (closed during summer)
 Mon-Thurs 9-8 (summer)
Circulation: Public (open stacks)
Reference Service: Telephone, mail
Reprographic Services: Yes
Interlibrary Loan: NILS (Western Regional Public Library System, above address)
Networks/Consortia: No
Publications: Orientation handbook; bibliographies; acquisitions list; newsletter; in-house periodical index
Special Programs: Group & individual tours; lectures; demonstrations; monthly exhibitions
Card Catalog
Cataloged Volumes: 20,000

Serial Titles: 45 (National Union Catalog; Cooperating Colleges of Great Springfield)
Holdings: 8 vertical file drawers; sales & auction catalogs; 9 exhibition catalogs
Subjects: Art, decorative arts, architecture, film & video, graphics, photography, music
Special Collections:
Aston Collection of Wood Engravings
Collection of wood engravings by important world-wide engravers.

AL 328
STERLING & FRANCINE CLARK ART INSTITUTE LIBRARY
225 South St, Box 8, Williamstown, MA 01267
Tel: 413-458-8109
Libn: Michael Rinehart

Academic Founded: 1964
Hours: Mon-Fri 8-11
 Mon-Fri 9-5 (during vacation)
 Sat 11-5
 Sun 2-11
Circulation: Restricted to use by scholars & Williams College graduate students in art history (open stacks)
Reference Service: In person
Reprographic Services: Yes
Interlibrary Loan: NILS
Networks/Consortia: No
Publications: Guide to the reference system
Special Programs: Group & individual tours
Card Catalog
Cataloged Volumes: 53,000 (38,000 titles)
Serial Titles: 374
Holdings: Vertical file drawer; 20,000 sales & auction catalogs; 300 reels of microfilms
Subjects: Art; primarily European art 1400–1900 & post-conquest American art
Special Collection: Robert Sterling Clark rare book collection

AL 329
SWAIN SCHOOL OF DESIGN LIBRARY
140 Orchard St, New Bedford, MA 02740
Tel: 617-999-5900
Dir: Cathy Sloat Shaw

Art School Founded: 1881
Hours: Mon-Fri 8:30-4:30
Circulation: Students, faculty/staff (open stacks)
Reference Service: Telephone, mail
Reprographic Services: Yes
Interlibrary Loan: Boston Public Library Southeastern Regional System
Networks/Consortia: SACHEM
Publications: Newsletter (for students & faculty)
Special Programs: Individual tours
Card Catalog
Cataloged Volumes: 12,000 (10,000 titles)
Holdings: 8 vertical file drawers; 12,000 slides
Subjects: Art, decorative arts, architecture, classical archaeology, film & video, graphics, photography, music, theatre, dance
Special Collection: New Bedford artist file

AL 330
UNIVERSITY OF LOWELL
University Library
Lowell, MA 01854

Tel: 617-454-8011, Exts 480; 377

Academic
Hours: Mon-Fri 8:30-10:30
 Sat 9-5
 Sun 2-10
Circulation: Students, faculty/staff (open stacks)
Reference Service: In person, telephone, mail
Interlibrary Loan: NILS (Joseph Santosuosso, O'Leary Library; Barbara Cohen, Alumni/Lydon Library); Lowell Area Council on Interlibrary Networks
Networks/Consortia: Lowell Area Council on Interlibrary Networks
Publications: Orientation handbook; in-house periodical index (Union List of Periodicals in the Libraries of the University of Lowell)
Special Programs: Group & individual tours; bibliographic instruction
Card Catalog
Cataloged Volumes: 285,187 (228,149 titles)
Serial Titles: 1,890
Holdings: 3 vertical file drawers; ERIC Collection
Subjects: Art, architecture, film & video, music, photography
Special Collections:
Lowell History Collection
Books & archival material on the development of the textile industry & system of locks & canals.

AL 331
UNIVERSITY OF MASSACHUSETTS, BOSTON HARBOR CAMPUS
Library/Fine Arts Department
Boston, MA 02125
Tel: 617-287-1900, Exts 2247; 2246
Libn: Andrew Castiglione

Academic Founded: 1965
Hours: Mon-Thurs 8-9 (academic year)
 Fri 8-5
 Sun 1-8 (closed summer)
 Mon-Thurs 8-7:30 (summer)
Circulation: Students, faculty/staff (open stacks)
Reference Service: In person, telephone
Reprographic Services: Yes
Interlibrary Loan: NILS (University of Massachusetts/Harbor Campus Library, Reference Department)
Networks/Consortia: No
Publications: Orientation handbook; serials list
Special Programs: Group & individual tours; bibliographic instruction; single lectures
Card Catalog
Cataloged Volumes: 9,130
Serial Titles: 150
Holdings: 440 artists' exhibition catalogs; 380 museum exhibition catalogs
Subjects: Art, decorative arts, architecture, classical archaeology, graphics, photography, music
Special Collections: Books, prints, photographs that are valuable, out of print, difficult to obtain, special editions

AL 332
WELLESLEY COLLEGE
Art Library
Jewett Art Center, Wellesley, MA 02181
Tel: 617-235-0320
Asst Libn: Muriel C Robinson

Academic Founded: 1876

Hours: Mon-Thurs 8:30-10:30
 Fri 8:30-10
 Sat 8:30-5
 Sun 2-10:30
Circulation: Students, faculty/staff (open stacks)
Reference Service: Telephone, mail
Reprographic Services: Yes
Interlibrary Loan: NILS (Interlibrary Loan, Margaret Clapp
 Library, Wellesley College, Wellesley, MA 02181)
Networks/Consortia: Boston Library Consortium, New
 England Library Information Network
Card Catalog
Cataloged Volumes: 25,000
Serial Titles: (National Union Catalog; the Boston Library
 Consortium; Union List of Serials Currently Received)
Subjects: Art, decorative arts, architecture, classical archae-
 ology, graphics, photography

AL 333
WHEATON COLLEGE
Fine Arts Library
Watson Fine Arts Center, Norton, MA 02766
Tel: 617-285-7722, Ext 436
Libn: Gertrude B Martin

Academic Founded: 1962
Hours: Mon-Thurs 8:30-5; 6:30-10:30
 Fri 8:30-5
 Sat 9-5
 Sun 1:30-5; 7-10:30
Circulation: Students, faculty/staff (open stacks)
Reference Service: In person, telephone, mail
Reprographic Services: Yes
Interlibrary Loan: NILS
Networks/Consortia: Southeastern Massachusetts Cooper-
 ating Libraries; New England Library Information Net-
 work
Publications: In-house periodical index
Special Programs: Individual tours; bibliographic instruction
Card Catalog
Cataloged Volumes: 11,922 (8,640 titles)
Serial Titles: c 60 (Southeastern Massachusetts Cooperating
 Libraries Union List of Serials)
Holdings: 2 vertical file drawers
Subjects: Art, decorative arts, architecture, graphics, music

AL 334
WILLIAMS COLLEGE
Chapin Library
Box 426, Williamstown, MA 01267
Tel: 413-597-2462
Custodian: Robert L Volz

Academic Founded: 1923
Circulation: Non-circulating reference & research library of
 rare books & manuscripts
Reference Service: In person, mail
Reprographic Services: Yes
Interlibrary Loan: No
Networks/Consortia: No
Publications: Bibliographies; acquisitions list; special cata-
 logs; descriptive brochures; in-house periodial index
 (Chapin Library Serials)
Special Programs: Group & individual tours; small group in-
 struction; lectures

Card Catalog
Cataloged Volumes: 20,500
Serial Titles: 43
Holdings: 70 vertical file drawers; 2,000 sales & auction
 catalogs; 200 exhibition catalogs; 50 reels microfilm
Subjects: Art, architecture, music, private press books
Special Collections: Illustrated books of the 15th-20th cen-
 turies; graphic arts; Americana; Incunabula

AL 335
WORCESTER ART MUSEUM
Art Reference Library
55 Salisbury St, Worcester, MA 01608
Tel: 617-799-4406
Libn: Penny G Mattern

Museum Founded: 1896 (Library 1909)
Hours: Tues-Fri 10-5 (Oct-May)
 Sun 2-5 (Oct-May)
Circulation: Restricted to staff use in museum & offices (open
 stacks; some are closed)
Reference Service: In person, telephone, mail
Reprographic Services: Yes
Interlibrary Loan: NILS; Worcester Area Cooperating
 Libraries
Networks/Consortia: No
Publications: In-house periodical index
Special Programs: Group & individual tours; bibliographic
 instruction
Card Catalog
Cataloged Volumes: 30,000 (including bound periodicals)
Serial Titles: 293 (subscription, exchange & gift) (Worcester
 Area Union List of Serials)
Holdings: Extensive sales & auction catalogs; extensive
 exhibition catalogs
Subjects: Art, decorative arts, architecture, film & video,
 graphics, photography

Michigan

AL 336
CAMPBELL-EWALD COMPANY
Reference Center
3044 W Grand Blvd, Detroit, MI 48202
Tel: 313-872-6200
Vice-President & Mgr: Elizabeth L Smith

Advertising Agency Founded: 1925
Hours: Mon-Fri 8-4:30
Circulation: Employees/clients; others by appointment only
 (open stacks)
Reference Service: In person, telephone, mail (limited to
 special circumstances)
Reprographic Services: Yes
Interlibrary Loan: No
Networks/Consortia: No
Publications: Orientation handbook; bibliographies; acquisi-
 tions list; newsletter; monthly abstracts by subject; book
 catalog; in-house periodical index
Special Programs: Group & individual tours; directed field
 experience programs for local university graduate students
 in Library Science; intern program
Card Catalog
Cataloged Volumes: 7,473

Serial Titles: 1,734
Holdings: 289 vertical file drawers; 491 catalogs & directories;
 111 college catalogs; 457 programs & yearbooks; ad proofs
Subjects: Art, art history, commercial art, photography
Special Collection: 1,500 files of pictures concerning com-
 mercial art; maps; ad files; automobilia; company archives
 (Amber McCoy, Sr Reference & Art Libn)

AL 337
CENTER FOR CREATIVE STUDIES/COLLEGE OF
 ART AND DESIGN
245 E Kirby, Detroit, MI 48202
Tel: 313-872-3118, Ext 30
Libn: Jean Peyrat

Art School Founded: 1966
Hours: Mon-Thurs 8:30-1; 2:15-6:30
 Fri 8:3-1; 2:15-4:30
Circulation: Students, faculty/staff (open stacks)
Reference Service: Telephone
Reprographic Services: No
Interlibrary Loan: No
Networks/Consortia: No
Special Programs: Group tours; bibliographic instruction
Card Catalog
Cataloged Volumes: 9,151 (9,005 titles)
Holdings: 32 vertical file drawers
Subjects: Art, decorative arts, architecture, film & video,
 graphics, photography

AL 338
CRANBROOK ACADEMY OF ART LIBRARY
500 Lone Pine Rd, Bloomfield Hills, MI 48013
Tel: 313-645-3328
Libn: Stel Toland

Art School
Circulation: Students, faculty/staff (open stacks only to
 students & faculty)
Reference Service: Telephone, mail
Reprographic Services: Yes
Interlibrary Loan: NILS
Networks/Consortia: No
Card Catalog
Cataloged Volumes: 19,000
Holdings: 31 vertical file drawers; exhibition catalogs
Subjects: Art, decorative arts, architecture, classical archae-
 ology, graphics, photography

AL 339
DETROIT INSTITUTE OF ARTS
Research Library
5200 Woodward Ave, Detroit, MI 48202
Tel: 313-833-7926
Libn: F Warren Peters, Jr

Museum Founded: 1905
Hours: Mon-Fri 9-5
Circulation: Faculty/staff; restricted to use within museum
 by curatorial staff (open stacks)
Reference Service: In person, telephone, mail
Reprographic Services: Yes
Interlibrary Loan: NILS
Networks/Consortia: No
Publications: Book catalog; in-house periodical index (Index to
 the Detroit Institute of Arts Bulletin)
Information Source: Cummings, F J. *The Detroit Institute of
 Arts Illustrated Handbook,* Wayne State University Press,
 Detroit, 1971

Special Programs: Group & individual tours
Card Catalog
Cataloged Volumes: 50,000 (6,000 bound periodicals)
Serial Titles: 100 (National Union Catalog)
Holdings: Extensive vertical file drawers; extensive sales &
 auction catalogs; exhibition catalogs (30% of book collec-
 tion)
Subjects: Art, decorative arts, architecture, classical archae-
 ology, graphics, photography, theatre
Special Collections: McPharlin Puppetry Collection;
 McPharlin Topography Collection

AL 340
DETROIT PUBLIC LIBRARY
Fine Arts Department
5201 Woodward Ave, Detroit, MI 48202
Tel: 313-833-1467
Libn: Shirley B Solvick

Public Library Founded: 1921
Hours: Mon, Tues, Thurs, Fri, Sat 9:30-5:30
 Wed 9-9
Circulation: Public (open stacks for ⅓ of collection)
Reference Service: In person, telephone, mail
Interlibrary Loan: NILS; State of Michigan, Wayne County
Networks/Consortia: Michigan Library Consortium
Publications: In-house periodical index
Special Programs: Group & individual tours
Card Catalog
Cataloged Volumes: 55,000
Serial Titles: 270 (Union List of Serials in the Wayne State
 University Library)
Holdings: 24 vertical file drawers; 15 microfiche; 40 reels
 microfilm
Subjects: Art, decorative arts, architecture, film & video,
 graphics, photography, costume

AL 341
EASTERN MICHIGAN UNIVERSITY
Center of Educational Resources—Humanities Division
Ypsilanti, MI 48197
Tel: 313-487-1016
Humanities Div Coordinator: Carol E Selby

Academic
Hours: Mon-Thurs 8-12
 Fri 8-11
 Sat 9-11
 Sun 1-12
Circulation: Students, faculty/staff (open stacks)
Reference Service: In person, telephone, mail
Reprographic Services: Yes
Interlibrary Loan: NILS
Networks/Consortia: Michigan Library Consortium
Special Programs: Bibliographic instruction; single lectures
Card Catalog
Cataloged Volumes: 10,000 art (9,500 music)
Serial Titles: 106
Holdings: 37 vertical file drawers
Subjects: Art, decorative arts, architecture, film & video,
 graphics, music, theatre, dance

AL 342
EDISON INSTITUTE (GREENFIELD VILLAGE &
 HENRY FORD MUSEUM)
Robert Hudson Tannahill Research Library
Dearborn, MI 48121
Tel: 313-271-1620, Ext 544
Asst Libn: Edward R Kukla

Museum
Hours: Mon-Fri 8:30-5 (by appointment)
Circulation: Faculty/staff
Reference Service: Telephone, mail; limited
Reprographic Services: Yes; permission necessary
Interlibrary Loan: No
Networks/Consortia: No
Publications: Orientation handbook; special catalogs; in-house
 holdings file
Information Source: Smith, Jerome Irving. *Robert Hudson
 Tannahill Research Library,* Edison Institute, 1974; *The
 Struggle & the Glory,* Edison Institute, 1976
Special Programs: Individual tours; single lectures
Card Catalog
Subjects: Decorative arts, architecture, graphics, photography
Special Collections: Americana with emphasis on the 18th &
 19th centuries

AL 343
GRAND RAPIDS ART MUSEUM
McBride Art Reference Library
230 E Fulton, Grand Rapids, MI 49503
Tel: 616-459-4676
Dir of Education, Advisor: Jean Hagman

Museum Founded: 1910; 1969
Hours: Mon-Sat 9-5
 Sun 2-5
Circulation: Museum members, staff (closed stacks)
Reference Service: In person, telephone, mail
Reprographic Services: Yes
Interlibrary Loan: Grand Rapids Public Library Art Depart-
 ment
Networks/Consortia: No
Publications: Book catalog; in-house periodical index
Cataloged Volumes: 1,578
Subjects: Art, architecture, classical archaeology, decorative
 arts, graphics, photography

AL 344
GRAND RAPIDS PUBLIC LIBRARY
Music & Art Department
Library Plaza, Grand Rapids, MI 49503
Tel: 616-456-4410
Libn: Lucija Skuja

Public Library Founded: 1871
Hours: Mon-Thurs 9-9
 Fri & Sat 9-5:30
Circulation: Public (open stacks)
Reference Service: In person, telephone, mail
Reprographic Services: Yes
Interlibrary Loan: NILS; Lakeland Library Federation
Networks/Consortia: University Consortium
Publications: Orientation handbook; bibliographies; news-
 letter
Special Programs: Group & individual tours; bibliographic
 instruction
Cataloged Volumes: 18,000 total; 4,500 art
Serial Titles: 60 total; 20 art (National Union Catalog; Grand
 Rapids Area Union List)
Holdings: 16 vertical file drawers
Subjects: Art, architecture, classical archaeology, dance,
 decorative arts, film & video, graphics, music, photog-
 raphy, theatre
Special Collection:
Furniture Design Collection
1,435 cataloged volumes relating to the history of furniture
 design and including catalogs of locally made furniture.

AL 345
KALAMAZOO INSTITUTE OF THE ARTS LIBRARY
314 S Park St, Kalamazoo, MI 49006
Tel: 616-349-7775
Libn: Helen Sheridan

Art School/Museum Founded: 1961
Hours: Tues-Fri 11-4:30 (Sept-June)
 Sat 9-4 (Sept-June)
 Sun 1:30-4:30
 Tues-Sat 10-4 (July)
Circulation: Faculty/staff, art institute members (open stacks
 except for valuable books & back periodicals)
Reference Service: In person, telephone, mail
Reprographic Services: Yes
Interlibrary Loan: No
Networks/Consortia: No
Publications: Newsletter
Special Programs: Group & individual tours; bibliographic
 instruction; intern program with Western Michigan Uni-
 versity Library School
Card Catalog
Cataloged Volumes: 5,000
Serial Titles: 56
Holdings: 28 vertical file drawers
Subjects: Art, decorative arts, architecture, film & video,
 graphics, photography
Special Emphasis: Contemporary American art, especially
 graphics

AL 346
LAWRENCE INSTITUTE OF TECHNOLOGY
LIBRARY
21000 W Ten Mile Rd, Southfield, MI 48075
Tel: 313-356-0200, Exts 79; 80
Dir of Lib: C A Phillips

Academic Founded: 1934
Hours: Mon-Fri 8:30-9:30
 Sat 10-4
 Sun 1-4
Circulation: Public (open stacks)
Reference Service: In person, telephone
Reprographic Services: Yes
Interlibrary Loan: NILS
Networks/Consortia: Michigan Library Consortium
Special Programs: Bibliographic instruction
Cataloged Volumes: 43,790 (41,587 titles)
Serial Titles: 371
Holdings: 16 vertical file drawers; 12,606 microforms
Subjects: Art, architecture, decorative arts, graphics, photog-
 raphy

AL 347
MICHIGAN STATE UNIVERSITY LIBRARIES
Art Library
East Lansing, MI 48824
Tel: 517-353-4593
Libn: Shirlee A Studt

Academic Founded: 1973
Hours: Mon-Fri 8-10:45
 Sat 9-10:45
 Sun 1-10:45
Circulation: Public; public must obtain special permits (open
 stacks)
Reference Service: In person, telephone, mail
Reprographic Services: Yes
Interlibrary Loan: NILS

Networks/Consortia: OCLC; Michigan Library Consortium
Publications: Bibliographies; newsletters; serials holding list on microfiche
Special Programs: Group & individual tours; bibliographic instruction; single lectures
Card Catalog
Cataloged Volumes: 33,000 (27,296 titles)
Serial Titles: 180 (National Union Catalog)
Holdings: 4 vertical file drawers; 800 sales & auction catalogs; 4,500 exhibition catalogs
Subjects: Art, decorative arts, architecture, graphics, photography
Special Collections:
Illuminated Manuscript Collection
Facsimiles of early Christian through Gothic illuminated manuscripts; emphasis on Carolingian & Romanesque.
Theatre Photograph Collection
Theatre photographs from the 1930s & 1940s; including Florence Vandam's photographs.

AL 348
MONROE COUNTY LIBRARY SYSTEM
3700 S Custer, Monroe, MI 48161
Tel: 313-241-5277
Dir: Bernard Margolis

Public Library
Hours: Mon-Thurs 9-9
 Fri-Sat 9-5:30
Circulation: Public (open stacks)
Reference Service: In person, telephone, mail
Reprographic Services: Yes
Interlibrary Loan: NILS; Raisin Valley Library System (Lila White, System Coordinator)
Networks/Consortia: Raisin Valley Library System
Publications: Bibliographies; special catalogs; special collections of materials; in-house Union List of Periodicals
Special Programs: Group & individual tours
Card Catalog
Cataloged Volumes: 444,157
Holdings: 64 vertical file drawers; 60 drawers microforms; various exhibition catalogs
Subjects: Art, architecture, dance, decorative arts, film & video, graphics, music, photography, theatre
Special Collections: George A Custer Collection; Michigan/Monroe History Collection

AL 349
OAKLAND UNIVERSITY
Kresge Library
Rochester, MI 48063
Tel: 313-377-2464
Head Libn Acquisitions-Serials Dept: Richard Pettengill

Academic Founded: 1957
Hours: Mon-Thurs 8-11:30
 Fri 8-5
 Sat 9-5
 Sun 2-11:30
Circulation: Students, researchers, faculty/staff (open stacks)
Reference Service: Telephone, mail
Reprographic Services: Yes
Interlibrary Loan: NILS
Networks/Consortia: Michigan Library Consortium; Midwest Region Library Network
Publications: Orientation handbook
Special Programs: Group tours; bibliographic instruction
Card Catalog
Cataloged Volumes: 7,300

Serial Titles: 39
Holdings: Limited vertical file drawers; limited exhibition catalogs
Subjects: Art, decorative arts, architecture, classical archaeology, film & video, photography, music, theatre, dance

AL 350
UNIVERSITY OF MICHIGAN
Fine Arts Library
103 Tappan Hall, Ann Arbor, MI 48109
Tel: 313-764-5404
Libn: Valerie D Meyer

Academic Founded: 1949
Hours: Mon-Thurs 8-5; 7-11
 Fri 8-5
 Sat 9-6
 Sun 2-6
 Mon-Fri 8-5 (summer, May-Aug)
Circulation: Public; reference books, research copies, periodicals, folio-size books, vertical file, seminary collections do not circulate (open stacks)
Reference Service: Telephone, mail
Reprographic Services: Yes
Interlibrary Loan: NILS (Interlibrary Loan Division, 314 Hatcher N, University of Michigan Library)
Networks/Consortia: Center for Research Libraries; OCLC
Publications: Semi-annual list of new reference material; in-house periodical file
Special Programs: Group & individual tours; single lectures
Card Catalog
Cataloged Volumes: 48,000
Serial Titles: 243 (National Union Catalog)
Holdings: 36 vertical file drawers; 102 microfilms; 3,000 pamphlets
Subjects: Art, decorative arts, architecture
Special Collections:
Oriental Seminar Collection
Collection of Far Eastern art, especially Chinese & Japanese.

AL 351
WESTERN MICHIGAN UNIVERSITY
Waldo Library
Kalamazoo, MI 49001
Tel: 616-383-4952
Dir of Libs: Carl Sachtleben

Academic Founded: 1903
Hours: Mon-Fri 7:45-11 (fall & winter)
 Mon-Fri 7:45-10 (spring & summer)
Circulation: Public (open stacks)
Reference Service: Yes
Reprographic Services: Yes
Interlibrary Loan: NILS; Center for Research Libraries; Kentucky, Ohio, Michigan Medical Service
Networks/Consortia: OCLC
Special Programs: Group & individual tours; bibliographic instruction; single lectures
Cataloged Volumes: 981,386 (430,407 titles)
Serial Titles: 11,046 (National Union Catalog)
Holdings: 339,865 microforms; 400 exhibition catalogs
Subjects: Art, architecture, classical archaeology, dance, decorative arts, film & video, graphics, music, photography, theatre

Minnesota

AL 352
BEMIDJI STATE UNIVERSITY
A C Clark Library
Bemidji, MN 56601
Tel: 218-755-2955
Libn: Les Mattison

Academic Founded: 1919
Hours: 8-10
Circulation: Students, faculty/staff (open stacks)
Reference Service: In person
Reprographic Services: Yes
Interlibrary Loan: NILS
Networks/Consortia: Minnesota Interlibrary Teletex Experiment
Publications: Orientation handbook; bibliographies; acquisitions list; newsletter; in-house periodical list (Bemidji State University)
Special Programs: Group tours; bibliographic instruction
Card Catalog
Cataloged Volumes: 200,000
Serial Titles: 1,300 (Minnesota Union List of Serials)
Holdings: 39 vertical file drawers; 500,000 microforms
Subjects: Art, decorative arts, architecture, classical archaeology, graphics, photography, music, theatre, dance

AL 353
MINNEAPOLIS COLLEGE OF ART & DESIGN LIBRARY
200 E 25 St, Minneapolis, MN 55404
Tel: 612-870-3291
Libn: Gail Hitt

Academic Founded: 1886
Hours: Mon-Fri 8-8
Circulation: Students, faculty/staff (open stacks)
Reference Service: In person, telephone, mail
Reprographic Services: Yes
Interlibrary Loan: No
Networks/Consortia: No
Special Programs: Group & individual tours; bibliographic instruction; single lectures
Card Catalog
Cataloged Volumes: 50,000 (48,000 titles)
Serial Titles: 104
Holdings: 12 vertical file drawers; 4 drawers sales & auction catalogs; 6 drawers exhibition catalogs; 40,000 slides
Subjects: Art, decorative arts, architecture, classical archaeology, film & video, graphics, photography, music, theatre, dance

AL 354
THE MINNEAPOLIS INSTITUTE OF ARTS
Arts Resource & Information Center
2400 Third Ave S, Minneapolis, MN 55404
Tel: 612-870-3131
Coordinator: Sandra L Oakes

Museum Founded: 1973
Hours: Tues, Wed, Fri, Sat 10-5
 Thurs 10-9
 Sun 12-5
Circulation: (open stacks)
Reference Service: In person, telephone, mail
Reprographic Services: No
Interlibrary Loan: No
Networks/Consortia: No
Publications: Booklets on local art resources
Information Sources: Sprout, Sally. *Ocular,* Ocular Corp, Summer Quarter 1977; Pinnell, Linda J. *Arts Resource & Information Center: An Overview of Organizational Factors,* University of Minnesota Graduate Thesis, July 1976
Special Programs: Group & individual tours; bibliographic instruction; intern program
Holdings: Slide packages; mobile exhibitions; teaching units
Subjects: Art, architecture, dance, decorative arts, film & video, graphics, music, photography, theatre
Special Collections: Information & referral center focusing on 685 art organizations & their activities in the Twin Cities metropolitan area; provides community information on local events, art organizations, speakers, class offerings, service organizations for the arts, & exhibition & performing space in the Twin City area

AL 355
MINNEAPOLIS INSTITUTE OF ARTS
Reference Library
2400 Third Ave S, Minneapolis, MN 55404
Tel: 612-870-3116; 3117; 3118
Libn/Editor: Harold Peterson

Museum Founded: 1915
Hours: Tues, Wed, Fri, Sat 10-5
 Thurs 10-9
 Sun 12-5
Reference Service: Telephone, mail
Reprographic Services: No
Interlibrary Loan: NILS
Networks/Consortia: No
Publications: Exhibition catalogs; checklists; special collections catalogs
Special Programs: Group & individual tours; bibliographic instruction; single lectures; intern program
Card Catalog
Cataloged Volumes: 25,000
Serial Titles: 100
Holdings: 6,300 sales & auction catalogs; 10,000 exhibition catalogs
Subjects: Art, decorative arts, graphics
Special Collection:
Leslie History of Printing Collection
Rare books & private press books.

AL 356
MINNEAPOLIS PUBLIC LIBRARY & INFORMATION CENTER
Art, Music & Films Department
30 Nicollet Mall, Minneapolis, MN 55401
Tel: 612-372-6520
Libn: Marlea R Warren

Public Library Founded: 1893 (art)
Hours: Mon-Thurs 9-9
 Fri-Sat 9-5:30 (closed Sat during summer)
Circulation: Public
Reference Service: In person, telephone, mail; fee for questions involving lengthy research
Reprographic Services: Yes
Interlibrary Loan: NILS; State Interlibrary Loans; Metropolitan Library Service Agency
Networks/Consortia: Metropolitan Library Services Agency; Minnesota Interlibrary Teletex Experiment
Publications: Bibliographies; Community libraries book catalog; in-house periodical index
Special Programs: Group tours

Card Catalog
Cataloged Volumes: 43,000
Serial Titles: 122 (National Union Catalog; Minnesota Union List of Serials)
Holdings: 45 vertical file drawers; 1 microform
Subjects: Art, architecture, decorative arts, graphics, music
Special Collections: Original bookplates; advertising cards; Valentine & Christmas cards; original art by Minnesota WPA artists
Color Plate Book Collections
Books & photographs on North American Indians; includes works by George Catlin, Seth Eastman & Edward S Curtis. John Audubon's *Birds of America* folio is part of the collection as well as other naturalists' works. Books published by Rudolph Ackerman are also represented in the collection.
Minnesota–Minneapolis Photography Collection
Includes several thousand glossy prints of historical Minneapolis & Minnesota; the Bromley collection of plate glass negatives & positives of the state & city from 1850–1914, Roth plate glass negatives of Minneapolis architecture in the 1920s & 1930s.

AL 357
MINNESOTA MUSEUM OF ART LIBRARY
305 Saint Peter St, Saint Paul, MN 55102
Tel: 612-227-7613, Ext 181
Libn: Leanne A Klein

Museum Founded: 1927
Hours: Tues-Sat 9-5
 Closed Aug
Circulation: Students, researchers, faculty/staff (open stacks)
Reference Service: Telephone, mail
Reprographic Services: Yes
Interlibrary Loan: NILS
Networks/Consortia: No
Publications: Acquisitions list
Card Catalog
Cataloged Volumes: 4,000
Serial Titles: 15
Holdings: 16 vertical file drawers; 1,000 sales & auction catalogs; 3,000 exhibition catalogs
Subjects: Art, architecture, decorative arts
Special Collections: Contemporary American graphics; Asian art; lace

AL 358
ST JOHN'S UNIVERSITY
Hill Monastic Manuscript Library
Collegeville, MN 56321
Tel: 612-363-3514
Dir: Dr Julian Plante

Research Center Founded: 1966
Circulation: Public; restricted to use within library (open stacks)
Reference Service: In person, mail; fee for extensive reference service
Reprographic Services: Yes; permission for original manuscripts
Interlibrary Loan: No
Networks/Consortia: No
Publications: Catalogs; checklists; progress reports
Special Programs: Group & individual tours; single lectures
Card Catalog
Cataloged Volumes: Acquisitions recorded in the Alcuin Library
Holdings: Sales & auction catalogs; exhibition catalogs; 45,000 microforms & slides

Subjects: Art
Special Collections: Ancient, Medieval & Renaissance books; archival materials from European libraries & archives

AL 359
SAINT PAUL PUBLIC LIBRARY
Arts-Audiovisual Services
90 W Fourth St, Saint Paul, MN 55102
Tel: 612-224-3383; Exts 40; 41; 42
Supervisor: Delores Sundbye

Public Library
Hours: Mon-Thurs 9-9
 Fri & Sat 9-5:30
Circulation: Public (open stacks except for bound periodicals)
Reference Service: In person, telephone, mail
Reprographic Services: Yes
Interlibrary Loan: NILS
Networks/Consortia: Cooperating Libraries in Consortium
Publications: Orientation handbook; aquisitions list; newsletter; book catalog; in-house periodical index (St Paul Dispatch-Pioneer Press Newspaper Index)
Special Programs: Group tours
Serial Titles: 65 (National Union Catalog; Minnesota Union Catalog)
Subjects: Art, architecture, decorative arts, graphics, music

AL 360
SOUTH ST PAUL PUBLIC LIBRARY
106 Third Ave N, South St Paul, MN 55075
Tel: 612-451-1093
Dir: Paul J Lareau

Public Library
Hours: Mon-Thurs 9-8
 Tues, Wed, Fri 9-6
 Sat 9-4
Circulation: Public (open stacks)
Reference Service: In person, telephone, mail
Reprographic Services: Yes
Interlibrary Loan: NILS
Networks/Consortia: Metropolitan Library Service Agency
Publications: In-house periodical index ("Our Minnesota Index")
Card Catalog
Cataloged Volumes: 63,900
Serial Titles: 161
Holdings: 13 vertical file drawers
Subjects: Art, decorative arts, architecture, classical archaeology, graphics, photography, music, theatre, dance
Special Collection: Original paintings by Minnesota artists & famous prints (144) for circulation

AL 361
UNIVERSITY OF MINNESOTA
Art Library
12 Walter Library, Minneapolis, MN 55455
Tel: 612-373-2875
Libn: Herbert G Scherer

Academic Founded: 1950
Hours: Mon-Thurs 8-9
 Fri 8-5
 Sat-Sun 1-5
 Mon, Wed, Fri 8-4:30 (summer)
 Tues 8-9 (summer)
Circulation: Students, faculty/staff; public restricted to use of materials within library (open stacks)

Reference Service: In person
Interlibrary Loan: NILS
Networks/Consortia: Minnesota Interlibrary Teletex Experiment
Publications: Bibliographies; special catalogs ("Use of the Card Catalog")
Information Source: Mauritz, Marilyn. *Library & Information Sources in the Twin Cities*, James J Hill Reference Library, St Paul, 1972
Special Programs: Group & individual tours; single lectures
Card Catalog
Cataloged Volumes: 50,159
Serial Titles: 290 (National Union Catalog; Union List of Serials)
Holdings: 15 vertical file drawers; 4,701 exhibition catalogs; 25 microforms
Special Collections: Original popular art artifacts including trade & post card albums; Scandanavian art & history

AL 362
UNIVERSITY OF MINNESOTA LIBRARIES
Children's Literature Research Collections
109 Walter Library, Minneapolis, MN 55455
Tel: 612-373-9731
Curator: Karen Nelson Hoyle

Academic Founded: 1949 (Kerlan Collection)
Hours: Mon-Fri 7:45-4:30
Circulation: Researchers; staff retrieval of material
Reference Service: In person, telephone, mail
Reprographic Services: Yes; no fragile materials, permission from original copyright holder
Interlibrary Loan: No
Networks/Consortia: No
Publications: Newsletter; special catalogs; brochure of Kerlan Collection
Information Sources: Nelson, Karen. "Newbery & Caldecott Award Miscellany in the Kerlan Collection," *Top of the News*, v 29, April 1973, pp 17-28; Hoyle, Karen Nelson. "International Projects in the Kerlan Collection," *Bookbird*, v XIII, no 2, 1976, pp. 17-28; Odland, Norine. "The Kerlan Collection of Children's Literature in the University of Minnesota Library," *Elementary English*, v 44, November 1967, pp 749-752
Special Programs: Group tours, single lectures
Card Catalog
Cataloged Volumes: 30,000
Holdings: Illustrations for 2,300 titles; manuscripts for 1,500 titles of children's books; figurines
Subjects: Art
Special Collections: Illustrations, manuscripts, Minnesota Indian tribes; Newbery & Caldecott Award Books; illustrators of children's books; dime novels; figurines of characters from children's literature; foreign language children's books; Big Little Books; Wanda Gag Collection; Paul Bunyan Collection

AL 363
WALKER ART CENTER
Staff Reference Library
Vineland Place, Minneapolis, MN 55403
Tel: 612-377-7500, Ext 74
Libn: Geraldine H Owens

Museum
Hours: Tues-Fri 9-5
Circulation: Staff, graduate students, scholars (with advance notice only)

Reference Service: In person only
Reprographic Services: Yes
Interlibrary Loan: No
Networks/Consortia: No
Cataloged Volumes: 3,000
Serial Titles: 85
Holdings: 14 vertical file drawers; 30,000 exhibition catalogs
Subjects: Art, architecture, decorative arts, design, film & video, graphics, performing arts, photography, sculpture
Special Collections:
One-Man Artists' Shows
5,000 catalogs & a clipping file.

AL 364
WINONA PUBLIC LIBRARY
151 W Fifth St, Winona, MN 55987
Tel: 507-452-4582
Dir: Barbara Juneau

Public Library Founded: 1886
Hours: Mon, Tues, Thurs 9-9
 Wed, Fri, Sat 9-6
Circulation: Public (open stacks)
Reference Service: In person, telephone, mail
Reprographic Services: Yes
Interlibrary Loan: SE Minneapolis libraries
Networks/Consortia: Minnesota Interlibrary Teletex Experiment
Special Programs: Group tours
Card Catalog
Cataloged Volumes: 4,500 (art)
Serial Titles: 14 (Minnesota Union List of Serials)
Subjects: Art, architecture, film & video, graphics, photography, music, theatre, dance

Mississippi

AL 365
MISSISSIPPI UNIVERSITY FOR WOMEN
John Clayton Fant Memorial Library
Columbus, MS 39701
Tel: 601-328-4808
Dir: David L Payne

Academic Founded: 1884
Hours: Sept-May 91 hours/week
 Jun-Aug 73 hours/week
Circulation: Students; public restricted to use of materials in library (open stacks)
Reference Service: Telephone, mail
Reprographic Services: Yes
Interlibrary Loan: NILS
Networks/Consortia: Bibliographic Retrieval Services; Mississippi Library Commission Information Services "Advertiser"; Mississippi Universities Cooperative Purchasing Program
Publications: Orientation handbook; acquisitions list; serials & special collections holdings print-outs; in-house periodical index (John Clayton Fant Memorial Library Periodical Holdings)
Special Programs: Group & individual tours
Card Catalog
Cataloged Volumes: 194,717
Serial Titles: 1,397 (Mississippi Union List of Periodicals)
Holdings: 25 vertical file drawers; 208,213 microforms
Subjects: Art, decorative arts, architecture, classical archaeology, graphics, photography, music, theatre, dance

Special Collections:
George Eliot Collection
First editions of the writer's works, original manuscript of
 Blanche Colton Williams' *Biography of George Eliot.*
Mississippiana Collection
Books, microforms, clippings, vertical files; documents on
 state & local history.

AL 366
VICKSBURG–WARREN COUNTY LIBRARY
Box 511, Vicksburg, MS 39180
Tel: 601-636-6411
Dir: David Bosca

Public Library Founded: 1916
Hours: Mon-Fri 9-7
 Sat 9-6
Circulation: Public (open stacks)
Reference Service: In person
Reprographic Services: Yes
Interlibrary Loan: NILS
Networks/Consortia: Jackson Metropolitan Library System
Publications: Bibliographies; acquisitions list; newsletter.
Special Programs: Group & individual tours; single lectures
Card Catalog
Cataloged Volumes: 60,000
Serial Titles: 125 (Mississippi Union List of Periodicals)
Holdings: 25 vertical file drawers; 700 reels of microfilms
Subjects: Art, decorative arts, architecture, classical archae-
 ology, film & video, graphics, photography, music, theatre,
 dance
Special Collection: Books about Mississippi & the Mississippi
 River; books by Mississippi authors

Missouri

AL 367
CROWDER COLLEGE
Learning Resources Center
Neosho, MO 64850
Tel: 417-451-3223, Ext 9
Dir: Barbara L Schade

Academic Founded: 1964
Hours: Mon-Thurs 8-8:30
 Fri 8-4:30
 Sun 2-6
Circulation: Students, faculty/staff (open stacks)
Reference Service: In person, telephone
Reprographic Services: Yes
Interlibrary Loan: NILS; Missouri State Interlibrary Loans
Networks/Consortia: Southwest Missouri Library Network
Publications: Newsletter; periodical index
Special Programs: Group tours
Card Catalog
Cataloged Volumes: 25,000
Serial Titles: 240
Holdings: 4 vertical file drawers; 7,699 microforms
Subjects: Art, film & video, photography, music

AL 368
DRURY COLLEGE LIBRARY
Springfield, MO 65802
Tel: 417-865-8731, Exts 282; 283
Dir: Judith Armstrong

Academic Founded: 1873
Hours: Mon-Thurs 7:45-5
 Fri 7:45-11
 Sat & Sun 2-11
 Closed Sat & Sun during summer
Circulation: Students, faculty/staff of Drury & local colleges;
 periodicals do not circulate (open stacks)
Reference Service: In person, telephone, mail
Reprographic Services: Yes
Interlibrary Loan: NILS (Reference Department)
Southeast Missouri Libraries Network
Publications: Orientation handbook; acquisitions list
Special Programs: Group & individual tours; semesterly
 course "Intro to the Library"
Cataloged Volumes: 150,000
Serial Titles: 950 (Southwest Missouri Libraries Network
 Union List of Serials)
Holdings: 20 vertical file drawers; 2,130 microfilms (periodi-
 cals only); 6 books on microfilm; limited exhibition catalogs
Subjects: Art, architecture, classical archaeology, dance,
 decorative arts, film & video, graphics, music, photography,
 theatre
Special Collections:
Major T P Walker Collection
A small rare book collection, including first editions, particu-
 larly of George Moore.

AL 369
KANSAS CITY ART INSTITUTE LIBRARY
4421 Warwick Blvd, Kansas City, MO 64111
Tel: 816-561-4852, Exts 23; 24
Lib Dir: Verna B Riddle

Art School Founded: 1885
Hours: Mon-Fri 8:30-10
 Sun 1-6
Circulation: Students, faculty/staff; reference books, rare
 materials & bound periodicals do not circulate (open stacks)
Reference Service: In person
Reprographic Services: Yes
Interlibrary Loan: NILS; Kansas City Regional Council for
 Higher Education; Union of Independent Colleges of Art
Networks/Consortia: No
Special Programs: Group & individual tours; bibliographic
 instruction; single lectures
Card Catalog
Cataloged Volumes: 26,270
Serial Titles: 90
Holdings: 36 vertical file drawers
Subjects: Art, architecture, decorative arts, film & video,
 graphics, photography

AL 370
KANSAS CITY PUBLIC LIBRARY
Art & Music Department
311 E 12 St, Kansas City, MO 64106
Tel: 816-221-2685, Ext 161

Public Library Founded: 1873
Hours: Mon-Thurs 8:30-7
 Fri & Sat 8:30-5
Circulation: Public (open stacks)
Reference Service: In person, telephone, mail
Reprographic Services: Yes
Interlibrary Loan: NILS
Networks/Consortia: Missouri Interlibrary Loan Network
Publications: In-house periodical index (Current Periodical
 Subscriptions)

Special Programs: Group & individual tours; intern program
Cataloged Volumes: 46,033 (art & music)
Serial Titles: 2,000 (total collection)
Holdings: 95 vertical file drawers; sales, auction & exhibition
catalogs
Subjects: Art, architecture, classical archaeology, dance,
decorative arts, film & video, graphics, music, photography,
theatre

AL 371
WILLIAM ROCKHILL NELSON GALLERY OF ART/ MARY ATKINS MUSEUM OF FINE ARTS
The Kenneth & Helen Spencer Art Reference Library
4525 Oak St, Kansas City, MO 64111
Tel: 816-561-4000, Ext 38
Libn: Anne E Tompkins

Museum Founded: 1933
Hours: Mon-Fri 9-12; 1-5
Circulation: Restricted to staff use in museum (closed stacks
except for graduate students & regular users)
Reference Service: Telephone, mail
Reprographic Services: Yes
Interlibrary Loan: NILS
Networks/Consortia: Kansas City Libraries Metropolitan
Information Network
Publications: Acquisitions list
Special Programs: Group & individual tours; bibliographic
instruction; single lectures
Card Catalog
Cataloged Volumes: 22,829
Serial Titles: 101
Holdings: 21 vertical file drawers; 173 microfiche cards
Subjects: Art, decorative arts, architecture, classical archae-
ology
Special Collection: Oriental Library

AL 372
SAINT JOSEPH MUSEUM LIBRARY
11 & Charles, St Joseph, MO 64501
Tel: 816-232-8471
Dir: Richard A Nolf

Museum Founded: 1926
Hours: Tues-Sat 1-5 (winter)
Tues-Sat 9-5 (summer)
Sun & Holidays 2-5
Circulation: Restricted to use within museum (open stacks;
research only)
Reference Service: In person
Reprographic Services: Yes
Interlibrary Loan: No
Networks/Consortia: No
Publications: Newsletter
Special Programs: Group tours
Card Catalog
Cataloged Volumes: 5,000
Serial Titles: 50 (Saint Joseph Library Union List)
Circulation: Vertical file drawers
Subjects: Art, decorative arts, architecture, graphics, muse-
ology

AL 373
ST LOUIS ART MUSEUM
Richardson Memorial Library
Forest Park, St Louis, MO 63110
Tel: 314-721-0067, Exts 36; 37
Libn: Ann B Abid

Museum Founded: 1915 (Museum: 1907)
Hours: Tues 2:30-5
Wed-Fri 10-5
Circulation: Faculty/staff; bound serials restricted to museum
use; special collections restricted to use in library (open
stacks except for serial stacks)
Reference Service: Telephone (10 minute limitations, Mon-
Fri, 8:30-5), mail
Reprographic Services: Yes, limited
Interlibrary Loan: NILS
Networks/Consortia: No
Publications: Orientation handbook; bibliographies; acquisi-
tions list
Information Source: "Richardson Memorial Library," *City
Art Museum Bulletin* 1, May 1915, p 2-5; Abid, Ann B.
"Richardson Memorial Library–The St Louis Art Mu-
seum," *Show-Me Libraries* 27, Aug 1976, p 23-25
Special Programs: Group & individual tours; bibliographic
instruction
Card Catalog
Cataloged Volumes: 23,000
Serial Titles: 300 (Union List of Serials; St Louis Union List
of Periodicals)
Holdings: 130 vertical file drawers; 6,000 sales & auction
catalogs; exhibition catalogs; 100 microforms; 300 exhibi-
tion posters
Subjects: Art, decorative arts, architecture, classical archae-
ology, film & video, graphics, photography, museology, St
Louis history, pre-Columbian art & archaeology

AL 374
ST LOUIS PUBLIC LIBRARY
Art Department
1301 Olive St, Saint Louis, MO 63103
Tel: 314-241-2288, Ext 204
Libn: Martha Hilligoss

Public Library Founded: 1865
Hours: Mon 9-9
Tues-Sat 9-5
Circulation: Public; restricted use of Steedman Architectural
Collection
Reference Service: In person, telephone, mail
Reprographic Services: Yes
Interlibrary Loan: NILS; local exchanges
Networks/Consortia: Higher Education Coordinating Council
Publications: In-house periodical index
Special Programs: Bibliographic instruction; state library
intern program
Card Catalog
Cataloged Volumes: 44,000
Serial Titles: 150 (National Union Catalog)
Holdings: 300 vertical file drawers; prints & postcards
Subjects: Art, decorative arts, architecture, graphics, photog-
raphy, antiques, costume
Special Collection:
Steedman Architectural Collection
Architecture & allied arts collection for use by architects.
Under ALA, St Louis Chapter Trust.

AL 375
SOUTHEAST MISSOURI STATE UNIVERSITY
Kent Library
Cape Girardeau, MO 63701
Tel: 314-651-2230
Dir: Jeff Roth

Academic Founded: 1873

Hours: Mon-Thurs 7:45-10:30
 Fri 7:45-5
 Sat 9-5
 Sun 1:30-10:30
Circulation: Public (open stacks)
Reference Service: In person, telephone, mail
Reprographic Services: Yes
Interlibrary Loan: NILS
Networks/Consortia: No
Publications: Bibliographies; acquisitions list
Special Programs: Group & individual tours; bibliographic
 instruction
Cataloged Volumes: 275,000
Serial Titles: 2,100
Holdings: 170,000 microforms
Subjects: Art, architecture, classical archaeology, dance,
 decorative arts, film & video, graphics, music, photography,
 theatre
Special Collections:
Charles L Harrison Collection of Rare Books
Collection of 800 volumes.

AL 376
SPRINGFIELD ART MUSEUM LIBRARY
1111 E Brookside Dr, Springfield, MO 65807
Tel: 417-866-2716
Lib: Lin Davis

Museum Founded: 1928
Hours: Tues-Sat 1-5
 Tues, Thurs 6:30-9:30
 Closed Mon
Circulation: Public (open stacks)
Reference Service: In person
Reprographic Services: Yes
Interlibrary Loan: No
Networks/Consortia: No
Special Programs: Individual tours
Card Catalog
Cataloged Volumes: 3,000
Serial Titles: 32
Holdings: 6 vertical file drawers; 600 sales & auction catalogs;
 200 exhibition catalogs
Subjects: Art, decorative arts, architecture, classical archae-
 ology, film & video, graphics, photography

AL 377
UNIVERSITY OF MISSOURI AT COLUMBIA
Ellis Library of Art, Archaeology & Music
Columbia, MO 65201
Tel: 314-882-7634
Art, Archaeology & Music Libn: Marcia Collins

Academic Founded: 1841
Hours: Mon-Fri 8-5 (departmental office hours)
 Stacks open 7 days a week
Circulation: Students, faculty/staff (open stacks; additional
 closed stack area)
Reference Service: In person, telephone, mail
Reprographic Services: Yes
Interlibrary Loan: NILS (Interlibrary Lending Service, Circu-
 lation Department, University of Missouri Library)
Networks/Consortia: OCLC; Midwest Region Library Net-
 work
Publications: In-house periodicals index
Information Sources: *Early Books on Art*, Department of Art
 History, University of Missouri at Columbia, 1977
Special Programs: Group & individual tours; bibliographic
 instruction; single lectures; intern program

Card Catalog
Cataloged Volumes: 65,000
Serial Titles: 1,200 in art history & archaeology (National
 Union Catalog)
Subjects: Art, architecture, classical archaeology, graphics,
 music, photography
Special Collections: European prehistory; Medieval art
 history & archaeology; Near Eastern & Mediterranean
 art & archaeology; Renaissance art history

AL 378
UNIVERSITY OF MISSOURI–KANSAS CITY
LIBRARY
5100 Rockhill Rd, Kansas City, MO 64110
Tel: 816-276-1531
Dir of Library Public Services: Dr Kenneth J LaBudde

Academic Founded: 1933
Hours: Mon-Thurs 9-10
 Fri 9-5
 Sat-Sun 1-5
 Mon-Fri 9-5 (intersessions)
Circulation: Students, faculty/staff (open stacks)
Reference Service: In person, telephone, mail
Reprographic Services: Yes
Interlibrary Loan: NILS
Networks/Consortia: Kansas City Libraries Metropolitan
 Information Network; Kansas City Regional Council for
 Higher Education
Special Programs: Group tours; bibliographic instruction
Card Catalog
Cataloged Volumes: 15,900 (15,842 titles)
Serial Titles: 82 (National Union Catalog)
Subjects: Art, architecture, film & video, theatre, dance

AL 379
WASHINGTON UNIVERSITY
Art & Architecture Library
Steinberg Hall, St Louis, MO 63130
Tel: 314-889-5268; 5218
Libn: Imre Meszaros

Academic
Hours: Mon-Thurs 8:30-11
 Fri 8:30-5
 Sat 9-5
 Sun 12-10
Circulation: Students, faculty/staff (open stacks)
Reference Service: Telephone, mail
Reprographic Services: Yes
Interlibrary Loan: NILS
Networks/Consortia: Higher Education Coordinating Council
 of Metropolitan St Louis; Midwest Region Library Net-
 work; Center for Research Libraries; OCLC
Publications: Orientation handbook; acquisitions list
Special Programs: Group & individual tours; bibliographic
 instruction; single lectures
Card Catalog
Cataloged Volumes: 60,000
Serial Titles: 473 (National Union Catalog; St Louis Union
 List of Periodicals)
Holdings: 36 vertical file drawers; 78 reels of microforms
Subjects: Art, decorative arts, architecture, classical archae-
 ology, graphics, photography, urban design, fashion design
 & costume
Special Collections: Sorger Collection on historic costume;
 Bryce Collection on architectural history; Baker Collection
 of fine bindings; Desloge Collection on French architecture;

East Asian art; Wulfing Collection on classical archaeology

Montana

AL 380
MONTANA HISTORICAL SOCIETY
Library Department
225 N Roberts, Helena, MT 59601
Tel: 406-449-2681

Museum Founded: 1865
Hours: Mon-Fri 8-5
Circulation: Public (closed stacks)
Reference Service: Yes
Reprographic Services: Yes
Interlibrary Loan: NILS
Networks/Consortia: Union List of Montana Serials; Pacific
 Northwest Library Association
Publications: In-house periodical index
Special Programs: Group & individual tours; single lectures
Cataloged Volumes: 50,000
Serial Titles: 500 (National Union Catalog)
Holdings: 50 vertical file drawers; Montana newspapers
Subjects: Art, Montana history, photography, Western art
Special Collection: Charles M Russell

AL 381
MONTANA STATE UNIVERSITY
Creative Arts Library
Creative Arts Complex, Bozeman, MT 59715
Tel: 406-994-4091
Libn: Ellen W Lignell

Academic Founded: 1973
Hours: Mon-Fri 7:45-10:45
 Summer & weekend: reduced hours
Circulation: Public; restricted use of special editions (open
 stacks)
Reference Service: In person
Reprographic Services: Yes
Interlibrary Loan: NILS; CASLIM
Networks/Consortia: No
Publications: Orientation handbook; acquisitions list; book
 catalog
Special Programs: Group & individual tours
Card Catalog
Cataloged Volumes: 12,000
Serial Titles: 90 (Union List of Serials for Montana)
Holdings: 4 vertical file drawers
Subjects: Art, decorative arts, architecture
Special Collection: Picture reproduction files

AL 382
UNIVERSITY OF MONTANA LIBRARY
Missoula, MT 59812
Tel: 406-243-6800
Dean of Library Service: Earle C Thompson

Academic Founded: 1893
Circulation: Public (open stacks)
Reference Service: In person, telephone, mail
Interlibrary Loan: NILS; PNBC; MINE
Networks/Consortia: No
Publications: Orientation handbook; bibliographies; acquisitions list; newsletter; in-house periodical index (University
 of Montana Serials List)

Special Programs: Group & individual tours; bibliographic
 instruction; single lectures
Cataloged Volumes: 564,702
Serial Titles: 6,739 (National Union Catalog; Union List of
 Montana Serials)
Holdings: 20,400 microform titles
Subjects: Art, dance, film & video, graphics, music, photography, theatre

AL 383
WESTERN MONTANA COLLEGE
Lucy Carson Memorial Library
710 S Atlantic St, Dillon, MT 59725
Tel: 406-683-7541
Libn: Ken Cory

Academic
Hours: Mon-Thurs 7:30-10
 Fri 7:30-4
Circulation: Students, faculty/staff (open stacks)
Reference Service: In person, telephone, mail
Reprographic Services: Yes
Interlibrary Loan: CASLIM
Networks/Consortia: No
Publications: Orientation handbook; acquisitions list
Special Programs: Individual tours; intern program
Cataloged Volumes: 80,000
Serial Titles: 400 (Union List of Montana Serials)
Subjects: Art
Special Collection:
Montana Room Collection

Nebraska

AL 384
CONCORDIA TEACHER COLLEGE OF SEWARD,
 NEBRASKA
Link Library
800 N Columbia Ave, Seward, NE 68434
Tel: 402-643-3651, Ext 258
Dir: Vivian A Peterson

Academic Founded: 1894
Hours: 81/week
Circulation: Public (open stacks)
Reference Service: Telephone, mail
Reprographic Services: Yes
Interlibrary Loan: NILS
Networks/Consortia: NEBASE
Special Programs: Group tours; bibliographic instruction
Card Catalog
Cataloged Volumes: 106,500 (104,300 titles)
Serial Titles: 650
Holdings: 72 vertical file drawers; 3,300 titles of microforms
Subjects: Art, decorative arts, architecture, classical archaeology, film & video, graphics, photography, music, theatre,
 dance

AL 385
JOSLYN ART MUSEUM LIBRARY
2200 Dodge St, Omaha, NE 68102
Tel: 402-342-3300, Ext 41
Libn: Margaret Prescott

Museum Founded: 1931

Hours: Tues-Fri 10-12; 1-5
Circulation: Faculty/staff (open stacks)
Reference Service: In person, telephone, mail
Reprographic Services: Yes
Interlibrary Loan: NILS
Networks/Consortia: Nebraska Union Catalog
Publications: Bibliographies; acquisitions list
Special Programs: Group & individual tours; bibliographic
 instruction; single lectures; volunteer program
Card Catalog
Cataloged Volumes: 10,000
Serial Titles: 80
Holdings: 100 vertical file drawers; 1,000 sales & auction
 catalogs
Subjects: Art, decorative arts, architecture, classical archae-
 ology, film & video, graphics, photography, music, theatre,
 history of the American West
Special Collection: Artists of the American West; native
 American art & history

AL 386
NEBRASKA STATE HISTORICAL SOCIETY FORT
ROBINSON MUSEUM
Fort Robinson Museum Research Library
Box 304, Crawford, NE 69339
Tel: 308-665-2852
Curator: Vance E Nelson

Museum Founded: 1956
Hours: Mon-Fri 8-5 (Apr 1-mid Nov)
 Sun 1-5 (Apr 1-mid Nov)
 By appointment in winter
Circulation: Restricted to use of material in museum (open
 stacks; patron must register)
Reference Service: As staff time permits
Reprographic Services: No
Interlibrary Loan: No
Networks/Consortia: No
Publications: In-house periodical index
Card Catalog
Cataloged Volumes: 1,000
Holdings: 2 vertical file drawers; some microforms
Subject: Western Americana

AL 387
OREGON TRAIL MUSEUM ASSOCIATION
LIBRARY
Box 427, Gering, NE 69341
Tel: 308-436-4340
Chief Ranger: Barry Cooper

Public Library Founded: 1961
Circulation: Association members; researchers
Reprographic Services: Not for publication
Interlibrary Loan: No
Networks/Consortia: No
Publications: Orientation handbook
Special Programs: Group & individual tours; single lectures
Card Catalog
Holdings: 5 vertical file drawers
Subjects: Art
Special Collections:
Oregon Trail Collection
Books about the Oregon Trail & materials from the William
 Henry Jackson Collection.

AL 388
STUHR MUSEUM OF THE PRAIRIE PIONEER
Stuhr Research Library

Route 2, Box 24, Grand Island, NE 68801
Tel: 308-384-1380
Educational Dir: Warren Rodgers

Museum Founded: 1961
Hours: Mon-Sat 9-5
 Sun 1-5
 Sun 9-7 (summer)
Circulation: Faculty/staff (open stacks; no check out)
Reference Service: Telephone, mail
Reprographic Services: No
Interlibrary Loan: No
Networks/Consortia: No
Publications: Newsletter
Card Catalog
Cataloged Volumes: 5,000
Subjects: Architecture, photography, music, Nebraska &
 Great Plains history

Nevada

AL 389
NEVADA HISTORICAL SOCIETY
The Library
1650 N Virginia St, Reno, NV 89503
Tel: 702-784-6397
Libn: Lee Mortensen

Historical Society Founded: 1903
Circulation: Researchers; materials circulate within museum
 only
Reference Service: In person, telephone, mail
Reprographic Services: Yes; restrictions on individual
 manuscript collection
Interlibrary Loan: Nevada State Library; selective materials
 only
Networks/Consortia: Sierra Libraries Information Consor-
 tium
Publications: Indexes (An Index to the Publications of the
 Nevada Historical Society, 1907–1971)
Special Programs: Group tours; slide-sound programs on
 Nevada history
Card Catalog
Cataloged Volumes: 10,000
Serial Titles: 170 (Nevada Union List of Serials)
Holdings: 20 vertical file drawers; manuscript collection of
 over 2,445 entries; historical picture file; map collection
Subjects: Art, Nevada history
Special Collection: Manuscript Collection

New Hampshire

AL 390
DARTMOUTH COLLEGE
Sherman Art Library
Hanover, NH 03755
Tel: 603-646-2305, Ext 2305
Libn: Molly M O'Connor

Academic
Hours: Mon-Fri 8-12
 Sat 9-6
 Sun 1-12
Circulation: Public (open stacks; some books do not circulate)
Reference Service: In person, telephone, mail

Reprographic Services: Yes
Interlibrary Loan: NILS
Networks/Consortia: No
Publications: Subject catalog on microfiche; in-house periodical catalog
Special Programs: Bibliographic instruction
Card Catalog
Cataloged Volumes: 45,000
Serial Titles: 450 (National Union Catalog)
Holdings: 28 vertical file drawers; sales & auction catalogs; exhibition catalogs; microforms
Subjects: Art, decorative arts, architecture, graphics, photography

AL 391
FRANKLIN PIERCE COLLEGE LIBRARY
Rindge, NH 03461
Tel: 603-899-5111, Ext 215
Libn: Robert W Chatfield

Academic
Hours: Mon-Fri 8-12
 Sat 9-5
 Sun 12-12
Circulation: Public (open stacks)
Reference Service: In person, telephone, mail
Reprographic Services: Yes
Interlibrary Loan: CONSORTIUM
Networks/Consortia: New Hampshire College & University Council
Publications: Acquisitions list
Card Catalog
Cataloged Volumes: 40,500
Serial Titles: 335
Subjects: Art, decorative arts, photography, music, theatre

AL 392
NEW HAMPSHIRE STATE LIBRARY
20 Park St, Concord, NH 03301
Tel: 603-271-2394
Libn: Avis M Duckworth

State Library
Hours: Mon-Fri 8:30-5 (winter)
 Mon-Fri 8-4:30 (summer)
Circulation: Public; restricted to residents
Reference Service: In person, telephone, mail
Reprographic Services: Yes
Interlibrary Loan: NILS
Networks/Consortia: New Hampshire Interlibrary Loan Network; New England Serials Service; New Hampshire College & University Council
Publications: Orientation handbook; bibliographies; acquisitions list; newsletter; special catalogs; directories; statistics
Special Programs: Group & individual tours
Card Catalog
Cataloged Volumes: 720,471
Serial Titles: 650 (National Union Catalog)
Holdings: 30 vertical file drawers; 68,261 microforms
Subjects: Art, decorative arts, architecture, classical archaeology, film & video, graphics, photography, music, theatre, dance
Special Collection: New Hampshiriana Collection

AL 393
PLYMOUTH STATE COLLEGE
Herbert H Lamson Library
Plymouth, NH 03264

Tel: 603-536-1550, Ext 257
Dir: Janice Gallinger

Academic Founded: 1871
Hours: Mon-Thurs 8-11 (fall & winter)
 Fri 8-6 (fall & winter)
 Sat 10-5:30 (fall & winter)
 Sun 12:30-11 (fall & winter)
 Mon-Fri 8-5 (spring & summer)
Circulation: Students, faculty/staff (open stacks)
Reference Service: In person
Reprographic Services: No
Interlibrary Loan: NILS; New Hampshire Statewide Interlibrary Loan
Networks/Consortia: OCLC; New England Library Information Network; New Hampshire College & University Council
Publications: Orientation handbook; acquisitions list; special catalogs; in-house periodical index
Special Programs: Group & individual tours; bibliographic instruction; single lectures
Card Catalog
Cataloged Volumes: 180,000
Serial Titles: 1,200
Holdings: 7,000 items in vertical files; 200,000 microforms; 27,000 slides
Subjects: Art, film & video, photography, music
Special Collections: New Hampshire; Robert Frost

AL 394
PORTSMOUTH ATHENAEUM, INC.
9 Market Sq, Box 848, Portsmouth, NH 03801
Libn: Eleanor Kelliher

Museum; Proprietors Library Founded: 1817
Hours: Tues by appointment
 Thurs 1-4
Circulation: Students, researchers, faculty/staff; permission for long research granted by application to Board of Directors
Reference Service: In person, mail
Reprographic Services: No
Interlibrary Loan: No
Networks/Consortia: No
Publications: History of Portsmouth Athenaeum
Special Programs: Group & individual tours; bibliographic instruction; single lectures
Card Catalog
Cataloged Volumes: 30,000
Subjects: Art, decorative arts, architecture
Special Collections: Rare, old books of New England & Canada; paintings; early New Hampshire history, genealogy, newspaper & nautical information

AL 395
SHARON ARTS CENTER LIBRARY
RFD 2, Box 361, Peterborough, NH 03458
Tel: 603-924-7256
Head: Christine Dixon

Art School Founded: 1946
Hours: Mon-Fri 9-5
Circulation: Students, faculty/staff (open stacks)
Reference Service: Limited
Reprographic Services: Yes
Interlibrary Loan: League of New Hampshire Craftsmen
Networks/Consortia: No
Serial Titles: 2
Subjects: Art, architecture, decorative arts, photography

New Jersey

AL 396
CALDWELL COLLEGE LIBRARY
Caldwell, NJ 07006
Tel: 201-228-4424
Dir: Sr Margaret Anne

Academic
Circulation: Public (open stacks)
Reference Service: In person only
Reprographic Services: Yes (students & faculty only)
Interlibrary Loan: NILS
Networks/Consortia: No
Publications: Acquisitions list
Cataloged Volumes: 91,300 (72,825 titles)
Serial Titles: 750
Holdings: 5,041 microforms
Subjects: Art, architecture, dance, music, photography, theatre

AL 397
FREE PUBLIC LIBRARY
Art & Music Department
120 Academy St, Trenton, NJ 08608
Tel: 609-392-7188, Ext 26
Libn: James N Kisthardt

Public Library Founded: 1900
Hours: Mon-Fri 9-9
 Sat 9-5
 Mon, Thurs 9-9 (summer)
 Tues, Wed, Fri 9-5 (summer)
 Sat 9-1 (summer)
Circulation: Public
Reference Service: Telephone, mail
Reprographic Services: Yes
Interlibrary Loan: NILS
Networks/Consortia: New Jersey Libraries
Card Catalog
Cataloged Volumes: 6,500
Serial Titles: 82 (Union List of Serials, Trenton-Mercer City
 Area)
Holdings: 4 vertical file drawers; 50 exhibition catalogs
Subjects: Art, decorative arts, architecture, classical archae-
 ology, graphics, photography, music, dance

AL 398
JERSEY CITY FREE PUBLIC LIBRARY
Fine Arts/Audiovisual Department
678 Newark Ave, Jersey City, NJ 07306
Tel: 201-547-4546
Principal Libn: Alfred Trattner

Public Library Founded: 1891
Hours: Mon 1-8
 Tues-Fri 10-6
 Sat 10-5
Circulation: Public (open stacks)
Reference Service: In person, telephone, mail
Reprographic Services: Yes
Interlibrary Loan: New Jersey State Library (Jersey City
 Public Library, General Reference, 472 Jersey Ave, Jersey
 City, NJ 07302)
Networks/Consortia: New Jersey State Library
Publications: Orientation handbook (Your Jersey City
 Public Library); bibliographies; acquisitions list; in-house
 periodical index (Union List of Periodicals and Newspapers
 in Hudson County Area Libraries)

Special Programs: Group & individual tours; single lectures;
 film program; concerts; consumer education series; chil-
 dren's theatre, puppet shows & story hours; career orienta-
 tion; nutrition programs; magic shows; video tape instruc-
 tion; intern program
Cataloged Volumes: 9,600
Serial Titles: 54
Holdings: Framed reproductions of paintings; extensive films,
 filmstrips, phonorecords & audiovisual materials
Subjects: Art, architecture, crafts, dance, decorative arts,
 film & video, graphics, music, photography, theatre
Special Collection:
New Jersey Room
Books, periodicals, rare items, early photographs, clippings &
 documents on local history.

AL 399
LODI MEMORIAL LIBRARY
53 Main St, Lodi, NJ 07644
Tel: 201-773-4845
Dir: N Paul Speziale

Public Library Founded: 1924
Hours: Mon-Fri 10-9
 Sat 10-5:30
 Mon-Fri 9-7 (summer)
Circulation: Public (open stacks)
Reference Service: In person, telephone
Reprographic Services: Yes
Interlibrary Loan: NILS; South Bergen Library Group
Networks/Consortia: New Jersey Library Network
Special Programs: Group & individual tours; bibliographic
 instruction; children's pre-school hour; film programs;
 craft workshops
Cataloged Volumes: 98,433 (97,797 titles)
Serial Titles: 284 (Union List of Public, Special & College
 Libraries of South Bergen & Passaic Counties)
Subjects: Art, architecture, classical archaeology, decorative
 arts, graphics, music, photography, theatre
Special Collections: Negro History Collection; Newbery-
 Caldecott Collection; Americana Collection

AL 400
MONTCLAIR ART MUSEUM
LeBrun Library
3 S Mountain Ave, Montclair, NJ 07042
Tel: 201-746-5555
Libn: Edith A Rights

Museum Founded: 1916
Hours: Tues-Fri 10-5
 Sat 10-1
 Closed Jul & Aug
Circulation: (open stacks)
Reference Service: Telephone, mail; appointment preferred
Reprographic Services: Yes; by librarian
Interlibrary Loan: No
Networks/Consortia: No
Publications: Special catalogs; museum bulletin; in-house
 periodical index
Card Catalog
Cataloged Volumes: 8,000
Serial Titles: 50
Holdings: 111 vertical file drawers; extensive sales & auction
 catalogs; extensive exhibition catalogs; bookplates; posters
Subjects: Art, decorative arts, architecture, graphics, Ameri-
 can Indian culture

AL 401
NEW BRUNSWICK THEOLOGICAL SEMINARY
Gardner A Sage Library
21 Seminary Place, New Brunswick, NJ 08901
Tel: 201-247-5241, Ext 6
Libn: D L Engelhardt

Academic Founded: 1875
Circulation: Students, faculty/staff, ministers; others by
 special permission (open stacks)
Reference Service: Telephone, mail
Reprographic Services: Yes, limited
Interlibrary Loan: NILS
Networks/Consortia: Rutgers University, New Brunswick,
 NJ; Southeastern Pennsylvania Theological Librarians
 Association; New York Metropolitan Library Association
Special Programs: Group & individual tours
Card Catalog
Cataloged Volumes: 2,810 (art)
Serial Titles: 3 (National Union Catalog; Libraries of Middle-
 sex County; Union List of Serials in New Jersey)
Subjects: Art, architecture, music

AL 402
NEWARK MUSEUM ASSOCIATION
Newark Museum Library
43-49 Washington St, Newark, NJ 07101
Tel: 201-733-6640; 6584
Libn: Eleanor Townsend

Museum Founded: 1909
Hours: Mon-Fri 12-5
Circulation: Faculty/staff; restricted to use within museum
 (stacks closed to all but staff)
Reference Service: In person, telephone, mail
Reprographic Services: Yes
Interlibrary Loan: NILS; agreement with Newark Public
 Library
Networks/Consortia: No
Publications: *Newark Museum Quarterly*
Information Sources: Lipton, Barbara. "The Small Museum
 Library," *Special Libraries*, v 65, no 1, Jan 1974; Lipton,
 Barbara. "Westerners in Tibet 1327-1950," *The Museum—
 New Series*, v 24, 2 & 3, 1972
Special Programs: Group & individual tours; bibliographic
 instruction; single lectures
Card Catalog
Cataloged Volumes: 21,000
Serial Titles: 200
Holdings: 84 vertical file drawers; extensive sales & auction
 catalogs; exhibition catalogs
Subjects: Art, decorative arts, architecture, classical archae-
 ology, graphics, photography, music
Special Collection:
Tibet Collection
Books, photographs, slides, catalogs, original manuscripts
 on Tibet.

AL 403
NEWARK PUBLIC LIBRARY
Art & Music Department
5 Washington St, Newark, NJ 07101
Tel: 201-733-7840

Public Library Founded: 1888
Hours: Mon, Wed, Thurs 9-9
 Tues, Fri 9-6
 Sat 9-5

Circulation: Public; reference materials & special collections
 restricted (open stacks)
Reference Service: Telephone, mail
Reprographic Services: Yes
Interlibrary Loan: NILS; New Jersey State Network
Networks/Consortia: Metropolitan Cooperative Library
 System
Publications: Orientation handbook; acquisitions list; catalogs;
 in-house periodical index
Information Sources: "Organizational Patterns in Public
 Libraries," *Library Trends*, Jan 1975, p 329-348; Dane,
 William J. "The Picture Collection," Shoe String Press,
 1968
Special Programs: Group & individual tours; intern program
Card Catalog
Cataloged Volumes: 55,000 (40,000 titles)
Holdings: 36 vertical file drawers; 2,500 exhibition catalogs;
 425 microforms
Subjects: Art, decorative arts, architecture, graphics, photog-
 raphy, music
Special Collections:
Fine Print Collection
Emphasis on 20th century graphic art processes, artists, maps,
 greeting cards, bank notes, music covers, Japanese prints,
 & stencils.
Jenkinson Collection of Fine Painting
Manuscripts, incunabula & works by noted 19th & 20th cen-
 tury printers.

AL 404
NEW JERSEY INSTITUTE OF TECHNOLOGY
New Jersey School of Architecture Information Center
323 High St, Newark, NJ 07102
Tel: 201-645-5547
Supervisor: Stephen H Van Dyk

Academic Founded: 1974
Hours: Mon-Fri 9-5
Circulation: Public (open stacks)
Reference Service: In person, telephone
Reprographic Services: Yes
Interlibrary Loan: NILS (Robert Van Houten Library, same
 address as above)
Networks/Consortia: OCLC
Publications: Orientation handbook; acquisitions list projected
Special Programs: Group tours; slide program on use of index
Cataloged Volumes: 54
Serial Titles: 35 (Union List of Serials)
Holdings: 8 vertical file drawers; 350 sales & auction catalogs;
 40 exhibition catalogs
Subjects: Architecture, building & construction, city planning

AL 405
PRINCETON UNIVERSITY
Marquand Library–Department of Art & Archaeology
McCormick Hall, Princeton, NJ 08540
Tel: 609-452-3783
Libn: Mary Morris Schmidt

Academic
Hours: Mon-Fri 9-12
 Sat 9-6
 Sun 12-12
 Mon-Fri 8:30-4:30 (summer)
Circulation: Restricted to use within library by students,
 faculty/staff
Reference Service: In person, telephone, mail
Reprographic Services: Yes; permission needed

Interlibrary Loan: No
Networks/Consortia: No
Information Source: Weld, Eleanor V, ed. *Princeton University Library Handbook for 1976-77*, p 15
Special Programs: Group tours; bibliographic instruction
Card Catalog
Cataloged Volumes: 105,458
Serial Titles: 848 (National Union Catalog)
Holdings: 11,355 sales & auction catalogs; 8,857 exhibition catalogs; 109 microfilm reels
Subjects: Art, decorative arts, architecture, classical archaeology, graphic, photography
Special Collections:
Far Eastern Library
Japanese & Chinese materials which pertain to study of Far Eastern Art.
Friend Collection
Study collection on medieval illumination.

AL 406
RUTGERS—THE STATE UNIVERSITY OF NEW JERSEY
Archibald Stevens Alexander Library—Art Library
Voorhees Hall, Queens Campus, New Brunswick, NJ 08901
Tel: 201-932-7739
Libn: Ferris Olds

Academic Founded: 1966
Hours: Mon-Thurs 9-10
 Fri 9-5
 Sat 12-5
 Sun 1-11
 Mon-Fri 9-5 (summer)
Circulation: (open stacks)
Reference Service: In person, telephone, mail
Reprographic Services: Yes
Interlibrary Loan: NILS
Networks/Consortia: Center for Research Libraries; Middle Atlantic Research Libraries Information Network
Publications: Guide to the University Libraries
Special Programs: Group & individual tours; bibliographic instruction; single lectures
Card Catalog
Cataloged Volumes: 27,000
Serial Titles: 280 (Periodicals in the Rutgers University Libraries; New Jersey Union List of Serials)
Holdings: 24 vertical file drawers; sales & auction catalogs; exhibition catalogs
Subjects: Art, decorative arts, architecture, classical archaeology, graphics, photography
Special Collections: Western Art/Architectural History; the Louis E Stern Collection of contemporary art; the Mary Bartlett Cowdrey Collection of American art

AL 407
SETON HALL UNIVERSITY
McLaughlin Library
South Orange, NJ 07079
Tel: 201-762-9000, Ext 276
Libn: Msgr W N Field

Academic Founded: 1856
Hours: Mon-Fri 9-11
 Sat 9-5
 Sun 12-9
Circulation: Students, faculty/staff; restricted use of rare books & bound periodicals (open stacks)
Reference Service: In person only

Reprographic Services: No
Interlibrary Loan: NILS
Networks/Consortia: Consortium of East New Jersey
Publications: Orientation handbook; bibliographies; acquisitions list; newsletter; special catalogs
Special Programs: Group tours
Card Catalog
Cataloged Volumes: 269,496 (211,432 titles)
Subjects: Art, music

AL 408
STOCKTON STATE COLLEGE LIBRARY
Pomona, NJ 08240
Tel: 609-652-1776, Ext 241
Dir of Lib Services: Raymond A Frankle

Academic Founded: 1971
Circulation: Public (open stacks)
Reference Service: Yes
Reprographic Services: Yes
Interlibrary Loan: NILS; New Jersey Interlibrary Loan Code (State Library, Trenton, NJ)
Networks/Consortia: Pennsylvania Area Library Network
Publications: Bibliographies; orientation handbook; newsletter; in-house periodical index
Special Programs: Group & individual tours; bibliographic instruction; single lectures
Cataloged Volumes: 93,000 (86,000 titles; 20,000 additional titles on microform)
Serial Titles: 1,600 (New Jersey Union List of Serials)
Holdings: 15 vertical file drawers; 55,784 microforms; 65,953 media items, including 60,000 slides
Subjects: Art, architecture, dance, film & video, music, photography, theatre
Special Collection: New Jersey Pine Barrens

New Mexico

AL 409
NEW MEXICO JUNIOR COLLEGE
Pannell Library
Lovington Hwy, Hobbs, NM 88240
Tel: 505-392-6526, Ext 231
Libn: Orin Walker Hatch

Academic Founded: 1965
Hours: Mon-Thurs 7:45-9:30
 Fri 7:45-5
 Sun 2-4:45
Circulation: Public (open stacks)
Reference Service: In person, telephone, mail
Interlibrary Loan: Southwest Academic Library Consortium
Networks/Consortia: Council of LRC Directors of New Mexico's Two-year Colleges
Publications: Orientation handbook
Special Programs: Group & individual tours
Card Catalog
Cataloged Volumes: 83,933
Serial Titles: 1,063 (Southwest Union List of Serials)
Holdings: 30 vertical file drawers; 6,849 microforms
Subjects: Art, architecture, classical archaeology, dance, decorative arts, film & video, graphics, music, photography, theatre
Special Collections: US Government Depository

AL 410
NEW MEXICO STATE UNIVERSITY AT
CARLSBAD LIBRARY
2900 W Church St, Carlsbad, NM 88220
Tel: 505-885-8831
Libn: Julia White

Academic
Hours: Mon-Fri 8-4; 6-8:30
Circulation: Public (open stacks)
Reference Service: In person, telephone
Reprographic Services: No
Interlibrary Loan: No
Networks/Consortia: Southwest Academic Library Consortium
Card Catalog
Cataloged Volumes: 14,500
Serial Titles: 109
Subjects: Art, decorative arts, architecture, classical archae-
 ology, film & video, graphics, photography, music, theatre,
 dance

AL 411
NEW MEXICO STATE UNIVERSITY AT GRANTS
LIBRARY
1500 Third St, Grants, NM 87020
Tel: 505-287-9349
Libn: Fred Wilding-White

Academic Founded: 1968
Hours: Mon-Thurs 9-5; 6-9
 Fri 9-12
Circulation: Public (open stacks)
Reference Service: In person, telephone, mail
Reprographic Services: Yes
Interlibrary Loan: NILS
Networks/Consortia: Southwest Academic Library Consor-
 tium; Council of New Mexico Academic Libraries
Publications: In-house periodical catalog
Special Programs: Group & individual tours; single lectures
Card Catalog
Cataloged Volumes: 13,550 (12,223 titles)
Serial Titles: 45
Holdings: 5 vertical file drawers; 8 microforms
Subjects: Art, decorative arts, architecture, classical archae-
 ology, film & video, graphics, photography, music, theatre,
 dance

AL 412
UNIVERSITY OF NEW MEXICO
Fine Arts Library
Albuquerque, NM 87131
Tel: 505-277-2901; 2325
Libn: James Wright

Academic
Hours: Mon-Thurs 8-12
 Fri 8-9
Circulation: Students, faculty/staff; restricted use of phono-
 records (open stacks)
Reference Service: In person, telephone, mail
Reprographic Services: Yes
Interlibrary Loan: NILS; Southwest Academic Library Con-
 sortium (Keitha Shoupe, Interlibrary Loan, Zimmerman
 Library); OCLC
Publications: Orientation handbook projected
Special Programs: Group & individual tours; intern program
Card Catalog
Cataloged Volumes: 62,000
Serial Titles: 313 (Microfiche serial list; National Union

Catalog; Southwestern Union Serial List)
Holdings: 12 vertical file drawers; 1,890 microforms; Sotheby
 Parke-Bernet auction catalogs; 5,000 exhibition catalogs
 (1963–present)
Subjects: Art, architecture, decorative arts, film & video,
 graphics, music, photography, sound recordings
Special Collections:
Archive of Southwestern Music
Over 1,200 hours of field recordings of music indigenous to
 the Southwest.
Batchelder-McPharlin Puppetry Collection
Over 2,000 items relating to all applications of puppetry, in-
 cluding original playscripts & correspondence, Punch &
 Judy material music for puppet theatre, Paul McPharlin
 manuscript by Dr Batchelder McPharlin.
Photography Collection
Historical collection of 19th & 20th century photographs,
 includes 350 original photographs and *Camera Notes* &
 Camera Work periodicals.
Robb Collection
Music manuscripts of J D Robb's compositions & articles by
 and about him.
Tamarind Archive
Historical records of the Tamarind Lithography Workshop
 (1960-1970) & Tamarind Institute (1970-present); prime
 catalysts in renaissance of American lithography.

New York

AL 413
ADELPHI UNIVERSITY LIBRARY
Fine Arts Library
South Ave, Garden City, NY 11530
Tel: 516-294-8700, Ext 7353
Libn: Erica Doctorow

Academic Founded: 1896
Hours: Mon-Thurs 8:30-10
 Fri 8:30-5
 Sat 9-5
 Sun 1-5
Circulation: Students, faculty/staff (open stacks)
Reference Service: In person, telephone, mail
Reprographic Services: Yes
Interlibrary Loan: NILS; Long Island Library Resources
 Council, Inc.
Networks/Consortia: Long Island Library Resources Council,
 Inc.
Publications: Special exhibition catalogs
Special Programs: Group & individual tours; bibliographic
 instruction; single lectures
Card Catalog
Cataloged Volumes: c 15,000
Serial Titles: 95 (New York State Union Catalog; Nassau
 Suffolk Union List of Serials)
Subjects: Art, decorative arts, architecture, classical archae-
 ology, graphics, music

AL 414
ALBANY INSTITUTE OF HISTORY & ART
McKinney Library
125 Washington Ave, Albany, NY 12210
Tel: 518-463-4478
Libn: James R Hobin

Museum Founded: 1791

Hours: Mon-Fri 8:30-4
 Sat 9-1
Circulation: Faculty/staff (open stacks)
Reference Service: Telephone, mail
Reprographic Services: Yes
Networks/Consortia: No
Special Programs: Group & individual tours
Card Catalog
Cataloged Volumes: 8,000 (6,500 titles)
Serial Titles: 35 (National Union Catalog)
Holdings: 6 vertical file drawers; 500 sales & auction
 catalogs; 2,500 exhibition catalogs; 250,000 manuscripts
Subjects: Art, decorative arts, architecture of Albany,
 Upper Hudson area
Special Collections:
Manuscript Collection
Papers of Albany Gallery of Fine Arts 1846–54, Ezra
 Ames, Thomas Cole, Sanford R Gifford, Erastus D Palmer,
 Walter L Palmer, John Q A Ward.

AL 415
ALBRIGHT-KNOX ART GALLERY
Educational Department Loan Service
1285 Elmwood Ave, Buffalo, NY 14222
Tel: 716-882-8700
Keeper of the Loan Service: Charlotte B Johnson

Museum Founded: 1937
Hours: Tues-Fri 12-4:40
 Sat 9-12
Circulation: Faculty/staff, teachers (open stacks)
Reference Service: No
Reprographic Services: No
Interlibrary Loan: No
Networks/Consortia: No
Publications: Brochures; accession book
Card Catalog
Subjects: Art, architecture
Special Collections: Twentieth century art

AL 416
ALBRIGHT-KNOX ART GALLERY
Gallery Research Library
1285 Elmwood Ave, Buffalo, NY 14222
Tel: 716-882-8700, Ext 25
Libn: Annette Masling

Museum Founded: 1905
Hours: Tues-Fri 2-5
 Sat 1-3
 Closed July & August
Circulation: Restrictions on use of rare books (open stacks)
Reference Service: In person, telephone, mail
Reprographic Services: Yes, limited
Interlibrary Loan: NILS; New York Library Resources
 Council; State University of New York at Buffalo Art
 Library
Networks/Consortia: Western New York Library Resources
 Council (Lafayette Sq, Buffalo, NY)
Special Programs: Group tours; bibliographic instruction;
 single lectures
Card Catalog
Cataloged Volumes: 16,500
Serial Titles: 200
Holdings: 130 vertical file drawers; 350 microforms; 1,000-
 1,500 sales & auction catalogs; 10,000 exhibition catalogs
Subjects: Art, architecture, classical archaeology, decorative
 arts, film & video, graphics, photography

Special Collection: Contemporary American & European Art
 Collection includes exhibition catalogs & material cover-
 ing the most current art

AL 417
AMERICAN COUNCIL FOR THE ARTS
Services Library
570 Seventh Ave, New York, NY 10018
Tel: 212-354-6655
Libn: Robert Porter

National Arts Service Organization Founded: 1960
Hours: Mon-Fri 9:30-5
Circulation: No (open stacks)
Reference Service: Members only
Reprographic Services: No
Interlibrary Loan: No
Networks/Consortia: No
Holdings: 40 vertical file drawers
Subjects: Art
Special Collection: Arts Administration

AL 418
AMERICAN CRAFTS COUNCIL
Research & Education Department Library
44 W 53 St, New York, NY 10019
Tel: 212-977-8976-7
Dir: Lois Moran

Specialized Library Founded: 1943; 1956
Hours: Tues, Wed, Fri 12-5
Circulation: (open stacks)
Reference Service: In person, telephone, mail
Reprographic Services: No
Interlibrary Loan: No
Networks/Consortia: No
Publications: Bibliographies; special catalogs; exhibition
 catalogs; bimonthly magazine, *Craft Horizons*; in-house
 periodical index (for *Craft Horizons*)
Special Programs: Group tours by appointment only; intern
 program
Card Catalog
Cataloged Volumes: 2,500
Serial Titles: 50
Holdings: 8 vertical file drawers; 1,000 exhibition catalogs
Subjects: Contemporary American crafts & craftsmen,
 decorative arts, film & video
Special Collections:
Contemporary American Crafts & Craftsmen Collection
Material about craftsmen, craft events, from state art agencies
 & craft groups. Includes *Portable Museum*, a slide & film
 sales rental service covering Museum of Contemporary
 Crafts exhibitions, craft processes & media surveys; video
 & audio tapes.

AL 419
AMERICAN HERITAGE PUBLISHING COMPANY
LIBRARY
10 Rockefeller Plaza, New York, NY 10020
Tel: 212-399-8930
Libn: Laura Lane Masters

Publishing Firm Founded: 1954
Hours: Mon-Fri 9:30-5:30
Circulation: Staff; appointment for non-company members
 (open stacks)
Reference Service: Telephone
Reprographic Services: Yes

Interlibrary Loan: No
Networks/Consortia: No
Publications: Acquisitions list
Special Programs: Group & individual tours
Card Catalog
Cataloged Volumes: 17,000
Serial Titles: 490
Subjects: Art, decorative arts, architecture, classical archae-
ology, film & video, photography, music, theatre, dance

AL 420
AMERICAN INSTITUTE OF GRAPHIC ARTS
LIBRARY
1059 Third Ave & 63 St, New York, NY 10021
Tel: 212-752-0812; 0814; 0816
Executive Dir: Flora Finn Gross

Non-profit Institute & Gallery Founded: 1914
Hours: Mon-Fri 9-5
Circulation: Yes; fees for some materials
Reference Service: In person
Reprographic Services: No
Interlibrary Loan: No
Networks/Consortia: No
Publications: Special catalogs
Special Programs: Group tours; plant tours to printing, en-
graving, art studios
Subjects: Art, graphic arts (commercial)

AL 421
BROOKLYN MUSEUM
Art Reference Library
188 Eastern Pkwy, Brooklyn, NY 11238
Tel: 212-638-5000, Ext 307
Libn: Margaret B Zorach

Museum Founded: 1820
Hours: Wed-Fri 1-5
Circulation: Faculty/staff (open stacks; staff only)
Reference Service: Telephone, mail (limited by staff size)
Reprographic Services: Yes
Interlibrary Loan: No
Networks/Consortia: No
Card Catalog
Cataloged Volumes: c 85,000
Serial Titles: c 400 (National Union Catalog)
Holdings: 96 vertical file drawers; c 8,000 sales & auction
catalogs; 5,000-8,000 exhibition catalogs
Subjects: Art, decorative arts, architecture, graphics, photog-
raphy, primitive, Oriental, Middle Eastern art & architec-
ture
Special Collections: Subjects related to Museum holdings;
original fashion sketches

AL 422
BROOKLYN MUSEUM
Wilbour Library of Egyptology
Eastern Pkwy, Brooklyn, NY 11238
Tel: 212-638-5000
Libn: Diane Guzman

Museum Founded: 1916
Hours: Mon-Fri 10-5 (by appointment only)
Circulation: (open stacks)
Reference Service: In person, telephone, mail (limited)
Reprographic Services: Yes
Interlibrary Loan: NILS
Networks/Consortia: No

Publications: Acquisitions list
Information Sources: Hutchinson, S A. "The Wilbour Library
Room," *Brooklyn Museum Quarterly,* v 22, no 1, Jan
1935, pp 22-25; "The Charles Edwin Wilbour Memorial
Library Room in the Brooklyn Museum," *Library Journal,*
v 60, Jan 1935, p 51; "The Wilbour Library, Brooklyn
Museum, Brooklyn, NY, Howe & Lescaze, Architects,"
American Architect, Dec 1935, p 14
Special Programs: Intern program with library school
Card Catalog
Cataloged Volumes: c 16,000 (c 12,000 titles)
Serial Titles: c 120 (National Union Catalog)
Holdings: 88 vertical file drawers; c 1,000 sales & auction
catalogs; c 2,000 exhibition catalogs; c 1,000 microforms
Subjects: Art, architecture, classical archaeology, Egyptian
philology, Nubiology

AL 423
BROOKLYN PUBLIC LIBRARY
Art & Music Department
Grand Army Plaza, Brooklyn, NY 11238
Tel: 212-636-3214
Libn: William R Johnson

Public Library Founded: 1897
Hours: Mon-Thurs 9-8
 Fri-Sat 10-6
 Sun 1-5 (winter only)
Circulation: Public (open stacks)
Reference Service: In person, telephone, mail (restricted mail
service)
Reprographic Services: Yes
Interlibrary Loan: NILS; New York State Interlibrary Loan;
New York Metropolitan Reference & Research Library
Agency
Networks/Consortia: No
Publications: Staff bulletin
Special Programs: Group tours by appointment
Card Catalog
Cataloged Volumes: 122,299
Serial Titles: 250 (National Union Catalog)
Holdings: 18 vertical file drawers; sales & auction catalogs;
exhibition catalogs; 358 framed prints
Subjects: Art, decorative arts, architecture, film, graphics,
photography, music, theatre, dance
Special Collections:
Chess & Checker Collection
Costume Collection

AL 424
CANAJOHARIE LIBRARY & ART GALLERY
Erie Blvd, Canajoharie, NY 13317
Tel: 518-673-2314
Dir: Kathleen Munson
Art Curator: Edward Lipowicz

Library Assoc/Art Gallery Founded: 1925
Hours: Mon-Thurs 10-5:15 (winter)
 Fri 10-5:15; 7-9
 Sat 10-2
 Mon-Thurs 9-4 (summer)
 Fri 9-4; 7-9
 Sat 9-1
Circulation: Public (open stacks except for historical mater-
ials)
Reference Service: In person, telephone, mail
Reprographic Services: No
Interlibrary Loan: NILS (Schenectady County Public
Library, Interlibrary Loan Department)

Networks/Consortia: Mohawk Valley Library Association
Publications: Art Gallery catalog; in-house periodical catalog
Special Programs: Group & individual tours; bibliographic instruction; single lectures; informal intern program
Cataloged Volumes: 30,000
Serial Titles: 30
Holdings: 8 vertical file drawers; 1 exhibition catalog; 10 local newspapers
Subjects: Art, architecture, classical archaeology, decorative arts, music, photography, theatre

AL 425
CENTER FOR INTER-AMERICAN RELATIONS LIBRARY
680 Park Ave, New York, NY 10021
Tel: 212-249-8950
President: Roger Stone

Museum Founded: 1967
Hours: Tues-Fri 12-6
Circulation: Special permission necessary
Reference Service: No
Reprographic Services: No
Interlibrary Loan: No
Networks/Consortia: No
Publications: Special catalogs (museum exhibitions)
Special Programs: Group tours; single lectures
Subjects: Art, decorative arts, architecture, museum's emphases

AL 426
COLUMBIA UNIVERSITY
Avery Architectural & Fine Arts Library
116 St & Broadway, New York, NY 10027
Tel: 212-280-3501
Libn: Adolf K Placzek

Academic
Hours: Mon-Thurs 9-11
 Fri 9-10
 Sat 10-5
 Sun 2-10
Circulation: Restricted to within library (open stacks; rare books & original drawings by request)
Reference Service: In person, telephone, mail
Reprographic Services: Yes; rare material not copied
Interlibrary Loan: No
Networks/Consortia: Research Library Group
Publications: Book catalog; in-house periodical index (Avery Index to Architectural Periodicals; Fine Arts Library Periodical Index)
Special Programs: Group tours; bibliographic instruction
Card Catalog
Cataloged Volumes: 170,000
Serial Titles: 1,000 (National Union Catalog)
Holdings: 6 vertical file drawers
Subjects: Art, decorative arts, architecture, classical archaeology, city planning
Special Collections: Architectural drawings

AL 427
COOPER-HEWITT MUSEUM—THE SMITHSONIAN INSTITUTION'S NATIONAL MUSEUM OF DESIGN
The Doris & Henry Dreyfuss Memorial Study Center
2 E 91 St, New York, NY 10028
Tel: 212-860-6883; 6882 (picture library)

Bureau Libn: Robert C Kaufmann

Museum Founded: 1896
Hours: Mon-Fri 9-5, by appointment only
Circulation: Restricted to serious research projects
Reference Service: In person
Interlibrary Loan: NILS
Networks/Consortia: No
Special Programs: Intern program
Card Catalog
Cataloged Volumes: 26,000
Serial Titles: 100
Holdings: 5 vertical file drawers; 10,000 sales & auction catalogs; exhibition catalog collection; picture library includes 1,500,000 items
Subjects: Architecture, advertising art, color, decorative arts, design, industrial design, natural history
Special Collections:
Color Archive
Books, journals, manuscripts, models, and color charts relating to all aspects of color; serves as the deposit library of the Inter-Society Color Council and *House and Garden* Color Archive.
Donald Deskey Material
Books, drawings, presentation books & manuscripts illustrating the career of the industrial designer, Donald Deskey.
Dreyfuss Archive
Includes books, reprints, models, drawings & presentation Notebooks illustrating the life & career of Henry Dreyfuss, the industrial designer, and concerning his "Symbols Sourcebook".
Industrial Design Thesis Abstract Archive
Abstracts & copies of Industrial Design theses from American universities & design schools; is a project of the Industrial Design Society of America.
Ladislav Sutnar Material
Archival material relating to the career of the noted Czech-American, Bauhaus-trained graphic designer.

AL 428
COOPER UNION FOR THE ADVANCEMENT OF SCIENCE & ART
The Library
Cooper Sq, New York, NY 10003
Tel: 212-254-6300, Ext 3
Libn: Fred H Graves

Academic Founded: 1859
Hours: Mon-Thurs 9-8
 Fri 9-6
Circulation: Students (open stacks)
Reference Service: In person
Reprographic Services: No
Interlibrary Loan: New York Metropolitan Reference & Research Library Agency
Networks/Consortia: Research Library Association
Special Programs: Group & individual tours; bibliographic instruction; single lectures
Card Catalog
Cataloged Volumes: c 16,000
Serial Titles: 80
Subjects: Art, architecture, graphics, photography

AL 429
CORNELL UNIVERSITY
Fine Arts Library
Sibley Dome, Ithaca, NY 14853

Tel: 607-256-3710
Libn: Judith E Holliday

Academic Founded: 1871
Hours: Mon-Thurs 8-11
 Fri 8-10
 Sat 9-5
 Sun 1-11
Circulation: Students, researchers, faculty/staff (open stacks; periodicals non-circulating)
Reference Service: In person, telephone, mail
Reprographic Services: Yes
Interlibrary Loan: NILS (ILL, Reference Department, Olin Library, Cornell University)
Networks/Consortia: Five Associated University Libraries of New York; OCLC
Publications: Acquisitons list
Special Programs: Group & individual tours; bibliographic instruction; single lectures
Card Catalog
Cataloged Volumes: 96,000
Serial Titles: 1,600 (National Union Catalog)
Holdings: 418 microforms
Subjects: Art, decorative arts, architecture, classical archaeology, graphics, photography, city & regional planning

AL 430
CORNING MUSEUM OF GLASS LIBRARY
Corning Glass Center–Annex, Corning, NY 14830
Tel: 607-937-5371
Libn: Norma P H Jenkins

Museum Founded: 1951
Hours: Mon-Fri 9-5
Circulation: Public (at the libn's discretion; open stacks except for rare material & material actively used by museum staff)
Reference Service: Yes
Reprographic Services: Yes; for study & research purposes only; frail & unwieldy material exempted
Interlibrary Loan: NILS; South Central Research Library Council; New York State Interlibrary Loan
Networks/Consortia: South Central Research Library Council; New York State Interlibrary Loan; OCLC; College Center of the Finger Lakes
Publications: Bibliographies; exhibition catalogs; Check List of Recently Published Articles & Books on Glass (published annually in *Journal of Glass Studies*)
Information Source: *Museum Under Water: The Corning Flood,* Corning Museum of Glass, 1977
Special Programs: Intern program as funding allows
Cataloged Volumes: 10,400
Serial Titles: 475 (South Central Research Library Council List of Serials)
Holdings: 12 vertical file drawers; 2,300 microfiche; 3,000 sales & auction catalogs; exhibition catalogs; 250 glass trade catalogs
Subjects: Art, architecture, classical archaeology, conservation, decorative arts, historical technology, history of glass, museology
Special Collection: International history & art of glass

AL 431
CORTLAND FREE LIBRARY
32 Church St, Cortland, NY 13045
Tel: 607-753-1042
Lib Dir: Warren S Eddy

Public Library Founded: 1886; 1925

Hours: Mon-Thurs 10-9
 Fri-Sat 10-5:30
Circulation: Public (open stacks)
Reference Service: In person
Reprographic Services: Yes
Interlibrary Loan: NILS; New York State Interlibrary Loan
Networks/Consortia: College Center of the Finger Lakes Library System
Card Catalog
Cataloged Volumes: 1,100 (970 titles)
Serial Titles: 395
Holdings: 1,000 reels of microforms
Subjects: Art, decorative arts, architecture, classical archaeology, music, theatre

AL 432
EAST HAMPTON FREE LIBRARY
Pennypacker Long Island Collection
159 Main St, East Hampton, NY 11937
Tel: 516-324-0222
Dir: Beth Gray

Public Library Founded: 1897
Hours: Mon-Sat 1:30-5:30 (winter)
 Tues, Thurs 7-9 (winter evenings)
 Mon-Sat 10-6 (summer)
 Tues, Thurs 7-9 (summer evenings)
Circulation: Public (open stacks; special collection restricted)
Reference Service: In person, mail
Reprographic Services: Yes; with librarian's permission
Interlibrary Loan: NILS; Suffolk Cooperative Library System (Box 187, Bellport, NY 11713)
Networks/Consortia: No
Publications: Newsletter; East Hampton Free Library, 1897–1962; in-house periodical index (East Hampton Star Index)
Special Programs: Individual tours
Card Catalog
Cataloged Volumes: 98 (98 titles)
Holdings: 4 vertical file drawers; 56 exhibition catalogs; 1 chest; 5 print boxes
Subjects: Art
Subject Collection:
Thomas Moran Collection
Collection of books, pamphlets, maps, deeds, letters & other documents pertaining to Long Island history & Thomas Moran & his family.

AL 433
ELMIRA COLLEGE
Gannett-Tripp Learning Center
Elmira, NY 14901
Tel: 607-734-3911, Exts 241; 242
Dir: James D Gray

Academic Founded: 1855
Hours: Mon-Thurs 8:30-11
 Fri 8:30-5
 Sat 11-5
 Sun 11-11
Circulation: Students, researchers, faculty/staff (open stacks)
Reference Service: In person only (some mail & phone reference for scholars)
Reprographic Services: Yes
Interlibrary Loan: NILS; New York State Interlibrary Loan; South Central Research Library Council
Networks/Consortia: No
Publications: Orientation handbook; acquisitions list; book catalog; in-house periodical index

Special Programs: Group & individual tours, bibliographic
instruction; single lectures; self-instruction program;
informal intern program
Card Catalog
Cataloged Volumes: 128,000 (120,000 titles)
Serial Titles: 704 (South Central Research Library Council
Union List)
Holdings: 8 vertical file drawers; 33,000 microforms
Subjects: Art, architecture, classical archaeology, dance,
decorative arts, film & video, graphics, music, photography,
theatre

AL 434
HARRIET FEBLAND'S ADVANCED PAINTERS
WORKSHOP LIBRARY
Premium Point, New Rochelle, NY 10801
Tel: 914-235-7322
Dir: Harriet FeBland

Art School Founded: 1962
Circulation: Researchers, faculty/staff
Reference Service: Telephone, mail
Reprographic Services: No
Interlibrary Loan: No
Networks/Consortia: No
Publications: Special catalogs; in-house periodical index
Special Programs: Single lectures
Subjects: Art, sculpture, constructions, exhibitions
Special Collections:
Harriet FeBland Collection
Works by Harriet FeBland, includes "Construction in Plas-
tic," "Totems," "FeBland works, 1957–1977," "Large
Scale Outdoor Sculpture," "FeBland Boxes."
Slide Collection of Exhibitions
Includes "Women in Art," "Potsdam Plastics," "Co-Op
City," "Forms in Focus."

AL 435
ROSWELL P FLOWER MEMORIAL LIBRARY
229 Washington St, Watertown, NY 13601
Tel: 315-788-2352
Dir: Anthony F Cozzie

Public Library Founded: 1904
Hours: Mon-Fri 8:30-8:30
 Sat 9-5
 Mon-Thurs 8:30-5:30 (July-Aug)
 Fri 8:30-8:30 (July-Aug)
Circulation: Public (open stacks)
Reference Service: Yes
Reprographic Services: Yes
Interlibrary Loan: New York State Interlibrary Loan System
Networks/Consortia: North County Library System
Card Catalog
Cataloged Volumes: 71,735 (53,495 titles)
Serial Titles: 383 (North Country Union List of Serials)
Holdings: 32 vertical file drawers; 10,000 microforms
Special Collections:
New York State Historical Collection
Books & material relating to local & state history.
United States Military History Collection
Books relating to US military history.

AL 436
FRICK ART REFERENCE LIBRARY
10 E 71 St, New York, NY 10021
Tel: 212-288-8700
Libn: Helen Sanger

Private Charitable Foundation Founded: 1920
Hours: Mon-Fri 10-4
 Sat 10-12
 Closed Sat–June & July
 Closed August
Circulation: Serious students beyond undergraduate level
Reference Service: In person, telephone, mail
Reprographic Services: Yes; in accordance with copyright laws
Interlibrary Loan: No
Publications: In-house periodical index
Card Catalog
Cataloged Volumes: 80,896
Holdings: 49,523 sales & auction catalogs; 62,651 exhibition
catalogs; 405,000 study photographs
Special Collections: Photographs & printed material covering
painting, sculpture, drawings, illuminated manuscripts
from 4th century A.D. to 20th century

AL 437
MORRIS GERBER COLLECTION
55 Sycamore St, Albany, NY 12208
Tel: 518-489-3051
Historian: Morris Gerber

Academic Founded: 1950
Hours: By appointment only
Circulation: Public
Reference Service: Telephone, mail
Reprographic Services: Yes
Interlibrary Loan: NILS
Networks/Consortia: Yes
Publications: Pictorial histories; book catalogs
Special Programs: Talks & exhibits on "Old Albany"
Holdings: 300 photographs; tear sheets; news clips; books;
posters; post cards; steroptican views; maps
Subjects: Architecture, film, graphics, photography, theatre

AL 438
THE SOLOMON R GUGGENHEIM MUSEUM
The Guggenheim Museum Library
1071 Fifth Ave, New York, NY 10028
Tel: 212-860-1300; 1338
Libn: Mary Joan Hall

Museum Founded: 1952
Hours: Mon, Wed, Thurs, Fri 11-5
 Tues 11-8
 (Appointment required)
Circulation: Staff & qualified researchers upon prior appoint-
ment (open stacks)
Reference Service: In person, telephone, mail
Interlibrary Loan: No
Networks/Consortia: No
Publications: Acquisitions list
Special Programs: Orientation tour for museum interns &
docents; intern program

Cataloged Volumes: 50,000
Serial Titles: 50
Holdings: 60,000 vertical file drawers; several hundred sales & auction catalogs; exhibition catalogs
Subjects: Art of the late 19th & 20th centuries

AL 439
HALL OF FAME FOR GREAT AMERICANS
Administrative Offices
2 Washington Sq Village, 1 F, New York, NY 10012
Tel: 212-533-4450
Executive Dir: Jerry Grundfest

Museum Founded: 1900
Hours: Mon-Sun 9-5
Circulation: In-house only
Reference Service: Telephone, mail
Reprographic Services: Yes
Interlibrary Loan: No
Networks/Consortia: No
Publications: Orientation handbook
Subjects: Art, American history, biography, sculpture, artists

AL 440
HAMILTON COLLEGE
Burke Library
Clinton, NY 13323
Tel: 315-859-7135
Libn: Frank K Lorenz

Academic Founded: 1812
Hours: Mon-Fri 8:30-12
 Sat 8:30-5
 Sun 12-12
Circulation: Public (open stacks)
Reference Service: In person, telephone, mail
Reprographic Services: Yes
Interlibrary Loan: NILS; Three R's; New York State Interlibrary Loan
Networks/Consortia: Three R's; New York State Interlibrary Loan
Publications: Orientation handbook; bibliographies; newsletter
Special Programs: Group & individual tours; bibliographic instruction; single lectures
Card Catalog
Cataloged Volumes: 4,500
Subjects: Art, decorative arts, architecture, classical archaeology, graphics, music, theatre, dance

AL 441
THE HISPANIC SOCIETY OF AMERICA LIBRARY
613 W 155 St, New York, NY 10032
Tel: 212-926-2235
Curator: Jean R Longland

Scholarly Society Founded: 1904
Hours: Tues-Fri 1-4:30
 Sat 10:30-4:30
 Closed holidays & August
Circulation: Restricted to within library
Reference Service: No
Reprographic Services: Yes; only microfilms of books printed before 1701 & manuscripts
Interlibrary Loan: No
Networks/Consortia: No
Publications: Bibliographies; special catalogs; books on art & literary subjects; book catalogs; in-house periodical index
Special Programs: Acoustiguide to museum

Card Catalog
Cataloged Volumes: c 150,000
Holdings: Sales & auction catalogs; exhibition catalogs
Subjects: Art, decorative arts, architecture, classical archaeology, music, theatre, dance

AL 442
ELBERT HUBBARD LIBRARY—MUSEUM
Village Hall, 571 Main St, East Aurora, NY 14052
Tel: 716-652-6000
Co-curators: Mr & Mrs Kenneth Whitney

Museum/Public Library Founded: 1962
Hours: Wed, Sat & Sun 2:30-4:30 (June-October)
 And by appointment
Circulation: Majority of volumes for use on premises only (open stacks)
Reference Service: In person, mail
Reprographic Services: No
Interlibrary Loan: No
Networks/Consortia: No
Publications: Orientation handbook
Special Programs: Group & individual tours
Cataloged Volumes: 1,700
Subjects: Crafts, furniture
Special Collection:
Elbert Hubbard Collection
Writings of Elbert Hubbard, publications of the Roycrofters, hand-illuminated books & examples of furniture, metal craft & leatherwork produced by Roycroft craftsmen.

AL 443
INTERNATIONAL MUSEUM OF PHOTOGRAPHY AT GEORGE EASTMAN HOUSE ARCHIVES
900 East Ave, Rochester, NY 14607
Tel: 716-271-3361, Exts 236; 235
Dir of Archives: Martha E Jenks

Museum Founded: 1939
Hours: Tues-Fri afternoons (by appointment)
Circulation: Faculty/staff
Reference Service: In person, telephone, mail (fee after first ½ hour)
Reprographic Services: Yes
Interlibrary Loan: Limited to providing photocopies
Networks/Consortia: OCLC
Publications: Quarterly periodical, *Image*; special catalogs & books; in-house periodical index
Special Programs: Group & individual tours; single lectures; intern program
Card Catalog
Serial Titles: 240 (Rochester Regional Research Library Council)
Holdings: 200 sales & auction catalogs; 700 exhibition catalogs; microforms; 450,000 original photographs
Subject: Photography

AL 444
HERBERT F JOHNSON MUSEUM OF ART/ CORNELL UNIVERSITY
Herbert F Johnson Museum Library
Cornell University, Ithaca, NY 14853
Tel: 607-256-6464
Asst Curator: Elizabeth C Evans

Museum 1953
Hours: Mon-Fri 9-5 (by appointment)

Circulation: Restricted to museum staff (open stacks; restricted to in-house)
Reference Service: No
Reprographic Services: No
Interlibrary Loan: No
Networks/Consortia: No
Special Programs: Student interns
Card Catalog
Cataloged Volumes: c 3,600
Serial Titles: 26
Holdings: 20 vertical file drawers; 1,800 sales & auction catalogs; exhibition catalogs
Subjects: Art, decorative arts, architecture, film & video, graphics, photography, crafts, drawings
Special Collections: Prints & photographs
Asian Art
Collection of exhibition catalogs, reference books, vertical files & subject monographs.

AL 445
LAKE PLACID SCHOOL OF ART/CENTER FOR MUSIC, DRAMA & ART
Fine Arts Library
Saranac Ave & Fawn Ridge, Lake Placid, NY 12946
Tel: 581-523-2591, Exts 30; 31
Libn: Stephen J Zietz

Art School Founded: 1975
Circulation: Public (open stacks)
Reference Service: In person
Reprographic Services: Yes
Interlibrary Loan: North Country Reference & Research Resources Council
Networks/Consortia: North Country Reference & Research Resources Council
Publications: Orientation handbook; bibliographies; in-house periodical index (Kardex File)
Special Programs: Group & individual tours; bibliographic instruction; single lectures; art bibliography & art history courses
Card Catalog
Cataloged Volumes: 3,829
Serial Titles: 140 (North Country Reference & Research Resources Council Union List of Serials)
Subjects: Art, decorative arts, architecture, film & video, graphics, photography

AL 446
M LOWENSTEIN & SONS, INC
Design Research Library
1430 Broadway, New York, NY 10018
Tel: 212-560-5610
Libn: Paula Pumplin

Textile Company Founded: 1935
Hours: Mon-Fri 9-1; 2-5
Circulation: Faculty/staff; restricted to use by company personnel (open stacks)
Reference Service: Telephone, mail
Reprographic Services: No
Interlibrary Loan: No
Networks/Consortia: No
Special Programs: Group & individual tours
Card Catalog
Cataloged Volumes: 1,200
Serial Titles: 20
Holdings: 13 vertical file drawers of pictures
Subjects: Art, decorative arts

Special Collection:
Textile Design
Seventy-five drawers of painted textile designs as well as 19th & 20th century textile swatches.

AL 447
MANHASSET PUBLIC LIBRARY
30 Onderdonk Ave, Manhasset, NY 11030
Tel: 516-627-2300
Dir: Elaine Seaton

Public Library Founded: 1945
Hours: Mon-Thurs 9-9 (Tues opens at 11)
 Fri 9-5:30
 Sat 9-5:30
 Sun 12-4:30
 Sat 9-3 (summer)
 Closed Sun (summer)
Circulation: Public (open stacks; reference collection non-circulating)
Reference Service: In person, telephone, mail
Reprographic Services: Yes
Interlibrary Loan: Nassau Library System; New York State Library System
Networks/Consortia: Nassau Library System; New York State Library System
Publications: Bibliographies; acquisitions list; newsletter; in-house periodical index (Card Catalog)
Special Programs: Group tours; bibliographic instruction
Card Catalog
Cataloged Volumes: 70,947
Serial Titles: 374 (Nassau-Suffolk Union List of Serials)
Holdings: 24 vertical file drawers; 47 microform titles
Subjects: Art
Special Collections:
Long Island Collection
History, social conditions, people & development that characterized the growth of Long Island life & communities.

AL 448
MEMORIAL ART GALLERY/UNIVERSITY OF ROCHESTER
Memorial Art Gallery Library
490 University Ave, Rochester, NY 14607
Tel: 716-275-4765
Libn: Beryl M Nesbit

Museum Founded: 1913
Hours: Tues-Sat 10-4
 Sun 1-5
 Closed July & Aug
Circulation: Faculty/staff, gallery members (open stacks)
Reference Service: Telephone, mail
Reprographic Services: Yes
Interlibrary Loan: NILS (through University of Rochester; ILL, Rush Rhees Library, University of Rochester, Rochester, NY 14627)
Networks/Consortia: No
Card Catalog
Cataloged Volumes: 12,400
Serial Titles: 86
Holdings: 24 vertical file drawers
Subjects: Art, decorative arts, architecture, classical archaeology, graphics, museology

AL 449
THE METROPOLITAN MUSEUM OF ART
Department of Prints

Fifth Ave & 82 St, New York, NY 10028
Tel: 212-879-5500, Ext 254
Libn: Mrs Colta F Ives

Museum Founded: 1870; 1917, Department of Prints
Hours: Tues-Fri 2-4:30 by appointment
Reprographic Services: Yes; photography by museum photographer
Interlibrary Loan: No
Networks/Consortia: No
Publications: Orientation handbook, general museum handbook, exhibition lists
Special Programs: By arrangement; intern program
Card Catalog
Subjects: Art, architecture, decorative arts, graphics, photography
Special Collections: Collection of original prints; rare books restricted to use in study room

AL 450
THE METROPOLITAN MUSEUM OF ART
Junior Museum Library
Fifth Ave & 82 St, New York, NY 10028
Tel: 212-879-5500, Ext 350
Museum Educator: Roberta Paine

Museum Founded: 1941
Hours: Tues-Sat 10-4:45
 Sun 1-4:45
Circulation: Restricted to research projects (open stacks)
Reference Service: In person only
Publications: Bibliographies
Card Catalog
Cataloged Volumes: 5,200
Subjects: Art, architecture, classical archaeology, dance, decorative arts, film & video, graphics, music, photography, theatre
Special Collection:
Children's Collection
Children's fiction & juvenile biographies relating to art & art history, and pre-school books.

AL 451
THE METROPOLITAN MUSEUM OF ART
The Thomas J Watson Library
Fifth Ave & 82 St, New York, NY 10028
Tel: 212-879-5500, Exts 221; 222
Libn: Elizabeth Reuter Usher

Museum Founded: 1881
Hours: Tues-Fri 10-4:45
 Closed holidays & Aug
Circulation: Faculty/staff; material circulates to offices only (open stacks; full-time staff only)
Reference Service: Telephone, mail
Reprographic Services: Yes
Interlibrary Loan: No
Networks/Consortia: New York Metropolitan Reference & Research Library Agency
Publications: Acquisitions list; special catalogs; exhibition check lists; exhibition catalog manual; book catalog; in-house periodical index (Guide to Periodicals)
Information Sources: Andrews, William Loring. "The Metropolitan Museum of Art—The Library, 1905," The Metropolitan Museum of Art *Bulletin, Supplement, Occasional Notes,* v 1, nos 1-4, March 1906; Bullock, Ena. "The Scope of the Library," *Library Journal,* v 71, December 1, 1947, pp 1688-1689; Clarke, Sir C Purdon. "The Scope

of the Library," The Metropolitan Museum of Art *Bulletin, Supplement, Occasional Notes,* v 1, no 4-5, March 1906; Humphry, James III. "The New Thomas J Watson Library at the Metropolitan Museum of Art," *Special Libraries,* v 56, Jul-Aug 1965, pp 393-399; Montignani, John B. "The Museum Library—Nucleus of a Study Collection?" *College Research Libraries,* v 4, Sept 1943, pp 289-293; Usher, Elizabeth R. "Rare Books and the Art Museum Library," *Special Libraries,* v 15-16, Jan 1961; Usher, Elizabeth R. "The Metropolitan Museum of Art Library (Research & Reference), (Memorial Name: The Thomas J Watson Library)," *Encyclopedia of Library & Information Science,* v 17, New York, Marcel Dekker, Inc., 1976, pp 472-481
Special Programs: Group & individual tours; bibliographic instruction; single lectures; intern program
Card Catalog
Cataloged Volumes: 206,852
Serial Titles: 1,200 (National Union Catalog)
Holdings: 99 vertical file drawers; sales & auction catalogs; exhibition catalogs; 447 microforms
Subjects: Art, decorative arts, architecture, classical archaeology, graphics, photography, music
Special Collection:
Art Sales Catalogs

AL 452
MUNSON-WILLIAMS-PROCTOR INSTITUTE
Art Reference Library
310 Genesee St, Utica, NY 13502
Tel: 315-797-0000, Ext 23
Libn: Martha S Maier

Museum/Art School Founded: 1940s
Hours: Tues-Sat 10-5
Circulation: Museum members, staff & school faculty (open stacks)
Reference Service: In person, telephone, mail
Reprographic Services: Yes
Interlibrary Loan: NILS; Central New York Library Resources Council
Networks/Consortia: Central New York Library Resources Council
Publications: Acquisitions list; newsletter
Card Catalog
Cataloged Volumes: 11,000
Serial Titles: 65 (Central New York Union List of Serials)
Holdings: 35 vertical file drawers; exhibition catalogs
Subjects: Art, decorative arts, architecture, graphics, photography
Special Collections: Autographs, bookplates, music covers
Fountain Elms Book Collection

AL 453
MUSEUM OF MODERN ART LIBRARY
21 W 53 St, New York, NY 10019
Tel: 212-956-7236; 7235
Libn: Clive Phillpot

Museum
Hours: Mon-Fri 1-5
Circulation: Faculty/staff (open stacks; only to staff)
Reference Service: In person, telephone, mail
Reprographic Services: Yes
Interlibrary Loan: NILS
Networks/Consortia: No
Publications: Exhibition catalogs; newsletter; in-house periodical catalog

Special Programs: Group & individual tours; bibliographic instruction; single lectures; intern program
Card Catalog
Cataloged Volumes: 35,000
Serial Titles: c 1,000
Subjects: Art, decorative arts, architecture, film & video, graphics, photography
Special Collections:
Paul Eluard-Camille Dausse Surrealism Collection
Manuscript & Paper Archives
Collection of artists' archives, including Curt Valentin & Hans Richter.

AL 454
NEW ROCHELLE PUBLIC LIBRARY
Fine Arts Department
662 Main St, New Rochelle, NY 11361
Tel: 914-632-7878
Dir: Eugene M Mittelgluck

Public Library Founded: 1892
Hours: Mon-Thurs 9-9
 Fri 9-6
 Sat 9-5
Circulation: Public (open stacks)
Reference Service: In person, telephone, mail
Reprographic Services: Yes
Interlibrary Loan: NILS; New York State Interlibrary Loan
Networks/Consortia: Westchester Library System
Cataloged Volumes: 5,000
Subjects: Art, architecture, classical archaeology, costume, dance, decorative arts, film & video, graphics, music, photography, theatre

AL 455
NEW YORK CITY COMMUNITY COLLEGE
Namm Hall Library/Learning Resource Center
300 Jay, Brooklyn, NY 11201
Tel: 212-643-5240
Libn: Edward Mapp

Academic Founded: 1947
Hours: Mon-Thurs 9-8
 Fri 9-5
Circulation: Students, faculty/staff (open stacks)
Reference Service: In person, telephone
Reprographic Services: Yes
Interlibrary Loan: NILS; CUNY Direct Access
Networks/Consortia: New York Metropolitan Reference & Research Library Agency; Academic Libraries of Brooklyn
Publications: Orientation handbook; bibliographies, newsletter; special catalogs; in-house periodical index (Periodicals in the Library)
Special Programs: Group & individual tours
Card Catalog
Cataloged Volumes: 111,539 (75,000 titles)
Serial Titles: 362
Holdings: 85 vertical file drawers; 4,000 microforms
Subjects: Art, architecture, graphics, photography
Special Collections:
The Picture Collection
File containing mounted pictures with special strength in portraits & reproductions of art masterpieces.

AL 456
THE NEW YORK PUBLIC LIBRARY
Donnell Library Center Art Library
20 W 53 St, New York, NY 10019

Tel: 212-790-6486
Libn: Rebecca Siekevitz

Public Library Founded: 1958
Circulation: Public (open stacks)
Reference Service
Reprographic Services: Yes
Interlibrary Loan: New York State Interlibrary Loan (Richard Muller, Interbranch Loan, 8 E 40 St, New York, NY 10016)
Networks/Consortia: No
Special Programs: Group & individual tours
Card Catalog: Also a book catalog
Cataloged Volumes: 16,000
Serial Titles: 75
Holdings: 20 vertical file drawers
Subjects: Art, architecture, classical archaeology, decorative arts, film & video, graphics, photography

AL 457
THE NEW YORK PUBLIC LIBRARY
Prints Division
Fifth Ave & 42 St, New York, NY 10018
Tel: 212-790-6207
Keeper of Prints: Elizabeth E Roth

Public Library Founded: 1900
Hours: Mon-Wed 1-6
 Fri-Sat 1-6
Circulation: Within the library only
Reference Service: Telephone, mail
Reprographic Services: Yes
Interlibrary Loan: No
Networks/Consortia: No
Publications: Book catalog
Card Catalog
Subjects: Graphics
Special Collections:
Eno Collection of New York City Views
Stokes Collection of American Historical Views

AL 458
THE NEW YORK PUBLIC LIBRARY
The Research Libraries
Fifth Ave & 42 St, New York, NY 10018
Tel: 212-790-6254
Dir: James W Henderson

Public Library
Hours: Mon-Wed 10-6
 Fri-Sat 10-6
Circulation: Within library only
Reference Service: In person, telephone, mail
Reprographic Services: Yes
Interlibrary Loan: Research Libraries Group (L Dawn Pohlman, Cooperative Services, New York Public Library)
Networks/Consortia: Research Libraries Group; New York Metropolitan Reference & Research Library Agency
Publications: Orientation handbook; in-house periodical index (Central Serial Record); book catalog
Special Programs: Group tours
Card Catalog
Cataloged Volumes: 4,672,995
Serial Titles: National Union Catalog; New York State Union List of Serials; Research Libraries Group Union List of Serials
Holdings: 2,522 linear feet of drawers; 1,208,040 microforms; 16 million prints, drawings, manuscripts

Subjects: Art, decorative arts, architecture, classical archaeology, film & video, graphics, photography, music, theatre, dance

Special Collections:

Arents Tobacco Collection

Books, pamphlets, manuscripts, drawings, prints & music relating to tobacco, including rare early works in foreign languages.

Art & Architecture Collection

Books on painting, sculpture, architectural design & history of decorative arts from prehistoric to contemporary with emphasis on Oriental, post-Columbian American art.

Dance Collection

Dance notations, scores for modern dance, archival material, rare books, oral tapes on all kinds of dance.

James Lenox Collection of Rare Books

Early Americana, American Revolution, Hulsius & De Bry voyages & travels.

Manuscripts & Archives

Medieval & Renaissance with major emphasis on American exploration, discovery, Spanish expansion & theatrical history.

Music Collection

Books & scores, complete works of standard composers, Elliott Shapiro Collection of Sheet Music, manuscripts & Rodgers & Hammerstein Archives of Recorded Sound.

Press Collection

Includes such works of private & special presses of Kelmscott Press, Ashendene, Golden Cockerel, Grabhorn, Nonesuch, etc.

Spencer Collection

Rare illustrated & illuminated manuscripts in fine bindings, book illustrations & book arts from all periods & countries.

The Theatre Collection

Includes performing artists, designers, producing firms, stage, films, TV, radio, vaudeville, circus, rodeo, magic, puppets as well as photographs, prints, lithographs, posters, motion pictures & TV stills, programs & playbills.

AL 459
NEW YORK STATE COLLEGE OF CERAMICS, ALFRED UNIVERSITY

Scholes Library of Ceramics
Harder Hall, State St, Alfred, NY 14802
Tel: 607-871-2492
Lib Dir: Robin R B Murray

Academic Founded: 1947
Hours: Mon-Thurs 8:30-10:30 pm
 Fri 8:30-4:30
 Sat 10-10:30
 Sun 1-5; 6:30-10:30
 Mon-Sun 8-4 (summer & holidays)
Circulation: Researchers, faculty/staff; reference library only (open stacks)
Reference Service: In person, telephone, mail (no extensive literature searches)
Reprographic Services: Yes
Interlibrary Loan: NILS; South Central Research Libraries Council (Martha A Mueller, Head, Readers' Service)
Networks/Consortia: South Central Research Libraries Council; State University of New York; OCLC
Publications: Bibliographies; acquisitions list; newsletter
Information Sources: Fréchette, Van Derck. "Impudence—and the Ceramic College Library," *Ceramic College Review*, v 2 (1), no 7-8, Jan-March 1971; Murray, Robin R B. "The Library of Ceramic Science and Art," *Special*

Libraries Association, Metals/Materials News, v 23 (4), no 3-4, May 1976; Connolly, Bruce E. "Scholes Library of Ceramics," Special Libraries Association Museum, Arts, and Humanities Divsion, *Bulletin,* Fall 1976

Special Programs: Group & individual tours; bibliographic instruction
Card Catalog
Cataloged Volumes: 15,000 (14,500 art titles)
Serial Titles: 200 Art; 1,600 engineering & science (National Union Catalog; Chemical Abstracts; New York State; SUNY; South Central Research Libraries Council)
Subjects: Art, decorative arts, architecture, classical archaeology, film & video, graphics, photography, pottery, porcelain, glass, refractories, whitewares, ceramics
Special Collections: Ceramics

AL 460
NEW YORK UNIVERSITY/INSTITUTE OF FINE ARTS

Stephen Chan Library of Fine Arts
1 E 78 St, New York, NY 10021
Tel: 212-988-5550
Chief Libn: Evelyn K Samuel

Academic
Hours: Mon-Fri 9-5
 Sat 10-2
Circulation: (open stacks)
Reference Service: In person, telephone; limited to catalog assistance
Reprographic Services: Yes
Interlibrary Loan: NILS
Networks/Consortia: No
Publications: Orientation handbook
Special Programs: Group tours; bibliographic instruction; single lectures
Card Catalog
Cataloged Volumes: 80,000
Serial Titles: 400 (National Union Catalog; Union List of Serials; New York University–UNISEC)
Holdings: 20 vertical file drawers; 100 microforms
Subjects: Art, architecture, classical archaeology, decorative arts, graphics, photography
Special Collections:
Conservation Center Library
Contains items on the conservation & restoration of works of art including such topics as chemical analysis, history of technology & offprint file.
Friedlander Source Collection
Includes source materials collected by Professor Walter Friedlander.

AL 461
ONONDAGA COUNTY PUBLIC LIBRARY

Art & Music Department
335 Montgomery St, Syracuse, NY 13202
Tel: 315-473-4492
Libn: Beatrice N Marble

Public Library Founded: 1916
Hours: Mon, Wed, Fri 9-9
 Tues, Thurs 9-5:30
 Sat 9-5
Circulation: Public (open stacks)
Reference Service: In person, telephone, mail
Reprographic Services: Yes
Interlibrary Loan: New York State Interlibrary Loan

Networks/Consortia: No
Special Programs: Group tours
Card Catalog
Serial Titles: 68
Subjects: Art, decorative arts, architecture, graphics, photography, music, dance

AL 462
PARRISH ART MUSEUM
Saarinen Art Reference Library
25 Jobs Lane, Southampton, NY 11968
Tel: 516-283-2118
Dir: Jean M Weber

Museum Founded: 1896
Hours: Tues-Sat 10-5
 Sun 2-5
Circulation: Restricted to within library (open stacks)
Reference Service: In person, telephone, mail
Reprographic Services: Yes; fee for photography
Interlibrary Loan: No
Networks/Consortia: No
Publications: Orientation handbook; newsletter; special
 catalogs
Special Programs: Group tours; single lectures
Card Catalog
Cataloged Volumes: c 2,500
Holdings: 150 sales & auction catalogs; 400 exhibition
 catalogs
Subjects: Art, architecture
Special Collections:
William Merritt Chase Archive
Contains 42 works, exhibition & sales catalogs, photographs,
 articles, reprints, memorabilia, slides about or by the
 American painter William Chase.

AL 463
PARSONS SCHOOL OF DESIGN
Adam L Gimbel Library
66 Fifth Ave, New York, NY 10011
Tel: 212-741-8914-5
Head Libn: Christiane C Collins

Art School Founded: 1896
Hours: Mon-Thurs 9-9
 Fri 9-6
Circulation: Students, faculty/staff (open stacks; rare &
 special collections do not circulate)
Reference Service: Telephone
Reprographic Services: No
Interlibrary Loan: No
Networks/Consortia: No
Special Programs: Group & individual tours; single lectures
Card Catalog
Cataloged Volumes: 30,000 (28,000 titles)
Serial Titles: 132 (National Union Catalog)
Holdings: 22,000 picture plates
Subjects: Art, architecture, city planning, costume, decorative
 arts, film & video, graphics, landscape architecture,
 photography

AL 464
THE PIERPONT MORGAN LIBRARY
29-33 E 36 St, New York, NY 10016
Tel: 212-685-0008
Dir: Charles A Ryskamp

Museum & Rare Book Library Founded: 1924

Hours: Tues-Sat 10:30-5
 Sun & Holidays 1-5
 Closed Aug
Circulation: Collection circulates for exhibition purposes only
Reference Service: In person, telephone, mail
Reprographic Services: Yes
Interlibrary Loan: No
Networks/Consortia: No
Publications: Orientation handbook; acquisitions list; special
 catalogs
Special Programs: Group & individual tours; single lectures;
 intern program
Card Catalog
Cataloged Volumes: 70,000
Serial Titles: 350
Holdings: 16 vertical file drawers; 5,000 sales & auction
 catalogs; 5,000 exhibition catalogs
Subjects: Art, manuscript illumination, autography, incu-
 nabula, rare books
Special Collections: Manuscript illumination, incunabula,
 bindings, Rembrandt etchings, cylinder seals, rare books,
 master drawings

AL 465
THE PLAYERS
The Walter Hampden–Edwin Booth Theatre Collection
 & Library
16 Gramercy Pk, New York, NY 10003
Tel: 212-228-7610
Curator & Libn: Louis A Rachow

Performing Arts Library Founded: 1957
Hours: Mon-Fri 10-5
Circulation: Researchers by application to librarian
Reference Service: Telephone, mail
Reprographic Services: Yes; except rare materials
Interlibrary Loan: No
Networks/Consortia: No
Information Sources: Novotny, Ann, ed. *Picture Sources 3*,
 New York, Special Libraries Association, 1975, p 216;
 Perry, Ted, ed. *Performing Arts Resources*, v 1, New
 York, Theatre Library Association, 1975, pp 13-14;
 Shattuck, Charles. *The Shakespeare Promptbooks: a
 Descriptive Catalogue*, Urbana, University of Illinois
 Press, 1965
Special Programs: Group & individual tours; bibliographic
 instruction; single lectures (all by appointment)
Card Catalog
Cataloged Volumes: 15,000
Serial Titles: 85
Holdings: 130 vertical file drawers; 200 sales & auction
 catalogs
Subjects: Film & video, theatre
Special Collections:
Actors & Actresses Archives
Includes manuscripts, correspondence, photographs, playbills
 & memorabilia of Tallulah Bankhead, Edwin Booth,
 Maurice Evans, Muriel Kirkland.
Romney Brent Collection
Numerous letters by actors & actresses to Mr Brent including
 a large collection of letters pertaining to Brent's foreign
 tours as an American Specialist for the US Department of
 State from 1967–68.
Chuck Callahan Burlesque Collection
300 burlesque scripts & vaudeville skits, music in manuscript,
 25 photographs in character, two period song books, note-
 book of stage gags & repartee, typescript of Chuck Callahan
 & memorabilia.

Max Gordon Collection
One hundred thirty typescripts of shows produced by Max
 Gordon and archival material.
Walter Hampden Collection
Official company records of Walter Hampden, Inc, numerous
 promptbooks & annotated scripts, correspondence from
 1896, photographs, clippings & blueprints & sketches of
 productions by Claude Bragdon.
Franklin Heller Collection
Correspondence, photographs, playscripts by Moss Hart &
 George S Kaufman, John Steinbeck, Thomas Wolfe, etc.
Henderson Collection of English Theatre Playbills
Indexed collection of bills of the English stage from 1734–
 1888.
Newman Levy Collection
Correspondence, research notes, 100 typescripts of short
 stories, plays & poems with holograph corrections & addi-
 tions, original typescript of unpublished biography of
 Franklin P Adams by Levy.
Robert Bruce Mantell Collection
Playscripts, with holograph stage directions, correspondence
 & archival material.
John Mulholland Magic Collection
Includes the first printed book on magic to contemporary
 publications in foreign languages, periodicals, letters by
 magicians, historical magic apparatus, artifacts, broad-
 sides, posters, photographs & memorabilia.

AL 466
PRATT INSTITUTE
Art & Architecture Department/Pratt Institute Library
Brooklyn, NY 11205
Tel: 212-636-3685
Assoc Professor: Sydney Keaveney

Art School Founded: 1887
Hours: Mon-Thurs 9-9
 Fri 9-5
 Sat 11-5
 Sun 1-6
Circulation: Students, faculty/staff (open stacks; non-
 circulating reference collection)
Reference Service: In person, telephone, mail
Reprographic Services: Yes
Interlibrary Loan: NILS
Networks/Consortia: New York Metropolitan Reference &
 Research Library Agency; Academic Libraries of Brook-
 lyn; Brooklyn Education & Cultural Alliance
Publications: Bibliographies; acquisitions list; special hand-
 books; in-house periodical catalog (Periodicals in the
 Libraries of Pratt Institute & St Joseph College)
Special Programs: Group & individual tours; bibliographic
 instruction; intern program
Card Catalog
Cataloged Volumes: 24,700
Serial Titles: 102 (in Art & Architecture Department)
Holdings: Exhibition catalogs
Subjects: Art, decorative arts, architecture, film & video,
 graphics, photography, music, theatre, dance, costume,
 city & regional planning, book arts, crafts, design arts
Special Collection:
Picture Collection
About 100,000 items consisting of subject clipping file,
 artist reproductions file, architects' file, architecture file,
 portraits & fashion designer files.

AL 467
PRATT–NEW YORK PHOENIX SCHOOL OF
DESIGN

Pratt Institute Library Branch
160 Lexington Ave, New York, NY 10016
Tel: 212-685-7064
Lib Trainee: Jane Tiarsmith

Art School
Hours: Mon-Thurs 9-4
Circulation: Students, faculty/staff (open stacks)
Reference Service: In person, telephone, mail
Reprographic Services: No
Interlibrary Loan: Pratt Institute Library System (Laura
 Noskowitz, Reference Department, Pratt Institute Library,
 Brooklyn, NY 11205)
Networks/Consortia: New York Metropolitan Reference &
 Research Library Agency; American Libraries of Brook-
 lyn; Brooklyn Educational & Cultural Alliance
Cataloged Volumes: 1,000
Serial Titles: 29 (current year only)
Holdings: 2 vertical file drawers of artists; 1 vertical file
 drawer of portraits; 6 vertical file drawers of pictures
Subjects: Art, decorative arts

AL 468
JAMES PRENDERGAST LIBRARY ASSOCIATION
509 Cherry St, Jamestown, NY 14701
Tel: 716-484-7135
Dir: Murray L Bob

Public Library Founded: 1889
Hours: Mon-Fri 9-9
 Sat 9-6; 9-5 June-Aug
 Sun 1-4 Nov-April only
Circulation: Public (open stacks)
Reference Service: In person, telephone, mail
Reprographic Services: No
Interlibrary Loan: NILS; New York State Interlibrary Loan;
 Chautauqua Cattaraugus Library System
Networks/Consortia: Western New York Library Resources
 Council
Publications: In-house periodical index
Special Programs: Group & individual tours; bibliographic
 instruction; single lectures
Cataloged Volumes: 180,000
Serial Titles: 400 (Western New York Union List of Serials)
Holdings: 36 vertical file drawers; 84 microforms; 100 exhibi-
 tion catalogs
Subjects: Art, architecture, classical archaeology, dance,
 decorative arts, film & video, graphics, music, photography,
 theatre

AL 469
QUEENS BOROUGH PUBLIC LIBRARY
Art & Music Division
89-11 Merrick Blvd, Jamaica, NY 11373
Tel: 212-739-1900, Ext 327
Head, Art & Music Div: Dorothea Wu

Public Library Founded: 1933
Hours: Mon-Fri 10-9
 Sat 10-5:30
 Sun 1-5 (mid Oct-May)
Circulation: Public (open stacks except for reference & circu-
 lating materials)
Reference Service: In person, telephone, mail
Reprographic Services: Yes
Interlibrary Loan: NILS; New York State Interlibrary Loan
 Program (Pearl Holford, Queens Borough Public Library
 Central Library); Metropolitan Reference & Research
 Library Agency

Networks/Consortia: No
Publications: In-house periodical index (Index to Symphonic
 Program Notes)
Special Programs: Group & individual tours
Card Catalog
Cataloged Volumes: 60,000
Serial Titles: 258 with over 100 continuations (National
 Union Catalog; Union List of Periodicals held by Queens
 Borough Public Library, Central Library; Queens College;
 Queensborough Community College; St Johns University;
 and York College—1973)
Holdings: 46 vertical file drawers; 1,000 microfilms
Subjects: Art, architecture, classical archaeology, dance,
 decorative arts, film & video, graphics, music, photography,
 theatre
Special Collections:
The Picture Collection
Over one million reproductions, photographs, postcards &
 clippings from books & magazines.

AL 470
QUEENS COLLEGE OF THE CITY UNIVERSITY
OF NEW YORK
Art Center, Paul Klapper Library
Kissena Blvd, Flushing, NY 11367
Tel: 212-520-7243
Libn: Gerd Muehsam

Academic
Circulation: Students, faculty/staff (open stacks)
Reference Service: Yes
Reprographic Services: For internal use only
Interlibrary Loan: NILS; New York Metropolitan Reference
 & Research Library Agency (Mimi Penchansky)
Networks/Consortia: OCLC
Special Programs: Group & individual tours; bibliographic
 instruction; single lectures; intern program
Cataloged Volumes: 20,000
Serial Titles: 150
Holdings: 120 vertical file drawers; 12,000 slides; 7,000
 exhibition catalogs
Subjects: Art, architecture, classical archaeology, graphics,
 photography
Special Collection:
Queens College Art Collection
Collection of paintings, sculpture, graphics, glass & other
 art objects dating from antiquity to the 20th century.

AL 471
ROCHESTER INSTITUTE OF TECHNOLOGY
Graphic Arts Information Service
One Lomb Memorial Dr, Rochester, NY 14623
Tel: 716-475-2791
Lib Asst: Sally Tuttle

Academic Founded: 1954
Hours: Mon-Fri 8-4
Circulation: Graduate students, researchers, faculty/staff;
 serials circulate to faculty/staff only (open stacks)
Reference Service: In person, telephone, mail
Interlibrary Loan: Yes
Networks/Consortia: No
Publications: Bibliographies; newsletter; special catalogs;
 reports; book catalog
Cataloged Volumes: 2,000
Serial Titles: 200
Holdings: 25 vertical file drawers; 20,000 articles on micro-
 forms
Subjects: Graphic arts, printing

AL 472
ROCHESTER INSTITUTE OF TECHNOLOGY
Wallace Memorial Library—Art Reference
One Lomb Memorial Dr, Rochester, NY 14623
Tel: 716-464-2569
Libn: Ray Anne Kibbey

Academic
Circulation: Students, faculty/staff (open stacks)
Reference Service: In person, telephone
Reprographic Services: Yes
Interlibrary Loan: NILS
Networks/Consortia: No
Publications: Bibliographies; acquisitions list; in-house
 periodical catalog (Periodical File)
Special Programs: Group tours; single lectures
Card Catalog
Cataloged Volumes: 250,000
Serial Titles: (Rochester Regional Resources Library Council
 Union List of Serials)
Subjects: Art, decorative arts, architecture, film & video,
 graphics, photography
Special Collections: Crafts, decorative arts, design & photog-
 raphy
Cary Library
Collection of fine printing & printing history.
Graphic Arts Research Center Collection

AL 473
ROCHESTER MUSEUM & SCIENCE CENTER
Museum Library
657 East Ave, Rochester, NY 14603
Tel: 716-223-4780, Ext 30
Libn: Janice Tauer Wass

Museum
Hours: Tues-Sat 9-12; 1-5
Reference Service: Telephone, mail
Reprographic Services: Yes
Interlibrary Loan: No
Networks/Consortia: Rochester Regional Research Library
 Council
Publications: Newsletter
Special Programs: Intern program
Card Catalog
Cataloged Volumes: 20,000
Serial Titles: 60 (Rochester Regional Research Library
 Council Union List)
Holdings: 29 vertical file drawers
Subjects: Art, architecture, classical archaeology, decorative
 arts, film & video, graphics, music, photography

AL 474
ROCHESTER PUBLIC LIBRARY
115 South Ave, Rochester, NY 14604
Tel: 716-428-7332
Dir: Harold Hacker

Public Library Founded: 1911
Hours: Mon-Thurs 9-9
 Fri 9-6
 Sat 9-5
 Closed Sat during summer
Circulation: Public (open stacks except for rare material &
 multiple copies)
Reference Service: In person, telephone, mail
Reprographic Services: Yes
Interlibrary Loan: NILS; Five County Pioneer Library
 System

Networks/Consortia: Rochester Regional Research Library Council; New York State Interlibrary Loan
Publications: In-house periodical catalog
Special Programs: Group tours; single lectures; book discussions
Cataloged Volumes: 428,470 total; 35,700 art
Serial Titles: 4,900 total; 175 art
Holdings: (Central Library figures): 8,383 microfilms; 29,150 microfiche
Subjects: Art, architecture, city planning, dance, decorative arts, film & video, graphics, music, photography, theatre

AL 475
STATE UNIVERSITY OF NEW YORK AT ALBANY LIBRARY
1400 Washington Ave, Albany, NY 12222
Tel: 518-457-8564
Dir of Libs: C James Schmidt

Academic
Hours: Sun-Thurs 7:30-12
Fri 7:30-10
Sat 9-8
Circulation: Students, faculty/staff (open stacks except for special collections material)
Reference Service: In person, telephone, mail
Reprographic Services: Yes
Interlibrary Loan: NILS; New York State Interlibrary Loan
Publications: Bibliographies; acquisitions list; in-house periodical index (Computer Print-out of Periodicals)
Special Programs: Group & individual tours; bibliographic instruction
Serial Titles: (New York State Union List; State University of New York Union List)
Subjects: Art, classical archaeology, decorative arts, music, theatre

AL 476
STATE UNIVERSITY OF NEW YORK AT BINGHAMTON
Fine Arts Library
Vestal Pkwy E, Binghamton, NY 13901
Tel: 607-798-4927; 2206
Fine Arts Libn: Thomas J Jacoby

Academic Founded: 1974
Hours: Mon-Thurs 8-11
Fri 8-5
Sat 12-6
Sun 12-11
Circulation: Public; rare items do not circulate (open stacks)
Reference Service: In person, telephone, mail
Reprographic Services: Yes
Interlibrary Loan: State University of New York Open Access System; Five Associated University Libraries; New York State University Loan; Center for Research Libraries; South Central Research Libraries Council (Reference Department, Interlibrary Loan Office, University Library)
Networks/Consortia: OCLC; Five Associated University Libraries; State University of New York; South Central Research Libraries Council
Publications: Orientation sheet; in-house periodical index (State University of New York at Binghamton Periodicals)
Special Programs: Group & individual tours; bibliographic instruction; single lectures
Cataloged Volumes: 65,000 (63,000 titles)
Serial Titles: 600 total; 225 art (State University of New York Union List; South Central Research Libraries Council Union List)

Holdings: 3,000 sales & auction catalogs; 7,000 exhibition catalogs; few microforms
Subjects: Art, architecture, classical archaeology, dance, decorative arts, film & video, graphics, music, photography, theatre
Special Collections: Western Art; Ancient Near East Art

AL 477
STATE UNIVERSITY OF NEW YORK AT BUFFALO
Art Library
Ellicott Complex, SUNYAB Amherst Campus, Buffalo, NY 14261
Tel: 716-636-2515; 2516
Libn: Florence S DaLuiso

Academic Founded: 1963
Hours: Mon-Tues 9-9
Wed-Fri 9-5
Sat 1-5
Sun 1-6
Circulation: Students, researchers, faculty/staff (open stacks)
Reference Service: Telephone, mail
Reprographic Services: Yes
Interlibrary Loan: NILS; State University of New York Open Access (R Kroll, IL Office, Lockwood Library, SUNY Buffalo, NY 14214)
Networks/Consortia: Five Associated University Libraries of New York State
Publications: Orientation handbook; bibliographies; in-house periodical index (Union List of Serials)
Special Programs: Group & individual tours; bibliographic instruction; single lectures; intern program
Card Catalog
Cataloged Volumes: 38,493
Serial Titles: 364 (National Union Catalog; SUNY List of Periodicals; New Serial Titles; Western New York List of Periodicals; New York State List of Periodicals)
Holdings: 4 vertical file drawers; 10,000 exhibition catalogs
Subjects: Art, decorative arts, architecture, classical archaeology, graphics, photography, theatre set design

AL 478
STATE UNIVERSITY OF NEW YORK COLLEGE AT CORTLAND
Memorial Library
Cortland, NY 13045
Tel: 607-753-2525
Dir of Libs: Selby Gration

Academic Founded: 1867
Hours: Mon-Thurs 8-11 pm
Fri 8-5
Sat 11-5
Sun 2-11
Circulation: Public, county residents & SUNY students (open stacks)
Reference Service: Telephone, mail
Reprographic Services: Yes
Interlibrary Loan: New York State Interlibrary Loan; OCLC; 3 R's; South Central Research Council
Networks/Consortia: No
Publications: Orientation handbook; bibliographies
Special Programs: Group & individual tours; bibliographic instruction; single lectures; slide/tape presentation on use of library
Card Catalog
Cataloged Volumes: 227,466
Serial Titles: 1,517
Holdings: 251,736 microfilm

Subjects: Art, architecture, classical archaeology, dance, decorative arts, film & video, graphics, music, photography, theatre
Special Collections: Palmer Collection of nature appreciation & study

AL 479
STATE UNIVERSITY OF NEW YORK COLLEGE AT NEW PALTZ
Sojourner Truth Library
New Paltz, NY 12561
Tel: 914-257-2200

Academic Founded: 1885
Hours: Mon-Thurs 8:30-11 pm
 Fri 8:30-10
 Sat 9-5
 Sun 1-11
 Mon-Fri 8:30-5 (intersessions only)
Circulation: Public (open stacks)
Reference Service: In person, telephone, mail
Reprographic Services: Yes
Interlibrary Loan: NILS; New York State Interlibrary Loan
Networks/Consortia: OCLC
Publications: Orientation handbook; bibliographies; acquisitions list; newsletter
Special Programs: Group tours; bibliographic instruction; single lectures
Cataloged Volumes: 280,000 total; 16,000 art
Serial Titles: 1,762
Holdings: 20 vertical file drawers; 470,000 microforms; exhibition catalogs
Subjects: Art, architecture, classical archaeology, dance, decorative arts, film & video, graphics, music, photography, theatre
Special Collection:
Asian & African Art Collection
Includes materials in English, Japanese & Chinese.

AL 480
SYRACUSE UNIVERSITY LIBRARIES
Fine Arts Department/Bird Library
205 Bird Library, Waverly Ave, Syracuse, NY 13210
Tel: 315-423-2440
Libn: Donald C Seibert

Academic Founded: 1871
Hours: Mon-Thurs 8-11 pm
 Fri 8-6
 Sat 10-6
 Sun 12-10
Circulation: Students, researchers, faculty/staff, alumni (open stacks)
Reference Service: In person, telephone, mail
Reprographic Services: Yes
Interlibrary Loan: NILS; CENTRO; Five Associated University Libraries of New York (ILL, Dorcas MacDonald, 116 Bird Library)
Networks/Consortia: OCLC; NASA; MEDLARS; Engineering Index
Publications: Acquisitions list; newsletter; special catalogs
Special Programs: Group & individual tours; bibliographic instruction; single lectures
Card Catalog
Cataloged Volumes: 40,000
Serial Titles: 100 (Central New York Union List of Serials; New York State Union List of Serials)
Holdings: 10,000 unmounted photographs; 3,000 mounted

photographs; 1,200 exhibition catalogs; 50 microfilm reels
Subjects: Art, decorative arts, architecture, graphics, photography, music, crafts, synesthetic education

AL 481
UNION OF AMERICAN HEBREW CONGREGATIONS
Synagogue Art & Architectural Library
838 Fifth Ave, New York, NY 10021
Tel: 212-249-0100
Dir: Myron E Schoen

National Religious Congregational Institution Founded: 1957
Hours: 9:30-5
Circulation: Restricted to in-house use of materials
Reprographic Services: No
Interlibrary Loan: No
Networks/Consortia: No
Cataloged Volumes: 200
Subjects: Art, Synagogue art & architecture, Judaica

AL 482
UNIVERSITY OF ROCHESTER
Fine Art Library/Rush Rhees Library
River Campus, Rochester, NY 14627
Tel: 716-275-4476
Libn: Stephanie Grontz

Academic Founded: 1955
Hours: Mon-Thurs 9-10 pm
 Fri 9-8
 Sat 12-5
 Sun 2-10
Circulation: Students, faculty/staff; restricted folios & periodicals are non-circulating (open stacks)
Reference Service: In person, telephone, mail
Reprographic Services: Yes
Interlibrary Loan: NILS; Five Associated University Libraries of New York; New York State Interlibrary Loan; Rochester Regional Research Library Council
Networks/Consortia: Five Associated University Libraries of New York; Rochester Regional Research Library Council
Publications: Orientation handbook; bibliographies; acquisitions list; in-house periodical index (University of Rochester Union List of Periodicals)
Special Programs: Individual tours; bibliographical instruction; single lectures
Card Catalog
Cataloged Volumes: 32,000
Serial Titles: 220 (National Union Catalog)
Holdings: 32 vertical file drawers; sales & auction catalogs; 500 exhibition catalogs; microforms
Subjects: Art, architecture, photography

AL 483
VASSAR COLLEGE
Art Library
Poughkeepsie, NY 12601
Tel: 914-452-7000, Ext 2136
Libn: Janis Ekdahl

Academic Founded: 1937
Hours: Mon-Thurs 8:30-12 pm
 Fri 8:30-10
 Sat 9-10
 Sun 10-12
 Mon-Fri 8:30-4:30 (vacations)
 Summer by appointment only

Circulation: Students, researchers, faculty/staff (open stacks)
Reference Service: Yes
Reprographic Services: Yes
Interlibrary Loan: New York State Interlibrary Loan; Southeastern New York Library Resources Council
Networks/Consortia: No
Publications: Bibliographies; acquisitions list
Special Programs: Bibliographic instruction
Card Catalog
Cataloged Volumes: 29,825
Serial Titles: 162 (National Union Catalog; Southeastern New York Library Resources Council Union List, 1973)
Holdings: 10 vertical file drawers; exhibition catalogs
Subjects: Art, decorative arts, architecture, classical archaeology, photography

AL 484
WHITNEY MUSEUM OF AMERICAN ART LIBRARY
945 Madison Ave & 75 St, New York, NY 10021
Tel: 212-794-0649
Libn: Arno Kastner

Museum Founded: 1954
Hours: Tues-Fri 10-12; 2-5 (by appointment)
Circulation: In-house use
Reference Service: In person, telephone, mail
Reprographic Services: Yes
Interlibrary Loan: No
Networks/Consortia: No
Special Programs: Individual tours; intern program
Card Catalog
Cataloged Volumes: 7,120 (5,957 titles)
Serial Titles: 70
Holdings: 72 vertical file drawers; 1,000 sales & auction catalogs; 122 microform reels
Subjects: Art
Special Collections:
American Art Research Council Archives
Lloyd Goodrich Archives
Hartley-McCausland Papers
Gertrude Vanderbilt Whitney Collection
Whitney Museum Archives

AL 485
YIVO INSTITUTE FOR JEWISH RESEARCH, INC.
Library, Archives, Slide Bank
1048 Fifth Ave, New York, NY 10028
Tel: 212-535-6700, Exts 43; 30; 32
Dir: Morris Laub

Research Institute Founded: 1925
Hours: Mon-Fri 9:30-5:30
Circulation: Faculty/staff
Reference Service: Telephone, mail (fee for extensive searches)
Reprographic Services: Yes; fragile material restricted
Interlibrary Loan: NILS
Networks/Consortia: National Union Catalog; Council on Research Libraries & Archives in Jewish Studies
Publications: Orientation handbook; bibliographies; acquisitions list; newsletter; special catalogs; monographs and serials
Information Sources: Abramowicz, Dina. "The YIVO Library," *The Jewish Book Annual*, v 25, 1967-8; Gilson, Estelle. "YIVO: where Yiddish scholarship lives," *Present Tense*, Autumn 1976
Special Programs: Group & individual tours
Card Catalog
Cataloged Volumes: 2,000

Serial Titles: 5 (National Union Catalog)
Holdings: 200 sales & auction catalogs; 200 exhibition catalogs
Subjects: Art, decorative arts, architecture, film & video, graphics, photography, music, theatre, dance
Special Collections:
Jewish Art & Artists
YIVO Original Art Collection
Original works & reference materials, including reproductions.

AL 486
YONKERS PUBLIC LIBRARY
Fine Arts Department
1500 Central Park Ave, Yonkers, NY 10710
Tel: 914-337-1500, Ext 21
Libn: Martita Schwarz

Public Library Founded: 1962
Circulation: Public (open stacks)
Reference Service: In person, telephone, mail
Reprographic Services: Yes
Interlibrary Loan: New York State Interlibrary Loan
Networks/Consortia: Westchester Library System
Publications: Orientation handbook; bibliographies; acquisitions list
Special Programs: Group tours; single lectures; intern program
Card Catalog
Cataloged Volumes: 11,323
Serial Titles: 63 (Westchester Library System)
Holdings: 28 vertical file drawers; 15,817 recordings (discs, tapes)
Subjects: Art, decorative arts, architecture, film & video, graphics, photography, music, theatre, dance

North Carolina

AL 487
BREVARD COLLEGE
James Addison Jones Library
Brevard, NC 28712
Tel: 704-883-8292, Ext 68
Libn: Jane Wright

Academic (junior college)
Hours: Mon-Fri 8-6:30 (during academic year)
 Mon-Fri 9-12; 1:30-4 (intersession)
Circulation: Public (open stacks)
Reference Service: In person, telephone, mail (for students, faculty/staff only)
Reprographic Services: Yes
Interlibrary Loan: North Carolina State Interlibrary Loan
Networks/Consortia: Yes
Publications: In-house periodical index
Special Programs: Orientation for new students
Cataloged Volumes: 36,600
Serial Titles: 280 (Western North Carolina Union List of Periodical Holdings)
Holdings: 16 vertical file drawers; *New York Times* on microform
Subjects: Art, architecture, dance, decorative arts, music, photography, theatre

AL 488
DUKE UNIVERSITY LIBRARIES
Durham, NC 27706
Tel: 919-684-3675
Libn: Evelyn Harrison

Academic Founded: 1888
Hours: Mon-Fri 8-12
 Sat 9-10:30
 Sun 12-12
Circulation: Public (open stacks; restricted use of journals &
 rare books)
Reference Service: In person, telephone, mail
Reprographic Services: Yes
Interlibrary Loan: NILS; daily loan service among libraries
 belonging to State University System in the Triangle area
 (Interlibrary Loan Librarian, Perkins Library, Duke Uni-
 versity)
Networks/Consortia: No
Publications: In-house periodical index
Special Programs: Group & individual tours; bibliographic
 instruction; single lectures
Card Catalog
Cataloged Volumes: 112,000
Serial Titles: 166 (National Union Catalog)
Holdings: 1,450 sales & auction catalogs
Subjects: Art, architecture, classical archaeology, dance,
 decorative arts, music, theatre

AL 489
EAST CAROLINA UNIVERSITY
School of Art Library
Greenville, NC 27834
Tel: 919-757-6785
Art Libn: Nancy J Pistorius

Academic Founded: 1967
Hours: Mon-Fri 8-12; 1-5
Circulation: Students, faculty/staff (open stacks)
Reference Service: In person, telephone, mail
Reprographic Services: Available through University Library
 only
Interlibrary Loan: Available through University Library only
Networks/Consortia: No
Special Programs: Bibliographic instruction
Subjects: Art, architecture, decorative arts, film & video,
 graphics, photography

AL 490
LANIER LIBRARY ASSOCIATION, INC.
114 Chestnut St, Tryon, NC 28782
Tel: 704-852-2951
Administrator: Mildred W Morgan

Membership Library Founded: 1890
Hours: Tues, Thurs, Sat 9:30-4:30
Circulation: Students, researchers, faculty/staff; restricted to
 members (open stacks)
Reference Service: Telephone, mail
Reprographic Services: No
Interlibrary Loan: North Carolina State Interlibrary Loan
 (Dept of Art, Culture & History, North Carolina State
 Library, Raleigh, NC 27611)
Networks/Consortia: No
Publications: Acquisitions list; newsletter; weekly newspaper
 book reviews; in-house periodical index
Information Source: *The Lanier Library, Diamond Jubilee
 1890–1965,* Tryon, North Caolina (privately printed)
Special Programs: Group & individual tours; single lectures;
 cultural programs
Card Catalog
Cataloged Volumes: 23,500 (23,000 titles)
Holdings: Vertical file drawers; 10 sales & auction catalogs;
 15 exhibition catalogs

Subjects: Art, decorative arts, architecture, classical archae-
 ology, graphics, photography, music, theatre, dance
Special Collections: Theatre, art appreciation & instruction
Civil War Collection
"Old Masters" Collection
Eighteen portfolios.

AL 491
MINT MUSEUM OF ART
Mint Museum of Art Library/Delhom-Gambrell Reference
 Library
501 Hempstead Place, Charlotte, NC 28207
Tel: 704-334-9725
Libn: Sara H Wolf

Museum Founded: 1955; 1969
Hours: Tues-Fri 10-12
Circulation: Staff, museum members, public by appointment
 (closed stacks)
Reference Service: No
Reprographic Services: No
Interlibrary Loan: No
Networks/Consortia: No
Cataloged Volumes: 4,130
Serial Titles: 41
Holdings: 4 vertical file drawers; 22 shelves of sales &
 auction catalogs
Subjects: Art, architecture, decorative arts, graphics, photog-
 raphy
Special Collections:
Delhom-Gambrell Library
Highly specialized historical collection relating to decora-
 tive arts, particularly pottery, porcelain & ceramics.
 Strong emphasis on English & Oriental decorative arts &
 in applied arts.

AL 492
MUSEUM OF EARLY SOUTHERN DECORATIVE
ARTS LIBRARY
924 S Main St, Winston-Salem, NC 27108
Tel: 919-722-6148
Dir: Tom Gray

Museum Founded: 1965
Hours: Mon-Fri 10-6
Circulation: No (open stacks)
Reference Service: In person only
Reprographic Services: Yes
Interlibrary Loan: NILS
Networks/Consortia: No
Special Programs: Individual tours; single lectures
Cataloged Volumes: 7,000
Subjects: Art, architecture, decorative arts, history
Special Collection:
Photographic Collection of Southern Decorative Arts
Photographic & written materials on Southern painting,
 metalwork, furniture, ceramics & textiles.

AL 493
NORTH CAROLINA CENTRAL UNIVERSITY
Fine Arts Library
Box 19845, Durham, NC 27707
Tel: 919-683-6220
Fine Arts Libn: Gene Leonardi

Academic
Hours: Mon-Thurs 8-5; 7-9
 Fri 8-4
 Sat 9-1

Circulation: Students, faculty/staff (open stacks)
Reference Service: In person only
Reprographic Services: No
Interlibrary Loan: No
Networks/Consortia: No
Publications: Acquisitions list for faculty; book catalog
Cataloged Volumes: 800
Serial Titles: 5–10 available through main library
Subjects: Art, music

AL 494
NORTH CAROLINA MUSEUM OF ART
Art Reference Library
Cultural Resources Department, Raleigh, NC 27611
Tel: 919-733-7568
Libn: Cheryl Warren

Museum Founded: 1956
Hours: Tues-Fri 10-5
Circulation: Staff; restricted to curatorial offices (open stacks)
Reference Service: In person, telephone, mail
Reprographic Services: No
Interlibrary Loan: Triangular institutions—University of North Carolina, Chapel Hill, Duke University and North Carolina State University
Networks/Consortia: No
Card Catalog
Cataloged Volumes: 15,000
Serial Titles: 32 (National Union Catalog; North Carolina Union Catalog)
Holdings: 72 vertical file drawers; 10 file boxes of sales & auction catalogs; 32 exhibition catalogs
Subjects: Art, decorative arts, classical archaeology, graphics, photography, pre-Columbian art
Special Collections:
Lady Culiffe-Owens Collection
Costumes & fashion plates.
Dr & Mrs Abram Knof Collection
Jewish ceremonial art & Jewish artists.
Dr Valentiner Collection
Dutch & Flemish art history.

AL 495
NORTH CAROLINA STATE UNIVERSITY
Harrye B Lyons Design Library
209 Brooks Hall, Raleigh, NC 27607
Tel: 919-737-2207
Libn: Maryellen LoPresti

Academic Founded: 1945
Hours: Mon-Thurs 8:30-9:30
 Fri 8:30-5
 Sat 9-1
 Sun 1-5
Circulation: Public; reference books & periodicals do not circulate; limited circulation of slides & prints (open stacks)
Reference Service: In person, telephone, mail
Interlibrary Loan: NILS (Ann Smith, Interlibrary Loan Dept, D H Hill Library, North Carolina State University)
Networks/Consortia: SOLINET; Cooperating Raleigh Colleges; North Carolina University System
Publications: Newsletter
Special Programs: Group & individual tours; bibliographic instruction; single lectures
Card Catalog
Cataloged Volumes: 14,200
Serial Titles: 4,184 (National Union Catalog; North Carolina Union Catalog)

Holdings: 2,761 items in vertical files; 72 microforms; 370 prints; 35,498 slides; 1,154 maps & plans; 3,356 trade literature
Subjects: Art, architecture, decorative arts, film & video, graphics, landscape architecture, painting, photography, product design, sculpture, urban design
Special Collections:
John Llewellyn Skinner Collection
Includes etchings of Raphael Loggia in the Vatican & Modern Masters Etchings.

AL 496
PUBLIC LIBRARY OF CHARLOTTE & MECKLENBURG COUNTY
310 N Tryon St, Charlotte, NC 28202
Tel: 704-374-2725
Dir of Libs: Arial A Stephens

Public Library Founded: 1903
Hours: Mon-Fri 9-9
 Sat 9-6
 Sun 2-6 Sept-May
Circulation: Public (open collection, closed stacks)
Reference Service: Yes
Reprographic Services: Yes
Interlibrary Loan: NILS
Networks/Consortia: No
Publications: Bibliographies; acquisitions list
Special Programs: Group tours
Cataloged Volumes: 655,231
Serial Titles: 956
Holdings: 185 vertical file drawers; 12,379 microforms
Subjects: Art, architecture, dance, decorative arts, film & video, music, theatre

AL 497
UNIVERSITY OF NORTH CAROLINA AT CHAPEL HILL
Art Library
Ackland Art Center 003-A, Chapel Hill, NC 27514
Tel: 919-933-2397
Libn: Philip A Rees

Academic
Hours: Mon-Fri 8-11
 Sat 8:30-5
 Sun 2-11
Circulation: Students, faculty/staff (open stacks)
Reference Service: In person (non-University patrons limited)
Reprographic Services: Yes
Interlibrary Loan: NILS; North Carolina Library Network (ILL, University of North Carolina, Wilson Library)
Networks/Consortia: SOLINET; OCLC
Publications: In-house periodical index (Periodicals & other Serials Held by the Libraries of the University of North Carolina, Chapel Hill)
Special Programs: Group tours for graduate students; bibliographic instruction
Card Catalog
Cataloged Volumes: 34,000
Serial Titles: 272 (National Union Catalog; New Serial Titles)
Holdings: 12 vertical file drawers; 1,500 sales & auction catalogs; 1,800 exhibition catalogs; 175 microforms
Subjects: Art, decorative arts, architecture, photography

North Dakota

AL 498
**STATE HISTORICAL SOCIETY OF NORTH
 DAKOTA LIBRARY**
Liberty Memorial Bldg, Bismarck, ND 58505
Tel: 701-224-2666
Supt: James E Sperry

Historical Society Founded: 1903
Hours: Mon-Fri 8-5
Circulation: Use within library only
Reference Service: In person, telephone, mail
Reprographic Services: Yes
Interlibrary Loan: NILS
Networks/Consortia: No
Card Catalog
Cataloged Volumes: 20,000
Serial Titles: 50
Subjects: Historic preservation, architecture & culture of
 North Dakota
Special Collections:
Homboe Film Collection
Films made in North Dakota from 1916–1920s.

Ohio

AL 499
AKRON ART INSTITUTE
Martha Stecher Reed Memorial Art Library
69 E Market, Akron, OH 44308
Tel: 216-376-9185
Libn/Registrar: Marjorie Harvey

Museum
Hours: Mon-Fri 9-5
Circulation: Staff, docents (closed stacks)
Reference Service: In person, telephone, mail
Reprographic Services: Yes
Interlibrary Loan: No
Networks/Consortia: No
Publications: Special catalogs; in-house periodical index
Serial Titles: National Union Catalog
Holdings: 30 vertical file drawers; sales & auction catalogs;
 500-600 exhibition catalogs
Subjects: Art, architecture, decorative arts, graphics, photog-
 raphy

AL 500
**BOWLING GREEN STATE UNIVERSITY
 LIBRARIES**
Reference Department
Bowling Green, OH 43403
Tel: 419-372-2362; 2658
Reference Dept Chairs: Angela Poulos & Marilyn Halpern

Academic Founded: 1914
Hours: Mon-Thurs 8-12 midnight
 Fri 8-10
 Sat 10-5
 Sun 1-12
Circulation: Public; periodicals do not circulate (open stacks)
Reference Service: In person, telephone, mail
Reprographic Services: Yes
Interlibrary Loan: NILS; RAILS

Networks/Consortia: Northwest Ohio Academic Library;
 OCLC
Publications: Orientation handbook; bibliographies; acquisi-
 tions list; newsletter; in-house periodical index (Bowling
 Green State University Serials List)
Special Programs: Group & individual tours; bibliographic
 instruction; single lectures
Cataloged Volumes: 599,108 (total collection)
Serial Titles: 4,825
Holdings: 30 vertical file drawers; 10 vertical file drawers of
 maps; 1,131,374 microforms; sales, auction & exhibition
 catalogs; 47,546 phonorecords; 328,498 government
 documents
Subjects: Art, architecture, dance, decorative arts, graphics,
 music, photography, theatre
Special Collections:
Audio Center
Collection of phonograph & tape recordings covering a wide
 range of subjects such as jazz, popular music, folklore,
 comedy, radio, oral history, documentaries, plays, poetry,
 & prose readings.
Curriculum Library
Collection of instructional materials for primary & secondary
 levels, including multimedia kits & pictures.
Northwest Ohio–Great Lakes Research Center
Collection of material pertaining to Great Lakes shipping,
 Northwest Ohio & the archives of Bowling Green State
 University. Includes published volumes, pamphlets, news-
 paper clippings, manuscripts, photographs, maps, naviga-
 tion charts & naval architectural drawings.
Popular Culture Library
Collection of popularly written fiction & non-fiction of the
 late 19th & 20th centuries and posters, campaign buttons &
 comic books relating to the period.

AL 501
CANTON ART INSTITUTE
Purdy Memorial Library
1001 Market Ave N, Canton, OH 44702
Tel: 216-453-7666, Ext 8
Libn: Jean McCuskey

Museum Founded: 1940
Hours: Tues, Wed, Thurs 10-5; 7-9
 Fri & Sat 10-5
 Sun 2-5
Circulation: Institute members only (open stacks)
Reference Service: Telephone, mail
Reprographic Services: No
Interlibrary Loan: Ohio State Library
Networks/Consortia: No
Card Catalog
Cataloged Volumes: 1,900
Subjects: Art, architecture, classical archaeology, decorative
 arts, graphics, photography
Special Collection: Fry Collection of Victorian art

AL 502
**CASE WESTERN RESERVE UNIVERSITY
 LIBRARIES**
11161 East Blvd, Cleveland, OH 44106
Tel: 216-368-2990
Dir: James Jones

Academic
Hours: Mon-Thurs 8-12
 Fri 8-10

Sat 9-10
Sun 12-12
Varies within academic calendar year
Circulation: Students, faculty/staff; periodicals & rare books do not circulate (open stacks)
Reference Service: In person, telephone, mail
Reprographic Services: Yes
Interlibrary Loan: NILS; Northeast Ohio Major Academic Libraries; Cleveland Area Metropolitan Library System (Daniel Stabe, Union Bibliographic Center)
Networks/Consortia: Northeast Ohio Major Academic Libraries; OCLC
Publications: Orientation handbook; bibliographies; acquisitions list; newsletter; in-house periodical index (Case Western Reserve University Serials Listing)
Special Programs: Group & individual tours; bibliographic instruction; intern program
Cataloged Volumes: 1,113,896
Serial Titles: 8,034 (National Union Catalog; Union List of Serials; Ohio College Library Center Data Base)
Holdings: 186,913 microforms
Subjects: Art, architecture, classical archaeology, dance, decorative arts, film & video, graphics, music, photography, theatre

AL 503
CLEVELAND INSTITUTE OF ART
Jessica Gund Memorial Library
11141 East Blvd, Cleveland, OH 44106
Tel: 216-421-4322, Ext 30
Head Libn: Karen Tschudy

Academic/Art School Founded: 1882
Hours: Mon-Thurs 9-9:30
 Fri 9-5
 Sat 9-4:30 (during school year)
 Mon-Fri 9-4:30 (intersession)
Circulation: Students, faculty/staff; restrictions on bound periodicals (open stacks except for selected periodicals)
Reference Service: Yes
Reprographic Services: Yes
Interlibrary Loan: NILS
Networks/Consortia: Union of Independent Colleges of Art
Publications: Acquisitions list
Special Programs: Group tours; bibliographic instruction; single lectures; intern program with Case Western Reserve
Cataloged Volumes: 30,000 (23,000 titles)
Serial Titles: 195 (National Union Catalog; Case Western Reserve Union List of Serials)
Holdings: 108 vertical file drawers; 6,380 microforms; exhibition catalogs
Subjects: Art, architecture, classical archaeology, dance, decorative arts, film & video, graphics, humanities, music, natural science, photography, social sciences, theatre
Special Collection:
School Archives
Collection of clippings, photos, exhibition notices of faculty, alumni & present students consisting of 27 bound volumes soon to be placed on microfilm.

AL 504
CLEVELAND STATE UNIVERSITY
Art Services
1860 E 22 St, Cleveland, OH 44115
Tel: 216-687-2486
Humanities Bibliographer: Carolyn Mateer

Academic Founded: 1965

Hours: 8-7
Circulation: Public (open stacks, with restrictions on special materials)
Reference Service: Telephone
Reprographic Services: Yes
Interlibrary Loan: NILS; CAIN Greater Cleveland Organization
Networks/Consortia: OCLC
Publications: Bibliographies; in-house periodical index (Cleveland State University Periodicals)
Special Programs: Group & individual tours; bibliographic instruction
Card Catalog
Cataloged Volumes: 7,000
Subjects: Art, architecture, dance, decorative arts, classical archaeology, film & video, graphics, music, photography, theatre

AL 505
COLUMBUS COLLEGE OF ART & DESIGN
Packard Library
470 E Gay St, Columbus, OH 43215
Tel: 614-224-9101, Exts 72; 73
Libn: Chilin Yu

Art School Founded: 1931
Hours: Mon & Fri 8:30-5
 Tues-Thurs 8:30-8
Circulation: Students, faculty/staff; public & researchers in-house only (open stacks)
Reference Service: In person, telephone (ready reference only)
Reprographic Services: Yes
Interlibrary Loan: No
Networks/Consortia: No
Publications: In-house periodical catalog (Periodical Catalog)
Special Programs: Bibliographic instruction; single lectures
Card Catalog
Cataloged Volumes: 14,912 (14,412 titles)
Serial Titles: 114
Holdings: 48 vertical file drawers; current sales & auction catalogs; 12 file drawers of exhibition catalogs
Subjects: Art, architecture, classical archaeology, dance, decorative arts, film & video, graphics, literature, music, philosophy, photography, psychology, theatre

AL 506
KENT STATE UNIVERSITY LIBRARY
Kent, OH 44242
Tel: 216-672-2962
Asst Provost for Learning Resources/Dir of University Libs: Hyman W Kritzer

Academic Founded: 1910
Circulation: Public (open stacks except for microform center, special collections & archives)
Reference Service: In person, telephone, mail
Reprographic Services: Yes
Interlibrary Loan: NILS; Northeastern Ohio Major Academic Libraries
Networks/Consortia: OCLC
Publications: Orientation handbook; bibliographies; acquisitions list; library guides; in-house periodical index (Periodical Directory)
Special Programs: Group & individual tours; bibliographic instruction; single lectures; intern program
Cataloged Volumes: 1,175,000 total library collection
Serial Titles: 5,000 (Union List of Serials; New Serial Titles)

Subjects: Art, architecture, classical archaeology, dance, decorative arts, film & video, graphics, music, photography, theatre

AL 507
OBERLIN COLLEGE
Clarence Ward Art Library
Allen Art Bldg, Oberlin, OH 44074
Tel: 216-775-8635
Art Libn: Christina Huemer

Academic/Museum Founded: 1917
Hours: Mon-Thurs 8-5; 7-11
 Fri 8-5; 7-10
 Sat 9-5
 Sun 1-5
 Abbreviated hours during summer & January
Circulation: Public; periodicals & catalogues raisonnes do not circulate (open stacks)
Reference Service: In person, telephone, mail
Reprographic Services: Yes
Interlibrary Loan: NILS (Interlibrary Loan Dept, Mudd Learning Center, Oberlin College)
Networks/Consortia: Art Research Libraries of Ohio; Cleveland Area Metropolitan Library System; OCLC
Publications: Bibliographies
Special Programs: Individual tours; bibliographic instruction; single lectures
Cataloged Volumes: 40,000
Serial Titles: 250 (National Union Catalog; Art Research Libraries of Ohio Union List of Serials)
Subjects: Art, architecture, classical archaeology, decorative arts, graphics, photography
Special Collection:
Jefferson Collection
Early books on architecture, including replicas of most of those in Thomas Jefferson's personal library.

AL 508
OHIO STATE UNIVERSITY
Fine Arts Library
1813 N High St, Columbus, OH 43210
Tel: 614-422-6184
Head Libn: Jacqueline D Sisson

Academic Founded: 1930
Hours: Mon-Thurs 8-10 (fall, winter, spring)
 Fri 8-5
 Sat 10-4
 Sun 2-10
 Mon-Thurs 8-8 (summer)
 Fri 8-5
 Sun 5-10
Circulation: Students, faculty/staff; serials & selected monographs do not circulate (open stacks)
Reference Service: In person, telephone on delayed basis
Reprographic Services: Yes
Interlibrary Loan: NILS; Art Research Libraries of Ohio (Interlibrary Loan Division, 1858 Neil Ave Mall)
Networks/Consortia: No
Publications: Acquisitions list
Special Programs: Group tours; bibliographic instruction; single lectures
Card Catalog
Cataloged Volumes: 58,000
Serial Titles: 350 (National Union Catalog; ARLO Union List of Serials)
Holdings: 7,500 microforms; 600 sales & auction catalogs;

3,400 exhibition catalogs; DIAL photographs; subscribes to South Asian Art & Marburg Photographic Archives
Subjects: Art, architecture, classical archaeology, decorative arts, graphics
Special Collections: Medieval art; Slavic publications on Byzantine art

AL 509
ZANESVILLE ART CENTER LIBRARY
620 Military Rd, Zanesville, OH 43701
Tel: 614-452-0741
Dir: Dr Charles Dietz

Museum Founded: 1936
Hours: Mon-Thurs & Sat 10-5
 Sun 2-5
 Closed Fri
Circulation: Public (open stacks)
Reference Service: In person, telephone, mail
Reprographic Services
Interlibrary Loan: Local universities
Networks/Consortia: No
Publications: Newsletter
Special Programs: Group & individual tours
Cataloged Volumes: 4,829
Subjects: Art, architecture, classical archaeology, dance, decorative arts, film & video, graphics, music, photography, theatre

Oklahoma

AL 510
MUSEUM OF THE GREAT PLAINS
Special Collections Library
Sixth St & Ferris, Lawton, OK 73502
Tel: 405-353-5675
Curator of Special Collections: Donnice Cochenour

Museum Founded: 1961
Hours: Mon-Fri 8-5
Circulation: Restricted to in-house use (open stacks)
Reference Service: Telephone, mail
Interlibrary Loan: NILS (Box 68, Lawton, OK 73502)
Networks/Consortia: No
Special Programs: Group & individual tours
Card Catalog
Cataloged Volumes: 15,000
Serial Titles: 85
Holdings: 10 vertical file drawers
Special Collection: History & prehistory of ten-state Great Plains region

AL 511
NO MAN'S LAND HISTORICAL MUSEUM
Sewell St, Goodwell, OK 73939
Tel: 405-349-2670
Curator: Dr Harold S Kachel

Museum Founded: 1934
Hours: Tues-Fri 9-5
 Sat & Sun 1-5
 Closed Mon
Circulation: Researchers, faculty/staff (open stacks limited to room use only)
Reference Service: Yes
Reprographic Services: Yes

Interlibrary Loan: No
Networks/Consortia: No
Publications: Newsletter; in-house periodical index
Special Programs: Group tours
Cataloged Volumes: 10
Subjects: Art, Western Oklahoma art, film & video, photography

Oregon

AL 512
CONCORDIA COLLEGE LIBRARY
2811 NE Holman St, Portland, OR 97211
Tel: 503-288-9371; Ext 241
Libn: Alma Dobbenfuld

Academic Founded: 1905
Hours: Mon-Thurs 8-9:30
 Fri 8-5
 Sat 10-5
 Sun 2-10
Circulation: Public (open stacks; restricted use of reserve
 items & periodicals)
Reference Service: Telephone, mail
Reprographic Services: Yes
Interlibrary Loan: NILS
Publications: Orientation handbook; acquisitions list
Special Programs: Group & individual tours; bibliographic
 instruction; single lectures
Card Catalog
Cataloged Volumes: 33,000 (32,000 titles)
Serial Titles: 350
Holdings: 15 vertical file drawers; 500 microforms; 45 micro-
 fiche
Subjects: Film & video, graphics, music, photography, theatre
Special Collections: Luther & Reformation Research Collec-
 tion

AL 513
**CONTEMPORARY CRAFTS ASSOCIATION
 LIBRARY**
3934 SW Corbett Ave, Portland, OR 97201
Tel: 503-223-2654
Chariman of the Board: Melody Teppla

Exhibition Gallery Founded: 1937
Hours: Mon-Fri 11-5
 Sat 11-4
 Sun 1-4
Circulation: Association members, exhibiting craftsmen (open
 stacks)
Reference Service: In person, telephone
Reprographic Services: No
Interlibrary Loan: No
Networks/Consortia: No
Publications: Newsletter; special catalogs; book catalog; in-
 house periodical index (Periodical List)
Special Programs: Group tours; single lectures
Cataloged Volumes: 152 (150 titles)
Serial Titles: 29
Holdings: 1 vertical file drawer; 1 sales & auction catalog;
 203 exhibition catalogs
Subjects: Art, architecture, decorative arts, graphics, photog-
 raphy
Special Collection: Crafts Collection

AL 514
OREGON STATE UNIVERSITY
William Jasper Kerr Library
Corvallis, OR 97331
Tel: 503-754-3411
Libn: Rodney Waldron

Academic Founded: 1858
Hours: Mon-Fri 8-11
 Sat 10-11
 Sun 12-10
Circulation: Public (open stacks)
Reference Service: In person
Reprographic Services: Yes
Interlibrary Loan: NILS: Oregon State System of Higher
 Education
Networks/Consortia: Oregon Regional Network
Publications: Orientation handbook; bibliographies; acquisi-
 tions list; in-house periodical index (The Library Catalog)
Special Programs: Group & individual tours; bibliographic
 instruction; single lectures; intern program
Card Catalog
Cataloged Volumes: 758,000 (9,532 titles in visual arts)
Serial Titles: National Union Catalog; Oregon Regional List
 of Serials
Subjects: Art, architecture, classical archaeology, dance,
 decorative arts, film & video, graphics, music, photography,
 theatre

AL 515
REED COLLEGE
Eric V Hauser Memorial Library
Portland, OR 97202
Tel: 503-771-1112, Exts 260; 261
Prof & Libn: Luella Rebecca Pollock

Academic
Circulation: Students, faculty/staff (open stacks)
Reference Service: In person, telephone, mail
Reprographic Services: No
Interlibrary Loan: NILS
Networks/Consortia: Oregon Regional Union List of Serials;
 OCLC; Northwest Association of Private Colleges &
 Universities
Publications: Orientation handbook; in-house periodical
 index (Reed College Periodical List)
Special Programs: Group & individual tours
Cataloged Volumes: 263,000
Serial Titles: 1,125 total; 85 visual art (Oregon Regional
 Union List)
Holdings: 8 vertical file drawers; 16,075 microforms
Subjects: Art, architecture, classical archaeology, dance,
 decorative arts, film & video, graphics, music, photography,
 theatre

Pennsylvania

AL 516
THE ATHENAEUM OF PHILADELPHIA LIBRARY
219 S Sixth St, Philadelphia, PA 19106
Tel: 215-925-2688
Secy & Libn: Dr Roger W Moss, Jr

Independent Research Library Founded: 1814
Hours: Mon-Fri 9-5
 Closed bank holidays

Circulation: Members (closed stacks; qualified non-members may use materials in-house)
Reference Service: In person, mail
Reprographic Services: Yes
Interlibrary Loan: NILS
Networks/Consortia: No
Publications: Bibliographies; acquisitions list; newsletter; in-house periodical index
Special Programs: Group tours; single lectures
Cataloged Volumes: 100,000 (90,000 titles)
Serial Titles: 50
Holdings: 250 linear ft horizontal & vertical files; 1,000 microform titles
Subjects: Architecture, decorative arts
Special Collections:
Architectural Records Collection
Historical collection of 400,000 items relating to the United States from 1845–1930, including 7,000 architectural drawings & 10,000 photographs.

AL 517
BUTEN MUSEUM OF WEDGEWOOD LIBRARY
246 N Bowman Ave, Merion, PA 19066
Tel: 215-664-9069
Dir: David Buten

Museum Founded: 1957
Hours: Tues-Thurs 2-5
 Sat 10-1
Circulation: Museum members, academic scholars (open stacks)
Reference Service: In person, telephone, mail
Reprographic Services: Yes
Interlibrary Loan: No
Networks/Consortia: No
Publications: Newsletter; monograph series; book catalog
Special Programs: Group tours by appointment; individual tours of museum collection; intern program
Cataloged Volumes: 1,250
Holdings: 12 vertical file drawers; 100 sales & auction catalogs
Subjects: Wedgewood ceramics

AL 518
CARNEGIE-MELLON UNIVERSITY
Hunt Library—Fine Arts
Schenley Park, Pittsburgh, PA 15213
Tel: 412-621-2600, Ext 425
Fine Arts Libn: Helen A Lingelbach

Academic Founded: 1900
Hours: Mon-Thurs 8-12
 Fri 8-9
 Sat 9-9
 Sun 1-12
Circulation: Students, faculty/staff (open stacks)
Reference Service: In person, telephone, mail
Interlibrary Loan: NILS
Networks/Consortia: Pittsburgh Regional Library Center; OCLC
Special Programs: Group tours; single lectures
Cataloged Volumes: 28,000 fine arts
Serial Titles: 300 (National Union Catalog)
Holdings: 8 vertical file drawers
Subjects: Art, architecture, classical archaeology, dance, decorative arts, film & video, graphics, music, photography, theatre

AL 519
DREXEL UNIVERSITY LIBRARIES
32 & Chestnut St, Philadelphia, PA 19104
Tel: 215-895-2768
Art & Architecture Libn: Tung Chu Chen

Academic Founded: 1891
Hours: Mon-Fri 8-12
 Sat 8-8
 Sun 12-12
Circulation: Students, faculty/staff (open stacks)
Reference Service: In person, telephone, mail
Reprographic Services: Yes
Interlibrary Loan: NILS; Center for Research Libraries; Interlibrary Delivery Service of Pennsylvania
Networks/Consortia: Pennsylvania Area Library Network; OCLC
Publications: Acquisitions list; monthly book bulletin distributed upon request; in-house periodical index (Drexel University Libraries, Serial File)
Special Programs: Group & individual tours; bibliographic instruction; single lecture; intern program
Card Catalog
Cataloged Volumes: 15,000
Serial Titles: 150 (National Union Catalog; Union List of Serials)
Subjects: Art, architecture, costume, decorative arts, dance, film & video, graphics, history of books & printing, interior design, music, photography, theatre
Special Collections:
Costume Collection
Emphasis on clothing history, historic & contemporary. Includes dress & fashion.
History of Books & Printing

AL 520
HAVERFORD COLLEGE
Magill Library
Haverford, PA 19041
Tel: 215-649-9600
Humanities Bibliographer: Shirley Stowe

Academic Founded: 1833
Circulation: Students, faculty/staff, registered borrowers; special art collection materials do not circulate
Reference Service: Telephone, mail; lengthy searches restricted to students & faculty
Reprographic Services: Yes
Interlibrary Loan: NILS
Networks/Consortia: OCLC; Pennsylvania Area Library Network
Publications: Orientation handbook; in-house periodical index (Periodicals Catalog: Haverford, Bryn Mawr, Swarthmore)
Special Programs: Group & individual tours; bibliographic instruction
Card Catalog
Cataloged Volumes: 6,200
Serial Titles: 28 (National Union Catalog; Union Library Catalogue of Pennsylvania)
Subjects: Art, classical archaeology, graphics, photography
Special Collections:
Brandywine School Collection
Books illustrated by members of the School.
Maxfield Parrish Collection
A small collection of his works.

AL 521
THE LIBRARY COMPANY OF PHILADELPHIA
1314 Locust St, Philadelphia, PA 19107

Tel: 215-546-3181
Libn: Edwin Wolf II

Research & Rare Book Library Founded: 1731
Hours: Mon-Fri 9-4:30
Circulation: No (closed stacks)
Reference Service: In person, telephone, mail
Reprographic Services: Yes
Interlibrary Loan: NILS
Networks/Consortia: Union Library Catalog
Publications: Bibliographies; newsletter; special catalogs;
 annual report; in-house periodical index
Information Sources: Wainwright, N. *Philadelphia in the
 Romantic Age of Lithography*, The Historical Society of
 Pennsylvania, 1958
Special Programs: Group & individual tours; bibliographic
 instruction; single lectures; intern program
Cataloged Volumes: 450,000 total collection
Serial Titles: National Union Catalog
Subjects: Art, architecture, Black history, classical archae-
 ology, decorative arts, graphics, music, ornithology,
 photography, religious & political history, woman's history
Special Collections:
Black History
Illustration file of Black history materials.
Prints & Drawings Collection
18th & 19th century documentary images of American his-
 tory, particularly Philadelphia history. Commercial &
 fine art portraits.

AL 522
PENNSYLVANIA STATE UNIVERSITY
Arts Library
E405 Pattee Library, University Park, PA 16802
Tel: 814-865-6481
Libn: Jean Smith

Academic Founded: 1957
Hours: Mon-Fri 8-12
 Sat 8-5
 Sun 1-12
 Closes at 10 during summer
Circulation: Public (open stacks)
Reference Service: Telephone, mail
Reprographic Services: Yes
Interlibrary Loan: NILS (Interlibrary Loan Service, Pattee
 Library)
Networks/Consortia: Pittsburgh Regional Library Center;
 Mid-Atlantic Research Libraries Information Network
Publications: Bibliographies; acquisitions list; in-house peri-
 odical index (Serial Holdings: The Pennsylvania State
 University Libraries)
Special Programs: Group & individual tours; bibliographic
 instruction; single lectures
Card Catalog
Cataloged Volumes: 36,160
Serial Titles: 517 (National Union Catalog)
Holdings: 2 vertical file drawers
Subjects: Art, architecture, decorative arts, graphics, music

AL 523
PHILADELPHIA MARITIME MUSEUM LIBRARY
321 Chestnut St, Philadelphia, PA 19106
Tel: 215-925-5439
Dir: Richard K Page

Museum Founded: 1960
Hours: Mon-Sat 10-5

Circulation: By appointment only (open stacks)
Reference Service: In person, telephone, mail
Reprographic Services: No
Interlibrary Loan: No
Networks/Consortia: No
Publications: In-house periodical index
Cataloged Volumes: 4,000
Serial Titles: 47
Holdings: 2 vertical file drawers; 80 microforms
Subjects: Art, decorative arts, maritime history
Special Collection:
Maritime History Collection
Includes history of Philadelphia Port & the Delaware River &
 Bay.

AL 524
PHILADELPHIA MUSEUM OF ART
The Marian Angell Boyer & Francis Boyer Library
26 St & Ben Franklin Pkwy, Philadelphia, PA 19101
Tel: 215-763-8100, Ext 229
Libn: Barbara Sevy

Museum Founded: 1876
Hours: Mon-Fri 9-5
 Mon, Wed & Fri 10-4 (library open to public)
Circulation: Faculty/staff (closed stacks)
Reference Service: In person only
Reprographic Services: Yes
Interlibrary Loan: NILS
Special Programs: Lectures & tours for students of Drexel
 graduate library school
Cataloged Volumes: 90,000 (80,000 titles)
Serial Titles: 750 (National Union Catalog)
Holdings: 44 vertical file drawers; 100 microforms; 42,000
 sales & auction catalogs; exhibition catalogs
Subjects: Art, architecture, decorative arts, graphics, photog-
 raphy

AL 525
TEMPLE UNIVERSITY
Tyler School of Art Library
Beech & Penrose Aves, Philadelphia, PA 19126
Tel: 215-224-7575, Ext 245
Libn: Ivy Bayard

Academic—Art School Founded: 1934
Hours: Mon-Thurs 8:30-9
 Fri 8:30-4
 Sat & Sun 11-4
Circulation: Students, faculty/staff (open stacks)
Reference Service: Telephone, mail
Reprographic Services: Yes
Interlibrary Loan: NILS (Interlibrary Loan Dept, Temple
 University Library, Philadelphia, PA 19122)
Networks/Consortia: No
Publications: Acquisitions list; in-house periodical index
 (Serials Holdings Temple University Libraries)
Special Programs: Group tours
Card Catalog
Cataloged Volumes: 15,613 (12,308 titles)
Serial Titles: 94 (National Union Catalog)
Subjects: Art, decorative arts, architecture, classical archae-
 ology, film & video, graphics, photography

South Carolina

AL 526
BROOKGREEN GARDENS LIBRARY
Murrells Inlet, SC 29576
Tel: 803-237-4218
Dir: G L Tarbox, Jr

Museum Founded: 1931
Reference Service: Mail
Card Catalog: Book Catalog
Cataloged Volumes: 1,485
Subjects: Art, architecture, fauna, flora, history, sculpture
Special Collections:
Fauna & Flora Collection
Plants & animals native to Southeast United States.
Sculpture Collection
19th & 20th century American sculptors, especially those
 exhibited at Brookgreen.
South Carolina Collection
History of South Carolina, especially relating to Georgetown
 County.

AL 527
PRESBYTERIAN COLLEGE
James H Thomason Library
Clinton, SC 29325
Tel: 803-833-2820, Ext 214
Libn: Dr Lennart Pearson

Academic Founded: 1880
Hours: Mon-Fri 7:45-11
 Intersession hours vary
Holdings: Public (open stacks)
Reference Service: In person only
Reprographic Services: Yes
Interlibrary Loan: NILS
Networks/Consortia: No
Publications: Acquisitions list; in-house periodical index
 (Periodicals Holding Record)
Special Programs: Individual tours; bibliographic instruction;
 single lectures
Cataloged Volumes: 105,000

South Dakota

AL 528
CIVIC FINE ARTS ASSOCIATION LIBRARY
235 W 10 St, Sioux Falls, SD 57102
Tel: 605-336-1167
Dir: Raymond Shermoe

Museum Founded: 1961
Hours: Tues-Sat 11:30-5
 Sun 2-5
 Closed Mon
Circulation: Public (open stacks)
Reference Service: In person, telephone, mail
Interlibrary Loan: No
Networks/Consortia: No
Publications: Newsletter; special catalogs
Special Programs: Group & individual tours; single lectures
Subjects: Art, architecture, dance, decorative arts, graphics,
 music, photography

AL 529
DAKOTA STATE COLLEGE
Karl E Mundt Library
Madison, SD 57042
Tel: 605-256-3551, Ext 226
Dir: J Paula Konis

Academic
Hours: Mon-Thurs 8-10
 Fri 8-5
 Sun 6-10
Circulation: Public (open stacks)
Reference Service: In person, telephone
Reprographic Services: Yes
Interlibrary Loan: NILS
Networks/Consortia: Mountain Plains Library Association
Special Programs: Group & individual tours; bibliographic
 instruction; single lectures
Cataloged Volumes: 62,000
Serial Titles: 558
Holdings: 18 vertical file drawers; 4,500 microforms
Subjects: Art, architecture, classical archaeology, dance,
 decorative arts, film & video, graphics, music, photography
 theatre
Special Collection: South Dakota Collection

AL 530
DAKOTA WESLEYAN UNIVERSITY
Layne Library
University Blvd, Mitchell, SD 57301
Tel: 605-996-6511, Ext 203
Dir of Learning Resources: Stanley Planton

Academic Founded: 1885
Hours: Mon-Fri 8-5; 6:30-10
 Sat 9-12; 1-5
 Sun 2-5; 7-10
Circulation: Public (open stacks)
Reference Service: In person, telephone, mail
Reprographic Services: Yes
Interlibrary Loan: NILS; Colleges of Mid-America
Networks/Consortia: Colleges of Mid-America
Publications: Acquisitions list; in-house periodical index
Special Programs: Group & individual tours; bibliographic
 instruction; single lectures; audiovisual assistance &
 instruction
Cataloged Volumes: 67,000 (62,000 titles)
Serial Titles: 350 (South Dakota Union List)
Holdings: 20 vertical file drawers; 250 microforms
Subjects: Art, architecture, classical archaeology, dance,
 decorative arts, film & video, graphics, music, photography,
 theatre
Special Collection: Jennewein Western History Collection

AL 531
MITCHELL PUBLIC LIBRARY
221 N Duff, Mitchell, SD 57301
Tel: 605-996-6693
Dir: Janus Olsen

Public Library Founded: 1903
Hours: Mon-Sat 9-6 (summer)
 Mon-Thurs 9:30-8:30
 Fri & Sat 9:30-6
 Sun 2-5 (winter)
Circulation: Public (open stacks)

Reference Service: In person, telephone, mail
Reprographic Services: Yes
Interlibrary Loan: NILS; South Dakota State Library System (South Dakota State Library, Pierre, SD 57501)
Networks/Consortia: No
Publications: In-house periodical index
Special Programs: Group & individual tours
Cataloged Volumes: 64,000
Serial Titles: 345
Holdings: 62 vertical file drawers; 2,000 microforms
Subjects: Art, architecture, classical archaeology, dance, decorative arts, film & video, graphics, music, photography, theatre
Special Collection: Photographs, maps & plot plans of the city of Mitchell

AL 532
NORTHERN STATE COLLEGE
Beulah Williams Library
Aberdeen, SD 57401
Tel: 605-622-2645
Dir of Lib: James O Mauseth

Academic Founded: 1902
Hours: Mon-Thurs 8-11
 Fri 8-5
 Sat 1-4
 Sun 3-11
Circulation: Yes (open stacks)
Reference Service: Yes
Reprographic Services: Yes
Interlibrary Loan: NILS
Networks/Consortia: No
Publications: Acquisitions list; newsletter
Special Programs: Group & individual tours; bibliographic instruction
Serial Titles: 695 (South Dakota Union List of Serials)
Holdings: 3 vertical file drawers; 28,000 microforms
Subjects: Art, architecture, classical archaeology, dance, decorative arts, film & video, graphics, music, photography, theatre

AL 533
PHOEBE APPERSON HEARST FREE LIBRARY
Lead, SD 57754
Tel: 605-584-2013

Public Library
Hours: Mon-Fri 1-7; 7-9
Circulation: Public; limited circulation for special collections (open stacks)
Reference Service: In person, telephone
Reprographic Services: Yes
Interlibrary Loan: NILS; Denver Bibliographic Center; Deadwood, Spearfish & Whitewood County Libraries
Networks/Consortia: No
Special Programs: Group & individual tours
Cataloged Volumes: 27,981
Holdings: 135 microforms of local newspaper from 1876–present
Subjects: Art, classical archaeology, decorative arts, music, theatre
Special Collections:
Custer Collection
. Collection of books, news articles, letters & photographs.
Foreign Language Collection
Volumes in German, Norwegian, Swedish, French, Italian, Spanish, Croatian, Lithuanian, Finnish.

South Dakota Room
Books by & about South Dakotans.

AL 534
SIOUX FALLS COLLEGE
Norman B Mears Library
Sioux Falls, SD 57101
Tel: 605-336-2850, Ext 121
Head Libn: Jane Kolbe

Academic Founded: 1883
Hours: Mon-Thurs 7:30-11
 Fri 7:30-5
 Sat 1-4
 Sun 2-11
Circulation: Public (open stacks)
Reference Service: In person, telephone, mail
Reprographic Services: Yes
Interlibrary Loan: NILS; Colleges of Mid-America
Networks/Consortia: Colleges of Mid-America; OCLC
Publications: Orientation handbook
Special Programs: Group tours; bibliographic instruction; single lectures
Cataloged Volumes: 72,000 (64,000 titles)
Serial Titles: 450 (South Dakota Union List of Serials)
Holdings: 22 vertical file drawers; 4,000 microforms
Subjects: Art, architecture, decorative arts, music, theatre
Special Collection:
South Dakota Collection
Collection of works by & about South Dakotans.

AL 535
SIOUX FALLS PUBLIC LIBRARY
201 N Main Ave, Sioux Falls, SD 57101
Tel: 605-339-7081
City Libn: Catherine Schoenmann

Public Library Founded: 1886
Hours: Mon-Fri 9:30-9
 Sat 9:30-6
Circulation: Public (open stacks)
Reference Service: In person, telephone, mail
Reprographic Services: Yes
Interlibrary Loan: NILS
Networks/Consortia: Denver Bibliographic Research Center
Special Programs: Group tours
Cataloged Volumes: 130,311
Serial Titles: 348 (South Dakota Union List of Serials)
Holdings: 21 vertical file drawers; 74 microforms of periodical titles
Subjects: Art, architecture, dance, decorative arts, film & video, graphics, music, photography, theatre
Special Collection:
Caille Room
Materials relating to the history of South Dakota & books by local authors.

AL 536
UNIVERSITY OF SOUTH DAKOTA
I D Weeks Library
Vermillion, SD 57069
Tel: 605-677-5371
Dir: Bob Carmack

Academic Founded: 1882
Circulation: Public (open stacks)
Reference Service: In person, telephone, mail
Reprographic Services: Yes

Interlibrary Loan: NILS; South Dakota TWX Network;
 SHARE
Networks/Consortia: Denver Bibliographic Center for
 Research
Publications: Orientation handbook; bibliographies; acquisi-
 tions list; in-house periodical index
Special Programs: Group & individual tours; bibliographic
 instruction; single lectures
Cataloged Volumes: 288,543
Serial Titles: 2,218 (National Union Catalog; South Dakota
 Union List of Serials)
Holdings: 111 vertical file drawers; 182,919 microforms;
 3,712 phonodiscs; 8,187 filmstrips & miscellany
Subjects: Art, architecture, classical archaeology, dance,
 decorative arts, film & video, graphics, music, photography,
 theatre
Special Collection:
Herman P Chilson Western Americana Collection
Historical & literary collection of South Dakota & Northern
 Great Plains materials, including some Western art.

AL 537
YANKTON COLLEGE LIBRARY
1016 Douglas, Yankton, SD 57078
Tel: 605-665-4662
Lib Dir: Patricia McDonald

Academic Founded: 1881
Hours: Mon-Thurs 8:30-9:45
 Fri 8:30-5
 Sat 1-3
 Sun 1:30-9:45
Circulation: Public (open stacks)
Reference Service: Yes
Reprographic Services: Yes
Interlibrary Loan: NILS
Networks/Consortia: Colleges of Mid-America
Publications: In-house periodical index
Special Programs: Group & individual tours
Cataloged Volumes: 58,000
Serial Titles: 456 (South Dakota Union List of Serials)
Holdings: 2,800 pamphlets; current sales & auction catalogs
Subjects: Art, architecture, dance, decorative arts, music,
 photography, theatre

Tennessee

AL 538
BROOKS MEMORIAL ART GALLERY LIBRARY
Overton Park, Memphis, TN 38112
Tel: 901-726-5266
Libn: Letitia B Proctor

Museum Founded: 1922
Circulation: Staff; public restricted to in-house use of material
Reference Service: In person, telephone, mail
Interlibrary Loan: NILS
Publications: In-house periodical index
Card Catalog
Cataloged Volumes: 8,000
Holdings: 60 vertical file drawers; 600 sales & auction
 catalogs; 600 exhibition catalogs
Subjects: Art, architecture, decorative arts, drawing, graphics,
 lithography, photography, sculpture

AL 539
FISK UNIVERSITY MUSEUM OF ART LIBRARY
18 & Jackson Sts, Nashville, TN 37203
Tel: 615-329-8685
Dir: Earl J Hooks
Curator: Robert Hall

Academic/Museum Founded: 1866; 1949
Hours: Mon-Fri 9-5
Circulation: Public; art department films do not circulate
 (closed stacks)
Reference Service: No
Reprographic Services: Yes
Interlibrary Loan: No
Networks/Consortia: No
Publications: Newsletter; special catalogs; in-house periodical
 index (Publications through the Department of Art, Fisk
 University)
Special Programs: Group & individual tours; single lectures
Cataloged Volumes: 600
Holdings: 40 exhibition catalogs
Subjects: Art, decorative arts

AL 540
HUNTER MUSEUM OF ART LIBRARY
10 Bluff View, Chattanooga, TN 37403
Tel: 615-267-0968, Ext 3
Curator of Education: Carla Michalove

Museum Founded: 1952; 1973
Hours: Tues-Sat 10-4:30
 Sun 1-4:30
Circulation: Researchers; staff; limited to in-house use by
 public; periodicals do not circulate (open stacks)
Reference Service: Telephone
Reprographic Services: No
Interlibrary Loan: No
Networks/Consortia: No
Card Catalog
Cataloged Volumes: 1,000
Serial Titles: 38
Holdings: 5 files of sales & auction catalogs; 7 files of exhibi-
 tion catalogs
Subjects: Art, architecture, decorative arts, graphics, photog-
 raphy
Special Collections: American Art Collection

AL 541
MEMPHIS STATE UNIVERSITY
Art History Department
Jones Hall 220, Memphis, TN 38152
Tel: 901-454-2071
Slide Curator: Georgianna H Ray

Academic Founded: 1969
Hours: 8-12; 1-4
Circulation: Faculty/staff; students restricted to use in slide
 library; senior papers circulate overnight
Publications: Orientation handbook
Special Programs: Group tour of Art Department includes
 slide library
Cataloged Volumes: 75 reference books
Holdings: 2 vertical file drawers; 25 exhibition catalogs
Subjects: Art, architecture, ceramics, decorative arts, graphics

AL 542
OAK RIDGE COMMUNITY ART CENTER
Badger Ave, Box 105, Oak Ridge, TN 37830
Tel: 615-482-1182
Acting Dir: Jewel Stallions

Art School/Museum Founded: 1952
Hours: 9-4
Circulation: No
Reference Service: No
Reprographic Services: No
Interlibrary Loan: No
Networks/Consortia: No
Special Programs: Group tours; single lectures
Subjects: Art, architecture, decorative arts
Special Collection:
Mary & Alden Gomez Collection
Permanent collection of Abstract Expressionism.

AL 543
THE PUBLIC LIBRARY OF NASHVILLE & DAVIDSON COUNTY
The Nashville Room
Eighth Ave N & Union, Nashville, TN 37203
Tel: 615-244-4700
Nashville Room Libn: Mary Glenn Hearne

Public Library
Hours: Mon-Fri 9-9
 Sat 9-5
 Sun 2-5, Oct-May
Circulation: Public
Reference Service: In person, telephone, mail
Reprographic Services: Yes
Interlibrary Loan: NILS (Area Resource Center)
Networks/Consortia: No
Publications: In-house periodical index (Nashville Newspaper Index)
Special Programs: Group tours
Cataloged Volumes: 8,000 (7,000 titles)
Serial Titles: 1,634 (Union List of Serials)
Holdings: 12 vertical file drawers of biographies; 3 drawers of microforms; 680 slides of local scenes, citizens & buildings; 300 photographs of local subjects; 2 videotapes
Subjects: Art, film & video
Special Collections:
Naff Collection
Programs, billboards & photographs of artists who performed at Ryman Auditorium.
Nashville Authors
Biographical & bibliographical material on local authors, past & present.

AL 544
THE TENNESSEE BOTANICAL GARDENS & FINE ARTS CENTER, INC, AT CHEEKWOOD
Fine Arts Library
Cheek Rd, Nashville, TN 37205
Tel: 615-352-5310
Dir of Fine Arts: John Henry Nozynski

Museum Founded: 1960
Hours: Tues-Sat 10-5
 Sun 1-5
 Closed Mon
Circulation: No (closed stacks; researchers & faculty/staff restricted to use on premises, with exceptions for students of art history)

Reference Service: In person only
Reprographic Services: No
Interlibrary Loan: NILS
Networks/Consortia: No
Cataloged Volumes: 4,000
Holdings: 60 vertical file drawers; 30 sales & auction catalogs
Subjects: Art, architecture, classical archaeology, conservation, film & video, graphics, photography, restoration
Special Collection: Period Rooms

AL 545
TENNESSEE TECHNOLOGICAL UNIVERSITY
Media Center
Cookeville, TN 38501
Tel: 615-528-4183
Media Libn: Carolyn Whitson

Academic Founded: 1975
Hours: Mon-Thurs 7:30-12
 Fri 7:30-6
 Sat 10-6
 Sun 1-12
Circulation: Students, faculty/staff (closed stacks)
Reference Service: In person, telephone
Reprographic Services: No
Interlibrary Loan: NILS (Linda Ogletree, Tennessee Technological University Library, Reference Department)
Networks/Consortia: OCLC
Publications: Orientation handbook; in-house periodical index for main library
Special Programs: Group & individual tours
Cataloged Volumes: 991 audiovisual; 115,836 microform titles
Holdings: 142,477 microforms
Subjects: Art, architecture, film & video, music, theatre

AL 546
UNIVERSITY OF TENNESSEE
James D Hoskins Library
1501 Cumberland Ave, Knoxville, TN 37916
Tel: 615-974-4301
Dir of Libs: Donald R Hunt

Academic Founded: 1838
Hours: Mon-Fri 8-11:30
 Sat 9-6
 Sun 1-11:30 (academic year)
 Mon-Fri 8-6 (intersession)
Circulation: Students, faculty/staff (open stacks)
Reference Service: Yes
Reprographic Services: Yes
Interlibrary Loan: NILS; Center for Research Libraries (Interlibrary Services Department)
Networks/Consortia: SOLINET
Publications: Orientation handbook; bibliographies; acquisitions list; in-house periodical index (Serials Holding List)
Special Programs: Group & individual tours; bibliographic instruction; single lectures
Cataloged Volumes: 1,332,780
Serial Titles: 10,363 (National Union Catalog; Union List of Serials; New Serials Titles)
Subjects: Art, architecture, decorative arts

AL 547
UNIVERSITY OF TENNESSEE
School of Architecture
102 Estabrook Hall, Knoxville, TN 37916
Tel: 615-974-4433

Libn: Tom Barnard

Academic Founded: 1958
Hours: Mon-Fri 9-10
Circulation: Public (open stacks)
Reference Service: No
Reprographic Services: Yes
Interlibrary Loan: NILS
Networks/Consortia: No
Publications: Book catalog; in-house periodical index (A List of Periodicals)
Special Programs: Intern program
Cataloged Volumes: 750
Subjects: Art, architecture, decorative arts, film & video, graphics, photography

AL 548
THE UNIVERSITY OF THE SOUTH
Jessie Ball duPont Library
Sewanee, TN 37375
Tel: 615-598-5931, Ext 265
Libn: Tom Watson

Academic Founded: 1858
Hours: Mon-Fri 8-11
 Sat 8-5:30
 Sun 1-11
Circulation: Public; restricted use of rare & archival materials (open stacks)
Reference Service: In person, telephone, mail
Reprographic Services: On a self-serve basis
Interlibrary Loan: NILS; Southern College & University Union
Networks/Consortia: SCUU; OCLC
Publications: Orientation handbook; bibliographies; acquisitions list; newsletter; in-house periodical index
Special Programs: Group & individual tours; bibliographic instruction; single lectures; formal classes
Card Catalog
Cataloged Volumes: 300,000
Serial Titles: 2,200 (National Union Catalog)
Holdings: 403 microforms
Subjects: Art, classical archaeology, graphics, music, photography, theatre
Special Collections: Theological Collection includes 60,000 volumes

Texas

AL 549
AMARILLO ART CENTER ASSOCIATION LIBRARY
2200 S Van Buren, Box 447, Amarillo, TX 79178
Tel: 806-372-8356
Dir: Tom Livesay

Museum Founded: 1970
Hours: Tues-Fri 10-5
 Sat & Sun 1-5
 Closed Mon
Circulation: Staff (open stacks)
Reference Service: No
Reprographic Services: No
Interlibrary Loan: No
Networks/Consortia: No
Special Programs: Group tours
Cataloged Volumes: 464
Holdings: 4 vertical file drawers
Subjects: Art

AL 550
AMARILLO PUBLIC LIBRARY
Box 2171, Amarillo, TX 79105
Tel: 806-372-4211
Libn: Alice Green

Public Library Founded: 1902
Hours: Mon-Thurs 9-9
 Fri & Sat 9-6
 Sun 2-6
Circulation: Public (open stacks)
Reference Service: In person, telephone, mail
Reprographic Services: Yes
Interlibrary Loan: NILS; Texas Information Exchange
Networks/Consortia: Texas Information Exchange; OCLC
Special Programs: Group & individual tours
Cataloged Volumes: 8,350 art-related
Serial Titles: Union List of Periodicals for the Top 25 Counties of Texas

AL 551
ART MUSEUM OF SOUTH TEXAS LIBRARY
Box 1010, Corpus Christi, TX 78403
Tel: 512-884-3844
Asst Curator: Melinda M Mayer

Museum
Hours: Tues-Fri 10-5
Circulation: No (open stacks)
Reference Service: Yes
Reprographic Services: Yes
Interlibrary Loan: No
Networks/Consortia: No
Publications: Special catalogs
Cataloged Volumes: 2,000
Holdings: 10 vertical file drawers
Subjects: Art, architecture, classical archaeology, decorative arts, graphics, photography
Special Collection: Modern & Contemporary Painting & Drawing

AL 552
AUSTIN PUBLIC LIBRARY
401 W Ninth, Box 2287, Austin, TX 78767
Tel: 512-472-5433
Dir of Libs: David Earl Holt

Public Library Founded: 1926
Hours: Mon-Thurs 9-9
 Fri & Sat 9-6
 Sun 2-6
Circulation: Public (open stacks)
Reference Service: In person, telephone, mail
Reprographic Services: Yes
Interlibrary Loan: NILS
Networks/Consortia: OCLC; Texas Library Network
Publications: Bibliographies; microfilm catalog; in-house periodical index (Title List of Newspapers & Periodicals); brief research guides on popular subjects
Cataloged Volumes: 551,056
Serial Titles: 750
Holdings: 32 vertical file drawers; 1,619 microfilms of periodicals
Subjects: Art, architecture, classical archaeology, dance, decorative arts, film & video, graphics, music, photography, theatre
Special Collections:
The American Experience Bicentennial Portfolio Series

Reproductions of drawings & photographs on US history produced by Smithsonian International.
Picture File
8 vertical file drawers of clippings on popular topics.
Portrait Gallery
Portrait collection published by Gale Research.

AL 553
STEPHEN F AUSTIN STATE UNIVERSITY
Ralph W Steen Library
Box 3055, Nacogdoches, TX 75962
Tel: 713-569-4200
Dir: Alvin C Cage

Academic Founded: 1923
Circulation: Public (open stacks)
Reference Service: In person, telephone, mail
Reprographic Services: Yes
Interlibrary Loan: NILS; Texas Information Exchange; Regional Information & Communications Exchange
Publications: Orientation handbook; bibliographies; acquisitions list; newsletter; in-house periodical index (Serials Printout)
Special Programs: Group tours; bibliographic instruction; single lectures
Cataloged Volumes: 300,000
Serial Titles: 4,022 (Texas Numeric Register)
Holdings: 72,746 microforms; 120,000 ERIC
Subjects: Art, architecture, decorative arts, film & video, graphics, music, photography, theatre
Special Collection: Archives relating to East Texas history & life

AL 554
BAYLOR UNIVERSITY
Art Library
Waco, TX 76701
Tel: 817-755-1867
Art History Lecturer: Mrs Vernie Logan

Academic Founded: 1845; Art Library Founded 1960
Hours: Daily 8-5
Circulation: Faculty/staff
Reference Service: Yes
Interlibrary Loan: NILS
Networks/Consortia: No
Publications: Book catalog
Special Programs: Single lectures
Card Catalog
Cataloged Volumes: 200
Serial Titles: 4
Holdings: 75 vertical file drawers; 50 sales & auction catalogs; 500 exhibition catalogs
Subjects: Art, architecture, classical archaeology, graphics, photography
Special Collections: Greek Vase Painting; Primitive Art; Art Education

AL 555
DALLAS PUBLIC LIBRARY
Fine Arts Division
1954 Commerce St, Dallas, TX 75201
Tel: 214-748-9071, Ext 252
Division Head: George Henderson

Public Library Founded: 1901
Hours: Mon-Fri 9-9
 Sat 9-6

Circulation: Public; rare books & archival materials do not circulate (open stacks)
Reference Service: In person, telephone, mail
Reprographic Services: Yes
Interlibrary Loan: NILS; Texas State Library Communications Network; Texas Information Exchange; AMIGOS Bibliographic Council
Networks/Consortia: No
Publications: In-house periodical index (Dallas Public Library: Central Research Library Periodicals List)
Special Programs: Group & individual tours; single lectures
Card Catalog
Cataloged Volumes: 40,000
Serial Titles: 560
Holdings: 400 vertical file drawers; 1,000 microforms; 1,500 sales & auction catalogs; 14,000 recordings
Subjects: Art, architecture, dance, decorative arts, film & video, graphics, music, photography, theatre
Special Collections:
Dallas Little Theatre Collection
Reviews, photographs & taped interviews of the historic Dallas Little Theatre.
Marion Flagg Collection
Personal correspondence, scrapbooks & photographs relating to Marion Flagg, coordinator of music for the Dallas Independent School District between 1944–1964.
William Ely Hill Theatre Collection (18th-20th centuries)
Playbills, posters of stage plays, minstrel shows & circuses, newspaper & magazine clippings as well as letters, portraits & photographs of leading American, British & European dramatists, actors, managers & other persons associated with the stage or performing arts.
Margo Jones Theatre Collection
Personal correspondence, organizational records, legal papers, scripts, programs, notices, reviews, clippings & photographs relating to Margo Jones & the establishment, productions & later activities of the Dallas Civic Theatre (Robert C Eason, Theatre Libn).
Lawrence Kelly Collection
Original costume & set designs executed for the Dallas Civic Opera.
Original Print Collection
60 original prints representing a variety of styles, periods & media, including Dutch engravings, Japanese woodcuts & samples of 20th century graphic artists.

AL 556
EL PASO PUBLIC LIBRARY
Art Section
501 N Oregon, El Paso, TX 79901
Tel: 915-543-3815
Head, Art & Southwest: Mary A Sarber

Public Library
Hours: Mon-Thurs 9-9
 Fri & Sat 9-5:30
Circulation: Public (open stacks)
Reference Service: In person, telephone, mail
Reprographic Services: Yes
Interlibrary Loan: NILS
Networks/Consortia: OCLC
Publications: In-house periodical index (Magazines & Newspapers: El Paso Public Library)
Special Programs: Group tours
Serial Titles: 22
Holdings: 36 vertical file drawers
Subjects: Art, antiques & collectibles, architecture, classical archaeology, decorative arts, graphics, photography, stamp & coin collecting

AL 557
FORT WORTH PUBLIC LIBRARY
Arts & Recreation Division
Ninth & Throckmorton, Fort Worth, TX 76102
Tel: 817-335-4781, Ext 34
Division Head: Lirl Treuter
Asst: Thomas Threatt

Public Library Founded: 1901
Hours: Mon-Thurs 10-9
 Fri & Sat 10-6
 Closed Sun
Circulation: Public (closed stacks)
Reference Service: In person, telephone, mail
Reprographic Services: Yes
Interlibrary Loan: NILS
Networks/Consortia: No
Publications: Bibliographies; in-house periodical index
Special Programs: Group tours
Cataloged Volumes: 42,000
Serial Titles: National Union Catalog
Holdings: 78 vertical file drawers
Subjects: Art, architecture, dance, decorative arts, film &
 video, games, graphics, handicrafts, hobbies, music,
 photography, sports, theatre
Special Collections:
Bookplate Collection
Clipping File Collection
Pictures, articles, pamphlets & programs.
Hal Coffman Collection
Music Collection
Includes sheet music, music scores, tune cards, phono-
 records.
Original Cartoon Art Collection
Painting Collection
Framed & matted reproductions of paintings.
Picture & Photograph Collection
Historical material that has been autographed by celebrities.

AL 558
LEE COLLEGE LIBRARY
Box 1818, Baytown, TX 77520
Tel: 713-427-5611, Ext 240
Dir: William K Peace

Academic Founded: 1935
Hours: Mon-Thurs 7:30-9:30
 Fri 7:30-4:30
 Sun 2-5
Circulation: Public (open stacks)
Reference Service: In person, telephone
Reprographic Services: Yes
Interlibrary Loan: NILS; University of Houston, Clear Lake
 Campus
Networks/Consortia: No
Publications: Orientation handbook; special catalogs; index
 of serials & audiovisual holdings
Special Programs: Group & individual tours; bibliographic
 instruction
Cataloged Volumes: 84,934
Serial Titles: 859
Holdings: 20 vertical file drawers; 15,494 microforms; 150
 sales & auction catalogs
Subjects: Art, architecture, decorative arts, film & video,
 music, photography, theatre

AL 559
MONTGOMERY COUNTY MEMORIAL LIBRARY
San Jacinto at Phillips, Conroe, TX 77301

Tel: 713-756-4486
Dir: Henry J Blasick

Public Library Founded: 1946
Hours: Mon, Wed, Fri 8:30-6
 Tues & Thurs 8:30-8
 Sat 10-2:30
Circulation: Public (open stacks)
Reference Service: In person
Interlibrary Loan: Yes, ties into national system through
 Houston Area Library System
Networks/Consortia: Houston Area Library Service
Special Programs: Group tours; single lectures
Card Catalog
Cataloged Volumes: 92,250
Serial Titles: 181
Holdings: 15 vertical file drawers; 600 microfilm
Subjects: Art
Special Collections: Texas Collection; Genealogy Collection
 of microfilm, microfiche & books

AL 560
NORTH TEXAS STATE UNIVERSITY
University Library—Humanities Division
Denton, TX 76203
Tel: 817-788-2411, Ext 212
Libn: Johnnye Louise Cope

Academic Founded: 1903
Hours: Mon-Thurs 8-11
 Fri 8-5
 Sat 9-5
 Sun 2-10
Circulation: Students, faculty/staff (open stacks accessible to
 public)
Reference Service: In person, telephone, mail
Reprographic Services: Yes
Interlibrary Loan: NILS; Interuniversity Council of the North
 Texas Area
Networks/Consortia: OCLC; Interuniversity Council of North
 Texas Area
Publications: In-house periodical index (North Texas State
 University Serials Record)
Special Programs: Group tours; bibliographic instruction;
 single lectures
Cataloged Volumes: 174,613 humanities division; 9,325 art
 titles
Serial Titles: 355 (Union List of Art Periodicals, Metroplex
 Region)
Holdings: 130 regional exhibition catalogs
Subjects: Art, architecture, decorative arts, film & video,
 graphics, photography, theatre
Special Collection:
Interior Design Product File
Catalogs of firms which manufacture furniture, drapery, wall &
 floor coverings for interior design. Cross-referenced by
 name of manufacturing firm & by subject.

AL 561
**OUR LADY OF THE LAKE UNIVERSITY OF SAN
 ANTONIO LIBRARIES**
411 SW 24 St, San Antonio, TX 78285
Tel: 512-434-6711, Ext 272
Dir of Libs: Sr Miriam Dorothy Lueb

Academic
Hours: Mon-Thurs 8-10
 Fri 8-5

Sat 9-2
Sun 2-6
Circulation: Students, researchers, faculty/staff (open stacks)
Reference Service: In person, telephone
Reprographic Services: Yes
Interlibrary Loan: NILS
Networks/Consortia: Texas Information Exchange
Publications: In-house periodical index (Subject Guide to
 Periodicals Owned by Our Lady of the Lake University)
Special Programs: Group & individual tours; bibliographic
 instruction; single lectures; slide-tape modules for
 individual instruction
Cataloged Volumes: 123,839
Serial Titles: 7,739 total; 46 art
Holdings: 12 vertical file drawers (general subjects); 178,520
 microforms
Subjects: Art, architecture, classical archaeology, dance,
 decorative arts, film & video, graphics, music, photography,
 theatre

AL 562
WILLIAM MARSH RICE UNIVERSITY
Art Library
Box 1892, Houston, TX 77001
Tel: 713-527-4832
Art Libn: Shelby Miller

Academic Founded: 1964
Hours: Mon-Fri 8:30-10
 Sat 1-5
 Sun 2-10
 Special hours during summer
Circulation: Public (open stacks)
Reference Service: In person, telephone, mail
Reprographic Services: Yes
Interlibrary Loan: NILS
Networks/Consortia: No
Publications: Acquisitions list
Special Programs: Group & individual tours
Cataloged Volumes: 29,800
Serial Titles: 231 (National Union Catalog; Union List of Art
 Periodicals, South Texas Region)
Holdings: 4 vertical file drawers; 6,000 exhibition catalogs
Subjects: Art, architecture, classical archaeology, decorative
 arts, film & video, graphics, photography

AL 563
SAN ANTONIO ART INSTITUTE LIBRARY
6000 N New Braunfels, Box 6092, San Antonio, TX 78209
Tel: 512-824-0531
Libn: Mrs Albert Johnson

Art School Founded: 1942
Hours: Mon-Fri 8:30-4:30
 Sat 9-12
Circulation: Students, faculty/staff (open stacks)
Reference Service: In person only
Reprographic Services: No
Interlibrary Loan: No
Networks/Consortia: No
Special Programs: Single lectures
Subjects: Art

AL 564
SAN ANTONIO COLLEGE
Moody Learning Center
1001 Howard St, San Antonio, TX 78284
Tel: 512-734-7311, Ext 257

Rare Book & Special Collections Libn: M Bates

Academic Founded: 1950
Hours: Mon-Thurs 8-10
 Fri 8-6
Circulation: Public (open stacks except for government docu-
 ments & periodicals)
Reference Service: In person, telephone, mail
Reprographic Services: Yes
Interlibrary Loan: NILS
Networks/Consortia: Council of Research & Academic
 Libraries
Publications: Orientation handbook; bibliographies; acquisi-
 tions list; newsletter; special catalogs; book catalog; in-
 house periodical index (San Antonio College Periodical
 Holdings Listing)
Special Programs: Group & individual tours; bibliographic
 instruction; single lectures
Cataloged Volumes: 206,710
Serial Titles: 1,350 (Council of Research & Academic
 Libraries Union List)
Holdings: 23,085 microforms
Subjects: Art, architecture, classical archaeology, dance,
 decorative arts, film & video, graphics, music, photography,
 theatre
Special Collection:
Morrison Collection
18th century English materials, with an emphasis on 1700–
 1750.

AL 565
SAN JACINTO COLLEGE
Lee Davis Library
8060 Spencer Hwy, Pasadena, TX 77505
Tel: 713-479-1501, Exts 241; 250
Dean of Lib Services; Dr Parker Gregoire

Academic (junior college) Founded: 1961
Hours: Mon-Thurs 7:30-10
 Fri 7:30-3
 Sun 1:30-5
Circulation: Public (open stacks)
Reference Service: In person, telephone, mail
Reprographic Services: Yes
Interlibrary Loan: NILS
Networks/Consortia: No
Publications: Orientation handbook; bibliographies; acquisi-
 tions list; in-house periodical index (List of Periodicals)
Special Programs: Group & individual tours; single lectures;
 intern program
Cataloged Volumes: 96,319
Serial Titles: 1,001
Holdings: 26 vertical file drawers; 9,991 microforms
Subjects: Art, architecture, decorative arts
Special Collection: Texas History

AL 566
TEXAS CHRISTIAN UNIVERSITY
Mary Couts Burnett Library
Fort Worth, TX 76129
Tel: 817-926-2461
University Libn: Paul Parham

Academic Founded: 1873
Hours: Mon-Thurs 7:30-12
 Fri 7:30-6
 Sat 9-6
 Sun 2-12

Circulation: Students, researchers, faculty/staff (open stacks except for selected materials)
Reference Service: In person, telephone, mail
Reprographic Services: Yes
Interlibrary Loan: NILS
Networks/Consortia: OCLC; Texas Information Exchange; Interuniversity Council
Publications: Orientation handbook; bibliographies; acquisitions list; special catalogs
Special Programs: Individual tours; bibliographic instruction; single lectures
Cataloged Volumes: 8,500
Serial Titles: 178 art-related (National Union Catalog; Texas Union List of Serials)
Subjects: Classical archaeology, film & video, graphics, music, photography, theatre, dance

AL 567
TEXAS WOMAN'S UNIVERSITY LIBRARY
Denton, TX 76204
Tel: 817-387-3444

Academic
Circulation: Students, researchers, faculty/staff (open stacks)
Reference Service: In person, telephone, mail
Reprographic Services: No
Interlibrary Loan: NILS
Networks/Consortia: Interuniversity Council of the North Texas Area; AMIGOS Bibliographic Council
Cataloged Volumes: 536,000 (total collection)
Subjects: Art, architecture, classical archaeology, dance, decorative arts, film & video, graphics, music, photography, theatre
Special Collection: Woman's Collection

AL 568
TYLER MUSEUM OF ART LIBRARY
1300 S Mahon, Tyler, TX 75701
Tel: 214-595-1001
Curator: Barbara Meyer

Museum Founded: 1971
Hours: Tues-Sat 10-5
 Sun 1-5
Circulation: Staff only (open stacks)
Reference Service: No
Reprographic Services: No
Interlibrary Loan: No
Networks/Consortia: No
Publications: Exhibition catalogs; book catalog
Special Programs: Group tours; single lectures
Card Catalog
Cataloged Volumes: 2,000
Subjects: Art, architecture, decorative arts, film & video, graphics, photography

AL 569
THE UNIVERSITY OF TEXAS
Art Library
23 & San Jacinto, Austin, TX 78712
Tel: 512-471-1636
Libn: Joyce Hess

Academic Founded: 1881; 1942
Hours: Mon-Thurs 8-10
 Fri 8-5
 Sat 10-4
 Sun 2-6

Circulation: Public; loans limited to registered borrowers (open stacks; reserve books, rare materials & unbound periodicals do not circulate)
Reference Service: In person, telephone, mail
Reprographic Services: Yes
Interlibrary Loan: NILS; Texas Information Exchange (Interlibrary Service, Perry Castañeda Library, 2.402A); TALON; Texas Numeric Register
Publications: Orientation handbook; bibliographies; acquisitions list; newsletter; special catalogs; material on collections development policy; various in-house publications; in-house periodical index (Serials Alpha List)
Special Programs: Group & individual tours; bibliographic instruction; single lectures
Card Catalog
Cataloged Volumes: 36,000
Serial Titles: 370 (National Union Catalog)
Holdings: 12 vertical file drawers; 9 microfilms
Subjects: Art, art education, decorative arts, graphics, photography

AL 570
WHARTON COUNTY JUNIOR COLLEGE
J M Hodges Learning Center
911 Boling Hwy, Wharton, TX 77488
Tel: 713-532-5046
Dir: Patsy Norton

Academic Founded: 1946
Circulation: Public (open stacks)
Reference Service: In person only
Reprographic Services: Yes
Interlibrary Loan: NILS
Networks/Consortia: No
Publications: In-house periodical index
Special Programs: Group & individual tours; intern program
Cataloged Volumes: 48,543
Serial Titles: 372
Holdings: 3,924 microforms
Subjects: Art

Utah

AL 571
SALT LAKE CITY PUBLIC LIBRARY
Fine Arts Department
209 E Fifth St, Salt Lake City, UT 84111
Tel: 801-363-5733, Ext 41
Head, Fine Arts Dept: Glenda Rhodes

Public Library
Hours: Mon-Fri 9-9
 Sat 9-6
 Sun 1-5 (winter only)
Circulation: Public (open stacks)
Reference Service: Yes
Reprographic Services: Yes
Interlibrary Loan: NILS (Margaret Brady, Head, Periodicals & Interlibrary Loan)
Networks/Consortia: Consortium for Library Innovation
Publications: Bibliographies
Special Programs: Group & individual tours
Serial Titles: 30
Holdings: 96 vertical file drawers; 600 exhibition catalogs
Subjects: Art, architecture, classical archaeology, dance, decorative arts, film & video, graphics, music, photography, theatre

Special Collections: Art & artists from Utah & the south-
western United States

AL 572
UNIVERSITY OF UTAH
Marriott Library
Salt Lake City, UT 84112
Tel: 801-581-8104
Dir of Libs: Roger K Hanson
Fine Arts Libn: Sharon Shepherd

Academic
Hours: Mon-Thurs 7:30-11
 Fri 7:30-8
 Sat 9-8
 Sun 1-10
Circulation: Public (open stacks except for archival & rare
 materials)
Reference Service: In person
Reprographic Services: Yes
Interlibrary Loan: Utah College Library Council; Biblio-
 graphic Center for Research
Networks/Consortia: OCLC
Publications: Orientation handbook; bibliographies; news-
 letter; special catalogs; in-house periodical index (Uni-
 versity of Utah Libraries Public Serials List)
Special Programs: Group & individual tours; bibliographic
 instruction
Card Catalog
Cataloged Volumes: 1,330,000 including all subjects
Serial Titles: 16,000 including all subjects (National Union
 Catalog; Ohio College Library Consortium Serial List)
Subjects: Art, architecture, dance, decorative arts, graphics,
 music, photography

Vermont

AL 573
CASTLETON STATE COLLEGE
Calvin Coolidge Library/Learning Resources Center
Castleton, VT 05735
Tel: 802-468-5611, Ext 257
Dir: Milimir Drazic

Academic Founded: 1843
Hours: Mon-Thurs 8-11
 Fri 8-6
 Sat 12-6
 Sun 1-11
Circulation: Public; reserve materials do not circulate (open
 stacks)
Reference Service: In person, telephone, mail
Reprographic Services: Yes
Interlibrary Loan: NILS; Vermont State Colleges Interlibrary
 Loan
Networks/Consortia: No
Publications: Orientation handbook; bibliographies; in-house
 periodical index (List of Periodicals at Castleton State
 College)
Special Programs: Group & individual tours; bibliographic
 instruction; single lectures
Card Catalog
Cataloged Volumes: 72,101
Serial Titles: 197
Holdings: 2,926 pamphlets; 10,275 microforms
Subjects: Art, architecture, classical archaeology, dance,

decorative arts, film & video, graphics, music, photography,
theatre
Special Collections: Vermont Room

AL 574
MOUNT VERNON LADIES' ASSOCIATION OF THE
UNION
Research & Reference Library
Mount Vernon, VT 22121
Tel: 703-780-2000
Libn: Ellen McCallister

Museum
Hours: Mon-Fri 9-5 (March-Oct)
 Mon-Fri 9-4:30 (Nov-Feb)
Circulation: No (open stacks except for original manuscript
 materials)
Reference Service: In person, telephone, mail
Reprographic Services: Yes
Interlibrary Loan: No
Networks/Consortia: No
Publications: Orientation handbook; annual report; book
 catalog
Cataloged Volumes: 12,000
Serial Titles: 12
Subjects: Art, architecture, decorative arts, music
Special Collection:
Washington Collection
Materials relating to the domestic lives of George & Martha
 Washington & the history of Mount Vernon from 1735–
 present.

AL 575
SHELBURNE MUSEUM LIBRARY
Route 7, Shelburne, VT 05482
Tel: 802-985-3344
Dir: Kenneth Wheeling

Museum
Hours: Daily 9-5 (May 15-Oct 15)
Circulation: No (closed stacks)
Reference Service: Yes
Interlibrary Loan: NILS
Networks/Consortia: No
Publications: Special catalogs; in-house periodical index;
 book catalog
Special Programs: Group tours
Cataloged Volumes: 11,000
Serial Titles: Vermont State Union List of Serials
Holdings: 12 vertical file drawers; 3,000 sales & auction
 catalogs; 500 exhibition catalogs
Subjects: Art, antiques, architecture, decorative arts, photog-
 raphy

AL 576
SPRINGFIELD ART & HISTORICAL SOCIETY
LIBRARY
Springfield, VT 05156
Tel: 802-885-2415
Sec/Rec: Mrs Fred R Herrick

Museum Founded: 1956
Hours: Mon-Fri 12-4:30
Circulation: No
Reference Service: No
Reprographic Services: No
Interlibrary Loan: No
Networks/Consortia: No
Card Catalog

Card Catalog
Cataloged Volumes: Small collection
Subjects: Art, history of Vermont & Springfield

Virginia

AL 577
BOTETOURT-ROCKBRIDGE REGIONAL LIBRARY
312 S Main, Lexington, VA 24450
Tel: 703-463-4324
Dir: Linda L Krantz

Regional Public Library Founded: 1946
Hours: Mon, Wed, Thurs, Sat 9-5
 Tues, Fri 9-9
Circulation: Public (open stacks)
Reference Service: In person, telephone, mail
Reprographic Services: Yes
Interlibrary Loan: NILS
Networks/Consortia: No
Publications: In-house periodical index
Special Programs: Group & individual tours; informal biblio-
 graphic instruction; presentations to clubs
Card Catalog
Cataloged Volumes: 73,069
Serial Titles: 101
Holdings: 15 vertical file drawers
Subjects: Art, architecture, classical archaeology, dance,
 decorative arts, film & video, graphics, music, photography,
 theatre

AL 578
BRIDGEWATER STATE COLLEGE
Alexander Mack Memorial Library
Bridgewater, VA 22812
Tel: 703-828-2501, Ext 510
Libn: Orland Wages

Academic Founded: 1880
Hours: Mon-Fri 8-10
 Sat 10-2
 Sun 2-10
Circulation: Students, faculty/staff (open stacks)
Reference Service: In person, telephone, mail
Reprographic Services: No
Interlibrary Loan: NILS
Networks/Consortia: Southeastern Library Network; Shenan-
 doah Valley Independent Colleges Library Cooperative
Publications: Orientation handbook; acquisitions list
Special Programs: Group tours; bibliographic instruction;
 intern program
Cataloged Volumes: 95,000
Serial Titles: 775
Holdings: 24 vertical file drawers; 1,900 microforms; 6,500
 microfiche
Subjects: Art, architecture, dance, decorative arts, film &
 video, graphics, music, photography, theatre

AL 579
HAMPTON INSTITUTE
William H Moses Jr, Library of Architecture
Queen St, Hampton, VA 23668
Tel: 804-727-5443
Libn: Frank Ducic

School of Architecture Founded: 1967

Hours: Mon-Fri 8:30-5
 Sun 1-5
Circulation: Students, faculty/staff (open stacks)
Reference Service: In person, telephone, mail
Reprographic Services: Yes
Interlibrary Loan: NILS
Networks/Consortia: No
Publications: Acquisitions list; in-house periodical index
 (Architectural periodical index)
Special Programs: Group tours
Cataloged Volumes: 7,000
Serial Titles: 120
Holdings: 6 vertical file drawers; 50 sales & auction catalogs
Subjects: Art, architecture, decorative arts, graphics, photog-
 raphy

AL 580
LONGWOOD COLLEGE
Dabney Lancaster Library
Farmville, VA 23901
Tel: 804-392-9376
Dir: Martha H LeStourgeon

Academic Founded: 1839
Circulation: Public; oversize art books do not circulate (open
 stacks)
Reference Service: In person, telephone, mail
Reprographic Services: Yes
Interlibrary Loan: NILS
Networks/Consortia: Southeastern Library Network
Publications: Orientation handbook; bibliographies
Special Programs: Group & individual tours
Cataloged Volumes: 162,942
Serial Titles: 1,304
Holdings: 36 vertical file drawers; 4,890 microforms
Subjects: Art, architecture, classical archaeology, dance,
 decorative arts, film & video, graphics, music, photography,
 theatre

AL 581
GEORGE MASON UNIVERSITY
Fenwick Library
4400 University Dr, Fairfax, VA 22030
Tel: 703-323-2390
Libn: Dr John Veenstra

Academic Founded: 1948
Hours: Mon-Thurs 7:30-11
 Fri 7:30-9
 Sat 9-5
 Sun 1-9
Circulation: Students, faculty/staff (open stacks)
Reference Service: In person, telephone, mail
Reprographic Services: Yes
Interlibrary Loan: NILS
Networks/Consortia: Consortium for Continuing Higher
 Education in Northern Virginia
Publications: Orientation handbook; bibliographies; news-
 letter; in-house periodical index (Periodical Listing,
 George Mason University–Fenwick Library)
Special Programs: Group & individual tours; bibliographic
 instruction; single lectures; self-guided taped tour
Cataloged Volumes: 144,000 (143,000 titles)
Serial Titles: 2,000 (Virginia Union List of Serials)
Holdings: 25 vertical file drawers; 6,500 microforms
Subjects: Art, architecture, classical archaeology, dance,
 decorative arts, film & video, graphics, music, photography,
 theatre

Special Collections:
Federal Theatre Project Research Center
Collection of playscripts, radioscripts, set & costume designs
& other creative materials produced by the Federal Theatre
of the 1930s.

AL 582
RANDOLPH-MACON WOMAN'S COLLEGE
Lipscomb Library
Norfolk Ave, Lynchburg, VA 24504
Tel: 804-846-7392, Ext 242
Libn: Miller Boord

Academic Founded: 1891
Hours: Mon-Sat 7:30-11
 Sun 2-11
Circulation: Students, faculty/staff (open stacks)
Reference Service: In person, telephone, mail
Reprographic Services: Yes
Interlibrary Loan: NILS; Tri-College Center of Virginia
Networks/Consortia: Lynchburg Area Library Cooperative
Publications: Orientation handbook; bibliographies; aquisi-
tions list; in-house periodical index (Lynchburg Area
Union List of Serials)
Special Programs: Group & individual tours; bibliographic
instruction
Cataloged Volumes: 135,000
Serial Titles: 679 (National Union Catalog; Lynchburg Area
Union List of Serials; Virginia Union List of Serials)
Holdings: 1,780 microforms
Subjects: Art, architecture, classical archaeology, dance,
decorative arts, film & video, graphics, music, photography,
theatre

AL 583
ROANOKE PUBLIC LIBRARY
706 Jefferson St, Roanoke, VA 24011
Tel: 703-981-2475
Mgr: Nancy E Himes

Public Library Founded: 1921
Hours: Mon-Thurs 9-9
 Fri 9-6
 Sat 9-5
Circulation: Public (open stacks)
Reference Service: In person, telephone, mail
Reprographic Services: Yes
Interlibrary Loan: NILS
Networks/Consortia: No
Special Programs: Group tours
Cataloged Volumes: 324,985
Serial Titles: 344 (Virginia Union Catalog of Serials)
Holdings: 30 vertical file drawers; 25,604 microforms
Subjects: Art, architecture, classical archaeology, dance,
decorative arts, music, photography, theatre

AL 584
SOUTHWEST VIRGINIA COMMUNITY COLLEGE
 LIBRARY
Box SVCC, Richlands, VA 24641
Tel: 703-964-2555, Ext 340
Coordinator: Frank Nunez

Academic Founded: 1968
Circulation: Public (open stacks)
Reference Service: In person, telephone, mail
Reprographic Services: Yes
Interlibrary Loan: NILS; Western Region Consortium for
Continuing Higher Education

Publications: Orientation handbook; bibliographies; acquisi-
tions list
Special Programs: Group & individual tours
Card Catalog
Cataloged Volumes: 29,840
Holdings: 12 vertical file drawers; 16,000 volumes microfilm;
2,000 microfiche
Subjects: Art, architecture, photography, music
Special Collections: Virginia Collection of books & materials
by or about Virginians

AL 585
UNIVERSITY OF RICHMOND
Boatwright Memorial Library
Richmond, VA 23173
Tel: 804-285-6215
University Libn: Dennis E Robison

Academic Founded: 1830
Hours: Mon-Thurs 8-11
 Fri 9-10
 Sat 9-5
 Sun 2-11
 Closed evenings & weekends between sessions
Circulation: Students, faculty/staff (open stacks)
Reference Service: Yes
Reprographic Services: No
Interlibrary Loan: NILS; inter-institutional cooperation with
area academic libraries
Networks/Consortia: Richmond Area Film Cooperative
Publications: Orientation handbook; bibliographies; special
catalogs
Special Programs: Group tours; bibliographic instruction
Cataloged Volumes: 283,000
Serial Titles: 1,800
Holdings: 40 vertical file drawers; 13,374 microforms
Subjects: Art

AL 586
UNIVERSITY OF VIRGINIA
Fiske Kimball Fine Arts Library
Bayly Dr, Charlottesville, VA 22903
Tel: 804-924-7024
Libn: Mary C Dunnigan

Academic Founded: 1970
Hours: Mon-Thurs 8-11
 Fri 8-10
 Sat 9-6
 Sun 1-11 (academic year)
 Mon-Fri 8-5 (interim period)
Circulation: Public; 50% of materials are non-circulating
(open stacks)
Reference Service: In person, telephone, mail
Reprographic Services: Yes
Interlibrary Loan: NILS (Interlibrary Loan Office, Alderman
Library, Charlottesville, VA 22901)
Networks/Consortia: No
Special Programs: Group & individual tours; bibliographic
instruction; single lectures
Cataloged Volumes: 48,795
Serial Titles: 479 (National Union Catalog; Virginia Union
List of Serials)
Holdings: 24 vertical file drawers; 436 microforms; sales &
auction catalogs; 2,950 exhibition catalogs
Subjects: Art, architecture, classical archaeology, dance,
decorative arts, drama, film, graphics, photography,
theatre, landscape architecture, urban planning

Special Collections:
Francis B Johnston Photographs of Virginia Architecture
Collection of 1,800 photographs of architecture in Virginia commissioned in the 1930s as a WPA project.
Special Collections, Including Rare Books
Books, serials, collections of loose plates, inscribed & presentation copies dating from the 15th century to present on such subjects as architecture, art, drama, landscape, architecture & planning.
Claude Monet Research Collection
Original & secondary research materials collected by William C Seitz during the 1950s for his book on Claude Monet. Includes 75 prints, 2,452 slides, photographs & notebooks.
William Morris Collection
471 volumes dating from the 15th century to present relating to art forgery & artists' materials.

AL 587
VIRGINIA COMMONWEALTH UNIVERSITY
James Branch Cabell Library
901 Park Ave, Richmond, VA 23284
Tel: 804-770-5992
Dir of University Libs: Gerard McCabe

Academic
Hours: Mon-Thurs 8-12
 Fri 8-6
 Sat 9-6
 Sun 1-12
Circulation: Public (open stacks)
Reference Service: In person, telephone, mail
Reprographic Services: Yes
Interlibrary Loan: NILS; SOLINET; Richmond Area Library Cooperative; Richmond Area Film Cooperative
Publications: Orientation handbook; bibliographies
Special Programs: Group & individual tours; bibliographic instruction; single lectures
Card Catalog
Cataloged Volumes: 101,167 bound; 180,258 monographic
Serial Titles: 3,600 (Virginia Union List of Serials)
Holdings: 64,505 microforms; sales & auction catalogs; exhibition catalogs; 31,678 media & curriculum materials
Subjects: Art, architecture, classical archaeology, costume, fashion, crafts, dance, decorative arts, film & video, graphics, music, photography, theatre
Special Collections: Cartoons & caricatures; Richmond authors; modern poetry

AL 588
VIRGINIA POLYTECHNIC INSTITUTE & STATE
UNIVERSITY
Architecture Library
Cowgill Hall, Blacksburg, VA 24061
Tel: 703-951-6182
Architecture Libn: Robert E Stephenson

Academic Founded: 1928
Hours: Mon-Thurs 8-11
 Fri 8-5
 Sat 2-5
 Sun 7-10
Circulation: Public (open stacks)
Reference Service: In person, telephone, mail
Reprographic Services: Yes
Interlibrary Loan: NILS (Interlibrary Loan Dept, Newman Library)
Networks/Consortia: Virginia Council on Higher Education; Western Regional Consortium

Publications: In-house periodical index (Periodicals Currently Received in the Virginia Polytechnic Institute & State University)
Special Programs: Group & individual tours; bibliographic instruction; single lectures
Cataloged Volumes: 30,000
Serial Titles: 328 (Union List of Serials; Virginia Union List of Serials)
Holdings: 27 vertical file drawers; 1,400 microforms
Subjects: Art, architecture, decorative arts, graphics, photography, urban & regional planning

Washington

AL 589
THE EVERGREEN STATE COLLEGE LIBRARY
Olympia, WA 98505
Tel: 206-866-6250
Dean of Lib Services: Jovana Brown

Academic Founded: 1970
Hours: Mon-Thurs 8-11
 Fri 8-7
 Sat 1-5
 Sun 1-9
Circulation: Public (open stacks with restrictions on rare materials, periodicals, art prints & slides)
Reference Service: In person, telephone, mail
Reprographic Services: Yes
Interlibrary Loan: NILS (Interlibrary Loan, Grace Phillipson)
Networks/Consortia: Washington Library Network
Publications: Orientation handbook; special catalogs; in-house periodical index (Periodical Holdings of the Washington State Library, Washington State Law Library & The Evergreen State College Library)
Special Programs: Group & indiviual tours; bibliographic instruction; single lectures; informal intern program
Cataloged Volumes: 115,000 total; 5,000 art
Serial Titles: 2,425 total; 25 art
Holdings: 85 vertical file drawers; 108,745 microforms & fiche; exhibition catalogs
Subjects: Art

AL 590
RESOURCES IN CONTEMPORARY ARTS
1525 10 Ave, Seattle, WA 98122
Tel: 206-324-5880
Libn: Ann Obery

Non-Profit Art Center/ Founded: 1975
 Contemporary Arts Library
Hours: Mon-Fri 11-6
Circulation: No (open stacks)
Reference Service: In person, telephone, mail
Reprographic Services: Yes
Interlibrary Loan: Informally, with interested organizations
Networks/Consortia: Informally
Publications: Bibliographies; newsletter; special catalogs; in-house periodical index
Special Programs: Tours as requested; workshops/seminars; informal discussions; concerts; single lectures
Serial Titles: 120
Holdings: 4 vertical file drawers; over 200 exhibition catalogs; several hundred books; recordings
Subjects: Art, contemporary art, dance, film & video, graphics, new music, photography, theatre

Special Collections: Periodicals on visual arts, performance,
new music, artists & the law, theatre, dance, video & film,
conceptual & written art, women in the arts & artists' publi-
cations

AL 591
SEATTLE PUBLIC LIBRARY
Art & Music Department
1000 Fourth Ave, Seattle, WA 98104
Tel: 206-625-4969
Head: Carolyn B Holmquist

Public Library
Hours: Mon-Thurs 9-9
 Fri & Sat 9-6
Circulation: Public (open stacks)
Reference Service: In person, telephone, mail
Reprographic Services: Yes
Interlibrary Loan: NILS
Networks/Consortia: Pacific Northwest Bibliographic Center
Publications: Bibliographies; acquisitions list; newsletter;
special catalogs; booklists by subject area; in-house peri-
odical index (Index of Current Periodicals in Seattle
Public Library)
Special Programs: Group & individual tours; bibliographic
instruction
Cataloged Volumes: 68,689
Serial Titles: 215 (National Union Catalog; King County
Library System Union List)
Holdings: 292 vertical file drawers; picture files on fine arts &
architecture; microforms; 199 sales & auction catalogs;
2,000 exhibition catalogs; 1,500 oversize reproductions of
paintings from primitive to contemporary
Subjects: Art, architecture, classical archaeology, dance,
decorative arts, graphics, music, photography, theatre
(stage design & architecture of theatres)
Special Collections:
Northwest Art Collection
Scrapbooks on artists & art subjects of the Northwest,
reproductions of Northwest artists' works as well as original
paintings, drawings, prints & sculpture of Northwest artists.
Orchid Collection
Reference book collection.
Photography Collection
Includes Old Seattle & Northwest historical photographs, J W
Thompson photographs of Washington State Indians ca
1950, Werner Lenggenhager photographs of Seattle &
Washington from 1950 to present.

AL 592
SPOKANE PUBLIC LIBRARY
Fine Arts Department
W 906 Main Ave, Spokane, WA 99201
Tel: 509-838-3361, Ext 58
City Libn: Betty W Bender
Fine Arts Libn: Janet Miller

Public Library Founded: 1894
Hours: Mon-Sat 9-9
Circulation: Public; reference & rare materials do not circulate
(open stacks; additional closed stacks house rare materials)
Reference Service: In person, telephone, mail
Reprographic Services: Yes
Interlibrary Loan: NILS
Networks/Consortia: No
Special Programs: Individual tours; bibliographic instruction;
single lectures; orientation film
Card Catalog

Serial Titles: 60 (National Union Catalog)
Holdings: 20 vertical file drawers; exhibition catalogs
Subjects: Art, architecture, classical archaeology, dance,
decorative arts, film & video, graphics, music, photography,
theatre
Special Collections: Costume; sheet music

AL 593
TACOMA PUBLIC LIBRARY
Handforth Gallery
1102 Tacoma Ave S, Tacoma, WA 98402
Tel: 206-572-2000, Ext 57
Dir: Clayton C Kirking

Public Library Founded: 1894
Hours: Mon-Thurs 9-9
 Fri-Sat 9-6
Circulation: Public; selected reference materials circulate
only for research purposes (open stacks; restricted use of
reference materials)
Reference Service: In person, telephone, mail
Reprographic Services: Yes
Interlibrary Loan: NILS; Washington Library Network
Publications: Bibliographies; acquisitions list; in-house
periodical index
Special Programs: Group & individual tours; single lectures
Card Catalog
Cataloged Volumes: 23,250
Serial Titles: 72 (Washington State Serial Holdings in Public
Libraries)
Subjects: Art, architecture, classical archaeology, dance,
decorative arts, film & video, graphics, music, photography,
theatre
Special Collections:
Northwest Literature Collection
Besides literature the collection also contains photographs,
prints & negatives & original local artists' work.

Wisconsin

AL 594
ALVERNO COLLEGE
Library Media Center
3401 S 39 St, Milwaukee, WI 53228
Tel: 414-671-5400, Ext 411
Cataloger & Reference Libn: Lola Stuller

Academic
Hours: 8-10
Circulation: Public (open stacks)
Reference Service: In person, telephone
Interlibrary Loan: Wisconsin Interlibrary Loans
Networks/Consortia: OCLC
Publications: Orientation handbook; bibliographies; in-house
periodical index (Turn On and Read: Classified List of
Serials)
Special Programs: Bibliographic instruction
Card Catalog
Cataloged Volumes: 8,607
Serial Titles: 179
Subjects: Art, architecture, dance, decorative arts, graphics,
music, photography, theatre

AL 595
CARDINAL STRITCH COLLEGE
San Damiano Library

6801 N Yates, Milwaukee, WI 53217
Tel: 414-352-5400
Lib Aid: Sr Mary May

Academic Founded: 1937
Hours: Mon-Fri 8-5
Circulation: No (open stacks)
Reference Service: No
Reprographic Services: No
Interlibrary Loan: No
Networks/Consortia: Wisconsin Interlibrary Loan Service
Special Programs: Group & individual tours; single lectures
Serial Titles: 8-10
Subjects: Art, architecture, classical archaeology, decorative
 arts, film & video, photography

AL 596
GATEWAY TECHNICAL INSTITUTE
Learning Resources Center
3520 30 Ave, Kenosha, WI 53142
Tel: 414-552-9600
District Coordinator: J Jerome Oehler

Vocational/Technical Institute (post-secondary level)
Hours: Daily 8-4:30
Circulation: Public; restricted used of select materials
 (open stacks; restricted use of reserve materials & some
 periodicals)
Reference Service: Telephone, mail
Reprographic Services: Yes
Interlibrary Loan: NILS; Tri County Library Council
Networks/Consortia: National Health Science Library Net-
 work
Publications: Orientation handbook; special catalogs; book
 catalog on microfiche
Special Programs: Group & individul tours; bibliographic
 instruction; single lectures
Card Catalog
Cataloged Volumes: 41,872 total; 1,789 art (1,439 titles)
Serial Titles: Tri County Library Council Union List of Serials
Holdings: 5,000 pamphlets (200 art-related); periodicals; 20
 student research papers
Subjects: Art, architecture, decorative arts, film & video,
 photography
Special Collections: Interior Decorating & Design; Textile
 Design

AL 597
GRAHAM PUBLIC LIBRARY
1215 Main St, Union Grove, WI 53182
Tel: 414-878-2910
Head Libn: Delores Saemisch

Public Library Founded: 1932
Circulation: Public (open stacks)
Reference Service: Telephone, mail
Reprographic Services: Yes
Interlibrary Loan: Burlington Interlibrary Loan System;
 Wisconsin State Library Loan System
Networks/Consortia: No
Publications: Bibliographies; in-house periodical index
Special Programs: Group & individual tours; bibliographic
 instruction
Card Catalog
Cataloged Volumes: 28,000
Serial Titles: 89
Holdings: 5,000 vertical file drawers; 10 microforms
Subjects: Art, architecture, classical archaeology, decorative
 arts, graphics, music, photography, theatre

AL 598
KENOSHA PUBLIC MUSEUM LIBRARY
Civic Center, Kenosha, WI 53140
Tel: 414-656-6026
Dir: Stephen H Schwartz

Museum Founded: 1933
Hours: Mon-Fri 9-12; 1-5
Circulation: No (closed stacks)
Reference Service: In person, telephone, mail
Reprographic Services: No
Interlibrary Loan: No
Networks/Consortia: No
Publications: Book catalog
Special Programs: Group & individual tours; single lectures
Cataloged Volumes: 1,000
Serial Titles: 10
Holdings: 4 vertical file drawers; 100 sales & auction catalogs;
 50 exhibition catalogs
Subjects: Art, classical archaeology, decorative arts

AL 599
LA CROSSE PUBLIC LIBRARY
800 Main St, La Crosse, WI 54601
Tel: 608-784-8623
Lib Dir: James W White

Public Library Founded: 1881
Hours: Mon-Thurs 9-9
 Fri & Sat 9-6
 Sun 1-5 (Oct-May)
Circulation: Public (open stacks)
Reference Service: In person, telephone, mail
Reprographic Services: Yes
Interlibrary Loan: NILS
Networks/Consortia: La Crosse Area Library System
Publications: In-house periodical index
Special Programs: Group & individual tours
Cataloged Volumes: 150,000
Holdings: 7,200 microforms
Subjects: Art, architecture, classical archaeology, dance,
 decorative arts, film & video, graphics, music, photography,
 theatre

AL 600
MADISON PUBLIC LIBRARY
Art & Music Division
201 W Mifflin St, Madison, WI 53703
Tel: 608-266-2311
Supervisor: Beverly J Brager

Public Library Founded: 1875; 1965
Hours: Mon-Fri 8:30-9
 Sat 9-5:30
Circulation: Public (open stacks)
Reference Service: In person
Interlibrary Loan: Wisconsin Interlibrary Loan System
Networks/Consortia: No
Publications: In-house periodical index
Special Programs: Group & individual tours; bibliographic
 instruction; single lectures
Card Catalog
Subjects: Art, architecture, dance, decorative arts, film &
 video, graphics, music, photography, theatre
Special Collections: Hathaway Collection of art books

AL 601
MARATHON COUNTY PUBLIC LIBRARY
400 First St, Wausau, WI 54401

Tel: 715-845-7214
Libn: Wayne Bassett

Public Library
Hours: Mon-Fri 8:30-9
 Sat 8:30-5:30
Circulation: Public (open stacks)
Reference Service: In person, telephone, mail
Reprographic Services: Yes
Interlibrary Loan: NILS; Wisconsin Valley Library Service
Networks/Consortia: OCLC
Publications: Bibliographies; film catalog; filmstrip catalog;
 in-house periodical index & book catalog (Local Wausau
 Record Herald)
Special Programs: Group & individual tours; bibliographic
 instruction; single lectures
Card Catalog
Cataloged Volumes: 200,000
Serial Titles: 737
Holdings: 150 vertical file drawers; 3,056 microforms
Subjects: Art, architecture, classical archaeology, dance,
 decorative arts, film & video, graphics, music, photography,
 theatre

AL 602
MILWAUKEE PUBLIC MUSEUM
Reference Library
800 W Wells St, Milwaukee, WI 53233
Tel: 414-278-2736
Museum Libn: Judith Campbell Turner

Museum Founded: 1883
Hours: Mon-Fri 8-4:45
Circulation: Staff (open stacks)
Reference Service: Telephone, mail
Reprographic Services: Yes
Interlibrary Loan: NILS; Wisconsin Interlibrary Loan
 Service; Library Council of Metropolitan Milwaukee
Networks/Consortia: No
Special Programs: Group & individual tours; bibliographic
 instruction; single lectures
Card Catalog
Cataloged Volumes: 78,000
Serial Titles: 808
Subjects: Art, architecture, classical archaeology, photog-
 raphy
Special Collections: Primitive arts

AL 603
MOUNT MARY COLLEGE LIBRARY
2900 N Menomonee River Pkwy, Milwaukee, WI 53222
Tel: 414-258-4810, Ext 234
Libn: Sister M Anne Lucy

Academic
Hours: Mon-Thurs 7:30-10
 Fri 7:45-5:30
 Sat 1-4
 Sun 1-4; 7:30-8:30
Circulation: Students, faculty/staff (open stacks)
Reference Service: In person, telephone, mail
Reprographic Services: No
Interlibrary Loan: NILS; Wisconsin Interlibrary Loan Sys-
 tem; Library Council of Metropolitan Milwaukee
Networks/Consortia: No
Publications: In-house periodical index
Special Programs: Individual tours
Card Catalog
Subjects: Art & artists

AL 604
OSHKOSH PUBLIC LIBRARY
106 Washington Ave, Oshkosh, WI 54901
Tel: 414-424-0473
Head Libn: Leonard B Archer, Jr

Public Library
Hours: Mon-Fri 9-9
 Sat 9-6
Circulation: Public (open stacks)
Reference Service: In person, telephone, mail
Reprographic Services: Yes
Interlibrary Loan: NILS
Networks/Consortia: OCLC
Publications: Orientation handbook; acquisitions list
Special Programs: Group tours
Cataloged Volumes: 232,496 (total collection)
Subjects: General, with a good collection in the fine arts

AL 605
OSHKOSH PUBLIC MUSEUM LIBRARY
1331 Algoma Blvd, Oshkosh, WI 54901
Tel: 414-424-0452
Libn & Archivist: Kitty A Hobson

Museum Founded: 1923
Hours: Tues-Sat 9-5
 Sun 1-5
Circulation: Restricted to in-house use (open stacks)
Reference Service: In person, telephone, mail
Reprographic Services: Yes
Interlibrary Loan: No
Networks/Consortia: No
Special Programs: Group tours; intern program
Card Catalog
Cataloged Volumes: 6,000
Serial Titles: 25 (National Union Catalog)
Holdings: 22 vertical file drawers; 3 sales & auction catalogs;
 1 exhibition catalog
Subjects: Art, architecture, classical archaeology, decorative
 arts, graphics, local art & history, photography
Special Collections: Files on Oshkosh, Fox Valley & Wiscon-
 sin artists

AL 606
PAINE ART CENTER & ARBORETUM
Paine Art Center Reference Library
1410 Algoma Blvd, Oshkosh, WI 54901
Tel: 414-235-4530-1, Ext 7
Libn: Jennie L O'Leary

Museum Founded: 1948
Hours: Tues-Sun 1-4:30 (summer)
 Tues & Thurs 1-4:30 (winter)
Circulation: Faculty/staff (open stacks)
Reference Service: In person, telephone, mail
Reprographic Services: Yes
Interlibrary Loan: No
Networks/Consortia: No
Publications: Newsletter; special catalogs
Special Programs: Group & individual tours
Cataloged Volumes: 1,642
Serial Titles: 25
Holdings: 4 vertical file drawers; sales & auction catalogs;
 extensive exhibition catalogs
Subjects: Art, architecture, decorative arts, graphics, photog-
 raphy
Special Collections:

Architecture
Interior & exterior detail; emphasis on English architecture.
Decorative Arts
Glass, pottery, rugs, furniture & sculpture.

AL 607
THE ROHR WEST MUSEUM LIBRARY
Park St & N Eighth, Manitowoc, WI 54220
Tel: 414-684-4181
Dir: Joseph S Hutchison

Museum Founded: 1942
Hours: Tues-Fri 9-4:30
 Sat & Sun 2-5
Circulation: No (open stacks)
Reference Service: In person, telephone, mail
Reprographic Services: No
Interlibrary Loan: Informal collaboration with Manitowoc
 Public Library
Networks/Consortia: No
Publications: In-house periodical index
Special Programs: Group tours
Cataloged Volumes: 1,800
Holdings: 3 vertical file drawers; 35-40 sales & auction
 catalogs; 150 exhibition catalogs
Subjects: Art, architecture, decorative arts, graphics, photog-
 raphy
Special Collections: North American Indian anthropology;
 Great Lakes shipping & ships; American art

AL 608
SOUTH MILWAUKEE PUBLIC LIBRARY
1907 10 Ave, South Milwaukee, WI 53172
Tel: 414-762-8692
Dir: Kathleen Gray

Public Library Founded: 1899
Circulation: Public (open stacks)
Reference Service: Telephone
Reprographic Services: Yes
Interlibrary Loan: Milwaukee Public Library loan system;
 Wisconsin Reference & Loan Library
Networks/Consortia: No
Publications: Bibliographies; acquisitions list (for in-house
 use); in-house periodical index
Special Programs: Group & individual tours; bibliographic
 instruction; single lectures
Card Catalog
Cataloged Volumes: 68,000
Serial Titles: 240
Holdings: 20 vertical file drawers; 180 microforms (New
 York Times: 1970–present); 40 microforms (South Mil-
 waukee Voice Journal: 1893–present)
Subjects: Art, architecture, classical archaeology, dance,
 decorative arts, film & video, graphics, music, photography,
 theatre

AL 609
SUPERIOR PUBLIC LIBRARY
1204 Hammond Ave, Superior, WI 54880
Tel: 715-394-0252
Dir: Dr Paul H Gaboriault

Public Library Founded: 1889
Hours: Mon-Thurs 9-9
 Fri 9-6
 Sat 9-5 (closed June-Aug)
 Sun 2-5 (except summer)

Circulation: Public (open stacks)
Reference Service: In person, telephone, mail
Reprographic Services: Yes
Interlibrary Loan: NILS (David H Lull, Head, Reference &
 Loan Services)
Networks/Consortia: Resource Library for the Northwest
 Wisconsin Library System
Publications: Bibliographies; in-house periodical index
 (Superior Public Library Periodical Holdings)
Cataloged Volumes: 110,819
Serial Titles: 221
Holdings: 84 vertical file drawers; 1,361 microforms; 286
 art slides; 29,116 pictures, 103 framed art prints; 45,950
 clippings; 21 newspapers
Subjects: Art, architecture, classical archaeology, decorative
 arts, music, theatre
Special Collections:
Anna Bates Butler Collection
Art books & reproductions.
Charles H Sunderland Collection
199 chromo-lithograph art prints published in London in
 1859–1897 by the Arundel Society.
Lorado Taft Dioramas
The Studio of Niccola Pisano at Pisa; Ghiberti Studying
 Andrea Pisano's Doors at the Baptistery of Florence.

AL 610
**UNIVERSITY OF WISCONSIN–BARABOO
LIBRARY**
Box 320, Baraboo, WI 53913
Tel: 608-356-8351, Exts 49; 51
Dir, Lib Learning Resource Center; Aural Umhoefer

Academic Founded: 1968
Hours: Mon-Fri 8-8 (during academic year)
Circulation: Public (open stacks)
Reference Service: In person, telephone
Reprographic Services: Faculty only
Interlibrary Loan: NILS; Wisconsin Interlibrary Loan Sys-
 tem
Networks/Consortia: No
Publications: In-house periodical index (Periodical Holdings–
 University of Wisconsin–Baraboo Library)
Special Programs: Group & individual tours; bibliographic
 instruction; single lectures
Cataloged Volumes: 37,000 (35,000 titles)
Serial Titles: 230
Subjects: Art, architecture, classical archaeology, dance,
 decorative arts, film & video, graphics, music, photography,
 theatre

AL 611
**UNIVERSITY OF WISCONSIN CENTER–
MARSHFIELD/WOOD COUNTY CAMPUS**
Learning Resource Center
2000 W Fifth St, Marshfield, WI 54449
Tel: 715-387-1147, Ext 31
Libn: Georgiane Bentzler

Academic Founded: 1964
Hours: Mon-Thurs 8-9
 Fri 8-4 (academic year & summer)
Circulation: Public; circulation restrictions on recordings
 (open stacks)
Reference Service: In person, telephone
Reprographic Services: No
Interlibrary Loan: Wisconsin Interlibrary Loan
Networks/Consortia: No

Publications: Orientation handbook; bibliographies; acquisitions list; in-house periodical index (Marshfield/Wood County Campus Periodical Holdings; Marshfield Union List of Periodicals)

Special Programs: Bibliographic instruction; seminars; self-guided tours

Cataloged Volumes: 27,000 (26,000 titles)

Serial Titles: 250

Holdings: 20 vertical file drawers

Subjects: Art, architecture, classical archaeology, dance, decorative arts, film & video, graphics, music, photography, theatre

AL 612
UNIVERSITY OF WISCONSIN–EAU CLAIRE
William D McIntyre Library
Park & Garfield Aves, Eau Claire, WI 54701
Tel: 715-836-3715
Dir of Libs: Robert O Fetvedt

Academic Founded: 1916
Hours: Mon-Thurs 7:30-12
 Fri 7:30-11
 Sat 7:45-9
 Sun 1-12
Circulation: Students, faculty/staff (open stacks)
Reference Service: In person, telephone, mail
Reprographic Services: Yes
Interlibrary Loan: NILS
Networks/Consortia: Wisconsin Interlibrary Loan Service; OCLC
Publications: Orientation handbook; in-house periodical index (List of Periodical Holdings)
Special Programs: Group & individual tours; bibliographic instruction; single lectures
Cataloged Volumes: 340,000 (320,000 titles)
Serial Titles: 2,353 periodicals; 1,419 continuations
Holdings: 50 vertical picture files; 524,500 microfilms, fiche & cards
Subjects: Art, architecture, classical archaeology, dance, decorative arts, film & video, graphics, music, photography, theatre

AL 613
UNIVERSITY OF WISCONSIN–LA CROSSE
Murphy Library
1631 Pine St, La Crosse, WI 54601
Tel: 608-785-8505
Chairman: Dale Gresseth

Academic
Circulation: Students, faculty/staff (open stacks)
Reference Service: In person, telephone, mail
Reprographic Services: No
Interlibrary Loan: Wisconsin Interlibrary Loan Service
Networks/Consortia: OCLC
Publications: Poetry journal; in-house periodical index
Special Programs: Group & individual tours; bibliographic instruction; single lectures
Cataloged Volumes: 374,216
Serial Titles: 2,698 (University of Wisconsin System Periodical Holdings List)
Holdings: 333,700 microforms; 500 exhibition catalogs
Subjects: Art, architecture, classical archaeology, dance, decorative arts, film & video, graphics, music, photography, theatre

AL 614
UNIVERSITY OF WISCONSIN–MILWAUKEE
School of Architecture & Urban Planning Information Center
2033 E Hartford, Box 413, Milwaukee, WI 53201
Tel: 414-963-5239
Information Center Dir: Thomas M Spellman

Academic Founded: 1967
Hours: Mon-Fri 9-5
Circulation: No (open stacks)
Reference Service: In person only
Reprographic Services: Yes
Interlibrary Loan: Through the main library
Networks/Consortia: Through the main library
Publications: Orientation handbook; acquisitions list; book catalog
Cataloged Volumes: 1,000
Subjects: Architecture, urban planning

AL 615
UNIVERSITY OF WISCONSIN–MILWAUKEE LIBRARY
Box 604, Milwaukee, WI 53201
Tel: 414-963-4785
Asst Dir for Public Services: Marianna Markowetz

Academic Founded: 1956
Circulation: Students (open stacks)
Reference Service: In person, telephone
Reprographic Services: No
Interlibrary Loan: NILS; Wisconsin Interlibrary Loan Services; Center for Research Libraries; Library Council of Metropolitan Milwaukee
Networks/Consortia: OCLC; Wisconsin Library Consortium
Cataloged Volumes: 50,224 (in two collections)
Serial Titles: 515
Subjects: Art, architecture, dance, decorative arts, music, theatre

AL 616
UNIVERSITY OF WISCONSIN–OSHKOSH
Forrest R Polk Library
801 Elmwood, Oshkosh, WI 54901
Tel: 414-424-3333
Acting Dir: Jean Pelletiere

Academic Founded: 1869; 1873
Hours: Mon-Thurs 7:45-10:45
 Fri-Sat 7:45-4:45
 Sun 2-10
Circulation: Public (open stacks)
Reference Service: In person, telephone, mail
Reprographic Services: Yes
Interlibrary Loan: Wisconsin Interlibrary Loan System (Nancy Marshall, Library, University of Wisconsin, Madison, WI)
Networks/Consortia: OCLC; FVLC; Wisconsin Library Consortium
Publications: Bibliographies; acquisitions list; newsletter; special catalogs; brochures; in-house periodical index (Post Index)
Special Programs: Group & individual tours; bibliographic instruction; single lectures; course-integrated lectures
Cataloged Volumes: 450,000
Serial Titles: 1,627 (University of Wisconsin Serial System)
Subjects: Art, classical archaeology, dance, decorative arts, film & video, graphics, music, photography, theatre

Special Collections: Educational Media Collection; University Archives

AL 617
UNIVERSITY OF WISCONSIN–PLATTEVILLE
Karrmann Library, Reference Department
Platteville, WI 53818
Tel: 608-342-1667
Lib Dir: Jerome Daniels

Academic
Hours: Mon-Fri 7:45-12
Circulation: Public (open stacks)
Reference Service: In person, telephone, mail
Reprographic Services: No
Interlibrary Loan: NILS; Wisconsin Interlibrary Loan System (Bryan Schwark, ILL Loan Dept)
Networks/Consortia: OCLC
Publications: Acquisitions list; library guide; in-house periodical index (Periodical, Newspaper, Abstracting & Indexing Services)
Special Programs: Group & individual tours; bibliographic instruction; single lectures
Card Catalog
Cataloged Volumes: 188,348 in general collection
Serial Titles: 1,674
Holdings: 215,050 microforms; 15,281 multi-media items; 32,335 maps; 16,675 items IML collection; 2,163 reference pamphlets; 1,254 reserve book collection; 128,024 government publications
Subjects: Art, architecture, dance, decorative arts, graphics, music, photography, theatre

AL 618
VITERBO COLLEGE
Zoeller Fine Arts Library
815 S Ninth, La Crosse, WI 54601
Tel: 608-784-0040, Ext 176
Libn: Sr Rosella Namer

Academic Founded: 1970
Hours: Mon-Fri 8-9:30
Circulation: Students, faculty/staff (open stacks)
Reference Service: In person
Reprographic Services: No
Interlibrary Loan: Wisconsin Interlibrary Loan (Memorial Library, University of Wisconsin, 728 State St, Madison, WI 53706)
Networks/Consortia: No
Cataloged Volumes: 3,323
Serial Titles: 42
Subjects: Art, architecture, dance, decorative arts, graphics, music, photography, theatre

AL 619
CHARLES A WUSTUM MUSEUM OF FINE ARTS LIBRARY
2519 Northwestern Ave, Racine, WI 53404
Tel: 414-636-9177
Dir: George Richard

Museum Founded: 1940
Hours: Mon-Thurs 11-9
 Fri-Sun 1-5
Circulation: Restricted to in-house use (open stacks)
Reference Service: No
Reprographic Services: No
Interlibrary Loan: No

Networks/Consortia: No
Publications: Newsletter

Wyoming

AL 620
WYOMING STATE ARCHIVES & HISTORICAL DEPARTMENT
Art Gallery Library
Barrett Bldg, Cheyenne, WY 82002
Tel: 307-777-7519
Curator: Laura Hayes

Museum
Hours: 8-5
Reference Service: In person, telephone, mail
Reprographic Services: No
Interlibrary Loan: No
Networks/Consortia: No
Card Catalog
Cataloged Volumes: 250
Subjects: Art

CANADA
Alberta

AL 621
EDMONTON PUBLIC LIBRARY
Central Library
7 Sir Winston Churchill Sq, Edmonton, Alberta TSJ 2V4
Tel: 403-423-2331
Chief Libn: Vincent Richard

Public Library
Hours: Mon-Fri 9-9
 Sat 9-6
 Sun 1-5
Circulation: Public (open stacks; additional closed Canadiana stacks)
Reference Service: In person, telephone, mail
Reprographic Services: Yes
Interlibrary Loan: NILS
Networks/Consortia: No
Publications: Orientation handbook; bibliographies; acquisitions list; newsletter
Information Source: Coburn, Morton, and James Pilton. "Edmonton's New Central Library," *Canadian Library*, 25, Nov-Dec 1968, pp 192-201 (reprint available)
Special Programs: Group tours; single lectures
Card Catalog
Cataloged Volumes: 290,000
Serial Titles: 1,700; 126 art-related (National Union Catalog)
Holdings: 5 auction catalogs
Subjects: Art, architecture, dance, decorative arts, film & video, graphics, music, photography, theatre

British Columbia

AL 622
KOOTENAY SCHOOL OF ART LIBRARY
2001 Silver King Rd, Nelson, British Columbia V1L 1C8

Dir: Ernest H Underhill

Academic/Art School Founded: 1965
Hours: Mon-Fri 8:30-4
Circulation: Students, faculty/staff (open stacks)
Reference Service: In person only
Reprographic Services: Yes; students, faculty/staff only
Interlibrary Loan: No
Networks/Consortia: No
Publications: In-house periodical index
Card Catalog
Subjects: Art, architecture, decorative arts, graphics,
 photography

AL 623
UNIVERSITY OF BRITISH COLUMBIA
Fine Arts Division
2075 Westbrook Place, Vancouver, British Columbia
 V6T 1W5
Tel: 604-228-4959
Head Libn: Melva J. Dwyer

Academic Founded: 1948
Hours: Mon-Thurs 8-11
 Fri 8-6
 Sat 9-5
 Sun 1-9
Circulation: Public (open stacks)
Reference Service: In person, telephone, mail
Reprographic Services: Yes
Interlibrary Loan: NILS; Pacific Northwest Bibliographic
 Center
Networks/Consortia: No
Publications: Orientation handbook; bibliographies; in-house
 periodical index (University of British Columbia Serials
 Holdings)
Special Programs: Group & individual tours; bibliographic
 instruction; single lectures
Cataloged Volumes: 66,017
Serial Titles: 300 (National Union Catalog; Pacific North-
 west Bibliographic Center Union List of Serials; Uni-
 versity of British Columbia Serials Holdings)
Holdings: 102 legal file drawers; 110 microforms; 1,000
 microfiche; 10,000 exhibition catalogs
Subjects: Art, architecture, community & regional planning,
 dance, decorative arts, graphics, history of photography
Special Collections: Northwest & Canadian History; Pre-
 Raphaelite Literature

Manitoba

AL 624
WINNIPEG ART GALLERY LIBRARY
300 Memorial Blvd, Winnipeg, Manitoba R3C 1V1
Tel: 204-786-6641
Libn: David W Roznjatowski

Art Gallery Founded: 1912
Hours: Mon-Fri 9-5
 Sat 12-4 (Sept-May)
 8:30-4:30 (June-Aug)
Circulation: Faculty/staff; art history students at University
 of Winnipeg (open stacks)
Reference Service: Telephone, mail
Reprographic Services: Yes
Interlibrary Loan: No
Networks/Consortia: No

Special Programs: Group & individual tours
Card Catalog
Cataloged Volumes: 7,500
Serial Titles: 47
Holdings: 34 vertical files; 384 microforms; 8,850 exhibition
 catalogs
Subjects: Art, architecture, classical archaeology, dance,
 decorative arts, film & video, graphics, music, photog-
 raphy, theatre
Special Collections:
Canadian Art & Artists and Eskimo Art Collections
Include critical studies of Canadian & Eskimo art, biographical
 studies of artists and catalogs of Eskimo prints.

Nova Scotia

AL 625
UNIVERSITE STE ANNE
Louis R Comeau Library
Church Point, Box 40, Nova Scotia B0W 1M0
Tel: 902-769-2114, Ext 163
Libn: J G Doucet

Academic Founded: 1870
Hours: Mon-Sat 8-9
 Fri 8-5
 Sun 2-5
Circulation: Public (open stacks)
Reference Service: In person, telephone, mail
Reprographic Services: Yes
Interlibrary Loan: NILS
Networks/Consortia: No
Card Catalog
Cataloged Volumes: 32,000
Serial Titles: National Union Catalog
Subjects: Art
Special Collection:
Acadiana Collection
Works by & about Acadians & the maritime provinces
 (Professor Alphonse Deveau).

Ontario

AL 626
BURLINGTON PUBLIC LIBRARY
2331 New St, Burlington, Ontario L7R 1J4
Tel: 416-639-3611
Libn: Lucille Galloway

Public Library Founded: 1873
Hours: Mon-Fri 10-9
 Sat 10-6
 Sun 1-5
Circulation: Public (open stacks)
Reference Service: In person, telephone, mail
Reprographic Services: Yes
Interlibrary Loan: NILS; Regional Interlibrary Loan
 System
Circulation: Public (open stacks)
Reference Service: In person, telephone, mail
Reprographic Services: Yes
Interlibrary Loan: NILS; Regional Interlibrary Loan
 System
Networks/Consortia: University of Toronto Library Auto-
 mated Systems
Publications: Orientation handbook; newsletter

Special Programs: Group & individual tours; bibliographic
 instruction
Card Catalog
Cataloged Volumes: 200,000
Serial Titles: South Central Regional List of Serials
Holdings: 20 vertical file drawers; LC Catalog on microfiche;
 reference service on microfiche; 3 files of newspapers
Subjects: Film & video

AL 627
KITCHENER-WATERLOO ART GALLERY
Eleanor Calvert Memorial Library
43 Benton St, Kitchener, Ontario N2G 3H1
Tel: 519-745-6671
Dir: Robert Ihrig

Museum Founded: 1956
Hours: Tues-Thurs 10-5; 7-9
 Fri & Sat 10-5
Circulation: Faculty/staff (open stacks)
Reference Service: In person, telephone, mail
Reprographic Services: No
Interlibrary Loan: No
Networks/Consortia: No
Cataloged Volumes: 1,000
Subjects: Art, architecture, classical archaeology, decorative
 arts, film & video, graphics, photography

AL 628
LONDON PUBLIC LIBRARY BOARD
London Public Libraries, Galleries, Museums
305 Queens Ave, London, Ontario N6B 3L7
Tel: 519-432-7166, Ext 38
Dir: E Stanley Beacock

Public Library Founded: 1894
Hours: Mon-Fri 9-9
 Sat 9-5
Circulation: Public (open stacks)
Reference Service: In person, telephone, mail
Reprographic Services: Yes
Interlibrary Loan: NILS (Lake Erie Regional Library Sys-
 tem, 380 Saskatoon St, London, Ontario N5W 4R3)
Networks/Consortia: No
Publications: Bibliographies; newsletter; special catalogs;
 in-house periodical index
Special Programs: Group & individual tours; bibliographic
 instruction; lecture series
Card Catalog
Cataloged Volumes: 15,250
Serial Titles: 150 (art, music & dance)
Holdings: 25 vertical file drawers; back issues of periodicals
 on microform; exhibition catalogs
Subjects: Art, architecture, classical archaeology, dance,
 decorative arts, film & video, graphics, music, photog-
 raphy, theatre

AL 629
ONTARIO CRAFTS COUNCIL
Craft Resource Centre
346 Dundas St W, Toronto, Ontario M5T 1G5
Tel: 416-366-3551
Libn, Coordinator: Irene Bolliger

Non-Profit Organization Founded: 1976
Hours: Tues-Fri 12-5
 Sat 10-5
 Closed Sat during July & Aug

Circulation: No (open stacks)
Reference Service: In person, telephone, mail
Reprographic Services: Yes
Networks/Consortia: Informal network of craft organizations
Publications: Orientation handbook; bibliographies; acquisi-
 tions list; newsletter; special catalogs; resource lists;
 exhibition lists; in-house periodical index (List of Periodi-
 cals Currently Received by the Craft Resource Centre)
Information Sources: Klement, Susan. *Who Knows What*,
 Metropolitan Toronto Library Board, 1976; Himmel,
 Susan & Elaine Lambert. *Handmade in Ontario*, Van
 Nostrand-Reinhold, 1976
Special Programs: Group & individual tours; single lectures;
 intern program
Cataloged Volumes: 300
Serial Titles: 50-60
Holdings: 18 vertical file drawers; 6 drawers of slides; 6
 drawers of archives; 1 drawer of exhibition catalogs
Subjects: Crafts, decorative arts
Special Collections:
Archives of Crafts Movement
Historical information on the origin & development of the
 crafts movement in Canada.
Portfolios of Canadian Craftsmen
Some 200 portfolios including slides, photographs & printed
 biographical information on each craftsman.

AL 630
RICHMOND HILL PUBLIC LIBRARY
24 Wright St, Toronto, Ontario L4C 4A1
Tel: 416-884-9288
Chief Libn: Mrs E Rowland

Public Library Founded: 1852
Hours: Tues-Fri 9-9
 Sat 10-5
Circulation: Public (open stacks except for special collections)
Reference Service: In person, telephone, mail
Reprographic Services: No
Interlibrary Loan: Central Ontario Regional Library System
Networks/Consortia: Central Ontario Regional Library
 System
Publications: Annual reports; orientation handbooks
Serial Titles: 340
Subjects: Art, architecture, classical archaeology, decorative
 arts, film & video, graphics, music, photography, theatre
Special Collections: Design & Crafts; Canadian History

Quebec

AL 631
MUSÉE D'ART CONTEMPORAIN
Bibliothèque de Musée d'Art Contemporain
Cité du Havre, Montreal, Québec H3C 3R4
Tel: 418-873-2878
Libn: Isabelle Montplaisir

Museum Founded: 1967
Hours: Tues-Fri 10-5
 Sat-Sun 10-6
 September-May only
Circulation: Faculty/staff (open stacks)
Reference Service: In person, telephone, mail
Reprographic Services: No
Interlibrary Loan: No
Networks/Consortia: No

Publications: Bibliographies; acquisitions list (for staff only)
Card Catalog
Cataloged Volumes: 1,600 (1,500 titles)
Serial Titles: 120 (Catalogue Collectif des Périodiques des Bibliothèques Gouvernementales du Quebec)
Holdings: 48 vertical file drawers; 4,200 exhibition catalogs
Subjects: Art, architecture, film & video, graphics, photography
Special Collections:
Collection of Contemporary Canadian & International Art
Paul Emile Borduas Archives
Includes 12,500 items.

AL 632
NATIONAL HISTORIC PARKS & SITES BRANCH, DEPARTMENT OF INDIAN & NORTHERN AFFAIRS
Research Information Section, Bibliographic Unit

10 Wellington St, Hull, Quebec
Tel: 819-996-4971
Bibliographer: Roseanne Wilson

Government Department Founded: 1971
Hours: Mon-Fri 8:30-5
Circulation: Researchers, staff (open stacks for government employees & post-graduate researchers)
Reference Service: Restricted to departmental employees
Reprographic Services: No
Interlibrary Loan: NILS
Networks/Consortia: No
Publications: Acquisitions list
Cataloged Volumes: 20,000
Serial Titles: 500
Holdings: 4 vertical file drawers
Subjects: Art, architecture, decorative arts, Canadian material culture, Canadian history

Subject Index to Special Collections

Arthurs, Stanley

Delaware Art Museum Library, AL 118

Artifacts—19th Century

Galena Historic District—Department of Conservation Library, AL 189

Artist Archives

Delaware Art Museum Library, AL 118
Otis Art Institute Library, AL 65
Smithsonian Institute, AL 144
Walker Art Center Reference Library, AL 363

Artist Archives—Arizona

Tucson Museum of Art Library, AL 21

Artist Archives—Illinois

Illinois State Museum Library, AL 192

Artist Correspondence

The Art Institute of Chicago, AL 183
Francis Bacon Foundation, Inc, AL 31

Artist Correspondence—19th Century

Freer Gallery of Art Library, AL 132

Artist Monographs

National Gallery of Art Library, AL 140

Artist Scrapbooks

Yale Univ, AL 117

Artists—American West

Joslyn Art Museum Library, AL 385
State Univ of New York at Binghamton, AL 478

Artists & Law—Periodicals

Resources in Contemorary Arts, AL 590

Artists Archives

Museum of Modern Art Library, AL 453

Artist Archives—Boston

Boston Public Library, AL 302

Artists—Arizona

Tucson Museum of Art Library, AL 21

Artists—Canada

Winnipeg Art Gallery Library, AL 624

Artists—Chicago

Chicago Public Library, AL 186

Artists—Fox Valley, Wisconsin

Oshkosh Public Museum Library, AL 605

Artist—Jewish

North Carolina Museum of Art, AL 494
YIVO Institute for Jewish Research Library, AL 485

Artists' Materials

Univ of Virginia, AL 586

Artists—Minnesota

South St Paul Public Library, AL 360

Artists—New Bedford, Massachusetts

Swain School of Design Library, AL 329

Artists—Oshkosh, Wisconsin

Oshkosh Public Museum Library, AL 605

Artists' Publications

Resources in Contemporary Arts, AL 590

Artists—Wisconsin

Oshkosh Public Museum Library, AL 605

Audubon, John

Minneapolis Public Library, AL 356

Authors—Concord, Massachusetts

Concord Free Public Library, AL 307

Authors—Mississippi

Vicksburg—Warren County Library, AL 366

Authors—Nashville, Tennessee

Public Library of Nashville & Davidson County, AL 543

Authors—Richmond, Virginia

Virginia Commonwealth Univ, AL 587

Autographs

Munson-Williams-Proctor, Institute, AL 452

Automobile Archives

Campbell-Ewald Reference Center, AL 336

Automobiles

Campbell-Ewald Reference Center, AL 336

Bank Notes

Newark Public Library, AL 403

Bankhead, Tallulah—Archives

The Players, AL 465

Bierstadt, Albert

New Bedford Free Public Library, AL 321
Delaware Art Museum Library, AL 118
Drexel Univ Libraries, AL 519
Ft Worth Public Library, AL 557
Mills College Library, AL 59
Minneapolis Institute of Arts, AL 355
Minneapolis Public Library, AL 356
Pierpont Morgan Library, AL 464
Munson-Williams-Proctor Institute, AL 452
New York Public Library, AL 458
Newberry Library, AL 196

Portland Public Library, AL 281

Rochester Institute of Technology, AL 472
Univ of Massachusetts/Boston Harbor Campus, AL 331
Univ of Minnesota Libraries, AL 362
Washington Univ, AL 379
Williams College, AL 334

Book Arts—American Indian

Minneapolis Public Library, AL 356

Book Jackets

Harvard Univ, AL 310

Books—Braille

Ontario City Library, AL 64

Books—Medieval

St John's Univ, AL 358

Books—Renaissance

St John's Univ, AL 358

Booth, Edwin—Archives

The Players, AL 465

Borduas, Paul Emile—Archives

Musee D'Art Contemporain, AL 631

Bradford, W

New Bedford Free Public Library, AL 321

Brandywine School

Haverford College, AL 520

Brent, Romney—Archives

The Players, AL 465

Broadsides

Univ of Georgia, AL 176

Bunyan, Paul

Univ of Minnesota Libraries, AL 362

Callahan, Chuck—Archives

The Players, AL 465

Canals

Univ of Lowell, 330

Cards

Henry Francis Dupont Winterthur Museum, AL 119

Caricatures

Virginia Commonwealth Univ, AL 587

Cartoons

Ft Worth Public Library, AL 557
Virginia Commonwealth Univ, AL 587

Catalogs—Department Stores

Chicago Public Library, AL 186

Catalogs—Manufacturers

Iowa State Univ, AL 232

Catlin, George—American Indian

Minneapolis Public Library, AL 356

Ceramics

New York State College of Ceramics, Alfred Univ, AL 459

Ceramics—Wedgewood

Buten Museum of Wedgewood Library, AL 517

Chase, William Merritt—Archives

Parrish Art Museum, AL 462

Children's Books

Univ of Minnesota Libraries, AL 362

Children's Books—Foreign Languages

Univ of Minnesota Libraries, AL 362

Children's Games & Toys

Henry Francis Dupont Winterthur Museum, AL 119

Christmas Decorations

Arcadia Public Library, AL 30

Civil War

Lanier Library Association, AL 490

Clippings

Ft Worth Public Library, AL 557

Coffman, Hal

Ft Worth Public Library, AL 557

Cole, Thomas—Manuscripts

Albany Institute of History & Art, AL 414

Color

Cooper-Hewitt Museum—The Smithsonian Institution's National Museum of Design, AL 427
Louisville School of Art Library, AL 253

Color Theory

Mills College Library, AL 59

Commercial Art—Pictures

Cornell College Library, AL 228

Conceptual Art—Periodicals

Resources in Contemoprary Arts, AL 590

Corbusier (Le)

Harvard Univ, AL 311
Univ of Kentucky, AL 255

Costumes

Brooklyn Public Library, AL 423
Drexel Univ Libraries, AL 519
Los Angeles County Museum of Art, AL 56
North Carolina Museum of Art, AL 494
Oakland Public Library, AL 63
Spokane Public Library, AL 592
Washington Univ, AL 379

Covey, Arthur

Southwestern College, AL 247

Goodrich, Lloyd—Archives

Whitney Museum of American
Art Library, AL 484

Gordon, Max—Archives

The Players, AL 465

**Government—United States—
Depository**

New Mexico Junior College,
AL 409

Grant, Ulysses S

Galena Historic District—
Department of Conservation
Library, AL 189

Graphic Arts

Bridgeport Public Library, AL 105
Dallas Public Library, AL 555
Fine Arts Museum of San
Francisco Library, AL 45
Herbert F Johnson Museum of
of Art, AL 444
Metropolitan Museum of Art,
AL 449
Mills College Library, AL 59
New York Public Library,
AL 458
Oakland Public Library, AL 63
Ringling School of Art, AL 161
Rochester Institute of Technology,
AL 472
South St Paul Public Library,
AL 360
Williams College, AL 334

**Graphic Arts, American—
Contemporary**

Kalamazoo Institute of the Arts
Library, AL 345
Minnesota Museum of Art
Library, AL 357

**Graphic Arts, American—
18th Century**

Boston Public Library, AL 303
The Library Company of
Philadelphia, AL 521

**Graphic Arts—American—
19th Century**

The Library Company of
Philadelphia, AL 521
Muscatine Art Center, AL 236

**Graphic Arts—American
Revolutionary War**

Boston Public Library, AL 303

**Graphic Arts—Arundel
Society, London**

Superior Public Library, AL 609

Graphic Arts—British

Boston Public Library, AL 303

**Graphic Arts—
Caricature-British**

Boston Public Library, AL 303

Graphic Arts—Commercial

American Institute of Graphic
Arts Library, AL 420

**Graphic Arts—Eskimos—
Catalogs**

Winnipeg Art Gallery Library,
AL 624

Graphic Arts—Fashion

North Carolina Museum of Art,
AL 494

**Graphic Arts—French—
19th Century**

Boston Public Library, AL 303

**Graphic Arts—Germany—
Contemporary**

Boston Public Library, AL 303

Graphic Arts—History

Frick Art Reference Library,
AL 436
Queens College of the City Univ
of New York, AL 470

**Graphic Arts—History—
United States**

Austin Public Library, AL 552

Graphic Arts—Illustrations

Yale Univ, AL 117

Graphic Arts—Islamic

Boston Public Library, AL 303

Graphic Arts—Japan

Newark Public Library, AL 403

Graphic Arts—Louisiana

Tulane Univ, AL 274

**Graphic Arts—
Modern Masters**

North Carolina State Univ,
AL 495

Graphic Arts—Natural History

New Bedford Free Public Library,
AL 321

Graphic Arts—19th Century

Newark Public Library, AL 403

Graphic Arts—Old Masters

Boston Public Library, AL 303
Lanier Library Association,
AL 490
Pierpont Morgan Library, AL 464

**Graphic Arts—Philadelphia—
18th & 19th Century**

The Library Company of
Philadelphia, AL 521

Graphic Arts—Portraits

The Library Company of
Philadelphia, AL 521

Graphic Arts—Processes

Newark Public Library, AL 403

Graphic Arts—Satire

Univ of Maryland, Baltimore
County, Library, AL 295

**Graphic Arts—16th & 17th
Century**

Francis Bacon Library, AL 31

**Graphic Arts—
Special Editions**

Univ of Massachusetts/Boston
Harbor Campus, AL 331

Graphic Arts—20th Century

Art Museum of South Texas
Library, AL 551
Newark Public Library, AL 403

**Graphic Arts—Vatican—
Raphael Loggia**

North Carolina State Univ,
AL 495

Greeting Cards

Newark Public Library, AL 403

Gypsies

Boston Athenaeum, AL 301

Hampden, Walter—Archives

The Players, AL 465

Hart, Moss—Playscripts

The Players, AL 465

**Hartley—McCausland—
Archives**

Whitney Museum of American
Art Library, AL 484

**Hill, William Ely—18th-20th
Centuries—Archives**

Dallas Public Library, AL 555

Hine, Lewis

Univ of Maryland, Baltimore
County, Library, AL 295

History—Afro-American

The Library Company of
Philadelphia, AL 521
Lodi Memorial Library, AL 399

History—Alaska

Fairbanks North Star Borough
Public Library, AL 7

History—American Indians

Newberry Library, AL 196

History—Ancient—Europe

Richmond Hill Public Library,
AL 630
Univ of Missouri at Columbia,
AL 377

History—Canada

Univ of British Columbia, AL 623

History—Great Plains

Museum of the Great Plains,
AL 510

History—Kansas

Colby Community College,
AL 243

History—Nebraska

Stuhr Museum of the Prairie
Pioneer, AL 388

History—Northwest

Univ of British Columbia, AL 623

History—Polar Regions

Univ of Alaska, AL 9

History—St Louis

St Louis Art Museum, AL 373

History—Third World

Cosumnes River College, AL 41

**History and Culture—Acadia,
Nova Scotia**

Univ Ste Anne, AL 626

**History and Culture—
Alabama**

Cullman County Public Library,
AL 3

History and Culture—American

American Antiquarian Society,
AL 297

**History and Culture—
American Indian**

Montclair Art Museum, AL 400

History and Culture—Arizona

Northern Arizona Univ
Libraries, AL 16

**History and Culture—
California**

Ventura County Historical
Museum, AL 92

History and Culture—Canada

National Historic Parks/
Department of Indian &
Northern Affairs, AL 632

**History and Culture—
Concord, Massachusetts**

Concord Free Public Library,
AL 307
Museum of the Concord
Antiquarian Society, AL 320

**History and Culture—
East Texas**

Stephen F Austin State Univ,
AL 553

**History and Culture—
English—18th Century**

San Antonio College, AL 564

History and Culture—Georgia

Colquitt-Thomas Regional
Library, AL 169
Valdosta State College Library,
AL 177

History and Culture—Gypsy

Boston Athenaeum, AL 301

History and Culture—Hawaii

Bernice P Bishop Museum,
AL 178

History and Culture—Indiana

Indiana State Library, AL 219
East Hampton Free Library,
AL 432
Manhasset Public Library,
AL 447
Louisiana State Univ Library,
AL 264
Southern Univ Library, AL 273
Univ of New Orleans, AL 275

History and Culture—Kentucky

Univ of Kentucky, AL 255

History and Culture—Maine

Dyer-York Library & Museum,
AL 278

Moore, George S—Rare Books

Drury College Library, AL 368

Moran, Thomas—Archives

East Hampton Free Library,
AL 432

Mulholland, John—Archives

The Players, AL 465

Murals

Public Art Workshop, AL 201

Museology

Saint Joseph Museum Library,
AL 372
St Louis Art Museum, AL 373
Wadsworth Atheneum, AL 113

Music

Ft Worth Public Library, AL 557
Loyola Univ, AL 265
New York Public Library, AL 458
Roosevelt Univ Library, AL 206

Music Archives

Jacksonville Public Library,
AL 154

Music Covers

Munson-Williams-Proctor
Institute, AL 452
Newark Public Library, AL 403

Music—Modern—Periodicals

Resources in Contemporary Arts,
AL 590

Music—Recordings

New Orleans Public Library,
AL 267

**Music—School Districts—
Dallas**

Dallas Public Library, AL 555

Music—Southwest—Archives

Univ of New Mexico, AL 412

Myers, Jerome

Delaware Art Museum Library,
AL 118

Nature Appreciation

State Univ of New York College
at Cortland AL 478

**Nature—Southeast
United States**

Brookgreen Gardens Library,
AL 526

Newberry—Caldecott Awards

Lodi Memorial Library, AL 399
Univ of Minnesota Libraries,
AL 362

Newspaper Clippings

Portsmouth Athenaeum, AL 394

**North Dakota—Films—20th
Century**

State Historical Society of
North Dakota Library, AL 498

Nubiology

Brooklyn Museum, AL 422

Opera—Costumes

Dallas Public Library, AL 555

Opera—Set Designs

Dallas Public Library, AL 555

Orchids

Seattle Public Library, AL 591

**Painting—American—
Contemporary**

Massachusetts Institute of
Technology, AL 315

**Painting—American—
19th Century**

Massachusetts Institute of
Technology, AL 315

Painting—Chinese

Univ of Kansas Art Library,
AL 249

Painting—Contemporary

Art Museum of South Texas
Library, AL 551

Painting—Greek Vases

Baylor Univ Art Museum, AL 554

Painting—History

Frick Art Reference Library,
AL 436
Queens College of the City Univ
of New York, AL 470

Painting—Italian—Photographs

Yale Univ, AL 117

Painting—Louisiana

Tulane Univ, AL 274

**Painting—Louisiana—
20th Century**

Tulane Univ, AL 274

Painting—North America

Henry Francis Dupont Winterthur
Museum, AL 120 & AL 122

Painting—Old Masters

E B Crocker Art Gallery Library,
AL 43
J Paul Getty Museum Library-
Photo Archives, AL 48

Paintings

Ft Worth Public Library, AL 557

**Palmer, Erastus D—
Manuscripts**

Albany Institute of History &
Art, AL 414

Palmer, Walter L—Manuscripts

Albany Institute of History &
Art, AL 414

Parrish, Maxfield

Haverford College, AL 520

Performing Arts

Georgetown Univ, AL 133
New York Public Library,
AL 458
Univ of California, Davis, AL 84

Performing Arts—Periodicals

Resources in Contemporary Arts,
AL 590

Perret, Ferdinand

Smithsonian Institution, AL 144

Pewter—Manuscripts

Henry Francis Dupont Winterthur
Museum, AL 119

Philology—Egyptian

Brooklyn Museum, AL 422

Photography

Blount County Memorial
Library, AL 2
Glendale Public Library, AL 49
International Museum of
Photography, AL 443
Herbert F Johnson Museum of
Art/Cornell Univ, AL 444
Univ of Georgia—Athens, AL 176
Univ of Maryland, Baltimore
County, Library, AL 295

**Photography—
American Indians**

Newberry Library, AL 196

Photography—American West

Boston Public Library, AL 303

**Photography—Archives—
China**

Honolulu Academy of the Arts,
AL 179

Photography—British

Henry E Huntington Library &
Art Center, AL 51

**Photography—History—
Collection**

Univ of New Mexico, AL 412

Photography Journals

Univ of New Mexico, AL 412

Photography—Los Angeles

Smithsonian Institution, AL 144

Photography—Minneapolis

Minneapolis Public Library,
AL 356

Photography—Minnesota

Minneapolis Public Library,
AL 356

Photography—Northwest

Seattle Public Library, AL 591
Tacoma Public Library, AL 593

Photography—Rare

Univ of Massachusetts/Boston
Harbor Campus, AL 331

Photography—Seattle

Seattle Public Library, AL 591

Photography—Southwest

Pomona Public Library, AL 70

Photography—Theatre

Michigan State Univ Art
Library, AL 347

Picture Books—Natural History

Jr Arts Center in Barnsdall
Park, AL 52

Pictures

Austin Public Library, AL 552
Chicago Public Library, AL 186
Metro Goldwyn Mayer Studio,
AL 58
Montana State Univ, AL 381
New Orleans Public Library,
AL 267
New York City Community
College, AL 455
Oakland Public Library, AL 63
Pratt Institute Library, AL 466
Queens Borough Public Library,
AL 469
Superior Public Library, AL 609

Pictures—Archive—Boston

Boston Public Library, AL 303

Pictures—Celebrities

Ft Worth Public Library, AL 557

Pictures—19th Century

Johns Hopkins Univ, AL 288

Playwrights—English

Francis Bacon Library, AL 31

Poetry—Modern

Virginia Commonwealth Univ,
AL 587

Porcelain—Chinese

Bridgeport Public Library, AL 104

Portraits—Pictures

Pratt Institute Library, AL 466

Post Cards

Muscatine Art Center, AL 236
Univ of Minnesota, AL 361

Posters—Theatre—Chicago

Chicago Public Library, AL 186

Posters—World Wars I & II

Oakland Public Library, AL 63

Primitive Art

Baylor Univ Art Library, AL 554
Brooklyn Museum, AL 421
Governors State Univ, AL 190
Heard Museum of Anthropology
& Primitive Art, AL 14
Milwaukee Public Museum
Library, AL 602
Peabody Museum of Archaeology
& Ethnology, Harvard Univ,
AL 322
Tucson Museum of Art Library,
AL 21

Puppetry

Detroit Institute of Arts, AL 339
Univ of New Mexico, AL 412

Pyle, Howard

Delaware Art Museum Library,
AL 118

Quakers

Earlham College Library, AL 215

Rare Books

Sterling & Francine Clark Art
Institute Library, AL 328
Drury College Library, AL 368
Georgetown Univ, AL 133
Metropolitan Museum of Art,
AL 449
Minneapolis Institute of Arts,
AL 355
Pierpont Morgan Library, AL 464
St John's Univ, AL 358
Southwest Missouri State Univ,
AL 375

Part Two
DIRECTORY OF VISUAL
RESOURCE COLLECTIONS

Alabama

VR 1
TROY STATE UNIVERSITY*
Art Department, Slide Library
Troy, AL 36081
Tel: 205-566-3000
Chairman: R C Paxson
Founded: 1959

VR 2
UNIVERSITY OF ALABAMA IN BIRMINGHAM
Dept of Art, Slide Collection
University College, University Station, Birmingham,
 AL 35294
Tel: 205-934-4941
Slide Libn: Antoinette Johnson
Founded: 1975
Hours: Mon-Fri 8-5

CIRCULATION POLICY
Slides: Restricted, faculty/staff
COLLECTIONS
Photographs: (not cataloged)
Slides: 24,000 University of Georgia & North Carolina.
 Architecture (Ancient, European, US); Sculpture
 (European, US); Painting (European, US)
SUBSCRIPTIONS
Carnegie Set (slides)
SPECIAL COLLECTIONS
Birmingham Architecture (slides)

VR 3
UNIVERSITY OF ALABAMA IN HUNTSVILLE,
 LIBRARY
Box 1247, Huntsville, AL 35807
Tel: 205-895-6540; 6526
Libn: Elizabeth B Pollard
Staff: 5
Founded: 1950
Hours: Mon-Fri 8-10
 Sat-Sun 12-6

CIRCULATION POLICY
Microforms: 128 reels LC. Architecture (US); Sculpture
Slides: Restricted, public
COLLECTIONS
Microfilms: 128 reels LC. Architecture (US); Sculpture
 (African, US); Painting (African, US); Graphic Arts
 (African, US); Decorative Arts (African, US)
Slides: 3,200 LC. Architecture (US); Sculpture (African,
 US); Painting (African, US); Graphic Arts (African, US);
 Decorative Arts (African, US)
SUBSCRIPTIONS
American Architectural Books, Research Publications, Inc
 (microforms)
Carnegie Set (slides)
SPECIAL COLLECTIONS
Afro-American Art & Artists (slides)

Alaska

VR 4
UNIVERSITY OF ALASKA—FAIRBANKS
Elmer E Rasmuson Library, Media Services Department

Fairbanks, AK 99701
Tel: 907-479-7296
Dir: Dr Edmund Cridge
Staff: 1
Hours: Mon-Fri 8-5

CIRCULATION POLICY
Films: Researchers, faculty/staff
Slides: Researchers, faculty/staff
Video: Researchers, faculty/staff
COLLECTIONS
Films: 2,436 LC
Photographs: 75,000
Slides: 456
Video: 49
SPECIAL COLLECTIONS
Alaskan Historic Photographs (photographs)
Skinner Collection (photographs)
SERVICES
Negatives: Prints available for sale subject to copyright and
 university regulations and fees

Arizona

VR 5
THE AMERIND FOUNDATION, INC
Research Library
Box 248, Dragoon, AZ 85609
Tel: 602-586-3003
Dir: Dr Charles C Di Peso
Founded: 1962
Hours: By appointment only

CIRCULATION POLICY
Slides: Students, researchers, faculty/staff (appointment
 required)
COLLECTIONS
Audiotapes: 11
Microforms: 4,737
Slides: 8,300. Architecture (Tribal American, Meso-
 American); Sculpture (Tribal American, Meso-
 American); Painting (Tribal American, Meso-American);
 Graphic Arts (Tribal American); Decorative Arts (Tribal
 American, Meso-Amercian)
SERVICES
Slides: Available for duplication

VR 6
ARIZONA STATE UNIVERSITY
Dept of Art, Slide Collection
Tempe, AZ 85281
Tel: 602-965-6163
Curator: Sally Squires Adelson
Staff: 1
Founded: ca 1960
Hours: Mon-Fri 7:15-5

CIRCULATION POLICY
Photographs: Restricted, faculty/staff (Art Dept only)
Slides: Restricted, faculty/staff (Art Dept only)
COLLECTIONS
Photographs: 2,100
Slides: 160,000 Fogg/modified. Architecture (Islamic,
 European); Sculpture (Ancient, Far East, European);
 Painting (Islamic, Far East, European, US); Graphic

Arts (European); Decorative Arts (Islamic, Far East, Tribal American, European)
SUBSCRIPTIONS
American Committee of South Asian Art (photographs, slides)
Asian Art Photographic Distribution (photographs, slides)
Carnegie Set (slides)
Chinese National Palace Museum (photographs, slides)

VR 7
ARIZONA STATE UNIVERSITY
Howe Architecture Library, Paolo Soleri Archives
Tempe, AZ 85281
Tel: 602-965-6400
Archivist: Lois S Harberger
Libn: Jane Henning
Staff: 2
Founded: 1972
Hours: Mon-Thurs 8-10
 Fri 8-5
 Sat 12-5
 Sun 5 pm-10
 Mon-Fri 8-5 (archives)

CIRCULATION POLICY
Drawings: Public (appointment suggested)
Photographs: Public (appointment suggested)
Slides: Public (appointment suggested)
COLLECTIONS
Films: 23. Architecture (European, US); Sculpture (US)
Microforms: 175
Photographs: 75. Architecture (US); Sculpture (US)
Slides: 2,500. Architecture (US); Sculpture (US); Graphic Arts (US)
Video: 10. Architecture (US)
SPECIAL COLLECTIONS
Paolo Soleri Archives
SERVICES
Slides: Available for duplication for non-profit purposes, subject to copyright regulations

VR 8
ARZONA STATE UNIVERSITY
School of Architecture, Audiovisual Department
Tempe, AZ 85281
Tel: 602-965-7253
Supervisor: Helen Ziffer
Founded: 1959
Hours: Mon-Fri 7-5

CIRCULATION POLICY
Slides: Restricted, students, researchers, faculty/staff, circulating (appointment suggested)
COLLECTIONS
Slides: 52,000. Architecture (Ancient, Islamic, Far East, African, Tribal American, Meso-American, Andean, European); Sculpture (Ancient, Islamic, Far East); Painting (Ancient); Graphic Arts (Ancient); Decorative Arts (Ancient)

VR 9
GLENDALE COMMUNITY COLLEGE
Instructional Materials Center
6000 W Olive Ave, Glendale, AZ 85302
Tel: 602-934-2211, Exts 239; 242
Media Coordinator: Jean Staten
Founded: 1965

CIRCULATION POLICY
Slides: Public
Video: Students, faculty/staff
COLLECTIONS
Microforms: 12,426
Slides: 7,411 LC. Architecture (Ancient, Islamic, Far East, Andean, European, US); Scultpure (Ancient, Islamic, Far East, African, Pacific, Andean, European, US); Painting (Ancient, Islamic, Far East, African, Pacific, Andean, European, US); Graphic Arts (Far East, European, US); Decorative Arts (Ancient, Far East, African, Andean)
Video: 12 LC. Architecture (Andean); Scultpure (Far East); Decorative Arts (Tribal American)

VR 10
NAVAJO COMMUNITY COLLEGE
Curriculum Development Center
Tsaile, RPO, AZ 86556
Tel: 602-724-3311, Ext 272
Dir: Peggy V Beck
Staff: 5

CIRCULATION POLICY
Photographs: Restricted (non-circulating)
Slides: Restricted (non-circulating)
Tapes: Restricted (non-circulating)
COLLECTIONS
Photographs: Sculpture (Tribal American); Painting (Tribal American); Decorative Arts (Tribal American)
Slides: Sculpture (Tribal American); Painting (Tribal American); Decorative Arts (Tribal American)
SPECIAL COLLECTIONS
Tribal American Art & Culture (photographs, slides, tapes)

VR 11
PHOENIX PUBLIC LIBRARY
Fine Arts & Recreation Department
12 E McDowell Rd, Phoenix, AZ 85004
Tel: 602-262-6451
Libn: Marylou Sutherland

CIRCULATION POLICY
Art Reproductions: Public, circulating
COLLECTIONS
Art Reproductions: 100

VR 12
TUCSON MUSEUM OF ART LIBRARY
235 W Alameda, Tucson, AZ 85701
Tel: 602-623-4881
Libn: Dorcas Worsley
Staff: 1
Founded: 1974
Hours. Mon-Fri 10-3

CIRCULATION POLICY
Photographs: Public (appointment suggested)
Slides: Public (appointment suggested)
COLLECTIONS
Photographs: 4,300. Architecture (Meso-American, Andean); Sculpture (African, Pacific, Meso-American, Andean); Painting (Meso-American, Andean); Graphic Arts (African, Pacific, Meso-American, Andean); Decorative Arts (African, Pacific, Tribal American, Meso-American, Andean)

Slides: 16,000. Architecture (Meso-American, Andean, European); Sculpture (Ancient, African, Pacific, Meso-American, Andean); Painting (Ancient, Far East, Meso-American, Andean, European, US); Graphic Arts (African, Pacific, Meso-American, Andean); Decorative Arts (Ancient, African, Pacific, Tribal American, Meso-American, Andean)

VR 13
TUCSON PUBLIC LIBRARY
Main Library, Fine Arts Room
200 S Sixth Ave, Tucson, AZ 85701
Tel: 602-791-4393
Head of Fine Arts Room: Janet Lombard
Staff: 3
Founded: 1901 (library)

CIRCULATION POLICY
Picture File: Public, circulating
COLLECTIONS
Picture File: 5 VF drawers
Video Cassettes: (new collection)

VR 14
UNIVERSITY OF ARIZONA
Art Department Slide Library
Tucson, AZ 85715
Tel: 602-884-1202
Slide Libn/Inst: Elizabeth T Woodin
Staff: 1
Hours: Mon-Fri 8:30-4:30

CIRCULATION POLICY
Photographs: Restricted, faculty/staff
Slides: Restricted, faculty/art dept seminar students
COLLECTIONS
Photographs: 2,000. Architecture (Ancient, European, US); Sculpture (Ancient, European, US); Painting (European, US); Graphic Arts (European, US); Decorative Arts (Ancient)
Slides: 85,000. Architecture (Ancient, Islamic, Far East, Meso-American, European, US); Sculpture (Ancient, Far East, African, Meso-American, European, US); Painting (Ancient, Far East, European, US); Graphic Arts (Far East, European, US); Decorative Arts (Ancient, Far East, Tribal American, Meso-American, European, US)
SUBSCRIPTIONS
Art in America (slides)
Art Now (slides)
Carnegie Set (slides)
University Prints (photographs)

VR 15
UNIVERSITY OF ARIZONA
Center for Creative Photography
843 E University, Tucson, AZ 85719
Tel: 602-884-4636
Staff: 3
Founded: 1975

CIRCULATION POLICY
Manuscripts: Restricted, researchers, faculty/staff (appointment suggested)
Photographs: Public (appointment suggested)
Slides: Public

COLLECTIONS
Photographs: 100,000
Slides: 5,000
SPECIAL COLLECTIONS
Archives of Ansel Adams, Wynn Bullock, Harry Callahan, Paul Strand, Frederick Sommer, Aaron Siskind
Manuscript and correspondence collection
SERVICES
Slides: 3000 slides of items in collection may be purchased

VR 16
UNIVERSITY OF ARIZONA
College of Architecture Library
Tucson, AZ 85721
Tel: 602-884-2498
Architecture Libn: Sara W Gresham
Founded: 1965
Hours: Mon-Fri 9-5

CIRCULATION POLICY
Slides: Restricted, faculty/staff
COLLECTIONS
Slides: 21,900 University of Arizona. Architecture (Ancient, Islamic, Meso-American, European, US)

VR 17
UNIVERSITY OF ARIZONA
Media Center
Tucson, AZ 85721
Tel: 602-884-3441
Dept Head: Steve Bahre
Founded: 1977

CIRCULATION POLICY
Slides: Public, circulating
Slide-sound: Public, circulating
Video: Public, circulating
COLLECTIONS
Films (8mm): 20 LC
Slides: 3,000 LC
Slide-sound: 50 LC
Video: 50 LC

Arkansas

VR 18
ARKANSAS ARTS CENTER*
Fine Arts & Drama, Slide Library
MacArthur Park, Little Rock, AR 72203
Tel: 501-372-4000
Slide Libn: Gordon M Garry
COLLECTIONS
Slides: 25,000

VR 19
UNIVERSITY OF ARKANSAS*
Art Department, Slide Library
Fayetteville, AR 72701
Tel: 501-575-2000

VR 20
UNIVERSITY OF ARKANSAS
School of Arkansas
Vol Walker Hall, Fayetteville, AR 72701
Tel: 501-575-4705
Instructor: Brenda Bullion

Founded: 1968
Hours: Mon-Fri (mornings by permission)

CIRCULATION POLICY
Slides: Public (appointment suggested)
COLLECTIONS
Films: 30
Slides: 50,000. Architecture (Ancient, Islamic, Far East, Meso-American, European, US); Sculpture (Ancient, Far East, European, US); Painting (Far East, European, US); Decorative Arts (Ancient, US)
Video: 35
SERVICES
Slides: Available for purchase and duplication subject to copyright and university regulations and fees

California

VR 21
ACADEMY OF MOTION PICTURE ARTS & SCIENCES
Margaret Herrick Library
8949 Wilshire Blvd, Beverly Hills, CA 90211
Tel: 213-278-8990
Libn: Mildred Simpson
Founded: 1927
Hours: Mon, Tues, Thurs, Fri 9-5

CIRCULATION POLICY
Collections non-circulating
COLLECTIONS
Films: 1,000
Photographs: 1,000,000
Slides: 500 (glass)
SERVICES
Negatives: Prints available for purchase
Slides: Available for duplication and sale

VR 22
ARCHIVES OF CALIFORNIA ART*
Oakland Museum
1000 Oak St, Oakland, CA 94607
Tel: 415-273-3402

VR 23
THE FRANCIS BACON FOUNDATION, INC
The Francis Bacon Library
655 N Dartmouth Ave, Claremont, CA 91711
Tel: 714-624-6305
Dir: E S Wrigley
Staff: 2
Founded: 1938
Hours: Mon-Fri 9-4:30

CIRCULATION POLICY
Drawings/engravings: Public (appointment suggested)
Manuscripts: Public (appointment suggested)
Photographs: Public (appointment suggested)
COLLECTIONS
Photographs: 1 verticle file Philadelphia Museum. Architecture (European); Painting (European, US)
SPECIAL COLLECTIONS
Arensberg Archives of manuscripts, correspondence with French & American artists of the 20th century
Drawings of Beatrice Wood

VR 24
BERKELEY PUBLIC LIBRARY
Art & Music Department
2090 Kittredge St, Berkeley, CA 94704
Tel: 415-644-6785
Supervising Libn: Bruce A Munly
Founded: 1960
Hours: Mon-Thurs 9-9
 Sat 9-6
 Sun 1-5

CIRCULATION POLICY
Slides: Public, circulating
COLLECTIONS
Slides: 10,000

VR 25
BEVERLY HILLS PUBLIC LIBRARY
Art Resources Library
444 N Rexford Rd, Beverly Hills, CA 90210
Tel: 213-550-4720
Fine Arts Libn: Nicholas Cellini
Staff: 2
Founded: 1974
Hours: Mon, Wed, Fri 10-6
 Tues, Thurs 10-9

CIRCULATION POLICY
Photographs: Public (appointment suggested)
Slides: Public, circulating (appointment suggested)
COLLECTIONS
Photographs: 8,650 Metropolitan
Slides: 3,500 Santa Cruz. Painting (US); Graphic Arts (US)
SUBSCRIPTIONS
Environmental Communications (slides)
SERVICES
Slides: Those not covered by copyright available for duplication, collection emphasis late 20th century art

VR 26
BRAND LIBRARY
1601 W Mountain St, Glendale, CA 91201
Tel: 213-956-2051
Libn: Jane Hagan
Staff: 1
Founded: 1956
Hours: Tues, Thurs 12-9
 Wed, Fri, & Sat 12-6
 Sun 1-5 (except July-2nd Sun of Sept)

CIRCULATION POLICY
Prints: Public, circulating
Slides: Public, circulating
COLLECTIONS
Microforms: (new collection)
Slides: 8,274. Architecture (European, US); Sculpture (Ancient, European, US); Painting (European, US); Decorative Arts (Far East, US)

VR 27
CABRILLO COLLEGE*
Art Department, Slide Library
6500 Soquel Ave, Aptos, CA 95003
Tel: 408-425-6464
Slide Libn: Nancy K Popin

VR 28
CALIFORNIA COLLEGE OF ARTS & CRAFTS
Media Center
Broadway at College, Oakland, CA 94618
Tel: 415-653-8118, Ext 65
Dir of Media: Harry Critchfield
Staff: 3
Founded: 1968
Hours: Mon-Fri 8-12, 1-5

CIRCULATION POLICY
Slides: Faculty/staff
COLLECTIONS
Slides: 36,000 Youngberg. Architecture (Ancient, Far East, European); Sculpture (Ancient, Far East, European); Painting (Ancient, European, US)

VR 29
CALIFORNIA INSTITUTE OF THE ARTS
Slide Library
24700 McBean Pkwy, Valencia, CA 91355
Tel: 805-255-1050, Ext 235
Slide Libn: Evy White
Founded: 1969
Hours: Mon-Fri 9-5

CIRCULATION POLICY
Slides: Students, faculty/staff
COLLECTIONS
Slides: 34,000 Santa Cruz. Architecture (Islamic, European, US); Sculpture (African, Tribal American, European, US); Painting (European, US); Graphic Arts (European, US); Decorative Arts (European, US)

VR 30
CALIFORNIA POLYTECHNIC STATE UNIVERSITY*
School of Architecture & Environmental Design
San Luis Obispo, CA 93407
Tel: 805-546-2497

VR 31
CALIFORNIA STATE COLLEGE—DOMINGUEZ HILLS
Art History Slide Library
1000 E Victoria, Dominguez Hills, CA 90747
Tel: 213-532-4300, Ext 295
Slide Curator: Evelyn Hitchcock
Founded: 1966
Hours: Mon-Fri 8-5

CIRCULATION POLICY
Slides: Senior students, faculty/staff
COLLECTIONS
Slides: 83,000 Fogg. Architecture (Ancient, Far East, European, US); Sculpture (Ancient, Far East, European, US); Painting (Far East, European, US); Graphic Arts (European, US); Decorative Arts (Ancient, European, US)
SUBSCRIPTIONS
Carnegie Set (slides)

VR 32
CALIFORNIA STATE UNIVERSITY—CHICO
Art History Slide Room
Art Department, 203 Tehama Hall, Chico, CA 95926
Tel: 916-895-6878

Slide Curator: Barbara J Brinkley
Founded: 1968
Hours: Mon-Fri 8-5 (academic school year only)

CIRCULATION POLICY
Slides: Restricted (campus only), students, faculty/staff
COLLECTIONS
Slides: 65,000. Architecture (Ancient, Islamic, Far East, Meso-American, Andean, European, US); Sculpture (Ancient, Far East, African, Meso-American, Andean, European, US); Painting (Ancient, Far East, Meso-American, Andean, European, US); Graphic Arts (Ancient, Meso-American, Andean, European, US); Decorative Arts (Ancient, Far East, African, Tribal American, Meso-American, Andean, European, US)
SUBSCRIPTIONS
Carnegie Set (slides)

VR 33
CALIFORNIA STATE UNIVERSITY—FRESNO
Art Department Slide Library
Fresno, CA 93740
Tel: 209-487-2123
Slide Curator: Michael Tilden
Founded: 1970
Hours: Mon-Fri 8-12, 1-5

CIRCULATION POLICY
Slides: Students, researchers, faculty/staff
COLLECTIONS
Slides: 45,000. Architecture (Ancient, Islamic, Far East, European, US); Sculpture (Ancient, Islamic, Far East, African, Meso-American, Andean, European, US); Painting (Ancient, Far East, European, US); Graphic Arts (US)

VR 34
CALIFORNIA STATE UNIVERSITY—HAYWARD
Art Department, Slide Library
Hayward, CA 94542
Tel: 415-881-3426
Slide Curator: Noreen W Benedette
Founded: ca 1966

CIRCULATION POLICY
Slides: Students, researchers, faculty/staff (appointment suggested)
COLLECTIONS
Photographs: 200. Architecture (European)
Slides: 65,000 Santa Cruz. Architecture (Ancient, Far East, European, US); Sculpture (Ancient, Far East, European, US); Painting (European, US); Graphic Arts (European, US); Decorative Arts (European, US)

VR 35
CALIFORNIA STATE UNIVERSITY— LONG BEACH*
Fine Arts Library
Long Beach, CA 90840
Tel: 213-498-4023
Sr Asst Fine Arts Libn: Ruth M Bryan

VR 36
CALIFORNIA STATE UNIVERSITY— LONG BEACH
Media Resources Library
1250 Bellflower Blvd, Long Beach, CA 90840

Tel: 805-498-4028
Head, Fine Arts/Media Resources Libn: Henry J DuBois
Staff: 2
Hours: Mon-Fri 7:30-midnight

CIRCULATION POLICY
Mixed Media: Restricted, public (appointment suggested)
Photographs: Restricted, public (appointment suggested)
Prints: Restricted, public (appointment suggested)
Slides: Restricted, public (appointment suggested)
Video: Restricted, public (appointment suggested)
COLLECTIONS
Microforms: n.a.
Photographs: 180 Fogg
Prints: 703 Fogg
Reproductions: 8,500 (uncataloged)
Slide/sound: 80
Slides: 60,000 Fogg

VR 37
CALIFORNIA STATE UNIVERSITY—
 LOS ANGELES
Art Department, Slide Library
5151 State University Dr, Los Angeles, CA 90032
Tel: 213-224-3524, Ext 3524
Slide Curator: Robert Evans
Founded: 1950
Hours: Mon-Thurs 7-5:30
 Fri 1-12

CIRCULATION POLICY
Photographs: Students, researchers, faculty/staff,
 circulating
Slides: Students, researchers, faculty/staff, circulating
COLLECTIONS
Films: 12
Models: 13
Photographs: 500
Slides: 102,000. Architecture (Ancient, Islamic, Far East,
 Meso-American, European, US); Sculpture (Ancient, Far
 East, African, Pacific, Tribal American, Meso-American,
 European, US); Painting (Ancient, Far East, European,
 US); Graphic Arts (Far East, European, US); Decorative
 Arts (Ancient, Islamic, Far East, European, US)
Tapes: 34
Video: 40

VR 38
CALIFORNIA STATE UNIVERSITY—
 NORTHRIDGE
Art Slide Library
Fine Arts Bldg, Rm 220, 18111 Nordhoff St, Northridge,
 CA 91330
Tel: 213-885-3049
Slide Curator: Dianne L Smith
Founded: 1958
Hours: Mon-Fri 8-5

CIRCULATION POLICY
Art Periodicals: Restricted, faculty/staff
Reproductions: Restricted, faculty/staff
Slides: Restricted, art students, art faculty/staff
COLLECTIONS
Reproductions: 750 Minnesota. Painting (European, US)
Slides: 82,000 Minnesota. Architecture (Ancient, Far East,
 European, US); Sculpture (Ancient, Far East, African,

Pacific, Tribal American, Meso-American, European,
US); Painting (Far East, European, US); Graphic Arts
(European, US); Decorative Arts (African, Pacific, Tribal
American, Meso-American)
SUBSCRIPTIONS
American Committee of South Asian Arts (slides)
Carnegie Set (slides)

VR 39
CALIFORNIA STATE UNIVERSITY—
 SACRAMENTO
Media Services Center, The Library
6000 J St, Sacramento, CA 95825
Tel: 916-454-6538
Media Libn: Sheila Johnson Marsh
Founded: 1975
Hours: Mon-Fri 8-10 (during academic sessions)

CIRCULATION POLICY
Audio: Restricted, students, researchers, faculty/staff,
 limited circulation
Filmstrip: Restricted, students, researchers, faculty/staff
Slide/audio: Restricted, students, researchers, faculty/staff
Slides: Restricted, students, researchers, faculty/staff,
 circulating
Video: Restricted, students, researchers, faculty/staff
COLLECTIONS
Audio: 6
Filmstrip: 23
Slide/audio: 10
Slides: 40,000 Santa Cruz. Architecture (Ancient, Meso-
 American, European, US); Sculpture (Ancient, Far
 East, African, European, US); Painting (Far East,
 European, US); Graphic Arts (European); Decorative
 Arts (US)
Video: 25. Sculpture (US)
SUBSCRIPTIONS
American Committee of South Asian Art (slides)

VR 40
CALIFORNIA STATE UNIVERSITY—
 SAN FRANCISCO∗
Art Department
1600 Holloway Ave, San Francisco, CA 94132
Tel: 415-469-2176
Photographer I: Irene Anderson

VR 41
CAL-POLY UNIVERSITY∗
School of Environmental Design, Slide Library
3801 W Temple, Bldg 7, Pomona, CA 91768
Tel: 714-598-4193
Slide Libn: Kathy I Morgan

VR 42
CONTRA COSTA COUNTY LIBRARY∗
Audiovisual Department
1750 Oak Park Blvd, Pleasant Hill, CA 94523
Tel: 415-937-4100, Ext 274
AV Coordinator: Helene J Kosher

VR 43
COSUMNES RIVER COLLEGE
Learning Resource Center
8401 Center Pkwy, Sacramento, CA 95823
Tel: 916-421-1000, Ext 249
Asst Dean, Learning Resources: Terry Kastanis

Staff: 3
Founded: 1970

CIRCULATION POLICY
Art Prints: Public, in-house circulating
Filmstrips: Public, in-house circulating
Loop Film: Public, in-house circulating
Multimedia Kits: Public, in-house circulating
Slides: Public, in-house circulating
COLLECTIONS
Art Prints: 634 Santa Cruz
Filmstrips: 27 LC
Microforms: 52 LC
Multimedia Kits: 8
Slides: 7,500 Santa Cruz. Architecture (Ancient, European); Sculpture (Ancient, European); Painting (European, US)
Slide Sets: 28 LC

VR 44
FINE ARTS GALLERY OF SAN DIEGO
Art Reference Library
Balboa Park, Box 2107, San Diego, CA 92105
Tel: 714-232-7931, Ext 28
Libn: Nancy J Andrews

CIRCULATION POLICY
Slides: Restricted
COLLECTIONS
Slides: 14,500. Painting (European, US)
SERVICES
Slides: Available for purchase of gallery collection

VR 45
GREENE & GREENE LIBRARY OF
THE GAMBLE HOUSE
4 Westmoreland, Pasadena, CA 91103
Tel: 213-793-3334
Libn: LaVerne LaMatte
Founded: 1968
COLLECTIONS
Microforms: 200. Architecture (US)
Slides: 400. Architecture (US)
SPECIAL COLLECTIONS
Greene & Greene blueprints & drawings (copies)
Greene & Greene views (microfilms)
SERVICES
Slides: Available for purchase of the Gamble House

VR 46
HEBREW UNION COLLEGE SKIRBALL MUSEUM
Slide Library
3077 University Mall, Los Angeles, CA 90039
Tel: 213-749-3424
Dir: Mary N Berman
Staff: 5
Founded: 1972 (in LA)
Hours: Gallery Tues-Fri 11-4
 Sun 10-5
 Office Mon-Fri 9-5

CIRCULATION POLICY
Films: Restricted, faculty/staff (appointment required)
Photographs: Restricted, students, researchers, faculty/staff, fee service, circulating (appointment required)
Slides: Public, fee service, circulating (appointment required)

Video: Restricted, students, researchers, faculty/staff (appointment required)
COLLECTIONS
Films: 1
Photographs: 1,000. Architecture (European, US, Judaica); Sculpture (European, US, Judaica); Painting (European, US, Judaica); Graphic Arts (European, US, Judaica)
Slides: 6,500. Architecture (Ancient, European, US, Judaica); Sculpture (Ancient, European, US, Judaica); Painting (European, US, Judaica); Graphic Arts (European, US, Judaica)
Video: 1
SPECIAL COLLECTIONS
Hebrew Union College Skirball Collection of Judaica (photographs, slides)
SERVICES
Negatives: Prints available for purchase for publication in scholarly journals and books only, subject to copyright and museum regulations
Slides: Available for purchase, dealing with Judaica and Near Eastern Archaeology

VR 47
HUMBOLDT STATE UNIVERSITY
Art Department
Arcata, CA 95521
Tel: 707-826-3432
Asst Prof: Ron Johnson

CIRCULATION POLICY
Slides: Restricted, faculty/staff
COLLECTIONS
Slides: 60,000 Humboldt State University. Sculpture (Ancient, European, US); Painting (Ancient, European, US); Photography (European, US)
SPECIAL COLLECTIONS
Historical Photographic Collection of Humboldt County (negatives)
SERVICES
Negatives: Prints are available for purchase from the office of Erich Schinips, Humboldt County Collection, subject to copyright and university regulations and fees

VR 48
HENRY E HUNTINGTON LIBRARY &
ART GALLERY
Art Reference Library
1151 Oxford Rd, San Marino, CA 91106
Tel: 213-792-6141, Ext 43
Curator of Art: Robert R Wark
Staff: 1
Founded: 1936
Hours: Tues-Sat 8:30-11:45, 1-4:20

CIRCULATION POLICY
Photographs: Researchers
Slides: Researchers
COLLECTIONS
Microforms: 30
Photographs: 75,000. Architecture (British); Sculpture (British); Painting (British); Graphic Arts (British); Decorative Arts (British)
Slides: 500. Architecture (British); Sculpture (British); Painting (British); Graphic Arts (British); Decorative Arts (British)

SUBSCRIPTIONS
Courtauld Institute Photo Survey of Private Collections
(photographs)
SPECIAL COLLECTIONS
Collection of British drawings numbering 5,000
SERVICES
Negatives: Objects in the gallery collections may be purchased on written request
Slides: Objects in the gallery collections may be purchased

VR 49
JR ARTS CENTER IN BARNSDALL PARK
Slide Library
4814 Hollywood Blvd, Los Angeles, CA 90027
Tel: 213-666-1093
Dir: Claire Isaacs
Staff: 2
Founded: 1967
Hours: Mon-Fri 9-5

CIRCULATION POLICY
Slides: Faculty/staff
COLLECTIONS
Slides: 15,000. Architecture (Ancient, European, US);
Sculpture (Ancient, African, European, US); Painting
(Ancient, European, US); Graphic Arts (European, US);
Decorative Arts (Ancient, Far East, African, Tribal
American)
SPECIAL COLLECTIONS
American Indians (slides)
Jr Arts Center, History of, & Student Work (films,
photographs, slides, video)
Murals (slides)

VR 50
**LA JOLLA MUSEUM OF CONTEMPORARY
ART LIBRARY**
700 Prospect St, La Jolla, CA 92037
Tel: 714-454-0183
Libn: Gail Richardson
Founded: 1940

CIRCULATION POLICY
Slides: Restricted
COLLECTIONS
Slides: 4,800 Santa Cruz. Sculpture (European, US);
Painting (European, US)

VR 51
LONG BEACH PUBLIC LIBRARY
Film Department
101 Pacific Ave, Long Beach, CA 90802
Tel: 213-436-9225
Film Libn: Mary Pierce

CIRCULATION POLICY
Films: Fee service
Photographs: Public
COLLECTIONS
Filmstrips: 566
Films: 732
Framed Art: 314
Photographs: 2,482

VR 52
LOS ANGELES COUNTY MUSEUM OF ART
Slide Library
5905 Wilshire Blvd, Los Angeles, CA 90036

Tel: 213-937-4250, Exts 303; 288
Museum Slide Libn: Robin Kaplan
Founded: ca 1966
Hours: Tues-Fri 11-4:30

CIRCULATION POLICY
Slides: Restricted, researchers, educators, faculty/staff,
fee service, circulating (appointment suggested)
COLLECTIONS
Slides: 86,000. Architecture (Ancient, Far East, European,
US); Sculpture (Ancient, Far East, European, US);
Painting (Ancient, Far East, European, US); Graphic
Arts (Far East, European, US); Decorative Arts (Far
East, European)
SUBSCRIPTIONS
American Committee of South Asian Art (slides)
Art Now Inc (slides)
Asian Art Photographic Distribution (slides)
SPECIAL COLLECTIONS
History of Photography (slides)
Los Angeles County Museum of Art (slides)
SERVICES
Slides: Available for purchase of the LACMofA collections
through the Museum Shop

VR 53
LOS ANGELES PUBLIC LIBRARY
Audio-Visual Department
630 W Fifth St, Los Angeles, CA 90071
Tel: 213-626-7461
Principal Libn: William J Speed
Staff: 2
Founded: 1950
Hours: Mon-Thurs 10-9
 Fri-Sat 10-5:30

CIRCULATION POLICY
Clippings: Public, circulating
Photographs: Public, circulating
Pictures: Public, circulating
Slides: Public, circulating
COLLECTIONS
Films: 3,000 Accession Number
Microforms: n.a.
Photographs: n.a.
Slides: 200 Subject
Sound Filmstrips: 600 Subject

VR 54
**MARITIME MUSEUM ASSOCIATION OF
SAN DIEGO**
Maritime Library
1306 N Harbor Dr, San Diego, CA 92101
Tel: 714-234-9153
Founded: 1926

CIRCULATION POLICY
Photographs: Restricted (appointment required)
Slides: Restricted (appointment required)

VR 55
MESA COLLEGE*
Library, Audiovisual Department
7250 Mesa College Dr, San Diego, CA 92111
Tel: 714-279-2300, Ext 381
A-V Coordinator: Margo Sasse

VR 56
MILLS COLLEGE
Art Department Slide Library
Oakland, CA 94613
Tel: 415-632-2700, Ext 328
Slide Libn: Blossom Michaeloff
Founded: 1972
Hours: Mon-Fri 12 noon-4

CIRCULATION POLICY
Slides: Students, researchers, faculty/staff, circulating
(appointment suggested)
COLLECTIONS
Slides: 25,000. Architecture (Far East, European); Sculp-
ture (Far East, European); Painting (Far East, European,
US); Decorative Arts (Far East)
SUBSCRIPTIONS
Carnegie Set (slides)
SPECIAL COLLECTIONS
Mills College Art Dept Graduate Student Work (slides)

VR 57
OAKLAND MUSEUM
Art Department
1000 Oak St, Oakland, CA 94607
Tel: 415-273-3005
Art Curator: George W Neubert
Staff: 1
Founded: 1916 (Oakland Art Gallery)
Hours: Mon-Fri 8-12, 1-5 (by appointment)

CIRCULATION POLICY
Photographs: Restricted, faculty/staff (appointment
suggested)
Slides: Public (appointment suggested)
COLLECTIONS
Photographs: Architecture (US); Sculpture (US); Painting
(US); Graphic Arts (US); Decorative Arts (US)
Slides: 40,000 Oakland. Architecture (US); Sculpture (US);
Painting (US); Graphic Arts (US); Decorative Arts (US)
SUBSCRIPTIONS
Carnegie Set (slides)
SPECIAL COLLECTIONS
Historic Photographs of Oakland, 1870-1940
(photographs)
Dorothea Lang Photograph Collection (photographs)
Oakland Museum of Art Collections (photographs, slides)
SERVICES
Negatives: Prints available from the Curator of objects in
the Special Collections, subject to copyright and museum
regulations and fees
Slides: Available for duplication at the discretion of the
Curator

VR 58
OTIS ART INSTITUTE
Slide Collection
627 S Carondelet St, Los Angeles, CA 90057
Tel: 213-625-0621, Ext 33
Slide Curator: Janice Felgar
Hours: Mon-Fri 8:30-4:30 (open to public by
appointment)

CIRCULATION POLICY
Films: Restricted, students, researchers, faculty/students,
circulating to faculty only (appointment suggested for
screening)
Slides: Restricted, students, researchers, faculty/students,
circulation to faculty only (appointment suggested)
Video: Restricted, students, researchers, faculty/students
(appointment suggested for screening)
COLLECTIONS
Films: 90 (by title).
Slides: 40,000 Fogg. Architecture (Ancient, European,
US); Sculpture (Ancient, European, US); Painting (US);
Graphic Arts (US); Emphases on Contemporary Art
Video: 21 (by title).

VR 59
PALOS VERDES LIBRARY DISTRICT
Audio-Visual Department
650 Deep Valley Dr, Palos Verdes Peninsula, CA 90274
Tel: 213-377-9584, Exts 38; 39
Supervisor: Myra Nadler
Founded: 1970
Hours: Mon-Fri 10-9
Sat 10-6
Sun 1-5

CIRCULATION POLICY
Art Reproductions: Public, circulating
Films: Public, circulating
Photographs: Public, circulating
Slides: Public, circulating
COLLECTIONS
Art Reproductions: 800
Films: 850
Microforms: 9,370
Slides: 250
Video: 6

VR 60
PASADENA PUBLIC LIBRARY
Fine Arts Division
285 E Walnut Dr, Pasadena, CA 91101
Tel: 213-577-4049
Fine Arts Coordinator: Josephine Pletscher
Hours: Mon-Thurs 9-9
Fri-Sat 9-6
Sun 1-5

CIRCULATION POLICY
Photographs: Public, circulating
COLLECTIONS
Films: 330
Photographs & Pictures: 131,000

VR 61
POMONA COLLEGE
Art Department Slide Library
Claremont, CA 91711
Tel: 714-626-8511, Ext 2221
Slide Libn: Jennifer B Young
Hours: Mon & Wed 8-5
Fri 9-5

CIRCULATION POLICY
Photographs: Restricted
Slides: Restricted, students, faculty/staff (appointment
suggested)
COLLECTIONS
Photographs: 5,000
Slides: 55,000 Minnesota. Architecture (Ancient, Euro-
pean, US); Sculpture (Ancient, European, US); Painting
(European, US); Graphic Arts (European, US)

SUBSCRIPTIONS
Carnegie Set (slides)
Courtauld Institute Illustration Archive (photographs)
SPECIAL COLLECTIONS
Archive of domestic housing in Los Angeles County including many now destroyed (slides)
SERVICES
Slides: Orozco and Lebrun murals only available for duplication

VR 62
POMONA PUBLIC LIBRARY
625 S Garey Ave, Pomona, CA 91766
Tel: 714-620-2033

CIRCULATION POLICY
Photographs: Public
Post Cards: Public
Slides: Public
COLLECTIONS
Audiotapes: 65
Films: 1,000
Microforms: 250
Photographs: 136,000
Slides: 4,500
Video: 3
SPECIAL COLLECTIONS
Citrus labels (graphic arts)
Views of California and the Southwest (photographs)
SERVICES
Negatives: Prints available for reproduction subject to copyright and library regulations and fees
Slides: Available for duplication subject to library and copyright fees and regulations

VR 63
PRESIDIO OF MONTEREY MUSEUM (US ARMY)
Bldg S-113, Presidio of Monterey, Monterey, CA 93940
Tel: 408-242-8547
Museum Curator/Post Historian: Margaret B Adams
Staff: 1
Founded: 1965
Hours: Mon-Fri 9-12:30, 1:30-4

CIRCULATION POLICY
Films: Researchers (appointment required)
Photographs: Public (appointment required)
COLLECTIONS
Films: 2 US Army Catalog. Architecture (US)
Photographs: 350 US Army Catalog. Architecture (US, California, Mexico, Spain); Sculpture (California, Mexico, Spain); Painting (California, Mexico, Spain); Decorative Arts (California, Mexico, Spain)
Slides: Architecture (California, Mexico, Spain)
SPECIAL COLLECTIONS
Photographs: for in-museum research only—California, Monterey history, art and architecture including early photographs and photos of early drawings
SERVICES
Negatives: Approx 50 negatives in collection, most are historic originals not available for use outside museum

VR 64
SAN DIEGO STATE UNIVERSITY
Library, Art Department
5300 Campanile Dr, San Diego, CA 92182

Tel: 714-286-6014
Libn: Lilla Sunatt

CIRCULATION POLICY
Original Art Works: Researchers, faculty/staff (appointment suggested)
Photographs: Students, researchers, faculty/staff
Reproductions: Students, researchers, faculty/staff
Slides: Researchers, faculty/staff (appointment suggested)
COLLECTIONS
Models: 50
Photographs: 10,000
Reproductions: 3,000. Architecture (Ancient); Sculpture (Ancient); Painting (Ancient)
Slides: 100,000. Architecture (Ancient, Islamic, Far East, African, Tribal American, Meso-American, Andean, European, US); Sculpture (Ancient, Islamic, Far East, African, Pacific, Tribal American, Meso-American, Andean, European, US); Painting (Ancient, Islamic, Far East, African, Tribal American, Meso-American, Andean, European, US); Graphic Arts (European, US); Decorative Arts (Ancient, Islamic, Far East, African, Pacific, Tribal American, Meso-American, Andean, European, US)

VR 65
SAN FRANCISCO ART INSTITUTE
Anne Bremer Memorial Library Media Department
800 Chestnut St, San Francisco, CA 94133
Tel: 415-771-7020, Ext 57
Media Asst/Head of Media Dept: Caroline Savage-Lee
Hours: Mon-Fri 10-5 (fall/spring)
 Mon-Fri 11-3 (summer)

CIRCULATION POLICY
Audiocassettes: 160 (new collection)
Films: (new collection)
Slides: 21,669. Architecture (Ancient); Sculpture (Ancient, Meso-American, European, US); Painting (Far East, European, US); Decorative Arts (Far East, Meso-American)
SPECIAL COLLECTIONS
Archive of the thesis films of SFAI graduates.
Some photographs and negatives relating to SFAI and dating from 1900 to the present are contained in archive. Not accessible.
SERVICES
Slides: Non-copyrighted material in slide collection is available for sale or duplication

VR 66
SAN FRANCISCO MARITIME MUSEUM
J Porter Shaw Library
Foot of Polk St, San Francisco, CA 94109
Tel: 415-673-0700
Photo Archivist: Isabel Bullen
Staff: 1
Founded: 1952
Hours: Mon-Fri 10-5

CIRCULATION POLICY
Photographs: Public, fee service (appointment suggested)
COLLECTIONS
Films: 10
Photographs: 100,000 Olmsted
Slides: 500
SPECIAL COLLECTIONS

Bethlehem Collection (negatives)
Hester Collection (negatives)
Muhlmann Collection (negatives)
Plummer Collection (negatives)
Procter Collection (negatives)
SERVICES
Negatives: Prints available for reproductive use subject to copyright and museum fees and regulations on marine, San Francisco, and California history
Slides: Available for duplication subject to copyright and museum regulations

VR 67
SAN FRANCISCO MUSEUM OF MODERN ART
Education Department Slide Library
McAllister at Van Ness, San Francisco, CA 94102
Tel: 415-863-8800
Slide Libns: Basil Brummel & Garna Muller
Founded: 1948
Hours: Mon-Fri 10-5

CIRCULATION POLICY
Slides: 18,000 San Francisco Museum of Art. Architecture (European, US); Sculpture (Ancient, Far East, African, Tribal American, Meso-American, Andean, European, US); Painting (Ancient, Far East, Pacific, Meso-American, European, US); Graphic Arts (Far East, Meso-American, European, US); Decorative Arts (Meso-American, European, US)
SUBSCRIPTIONS
Carnegie Set (slides)
SERVICES
Slides: Works in the permanent collections of the museum are available for purchase or duplication

VR 68
SAN FRANCISCO PUBLIC LIBRARY*
Art & Music Department
Civic Center, San Francisco, CA 94102
Tel: 415-558-3687

VR 69
SAN JOSE CITY COLLEGE
Art History Slide Collection
2100 Moor Park Ave, San Jose, CA 95120
Tel: 408-298-2181
Art Historian: Luraine Tansey
Founded: 1956

CIRCULATION POLICY
Slides: Restricted, students, researchers, faculty/staff (appointment required)
COLLECTIONS
Slides: 25,000 Santa Cruz. Architecture (Ancient, European, US); Sculpture (Ancient, European, US); Painting (Ancient, European, US); Graphic Arts (Ancient, European, US)
SUBSCRIPTIONS
Carnegie Set (slides)

VR 70
SAN JOSE STATE UNIVERSITY
Art Department
S Ninth St, San Jose, CA 95192
Tel: 408-277-2562, Ext 72562
Slide Curator: Patricia E Pinkerton
Founded: ca 1962
Hours: Mon-Fri 8:30-5

CIRCULATION POLICY
Slides: Students, researchers, faculty/staff, fee service, circulating
COLLECTIONS
Slides: 180,000 Fogg. Architecture (Ancient, Islamic, Far East, African, Tribal American, Meso-American, Andean, European, US); Sculpture (Ancient, Far East, African, Pacific, Tribal American, Meso-American, Andean, European, US); Painting (Ancient, Far East, African, European, US); Graphic Arts (Islamic, Far East, European, US); Decorative Arts (Meso-American, Andean, European, US)
SUBSCRIPTIONS
Carnegie Set (slides)

VR 71
SANTA MONICA COLLEGE LIBRARY*
Media Department
1815 Pearl St, Santa Monica, CA 90405
Tel: 213-392-4911, Ext 296
Media Library Clerk I: Marva R Lassoff

VR 72
STANFORD UNIVERSITY
Department of Art Slide Collection
Stanford, CA 94305
Tel: 415-497-3320
Slide Curator: Carol Ulrich
Staff: 1
Founded: 1963
Hours: Mon-Fri 8:30-5

CIRCULATION POLICY
Slides: Restricted, art students with permission, art department faculty
COLLECTIONS
Slides: 140,000 Minnesota. Architecture (European, US); Sculpture (European, US); Painting (Far East, European, US); Graphic Arts (European); Decorative Arts (Far East, European)
SUBSCRIPTIONS
American Committee of South Asian Art (slides)
Asian Art Photographic Distribution (slides)
Carnegie Set (slides)
Saskia (slides)
University Colour Slide Scheme (slides)

VR 73
THE UNIVERSITY OF CALIFORNIA—BERKELEY
The Bancroft Library, Pictorial Collections
Berkeley, CA 94720
Tel: 415-642-6481
Curator of Pictorial Collection: Lawrence Dinnean
Founded: 1905
Hours: Mon-Fri 1-5
Sat 1-5

CIRCULATION POLICY
Drawings: Public
Paintings: Public
Photographs: Public
COLLECTIONS
Prints: 10,000. Graphic Arts (US)
Paintings: 5,000. Paintings (US)
Photographs: 750,000
SPECIAL COLLECTIONS
Graves Collection (photographs)

Honeyman Collection (photographs))
SERVICE
Negatives: Prints available for purchase for private
 reference use only

VR 74
UNIVERSITY OF CALIFORNIA—BERKELEY
Dept of Architecture, Visual Aids Collection
Wurster Hall, Berkeley, CA 94720
Tel: 415-642-3439
Libn: Judy Weiss

CIRCULATION POLICY
Films: Restricted, faculty/staff
Photographs: Restricted, students, researchers, faculty/staff
Slides: Restricted, students, researchers, faculty/staff
COLLECTIONS
Films: 5
Photographs: 20,000. Architecture (Ancient, Islamic, Meso-
 American, European, US)
Slides: 110,000. Architecture (Ancient, Islamic, Meso-
 American, European, US)
SUBSCRIPTIONS
Wayne Andrews (photographs)
Carnegie Set (slides)
SPECIAL COLLECTIONS
Denise Scott Brown Wheaton Collection (slides)

VR 75
UNIVERSITY OF CALIFORNIA—BERKELEY
Dept of History of Art, Slide Collection & Photograph
 Archive
308A Main Library, Berkeley, CA 94720
Tel: 415-642-5474
Curator: Keith Livingston Thoreen
Founded: ca 1938
Hours: Mon-Fri 9-5

CIRCULATION POLICY
Photographs: Restricted, graduate students, researchers,
 faculty/staff
Slides: Restricted, graduate students, researchers, faculty/
 staff
COLLECTIONS
Photographs: 100,000. Architecture (European); Sculpture
 (Far East, European); Painting (Ancient, Far East,
 European, US); Graphic Arts (Far East); Decorative
 Arts (Far East)
Slides: 225,000. Architecture (Ancient, Islamic, Far East,
 European, US); Sculpture (Ancient, Far East, European,
 US); Painting (Ancient, Far East, European, US);
 Graphic Arts (Far East, European, US); Decorative
 Arts (Ancient, Far East, European, US)
SUBSCRIPTIONS
Asian Art Photographic Distribution (photographs)
James Austin (photographs)
Berenson Archives (photographs)
Carnegie Set (slides)
Courtauld Institute Photo Survey of Private Collections
 (photographs)
Decimal Index of the Art of Low Countries (photographs)
Illustrated Bartsch (photographs)
University Colour Slide Scheme (slides)

VR 77
UNIVERSITY OF CALIFORNIA—DAVIS
Art Department Library
Davis, CA 95616

Tel: 916-752-3138
Libn: Barbara D Hoermann
Founded: 1966
Hours: Mon-Fri 9-12, 1-5

CIRCULATION POLICY
DIAL: Restricted, researchers
Microforms: Public
Pamphlets: Public, circulating
Photographs: Restricted
Reproductions: Public, circulating
Slides: Restricted
COLLECTIONS
Mounted Reproductions: 23,000. Architecture (European,
 US); Sculpture (Ancient)
Photographs: 3,700
Slides: n.a.
SUBSCRIPTIONS
Wayne Andrews (photographs)
Arts of the United States (slides)
Courtauld Institute Illustration Archive (reproductions)
Decimal Index of the Art of Low Countries (photographs)
Marburger Index (microfiche)
Turner Watercolors & Sketches—British Museum
 (microfilm)
Victoria & Albert Museum Microfiche Collection
 (microfiche)

VR 78
UNIVERSITY OF CALIFORNIA—DAVIS
Art Department Slide Library
Davis, CA 95616
Tel: 916-752-6043
Library Asst: Phyllis G Allen
Founded: 1966
Hours: Mon-Fri 8-12, 1-5

CIRCULATION POLICY
Slides: Graduate students, faculty/staff
COLLECTIONS
Slides: 95,000. Architecture (European, US); Sculpture
 (European); Painting (Far East, European, US); Graphic
 Arts (European)
SUBSCRIPTIONS
Asian Art Photographic Distribution (slides)
Chinese National Palace Museum Photo Archives (slides)
University Colour Slide Scheme (slides)

VR 79
UNIVERSITY OF CALIFORNIA—IRVINE
Art History, Slide Library
School of Fine Arts, Irvine, CA 92717
Tel: 714-833-6461
Slide Curator: Jeanie Gillespie
Founded: 1965
Hours: Mon-Fri 8-12, 1-5

CIRCULATION POLICY
Photographs: Restricted, researchers, faculty/staff,
 circulating
Slides: Restricted, researchers, faculty/staff, circulating
COLLECTIONS
Photographs: 200
Slides: 60,000 Fogg. Architecture (Ancient, Far East,
 Meso-American, European, US); Sculpture (Ancient,
 Islamic, Far East, African, Meso-American, European,
 US); Painting (Ancient, Islamic, Far East, European,

US); Graphic Arts (European, US); Decorative Arts (African, European, US)

VR 80
UNIVERSITY OF CALIFORNIA—LOS ANGELES*
Dept of Art, Slide & Photograph Collections
405 Hilgard Ave, Los Angeles, CA 90024
Tel: 213-224-3521
Founded: 1952

VR 81
UNIVERSITY OF CALIFORNIA—LOS ANGELES
Instructional Media Library
405 Hilgard Ave, 8 Royce Hall, Los Angeles, CA 90024
Tel: 213-825-0755
Supervisor: Helga Trachinger
Staff: 4
Hours: Mon-Fri 8-5:30

CIRCULATION POLICY
Film Strips: Public, fee service, circulating
Films: Public, fee service, circulating
Video Cassettes: Public, fee service, circulating
COLLECTIONS
Films: 2,100 NICEM
Video: 20 NICEM

VR 82
UNIVERSITY OF CALIFORNIA—RIVERSIDE
Dept of Art History, Slide Library
Riverside, CA 92521
Tel: 714-787-4628
Curator of Visual Resources: Rikki Robison
Hours: Mon-Fri 8-5

CIRCULATION POLICY
Photographs: Restricted, faculty/staff
Slides: Restricted, faculty/staff
COLLECTIONS
Photographs: 20,000 Fogg. Architecture (Ancient, European, US); Sculpture (Ancient, European, US); Painting (Ancient, European, US); Graphic Arts (European, US)
Slides: 70,000 Fogg. Architecture (Ancient, European, US); Sculpture (Ancient, European, US); Painting (Ancient, European, US); Graphic Arts (European, US)

VR 83
UNIVERSITY OF CALIFORNIA—SAN DIEGO
Slide Collection, Central University Library
La Jolla, CA 92093
Tel: 714-452-4811
Curator: Karin Ozudogru
Staff: 2½
Founded: 1973
Hours: Mon-Fri 8-4:30

CIRCULATION POLICY
Slides: Students, researchers, faculty/staff, circulating
COLLECTIONS
Slides: 80,000 Fogg. Architecture (Ancient, Islamic, Meso-American, European, US); Sculpture (Ancient, European, US); Painting (Ancient, Far East, European, US); Graphic Arts (US)

VR 84
UNIVERSITY OF CALIFORNIA—
SANTA BARBARA

Art Department, Slide Collection
Santa Barbara, CA 93106
Tel: 805-961-2509
Slide Curator: Troy-John Bromberger
Staff: 2
Founded: ca 1960
Hours: Mon-Fri 8-5

CIRCULATION POLICY
Slides: Restricted, researchers, faculty, circulating
COLLECTIONS
Negatives: 20,000
Slides: 200,000. Architecture (Ancient, Islamic, Far East, Meso-American, Andean, European, US); Sculpture (Ancient, Far East, African, Pacific, Tribal American, Meso-American, Andean, European, US); Painting (Far East, European, US); Graphic Arts (European, US); Decorative Arts (African, Tribal American, European, US)
SUBSCRIPTIONS
American Committee of South Asian Art (slides)
Wayne Andrews (photographs)
Asian Art Photographic Distribution (slides)
Decimal Index of the Art of Low Countries (photographs)

VR 85
UNIVERSITY OF CALIFORNIA—
SANTA BARBARA
UCSB Art Museum
Santa Barbara, CA 93106
Tel: 805-961-2951
Dir: David Gebhard
Staff: 3
Hours: Tues-Sat 10-4
 Sun 1-5

CIRCULATION POLICY
Architectural Drawings: Public (appointment suggested)
SPECIAL COLLECTIONS
Morgenroth Collection of Renaissance Medals
Southern California Architectural Archives (original drawings)
SERVICES
Negatives: Prints are available for purchase subject to copyright and museum regulations and fees

VR 86
UNIVERSITY OF CALIFORNIA, SANTA CRUZ*
Main Library, Slide Collection
Santa Cruz, CA 95064
Tel: 408-429-2791
Head, Slide Collection: Kathleen E Hardin

VR 87
UNIVERSITY OF SOUTHERN CALIFORNIA
Architecture & Fine Arts Library Slide Library
Watts Hall, University Park, Los Angeles, CA 90007
Tel: 213-746-6058
Library Supervisory Assistant II: Christine Bunting
Founded: 1950
Hours: Mon-Fri 8:30-5

CIRCULATION POLICY
Photographs: Faculty/staff
Slides: Faculty/staff
COLLECTIONS
Photographs: 2,000

Slides: 101,000 Fogg. Architecture (Ancient, Islamic, Far
East, European, US); Sculpture (Ancient, Islamic, Far
East, European, US); Graphic Arts (Far East, European,
US); Decorative Arts (Islamic, European, US)
SUBSCRIPTIONS
Wayne Andrews (photographs)
Carnegie Set (slides)
SERVICES
Slides: Available for duplication subject to copyright and
library regulations

VR 88
UNIVERSITY OF SOUTHERN CALIFORNIA
The Gamble House, Greene & Greene Library
4 Westmoreland Place, Pasadena, CA 91103
Tel: 213-793-3334
Curator: Randell Makinson
Staff: 5
Founded: 1968

CIRCULATION POLICY
Drawings: Public (appointment suggested)
Letters: Public (appointment suggested)
Photographs: Public (appointment suggested)
Slides: Public (appointment suggested)
COLLECTIONS
Letters: "many"
Microforms: n.a.
Photographs: "many"
Slides: "few"
SPECIAL COLLECTIONS
Most complete collection of drawings, correspondence,
photographs, memorabilia of architects Charles Sumner
Greene and Henry Mather Greene
SERVICES
Photocopies: Available for publication, permission and fees
must be arranged with institution holding original
document
Slides: Available for purchase, expanded selection
anticipated

VR 89
UNIVERSITY OF THE PACIFIC
The Pacific Center for Western Studies
3600 Pacific Ave, Stockton, CA 95211
Tel: 209-946-2404
Dir: Dr Walter Payne
Founded: 1851
Hours: Mon-Fri 8:30-5

CIRCULATION POLICY
Photographs: Public (appointment required on weekends)
Slides: Public (appointment required on weekends)
COLLECTIONS
Photographs: 50,000. Painting (US)
SPECIAL COLLECTIONS
John Pitcher Spooner Collection of Californiana (Late
19th century Stockton, mother lode gold country, and
far east) (photographs)
SERVICES
Negatives: Prints available for purchase subject to copy-
right and university regulations

VR 90
WHITTIER COLLEGE*
Art Department Slide Collection
Whittier, CA 90608
Tel: 213-693-0771

Colorado

VR 91
COLORADO COLLEGE
Art Slide Library
Cache la Poudre, Colorado Springs, CO 80903
Tel: 303-473-2233, Ext 512
Slide Libn: Kathleen Snyder
Hours: Mon-Fri 8:30-5

CIRCULATION POLICY
Slides: Restricted, students, faculty/staff, internal circulat-
ing (appointment required)
COLLECTIONS
Slides: 30,000 Fogg. Architecture (Ancient, Islamic, Far
East, European, US); Sculpture (Ancient, Islamic, Far
East, European, US); Painting (Ancient, Islamic, Far
East, European, US); Graphic Arts (Ancient, European,
US); Decorative Arts (Ancient, Far East, European)
SUBSCRIPTIONS
Carnegie Set (slides)

VR 92
THE DENVER ART MUSEUM*
Dept of Education, Slide Library
100 W 14 Ave Pkwy, Denver, CO 80204
Tel: 303-575-2265

VR 93
DENVER PUBLIC LIBRARY
Western History Department
1357 Broadway, Denver, CO 80203
Tel: 303-573-5152, Ext 265
Libn: Eleanor M Gehres
Staff: 9
Founded: 1934
Hours: Mon-Thurs 10-9
 Fri-Sat 10-5:30

CIRCULATION POLICY
Architectural Drawings: Restricted, fee service
Films: Restricted
Original Prints: Restricted, fee service
Photographs: Restricted, fee service
Slides: Restricted, fee service
Video: Restricted
COLLECTIONS
Architectural Drawings: 175
Films: 4
Microforms: 1,000
Negatives & graphics: 280,000
Original Prints: 500. Architecture (Western US); Sculpture
(Western Americana); Painting (Western Americana);
Graphic Arts (Western Americana); Decorative Arts
(Western Americana)
Slides: n.a.
Video: 20
SPECIAL COLLECTIONS
Western Americana Collections
SERVICES
Negatives: Prints available for purchase subject to copy-
right and library regulations and fees
Slides: Available for purchase

VR 94
GRAND CITY MUSEUM
Box 168, Hot Sulphur Springs, CO 80451
Tel: 303-722-2226; 726-5389
Person in Charge: R M Black
Founded: 1975
Hours: Mon-Fri 12-4

CIRCULATION POLICY
Photographs: Students, researchers
SPECIAL COLLECTIONS
Grand County, Colorado History (photographs)
SERVICES
Negatives: Prints are available for purchase subject to
 copyright and museum regulations and fees
Slides: Available for duplication

VR 95
NORTHEASTERN JUNIOR COLLEGE
Learning Resource Center
Sterling, CO 80751
Tel: 303-522-6600, Ext 613
Director Learning Resources Center: Joan L Weber
Founded: 1941

CIRCULATION POLICY
Cassettes: Public, circulating
Filmstrips: Public, circulating
Slides: Public, circulating
Video: Public (appointment suggested)
COLLECTIONS
Cassettes: 300 LC
Films: 3 LC
Microforms: 3 LC
Models: 3 LC
Slides: 100 LC
Video: 100 LC. Architecture (US); Painting (Tribal
 American, US)

VR 96
UNITED STATES GEOLOGICAL SURVEY
 LIBRARY
Stop 914, Box 25046, Denver Federal Center,
 Denver, CO 80225
Tel: 303-234-4004
Libn: Marjorie E Dalechek
Founded: 1954
Hours: Mon-Fri 8:00-4:30

CIRCULATION POLICY
Photographs: Public, fee service
Slides: Public, fee service
COLLECTIONS
Photographs: 190,000
Slides: 10,000
SPECIAL COLLECTIONS
Hayden Survey Photographs taken by W H Jackson
 (photographs)
King Survey Photographs taken by T H O'Sullivan and
 C E Watkins (photographs)
Powell Survey Photographs taken by J K Hillers,
 E O Beaman, James Fennemore (photographs)
Wheeler Survey Photographs taken by T H O'Sullivan and
 W Bell (photographs)
SERVICES
Negatives: Photographs in public domain, prints available

for purchase subject to library fees and regulations.
Collection contains nitrate, glass and safety negatives,
lantern slides, color transparencies, stereoviews, color
negatives.
Slides: Available for duplication and sale

VR 97
UNIVERSITY OF COLORADO*
College of Environmental Design
Boulder, CO 80302
Tel: 303-492-7711

VR 98
UNIVERSITY OF COLORADO
Fine Arts Department, Slide Collection
FA 202, Boulder, CO 80302
Tel: 303-492-6136
Slide Curator: E Theotokatos
Hours: Mon-Fri 8-12, 1-5

CIRCULATION POLICY
Slides: Restricted, faculty/staff (appointment suggested)
COLLECTIONS
Slides: 130,000 Yale. Architecture (Islamic, Tribal
 American, Meso-American, Andean)

VR 99
UNIVERSITY OF DENVER
Art Slide Office, Art Department
Bradford House, Denver, CO 80208
Tel: 303-753-3482
Libn: Peter A Dulin, Jr
Founded: 1957
Hours: Mon-Fri 9-1

CIRCULATION POLICY
Photographs: Public, students, researchers, faculty/staff,
 circulating
Slides: Public, students, researchers, faculty/staff,
 circulating
COLLECTIONS
Photographs: n.a.
Slides: 50,000 Santa Cruz. Architecture (Ancient, Islamic,
 Far East, Tribal American, Meso-American, European,
 US); Sculpture (Ancient, Far East, African, Tribal
 American, Meso-American, European, US); Painting
 (Ancient, Far East, European, US); Graphic Arts (Far
 East, European, US); Decorative Arts (Ancient, Far
 East, Tribal American, Meso-American, European, US)
SUBSCRIPTIONS
American Committee of South Asian Art (slides)
Asian Art Photographic Distribution (slides)
Carnegie Set (slides)
Chinese National Palace Museum Photograph Archives
 (slides)
Decimal Index of Art of Low Countries (slides)
Edward S Curtis Photographs (slides)
SERVICES
Slides: Edward S Curtis Photograph Collection are
 available for purchase

Connecticut

VR 100
CONNECTICUT COLLEGE
Art History Department, Slide Library

Box 1591, New London, CT 06320
Tel: 203-442-5391, Ext 497
Slide Libn: Eileen Heinz
Hours: Mon-Fri 8:30-5

CIRCULATION POLICY
Slides: Researchers, faculty/staff
COLLECTIONS
Slides: 60,000 Fogg. Architecture (Ancient, Far East,
 Meso-American, European, US); Sculpture (Ancient,
 Far East, Meso-American, European, US); Painting
 (Ancient, Far East, Meso-American, European, US);
 Graphic Arts (European, US)
SUBSCRIPTIONS
Carnegie Set (slides)
SERVICES
Slides: Duplicates available on request subject to copyright
 and library regulations and fees

VR 101
GREENWICH LIBRARY
Film Department
101 W Putnam Ave, Greenwich, CT 06830
Tel: 203-622-7922
Film Services Coordinator: Wayne T Campbell
Staff: 12
Founded: 1949
Hours: Mon-Fri 9-9
 Sat 9-5
 Sun 1-5 (Oct-April)

CIRCULATION POLICY
Films: Public, circulating (appointment suggested)
COLLECTIONS
Films: 900
Video: 50
SPECIAL COLLECTIONS
Historic Views of Greenwich (photographs)
SERVICES
Negatives: Prints available for purchase subject to copy-
 right and library regulations and fees

VR 102
HOUSATONIC COMMUNITY COLLEGE*
Art Department
510 Barnum Ave, Bridgeport, CT 06608
Tel: 203-579-6440
Chairman: Burt Chernou

VR 103
ST JOSEPH COLLEGE
Pope Pius XII Library
1678 Asylum Ave, West Hartford, CT 06117
Tel: 203-232-4571, Ext 208
Serials & AV Libn: Linda Geffner
Founded: 1932

CIRCULATION POLICY
Archives: Restricted, students, researchers, faculty/staff
 (appointment suggested)
Filmstrips: Students, researchers, faculty/staff, circulating
Kits: Students, researchers, faculty/staff, circulating
Records: Students, researchers, faculty/staff, circulating
Slides: Students, researchers, faculty/staff, circulating
COLLECTIONS
Films: 99
Microforms: 1,827 Dewey

Slides: 2,737. Architecture (Ancient, European, US);
 Sculpture (Ancient, European, US); Painting (Ancient,
 European, US)
SPECIAL COLLECTIONS
Rhoda Kellogg Child Art Collection (fiche)

VR 104
TRINITY COLLEGE
Austin Arts Center, Slide Library
Summit St, Hartford, CT 06106
Tel: 203-527-3151, Ext 415
Slide Libn: Trudy J Buxton
Founded: ca 1965
Hours: Mon-Fri 8:30-3:30

CIRCULATION POLICY
Slides: Faculty
COLLECTIONS
Slides: 80,000 Fogg/Metropolitan. Architecture (Ancient,
 Far East, European, US); Sculpture (Ancient, Far East,
 European, US); Painting and Graphic Arts (Far East,
 European, US); Decorative Arts (European, US)
SUBSCRIPTIONS
American Committee of South Asian Art (slides)

VR 105
UNIVERSITY OF CONNECTICUT*
Art Department, Slide Library
School of Fine Arts, U-99, Storrs, CT 06268
Tel: 203-486-3930
Slide Libn: Katharine A Farina

VR 106
UNIVERSITY OF HARTFORD
Art History Slide Library
200 Bloomfield Ave, Rm 132H, West Hartford, CT 06117
Tel: 203-243-4742
Slide Curator: Jerome Wolf
Founded: 1964
Hours: Mon-Fri 10-5

CIRCULATION POLICY
Slides: Restricted, faculty/staff
COLLECTIONS
Slides: 30,000. Architecture (Ancient, European, US);
 Sculpture (Ancient, European, US); Painting (Ancient,
 European, US); Graphic Arts (Ancient, European, US);
 Decorative Arts (Ancient, European, US)

VR 107
WADSWORTH ATHENAEUM*
Morgan & Avery Memorials, Education Department
25 Athenaeum Sq N, Hartford, CT 06103
Tel: 203-278-2670
Founded: 1930s

VR 108
WESLEYAN UNIVERSITY*
Art Department, Slide Library
Middletown, CT 06457
Tel: 203-347-9411
Slide Libn: Deborah G Boothby

VR 109
WESTPORT PUBLIC LIBRARY
Westport, CT 06880
Tel: 203-227-8411

Art Libn: Thelma Gordon
Hours: Mon 9-6
Thurs 9-9

CIRCULATION POLICY
Clippings: Public, circulating
Photographs: Restricted
COLLECTIONS
Clippings: n.a.
Photographs: 200,000

VR 110
YALE CENTER FOR BRITISH ART
Photograph Archive
Box 2120 Yale Station, New Haven, CT 06520
Tel: 203-432-4098
Ref Libn & Acting Head: Jaylyn Olivo
Founded: 1972
Hours: Tues-Fri 10-4:30

CIRCULATION POLICY
Photographs: Public
COLLECTIONS
Photographs: *0,000 Yale-Museum Computer Network.
 Painting (British)
SUBSCRIPTIONS
Courtauld Institute Photo Survey of Private Collections
 (photographs)
Gernsheim Collection-British drawings (photographs)

VR 111
YALE UNIVERSITY
Art & Architecture Library Slide & Photograph Collection
Box 16005A Yale Station, New Haven, CT 06520
Tel: 203-436-4272
Libn: Helen Chillman
Staff: 3
Founded: 1935-40
Hours: Mon-Fri 8:30-5

CIRCULATION POLICY
Photographs: Public (appointment suggested)
Slides: Faculty/staff (appointment suggested)
COLLECTIONS
Photographs: 157,000. Architecture (Ancient, Islamic,
 Far East, Meso-American, European, US); Sculpture
 (Ancient, Far East, African, Meso-American, Euro-
 pean, US); Painting (Ancient, Far East, Meso-
 American, European, US); Graphic Arts (Ancient, Far
 East, Meso-American, European, US); Decorative Arts
 (Ancient, Far East, African, Meso-American, European,
 US)
Slides: 210,200. Architecture (Ancient, Islamic, Far East,
 Meso-American, European, US); Sculpture (Ancient,
 Islamic, Far East, African, Meso-American, European,
 US); Painting (Ancient, Islamic, Far East, Meso-
 American, European, US); Graphic Arts (Ancient,
 Far East, Meso-American, European, US); Decorative
 Arts (Ancient, Far East, African, Meso-American,
 European, US)
SUBSCRIPTIONS
Wayne Andrews (photographs)
Asian Art Photographic Distribution (photographs)
James Austin (photographs)
Berenson Archives (photographs)
Carnegie Set (slides)

Chinese National Palace Museum Photo Archive
 (photographs, slides)
Decimal Index of the Art of Low Countries (photographs)
Illustrated Bartsch (photographs)
University Colour Slide Scheme (slides)
SPECIAL COLLECTIONS
Connecticut Architecture (photographs)
"Various collections of photographs exist throughout the
 Yale University Library system, usually as personal
 archives (Steiglitz, Binham, Drier, etc.) Inquiries can be
 made to the Slide and Photograph Collection who will
 forward them to the appropriate department."
SERVICES
Slides: Available from the following: Yale Art Gallery
 and the Yale Center for British Art and British Studies

VR 112
YALE UNIVERSITY*
Beinecke Library
Western Americana Collection
Wall & High Sts, New Haven, CT 06520
Tel: 203-436-8438

Delaware

VR 113
ELEUTHERIAN MILLS*
Historical Library, Pictorial Collections
Greenville, Wilmington, DE 19807
Tel: 302-658-2401

VR 114
UNIVERSITY OF DELAWARE
Art History Department, Slide Library
333 Smith Hall, Newark, DE 19711
Tel: 302-738-2418
Curator of Slides & Photographs: Charlotte A Kelly
Staff: 1
Hours: Mon-Fri 8:30-12, 1-5 (office)

CIRCULATION POLICY
Photographs: Graduate students, researchers, faculty
Slides: Graduate students, faculty
COLLECTIONS
Photographs: 30,000. Architecture (US); Sculpture (US);
 Graphic Arts (Ancient)
Slides: 135,000 National Gallery of Art. Architecture
 (Ancient, European, US); Sculpture (Ancient, Euro-
 pean, US); Painting (Ancient, European, US); Graphic
 Arts (Ancient, European, US); Decorative Arts
 (Ancient, European, US)
SUBSCRIPTIONS
Wayne Andrews (photographs)
Carnegie Set (slides)
Decimal Index of the Art of Low Countries (photographs)
Illustrated Bartsch (photographs)
Index of American Sculpture (photographs)
SPECIAL COLLECTIONS
Iconographic Index to the Bartsch photographs compiled
 by University of Delaware & Princeton University
 (photographs)
Index of American Sculpture begun by Professor Wayne
 Craven (photographs)

VR 115
H F du PONT WINTERTHUR MUSEUM
LIBRARIES
Decorative Arts Photographic Collection—Photographic
Index of American Art & Design
Winterthur, DE 19735
Tel: 302-656-8591, Ext 258
Libn: Deborah D Walters
Founded: 1955/1966
Hours: Mon-Fri 8:30-4:30

CIRCULATION POLICY
Photographs: Restricted, public (appointment suggested)
COLLECTIONS
Photographs: 85,000. Architecture (US); Sculpture (US);
 Painting (US); Graphic Arts (US); Decorative Arts
 (US)
SPECIAL COLLECTIONS
DAPC/NEA-funded Survey of Decorative and Folk Arts
 of the Delaware Valley (photographs)
Allan Ludwig Collection of Photographs of New England
 and English Gravestones (photographs)
Mary N Northend Collection of Photographs—New
 England ca 1900-1910
R W Symonds Collection of Photographs of British
 Furniture and Clocks
SERVICES
Negatives: With owner's permission, prints available for
 study or publication of Field Survey photographs,
 Gustav Stickley furniture catalogue photographs, Mary
 N Northend Collection
Photocopies: Available for study use

VR 116
H F du PONT WINTERTHUR MUSEUM
Slide Library
Winterthur, DE 19735
Tel: 302-656-8591, Ext 287
Libn in Charge of Photo & Slide Collection: Kathryn K
 McKenney
Hours: Mon-Fri 8:30-4:30

CIRCULATION POLICY
Slides: Restricted, researchers, faculty/staff (appointment
 suggested)
COLLECTIONS
Slides: 60,000 Santa Cruz. Architecture (European, US);
 Sculpture (European, US); Painting (European, US);
 Graphic Arts (European, US); Decorative Arts (Euro-
 pean, US)
SUBSCRIPTIONS
Carnegie Set (slides)
SPECIAL COLLECTIONS
Shaker Collections (slides)
Winterthur Rare Book and Manuscript Collections (slides)
SERVICES
Negatives: Prints available for purchase of material in
 Rare Books and Manuscript Libraries and in Northend
 Collection of glass plate negatives

District of Columbia

VR 116A
AMERICAN INSTITUTE OF ARCHITECTS
LIBRARY
1735 New York Avenue NW, Washington, DC 20006

Tel: 202-785-7293
Libn: Susan C Holton
Hours: Mon-Fri 8:30-5 (by appointment only)

CIRCULATION POLICY
(By appointment only)
COLLECTIONS
Photographs
Postcards

VR 117
AMERICAN UNIVERSITY
Dept of Art
Washington, DC 20016
Tel: 202-686-2114
Person in Charge: Catherine Batza
Founded: 1960

CIRCULATION POLICY
Slides: Restricted, faculty/staff
COLLECTIONS
Films: 5
Slides: 42,000 National Gallery of Art. Architecture
 (Ancient, European, US); Sculpture (Ancient, Euro-
 pean, US); Painting (Far East, European, US); Graphic
 Arts (Ancient, Far East, European, US); Decorative
 Arts (European, US)
SUBSCRIPTIONS
Carnegie Set (slides)
Courtauld Institute Photographic Survey of Private
 Collections (slides)

VR 117A
ARCHITECT OF THE CAPITOL
Art & Reference Division
Rm HB 28, United States Capitol, Washington, DC 20515
Tel: 202-225-1222
Head: Florian H Thayn
Hours: Mon-Fri 8:30-5
 Sat 8:30-12:30

COLLECTIONS
Photographs
Slides

VR 118
ARCHIVES OF AMERICAN ART
Smithsonian Institution
FA-PG Bldg, Eighth and F Sts, Washington, DC 20560
Tel: 202-381-6174
Dir: Arthur Breton
Founded: 1954
Hours: Mon-Fri 9-5

CIRCULATION POLICY
Photographs: Researchers (appointment suggested)
Slides: Researchers (appointment suggested)
COLLECTIONS
Microforms: 3,900 films
Photographs: 200,000. Architecture (US); Sculpture
 (US); Painting (US); Graphic Arts (US); Decorative
 Arts (US)
Slides: ca 1,500. Architecture (US); Sculpture (US);
 Painting (US); Graphic Arts (US); Decorative Arts
 (US)
SPECIAL COLLECTIONS
"The Archives of American Art collects, arranges,

catalogs, microfilms, and preserves primary source material relating to the history of the visual arts in the United States from colonial times to the present, and makes these documents available to researchers through five area research centers and through interlibrary loan of microfilm. These documents comprise the personal papers of artists, craftsmen, art historians, art dealers, art collectors, and the records of museums, galleries, art societies, art schools, and other art organizations. The documents include correspondence, diaries, exhibition catalogs, newspaper clippings and periodical articles, manuscripts of writing on art and of creative writing, business records, legal documents, sketches and sketchbooks, photographs of works of art and personal photographs, 35mm slides, art auction catalogs, and oral histories."

REGIONAL CENTERS
Archives of American Art
Administrative Headquarters and Area Research and
 Collecting Center
41 E 65 St, New York, NY 10021
Tel: 212-826-5722
Dir: William McNaught

Archives of American Art
Area Research and Collecting Center
5200 Woodward Ave, Detroit, MI 48202
Tel: 313-226-7544
Dir: Dennis Barrie

Archives of American Art
Area Research and Collecting Center
87 Mt Vernon St, Boston, MA 02108
Tel: 617-223-0951
Dir: Robert Brown

Archives of American Art
Area Research and Collecting Center
M H de Young Memorial Museum
Golden Gate Park, San Francisco, CA 94118
Tel: 415-556-2530
Dir: Paul Karlstrom
SERVICES
Negatives: Prints available for purchase subject to
 copyright restrictions

VR 118A
CATHOLIC UNIVERSITY
Oliveira Lima Library
620 Michigan Avenue NE, Washington, DC 20017
Tel: 202-635-5059
Curator: Manoel Cardozo
Hours: Mon-Fri 9-5 (appointments requested)

CIRCULATION POLICY
(appointments requested)
COLLECTIONS
Photographs

VR 119
CORCORAN SCHOOL OF ART LIBRARY*
17 St & New York Ave, Washington, DC 20006
Tel: 202-638-3211, Ext 75
Libn: Deena M Pers

VR 120
DAUGHTERS OF THE AMERICAN
 REVOLUTION MUSEUM
Museum Reference Library
1776 D St NW, Washington, DC 20006
Tel: 202-628-1776, Ext 236
Curator: Jean T Federico
Founded: 1970
Hours: Mon-Fri 9-4

CIRCULATION POLICY
Slides: Restricted, students, researchers
COLLECTIONS
Slides: 200. Decorative Arts (US)

VR 121
DISTRICT OF COLUMBIA PUBLIC LIBRARY
Martin Luther King Memorial Library
901 G St NW, Washington, DC 20001
Tel: 202-727-1238
Libn: Lois Kent Stiles
Staff: 3
Hours: Mon-Thurs 9-9
 Fri-Sat 9-5:30

CIRCULATION POLICY
Audio-Visual Division: Public, circulating
Framed Prints: Public, circulating
Pictures, Art Division: Public, circulating
Video: Public
COLLECTIONS
Films: 140
Framed Prints: 296
Photographs: 27 drawers. Architecture (US-Washington,
 DC)
Pictures: 240 drawers
Slides: 48
Video: 2. Sculpture (African)
SPECIAL COLLECTIONS
E B Thompson Collection (lantern slides, negatives,
 positives)

VR 122
DUMBARTON OAKS RESEARCH LIBRARY &
 COLLECTIONS
Center for Byzantine Studies, Photograph Collection
1703 32 St NW, Washington, DC 20007
Tel: 202-232-3101, Ext 262
Head: Judith O'Neill
Staff: 2
Founded: pre-1953
Hours: Mon-Fri 9-5

CIRCULATION POLICY
Photographs: Restricted, resident researchers, resident
 faculty/staff (appointment required)
Slides: Restricted, resident researchers, resident
 faculty/staff (appointment required)
COLLECTIONS
Photographs: 55,670. Architecture (Byzantine); Sculpture (Byzantine); Painting (Byzantine); Decorative Arts (Byzantine); Mosaics (Byzantine)
Slides: 16,791. Architecture (Byzantine); Sculpture (Byzantine); Painting (Byzantine); Decorative Arts (Byzantine); Mosaics (Byzantine)
SUBSCRIPTIONS
Princeton Index (photographs)

SPECIAL COLLECTIONS
Byzantine Archaeological Sites Field Work Records
 (photographs)
Dumbarton Oaks Collections (photographs, slides)
SERVICES
Negatives: Available for purchase for study and
 publication/reproduction
Slides: Available for purchase
Transparencies: Available for loan covering museum
 collection

VR 123
FOLGER SHAKESPEARE LIBRARY
201 E Capitol, Washington, DC 20003
Tel: 202-LI6-4800
Dir: O B Hardison, Jr
Staff: 40
Founded: 1930
Hours: Restricted, by special appointment

COLLECTIONS
Films: 81 LC
Microforms: 2,449
Photographs: 3,500 LC
Video: 6
SERVICES
Photoduplication Service: Prints and microfilm available
 for purchase
Slides: Available for purchase from Sales Office

VR 124
FREER GALLERY OF ART LIBRARY
12 St & Jefferson Dr SW, Washington, DC 20560
Tel: 202-381-5332
Slide Librarian: Sarah L Newmeyer
Founded: 1923
Hours: Mon-Fri 10-4:30

CIRCULATION POLICY
Films: Public, fee service, circulating
Photographs: Public
Slides: Public, circulating
COLLECTIONS
Films: 1
Microforms: 38
Photographs: 25,000. Architecture (Islamic, Far East);
 Sculpture (Islamic, Far East); Painting (Islamic, Far
 East)
Slides: 50,000. Architecture (Islamic, Far East); Sculpture
 (Islamic, Far East); Painting (Islamic, Far East, US);
 Graphic Arts (Far East)
SUBSCRIPTIONS
Asian Art Photographic Distribution (photographs, slides)
Chinese National Palace Museum Photo Archives
 (photographs, slides)
SPECIAL COLLECTIONS
Avery Brundage Chinese Bronze Collection (photographs)
Numerous private collections (photographs, slides)
SERVICES
Negatives: Prints available for purchase
Slide Loan Service
Slides: Available for sale through the Sales Desk

VR 124A
GEORGE WASHINGTON UNIVERSITY
Dept of Art, Slide Collection
2000 G St, Washington, DC 20052
Tel: 202-676-6085

CIRCULATION POLICY
Slides: Faculty/staff
COLLECTIONS
Slides: (# small). Architecture (Ancient, European,
 US); Sculpture (Ancient, European, US); Painting
 (Ancient, European, US); Graphic Arts (Ancient,
 European, US); Decorative Arts (Ancient, European,
 US)

VR 125
GEORGETOWN UNIVERSITY
Lauinger Library, Special Collections Division
Washington, DC 20057
Tel: 202-625-3230
Special Collections Libn: George M Barringer
Staff: 2

CIRCULATION POLICY
Photographs: Public (appointment suggested)
COLLECTIONS
Photographs: 150,000
SPECIAL COLLECTIONS
Quigley Photographic Archive (photographs) of the
 motion picture industry
SERVICES
Negatives: Prints available for purchase subject to copy-
 right and university regulations and fees

VR 125A
HIRSHHORN MUSEUM & SCULPTURE GARDEN
Photoarchive
Seventh & Jefferson Dr SW, Washington, DC 20560
Tel: 202-381-6760
Photoarchivist: Francie Woltz
Hours: Mon-Fri 8:45-5:15 (appointment recommended)

CIRCULATION POLICY
(appointment recommended)
COLLECTIONS
Photographs
Slides

VR 126
HOWARD UNIVERSITY
Architecture & Planning Library
Washington, DC 20059
Tel: 202-636-7774
Libn: Mod Mekkawi
Founded: 1971
Hours: Mon-Thurs 8:30-8
 Fri 8:30-5
 Sat 1-5
 Mon-Fri 8:30-5 (office)

CIRCULATION POLICY
Photographs: Restricted, faculty/staff
Slides: Restricted, faculty/staff
COLLECTIONS
Microforms: 96
Photographs: 500
Slides: 26,400. Architecture (Ancient, Islamic, African,
 Meso-American, European, US); Painting (European);
 Graphic Arts (US)
SUBSCRIPTIONS
Carnegie Set (slides)
SPECIAL COLLECTIONS
Indigenous African Architecture (slides)

VR 127
THE LIBRARY OF CONGRESS
Prints & Photographs Division
Washington, DC 20540
Tel: 202-426-5836
Asst Chief: Dale K Hawoizth
Hours: Mon-Fri 8:30-5

CIRCULATION POLICY
Films: Restricted, researchers (appointment required)
Photographs: Public (appointment suggested)
Posters: Public (appointment suggested)
Prints & Drawings: Public (appointment suggested)
COLLECTIONS
Films: 75,000
Graphics: 240,000. Graphic Arts (European, US)
Photographs: 8,500,000. Architecture (US); Graphic Arts
 (European, US)
Video: 2,000
SPECIAL COLLECTIONS
Farm Security Administration/Office of War Information
 (photographs)
Historic American Buildings Survey (drawings,
 photographs)
Master Photographs Collection (photographs)
SERVICES
Negatives: Prints are available for purchase subject to
 copyright and library regulations and fees within the
 realm of American life, portraits, landscapes,
 architecture
A new "Guide to the Special Collections of Prints &
 Photographs" in preparation, 1978

VR 128
MUSEUM OF AFRICAN ART
Eliot Elisofon Archives
318 A St NE, Washington, DC 20002
Tel: 202-546-7710
Archivist: Frederick Lamp
Staff: 3
Founded: 1973
Hours: Mon-Fri 9-5:30

CIRCULATION POLICY
Films: Public (appointment suggested)
Photographs: Public (appointment suggested)
Slides: Public, circulating (appointment suggested)
COLLECTIONS
Films: 30. Architecture (African); Sculpture (African);
 Painting (African); Decorative Arts (African)
Photographs: 100,000. Architecture (Ancient, African,
 Pacific); Sculpture (Ancient, African, Pacific); Paint-
 ing (Ancient, African, Pacific); Decorative Arts
 (Ancient, African, Pacific)
Slides: 60,000. Architecture (Ancient, African, Pacific);
 Sculpture (Ancient, African, Pacific); Painting
 (Ancient, African, Pacific); Decorative Arts (Ancient,
 African, Pacific)
SUBSCRIPTIONS
Encyclopaedia Britannica "The Creative Heritage of
 Africa" Kit (photographs, slides)
SPECIAL COLLECTIONS
Eliot Elisofon Slide and Photographic Collection
 (photographs, slides)
SERVICES
Negatives: Prints available for purchase

Photographs—color: Available for loan with reproduction
 rights granted for fee

VR 129
NATIONAL ARCHIVES & RECORDS SERVICE
(GSA)
Audiovisual Archives Division (NNV)
Eighth & Pennsylvania Ave NW, Washington, DC 20408
Tel: 202-523-3010
Dir: James W Moore
Staff: 13
Founded: 1934
Hours: Mon-Fri 8:45-5:15

CIRCULATION POLICY
Films: Public (appointment suggested)
Photographs: Public
Slides: Public
Sound Recordings: Public (appointment suggested)
Video: Public, students, researchers (appointment
 suggested)
COLLECTIONS
Films: 103,000 reels
Photographs: 5,000,000
Slides: 5,000
Video: 25,000
SPECIAL COLLECTIONS
Audiovisual Archives is the documentation agency of the
 Federal Government's activities and programs
Ford Film Collection (films)
Harmon Foundation (photographs)
Major network news broadcasts, 1974 and later (video)
March of Time (films)
National Public Radio news broadcasts, 1971 and later
 (sound)
Universal Newsreel, 1929-1967 (films)
SERVICES
Material not encumbered by copyright or other restrictions
 is available for purchase at established Federal price
 schedule of fees
Negatives: Photographic negatives exist for a large portion
 of Federal Government's photographic archives
Slides: Available for a variety of subjects relating to
 Federal activities

VR 130
NATIONAL ARCHIVES & RECORDS SERVICE
(GSA)
Still Picture Branch
Eighth & Pennsylvania Ave NW, Washington, DC 20408
Tel: 202-523-3054
Chief: Joe D Thomas
Staff: 4
Founded: 1934
Hours: Mon-Fri 8:45-5

CIRCULATION POLICY
Photographs: Public, fee service
COLLECTIONS
Photographs: 5,000,000
SPECIAL COLLECTIONS
Matthew Brady Civil War Photographs (photographs)
Foreign Poster Collection of World War I and II (posters)
Harmon Foundation Photograph Collection of Artworks
 by 20th Century Black American and African Artists
 (photographs)

Dorothea Lang Photographs of the relocation of Japanese-Americans (photographs)

Russell Lee Photographs of Coal Mining activities (photographs)

SERVICES

Negatives: Prints available for publication or reproduction subject to copyright regulations and fees

Archival files of over 135 Federal Government agencies documenting their official activities as well as American (and world) cultural, social, environmental, economic, technological, and political history of a non-government nature, primarily 1860-1960.

VR 131
NATIONAL COLLECTION OF FINE ARTS, SMITHSONIAN INSTITUTION
Inventory of American Paintings Executed Before 1914
Eighth & G Sts NW, Washington, DC 20560
Tel: 202-381-6365
Coordinator: Martha Shipman Andrews
Founded: 1971
Hours: Mon-Fri 10-5:15

CIRCULATION POLICY

Photographs: Restricted, reference only, public (appointment required)

COLLECTIONS

Images: 40,000. Painting (US)

VR 132
NATIONAL COLLECTION OF FINE ARTS
Smithsonian Institution, Office of Slides & Photography
Ninth & G Sts NW, Washington, DC 20560
Tel: 202-381-5541, Ext 4316
Chief: Eleanor E Fink
Staff: 2
Founded: 1973, re-organized 1976
Hours: Mon-Fri 10-5:15

CIRCULATION POLICY

Color Transparencies: Students, researchers, faculty/staff, circulating

Photographs: Restricted, students, researchers, faculty/staff

Slides: Restricted, students, researchers, faculty/staff, circulating

COLLECTIONS

Color Transparencies: 5,000

Negatives: 150,000 NCFA-Computer

Photographs: 50,000 NCFA-Computer. Sculpture (European, US); Painting (European, US); Graphic Arts European, US); Decorative Arts (US)

Slides: 35,000 NCFA-Computer. Architecture (US); Sculpture (European, US); Painting (European, US); Graphic Arts (European, US); Decorative Arts (US)

SUBSCRIPTIONS

Carnegie Set (slides)

SPECIAL COLLECTIONS

Peter Juley and Son Collection of American artists of past 80 years

SERVICES

Negatives: Prints available for purchase subject to copyright and museum regulations

Slides: Available for purchase

VR 133
THE NATIONAL GALLERY OF ART
Dept of Extension Programs

Sixth & Constitution Ave NW, Washington, DC 20565
Tel: 202-737-4215, Ext 251; 252
Curator-in-Charge: Joseph J Reis
Staff: 2
Founded: 1954
Hours: Mon-Fri 9-5:30

CIRCULATION POLICY

Films: Public, circulating

Slides: Public, circulating

COLLECTIONS

Films: Painting (European, US); Graphic Arts (European)

Slides: Painting (European, US); Decorative Arts (European, US)

VR 134
NATIONAL GALLERY OF ART
Photographic Archives
Constitution Ave at Sixth St, Washington, DC 20565
Tel: 202-737-4215, Ext 231
Curator: Ruth R Philbrick
Staff: 5
Founded: 1971
Hours: Mon-Fri 9-5

CIRCULATION POLICY

Photographs: Restricted, students, researchers, faculty/staff

COLLECTIONS

Photographs: 750,000. Architecture (Ancient, European, US); Sculpture (Ancient, European, US); Painting (Ancient, European, US); Graphic Arts (European, US); Decorative Arts (Ancient, European, US)

SUBSCRIPTIONS

Alinari, etc (photographs)

Wayne Andrews (photographs)

James Austin (photographs)

Berenson Archives (photographs)

Bohm (photographs)

British 18th Century Portraits (photographs)

A C Cooper (photographs)

Courtauld Institute Photo Survey of Private Collections (photographs)

Decimal Index of the Art of Low Countries (photographs)

Max Hutzel (photographs)

Illustrated Bartsch (photographs)

Italian Medals (photographs)

Scottish National Portrait Gallery (photographs)

Zodiac (photographs)

SPECIAL COLLECTIONS

Art International (photographs)

Ehrich Gallery (photographs)

George Richter (photographs)

Schaeffer Gallery (photographs)

Van Diemen-Lilenfeld Gallery (photographs)

SERVICES

Negatives: Prints available for purchase subject to copyright and gallery regulations and fees (Content of negative collection: Parke Bernet and Sotheby Parke Bernet, 1938-1972; A.A.A.-Anderson, 1930s-1940s (incomplete); Gramstorff Bros, Reali, Rigamonti, Clarence Ward, Robert Enggass.)

VR 135
THE NATIONAL GALLERY OF ART
Slide Library

Sixth & Constitution Ave NW, Washington, DC 20565
Tel: 202-737-4215, Ext 267
Slide Libn: Anne von Rebhan
Founded: 1942
Hours: Mon-Fri 10-5

CIRCULATION POLICY
Slides: Public, circulating
COLLECTIONS
Slides: 77,000 National Gallery. Architecture (African,
 European, US); Sculpture (African, European, US);
 Painting (European, US); Graphic Arts (European,
 US); Decorative Arts (Far East, Tribal American)
SUBSCRIPTIONS
Carnegie Set (slides)
University Colour Slide Scheme (slides)
SPECIAL COLLECTIONS
National Gallery Collections (slides)
SERVICES
Slide Loans: Temporary Exhibitions slide loans available
Slides: Available for purchase and duplication

VR 136
NATIONAL GEOGRAPHIC SOCIETY
Illustrations Library
17 & M Sts NW, Washington, DC 20036
Tel: 202-857-7492
Illustrations Libn: L Fern Dame
Staff: 32
Founded: 1919
Hours: Mon-Fri 8:30-5

CIRCULATION POLICY
Art: Restricted, staff (appointment required)
Photographs: Restricted, staff (appointment required)
Slides: Restricted, staff (appointment required)
COLLECTIONS
Art: 8,500
Photographs: 460,000
Slides: 8,000,000
SPECIAL COLLECTIONS
Hiram Bingham—Machu Picchu, Peru (photographs)
Robert F Griggs—Mt Katmai, Alaska (photographs)
Peary Files (photographs)
Herbert G Ponting—Antarctic (photographs)
Joseph F Rock—China (photographs)
George Shiras 3rd—Wildlife (photographs)
SKYLAB (photographs)
Space Collection (photographs)
Bradford Washburn—Yukon (photographs)

VR 137
NATIONAL PORTRAIT GALLERY
Smithsonian Institution, Catalog of American Portraits
F St at Eighth, Washington, DC 20560
Tel: 202-381-5861
Keeper, Catalog of American Portraits: Mona L Dearborn
Staff: 3
Founded: 1966
Hours: By appointment

COLLECTIONS
Photographs: 30,000. Sculpture (US); Painting (Tribal
 American, US)

VR 138
NATIONAL TRUST FOR HISTORIC
PRESERVATION
Audiovisual Department
740 Jackson Place NW, Washington, DC 20006
Tel: 202-638-5200
Iconographer: Cathie Wardell
Hours: Mon-Fri 9-5

CIRCULATION POLICY
Audio/video tapes: Public, fee service (appointment
 suggested)
Films: Public, fee service (appointment suggested)
Photographs: Public, fee service (appointment suggested)
Slide Lectures: Public, fee service (appointment suggested)
Slides: Public, fee service (appointment suggested)
COLLECTIONS
Films: 25. Architecture (US)
Photographs: 8,000. Architecture (US)
Slide Lectures: 15. Architecture (US)
Slides: 18,000. Architecture (US); Decorative Arts (US)
Video: 35. Architecture (US)
SERVICES
Negatives: Prints available for purchase
Slides: Available for duplication

VR 138A
OFFICE OF FINE ARTS & HISTORIC
PRESERVATION (GSA)
19 & E Sts NW, Washington, DC 20405
Tel: 202-343-8667
Counselor to the Administrator for Fine Arts & Historic
 Preservation: Karel Yasko
Hours: Mon-Fri 8-4:30 (by appointment)

CIRCULATION POLICY
(by appointment)
COLLECTIONS
Photographs
Transparencies

VR 138B
THE PHILLIPS COLLECTION
1600-1612 21 St NW, Washington, DC 20009
Tel: 202-387-2151; 2152
Asst Curator: William de Looper
Hours: Tues-Sat 2-7
 Tues-Fri 10-5 (researchers by appointment)

CIRCULATION POLICY
(researchers by appointment)
COLLECTIONS
Photographs
Reproductions

VR 138C
RENWICK GALLERY
Smithsonian Institution
1661 Pennsylvania Ave NW, Washington, DC 20560
Tel: 202-381-5811
Dir: Lloyd E Herman
Hours: Mon-Fri 10-5:30 (by appointment)

CIRCULATION POLICY
(by appointment)
COLLECTIONS
Photographs
Slides

VR 139
TRINITY COLLEGE LIBRARY
Michigan Ave & Franklin St NE, Washington, DC 20017
Tel: 202-269-2252
Libn: Sister Dorothy Beach
Founded: 1897
Hours: School Term:
 Mon-Thurs 9-11
 Fri 9-5
 Sat 10-5
 Sun 1-11

CIRCULATION POLICY
Microforms: 4,000
Slides: 10,000 National Gallery of Art. Architecture
(Ancient, European, US); Sculpture (Ancient, European, US); Painting (European, US)
SUBSCRIPTIONS
Carnegie Set (slides)

VR 140
WHITE HOUSE HISTORICAL ASSOCIATION
5026 New Executive Office Bldg, Washington, DC 20506
Tel: 202-737-8292
Executive Dir: Hillory A Tolson
Hours: Mon-Fri 8:30-4
COLLECTIONS
Photographs
Slides
Transparencies

Florida

VR 141
CUMMER GALLERY OF ART
829 Riverside, Jacksonville, FL 32204
Tel: 904-356-6857
Dir: R W Scwageter
Founded: 1958
Hours: Tues-Fri 10-5
 Sat 12-5
 Sun 2-5

CIRCULATION POLICY
Photographs: Public (appointment required)
Slides: Public (appointment required)
COLLECTIONS
Photographs: 1,000 alphabetical. Painting (European, US); Decorative Arts (European)
Slides: 2,000 alphabetical. Decorative Arts (US)
SERVICES
Negatives: Prints available for publication subject to copyright and gallery regulations and fees
Slides: Available for purchase of gallery collection

VR 142
FLORIDA GULF COAST ART CENTER
222 Ponce de Leon Blvd, Clearwater, FL 33528
Tel: 813-584-8634
Libn: Marion Davis
Founded: 1948
Hours: Mon-Sat 10-4
 Sun 3-5

CIRCULATION POLICY
Photographs: Members, students, researchers, faculty/staff, circulating
Prints: Members, students, faculty/staff, circulating
Slides: Members, students, researchers, faculty/staff, circulating (appointment suggested)
COLLECTIONS
Prints: 75 Frick. Architecture (European); Painting (European, US)
Slides: 200 Frick. Painting (European, US)

VR 143
FLORIDA INTERNATIONAL UNIVERSITY
Fine Arts Department
Tamiami Trail, Miami, FL 33199
Tel: 305-552-2895
Asst Prof Art History: Sandra L Langer
Founded: 1970
Hours: By appointment

CIRCULATION POLICY
Photographs: Students, researchers, faculty/staff (appointment suggested)
Slides: Restricted, students, researchers, faculty/staff (appointment suggested)
COLLECTIONS
Films: 1
Microforms: 10
Photographs
Slides: 25,000. Architecture (US); Sculpture (Far East, European, US); Painting (Far East, European, US); Decorative Arts (Far East)
Video: 20

VR 144
FLORIDA STATE UNIVERSITY
Fine Arts, Slide Library
FAB #223, Tallahassee, FL 32384
Tel: 404-644-3436
Libn: Deberah Ryan
Hours: Mon-Fri 8-4

CIRCULATION POLICY
Slides: Restricted, graduate students, faculty/staff
COLLECTIONS
Slides: 60,000

VR 145
FLORIDA TECHNOLOGICAL UNIVERSITY*
Library, Slide Library
Box 25000, Orlando, FL 32816
Tel: 305-275-2574

VR 146
CONNI GORDON, INC—TV DIVISION
530 Lincoln Rd, Miami Beach, FL 33139
Tel: 305-532-1001
Dir: Conni Gordon
Staff: 3
Founded: 1950
Hours: Mon-Fri 10-5

CIRCULATION POLICY
Video: Restricted
COLLECTIONS
Video: 26
SPECIAL COLLECTION

Public Broadcasting Service Art Instruction Tapes
 (video) by Conni Gordon

VR 147
JACKSONVILLE ART MUSEUM
Duval County School Art Department Visual Education
 Center
4160 Blvd Center Dr, Jacksonville, FL 32207
Tel: 904-398-8043
Libn: Julia Schlegel
Founded: 1967
Hours: Mon-Fri 9-5

CIRCULATION POLICY
Filmstrips: Restricted, county area teachers, circulating
Reproduction & art collection: Restricted, county area
 teachers, circulating
Slides: Restricted, county area teachers, circulating
SPECIAL COLLECTION
Nellie Gannon Memorial Collection of Ceramics

VR 148
JACKSONVILLE PUBLIC LIBRARY
Art & Music Department
122 N Ocean St, Jacksonville, FL 32202
Tel: 904-633-3748
Chief, Art & Music Dept: Jeff Driggers
Staff: 4
Founded: 1965
Hours: Mon-Fri 9-9
 Sat 9-6

CIRCULATION POLICY
Films: Public
Photographs: Public
Prints (framed): Public
Slides: Public
COLLECTIONS
Films: 1,821
Microforms: 200
Photographs: 3,000
Prints (framed): 950
Slides: 5,853

VR 149
LOWE ART MUSEUM, UNIVERSITY OF MIAMI
1301 Miller Drive, Coral Gables, FL 33146
Tel: 305-284-3536
Founded: 1952
Hours: Mon-Fri 12-5
 Sat 10-5
 Sun 12-5

CIRCULATION POLICY
Photographs: Restricted
Slides: Restricted
COLLECTIONS
Photographs
Slides: Architecture (Ancient, Far East, Tribal American,
 Meso-American, European, US); Scultpure (Ancient,
 Meso-American, European, US); Painting (Ancient);
 Graphic Arts (Ancient); Decorative Arts (Ancient, Far
 East, African)

VR 150
MUSEUM OF FINE ARTS OF ST PETERSBURG, FLORIDA, INC
255 Beach Dr N, St Petersburg, FL 33701
Tel: 813-896-2667
Dir: Lee Malone
Founded: 1961
Hours: Tues-Fri 10-5

CIRCULATION POLICY
Films: Restricted, public
Slides: Restricted, public (appointment suggested)
Video: Restricted, public
COLLECTIONS
Films: 6. Painting (European, US); Decorative Arts
 (Andean)
Slides: 4,500. Architecture (Ancient, European); Sculpture
 (Ancient, Islamic, Far East, Andean, European, US);
 Painting (Ancient, European, US); Graphic Arts
 (European, US)
Video: 24

VR 151
NORTH FLORIDA JUNIOR COLLEGE
Jennyethel Merritt Resource Center
Turner Davis Dr, Madison, FL 32340
Tel: 904-973-2288, Ext 31
Dir: Sheila Hicks Hales
Founded: 1966
Hours: Mon-Fri 8-5

CIRCULATION POLICY
Slides: Public, students, researchers, faculty/staff
COLLECTIONS
Films: 5. Sculpture (US)
Slides: 1,533. Architecture (US); Sculpture (US); Painting
 (European)

VR 152
RINGLING MUSEUM OF ART
Education Department
Box 1838, Sarasota, FL 33578
Tel: 813-355-5101, Ext 30
Founded: 1946
Hours: Mon-Fri 8:30-5

CIRCULATION POLICY
Slides: Restricted, faculty/staff
COLLECTIONS
Slides: 12,000. Painting (European)

VR 153
RINGLING SCHOOL OF ART LIBRARY
1191 27 St, Sarasota, FL 33580
Tel: 813-351-1437
Head Libn: Elsie H Straight
Staff: 3
Founded: 1932
Hours: Mon-Fri 8:45-9

CIRCULATION POLICY
Prints: Restricted (appointment suggested)
Slides: Restricted, public, circulating (appointment
 suggested)
COLLECTIONS
Prints: 50. Painting (Ancient); Decorative Arts (Ancient)

Slides: 8,000. Architecture (Ancient, European, US); Sculpture (Ancient, Far East, Tribal American, European, US); Painting (Ancient, European, US); Graphic Arts (European, US); Decorative Arts (Ancient, European, US)
SUBSCRIPTIONS
Courtauld Institute Photograph Survey of Private Collections (photographs)
SPECIAL COLLECTION
Graphic Arts, Advertising, Illustration, etc (slides)

VR 154
SANTA FE COMMUNITY COLLEGE
Learning Resource Center
3000 NW 83 St, Gainesville, FL 32602
Tel: 904-377-5161
Dean: Dr Robert Meyer

CIRCULATION POLICY
Films: Student, faculty/staff (appointment suggested)
COLLECTIONS
Films: 10
Photographs: 90
Prints: 30
Slides: 7,000. Painting (European)

VR 155
TAMPA PUBLIC LIBRARY*
Fine Arts Department
900 N Ashley, Tampa, FL 33602
Tel: 813-233-8864
Fine Arts Libn: Robert Barnes

VR 156
UNIVERSITY OF FLORIDA*
College of Architecture & Fine Arts, Audio-Visual Collection
Gainesville, FL 32601
Tel: 904-392-0205
Founded: ca 1952

VR 158
UNIVERSITY OF SOUTH FLORIDA
Learning Resource Center
Art Department, Tampa, FL 33620
Tel: 813-974-2360, Ext 05
Learning Resource Specialist: Linda McRae Walther
Founded: 1963
Hours: Mon-Fri 8-5 (office)

CIRCULATION POLICY
Slides: Public
COLLECTIONS
Slides: 40,000 Yale. Architecture (Ancient, Far East, European, US); Sculpture (Ancient, Far East, European, US); Painting (Ancient, Far East, European, US); Graphic Arts (Far East, European, US)
SPECIAL COLLECTION
Graphicstudio Collection (slides)
SERVICES
Slides: Available for purchase or duplication subject to copyright restrictions

VR 159
VIZCAYA MUSEUM
Vizcaya Guides Library
3251 S Miami Ave, Miami, FL 33129

Tel: 305-579-2808
Library Chairman: Alice Miller
Volunteers: 5
Founded: 1954

CIRCULATION POLICY
Photographs: Guides (appointment suggested)
Slides: Guides (appointment suggested)
COLLECTIONS
Photographs: Architecture (European, US); Decorative Arts (European, US)
Slides: 7,000. Architecture (European, US); Decorative Arts (European, US)
SERVICES
Slides: Available for sale through the museum office of objects in the museum

Georgia

VR 160
ATLANTA COLLEGE OF ART LIBRARY
1280 Peachtree St, Atlanta, GA 30309
Tel: 404-892-3600, Ext 212
Audio-Visual Collections Curator: Sarah Daniels
Hours: Mon-Fri 9-5 (office)

CIRCULATION POLICY
Slides: Faculty/staff
Video: Faculty/staff
COLLECTIONS
Slides: 28,000 Chicago. Architecture (Ancient, Meso-American, European, US); Sculpture (Ancient, Islamic, Tribal American, European, US); Painting (Ancient, Far East, European, US); Graphic Arts (European, US); Decorative Arts (Islamic, European, US); Contemporary Arts (European, US)

VR 161
DEKALB LIBRARY SYSTEM
Maud M Burrows Library Fine Arts Department
215 Sycamore St, Decatur, GA 30032
Tel: 404-378-7569
Fine Arts Libn: Virginia J Engelland
Founded: 1925

CIRCULATION POLICY
Framed Reproductions: Public, circulating
COLLECTIONS
Framed Reproductions: 600

VR 162
EMORY UNIVERSITY*
Dept of the History of Art, Slide Library
Atlanta, GA 30322
Tel: 404-329-6555
Founded: 1965

VR 163
GEORGIA INSTITUTE OF TECHNOLOGY
College of Architecture Library
225 North Ave NW, Atlanta, GA 30332
Tel: 404-894-4877
Libn: Frances K Drew
Founded: 1885
Hours: Mon-Fri 8-5

CIRCULATION POLICY
Slides: Restricted, faculty/staff (appointment suggested)
COLLECTIONS
Slides: 38,544 Santa Cruz. Architecture (Ancient, Far East, Meso-American, European, US, Canada); Sculpture (US); Painting (Ancient, Far East, Meso-American, European, US); Decorative Arts (Ancient, Islamic, Far East, African, European, US)
SPECIAL COLLECTION
Faculty collections duplicated by library (slides)
SERVICES
Slides: Available for duplication

VR 164
GEORGIA STATE UNIVERSITY
GSU Art Department Library & Harris Reading Room
Arts & Music Bldg, Rm 265, University Plaza,
 Atlanta, GA 30303
Tel: 404-658-2973
Curator: Temme B Balser
Staff: 4
Founded: ca 1970
Hours: Mon-Fri 8-5

CIRCULATION POLICY
Slides: Public, circulating (appointment suggested)
COLLECTIONS
Slides: 80,000 Minnesota. Architecture (Ancient, Islamic, Far East, African, Pacific, Tribal American, Meso-American, Andean, European, US); Sculpture (Ancient, Islamic, Far East, African, Pacific, Tribal American, Meso-American, Andean, European, US); Painting (Ancient, Islamic, Far East, African, Pacific, Tribal American, Meso-American, Andean, European, US); Graphic Arts (European, US); Decorative Arts (African, Tribal American, European, US)
SERVICES
Slides: Available for duplication subject to copyright restrictions

VR 165
TELFAIR ACADEMY OF ARTS & SCIENCES, INC
Box 10081, Savannah, GA 31402
Tel: 912-232-1177
Person in Charge: Glenda H Nahoon
Staff: 5
Hours: Mon-Fri 10-4:30

CIRCULATION POLICY
Slides: Restricted
COLLECTIONS
Slides: 1,500 Fogg. Painting (European, US); Decorative Arts (US)
SERVICES
Slides: Available for duplication subject to academy and copyright regulations and fees

VR 166
UNIVERSITY OF GEORGIA
Dept of Art, Media Center, Slide Room
Athens, GA 30602
Tel: 404-542-1511, Ext 43
Senior Slide Libn: Marty Mincey
Staff: 1
Founded: 1951
Hours: Mon-Fri 8-5 (office)

CIRCULATION POLICY
Slides: Faculty/staff
COLLECTIONS
Slides: 150,000 New York University. Architecture (Ancient, Far East, European, US); Sculpture (Ancient, Far East, African, Pacific, Tribal American, Meso-American, Andean, European, US); Painting (Ancient, Far East, African, Pacific, Tribal American, Meso-American, Andean, European, US); Graphic Arts (Far East, European, US); Decorative Arts (Ancient, Far East, African, Pacific, Tribal American, Meso-American, Andean, European, US)
SUBSCRIPTIONS
Carnegie Set (slides)
SPECIAL COLLECTION
Rinhart Collection of Early American Photography, 1829-1880 (slides)

VR 167
UNIVERSITY OF GEORGIA
Library, Rare Books & Special Collections Area, & Manuscript Divisions
Athens, GA 30602
Tel: 404-542-2716
Rare Books & Special Collections Libn: Richard B Harwell
Ms Libn: A R Dees
Hours: Mon-Thurs 8-12
 Fri-Sat 8-6
 Sun 2-12

CIRCULATION POLICY
Photographs: Students
SPECIAL COLLECTIONS
American Negro Life Glass Negatives 1890 (glass negatives)
Telamon Cuyler Collection (glass negatives, paper negatives, photographs) from 1885-1935
The Stafford Harris Collection (Daguerreotypes)
The Heckman Collection (Daguerreotypes)
Lewis Hine Photographic Study of Child Labor in Georgia 1909-1913 (photographs)
Jones Family Daguerreotypes from the C C Jones, Joseph Jones, and Thomas Jones Collections (Daguerreotypes)
The North American Indian by Edward S Curtis (photogravures)
Old Closes and Streets, Glasgow 1868-1899
Photographic Views of Sherman's Campaign by George N Barnard
Savannah and Vicinity Stereograph Album (stereographs)
Street Life in London by James Thomson
The William E Wilson Photographic Archive of Savannah, Georgia, ca 1888 (glass negatives, prints)

Hawaii

VR 168
BISHOP MUSEUM
Photo Collection
Box 6037, Honolulu, HI 96818
Tel: 808-847-3511, Ext 182
Photo Libn: Lynn Davis
Staff: 1
Founded: 1890
Hours: Tues-Thurs 1-4

CIRCULATION POLICY
Photographs: Public
Slides: Public
COLLECTIONS
Photographs: 250,000 Santa Cruz. Architecture (Pacific);
 Sculpture (Pacific)
Slides: 5,000. Architecture (Pacific); Sculpture (Pacific)
SERVICES
Negatives: Prints available for reference and personal
 use only, other uses permission required. Material
 includes historic Hawaii and the Pacific and museum
 collections.

VR 169
HONOLULU ACADEMY OF ARTS
Audio-Visual Center
900 S Beretania St, Honolulu, HI 96814
Tel: 808-538-3693, Ext 52
Keeper: Brone Jameikis
Staff: 1
Founded: 1962
Hours: Tues-Fri 1-4
 Sat 8-12

CIRCULATION POLICY
Films: Restricted, researchers, faculty/staff, circulating
Filmstrips: Restricted, students, researchers, faculty/staff,
 circulating
Slide Cassettes: Restricted, students, researchers, faculty/
 staff, circulating
Slides: Restricted, students, researchers, faculty/staff,
 circulating
COLLECTIONS
Films: 105
Filmstrips: 8
Slide Cassettes: 49
Slides: 35,000 University of Michigan. Architecture
 (Ancient, Far East, European, US); Sculpture (Ancient,
 Far East, African, European, US); Painting (Ancient,
 Far East, Pacific, European, US); Graphic Arts (Far
 East, European, US); Decorative Arts (Ancient, Far
 East, Pacific, Tribal American, European, US)
Video: 2
SUBSCRIPTIONS
American Committee of South Asian Art (slides)
Carnegie Set (slides)
SERVICES
Negatives: Limited selection of prints available for pur-
 chase in Academy Shop
Slides: Available for sale in Academy Shop; available for
 duplication subject to copyright restrictions

VR 170
HONOLULU ACADEMY OF ARTS
Robert Allerton Library
900 S Beretania St, Honolulu, HI 96814
Tel: 808-538-3693, Ext 35
Libn: Anne T Seaman
Staff: 1½
Founded: 1927
Hours: Tues-Fri 10-4
 Sat 10-3

CIRCULATION POLICY
Photographs: Restricted, students, researchers, faculty/
 staff (appointment suggested)

Slides: Restricted, students, researchers, faculty/staff
 (appointment suggested)
COLLECTIONS
Photographs: 6,000. Sculpture (Far East); Painting (Far
 East)); Decorative Arts (Far East)
Slides: 2,000 University of Michigan. Sculpture (Far East);
 Painting (Far East); Decorative Arts (Far East)
SUBSCRIPTIONS
Chinese National Palace Museum Photo Archives
 (photographs, slides)

VR 171
UNIVERSITY OF HAWAII*
Art Department, Slide Library
2560 Campus Rd, George Hall, Rm 131, Honolulu,
 HI 96822
Tel: 808-948-8251

VR 172
UNIVERSITY OF HAWAII*
Dept of Architecture
Honolulu, HI 96822
Tel: 808-948-7225

VR 173
UNIVERSITY OF HAWAII—MANOA
Art Department, Slide Library
Art Bldg, Honolulu, HI 96822
Tel: 808-948-8364
Slide Curator: Jean Jackson
Founded: ca 1945

CIRCULATION POLICY
Slides: Restricted, faculty/staff (appointment suggested)
COLLECTIONS
Photographs: 7,500
Reproductions: 500. Painting (European)
Slides: 100,000. Architecture (Ancient, Far East, African,
 Pacific, Tribal American, European, US); Sculpture
 (Ancient, Far East, African, Pacific, Tribal American,
 European, US); Painting (Ancient, Far East, African,
 Pacific, Tribal American, European, US); Graphic Arts
 (Far East, African, Pacific, Tribal American, European,
 US); Decorative Arts (Ancient, Far East, African,
 Pacific, Tribal American, European, US)
SUBSCRIPTIONS
Carnegie Set (photographs)
Chinese National Palace Museum Photographic Archives
 (photographs)
SPECIAL COLLECTIONS
Indian (Asian) Art (slides)

Illinois

VR 174
ART INSTITUTE OF CHICAGO
Ryerson Slide Department
Michigan Ave at Adams, Chicago, IL 60603
Tel: 312-443-3672
Head of Ryerson Slide Dept:Rosann M Auchstetter
Staff: 1
Founded: ca 1904
Hours: Mon-Fri 10:30-4 (office)

CIRCULATION POLICY
Slides: Restricted, students (with faculty permission), faculty/staff, circulating
COLLECTIONS
Lantern Slides: 33,800 Art Institute of Chicago
Slides: 150,000 Art Institute of Chicago. Architecture (Meso-American, European, US); Sculpture (European, US); Painting (European, US); Graphic Arts (European, US); Decorative Arts (Meso-American, European, US)
SPECIAL COLLECTIONS
Art Institute of Chicago Exhibits (slides)
Frank Lloyd Wright & Prairie School (slides)

VR 175
CHICAGO PUBLIC LIBRARY*
Audio-Visual Section
78 E Washington St, Fourth Floor, Chicago, IL 60602
Tel: 312-269-2900
A-V Libn: Mike Morrison
Staff: 4

CIRCULATION POLICY
Slides: Public, circulating
COLLECTIONS
Slides: 10,000 (unclassified)

VR 176
CHICAGO PUBLIC LIBRARY
Fine Arts Department
78 E Washington St, Chicago, IL 60602
Tel: 312-269-2858
Asst to Chief, Fine Arts Div: Nancy E Harvey

COLLECTIONS
Clippings/mounted plates: 1,000,000

VR 177
CHICAGO PUBLIC LIBRARY CULTURAL CENTER
Audio-Visual Center
78 E Washington St, Chicago, IL 60602
Tel: 312-269-2910
Head, A-V Center: Diane M Purtill
Staff: 3
Hours: Mon-Thurs 9-9
 Fri 9-6
 Sat 9-5
 Mon-Fri 9-5 (office)

CIRCULATION POLICY
Films: Circulating
Slides: Public, circulating
COLLECTIONS
Films: 1,975
Slides: 18,815. Architecture (Ancient, European, US); Sculpture (Ancient, US); Painting (European, US)

VR 178
COLLEGE OF DUPAGE*
Learning Resources Center
Glen Ellyn, IL 60137
Tel: 312-858-2800

VR 179
RICHARD J DALEY COLLEGE
Learning Resources Center, Audio-Visual Services
7500 S Pulaski Rd, Chicago, IL 60652

Tel: 312-735-3000, Ext 227
Chairperson, LRC: Marilyn Mayer
Founded: 1961
Hours: Mon-Fri 8-10

CIRCULATION POLICY
Film: Students, faculty/staff
Filmstrips: Students, faculty/staff
Slides: Students, faculty/staff
COLLECTIONS
Films: 450. Architecture (European)
Microforms: 2,000
Slides: 20,000. Architecture (Ancient, Islamic, Meso-American, Europeon, US); Sculpture (Ancient, European, US); Painting (Ancient, European, US); Decorative Arts (Far East, Pacific)

VR 180
ELMHURST COLLEGE*
A C Buehler Memorial Library, Special Collections
Elmhurst, IL 60126
Tel: 312-279-4100
Asst Libn: Carol Barry
Founded: 1967

COLLECTIONS
Slides: 10,000

VR 181
EVANSTON PUBLIC LIBRARY
Art, Music & Film Department
1703 Orrington, Evanston, IL 60201
Tel: 312-475-6700, Exts 58; 59
Person in Charge: Linda Seckelson-Simpson
Founded: 1893 (library)
Hours: Mon-Fri 9-9
 Sat 9-6
 Sun 1-5 (Sept-May)
 Mon-Fri 9-5 (office)

CIRCULATION POLICY
Art Reproductions: Public, fee service, circulating
Films: Restricted, fee service
Slides: Public, circulating
COLLECTIONS
Art Reproductions: 195 (accession number)
Films: 330 (accession number)
Slides: 3,500

VR 182
GOVERNORS STATE UNIVERSITY
Learning Resources Center
Park Forest S, IL 60466
Tel: 312-534-5000, Ext 2326
Person in Charge: Donna Barber
Founded: 1971
Hours: Mon-Fri 8:30-9:30
 Sat 8:30-4

COLLECTIONS
Slides: 15,000 Santa Cruz

VR 183
ILLINOIS STATE MUSEUM
Decorative Art Department, Fine Arts Department
Spring & Edwards Sts, Springfield, IL 62706
Tel: 217-782-7125

Person in Charge: Betty Madden (Decorative Arts)
 Robert Evans (Fine Arts)
Founded: 1928
Hours: Mon-Fri 8:30-5

CIRCULATION POLICY
Photographs: Restricted
Slides: Restricted
COLLECTIONS
Films: 4,200
Photographs: Painting (Illinois); Decorative Arts (Illinois)
Slides: 3,558. Painting (Illinois); Decorative Arts (Illinois)
SPECIAL COLLECTIONS
Illinois Arts and Crafts
SERVICES
Negatives: Prints available for purchase of museum
 collection subject to copyright and museum regulations
Slides: Available for purchase

VR 184
ILLINOIS STATE UNIVERSITY*
Art Department, Slide Library
Normal, IL 61761
Tel: 309-436-6127
Slide Libn: Young S Chung

VR 185
MORAINE VALLEY COMMUNITY COLLEGE
Learning Resources Center
10900 S 88 Ave, Palos Hills, IL 60465
Tel: 312-974-4300, Exts 220; 221
Asst Dean: Vicky R Smith
Staff: 4½
Founded: 1968
Hours: Mon-Thurs 7:30-9:30
 Fri 7:30-5

CIRCULATION POLICY
Slides: Students, faculty/staff, circulating
COLLECTIONS
Films: 250 LC. Architecture (European); Sculpture (Euro-
 pean); Painting (European)
Microforms: 8,000 LC
Models: 10 LC
Slide Sets: 600 titles, LC
Slides: 8,500 Santa Cruz. Architecture (Ancient, Euro-
 pean); Sculpture (Ancient, European, US); Painting
 (European, US); Graphic Arts (European, US);
 Decorative Arts (African)
SUBSCRIPTIONS
University Prints (prints)

VR 186
MUSEUM OF CONTEMPORARY ART
Education Department, Library, Slide Library
237 E Ontario St, Chicago, IL 60611
Tel: 312-943-7755
Dir of Education: Philip Yenawine
Staff: 1
Founded: 1967
Hours: Mon-Fri 10-5

CIRCULATION POLICY
Slides: Restricted, faculty/staff (appointment suggested)
COLLECTIONS
Slides: 3,000. Sculpture (US-20th Century); Painting (US-
 20th Century); Graphic Arts (US-20th Century)

SPECIAL COLLECTIONS
Museum Exhibitions (slides)

VR 187
NEWBERRY LIBRARY*
Wing Collection & Ayer Collection
60 W Walton St, Chicago, IL 60610
Tel: 312-943-9090

VR 188
NORTHEASTERN ILLINOIS UNIVERSITY*
Slide Library
Bryn Mawr at Saint Louis Ave, Chicago, IL 60625
Tel: 312-583-4050

VR 189
NORTHERN ILLINOIS UNIVERSITY
Art Department, Slide Library
DeKalb, IL 60115
Tel: 815-753-0293
Slide Libn: Alice T Holcomb
Founded: 1965
Hours: Mon-Fri 7:30-5 (office)

CIRCULATION POLICY
Slides: Restricted, researchers, faculty/staff (appointment
 suggested)
COLLECTIONS
Slides: 125,000. Architecture (Ancient, Islamic, Far East,
 African, Tribal American, Meso-American, European,
 US, Canadian); Sculpture (Ancient, Far East, African,
 Meso-American, European, US); Painting (Ancient,
 European, US); Graphic Arts (European, US);
 Decorative Arts (Ancient, Islamic, Far East, African,
 European, US)
SUBSCRIPTIONS
Asian Art Photographic Distribution (slides)
Carnegie Set (slides)

VR 190
NORTHWESTERN UNIVERSITY
Art History Department, Slide & Photography Library
1859 Sheridan Rd, Evanston, IL 60201
Tel: 312-492-3230
Curator: Frances Freiwald
Hours: Mon-Fri 8:30-12, 1-5 (office)

CIRCULATION POLICY
Photographs: Restricted, faculty/staff
Slides: Restricted, faculty/staff
COLLECTIONS
Photographs: 40,000 Fogg. Architecture (Ancient, Islamic,
 Far East, African, Pacific, Tribal American, Meso-
 American, European, US); Sculpture (Ancient, Far
 East, African, Pacific, Tribal American, Meso-
 American, European, US); Painting (Ancient, Far East,
 African, Pacific, Tribal American, European, US);
 Decorative Arts (Far East, US)
Slides: 110,000 Fogg. Architecture (Ancient, Islamic, Far
 East, African, Pacific, Tribal American, Meso-American,
 European, US); Sculpture (Ancient, Far East, African,
 Pacific, Tribal American, Meso-American, European,
 US); Painting (Ancient, Far East, African, Pacific,
 Tribal American, European, US); Graphic Arts (Euro-
 pean); Decorative Arts (Ancient, Far East, African,
 Tribal American, European, US)

SUBSCRIPTIONS
American Committee of South Asian Art (slides)
Wayne Andrews (photographs)
Carnegie Set (slides)
Chinese National Palace Museum Photo Archives (slides)
Gernsheim Collection (slides)
University Colour Slide Scheme (slides)
SPECIAL COLLECTIONS
Walter Burley Griffin architectural plans drawn by Marion
 Mahoney Griffin (architectural plans)
Rosenthal Architecture & Art Negative Collections
 (negatives)

VR 191
HELEN PLUM MEMORIAL LIBRARY
110 W Maple, Lombard, IL 60126
Tel: 312-627-0316
Dir: Charles C Herrick
Founded: 1927
Hours: Mon-Fri 9-9
 Sat 9-5

CIRCULATION POLICY
Art Reproductions: Public, circulating
Film Loops: Public, circulating
Filmstrips: Public, circulating
Slides: Public, circulating
COLLECTIONS
Art Reproductions: 92
Film Loops: 16
Filmstrips: 25
Slides: 1,1625

VR 192
THE POLISH MUSEUM OF AMERICA
984 N Milwaukee Ave, Chicago, IL 60622
Tel: 312-384-3352
Dir: Rev Donald Bilinski, OFM
Founded: 1937

CIRCULATION POLICY
Photographs: Restricted (appointment suggested)
Slides: Restricted (appointment suggested)
SERVICES
Negatives: Prints available for purchase

VR 193
PUBLIC ART WORKSHOP
Mural Resource Center
5623 W Madison, Chicago, IL 60644
Tel: 312-626-1713
Dir: Barbara Russum
Staff: 1
Founded: 1972
Hours: Mon-Fri 10-6

CIRCULATION POLICY
Slides: Students, researchers, faculty/staff (appointment
 required)
COLLECTIONS
Slides: 2,000 (in-house). Painting (murals) (Mexico,
 European, US); Decorative Arts (Mexico, European,
 US)
SUBSCRIPTIONS
Environmental Communications (slides)
Rosenthal Art Slides (slides)

VR 194
QUINCY COLLEGE
Art Department
1831 College Ave, Quincy, IL 62301
Tel: 217-222-8020
Person in Charge: Rev Tom Brown
Hours: Mon-Fri 9-5 (office)

CIRCULATION POLICY
Photographs: Restricted, students (for special projects),
 faculty/staff
Slides: Restricted, students (for special projects),
 faculty/staff
COLLECTIONS
Photographs: 5,000 (by course)
Slides: 30,000 (by course). Architecture (Ancient, Islamic,
 Far East, Meso-American, Andean, European, US);
 Sculpture (Ancient, Far East, African, US); Painting
 (Ancient, Meso-American, European, US); Graphic Arts
 (US)

VR 195
ROCKFORD COLLEGE
Howard Coleman Library
5050 E State St, Rockford, IL 61101
Tel: 815-226-4036
Person in Charge: Joan B Surrey

CIRCULATION POLICY
Slides: Public, fee service, circulating
COLLECTIONS
Microforms: 1,411
Slides: 8,585. Painting (European, US)

VR 196
ROCKFORD PUBLIC LIBRARY
Children's & Arts, Music, Literature Divisions
215 N Wyman St, Rockford, IL 61101
Tel: 815-965-6731

CIRCULATION POLICY
Films: Public, fee service, circulating (advance booking
 required)
Filmstrips: Public, circulating
Photographs: Public, circulating
Reproductions: Public, circulating
Slides: Public, circulating
COLLECTIONS
Art Reproductions & Posters: 1,004 (accession number)
Films: 155 (accession number)
Microforms: 6,667 Title
Photographs: 29,450
Slides: 15,288 (accession number)

VR 197
ROCKFORD PUBLIC LIBRARY/NORTHERN
 ILLINOIS LIBRARY SYSTEM
Audiovisual Division
215 N Wyman, Rockford, IL 61101
Tel: 815-965-6731, Ext 47
Head, AV: Ray Reinholtzen
Staff: 1
Founded: 1902

CIRCULATION POLICY
Audiovisual Collections: Restricted, public, fee service

COLLECTIONS
Art Reproductions: 1,500 (accession number)
Films: 2,100 (accession number)
Filmstrips: 2,200 (accession number)
Sculpture: 238 (accession number)
Slides & Stereo slides: 770 (accession number)

VR 198
ROOSEVELT UNIVERSITY
Art Department, Slide Collection
430 S Michigan Ave, Chicago, IL 60605
Tel: 312-341-3673
Person in Charge: Susan Weininger
Staff: 1
Founded: 1946

CIRCULATION POLICY
Slides: Restricted, researchers, faculty/staff
COLLECTIONS
Films: 24. Sculpture (Tribal American, European, US);
 Painting (Ancient)
Slides: 30,000 Santa Cruz. Architecture (Ancient, Far
 East, European, US); Sculpture (Ancient, Far East,
 African, Pacific, Tribal American, Meso-American,
 Andean, European, US); Painting (Ancient, Far East,
 European, US); Graphic Arts (Ancient, Far East,
 European, US); Decorative Arts (Ancient)

VR 199
SANGAMON STATE UNIVERSITY*
Library, Instructional Services
Springfield, IL 62703
Tel: 217-786-6600
Instructional Services Libn: Marcia L Dworak

VR 200
SOUTHERN ILLINOIS UNIVERSITY AT
EDWARDSVILLE
Dept of Art & Design, Slide Library
Box 64, SIU, Edwardsville, IL 62026
Tel: 618-692-3184
Slide Libn/Graduate Student: E Allie Evans
Founded: 1966

CIRCULATION POLICY
Photographs: Students, researchers, faculty/staff
Slides: Students, researchers, faculty/staff
COLLECTIONS
Photographs: n.a.
Slides: 39,000 University of Georgia. Architecture
 (Ancient, African, Pacific, Tribal American, Meso-
 American, Andean, European, US); Sculpture (Ancient,
 African, Pacific, Tribal American, Meso-American,
 Andean, European, US); Painting (Ancient, European,
 US); Graphic Arts (European, US); Decorative Arts
 (Ancient, African, Pacific, Tribal American, Meso-
 American, Andean, European, US)

VR 201
TRITON COLLEGE
Learning Resource Center
2000 Fifth Ave, River Grove, IL 60171
Tel: 312-456-0300
Coordinator of Lib Service: Mary L Lowrey
Staff: 5
Founded: 1964

Hours: Mon-Thurs 8-10
 Fri 8-5

CIRCULATION POLICY
Films: Public
Microforms: Public
Slides: Public, partially circulating
Video: Public
COLLECTIONS
Films: 1,316 LC
Filmstrips: 1,902 LC
Microforms: 3,570 LC
Photographs: 200 LC
Slides: 170 slide sets LC
Video: 580 LC

VR 202
UNIVERSITY OF CHICAGO*
Dept of Art, Epstein Archive
1050 E 59 St, Chicago, IL 60637
Tel: 312-753-2887

VR 203
UNIVERSITY OF CHICAGO*
Dept of Art, History of Art, Slide Library
401 Goodspeed Hall, Chicago, IL 60637
Tel: 312-753-1234

VR 204
UNIVERSITY OF ILLINOIS AT CHICAGO CIRCLE
Architecture & Art Resources Center/College of
 Architecture, Art & Urban Sciences
Box 4348, Chicago, IL 60680
Tel: 312-996-4469
Dir: Virginia Kerr
Founded: 1965/1976
Hours: Mon-Fri 8:30-5 (office)

CIRCULATION POLICY
Photographs: Faculty/staff
Slides: Faculty/staff
COLLECTIONS
Photographs: 4,500. Architecture (European, US)
Slides: 184,000. Architecture (Ancient, Far East, Euro-
 pean, US); Sculpture (Ancient, Far East, European,
 US); Painting (Far East, European, US); Graphic Arts
 (European, US); Decorative Arts (Far East)
SUBSCRIPTIONS
Wayne Andrews (photographs, slides)
James Austin (photographs)
Carnegie Set (slides)
SPECIAL COLLECTIONS
Julius & John Rosenthal Collection (glass & film negative
 file)

VR 205
UNIVERSITY OF ILLINOIS AT URBANA—
CHAMPAIGN
Slide Library
210B Architecture Bldg, Champaign, IL 61820
Tel: 217-333-3292
Slide Curator: Jane A Goldberg
Hours: Mon-Fri 9-5

CIRCULATION POLICY
Films: Restricted, students with permission, researchers
 with permission, faculty/staff

Photographs: Restricted, students with permission, researchers with permission, faculty/staff
Slides: Restricted, students with permission, researchers with permission, faculty/staff
COLLECTIONS
Films: 11 (uncataloged). Decorative Arts (US)
Photographs: 800 (uncataloged). Painting (Far East); Graphic Arts (Far East); Decorative Arts (Far East)
Slides: 150,000 Dewey/Metropolitan. Architecture (Ancient, US); Sculpture (Ancient, Far East, African, Pacific, European, US); Painting (Ancient, Far East, African, European, US); Graphic Arts (Ancient, Far East, African, European, US); Decorative Arts (Ancient, Far East, African, Pacific, Tribal American, European, US)
SUBSCRIPTIONS
Asian Art Photographic Distribution (photographs, slides)
Carnegie Set (slides)
University Colour Slide Scheme (slides)
SERVICES
Slides: Restricted duplication permitted with permission

VR 206
UKRAINIAN NATIONAL MUSEUM
2453 W Chicago Ave, Chicago, IL 60622
Tel: 312-AR 6-6565
Person in Charge: Dr R Weres
Staff: 3
Founded: 1954
Hours: Mon-Fri 10-2 (office)

CIRCULATION POLICY
Photographs: Researchers (appointment required)
Slides: Restricted, researchers (appointment required)
SPECIAL COLLECTIONS
Ukranian Memorabilia in Illinois as well as other parts of the United States
SERVICES
Slides: Available for duplication

VR 207
WESTERN ILLINOIS UNIVERSITY*
Art Department, Slide Library
900 W Adams, Macomb, IL 61455
Tel: 309-298-1675
Slide Curator: Julia Hainline

Indiana

VR 208
BALL STATE UNIVERSITY*
Art Department, Slide Library
Muncie, IN 47306
Tel: 317-289-1241

VR 209
BALL STATE UNIVERSITY
College of Architecture & Planning Library
Architecture Bldg, Muncie, IN 47306
Tel: 317-285-4776
Libn: Marjorie H Joyner
Staff: 1
Founded: 1965
Hours: Mon-Fri 8-5

CIRCULATION POLICY
Slides: Students, faculty/staff, circulating
COLLECTIONS
Slides: 40,000 Santa Cruz. Architecture (Ancient, Meso-American, European, US)

VR 210
EARLHAM COLLEGE
Lilly Library, Slide Room
Richmond, IN 47374
Tel: 317-962-6561, Ext 314
Slide Curator: Nancy McDowell
Hours: Mon-Fri 9-12

CIRCULATION POLICY
Slides: Restricted
COLLECTIONS
Slides: 25,000
SUBSCRIPTIONS
Carnegie Set (slides)
SPECIAL COLLECTIONS
Japanese Architecture, Painting, Sculpture (slides)

VR 211
EVANSVILLE MUSEUM OF ARTS & SCIENCE
Henry B Walker Jr Memorial Art Library
411 SE Riverside Dr, Evansville, IN 47713
Tel: 812-425-2406
Research Curator: Mrs George F Martin
Founded: 1904
Hours: Tues-Fri 10-5

CIRCULATION POLICY
Slides: Public (non-circulating)
COLLECTIONS
Photographs: Architecture (US); Sculpture (European, US); Painting (European, US); Graphic Arts (European, US); Decorative Arts (European, US)
Slides: Architecture (US); Sculpture (European, US); Painting (European, US); Graphic Arts (European, US); Decorative Arts (European, US)
SERVICES
Negatives: Prints available for purchase subject to copyright and museum regulations and fees of museum objects
Slides: Available for duplication subject to copyright and museum regulations

VR 212
FORT WAYNE ART INSTITUTE, MUSEUM OF ART LIBRARY*
1202 W Wayne St, Fort Wayne, IN 46804

VR 213
HERRON SCHOOL OF ART, IUPUI
Herron School of Art Library, IUPUI
1701 N Pennsylvania St, Indianapolis, IN 46202
Tel: 317-923-3651, Ext 32
Libn: Maudine B Williams
Staff: 1
Founded: 1970
Hours: Mon, Tues, Thurs 8-7
 Wed 8-9
 Fri 8-5

CIRCULATION POLICY
Reproductions: Public, circulating
Slides: Restricted, faculty/staff

COLLECTIONS
Slides: 40,000. Architecture (US); Sculpture (European, US); Painting (European, US)
SUBSCRIPTIONS
Chinese National Palace Museum Photo Archives (slides)
Museum of the American Indian (slides)
SERVICES
Slides: Available for purchase and duplication subject to copyright regulations

VR 214
INDIANA CENTRAL UNIVERSITY*
Art Department
1400 E Hanna Ave, Indianapolis, IN 46227
Tel: 317-788-3368
Chairman of Fine Arts: Gerald G Boyce

COLLECTIONS
Slides: 10,000

VR 215
INDIANA STATE UNIVERSITY*
Cunningham Memorial Library, Teaching Materials Center
Terre Haute, IN 47809
Tel: 812-232-6311
Founded: 1950

VR 216
INDIANA UNIVERSITY
Fine Arts, Slide Library
Fine Arts #415, Bloomington, IN 47401
Tel: 812-337-6717
Slide Libn: Eileen Fry
Founded: ca 1935
Hours: Mon-Fri 8-5

CIRCULATION POLICY
Photographs: Restricted, students, faculty/staff
Slides: Restricted, students, researchers, faculty/staff, circulating with permission (appointment suggested)
COLLECTIONS
Photographs: 50,000 Metropolitan
Slides: 200,000 Metropolitan. Architecture (Ancient, Far East, African, Pacific, Tribal American, Meso-American, European); Sculpture (Ancient, Far East, African, Pacific, Tribal American, Meso-American, European); Painting (Far East, African, Pacific, Tribal American, Meso-American, European, US); Graphic Arts (Far East, African, Pacific, Tribal American, European, US); Decorative Arts (Ancient, Far East, African, Pacific, Tribal American, Meso-American, European)
SUBSCRIPTIONS
American Committee of South Asian Art (slides)
American Crafts Council (slides)
Wayne Andrews (photographs)
Asian Art Photographic Distribution (slides)
Carnegie Set (slides)
Chinese National Palace Museum Photo Archives (photographs)
Decimal Index of the Art of Low Countries (photographs)
Eliosofon Photographs (photographs)
University Colour Slide Scheme (slides)
SPECIAL COLLECTIONS
Burton Y Berry Ancient Jewelry Collection (slides)
Evolution of the Buddha Image (slides)
Indiana University Oakleaf Collection (lantern slides)

VR 217
INDIANA UNIVERSITY AT SOUTH BEND*
Dept of Fine Arts, Slide Collection
1825 Northside Blvd, South Bend, IN 46615
Tel: 219-237-4278

VR 218
INDIANAPOLIS MUSEUM OF ART*
Education Division, Slide Collection
1200 W 38 St, Indianapolis, IN 46208
Tel: 317-923-1331, Ext 35
Asst Curator: Carolyn Metz
Founded: ca 1920

VR 219
UNIVERSITY OF NOTRE DAME
Architecture Library
Notre Dame, IN 46556
Tel: 219-283-6654
Dir: G Decker

CIRCULATION POLICY
Slides: Restricted, graduate students, faculty/staff, circulating
COLLECTIONS
Slides: Architecture (Ancient, European, US)
SERVICES
Slide duplication permitted of material not covered by copyright

VR 220
UNIVERSITY OF NOTRE DAME
Dept of Art, Slide Library
O'Shaughnessy Hall, Rm 125, Notre Dame, IN 46556
Tel: 219-283-7452
Curator: Betty Dodge
Founded: 1950
Hours: Mon-Fri 9-12
 Mon-Fri 9-12, 1-5 (office)

CIRCULATION POLICY
Slides: Restricted, students, researchers, faculty/staff, circulating
COLLECTIONS
Photographs: 2,000
Slides: 47,325. Architecture (Ancient, European, US); Sculpture (Ancient, African, Meso-American, European, US); Graphic Arts (European, US)
SPECIAL COLLECTIONS
Ambrosiana Library of Milan (microfilm, negatives, slides)

VR 221
LOUIS A WARREN LINCOLN LIBRARY & MUSEUM
1300 S Clinton St, Fort Wayne, IN 46802
Tel: 219-424-5421, Ext 7916
Dir: Mark E Neeny, Jr
Founded: 1928
Hours: Mon-Thurs 8-4:30
 Fri 8-12:30

CIRCULATION POLICY
Photographs: Public
Prints: Public
COLLECTIONS
Photographs: 500

Prints: 6,000. Graphic Arts (US)
SPECIAL COLLECTIONS
Lincoln and Lincoln-related collection (photographs, portraits, prints)

Iowa

VR 222
DAVENPORT MUNICIPAL ART GALLERY
1737 W 12, Davenport, IA 52804
Tel: 319-326-7804, Ext 9
Dir of Education: A Vance
Founded: 1925

CIRCULATION POLICY
Photographs: Faculty/staff
Slides: Faculty/staff
COLLECTIONS
Films: 4
Photographs: n.a.
Slides: 4,933. Architecture (Ancient, European, US);
 Sculpture (Ancient, European, US); Painting
 (European, US)
SUBSCRIPTIONS
Carnegie Set (slides)
SPECIAL COLLECTIONS
Haitian Primitives Sculpture and Paintings (slides)
SERVICES
Slides: Available for duplication subject to gallery and
 copyright regulations

VR 223
GRINNELL COLLEGE
Art Department, Slide Room
Grinnell, IA 50112
Tel: 515-236-6181, Ext 318
Chairman Dept of Art: William Wolf
Staff: 1 (part-time)
Founded: 1930
Hours: By arrangement

CIRCULATION POLICY
Slides: Restricted, students on approval, researchers on
 approval, faculty/staff (appointment suggested)
COLLECTIONS
Slides: 29,000. Architecture (Ancient, European, US);
 Sculpture (Ancient, European, US); Painting (Ancient,
 Far East, European, US); Decorative Arts (Ancient,
 African, European, US)
SUBSCRIPTIONS
Carnegie Set (slides)

VR 224
IOWA STATE UNIVERSITY*
Dept of Architecture
Ames, IA 50010
Tel: 515-294-4718

VR 225
CHARLES H MACNIDER MUSEUM
303 Second St SE, Mason City, IA 50401
Tel: 515-423-9563
Dir: Richard E Leet
Staff: 5
Founded: 1966

CIRCULATION POLICY
Slides: Restricted, faculty/staff
COLLECTIONS
Slides

VR 226
MUSCATINE ART CENTER
1314 Mulberry Ave, Muscatine, IA 52761
Tel: 319-263-8282
Dir: Clifford Larson
Staff: 2
Founded: 1965

COLLECTIONS
Photographs: (new collection)
Slide: (new collection)
SPECIAL COLLECTIONS
American Antique Furniture & Decorative Arts (slides)
Antique and Modern Glass Paperweights (slides)
Historic Views of Muscatine (glass negatives)

VR 227
SANFORD MUSEUM & PLANETARIUM
117 E Willow, Cherokee, IA 51012
Tel: 712-225-3922
Dir: Robert Wilson Hoge
Staff: 1
Founded: 1951
Hours: Mon-Fri 9-5
 Sat-Sun 2-5

CIRCULATION POLICY
Photographs: Restricted (appointment suggested)
Slides: Restricted, researchers (appointment suggested)
COLLECTIONS
Films: 4
Photographs: Architecture (Tribal American); Painting
 (Tribal American); Decorative Arts (Tribal American)
Slides: 3500. Architecture (Ancient, African, Tribal
 American, European); Painting (Tribal American);
 Decorative Arts (African, Tribal American, US)
SPECIAL COLLECTIONS
Museum exhibitions (photographs, slides)
SERVICES
Slides: Restricted duplication permitted, permission
 required

VR 228
UNIVERSITY OF IOWA
Visual Materials
School of Art & Art History, Iowa City, IA 52241
Tel: 319-353-4113
Curator of Visual Materials: Carolyn Milligan
Hours: Mon-Fri 8-5 (office)

CIRCULATION POLICY
Photographs: Restricted, graduate students, faculty/staff
Slides: Restricted, graduate students, faculty/staff, fee
 service, circulating
COLLECTIONS
Lantern Slides: 40,000
Photographs: 170,000. Architecture (Ancient, European);
 Sculpture (Ancient, Far East, European); Painting
 (Ancient, Far East, European); Graphic Arts (Ancient,
 Far East, European); Decorative Arts (Ancient, Far
 East)
Slides: 170,000. Architecture (Ancient, Islamic, Far East,

Meso-American, Andean, European, US); Sculpture
(Ancient, Far East, African, Pacific, Tribal American,
Meso-American, Andean, European, US); Painting
(Ancient, Islamic, Far East, European, US); Graphic
Arts (Ancient, Far East, African, Pacific, Tribal
American, Meso-American, Andean, European, US);
Decorative Arts (Ancient, Islamic, Far East, African,
Pacific, Tribal American, Meso-American, Andean,
European, US)
SUBSCRIPTIONS
Alinari (photographs)
Asian Art Photographic Distribution (microfiche)
Bartsch Catalog and Prints (photographs)
Chinese National Palace Museum Photo Archives
(microfilm, photographs, slides)
Courtauld Archives (photographs)
Decimal Index of the Art of Low Countries (photographs)
University Colour Slide Scheme (slides)

VR 229
UNIVERSITY OF NORTHERN IOWA
Art & Music Room
Cedar Falls, IA 50613
Tel: 319-273-6252
Person in Charge: Verna Ford Ritchie

CIRCULATION POLICY
Art Reproductions: (new collection)
Slides: (new collection)
COLLECTIONS
Art Reproductions: 900
Slides: 7,000

Kansas

VR 230
COLBY COMMUNITY COLLEGE
H F Davis Memorial Library
Colby, KS 67701
Tel: 913-462-3984, Ext 255
Media Libn: Donna Jones
Hours: Mon-Thurs 7:30-9
 Fri 7:30-4
 Sun 9-12

CIRCULATION POLICY
Art Reproductions: Public
Slides: Public
COLLECTIONS
Art Reproductions
Slides

VR 231
CULTURAL HERITAGE & ARTS CENTER
Box 1275, 1000 Second Ave, Dodge City, KS 67801
Tel: 316-227-2823
Dir: Jane R Robison
Founded: 1967
Hours: Mon-Fri 8-5

CIRCULATION POLICY
Films: Public, fee service
Photographs: Public, fee service (appointment suggested)
Slides: Public, fee service (appointment suggested)
COLLECTIONS
Films

Kits
Microforms
Models
Slides: Painting (US); Graphic Arts (US); Decorative
Arts (US)
Video

VR 232
KANSAS STATE UNIVERSITY*
Dept of Art, College of Arts & Sciences, Slide Library
Manhattan, KS 66502
Tel: 913-532-6011
Founded: 1964

VR 233
TOPEKA PUBLIC LIBRARY
Division of Fine Arts
1515 W Tenth St, Topeka, KS 66604
Tel: 913-233-2040, Exts 37; 31
Head, Div of Fine Arts: Robert H Daw
Staff: 1
Hours: Mon-Fri 9-9
 Sat 9-6
 Sun 2-6

CIRCULATION POLICY
Films: Public
Slides: Public, circulating
COLLECTIONS
Films: 200. Architecture (Far East); Sculpture (US);
 Painting (European); Decorative Arts (European)
Slides: 4,500. Architecture (European, US); Sculpture
 (African, Tribal American); Painting (US); Decorative
 Arts (European, US)

VR 234
UNIVERSITY OF KANSAS
Kress Foundation Department of Art History
Helen F Spencer Museum of Art, Lawrence, KS 66045
Tel: 913-864-4713
Slide Curator: Mary Traylor Troup
Founded: ca 1950
Hours: Mon-Fri 9-4 (office)

CIRCULATION POLICY
Photographs: Restricted, students, researchers, faculty/staff
 (appointment suggested)
Slides: Restricted, student projects, researchers,
 faculty/staff (appointment suggested)
COLLECTIONS
Photographs: 42,000 University of Michigan. Architecture
 (Ancient, Far East, European, US); Sculpture (Ancient,
 Far East, European, US); Painting (Ancient, Far East,
 European, US); Graphic Arts (Far East, European,
 US); Decorative Arts (Far East, European, US)
Slides: 150,000 University of Michigan. Architecture
 (Ancient, Far East, African, European, US); Sculpture
 (Ancient, Far East, African, European, US); Painting
 (Ancient, Far East, African, European, US); Graphic
 Arts (Ancient, Far East, European, US); Decorative
 Arts (Ancient, Far East, European, US)
SUBSCRIPTIONS
Asian Art Photographic Distribution (photographs, slides)
Carnegie Set (slides)
Chinese National Palace Museum Photo Archives
 (photographs, slides)
Decimal Index of the Art of Low Countries (photographs)

VR 235
UNIVERSITY OF KANSAS*
School of Architecture & Urban Design
Lawrence, KS 66044
Tel: 913-864-4281

VR 236
WICHITA ART MUSEUM
Education Department
619 Stackman Dr, Wichita, KS 67203
Tel: 316-264-0324
Curator of Education: Novelene Ross
Hours: Mon-Fri 9-5

CIRCULATION POLICY
Slides: Restricted, faculty/staff
COLLECTIONS
Slides: 4,500 Fogg. Architecture (European, US);
 Sculpture (European, US); Painting (European, US);
 Graphic Arts (US)
SERVICES
Negatives: Prints available for purchase; permission to
 reproduce required
Slides: Selected works from the Roland P Murdock
 Collection available for purchase from the Museum
 Shop
Transparencies: Available for rental

VR 237
WICHITA STATE UNIVERSITY
Art History Department, Slide Library
1845 N Fairmount, Wichita, KS 67208
Tel: 316-684-3654
Slide Curator: Pamela E Mallory
Hours: Mon-Fri 9-1 (office)

CIRCULATION POLICY
Slides: Restricted, graduate students, art faculty/staff
 (appointment suggested)
COLLECTIONS
Slides: Columbia. Architecture (Ancient, European, US);
 Sculpture (Ancient, European, US); Painting (Ancient,
 European, US); Graphic Arts (European, US);
 Decorative Arts (European, US)
SUBSCRIPTIONS
Art Now (slides)
Carnegie Set (slides)
Kaidib (slides)
Saskia (slides)
SERVICES
Slides: Available for duplication subject to copyright
 restrictions

Kentucky

VR 238
ASBURY COLLEGE*
Morrison-Kenyon Library, Slide Collection
Wilmore, KY 40390
Tel: 606-858-3511

VR 239
LOUISVILLE FREE PUBLIC LIBRARY
Audio-Visual Department
Fourth & York Sts, Louisville, KY 40203

Tel: 502-583-1864; 584-4154, Ext 28
Libn: Dorothy L Day
Founded: 1949
Hours: Mon-Fri 9-6
 Sat 9-5

CIRCULATION POLICY
Slides: Public, circulating
COLLECTIONS
Films: 3,000. Architecture (Ancient, Far East, African,
 European, US); Sculpture (European, US); Painting
 (Ancient, Far East, European, US)
Slide Sets: 100. Sculpture (Ancient, Far East, European,
 US); Painting (European, US)

VR 240
J B SPEED ART MUSEUM
2035 S Third St, Louisville, KY 40208
Tel: 502-636-2893
Person in Charge: Inez M Pryor
Hours: Tues-Fri 10-4

CIRCULATION POLICY
Slides: Public (appointment suggested)
COLLECTIONS
Slides: Metropolitan. Architecture (Ancient, Islamic, Far
 East, African, European, US); Sculpture (Ancient);
 Painting (Islamic, Far East, African, Pacific, Tribal
 American, European, US); Decorative Arts (Islamic,
 Far East, European, US)
SERVICES
Negatives: Prints available for purchase
Slides: Available for purchase of museum collection

VR 241
UNIVERSITY OF KENTUCKY
College of Architecture, Audiovisual Department
Pence Hall, Lexington, KY 40506
Tel: 606-257-2610
Curator, Jerry Rozenberg
Staff: 1
Hours: Mon-Fri 8-5

CIRCULATION POLICY
Audio: Students, researchers, faculty/staff
Film: Students, researchers, faculty/staff
Slides: Students, researchers, faculty/staff
Video: Students, researchers, faculty/staff
COLLECTIONS
Slides: 60,000. Architecture (Ancient, Far East, Euro-
 pean, US); Painting (Ancient, Far East, European, US)
SERVICES
Slides: Non-copyrighted slides available for duplication

VR 242
UNIVERSITY OF LOUISVILLE
Fine Arts Department, Slide Collection
Rm 209 Humanities Bldg, Belknap Campus, Louisville,
 KY 40208
Tel: 502-588-5917
Curator of Slides: Ann S Coates
Staff: 1
Founded: ca 1940
Hours: Mon-Fri 8:30-4:30 (office)

CIRCULATION POLICY
Slides: Public, circulating (appointment suggested)

COLLECTIONS
Lantern Slides: 17,000 University of Louisville.
Slides: 150,000 University of Louisville. Architecture
 (Ancient, European, US); Sculpture (Ancient, Euro-
 pean, US); Painting (European, US)
SUBSCRIPTIONS
Wayne Andrews (slides)
Carnegie Set (slides)
Gernsheim Collection (slides)
SPECIAL COLLECTIONS
Architecture of Louisville (slides)
University of Louisville Photographic Archives (slides)
SERVICES
Slides: Available for duplication subject to copyright
 restrictions

VR 243
UNIVERSITY OF LOUISVILLE
Photographic Archives
Louisville, KY 40208
Tel: 502-588-6752
Curator: James C Anderson
Staff: 1
Founded: 1967
Hours: Mon-Fri 8:30-12, 1-5

CIRCULATION POLICY
Photographs: Public
COLLECTIONS
Photographs: 600,000 (partially cataloged) Graphic Arts
 (US)
SPECIAL COLLECTIONS
University of Louisville Photographic Archives
 (catalogs, ephemera, equipment, letters, manuscripts,
 photographs)
Antique Media
Lou Block Collection
Will Bowers Collection
Theodore M Brown/Robert J Doherty Collection
Caulfield and Shook Collection
Vida Hunt Francis Collection
Georgetown (Bradley) Collection
Mary D Hill Collection
Jean Thomas ("The Traipsin' Woman") Collection
Kugelman Collection
Clarence John Laughlin Collection
Macaulen Collection
Kate Matthews Collection
Metropolitan Sewer District Collection
R G Potter Collection
J C Rieger Collection
Standard Oil of New Jersey Collection
Roy Emerson Stryker Collection
SERVICES
Slides: Available for sale of any photographic item in
 collection subject to copyright and university regulations

Louisiana

VR 244
CONTEMPORARY ARTS CENTER
Artists Resource Center of the Contemporary Arts Center
900 Camp St, New Orleans, LA 70130
Tel: 504-523-1216
Dir: Don Marshall

Staff: 1
Founded: 1977
Hours: Tues-Sat 10-5

CIRCULATION POLICY
Music: Public
Photographs: Public
Slides: Public
Video: Public
COLLECTIONS
(Under development)

VR 245
GRAMBLING STATE UNIVERSITY
Microprint
Box 3, Grambling, LA 71245
Tel: 318-247-6941, Ext 220
Media Libn: Lucy Melvin
Hours: Mon-Thurs 7-10
 Fri 8-5
 Sat 8-3
 Sun 6-10

CIRCULATION POLICY
Cassettes: Public
Filmstrips: Public
Microforms: Public, fee service
COLLECTIONS
Cassettes: 279 Dewey
Films: 1 Dewey
Filmstrips: n.a.
Microforms: 106,268 Dewey

VR 246
THE HISTORIC NEW ORLEANS COLLECTION
Curatorial Department
533 Royal St, New Orleans, LA 70130
Tel: 504-523-7146
Person in Charge: Mrs Ralph Platou
Staff: 6
Founded: 1966
Hours: Tues-Sat 10-5

CIRCULATION POLICY
Films: Public
Microforms: Public
Models: Public
Photographs: Public
Slides: Public
Video: Public
COLLECTIONS
Films: 15
Photographs: Architecture (US); Sculpture (US);
 Painting (US); Graphic Arts (US); Decorative Arts
 (US)
SPECIAL COLLECTIONS
L V Huber Collection of New Orleans & Louisiana
 History (photographs, prints)
Waud Collection of Drawings of New Orleans Views,
 1866 and 1871 (drawings) produced to illustrate
 Harper's Weekly of the same years
SERVICES
Negatives: Prints available for purchase subject to
 copyright and collection regulations and fees
Slides: Available for purchase or duplication subject to
 copyright and collection regulations and fees

VR 247
LOUISIANA POLYTECHNIC INSTITUTE*
Dept of Art & Architecture, Slide Collection
Ruston, LA 71270
Tel: 318-257-0211

VR 248
LOUISIANA STATE UNIVERSITY
Dept of Architecture Slide Collection
105 Hill Memorial Bldg, Baton Rouge, LA 70803
Tel: 504-388-2821
Prof of Architecture: R W Heck
Founded: 1958

CIRCULATION POLICY
Slides: Restricted, faculty/staff
COLLECTIONS
Slides: 19,000. Architecture (Ancient, Far East, European,
US)

VR 249
LOUISIANA STATE UNIVERSITY
School of Environmental Design, Slide Room
210 Foster Hall, Baton Rouge, LA 70803
Tel: 504-388-5402
Slide Curator: Willemina Minster
Founded: 1963
Hours: Mon-Fri 7:30-4:00

CIRCULATION POLICY
Slides: Restricted
COLLECTIONS
Slides: 46,000. Architecture (Ancient, Islamic, African,
Meso-American, Andean, European, US); Sculpture
(Ancient, Meso-American, Andean, European, US);
Painting (Ancient, Meso-American, European, US);
Graphic Arts (European, US); Decorative Arts
(Ancient, European, US)

VR 249A
LOYOLA UNIVERSITY
Media Center
6363 Saint Charles Ave, New Orleans, LA 70118
Tel: 504-865-2549
Director: Dr Bobs M Tusa
Founded: 1976
Hours: Mon-Fri 8:30-4:30 (office)

CIRCULATION POLICY
Audio Cassettes: Faculty/staff, circulating
Audio Tapes: Faculty/staff, circulating
Films: Faculty/staff, circulating
Filmstrips: Faculty/staff, circulating
Photographs: Faculty/staff, circulating
Slides: Faculty/staff, circulating
Transparencies: Faculty/staff
COLLECTIONS
Films: 45 AECT
Photographs: 50 AECT
Slides: 5,000 AECT. Architecture (Ancient, Islamic,
European, US); Sculpture (Ancient, European, US);
Painting (Ancient, European, US); Graphic Arts
(Ancient, European, US)
Video: 10 AECT

VR 250
NEW ORLEANS PUBLIC LIBBRARY
Art, Music & Recreation Division
219 Loyola Ave, New Orleans, LA 70140
Tel: 504-586-4938
Head: Marlyn Wilkins
Hours: Mon-Fri 9-9
 Sat 9-5

CIRCULATION POLICY
Films: Public, circulating
Pictures: Public, circulating
Prints: Public, circulating

VR 251
NEWCOMB COLLEGE OF TULANE UNIVERSITY
Art Department, Slide Library
Tulane University, New Orleans, LA 70118
Tel: 504-865-4631
Slide Libn: Susan Fox
Founded: ca 1940
Hours: Mon-Fri 9-5 (office)

CIRCULATION POLICY
Slides: Restricted, students, faculty/staff, circulating
COLLECTIONS
Slides: 66,500. Architecture (Meso-American, US);
Sculpture (Meso-American); Painting (European, US);
Decorative Arts (Meso-American, European, US)
SUBSCRIPTIONS
Carnegie Set (housed in Humanities-Fine Arts Div)
SPECIAL COLLECTIONS
Art & Architecture of Louisiana
Decorative Arts of Louisiana

VR 252
SOUTHERN UNIVERSITY
Art & Architecture Branch Library
Southern Branch PO, Baton Rouge, LA 70813
Tel: 504-771-3290
Libn: Doris W Graham
Founded: 1971

CIRCULATION POLICY
Slides: Public, circulating
COLLECTIONS
Slides: 9,924 LC. Architecture (Ancient, European, US);
Sculpture (US); Painting (European, US); Graphic
Arts (US); Decorative Arts (US)
SUBSCRIPTIONS
Carnegie Set (slides)
SPECIAL COLLECTIONS
Southern University Riverbend Collection of works by
black artists (slides)
SERVICES
Slides: The Riverbend Collection is available for duplica-
tion subject to copyright and university regulations and
fees

VR 253
SOUTHERN UNIVERSITY LIBRARY
3050 Cooper Rd, Shreveport, LA 71107
Tel: 318-424-6552, Ext 238
Head Libn: Thelma Patterson
Founded: 1967

CIRCULATION POLICY
Paintings: Faculty/staff, circulating
SPECIAL COLLECTIONS
African Collection (artifacts)
Fine Art Picture Collections (framed paintings)

VR 254
TULANE UNIVERSITY
School of Architecture, Slide Library
Richardson Memorial Bldg, New Orleans, LA 70118
Tel: 504-865-6472, Ext 21
Slide Libn: Celia Maddox
Founded: 1945
Hours: Mon-Fri 8:30-5

CIRCULATION POLICY
Slides: Restricted, students, faculty/staff, limited circulation
(appointment suggested)
COLLECTIONS
Films: 15. Architecture (Ancient, US)
Slides: 24,000. Architecture (Ancient, Far East, Meso-American, Andean, European, US); Sculpture (Ancient, Meso-American, Andean, European, US); Painting (Ancient, European, US); Graphic Arts (US); Decorative Arts (Ancient, European, US)
Tapes: 20
SPECIAL COLLECTIONS
Abraham Guillen Collection of Pre-Columbian Art and Architecture (slides)
Richard Koch Collection of World Architecture (slides)

Maine

VR 256
BATH MARINE MUSEUM
963 Washington St, Bath, ME 04530
Tel: 207-443-6311
Asst Curator: Marion S Lilly
Founded: 1964
Hours: By appointment

CIRCULATION POLICY
Slides: Students, researchers, faculty/staff (appointment suggested)
COLLECTIONS
Photographs: 4,500. Painting (European, US)
Slides: 1,000. Painting (European, US)
SPECIAL COLLECTIONS
Bath Marine Museum Collection (photographs)
SERVICES
Negatives: Prints available for purchase, permission required for publication
Slides: Available for duplication subject to copyright regulations

VR 257
BOWDOIN COLLEGE
Art Department Library
Visual Art Center, Brunswick, ME 04011
Tel: 207-725-8731, Ext 695
Libn: Susan D Simpson
Founded: 1930s

CIRCULATION POLICY
Photographs: Public, circulating

Slides: Restricted, researchers, faculty/staff (appointment suggested)
COLLECTIONS
Lantern Slides: 30,000
Photographs: 150,000. Architecture (Ancient, European); Sculpture (Ancient, European); Painting (Ancient, European, US); Graphic Arts (Ancient, European, US); Decorative Arts (Ancient, European, US)
Slides: 24,000. Architecture (Ancient, European, US); Sculpture (Ancient, Islamic, Far East, European, US); Painting (Ancient, European, US); Graphic Arts (Ancient, European, US); Decorative Arts (Ancient, Islamic, Far East, European, US)
SERVICES
Slides: Available for sale or duplication subject to copyright and library regulations and fees

VR 258
WILLIAM A FARNSWORTH ART MUSEUM LIBRARY
31 Elm St, Rockland, ME 04841
Tel: 207-596-6457
Curator: Sandra L Gordon
Founded: 1948
Hours: Mon-Sat 10-5; Sun 1-5 (June-Sept)
Tues-Sat 10-5; Sun 1-5 (Oct-May)

CIRCULATION POLICY
Photographs: Public, fee service (appointment suggested)
Rare Books: Public on request, students, researchers, faculty/staff (appointment suggested)
Slides: Public, fee service (appointment suggested)
COLLECTIONS
Films: 3
Photographs: 750
Slides: 1,200. Architecture (US); Sculpture (US); Painting (US); Graphic Arts (US); Decorative Arts (European, US)
Video: 12
SPECIAL COLLECTIONS
Illustrated Books by Maine Artists—Andrew Wyeth, N C Wyeth, Rockwell Kent, Waldo Pierce
SERVICES
Negatives: Prints available for purchase and publication subject to permission and fee payment

VR 259
PENOBSCOT MARINE MUSEUM LIBRARY
US #1 & Church St, Searsport, ME 04974
Tel: 207-548-6634
Dir: Richard V Palmer
Founded: 1936
Hours: Mon-Sat 9-5

CIRCULATION POLICY
Photographs: (appointment required)
SPECIAL COLLECTIONS
Ship Photograph Collection

VR 260
PORTLAND SCHOOL OF ART*
Slide Collection
93 High St, Portland, ME 04101
Tel: 207-773-1233

VR 261
THE SHAKER LIBRARY
Sabbathday Lake, Poland Spring, ME 04274
Tel: 207-926-4865
Dir: Dr Theodore E Johnson
Founded: 1882

CIRCULATION POLICY
Photographs: Students, researchers, faculty/staff, fee
service (appointment required)
Slides: Students, researchers, faculty/staff, fee service
(appointment required)
COLLECTIONS
Microfilms: 250
Photographs: 7,000. Architecture (US); Painting (US);
Graphic Arts (US); Decorative Arts (US)
Slides: 5,000. Architecture (US); Painting (US); Graphic
Arts (US); Decorative Arts (US)
SPECIAL COLLECTIONS
Elder Delmer C Wilson Collection (glass plate negatives)
SERVICES
Negatives: Prints available for purchase and publication
pending prior written permission and fee payment
Slides: Available for purchase and duplication subject to
copyright regulations and fee payment

VR 262
UNIVERSITY OF MAINE*
Art Gallery, Carnegie Hall, Slide Library
Orono, ME 04473
Tel: 207-581-1110

Maryland

VR 263
BALTIMORE MUSEUM OF ART
Slide & Photographic Services
Art Museum Dr, Baltimore, MD 21218
Tel: 301-396-6318
Coordinator of Slides & Photographic Services: Nancy B
Press
Founded: 1929
Hours: Mon-Fri 9-5 (office, by appointment)

CIRCULATION POLICY
Photographs: Public, fee service, circulating (appointment
suggested)
Transparencies: Researchers, faculty/staff, fee service,
circulating (appointment suggested)
Slides: Public, fee service, circulating (appointment
suggested)
COLLECTIONS
Photographs: 10,000 (accession number). Sculpture
(African, European, US); Painting (European, US);
Graphic Arts (European, US); Decorative Arts
(European, US)
Slides: 8,000. Architecture (European, US); Sculpture
(African, European, US); Painting (European, US);
Graphic Arts (European, US); Decorative Arts (Euro-
pean, US)
SPECIAL COLLECTION
Baltimore Museum of Art (photographs, slides)
SERVICES
Negatives: Prints available for purchase subject to copy-
right and museum regulations
Slides: Available for purchase of museum collections

Transparencies: Available for publication use subject to
copyright and museum regulations

VR 264
CATONSVILLE COMMUNITY COLLEGE*
Audiovisual Department, Library
Catonsville, MD 21228
Tel: 301-455-6050

VR 265
ENOCH PRATT FREE LIBRARY*
Art Department
400 Cathedral St, Baltimore, MD 21201
Tel: 301-396-5430

VR 266
GOUCHER COLLEGE
Art Office
Dulaney Valley Rd, Towson, MD 21204
Tel: 301-825-3300, Ext 367
Art Asst: Dorothy Cartlidge Campbell
Hours: Mon-Fri 8:45-5 (office)

CIRCULATION POLICY
Films: Restricted
Photographs: Students, faculty/staff, circulating
(restricted)
Slides: Students, faculty/staff, circulating (restricted)
COLLECTIONS
Films: 75
Photographs: 26,600 Fogg. Architecture (European, US);
Sculpture (Ancient, European, US); Painting (European,
US); Graphic Arts (European, US); Decorative Arts
(European, US)
Slides: 48,500 Fogg. Architecture (Ancient, Far East,
European, US); Sculpture (Ancient, European, US);
Painting (European, US); Graphic Arts (European, US);
Decorative Arts (Ancient, Far East, Meso-American,
European, US)
SUBSCRIPTIONS
Alinari (photographs)
Wayne Andrews (photographs)
Carnegie Set (slides)
SPECIAL COLLECTIONS
Dance history (slides)
Technique-painting, sculpture, graphics, drawing, minor
arts (slides)
Theater history and technique (slides)

VR 267
THE JOHNS HOPKINS UNIVERSITY
Dept of the History of Art
Baltimore, MD 21218
Tel: 301-338-7122
Curator: Ajota Gold

CIRCULATION POLICY
Slides: Restricted
COLLECTIONS
Slides

VR 268
LOYOLA-NOTRE DAME LIBRARY
Audio-Visual Center
200 Winston Ave, Baltimore, MD 21212
Tel: 301-532-8787
Audio-Visual Specialist: Barry Pierce

Founded: 1973
Hours: Mon-Fri 9:30-10
 Fri 8:30-5:30
 Sat 9-5:30
 Sun 12-10

CIRCULATION POLICY
Slides: Public
COLLECTIONS
Slides: 7,000 Santa Cruz. Architecture (Ancient, Meso-American, European, US); Sculpture (Ancient, Far East, European, US); Painting (Far East, European, US); Graphic Arts (European); Decorative Arts (Far East, Meso-American)

VR 269
MARYLAND COLLEGE OF ART & DESIGN
Stites Library
10500 Georgia Ave, Silver Springs, MD 20902
Tel: 301-649-4454
Libn: Kathy Kelly
Founded: 1955
Hours: Mon-Fri 9:30-4

CIRCULATION POLICY
Slides: (appointment suggested)
COLLECTIONS
Slides: 1,000. Sculpture (European, US); Painting (European, US); Graphic Arts (European, US)

VR 270
MARYLAND INSTITUTE, COLLEGE OF ART
The Decker Library, Slide Library
1400 Cathedral St, Baltimore, MD 21201
Tel: 301-669-9200, Ext 45
Slide Libn: Pamela A Potter
Founded: 1961
Hours: Mon-Fri 8:30-4:30

CIRCULATION POLICY
Slides: Students, researchers, faculty/staff
COLLECTIONS
Lantern Slides: 8,000
Slides: 68,000. Architecture (Ancient, European, US); Sculpture (Ancient, European, US); Painting (Far East, European, US); Graphic Arts (European, US); Decorative Arts (Ancient, European, US)
SUBSCRIPTIONS
Carnegie Set (slides)
University Colour Slide Scheme (slides)

VR 271
GEORGE WALTER VINCENT SMITH ART MUSEUM
Curatorial Files
222 State St, Springfield, MD 01103
Tel: 413-733-4214, Ext 2
Registrar: Mary Linda
Staff: 2
Founded: 1976
Hours: By appointment

CIRCULATION POLICY
Photographs: Students, researchers, faculty/staff, fee service (appointment required)
Slides: Students, researchers, faculty/staff, fee service (appointment required)

COLLECTIONS
Photographs: 250. Painting (US); Decorative Arts (Ancient, Far East)
Slides: 150. Painting (US); Decorative Arts (Ancient, Far East)
SERVICE
Negative: Prints available for purchase of museum collection subject to copyright and museum regulations and fees
Slides: Available for purchase subject to copyright and museum regulations and fees

VR 272
UNIVERSITY OF MARYLAND
Art Department, Picture Collection
College Park, MD 20012
Tel: 301-454-3431
Prof: Donald Denny
Founded: 1967
Hours: Appointment suggested

CIRCULATION POLICY
Mounted Reproductions (not yet prepared for circulation)
COLLECTIONS
Mounted Reproductions: 22,000. Architecture (Ancient, European); Sculpture (Ancient, European); Painting (Ancient, European, US)

VR 273
UNIVERSITY OF MARYLAND
Art Department, Slide Library
College Park, MD 20795
Tel: 301-454-3431
Curator of Slides: Mary DeLeiris
Founded: 1965
Hours: Mon-Fri 9-4 (office)

CIRCULATION POLICY
Slides: Restricted, faculty/staff
COLLECTIONS
Slides: 275,000. Architecture (Ancient, Far East, African, Meso-American, Andean, European, US); Sculpture (Ancient, Far East, African, Meso-American, Andean, US); Painting (Ancient, Far East, African, Meso-American, Andean, European, US); Graphic Arts (Far East, European, US); Decorative Arts (Ancient, Far East, African, Meso-American, Andean, European, US)

VR 274
UNIVERSITY OF MARYLAND
School of Architecture, Collection of Slides & Visual Aids
College Park, MD 20742
Tel: 301-454-5422
Curator of Slides & Visual Aids: Elizabeth D Alley
Founded: 1968
Hours: Mon-Fri 8:30-4:30 (office)

CIRCULATION POLICY
Films: Restricted, architecture students, faculty
Slides: Restricted, architecture students, faculty
COLLECTIONS
Films: 24 Princeton. Architecture (European, US)
Slides: 95,000 Princeton. Architecture (Ancient, Islamic, Far East, African, Pacific, Tribal American, Meso-American, Andean, European, US)

VR 275
UNIVERSITY OF MARYLAND, BALTIMORE
 COUNTY, LIBRARY
5401 Wilkins Ave, Baltimore, MD 21228
Tel: 301-455-2232
Libn: Suzanne R Thompson
Founded: 1966

CIRCULATION POLICY
Films: Faculty
Microforms: Public
Photographs: Public (appointment suggested)
Slides: Public
COLLECTIONS
Cameras: 100
Films: 689
Microforms: 77,982
Photographs: 200,000. Architecture (Ancient, European,
 US)
Slides: 36,631 Santa Cruz. Architecture (Ancient, Euro-
 pean, US); Sculpture (Ancient, European, US); Painting
 (Ancient, European, US); Graphic Arts (European, US)
Video: 83
SPECIAL COLLECTIONS
Comic Book Collection
Postcard Collection
Science Fiction Manuscripts
SERVICES
Negatives: Prints available for purchase subject to copy-
 right restrictions
Slides: Available for purchase

Massachusetts

VR 276
THE ARCHITECTS COLLABORATIVE LIBRARY
46 Brattle St, Cambridge, MA 02138
Tel: 617-868-4200, Ext 253
Libn: Anne Hartmere
Founded: 1966
Hours: Mon-Fri 9-5:45 (office)

CIRCULATION POLICY
Slides: Students, researchers, staff (staff circulating only)
COLLECTIONS
Slides: 70,000 (job number). Architecture (Firm's work);
 Graphic Arts (Firm's work)

VR 277
ART INSTITUTE OF BOSTON LIBRARY
700 Beacon St, Boston, MA 02115
Tel: 617-262-1223, Ext 261
Libn: Allyson Edmonston
Hours: Mon-Thurs 9-9
 Fri 9-5

CIRCULATION POLICY
Photographs: Restricted, staff
Slides: Restricted, students (in library), researchers, faculty/
 staff, circulating
COLLECTIONS
Photographs: 5,000
Slides: 10,000 Fogg. Architecture (Ancient, European);
 Sculpture (Ancient, African, European); Painting
 (Ancient, European); Graphic Arts (Ancient)

VR 278
BOSTON ARCHITECTURE CENTER
Slide Library
320 Newbury St, Boston, MA 02115
Tel: 617-536-9018
Slide Libn: Margaret Jay Braatz
Hours: Mon-Thurs 10-10
 Mon-Thurs 2-10 (summer)
 Fri 9-5 (all year)

CIRCULATION POLICY
Slides: Restricted public, students, researchers, faculty/
 staff (appointment suggested)
COLLECTIONS
Lantern Slides: 1,800 Fogg/Santa Cruz
Photographs: (uncataloged)
Slides: 26,000 Santa Cruz/Fogg. Architecture (Ancient,
 Islamic, European, US); Photography (European, US)
SUBSCRIPTIONS
Carnegie Set (slides)
SPECIAL COLLECTIONS
Boston Architecture (slides)

VR 279
BOSTON PUBLIC LIBRARY
Fine Arts Department
Dartmouth St, Copley Sq, Boston, MA 02117
Tel: 617-536-5400, Ext 304
Libn: n.a.
Founded: 1852
Hours: Mon-Fri 9-9
 Sat 9-6

CIRCULATION POLICY
Films: Public, restricted circulation
Photographs: Restricted, public
COLLECTIONS
Films: 400,000 LC
Photographs: 111,000 Metropolitan. Architecture (Ancient,
 Islamic, Far East, African, European, US); Sculpture
 (Ancient, Islamic, Far East, African, European, US);
 Painting (Far East, European, US); Graphic Arts (Euro-
 pean, US); Decorative Arts (Islamic, Far East, African,
 Tribal American, European, US)
SUBSCRIPTIONS
Wayne Andrews (photographs)
SPECIAL COLLECTIONS
Museum of Fine Arts, Boston Photograph Collection
 (photographs)
Photographic Survey of the History of Art (photographs)
Portrait Collection (photographs, prints, reproductions)

VR 280
BOSTON UNIVERSITY
Art History Department, Slide Collection
725 Commonwealth Ave, Boston, MA 02215
Tel: 617-353-2520
Slide Libn: Jeanne E Ouellette
Staff: 1
Hours: Mon-Fri 9-5 (office)

CIRCULATION POLICY
Slides: Restricted, art history students, faculty/staff
COLLECTIONS
Slides: 120,000 Boston Museum of Fine Arts. Architecture
 (Ancient, European, US); Sculpture (Ancient, African,
 European, US); Painting (Ancient, European, US);

Graphic Arts (European); Decorative Arts (Ancient, African, European, US)
SUBSCRIPTIONS
James Austin (slides)
Carnegie Set (slides)
Dunlap Society(microfiche, slides)
University Colour Slide Scheme (slides)
SPECIAL COLLECTIONS
History of American Art (slides)
History of Photography (slides)

VR 281
BRANDEIS UNIVERSITY
Fine Arts Department, Slide Library
415 South Street, Waltham, MA 02154
Tel: 617-647-2556
Slide Libn: Eunice M Cohen
Founded: 1958
Hours: Mon-Fri 9-5 (office)

CIRCULATION POLICY
Photographs: Restricted, seminar students, researchers, faculty/staff (appointment suggested)
Slides: Restricted, seminar students, researchers, faculty/staff (appointment suggested)
COLLECTIONS
Photographs: 10,000. Architecture (Ancient, Far East, European, US); Sculpture (Ancient, Far East, European, US); Painting (Ancient, Far East, European, US); Decorative Arts (Ancient, Far East)
Slides: 80,000 Metropolitan. Architecture (Ancient, Islamic, Far East, African, Meso-American, European, US); Sculpture (Ancient, Islamic, Far East, African, Pacific, Tribal American, Meso-American, Andean, European, US); Painting (Ancient, Islamic, Far East, Meso-American, European, US); Graphic Arts (European, US); Decorative Arts (Ancient, Islamic, Far East, European, US)
SUBSCRIPTIONS
Asian Art Photographic Distribution (slides)
Carnegie Set (slides)

VR 282
BRIDGEWATER STATE COLLEGE*
Clement C Maxwell Library, Audiovisual Department
Shaw Rd, Bridgewater, MA 02324
Tel: 617-697-8321

VR 283
THE BROCKTON ART CENTER LIBRARY
Oak St, Brockton, MA 02401
Tel: 617-588-6000
Education Coordinator: Adrienne Weinberger
Staff: 2
Founded: 1969
Hours: Tues-Fri 1-5

CIRCULATION POLICY
Slides: Researchers, faculty/staff, circulating (appointment suggested)
COLLECTIONS
Slides: 5,000. Sculpture (Ancient, African, European, US); Painting (European, US); Decorative Arts (US)
SERVICES
Slides: Available for purchase

VR 284
STERLING & FRANCINE CLARK ART
INSTITUTE
Photograph & Slide Collection
225 South St, Williamstown, MA 01267
Tel: 413-458-8109
Photograph & Slide Libn: J Dustin Wees
Staff: 2
Founded: 1967
Hours: Mon-Fri 9-5 (office)

CIRCULATION POLICY
Photographs: Students, researchers, faculty/staff
Slides: Students, researchers, faculty/staff
COLLECTIONS
Clippings: 700,000 Metropolitan
Fiche: 1,000
Microfilm: 43
Photographs: 105,000 Metropolitan. Architecture (European); Sculpture (Ancient, European); Paintings (European); Graphic Arts (European); Decorative Arts (European)
Slides: 60,000 Metropolitan. Sculpture (European, US); Painting (European, US); Graphic Arts (European, US); Decorative Arts (US)
SUBSCRIPTIONS
Anderson Archives (photographs)
James Austin (photographs)
Courtauld Institute Illustrated Archives (photographs)
Courtauld Institute Photo Survey of Private Collections (photographs)
Decimal Index of the Art of Low Countries (photographs)
Illustrated Bartsch (photographs)
University Colour Slide Scheme (slides)
SPECIAL COLLECTIONS
Duveen Brothers photographic archives (photographs)
Dr W R Juynboll's collection of clippings (clippings)
SERVICES
Photographs: Available of every work of art in collection for purchase. Permission for publication must be obtained
Slides: Available for purchase of entire painting collection; free loan collection of slides of all paintings available

VR 285
CONCORD FREE PUBLIC LIBRARY
129 Main St, Concord, MA 01742
Tel: 617-369-5324
Curator: Marcia Moss
Founded: 1873
Hours: Mon-Fri 10-5

CIRCULATION POLICY
Photographs: Restricted, researchers, (appointment required)
COLLECTIONS
Audio tapes: 18
Photographs: 5,000
Video: 35
SPECIAL COLLECTIONS
Concord Authors (photographs)
Concord Fight Bicentennial (photographs, video)
Concord History and Architecture (photographs)
SERVICES
Negatives: Prints available for sale subject to copyright and library regulations and fees

VR 286
FORBES LIBRARY
Art & Music Department
20 West St, Northampton, MA 01060
Tel: 413-584-8550
Libn: Hollee Haswell
Founded: 1894
Hours: Mon-Sat 9-6
 Wed 9-9

CIRCULATION POLICY
Photographs: Restricted
COLLECTIONS
Photographs: 7,000. Architecture (Far East, European,
US); Sculpture (European, US); Painting (European,
US); Decorative Arts (European, US)
SPECIAL COLLECTIONS
Lyman Collection of Japanese wood block prints

VR 287
HARVARD UNIVERSITY
Fine Arts Library, Visual Collections
Fogg Art Museum, Cambridge, MA 02138
Tel: 617-495-3376
Curator of Visual Collections: Helene E Roberts
Staff: 1
Founded: 1895

CIRCULATION POLICY
Photographs: Restricted, students, researchers, faculty/
staff
Slides: Restricted, faculty/staff
COLLECTIONS
Films: 15
Photographs: 674,950 Fogg. Architecture (Ancient,
Islamic, Far East, European, US); Sculpture (Ancient,
Far East, African, Pacific, Tribal American, European,
US); Painting (Ancient, Islamic, Far East, European,
US); Graphic Arts (European); Decorative Arts
(Ancient, Islamic, Far East, African, Pacific, Tribal
American, European, US)
SUBSCRIPTIONS
American Committee of South Asian Art (slides)
Wayne Andrews (photographs)
Asian Art Photographic Distribution (photographs)
James Austin (photographs)
Berenson Archives (photographs)
Osvaldo Bohm (Venice) (photographs)
Carnegie Set (slides)
Chinese National Palace Museum Photo Archives
(photographs)
Courtauld Institute Photo Survey of Private Collections
(photographs)
Decimal Index of the Art of Low Countries (photographs)
Gernsheim Collection (photographs)
Illustrated Bartsch (photographs)
University Colour Slide Scheme (slides)
Warburg Medals (photographs)
SPECIAL COLLECTIONS
Anne de Egry Collection of Spanish Medieval Architecture
(photographs)
Arthur Haskell American Colonial Architecture
(photographs)
Arthur Kingsley Porter Collection of Medieval and related
are (photographs)
Judith De Sandoval Collection of Mexican Colonial
Architecture (photographs)

SERVICES
Negatives: Prints available of the Arthur Kingsley Porter
negatives subject to copyright regulations, and fees
through the Fogg photographer

VR 288
HARVARD UNIVERSITY
Graduate School of Design, Frances Loeb Library,
 Visual Services
Cambridge, MA 02138
Tel: 617-495-2574
Visual Services Libn: Susan Shearer
Founded: ca 1915
Hours: Mon-Fri 2-5

CIRCULATION POLICY
Audio-tapes: Restricted
Films: Restricted
Maps & Plans: Restricted
Photographs: Restricted
Slides: Restricted, public (appointment suggested)
Video: Restricted
COLLECTIONS
Audio-tapes: 74
Films: 11
Microforms: 703
Photographs: 12,310. Architecture (European, US)
Slides: 60,500. Architecture (Ancient, Islamic, Far East,
African, European, US)
Video: 45
SUBSCRIPTIONS
Wayne Andrews (photographs)
Archive Colour Slides—Modern European Architecture
1779-1963 (slides)
Environmental Communications (slides)

VR 289
MASSACHUSETTS COLLEGE OF ART
Slide Library
364 Brookline Ave, Boston, MA 02215
Tel: 617-731-2340, Ext 26
Libn: Suzanne V Smith
Founded: 1968
Hours: Mon-Fri 9-5 (office)

CIRCULATION POLICY
Films: Students, faculty/staff, circulating
Slides: Students, faculty/staff, circulating
Video: Students, faculty/staff, circulating
COLLECTIONS
Films: 460. Architecture (Ancient, European, US);
Sculpture (European, US); Painting (Ancient, European,
US); Graphic Arts (European, US); Decorative Arts
(European, US)
Picture Files: 10 drawers. Painting (US); Decorative Arts
(US)
Slides: 65,000. Architecture (Ancient, Islamic, Far East,
European, US); Sculpture (Ancient, Islamic, Far East,
African, Pacific, Tribal American, Meso-American,
Andean, European, US); Painting (Ancient, Islamic, Far
East, African, Tribal American, European, US); Graphic
Arts (Far East, European, US); Decorative Arts
(Ancient, Islamic, Far East, African, Pacific, Tribal
American, Meso-American, Andean, European, US)
Video: 80. Painting (US); Decorative Arts (US)
SUBSCRIPTIONS
Carnegie Set (slides)

SPECIAL COLLECTION
Contemporary Artists' Film & Video Collection (film,
 video)
Contemporary Crafts Collection on Ceramics, Glass,
 Textiles (film, slides, video)

VR 290
MASSACHUSETTS INSTITUTE OF TECHNOLOGY*
Dept of Architecture
Cambridge, MA 02139
Tel: 617-253-4411

VR 291
MASSACHUSETTS INSTITUTE OF TECHNOLOGY*
Humanities Library, Bldg 14
Cambridge, MA 02139
Tel: 617-253-5681

VR 292
MASSACHUSETTS INSTITUTE OF TECHNOLOGY
Rotch Library Visual Collection
Louis Skidmore Rm 7-304, Cambridge, MA 02139
Tel: 617-253-7098
Asst Rotch Libn for Visual Collections: Nancy C Schrock
Founded: ca 1900
Hours: Mon-Fri 8:30-5:30

CIRCULATION POLICY
Films: Restricted, faculty/staff
Photographs: Restricted, students, researchers, faculty/
 staff
Slides: Restricted, students, researchers, faculty/staff,
 circulating
Video: Restricted, students, researchers, faculty/staff
COLLECTIONS
Films: 25 LC. Architecture (US); Painting (US)
Lantern Slides: 40,000 Fogg.
Photographs: 42,000. Architecture (Ancient, Islamic,
 Far East, European, US); Sculpture (Ancient, European,
 US); Painting (Ancient, European, US); Decorative Arts
 (Ancient)
Slides: 110,000. Architecture (Ancient, Islamic, Far East,
 African, Pacific, Tribal American, Meso-American,
 Andean, European, US); Sculpture (Ancient, Far East,
 African, Tribal American, Meso-American, Andean,
 European, US); Painting (Ancient, Far East, European,
 US); Graphic Arts (European, US); Decorative Arts
 (Ancient, Far East, Tribal American, Meso-American,
 Andean, European, US)
Video: 24 LC. Architecture (US)
SUBSCRIPTIONS
Wayne Andrews (photographs)
Archives Colour Slides of Modern Architecture (slides)
Dunlap Society (fiche, slides)
Pictorial Archive of Near Eastern History—Crusades
 (slides)
University Colour Slide Scheme (slides)
SPECIAL COLLECTIONS
Archives of Architectural Drawings & Models in European
 and American Collections—largely Italian Baroque,
 some American (photographs)
Boston 1954, urban & social documentation (photographs)
SERVICES
Negatives: Prints available for purchase by permission of
 the Boston 1954 exhibition

VR 293
MERRIMACK VALLEY TEXTILE MUSEUM
LIBRARY
800 Massachusetts Ave, North Andover, MA 01845
Tel: 617-686-0191
Libn: Helen Wright
Founded: 1960
Hours: Mon-Fri 9-5

CIRCULATION POLICY
Photographs: Restricted, public, fee service (appointment
 suggested)
Slides: Restricted, public, fee service (appointment
 suggested)
COLLECTIONS
Photographs: 15,500. Architecture (US); Decorative Arts
 (US)
Slides: 1,200. Architecture (US); Decorative Arts (US)
SPECIAL COLLECTIONS
Essex Company, architectural & engineering drawings,
 Lawrence, Massachusetts, 1845-1920 (drawings)
Textile Study Collection: swatch books, shawls, blankets,
 coverlets, linens
SERVICES
Negatives: Prints are available of museum collections;
 reproduction fees and permission required
Slides: Available for purchase and duplication subject to
 copyright regulations

VR 294
MOUNT HOLYOKE COLLEGE
Art Department Slide Room
South Hadley, MA 01075
Tel: 413-538-2205
Slide Curator: Linda Callahan
Hours: Mon-Fri 9-5 (office)

CIRCULATION POLICY
Photographs: Restricted, faculty/staff
Slides: Restricted, students, faculty/staff, fee service,
 circulating
COLLECTIONS
Photographs: 5,000. Architecture (Ancient, Islamic, Far
 East, Tribal American, European, US); Sculpture
 (Ancient, Islamic, Far East, Tribal American, Euro-
 pean, US); Painting (Ancient, Islamic, Far East, Tribal
 American, European, US); Graphic Arts (Far East,
 European, US); Decorative Arts (Ancient, Far East,
 European, US)
Slides: 75,000. Architecture (Ancient, Islamic, Far East,
 Tribal American, European, US); Sculpture (Ancient,
 Islamic, Far East, Tribal American, European, US);
 Painting (Ancient, Islamic, Far East, Tribal American,
 European, US); Graphic Arts (Far East, European,
 US); Decorative Arts (Ancient, Far East, European,
 US)
SUBSCRIPTIONS
Art Now (slides)
SERVICES
Slides: Available for sale or duplication subject to
 copyright and college regulations and fees

VR 295
MUSEUM OF FINE ARTS
Slide Library
465 Huntington Ave, Boston, MA 02115
Tel: 617-267-9300, Exts 317; 318

Slide Libn: Janice Sorkow
Staff: 1
Hours: Tues 10-7
 Thurs 10-4

CIRCULATION POLICY
Photographs: Researchers, fee service
Slides: Public, fee service, circulating
COLLECTIONS
Photographs: 90,000. Sculpture (Ancient, Far East, European, US); Painting (Islamic, Far East, European, US); Graphic Arts (Far East, European, US); Decorative Arts (Ancient, Far East, European, US)
Slides: 75,000 Metropolitan. Sculpture (Ancient, Far East, European, US); Painting (Far East, European, US); Graphic Arts (European, US); Decorative Arts (European, US)
SPECIAL COLLECTIONS
Museum of Fine Arts Collections (slides)
SERVICES
Negatives: Prints available for purchase and reproduction of museum collection subject to copyright and museum regulations and fess
Slides: Available for purchase and duplication of museum objects

VR 296
NEW BEDFORD FREE PUBLIC LIBRARY
Box C 902, New Bedford, MA 02741
Tel: 617-999-6291
Founded: 1852 (library)

CIRCULATION POLICY
Films: Public, circulating
Filmstrips: Public
Photographs: Public
Prints: Public, circulating
COLLECTIONS
Films: 276
Filmstrips: 249

VR 297
PEABODY MUSEUM OF ARCHAEOLOGY & ETHNOLOGY
Photographic Archives
11 Divinity Ave, Cambridge, MA 02138
Tel: 617-495-3329
Photo Archivist: Daniel W Jones
Staff: 4
Founded: 1866
Hours: Mon-Fri 9-5 (office)

CIRCULATION POLICY
Photographs: Students, researchers, faculty/staff, fee service (appointment required)
Slides: Students, researchers, faculty/staff (appointment required)
Transparencies: Students, researchers, faculty/staff (appointment required)
COLLECTIONS
Negatives: 70,000. Anthropology/Archaeology/Ethnology (African, Pacific, Tribal American, Meso-American, Andean, US)
Photographs: 22,000. Anthropology/Archaeology/Ethnology (African, Pacific, Tribal American, Meso-American, Andean, US)
Slides: 8,000. Anthropology/Archaeology/Ethnology (African, Pacific, Tribal American, Meso-American, Andean, US)
SPECIAL COLLECTIONS
Carnegie Institute of Washington Central American Archaeological Expeditions 1929-1957 (negatives, prints)
SERVICES
Negatives: Prints available for purchase subject to copyright and museum regulations and fees
Slides: Available for duplication subject to copyright and museum regulations and fees

VR 298
SMITH COLLEGE
Hillyer Art Library, Slide Room
Elm St, Northhampton, MA 01063
Tel: 413-584-2700, Exts 727; 893
Curator of Slides: Alice Margosian
Founded: 1920
Hours: Mon-Fri 8-4

CIRCULATION POLICY
Slides: Restricted, seminar students, faculty
COLLECTIONS
Slides: 128,000. Architecture (Ancient, Far East, European, US); Sculpture (Ancient, Far East, European, US); Painting (Ancient, Far East, European, US); Graphic Arts (Ancient, Far East, European, US); Decorative Arts (Ancient, Far East, European, US)
SUBSCRIPTIONS
American Committee of South Asian Art (slides)
Asian Art Photographic Distribution (slides)
Budek Films & Slides (slides)
Carnegie Set (slides)
Thomas Donaldson (slides)
Saskia (slides)

VR 299
SMITH COLLEGE
Hillyer Art Library, Visual Resources Collection
Elm St, Northhampton, MA 01063
Tel: 413-584-2700, Ext 2173
Curator: Sharon L Poirrier
Founded: 1920
Hours: Mon-Fri 8-4:30 (office)

CIRCULATION POLICY
Photographs: Restricted, students, faculty/staff
Slides: Restricted, students, faculty/staff
COLLECTIONS
Photographs: 61,200 Yale. Architecture (Ancient, European, US); Sculpture (Ancient, Far East, European) Painting (Far East, European, US); Graphic Arts (European)
Slides: 1,200 Santa Cruz
SUBSCRIPTIONS
Wayne Andrews (photographs)
Asian Art Photographic Distribution (photographs)
James Austin (photographs)
Chinese National Palace Museum Photo Archives (photographs)

VR 300
TUFTS UNIVERSITY
Fine Arts Department, Slide Collection
11 Talbot Ave, Medford, MA 02155
Tel: 617-628-5000, Ext 396

Person in Charge: Patricia Rogers Pelnar
Hours: Mon-Fri 9-5 (office)

CIRCULATION POLICY
Slides: Restricted
COLLECTIONS
Slides: 60,000. Architecture (Ancient, European, US);
 Sculpture (Ancient, European, US); Painting (Ancient,
 European, US); Graphic Arts (European, US);
 Decorative Arts (European, US)
SUBSCRIPTIONS
Carnegie Set (slides)

VR 301
UNIVERSITY OF LOWELL
Art Department
South Campus, Lowell, MA 01854
Tel: 617-454-8011, Ext 455
Prof of Art History: Liana Cheney
Founded: 1975
Hours: Mon-Fri 9-3 (office)

CIRCULATION POLICY
Photographs: Restricted, faculty/staff (appointment
 suggested)
Slides: Restricted, faculty/staff (appointment suggested)
COLLECTIONS
Films: 30
Slides: 15,000. Architecture (Ancient, Far East, Euro-
 pean); Sculpture (Ancient, Far East, European);
 Painting (Ancient, Far East, European); Graphic Arts
 (Ancient, European)
SUBSCRIPTIONS
Scala (slides)

VR 302
UNIVERSITY OF LOWELL
O'Leary Library Media Center
Lowell, MA 01854
Tel: 617-454-8011, Ext 487
Person in Charge: Paul Coppens

CIRCULATION POLICY
Audio-tapes: Students, researchers, faculty/staff,
 circulating
Films: Students, researchers, faculty/staff, circulating
Video: Students, researchers, faculty/staff, circulating
COLLECTIONS
Films: 190
Video: 30

VR 303
UNIVERSITY OF MASSACHUSETTS
Art Department, Slide & Print Library
Bartlett Hall, Amherst, MA 01003
Tel: 413-545-3595
Dir/Curator: Dr Dorothy W Perkins
Staff: ½
Founded: 1958
Hours: Mon-Fri 8-4:30 (office)

CIRCULATION POLICY
Slides: Student presentations, faculty/staff
COLLECTIONS
Photographs: (new) Santa Cruz
Slides: 200,000 Santa Cruz. Architecture (Ancient,
 Islamic, Far East, US); Sculpture (Ancient, Far East,

African, European, US); Painting (Islamic, Far East,
European, US); Graphic Arts (European, US);
Decorative Arts (Ancient, Islamic, European, US)

VR 304
UNIVERSITY OF MASSACHUSETTS AT BOSTON
Art Department, Slide Room
Harbor Campus, Dorchester, MA 02125
Tel: 617-287-1900, Ext 2896
Slide Curator: Sarah F Hill
Hours: 8:30-5 (office)

CIRCULATION POLICY
Slides: Restricted, art seminar students, faculty
COLLECTIONS
Slides: 80,000 Fogg. Architecture (Ancient, Meso-
 American, European, US); Sculpture (Ancient,
 African, Meso-American, European, US); Painting
 (Ancient, Tribal American, European, US); Graphic
 Arts (European, US); Decorative Arts (European, US)
SUBSCRIPTIONS
American Committee of South Asian Art (slides)

VR 305
WELLESLEY COLLEGE
Art Department, Slide Library
Jewett Arts Center, Wellesley, MA 02181
Tel: 617-235-0320, Ext 316
Keeper of Slides & Photographs: Susan Waller
Staff: 2
Founded: 1897
Hours: Mon-Fri 8:30-4:30

CIRCULATION POLICY
Photographs: Restricted, students, faculty/staff
Slides: Faculty/staff
COLLECTIONS
Photographs: 60,000 Metropolitan. Architecture (Ancient,
 Far East, European, US); Sculpture (Ancient, Far
 East, European, US); Painting (Ancient, Far East,
 European, US); Graphic Arts (European)
Slides: 72,500 Metropolitan. Architecture (Ancient,
 Far East, European, US); Sculpture (Ancient, Far
 East, European, US); Painting (Ancient, Far East,
 European, US); Graphic Arts (European)
SUBSCRIPTIONS
American Committee of South Asian Art (slides)
Wayne Andrews (photographs)
Asian Art Photographic Distribution (slides)
James Austin (photographs, slides)
Courtauld Institute Photo Survey of Private Collections
 (photographs)

VR 306
WHEATON COLLEGE
Art Department, Slide and Photograph Collection
Watson Fine Arts Bldg, Norton, MA 02766
Tel: 617-285-7722, Ext 439
Curator of Slides & Photographs: Jacqueline Silvi
Founded: 1931
Hours: Mon-Fri 8:30-12:30, 1:30-4:30 (office)

CIRCULATION POLICY
Films: Faculty
Photographs: Faculty
Slides: Faculty

COLLECTIONS

Photographs: 10,000. Architecture (European, US); Sculpture (European, US); Painting (European, US); Graphic Arts (European, US)

Slides: 50,000. Architecture (Ancient, Far East, European, US); Sculpture (Ancient, Far East, European, US); Painting (Ancient, Far East, European, US); Graphic Arts (Ancient, Far East, European, US); Decorative Arts (European, US)

VR 307
WILLIAMS COLLEGE*
Art Library, Slide Library
Main St, Williamstown, MA 02167
Tel: 413-597-2501

VR 308
WORCESTER ART MUSEUM
Slide Library
55 Salisbury St, Worcester, MA 01608
Tel: 617-799-4406, Ext 32
Slide Libn: Maureen Killoran
Founded: 1911
Hours: Tues-Thurs 10-1, 2-5

CIRCULATION POLICY

Slides: Public, fee service, circulating

COLLECTIONS

Slides: 33,500 Old Metropolitan. Architecture (Ancient, European, US); Sculpture (Ancient, Far East, European, US); Painting (Far East, European, US); Decorative Arts (Ancient, European)

Michigan

VR 309
CENTER FOR CREATIVE STUDIES
College of Art & Design
245 E Kirby, Detroit, MI 48202
Tel: 313-872-3118, Ext 30
Libn: Jean Peyrat
Founded: 1969

CIRCULATION POLICY

Slides: Faculty/staff

COLLECTIONS

Slides: 19,102. Architecture (European, US); Sculpture (Ancient, Far East, European, US); Painting (European, US)

VR 310
CRANBOOK ACADEMY OF ART LIBRARY
500 Lone Pine Rd, Bloomfield Hills, MI 48013
Tel: 313-645-3328
Libn: Stel Toland

CIRCULATION POLICY

Slides: Students, researchers, faculty/staff

COLLECTIONS

Slides: 15,000

VR 311
THE DETROIT INSTITUTE OF ARTS
Research Library
5200 Woodward Ave, Detroit, MI 48202

Tel: 313-833-7926
Libn: F Warren Peters, Jr
Staff: 1
Founded: 1905
Hours: Mon-Fri 9-5

CIRCULATION POLICY

Photographs: Restricted, researchers, faculty/staff
Slides: Public, fee service, circulating

COLLECTIONS

Photographs: 70,000 Courtauld. Architecture (Ancient, European, US); Sculpture (Ancient, European, US); Painting (Ancient, European, US); Graphic Arts (Ancient, European, US); Decorative Arts (Ancient, European, US)

Slides: 42,000. Architecture (Ancient, Islamic, Far East, African, European, US); Sculpture (Ancient, Islamic, Far East, African, European, US); Painting (Ancient, Islamic, Far East, African, European, US); Graphic Arts (Ancient, Islamic, Far East, African, European, US); Decorative Arts (Ancient, Islamic, Far East, African, European, US)

SUBSCRIPTIONS

Wayne Andrews (photographs, slides)
Carnegie Set (slides)
Courtauld Institute Photo Survey of Private Collections (photographs)
Decimal Index of the Art of Low Countries (photographs)
University Colour Slide Scheme (slides)

VR 312
EASTERN MICHIGAN UNIVERSITY
Slide Library
118 Sill Hall, Ypsilanti, MI 48197
Tel: 313-487-3388
Asst Prof of Art History: Sandra Braun
Founded: ca 1965
Hours: Mon-Fri 8-9 (office)

CIRCULATION POLICY

Slides: Restricted, art students, art faculty/staff

COLLECTIONS

Slides: 45,000. Architecture (Ancient, Islamic, European, US); Sculpture (Ancient, Islamic, European, US); Painting (Islamic, European, US); Graphic Arts (European); Decorative Arts (Islamic, US)

VR 313
FLINT PUBLIC LIBRARY*
Art, Music & Drama Department
1026 E Kearsley, Flint, MI 48502
Tel: 313-232-7111
Head, Art, Music & Drama Dept: Forrest Alter

VR 314
HENRY FORD COLLEGE*
Art Department
5101 Evergreen, Dearborn, MI 48126
Tel: 313-271-2750
Art Inst: Donald R Criner

VR 315
HENRY FORD MUSEUM & GREENFIELD VILLAGE
Audio-Visual Services, Slide Collection
Dearborn, MI 48121
Tel: 313-271-1620

VR 316
GRAND VALLEY STATE COLLEGE*
Department of Fine Arts, Slide Collection
College Landing, Allendale, MI 49401
Tel: 616-895-6611

VR 317
KALAMAZOO INSTITUTE OF ARTS LIBRARY*
315 S Park St, Kalamazoo, MI 49006
Tel: 616-349-7775
Libn: Helen Sheridan

COLLECTIONS
Slides: 8,000

VR 318
MICHIGAN STATE UNIVERSITY
116 Kresge Art Center
East Lansing, MI 48823
Tel: 517-355-7640
Curator: Janice Simpson
Hours: Mon-Fri 8-5 (office)

CIRCULATION POLICY
Photographs: Art students, faculty/staff, circulating
 (appointment suggested)
Slides: Art students, faculty/staff, circulating
 (appointment suggested)
COLLECTIONS
Photographs: 25,000 Minnesota. Architecture (Ancient,
 European, US); Sculpture (Ancient, European);
 Painting (Ancient, European)
Slides: 100,000 Minnesota. Architecture (Ancient, Euro-
 pean, US); Sculpture (Ancient, European, US);
 Painting (Ancient, European, US)
SUBSCRIPTIONS
Carnegie Set (slides)
Courtauld Institute Photograph Survey of Private
 Collections (photographs)

VR 319
**MICHIGAN STATE UNIVESRITY—
 EAST LANSING***
Dept of Art, Slide Collection
East Lansing, MI 48824
Tel: 517-355-1855
Slide Curator: Janice Simpson

VR 320
MONROE COUNTY LIBRARY SYSTEM
Audio Visual Center
3700 S Custer Rd, Monroe, MI 48161
Tel: 313-241-5278
Dir: Bernard Margolis
Hours: Mon-Fri 8-5
 Sat 12-5 (Sept-June 15)

CIRCULATION POLICY
Film Loops: Public
Films: Public
Filmstrips: Public
Slides: Public
COLLECTIONS
Film Loops: 1,200
Films: 1,500
Filmstrips: 3,000
Slides: 1,000

VR 321
OAKLAND UNIVERSITY
Dept of Art & Art History, Slide Library
310 Wilson Hall, Rochester, MI 48063
Tel: 313-377-3378
Slide Curator: Lynn Cameron
Founded: 1957
Hours: Mon-Fri 8-5 (office)

CIRCULATION POLICY
Slides: Restricted, faculty/staff
COLLECTIONS
Slides: 80,000. Architecture (Ancient, European, US);
 Sculpture (Ancient, European, US); Painting (Ancient,
 European, US); Graphic Arts (Ancient, European, US)

VR 322
UNIVERSITY OF DETROIT*
Library, Reference Department
2001 W McNichols Rd, Detroit, MI 48221
Tel: 313-927-1000

VR 323
UNIVERSITY OF DETROIT*
School of Architecture
Detroit, MI 48221
Tel: 313-927-1149

VR 324
UNIVERSITY OF MICHIGAN*
Architecture Library, College of Architecture & Design
240 Arch & Design, Ann Arbor, MI 48104
Tel: 313-764-1817

VR 325
UNIVERSITY OF MICHIGAN
Asian Art Archives
Tappan Hall, Rm 4, Ann Arbor, MI 49109
Tel: 313-764-5555
Archivist: Alita J Mitchell
Staff: 1
Founded: 1962
Hours: Mon-Fri 8-5 (office)

CIRCULATION POLICY
Photographs: Students, researchers, faculty/staff
COLLECTIONS
Photographs: 32,000. Architecture (Far East); Sculpture
 (Far East); Painting (Far East)
SUBSCRIPTIONS
American Committee of South Asian Art (photographs)
Asian Art Photographic Distribution (photographs)
Chinese National Palace Museum Photo Archives
 (photographs)

VR 326
UNIVERSITY OF MICHIGAN
Audio-Visual Education Center
416 Fourth St, Ann Arbor, MI 48109
Tel: 313-764-5360
Dir: Ford L Lemler
Staff: 10
Hours: Mon-Fri 8-5 (office)

CIRCULATION POLICY
Films: Public, fee service, circulating

COLLECTIONS
Films: 17,000

VR 327
UNIVERSITY OF MICHIGAN
History of Art Department, Slide & Photograph College
107 Tappan Hall, 519 S State St, Ann Arbor, MI 48109
Tel: 313-764-5404
Curator of Photograph Collection: Linda Owen Wells
Staff: 4½
Founded: 1911
Hours: Mon-Fri 8:30-1, 2-5 (office)

CIRCULATION POLICY
Photographs: Restricted, students, researchers, faculty/
staff (appointment suggested)
Slides: Restricted, faculty/staff, fee service (appointment
suggested)
COLLECTIONS
Photographs: 70,000 Fogg. Architecture (Ancient,
Islamic, Far East, European, US); Sculpture (Ancient,
Islamic, Far East, European, US); Painting (Ancient,
Islamic, Far East, European, US); Graphic Arts
(Ancient, Islamic, Far East, European, US); Decorative
Arts (Ancient, Islamic, Far East, European, US)
Slides: 186,000 Fogg. Architecture (Ancient, Islamic,
Far East, European, US); Sculpture (Ancient, Islamic,
Far East, European, US); Painting (Ancient, Islamic,
Far East, European, US); Graphic Arts (Ancient,
Islamic, Far East, European, US); Decorative Arts
(Ancient, Islamic, Far East, European, US)
Video: 15
SUBSCRIPTIONS
American Committee of South Asian Art (slides)
Asian Art Photographic Distribution (slides)
James Austin (photographs)
Berenson Archives (photographs)
Carnegie Set (slides)
Chinese National Palace Museum Photo Archives (slides)
Courtauld Institute Photo Survey of Private Collections
(photographs)
SPECIAL COLLECTIONS
Romanesque Archive (photographs)

VR 328
UNIVERSITY OF MICHIGAN—DEARBORN
College of Arts, Sciences and Letters, Slide Collection
4901 Evergreen Rd, Dearborn, MI 48128
Tel: 313-271-2300, Ext 301
Curator: Ann L Detwiler
Staff: 2
Founded: 1974
Hours: Mon-Fri 8:30-4:30

CIRCULATION POLICY
Slides: Students, researchers, faculty/staff
COLLECTIONS
Photographs: (new)
Slides: 13,000 Fogg. Architecture (Ancient, Far East,
European, US); Sculpture (Ancient, Far East, Euro-
pean, US); Painting (Ancient, Far East, European,
US); Graphic Arts (European, US); Decorative Arts
(Far East)

VR 329
WAYNE STATE UNIVERSITY
Art & Art History Department, Slide Library

150 Community Arts, Detroit, MI 48202
Tel: 313-577-2988
Slide Curator: Marjorie Lynn Barry
Founded: 1966
Hours: Mon-Fri 8:30-430

CIRCULATION POLICY
Photographs: Restricted
Slides: Faculty/staff
COLLECTIONS
Films: 7. Painting (European, US)
Photographs: 3,000. Architecture (European, US)
Slides: 90,000
SUBSCRIPTIONS
American Committee of South Asian Art (slides)
Wayne Andrews (photographs, slides)
Asian Art Photographic Distribution (slides/selected)
Chinese National Palace Museum Photographic Archive
(slides)
Detroit Institute of Art (slides)
Landfall Press (slides)
Light Impressions (slides)
SPECIAL COLLECTIONS
Asian Cultures (slides)
Third World Cultures (slides)

VR 330
WESTERN MICHIGAN UNIVERSITY
Art Department Slide Library/Waldo Library
 Audio-Visual Center
Kalamazoo, MI 49008
Tel: 616-383-4952 (Waldo Lib)
Chairman, Art Dept: John Link
Founded: 1903

CIRCULATION POLICY
Photographs: Restricted, faculty/staff
Slides: Restricted, faculty/staff
COLLECTIONS
Films: 117. Architecture (Ancient, European); Sculpture
(Far East, African, European, US); Painting (Far
East, European, US); Graphic Arts (Far East, Euro-
pean, US)
Photographs: 1,500
Slides: 40,000. Architecture (Ancient, Far East, Meso-
American, European, US); Sculpture (Ancient, Far
East, African, Meso-American, European, US);
Painting (Ancient, Far East, European, US); Graphic
Arts (Far East, European, US); Decorative Arts
(Ancient, Far East, African, European, US)
SUBSCRIPTIONS
Carnegie Foundation Photographs (photographs)
Carnegie Set (slides)

Minnesota

VR 331
CARLETON COLLEGE
Dept of Art
Northfield, MN 55057
Tel: 507-645-4431, Ext 400
Person in Charge: Lauren Soth
Hours: Mon-Fri 8-5

CIRCULATION POLICY
Slides: Restricted
COLLECTIONS
Slides: 40,000
SUBSCRIPTIONS
Carnegie Set (slides)

VR 332
COLLEGE OF ST CATHERINE*
Art Department, Slide Collection
St Paul, MN 55116
Tel: 612-690-6000

VR 333
COLLEGE OF ST TERESA*
Library, Audio Visual Center
Winona, MN 55987
Tel: 507-454-2930
A-V Dir: Sr Louise Macket

COLLECTIONS
Reproductions: n.a.
Slides: 5,000

VR 334
LAKEWOOD COMMUNITY COLLEGE*
Art Department, Slide Collection
White Bear Lake, MN 55110
Tel: 612-770-1331
Art Historian: Karin McGuinis

VR 335
MINNEAPOLIS COLLEGE OF ART & DESIGN
Slide Library
200 E 25 St, Minneapolis, MN 55404
Tel: 612-870-3292
Slide Libn: Peggy Rudberg
Founded: 1957
Hours: Mon-Thurs 9-2 (office)

CIRCULATION POLICY
Slides: Students, researchers, faculty/staff, circulating
COLLECTIONS
Slides: 40,000 Minnesota. Architecture (Ancient, Islamic, Far East, European, US); Sculpture (Ancient, Far East, African, Tribal American, European, US); Painting (Ancient, Far East, European, US); Graphic Arts (Far East, European, US); Decorative Arts (Ancient, Far East, Tribal American, Meso-American, European, US)

VR 336
MINNEAPOLIS INSTITUTE OF ARTS
Arts Resource & Information Center
2400 Third Ave S, Minneapolis, MN 55404
Tel: 612-870-3131
Coordinator: Sandra Oakes
Staff: 1
Hours: Tues, Wed, Fri, Sat 10-5
 Thurs 10-9
 Sun 12-5

CIRCULATION POLICY
Films: Public, fee service, circulating (appointment suggested)
Slides: Public, fee service, circulating (appointment suggested)

Study Exhibitions: Public, fee service, circulating (appointment suggested)
Video: Public, fee service, circulating (appointment suggested)
COLLECTIONS
Films: 3
Slide Packages: 10
Study Exhibitions: 9
Video: 4
SERVICES
Circulating Educational Materials (films, slides, study exhibitions, video)
Slides: Available for purchase and duplication of all available slide packages

VR 337
MINNEAPOLIS INSTITUTE OF ARTS
Audio-Visual Center
2400 Third Ave S, Minneapolis, MN 55404
Tel: 612-870-3195
A-V Center Supervisor: Jerry Downes
Staff: 2
Hours: Mon-Fri 8:30-5

CIRCULATION POLICY
Audio Tapes: Faculty/staff
Film: Restricted, faculty/staff, fee service (appointment suggested)
Multi-media: Restricted, faculty/staff (appointment suggested)
Slide/text: Restricted, fee service, circulating
Slides: Restricted, faculty/staff, circulating
Video: Restricted, circulating (appointment suggested)
COLLECTIONS
Films: 10
Multi-media: 8
Slide/text: 6
Slides: 70,000 Minnesota. Architecture (Ancient, Far East, African, European, US); Sculpture (Ancient, Far East, African, European, US); Painting (Ancient, Far East, African, European, US); Graphic Arts (European, US); Decorative Arts (Ancient, Far East, African, European, US)
Video: 20 (uncataloged). Decorative Arts (Ancient, Tribal American, European)
SPECIAL COLLECTIONS
Charles Biederman Archive (slides)
Museum & University of Minnesota produced video programs (video)
SERVICES
Negatives: Prints available of objects in MIA collections; request through appropriate curator
Slides: Available for purchase or duplication subject to copyright and museum regulations and fees

VR 338
MINNEAPOLIS PUBLIC LIBRARY & INFORMATION CENTER
Art, Music & Films Department, Films Desk
300 Nicollet Mall, Minneapolis, MN 55401
Tel: 612-372-6558
Media Specialist: Elizabeth Bingaman
Staff: 1
Founded: 1947
Hours: Mon-Thurs 9-9 (all year)
 Fri-Sat 9-5 (winter)
 Fri 9-5:30 (summer)

CIRCULATION POLICY
Films: Public, fee service, circulating
Filmstrips: Public, circulating
Slides: Public: circulating
COLLECTIONS
Films 2,670
Photographs: n.a.
Slides: 39,900 Dewey
Video: 28 Library of Congress
SPECIAL COLLECTIONS
American Crafts selected from watercolors in the Index
 of American Design/National Gallery of Art
SERVICES
Slides: Available for duplication subject to copyright
 restrictions by special arrangement

VR 338A
ST JOHN'S UNIVERSITY
Hill Monastic Manuscript Library
Collegeville, MN 56821
Tel: 612-363-3514
Director: Dr Julian G Plante
Staff: 4
Founded: 1966

CIRCULATION POLICY
Microforms: Restricted
Slides: Restricted
COLLECTIONS
Microforms: 45,000 (exposures)
Slides: 10,000
SPECIAL COLLECTIONS
Manuscripts: Ancient, Medieval and Renaissance books of
 literary, historical nature; archival materials from
 European libraries and archives. Countries represented:
 Austria, Spain, Malta, Ethiopia, some from Italy and
 elsewhere.
SERVICES
Negatives: Prints available for purchase with written
 permission of library owning the original

VR 339
SCHOOL OF THE ASSOCIATED ARTS LIBRARY*
344 Summit Ave, St Paul, MN 55102
Tel: 612-224-3416

VR 340
SOUTHWEST MINNESOTA STATE COLLEGE*
Library, Slide Collection
Marshall, MN 56258
Tel: 507-537-7021

VR 341
UNIVERSITY OF MINNESOTA*
Architecture Library
160 Arch Bldg, Minneapolis, MN 55455
Tel: 612-373-2851

VR 342
UNIVERSITY OF MINNESOTA*
Dept of Art History, Slide Library
108 Jones Hall, Minneapolis, MN 55455
Tel: 612-373-3057
Slide Curator: Mary Meihak

VR 343
WALKER ART CENTER
Slide Library
Vineland Place, Minneapolis, MN 55403
Tel: 612-377-7500, Ext 41
Slide Curator: Bonita L Everts
Founded: 1974
Hours: Mon-Fri 1-5

CIRCULATION POLICY
Slides: Restricted, students by permission, researchers
 by permission, faculty/staff, fee service (appointment
 suggested)
COLLECTIONS
Slides: 45,000. Architecture (European, US); Sculpture
 (African, Pacific, Tribal American, European, US);
 Painting (European, US); Graphic Arts (European,
 US); Decorative Arts (African, Tribal American, US)
SERVICES
Slides: Walker Art Center permanent collection available
 for sale on request

Mississippi

VR 344
UNIVERSITY OF SOUTHERN MISSISSIPPI*
Dept of Art, Slide Collection
Box 33, Hattiesburg, MS 39401
Tel: 601-266-7281

Missouri

VR 345
DRURY COLLEGE
Art Department
Harwood Hall, Springfield, MO 65802
Tel: 417-865-8731, Ext 263
Person in Charge: John Simmons
Staff: 2
Founded: 1873
Hours: Mon-Fri 8-5

CIRCULATION POLICY
Slides: Restricted, researchers, faculty/staff (appointment
 suggested)
COLLECTIONS
Slides: 24,000. Architecture (Ancient, Islamic, Far East,
 Tribal American, Meso-American, Andean, European,
 US); Sculpture (Ancient, Islamic, Far East, African,
 Pacific, Tribal American, Meso-American, Andean,
 European, US); Painting (Ancient, Far East, African,
 Tribal American, Meso-American, European, US);
 Graphic Arts (Far East, European, US); Decorative
 Arts (Ancient, Islamic, Far East, African, Tribal
 American, Meso-American, European, US)
SERVICES
Slides: Available for duplication subject to copyright and
 college regulations

VR 346
KANSAS CITY ART INSTITUTE
Media Center
4415 Warwick Blvd, Kansas City, MO 64111
Tel: 816-561-4852, Ext 73
Person in Charge: Michael King

Staff: 2
Founded 1970
Hours: Mon-Fri 8-5

CIRCULATION POLICY
Slides: Restricted, students, faculty/staff
COLLECTIONS
Films: 13
Slides: 40,000 Fogg. Architecture (Ancient, Far East,
 European, US); Sculpture (Ancient, Far East, Euro-
 pean, US); Painting (Far East, European, US);
 Graphic Arts (US)
SPECIAL COLLECTIONS
Rhode Island School of Design Nature Series (slides)

VR 347
KANSAS CITY PUBLIC LIBRARY
Film Department
311 E 12 St, Kansas City, MO 64106
Tel: 816-221-2685, Ext 165
Head, Film Dept: Penny Northern
Hours: Mon-Thurs 8:30-7
 Fri-Sat 8:30-5

CIRCULATION POLICY
Picture Clips: Public, circulating
Reproductions (framed): Public, circulating
Slides: Public, circulating
COLLECTIONS
Films: 1,400
Slides: 2,200. Architecture (Ancient, European, US);
 Sculpture (Ancient, European, US); Painting (Euro-
 pean, US); Graphic Arts (European, US)

VR 348
THE LINDENWOOD COLLEGES*
Art Department, Slide Collection
St Charles, MO 63301
Tel: 314-723-7152
Slide Curator: Nancy Follis

COLLECTIONS
Slides: 20,000

VR 349
WILLIAM ROCKHILL NELSON GALLERY—
ATKINS MUSEUM
Slide Library
4525 Oak St, Kansas City, MO 64111
Tel: 816-561-4000, Ext 39
Slide Libn: Jan B McKenna
Founded: 1933
Hours: Mon-Fri 9-5

CIRCULATION POLICY
Films: Public, circulating
Photographs: Public (appointment suggested)
Slides: Extension students, faculty/staff (appointment
 suggested)
COLLECTIONS
Films: 8
Photographs: 40,000
Slides: 30,590 Fogg. Sculpture (Far East); Painting (Far
 East); Decorative Arts (Far East)
SERVICES
Photographs: Prints available for purchase of museum
 collection

Slides: Available for purchase of most of museum
 collection

VR 350
NORTHWEST MISSOURI STATE UNIVERSITY*
Dept of Art
Maryville, MO 64468
Tel: 816-582-7141
Asst Prof of Art: Robert Sunkel

VR 351
ST LOUIS ART MUSEUM
Dept of Education, Resource Center
Forest Park, St Louis, MO 63122
Tel: 314-726-2316
Coordinator: Kathleen W Rubin
Hours: Mon-Fri 8:30-5

CIRCULATION POLICY
Posters: Public, circulating
Slide Kits: Public, circulating
Slides: Public, circulating
Video Cassettes: Public, circulating
COLLECTIONS
Slides: 3,300
SPECIAL COLLECTIONS
St Louis Art Museum Collections (slides)

VR 352
ST LOUIS ART MUSEUM
Richardson Memorial Library
Forest Park, St Louis, MO 63110
Tel: 314-721-0067, Exts 36; 37
Libn: Ann B Abid
Staff: 2
Founded: 1915
Hours: Mon-Fri 10-5
 Tues 2:30-5
 Mon-Fri 8:30-5 (office)

CIRCULATION POLICY
Photographs: Public, circulating
Slides: Restricted, researchers, faculty/staff
COLLECTIONS
Photographs: 20,000 Art Institute of Chicago
Slides: 18,000 Art Institute of Chicago. Architecture
 (European, US); Sculpture (Ancient, US); Painting
 (European, US); Graphic Arts (European, US);
 Decorative Arts (Ancient, Far East, European, US)
SUBSCRIPTIONS
Carnegie Set (slides)
SERVICES
Slides: Available for purchase; available for duplication
 subject to copyright regulations and Department of
 Education regulations

VR 353
SOUTHEAST MISSOURI STATE UNIVERSITY
Art Department
Cape Girardeau, MO 63701
Tel: 314-651-2143
Chairman, Art Dept: Bill Needle
Staff: 11
Hours: Mon-Fri 8-5

CIRCULATION POLICY
Slides: Researchers, faculty/staff (appointment suggested)

COLLECTIONS
Films: 30. Architecture (European); Sculpture (European, US); Painting (European, US)
Slides: 10,000. Architecture (Ancient, Meso-American, European, US); Sculpture (Ancient, Far East, African, Pacific, European, US); Painting (Ancient, Far East, Tribal American, European, US); Graphic Arts (US); Decorative Arts (Tribal American, Meso-American, Andean, US)

VR 354
SOUTHWEST MISSOURI STATE UNIVERSITY
Art Department, Slide Library
Springfield, MO 65802
Tel: 417-836-5499
Slide Curator: Phyllis Quick
Hours: Mon-Fri 8-5 (office)

CIRCULATION POLICY
Slides: Faculty/staff
COLLECTIONS
Slides: 75,000 Fogg. Sculpture (European, US); Painting (European, US)

VR 355
UNIVERSITY OF MISSOURI—COLUMBIA
Dept of Art History & Archaeology, Slide & Photograph Archives
109 Pickard Hall, Columbia, MO 65201
Tel: 314-882-6711
Curator of Slides & Photographs: Lora Holtz
Hours: Mon-Fri 8-5 (office)

CIRCULATION POLICY
Photographs: Restricted
Slides: Students, faculty/staff
COLLECTIONS
Photographs: 70,000. Architecture (Ancient, European, US); Sculpture (Ancient, European, US); Painting (Ancient, European, US); Decorative Arts (European)
Slides: 78,000 Metropolitan. Architecture (Ancient, Islamic, Far East, European, US); Sculpture (Ancient, European, US); Painting (Ancient, Far East, European, US); Graphic Arts (European, US); Decorative Arts (European, US)
SUBSCRIPTIONS
American Committee of South Asian Art (slides)
Anderson-Alinari Photo Collection (photographs)
Carnegie Set (slides)
Courtauld Institute Photo Survey of Private Collections (photographs)

VR 356
UNIVERSITY OF MISSOURI—KANSAS CITY
Dept of Art & Art History, Slide & Photograph Collection
Kansas City, MO 64110
Tel: 816-276-1501, Ext 22
Curator of Slides & Photographs: Nancy DeLaurier
Founded: 1948
Hours: Mon-Fri 9-5 (office)

CIRCULATION POLICY
Photographs: Restricted, authorized students, researchers, faculty/staff
Slides: Restricted, authorized students, faculty/staff
COLLECTIONS
Photographs & Clippings: 39,000 Fogg. Architecture (European); Sculpture (European); Painting (European, US); Graphic Arts (European)
Slides: 60,000 Fogg. Architecture (Ancient, European, US); Sculpture (Ancient, European); Painting (European, US); Graphic Arts (European); Decorative Arts (European)
SPECIAL COLLECTIONS
Kansas City Historical Architecture (slides)

VR 357
UNIVERSITY OF MISSOURI—ST LOUIS
Art Department, Art Slide Library
8001 Natural Bridge Rd, St Louis, MO 63121
Tel: 314-453-5975
Slide Curator: Nancy Follis
Founded: 1963
Hours: Mon-Fri 7:30-3:30

CIRCULATION POLICY
Photographs: Students, researchers, faculty/staff
Slides: Students, researchers, faculty/staff
COLLECTIONS
Slides: 70,000 (medium). Architecture (Ancient, European, US); Sculpture (Ancient, African, Pacific, Tribal American, European, US); Painting (Ancient, European, US); Graphic Arts (European, US)
SUBSCRIPTIONS
Carnegie Set (slides)

VR 358
WASHINGTON UNIVERSITY
Art & Architecture Library
Steinberg Hall, St Louis, MO 63130
Tel: 314-889-5268; 5218
Libn: Imre Meszaros
Hours: Mon-Thurs 8:30-11
 Fri 8:30-5
 Sat 9-5
 Sun 12-10

CIRCULATION POLICY
Photographs: Public, circulating
COLLECTIONS
Photographs: 10,000. Sculpture (European, US); Painting (European, US); Graphic Arts (European, US)
SPECIAL COLLECTIONS
Sorger Collection of English and American Fashion Plates from 1846-1938 (hand colored chromolithographs)

VR 359
WASHINGTON UNIVERSITY
Slide Library
Forsyth & Skinker, St Louis, MO 63130
Tel: 314-863-0100, Exts 4807; 4808
Slide Curator: Jeannine Quinn
Hours: Mon-Fri 8:30-5

CIRCULATION POLICY
Slides: Restricted, faculty/staff
COLLECTIONS
Films: n.a.
Microforms: n.a.
Models: n.a.
Photographs: n.a.
Slides: 115,000. Architecture (Ancient, Far East, European, US); Sculpture (Ancient, Far East, European); Painting (Ancient, Far East, European, US)

Montana

VR 360
DOUGLAS GRIMM
Rt 7, W Rattlesnake, Missoula, MT 59801
Tel: 406-543-7970
Owner: Douglas Grimm
Staff: 1
Founded: 1967
Hours: By appointment

CIRCULATION POLICY
Slides: Public (appointment suggested)
COLLECTIONS
Slides: 20,000. Sculpture (US); Painting (US); Graphic
 Arts (US)
SPECIAL COLLECTIONS
Contemporary American Ceramics (slides)
SERVICES
Slides available for purchase

VR 361
MONTANA STATE UNIVERSITY
Creative Arts Library, Audio-Visual Center
Bozeman, MT 59715
Tel: 406-994-4191
Slide Curator: Emily B Gadd
Founded: 1973
Hours: Mon-Fri 8-5

CIRCULATION POLICY
Slides: Restricted, students, faculty/staff
COLLECTIONS
Films: 10
Slides: 45,000 Kent State University. Architecture
 (Ancient, Islamic, Far East, European, US); Sculpture
 (Ancient, Far East, European, US); Painting (Ancient,
 Far East, European, US)
SUBSCRIPTIONS
Carnegie Set (slides)

VR 362
UNIVERSITY OF MONTANA
Art Department
Missoula, MT 59801
Tel: 406-243-4091
Art Historian: Joel Bernstein
Hours: Mon-Fri 8-5 (office)

CIRCULATION POLICY
Slides: Restricted, researchers, faculty/staff, fee service
 (appointment suggested)
COLLECTIONS
Slides: 18,000. Architecture (Tribal American); Sculpture
 (Tribal American); Painting (Tribal American);
 Graphic Arts (Tribal American); Decorative Arts
 (Tribal American)

VR 363
WESTERN MONTANA COLLEGE LIBRARY
710 S Atlantic St, Dillon, MT 59725
Tel: 406-683-7541
Libn: Ken Cory
Hours: Mon-Thurs 7:30-10:30 pm
 Mon-Thurs 8-5 (office)

CIRCULATION POLICY
Film loops: Restricted, students, faculty/staff
Film strips: Restricted, students, faculty/staff
Photographs: Restricted, students, faculty/staff
Slides: Restricted, students, faculty/staff
Transparencies: Restricted, students, faculty/staff
COLLECTIONS
Films: 600
Microforms: 2,220
Photographs: 800
Slides: 3,465
Video: 240

Nebraska

VR 364
**CONCORDIA TEACHERS COLLEGE OF SEWARD,
 NEBRASKA**
Link Library
800 Columbia, Seward, NE 68434
Tel: 402-643-3651, Ext 258
Libn: Vivian A Peterson
Staff: 3
Founded: 1894

CIRCULATION POLICY
Integrated Media Collection: Public, circulating
COLLECTIONS
Films
Microforms
Photographs
Slides
Transparencies
Video

VR 365
JOSLYN ART MUSEUM
Slide Library
2200 Dodge St, Omaha, NE 68102
Tel: 402-342-3300, Ext 41
Libn: Margaret Prescott
Founded: 1931

CIRCULATION POLICY
Film: Faculty/staff
Photographs: Faculty/staff
Slides: Faculty/staff
COLLECTIONS
Films: 5
Photographs: 15 drawers VF
Slides: 22,000 Fogg. Architecture (Ancient, African,
 Pacific, Tribal American, Meso-American, Euro-
 pean, US); Sculpture (Ancient, Islamic, Far East,
 African, Pacific, Tribal American, Meso-American,
 Andean, European, US); Painting (Ancient, Far East,
 Tribal American, European, US); Graphic Arts (Euro-
 pean, US); Decorative Arts (Islamic, African, Pacific,
 Tribal American, European, US)
SERVICES
Slides: Available for purchase; available for duplication
 subject to copyright regulations

VR 366
UNIVERSITY OF NEBRASKA*
College of Architecture
Lincoln, NE 68508
Tel: 402-472-3593

New Hampshire

VR 367
DARTMOUTH COLLEGE
Art Department
106 Carpenter Hall, Hanover, NH 03755
Tel: 603-646-2572
Curator of Slides: Elizabeth S O'Donnell
Staff: 1

CIRCULATION POLICY
Slides: Restricted
COLLECTIONS
Slides: 125,000. Architecture (Ancient, European, US);
 Sculpture (Ancient, African, European, US); Painting
 (Ancient, European, US); Graphic Arts (European, US);
 Decorative Arts (European, US)
SUBSCRIPTIONS
Carnegie Set (slides)

VR 368
PLYMOUTH STATE COLLEGE
Herbert H Lamson Library
Plymouth, NH 03264
Tel: 503-536-1550, Ext 257
Slide Libn: William Kietzman

CIRCULATION POLICY
Slides: Public (appointment suggested)
COLLECTIONS
Microforms: 200,000
Slides: 27,000 Santa Cruz. Architecture (Ancient); Sculp-
 ture (Ancient, European, US); Painting (Islamic, Far
 East, European, US); Graphic Arts (European, US)
SUBSCRIPTIONS
Carnegie Set (slides)

New Jersey

VR 369
CALDWELL COLLEGE
Art Department Slide Collection
Bloomfield & Ryerson Aves, Caldwell, NJ 07006
Tel: 201-228-4424, Ext 44A
Chairman: Geraldine Mueller
Founded: 1967
Hours: Mon-Fri 9-4
 Mon-Fri 9-5 (office)

CIRCULATION POLICY
Slides: Students, researchers, faculty/staff
COLLECTIONS
Slides: 12,000. Architecture (Ancient, Meso-American,
 European, US); Sculpture (Ancient, Meso-American,
 European, US); Painting (European, US)

VR 370
JERSEY CITY FREE PUBLIC LIBRARY
Fine Arts/Audiovisual
678 Newark Ave, Jersey City, NJ 07306
Tel: 201-547-4546
Fine Arts/AV Libn: Alfred Trattner
Founded: 1881

CIRCULATION POLICY
Films: Public, circulating

Filmstrips: Public, circulating
Photographs: Public, circulating
Slides: Public, circulating
COLLECTIONS
Films: 278
Photographs: 1,500 Subject
Slides: 900 Subject. Painting (European)
Video: 60

VR 371
LODI MEMORIAL LIBRARY
53 Main St, Lodi, NJ 07644
Tel: 201-773-4845
Dir: N Paul Speziale
Staff: 1
Founded: 1924

CIRCULATION POLICY
Cassettes: Public, circulating
Films: Restricted, researchers, faculty/staff (appointment
 suggested)
COLLECTIONS
Cassettes
Films

VR 372
MONTCLAIR ART MUSEUM
The LeBrun Library
3 S Mountain Ave, Montclair, NJ 07042
Tel: 201-746-5555
Libn: Edith A Rights

CIRCULATION POLICY
Slides: Public, fee service (appointment suggested)
COLLECTIONS
Slides: 13,000. Architecture (Ancient, Tribal American,
 European, US); Sculpture (Ancient, Tribal American,
 European, US); Painting (Ancient, Tribal American,
 European, US)

VR 373
MONTCLAIR STATE COLLEGE*
Fine Arts Department, Slide Collection
Upper Montclair, NJ 07043
Tel: 201-893-4000

VR 374
NEW JERSEY INSTITUTE OF TECHNOLOGY
School of Architecture, Information Center
323 High St, Newark, NJ 07102
Tel: 201-645-5547
Supervisor of Information Center: Stephen H Van Dyk
Staff: 1
Founded: 1974
Hours: Mon-Fri 9-5

CIRCULATION POLICY
Slides: Public, circulating
COLLECTIONS
Maps/plans: 670
Models: 50
Slides: 33,000 Santa Cruz. Architecture (Ancient, Isalmic,
 Far East, African, Andean, European, US); Sculpture
 (Ancient, African, European, US); Painting (Islamic,
 European, US); Graphic Arts (US); Decorative Arts
 (European, US)
Video: 4

SPECIAL COLLECTIONS
Man-made environment (slides)
New York City/New Jersey Metropolitan area (slides)

VR 375
NEWARK MUSEUM ASSOCIATION
Newark Museum Library
43-49 Washington St, Newark, NJ 07101
Tel: 201-733-6640; 6584
Lib Asst: Helen Olsson
Founded: 1909
Hours: Mon-Fri 12-5, 9-5

CIRCULATION POLICY
Photographs: Restricted, public (appointment suggested)
Slides: Restricted, public (appointment suggested)
COLLECTIONS
Photographs: 17,700. Sculpture (Ancient, Far East,
 African, Tribal American, US); Painting (Far East,
 US); Decorative Arts (Ancient, Far East, African,
 Tribal American, US)
Slides: 2,000. Sculpture (Ancient, Far East, African, Tribal
 American, US); Painting (Far East, US); Decorative
 Arts (Ancient, Far East, African, Tribal American, US)
SPECIAL COLLECTIONS
East Orange, NJ Historical Society (photographs)
Tibetan Art (photographs)
SERVICES
Photographs: Available for purchase and publication
Slides: Available for purchase
Transparencies: Available for use in publication with per-
 mission of museum

VR 376
NEWARK PUBLIC LIBRARY
Art & Music Department
5 Washington St, Newark, NJ 07101
Tel: 201-733-7840
Supervising Libn, Art & Music: William J Dane
Staff: 8
Founded: 1888
Hours: Mon, Wed, Thurs 9-9
 Tues, Fri 9-6
 Sat 9-5

CIRCULATION POLICY
Circulating Prints: Public, circulating
Fine Prints: Public (appointment suggested)
Pictures: Public, circulating
Posters: Public (appointment suggested)
Slides: Public, circulating
COLLECTIONS
Microforms: 425
Pictures: 1,000,000
Portfolios of plates: 2,000
Posters: 2,500
Prints: 10,000
Slides: 12,000. Architecture (Ancient, European, US);
 Sculpture (Ancient, Far East, African, European, US);
 Painting (Ancient, Far East, European, US); Decorative
 Arts (European)
SUBSCRIPTIONS
Courtauld Institute Illustration Archives (plates)
SPECIAL COLLECTIONS
Edouard Colonna Collection of Original Drawings &
 Photographs

SERVICES
Negatives: Prints are available for purchase

VR 377
NEWARK STATE COLLEGE*
Fine Arts Department, Slide Collection
Morris Ave, Union, NJ 07083
Tel: 201-527-2000

VR 379
PRINCETON UNIVERSITY
Dept of Art & Archaeology, Far Eastern Photographic
 Research Archives
Rm 218, McCormick Hall, Princeton, NJ 08540
Tel: 609-452-3770
Curator, Far Eastern Seminar: Alfreda Murck
Founded: ca 1930
Hours: Mon-Fri 9-5 (office)

CIRCULATION POLICY
Photographs: Restricted, public (appointment suggested)
COLLECTIONS
Photographs: 16,400. Architecture (Far East); Sculpture
 (Far East); Painting (Far East); Decorative Arts (Far
 East)
SUBSCRIPTIONS
Asian Art Photographic Distribution (photographs)
Chinese National Palace Museum Photo Archives
 (photographs)
SPECIAL COLLECTIONS
Paintings in the Soeul National Museum (Korea)
 (photographs)
Tun Huang Caves photographs by James and Lucy Lo
 (photographs)

VR 380
PRINCETON UNIVERSITY
Dept of Art & Archaeology, Section of Slides &
 Photographs
207 McCormick Hall, Princeton, NJ 08540
Tel: 609-452-3776
Dir of Section of Slides & Photographs: Cynthia L Clark
Staff: 1
Founded: 1880s
Hours: Mon-Fri 9-5 (office)

CIRCULATION POLICY
Photographs: Restricted, departmental students,
 researchers, faculty/staff
Slides: Restricted, departmental students, faculty/staff
COLLECTIONS
Photographs: 164,765 Princeton. Architecture (Ancient,
 European, US); Sculpture (Ancient, European, US);
 Decorative Arts (Ancient, European)
Research Photographs: 1,000,000 (unclassified)
Slides: 163,877 Princeton. Architecture (Ancient, Far East,
 European, US); Sculpture (Ancient, Far East, European,
 US); Decorative Arts (Ancient, Far East, European)
SUBSCRIPTIONS
Wayne Andrews (photographs)
James Austin (photographs)
Berenson Archives (photographs)
Carnegie Set (slides)
Decimal Index of the Art of Low Countries (photographs)
Illustrated Bartsch (photographs)
Princeton Index (photographs)

SPECIAL COLLECTIONS
McLaughlin Pre-Columbian Index (reproductions &
 bibliography)
Platt Collection (Painting from Trecento-19th Century;
 photographs & clippings
SERVICES
Negatives: Prints available for purchase by direct appli-
 cations to the Curator of Research Collections for
 the following: 1) H C Butler: Archaeological Expeditions
 to Syria: 1899-1900; 1904-1905; 1909. 2) Antioch
 Collections: negatives of Princeton Archaeological
 Expeditions. 3) Brunnow & Domaszewski Collections:
 photographs of Syrian architecture taken for "Die
 Provincia Arabia," based on two expeditions in
 1897-98

VR 380A
PRINCETON UNIVERSITY*
School of Architecture & Urban Planning
Princeton, NJ 08540
Tel: 609-452-3737

VR 381
RAMAPO COLLEGE OF NEW JERSEY LIBRARY*
Ramapo Valley Rd, Box 542, Mahwah, NJ 07430
Tel: 201-825-2800

VR 382
RUTGERS UNIVERSITY
Douglass College, Art Dept, Slide Collection
New Brunswick, NJ 08903
Tel: 201-932-1766
Founded: 1920s

VR 383
STOCKTON STATE COLLEGE LIBRARY
Pomona, NJ 08240
Tel: 201-652-1776, Ext 241
Slide Collection Specialist: Phyllis Durham
Founded: 1973
Hours: Mon-Thurs 9-8
 Fri 9-5

CIRCULATION POLICY
Films: Public, circualting (appointment suggested)
Slides: Public, circulating (appointment suggested)
Video: Public, circulating (appointment suggested)
COLLECTIONS
Films: 400
Microforms: 60,000
Photographs: 200
Slides: 70,000. Architecture (Ancient, Far East, Meso-
 American, Andean, European, US); Sculpture (Ancient,
 Far East, Meso-American, Andean, European, US);
 Painting (Ancient, European, US); Graphic Arts
 (European, US)
Video: 100
SUBSCRIPTIONS
American Committee of South Asian Art (slides)
SPECIAL COLLECTIONS
American Civilization (slides)
New Jersey Pine Barrens (slides)
Photography (slides)
Theatre History (slides)

New Mexico

VR 384
NEW MEXICO JUNIOR COLLEGE
Pannell Library & Instructional Resources Center
Lovington Hwy, Hobbs, NM 88240
Tel: 505-392-6526, Ext 231
Libn & Dir of IRC: Orin W Hatch
Staff: 2
Founded: 1965

CIRCULATION POLICY
Films: Public
Microforms: Public
Slides: Public
Video: Public
COLLECTIONS
Films: 250
Microforms: 3,151
Slides: 5,473
Video: 38

VR 385
NEW MEXICO STATE UNIVERSITY AT
 CARLSBAD LIBRARY
2900 W Church St, Carlsbad, NM 88220
Tel: 505-885-8831, Ext 27
Libn: Julia White

CIRCULATION POLICY
Microforms: Public
Photographs: Public
COLLECTIONS
Microforms: n.a.
Photographs: n.a.
Slide/Cassettes: 1,265

VR 386
NEW MEXICO STATE UNIVERSITY AT
 GRANTS LIBRARY
1500 Third St, Grants, NM 87020
Tel: 505-287-9349
Libn: Fred Wilding-White
Founded: 1968
Hours: Mon-Thurs 9-5; 6-9
 Fri 9-Noon

CIRCULATION POLICY
Photographs: Researchers, faculty/staff
Slides: Researchers, faculty/staff
COLLECTIONS
Filmstrips: 90
Microforms: 6,500
Photographs: 500
Slides: 400. Sculpture (European); Painting (European);
 Decorative Arts (Far East)

VR 387
UNIVERSITY OF NEW MEXICO
Fine Arts Slide Library
Fine Arts Center, Rm 2010, Albuquerque, NM 87131
Tel: 505-277-4908
Slide Libn: Arlene Zelda Richardson
Staff: 2
Hours: Mon-Fri 8-5 (office)

CIRCULATION POLICY
Photographs: Restricted, faculty/staff (appointment
 suggested)
Slides: Restricted, faculty/staff (appointment suggested)
COLLECTIONS
Photographs: 10,000. Architecture (European); Sculpture
 (European); Painting (European); Graphic Arts (Euro-
 pean); Decorative Arts (European)
Slides: 240,000. Architecture (Ancient, Islamic, Tribal
 American, Meso-American, Andean, European, US);
 Sculpture (Ancient, Islamic, African, Pacific, Tribal
 American, Meso-American, Andean, European, US);
 Painting (Ancient, Tribal American, Meso-American,
 European, US); Graphic Arts (European, US);
 Decorative Arts (European, US)

VR 388
UNIVERSITY OF NEW MEXICO*
School of Architecture & Planning
Albuquerque, NM 87106
Tel: 505-277-2903

New York

VR 389
ADELPHI UNIVERSITY
Library, Fine Arts Department
South Ave, Garden City, NY 11530
Tel: 516-294-8700, Ext 7353
Head, Fine Arts Lib: Erica Doctorow
Staff: 2
Hours: Mon-Thurs 8:30-10
 Fri 8:30-5
 Sat 9-5
 Sun 1-5

CIRCULATION POLICY
Cassettes: Public
Slides: Public
COLLECTIONS
Slides: 12,819 Metropolitan/Santa Cruz. Architecture
 (Ancient, Far East, Meso-American, European, US);
 Sculpture (Ancient, Far East, African, Tribal American,
 Meso-American, European, US); Painting (Ancient, Far
 East, Meso-American, European, US); Graphic Arts
 (European, US); Decorative Arts (Ancient, Far East,
 African, Tribal American, Meso-American, European,
 US)

VR 390
ADELPHI UNIVERSITY
Library, Nonprint Media Department
South Ave, Garden City, NY 11530
Tel: 516-294-8700, Ext 7334
Person in Charge: Allan Rough
Hours: Mon-Thurs 8:30-10
 Sat 9-5
 Sun 1-5

CIRCULATION POLICY
Audio Cassettes: Public
Slide Sets: Public
Video: Public
COLLECTIONS
Audio Cassettes: 11 LC
Slide Sets: 49 LC. Architecture (European, US); Sculpture

(European, US); Painting (European, US); Decorative
 Arts (European)
Video: 1 LC
SUBSCRIPTIONS
Carnegie Set (slides)

VR 391
ALBRIGHT-KNOX ART GALLERY*
Department of Education, Slide Collection
1285 Elmwood Ave, Buffalo, NY 14222
Tel: 716-882-8700
Curator: Charlotte Buel Johnson

VR 392
AMERICAN CRAFTS COUNCIL
Research & Education Department Library
44 W 53 St, New York, NY 10019
Tel: 212-977-8976
Dir: Lois Moran
Staff: 2
Founded: 1956 (library)
Hours: Tues, Wed, Fri 12-5

CIRCULATION POLICY
Audio/Video: Public
Photographs: Public
Portfolio Files: Public
Slides: Public
COLLECTIONS
Films: 7. Contemporary Crafts (US)
Photographs: 5,000. Contemporary Crafts (US)
Slides: 30,000. Contemporary Crafts (US)
Video: 100 reels. Contemporary Crafts (US)
SPECIAL COLLECTIONS
Archives of the Museum of Contemporary Crafts
Craftsmen Portfolio Files & Archives
Your Portable Museum (films, filmstrips, slide kits)
SERVICES
Negatives: Prints available for purchase subject to copy-
 right and museum regulations and fees, dealing with
 museum exhibitions
Slides: Available for sale, catalog available

VR 393
AMERICAN MUSEUM OF NATURAL HISTORY*
Slide Library
Central Park W at 79 St, New York, NY 10024
Tel: 212-873-1300
Assoc Mgr Photograph Collection: Dorothy M Fulton

VR 394
THE ARCHAEOLOGICAL INSTITUTE OF
 AMERICA*
Slides Archive
260 W Broadway, New York, NY 10013
Tel: 212-925-7333
Hours: Mon-Fri 9-4:30

COLLECTION
Slides: 10,000
SERVICES
Slides: Available for purchase only

VR 395
BARNARD COLLEGE*
Art History Department, Slide Collection
606 W 120 St, New York, NY 10027
Tel: 212-280-2118

VR 396
BROOKLYN COLLEGE OF THE CITY
UNIVERSITY
Art Department Slide Collection
Brooklyn, NY 11210
Tel: 212-780-5182
Curator of Slides: Stephen Margolies
Staff: 2
Founded: 1940
Hours: Mon-Fri 9:30-5:30 (office)

CIRCULATION POLICY
Slides: Restricted, faculty/staff
COLLECTIONS
Slides: 70,000. Architecture (Ancient, European, US);
 Sculpture (Ancient, African, European, US); Painting
 (Ancient, Far East, European, US); Decorative Arts
 (African)
SUBSCRIPTIONS
Archaeological Institute of America (slides)
Carnegie Set (slides)

VR 397
BROOKLYN MUSEUM*
Slide Library
Eastern Pkwy & Washington Ave, Brooklyn, NY 11238
Tel: 212-638-5000
Hours: Wed, Thurs, Fri 1-5

CIRCULATION POLICY
Slides: Restricted to use in library only
COLLECTIONS
Slides: 25,000 Brooklyn Museum. Sculpture & Painting
 (museum collection)

VR 398
BROOKLYN PUBLIC LIBRARY
Art & Music Department
Grand Army Plaza, Brooklyn, NY 11238
Tel: 212-636-3214
Chief: William R Johnson
Founded: 1897
Hours: Mon-Thurs 9-8
 Fri-Sat 10-6
 Sun 1-5 (winter only)

CIRCULATION POLICY
Films: Public
Filmstrips: Public
Slides: Public
Video: Public
COLLECTIONS
Films: 2,210
Filmstrips: 870
Slides: 2,816
Video: 30

VR 399
CENTER FOR INTER-AMERICAN RELATIONS
Visual Arts Program
680 Park Ave, New York, NY 10021
Tel: 212-249-8950, Exts 24; 25; 53
Person in Charge: James Wolfe
Staff: 2
Founded: 1967
Hours: Tues-Fri 12-6

CIRCULATION POLICY
Photographs: Restricted, researchers, faculty/staff

(appointment suggested)
Slides: Restricted, researchers, faculty/staff (appointment
 suggested)
COLLECTIONS
Photographs: Sculpture (North & South America); Painting
 (North & South America)
Slides: Sculpture (North & South America); Painting
 (North & South America)

VR 400
CITY COLLEGE OF NEW YORK*
Art Department, Slide Library
Convent Ave & 139 St, New York, NY 10031
Tel: 212-690-6741

VR 401
THE CITY UNIVERSITY OF NEW YORK,
GRADUATE CENTER*
Slide Library
33 W 42 St, New York, NY 10036
Tel: 212-790-4395

VR 401A
THE CITY UNIVERSITY OF NEW YORK
Research Center for Musical Iconography
33 W 42 St, New York, NY 10036
Tel: 212-790-4282; 4554
Research Assoc: Barbara Hampton Renton

CIRCULATION POLICY
By appointment
COLLECTIONS
Photographs

VR 402
COLGATE UNIVERSITY*
Department of Fine Arts, Slide Collection
Hamilton, NY 13346
Tel: 315-824-1000
Curator: Betty Conner

VR 403
COLLEGE OF MT ST VINCENT*
Art Department, Slide Collection
Riverdale, NY 10471
Tel: 212-549-8000

VR 404
COLUMBIA UNIVERSITY
Dept of Art History & Archaeology Photograph Collection
420 Schermerhorn Hall, New York, NY 10027
Tel: 212-280-5203
Head Curator: Wendy Schonfeld
Hours: Mon-Fri 10-5

CIRCULATION POLICY
Photographs: Restricted, researchers, students, faculty/
 staff (non-circulating)
COLLECTIONS
Photographs: 150,000 Columbia. Architecture (European);
 Sculpture (Ancient, African, Meso-American); Painting
 (Far East, European)
SUBSCRIPTIONS
Paul Arndt (ancient sculpture)
James Austin
Berenson Archives
Bibles Moralisses (Vienna and Toledo)

Burke (Japanese)
Chatsworth Collection (Italian Renaissance)
Chinese National Palace Museum Photo Archives
Courtauld Institute Photo Survey of Private Collections
Decimal Index of the Art of Low Countries
Haseloff
Kingsley Porter
Partsche Gaigneries
Popo (Persian Art)
Tun Huang Cave
Windsor Castle drawings
SPECIAL COLLECTIONS
African Metalwork
Aztec Sculpture
Millard Meiss
Sarcophagi

VR 405
COLUMBIA UNIVERSITY*
Graduate School of Architecture & Planning
Slide Library
New York, NY 10027
Tel: 212-280-5118

VR 406
COLUMBIA UNIVERSITY
Slide Collection
612 Schermerhorn Hall, 119 St & Amsterdam Ave,
 New York, NY 10027
Tel: 212-280-3044
Founded: 1928
Hours: Mon-Fri 9-5

CIRCULATION POLICY
Slides: Restricted, students, faculty/staff, fee service
COLLECTIONS
Slides: 400,000 Columbia. Architecture (Ancient, Islamic,
 Far East, African, Pacific, Tribal American, Meso-
 American, Andean, European, US); Sculpture (Ancient,
 Islamic, Far East, African, Pacific, Tribal American,
 Meso-American, Andean, European, US); Painting
 (Ancient, Islamic, Far East, African, Pacific, Tribal
 American, Meso-American, Andean, European, US);
 Graphic Arts (Ancient, Islamic, Far East, African,
 Pacific, Tribal American, Meso-American, Andean,
 European, US); Decorative Arts (Ancient, Islamic, Far
 East, African, Pacific, Tribal American, Meso-
 American, Andean, European, US)
SUBSCRIPTIONS
University Colour Slide Scheme (slides)
SPECIAL COLLECTIONS
Pre-Columbian & Primitive Fieldwork Studies (slides)
SERVICES
Slides: Available for duplication from collection by
 special order

VR 407
COOPER-HEWITT MUSEUM, SMITHSONIAN
INSTITUTION
Picture Library, Doris & Henry Dreyfuss Study Center
2 E 91 St, New York, NY 10028
Tel: 212-860-6882
Libn: Robert C Kaufmann
Staff: 2
Founded: 1896
Hours: Mon-Fri 9-5 (by appointment)

CIRCULATION POLICY
Photographs: Public (appointment required)
Pictures: Public (appointment required)
COLLECTIONS
Photographs & Pictures: 1,500,000 Subject. Architecture
 (Ancient, Islamic, Far East, African, Pacific, Tribal
 American, Meso-American, Andean, European, US);
 Graphic Arts (European, US); Decorative Arts
 (Ancient, Islamic, Far East, African, Pacific, Tribal
 American, Meso-Amercian, Andean, European, US)
SPECIAL COLLECTIONS
Therese Bonney Photographs of Art Deco, Decorative
 Arts (photographs)
Kubler Collection of 19th century Woodcuts & Engrav-
 ings (graphic arts)
John Maximus Collection (Designs & Decorative Art—all
 paper media)
Rose Collections of Woodcuts & Wood Engravings
SERVICES
Slide Kits: Available for sale subject to copyright and
 museum regulations and fees

VR 408
COOPER UNION FOR THE ADVANCEMENT OF
SCIENCE & ART
Slide & Picture Collection
Cooper Square, New York, NY 10003
Tel: 212-254-6300, Ext 330
Asst Libn: Elizabeth B Kline
Founded: ca 1955
Hours: Mon-Fri 9-5

CIRCULATION POLICY
Slides: Students, faculty/staff, circulating
COLLECTIONS
Slides: 33,000 Metropolitan. Architecture (Ancient, Far
 East, European, US); Sculpture (Ancient, European);
 Painting (European, US); Graphic Arts (European)

VR 409
CORNELL UNIVERSITY
College of Architecture, Art & Planning, Slide Library
B-30 Sibley Hall, Ithaca, NY 14853
Tel: 607-256-3300
Slide Curator: Margaret N Webster
Staff: 2
Founded: ca 1880

CIRCULATION POLICY
Slides: Restricted, approved students, researchers, faculty/
 staff, circulating
COLLECTIONS
Slides: 250,000. Architecture (Ancient, European, US)
SUBSCRIPTIONS
Carnegie Set (slides)
SPECIAL COLLECTIONS
Architectural Construction Techniques (slides)
Photography (slides)
SERVICES
Slides: Available for duplication subject to copyright
 regulations and departmental regulations

VR 410
CORNELL UNIVERSITY
History of Art Department
28 Goldwin Smith Hall, Ithaca, NY 14853
Tel: 607-256-4907
Curator: Andrea Wetherbee

Founded: 1950s
Hours: Mon-Fri 8-4 (office)

CIRCULATION POLICY
Photographs: Restricted, faculty/staff
Slides: Restricted, faculty/staff
COLLECTIONS
Films: 3
Photographs: 25,000 Yale. Architecture (Far East, European); Sculpture (Far East); Painting (Far East, European, US); Graphic Arts (Far East); Decorative Arts (Far East)
Slides: 200,000 Yale. Architecture (Ancient, Far East, European, US); Sculpture (Ancient, Far East, Meso-American, European, US); Painting (Ancient, Far East, European, US); Graphic Arts (Far East, European, US); Decorative Arts (Ancient, Far East)
SUBSCRIPTIONS
American Committee of South Asian Art (slides)
Asian Art Photographic Distribution (photographs, slides)
Boston Museum of Fine Arts (slides)
Saskia (slides)
SPECIAL COLLECTIONS
Archives of Chinese Art (photographs)

VR 411
THE CORNING MUSEUM OF GLASS
Corning Glass Center, Corning, NY 14830
Tel: 607-937-5371
Registrar: Priscilla Price
Staff: 1
Founded: 1951
Hours: Mon-Fri 9-5

CIRCULATION POLICY
Photographs: Students, researchers, faculty/staff (appointment required)
Slides: Students, researchers, faculty/staff (appointment required)
COLLECTIONS
Photographs: 5,000 Period/Provenance. Decorative Arts (Ancient, Islamic, Far East, European, US)
Slides: 24,000 Period/Provenance. Architecture (Ancient); Decorative Arts (Ancient, Islamic, Far East, European, US)
SERVICES
Negatives: Prints available for purchase and publication subject to copyright and museum regulations and fees, of objects in museum collection
Slides: 1,000 slides available for purchase of museum collection

VR 412
ELMIRA COLLEGE
Gannett-Tripp Learning Center
Elmira, NY 14901
Tel: 607-734-3911, Exts 241; 242
Person in Charge: James D Gray
Staff: 4
Hours: Mon-Thurs 8:30-11
 Fri 8:30-5
 Sat 11-5
 Sun 11-11

CIRCULATION POLICY
Films: Students, researchers, faculty/staff, circulating (appointment suggested)

Photographs: Researchers, faculty/staff (appointment required)
Slides: Researchers, faculty/staff (appointment suggested)
Slide/tape kits: Students, researchers, circulating
Tapes: Students, researchers, faculty/staff, circulating
COLLECTIONS
Films: 212
Microforms: 33,000
Photographs: 100
Slides: 12,000
Slide/tape kits: 700
Tapes: 15,000
Video: 20
SPECIAL COLLECTIONS
General Historical Collection (glass slides)
Historic Elmira (negatives)
SERVICES
Negatives: Prints available for purchase subject to copyright and college regulations and fees
Slides: Available for purchase

VR 413
FORDHAM UNIVERSITY*
Department of Fine Arts, Slide Collection
Bronx, NY 10458
Tel: 212-933-2233

VR 414
FRICK ART REFERENCE LIBRARY
10 E 71 St, New York, 10021
Tel: 212-BU 8-8700
Asst Libn: Helen Sanger
Founded: 1920
Hours: Mon-Fri 10-4
 Sat 10-12 (noon)
 Closed Sats June & July
 Closed August

CIRCULATION POLICY
Photographs: Researchers (non-circulating)
COLLECTIONS
Photographs: 405,000 Frick. Painting (European, US)
SUBSCRIPTIONS
Courtauld Institute Photo Survey of Private Collections (photographs)
Decimal Index of the Art of Low Countries (photographs)
Gernsheim Collection (photographs)
SERVICES
Negatives: Prints available for purchase subject to copyright and library regulations

VR 415
THE GRANGER COLLECTION
1841 Broadway, New York, NY 10023
Tel: 212-586-0971
Dir: William Glover
Staff: 4
Founded: 1964
Hours: Mon-Fri 9-5

CIRCULATION POLICY
Illustrations: Restricted, professional users only
COLLECTIONS
Illustrations: 3,000,000
SPECIAL COLLECTIONS
Photographs & prints include following subject areas: art, decorative arts, architecture, classical archaeology,

film & video, graphics, photography, music, theater,
dance, portraits, cartoons, history
SERVICES
Reproductive services are available to serve the needs of
the professional illustrations user

VR 416
SOLOMON R GUGGENHEIM MUSEUM
Slide Collection
1071 Fifth Ave, New York, NY 10028
Tel: 212-860-1338
Slide Libn: Mary Joan Hall
Hours: Mon-Fri 11-5

CIRCULATION POLICY
Slides: Restricted, researchers (by appointment only)
COLLECTIONS
Slides: 5,000 Alphabetical by artist. Contemporary Sculp-
ture, Painting & Graphic Arts
SPECIAL COLLECTION
Permanent Guggenheim Collection
SERVICES
Slides: Available for duplication if for study purposes

VR 417
HALL OF FAME FOR GREAT AMERICANS
2 Washington Square Village, 1 F, New York, NY 10012
Tel: 212-533-4450
Executive Dir: Dr Jerry Grundfest
Staff: 2
Founded: 1900
Hours: Mon-Fri 9-5

CIRCULATION POLICY
Models: Restricted (appointment suggested)
Photographs: Restricted, researchers, fee service
(appointment suggested)
Slides: Restricted, researchers, fee service (appointment
suggested)
COLLECTIONS
Models: 10
Photographs: 1,000. Architecture (US); Sculpture (US)
Slides: 200
SPECIAL COLLECTIONS
Hall of Fame recipients (sculpture)
SERVICES
Negatives: Available for purchase, subject to copyright
regulations and fees
Slides: Available for purchase and duplication subject
to copyright regulations

VR 418
HISPANIC SOCIETY
Department of Iconography
613 W 155 St, New York, NY 10032
Tel: 212-926-2234
Assoc Curator of Iconography: Lyndia A Dufour
Staff: 1
Founded: 1904
Hours: Tues-Fri 1-4:30
 Sat 10:30-4:30

CIRCULATION POLICY
Photographs: Restricted (appointment suggested)
Prints: Restricted (appointment suggested)
Slides: Restricted (appointment suggested)

COLLECTIONS
Films: 10
Photographs: 200,000. Architecture (Islamic-Spain,
Andean, European); Sculpture (European); Painting
(European); Graphic Arts (European); Decorative Arts
(Islamic-Spain, European)
Prints: 8,000
Slides: 5,000
Video: 10
SPECIAL COLLECTIONS
Hispanic Society co-sponsored Expeditions (photographs)
Schindler Collection (photographs)
Shipley Collection (photographs)
Solano Collection (photographs)
Yale-Peruvian Expedition by Hiram Gingham
(photographs)
SERVICES
Negatives: Prints available for purchase of Society and
library holdings, subject to copyright regulations and
fees
Slides: Available for purchase of Society/museum and
library collections

VR 419
INTERNATIONAL MUSEUM OF PHOTOGRAPHY
AT GEORGE EASTMAN HOUSE
Archives
900 East Ave, Rochester, NY 14607
Tel: 716-271-3361, Exts 236; 235
Dir of Archives: Martha E Jenks
Staff: 3
Founded: 1939
Hours: Tues-Fri 1:30-4:45 (by appointment)

CIRCULATION POLICY
Photographs: Restricted (appointment suggested)
Slides: Restricted
COLLECTIONS
Photographs: 450,000
SERVICES
Negatives: Prints available for study, publications,
exhibitions from the museum's collections

VR 420
HERBERT F JOHNSON MUSEUM OF ART
Cornell University, Ithaca, NY 14853
Tel: 607-256-6464
Asst Curator: Elizabeth C Evans
Staff: 1
Founded: 1953
Hours: Mon-Fri 9-5

CIRCULATION POLICY
Photographs: Restricted (appointment required)
Slides: Restricted (appointment required)
COLLECTIONS
Photographs: 900
Slides: 3,500. Sculpture (Far East, African, Meso-
American, European, US); Painting (Far East, Euro-
pean, US); Graphic Arts (European, US); Decorative
Arts (Meso-American)
Video: 25
SERVICES
Negatives: Prints available for purchase of approximately
half of the museum collection
Slides: Available for purchase

VR 421
**KINGSBOROUGH COMMUNITY COLLEGE OF
 THE CITY UNIVERSITY OF NEW YORK***
Department of Speech, Music & Art, Slide Library
Oriental Blvd, Manhattan Beach, Brooklyn, NY 11235
Tel: 212-769-9200

VR 422
LAKE PLACID SCHOOL OF ART*
Fine Arts Library
Saranac Ave at Fawn Ridge, Lake Placid, NY 12946
Tel: 518-523-2115
Acting Head Libn: Laurie J Averill

VR 423
SARAH LAWRENCE COLLEGE*
Slide Library
Bronxville, NY 10708
Tel: 914-337-0700

VR 424
MANHASSET PUBLIC LIBRARY
30 Onderdonk Ave, Manhasset, NY 11030
Tel: 516-627-2300
Dir: Elaine Seaton
Founded: 1945
Hours: Mon-Thurs 9-9
 Fri-Sat 9-5:30
 Sun 12-4:30

CIRCULATION POLICY
Slides: Public, circulating
COLLECTIONS
Slides: 300

VR 425
MANHATTAN COLLEGE*
Fine Arts Department, Slide Collection
Bronx, NY 10471
Tel: 212-548-1400

VR 426
METROPOLITAN MUSEUM OF ART
Department of Primitive Art, Robert Goldwater Library,
 Photograph Study Collection
Fifth Avenue at 82 St, New York, NY 10028
Tel: 212-535-7710
Hours: Tues-Fri 10-4:45
 Closed August

CIRCULATION POLICY
Photographs: Restricted reference only, public
COLLECTIONS
Photographs: Architecture (African, Pacific, Meso-
 American, Andean); Sculpture (African, Pacific, Tribal
 American, Meso-American, Andean); Painting (African,
 Pacific, Tribal American, Meso-American, Andean);
 Graphic Arts (African, Pacific, Tribal American, Meso-
 American, Andean); Decorative Arts (Tribal American,
 Meso-American, Andean)

VR 427
METROPOLITAN MUSEUM OF ART
Photograph & Slide Library
Fifth Ave at 82 St, New York, NY 10028
Tel: 212-879-5500, Ext 260
Chief Libn: Margaret P Nolan

Staff: 5
Founded: 1905
Hours: Tues-Fri 10-4:45
 Closed August

CIRCULATION POLICY
Photographs: Restricted reference, public, staff circulating
 only
Slides: Public, fee service, circulating
COLLECTIONS
Photographs: 252,000 Metropolitan. Architecture (Ancient,
 Far East, European, US); Sculpture (Ancient, Far East,
 European, US); Painting (Ancient, Far East, European,
 US); Decorative Arts (Far East, European, US)
Slides: 330,000 Metropolitan. Architecture (Ancient,
 Islamic, Far East, African, Pacific, Tribal American,
 Andean, European, US); Sculpture (Ancient, Far East,
 African, Pacific, Tribal American, European, US);
 Painting (Ancient, Islamic, Far East, European, US);
 Graphic Arts (European, US); Decorative Arts (Ancient,
 Islamic, Far East, African, Pacific, Tribal American,
 European, US)
SUBSCRIPTIONS
Wayne Andrews (slides)
Carnegie Set (slides)
University Colour Slide Scheme (slides)
SPECIAL COLLECTIONS
William Keighley Color Slide Collection (slides) of
 ecclesiastical and domestic architecture and decorative
 arts of France, England, Germany, Spain, Italy and
 the Holy Land
SERVICES
Negatives: Prints available for purchase for study and
 reproduction of museum objects subject to copyright
 and museum regulations and fees
Slides: Available for purchase and duplication of museum
 objects subject to copyright and museum regulations
 and fees

VR 428
MORRIS GERBER COLLECTION
55 Sycamore St, Albany, NY 12208
Tel: 518-489-3051
Historian: Morris Gerber
Founded: 1950
Hours: By appointment

CIRCULATION POLICY
Films: Public, fee service (by appointment)
Photographs: Public, fee service (by appointment)
Slides: Public, fee service (by appointment)
COLLECTIONS
Films
Microforms
Photographs
Slides
SPECIAL COLLECTIONS
Morris Gerber Collection (photographs, slides)
SERVICES
Photographs: Available for purchase and use in publication
 with permission
Slides: Available for purchase

VR 429
**MUNSON-WILLIAMS-PROCTOR INSTITUTE
 LIBRARY**
310 Genesee Dr, Utica, NY 13502
Tel: 315-797-0000, Ext 23

Person in Charge: Martha S Maier
Founded: 1940s
Hours: Tues-Sat 10-5

CIRCULATION POLICY
Slides: Public, circulating to museum members
COLLECTIONS
Slides: 15,000. Architecture (Ancient, European, US);
Sculpture (Ancient, Meso-American, European, US);
Painting (Far East, Tribal American, European, US);
Graphic Arts (Far East, European, US); Decorative
Arts (African, Tribal American, Meso-American,
European, US)
SUBSCRIPTIONS
Carnegie Set (slides)
SERVICES
Negatives: Prints available for sale and publication use,
subject to museum and copyright regulations
Slides: Available for sale and duplication of works in
museum collection
Transparencies: Available for use in publications subject
to museum and copyright regulations

VR 430
MUSEUM OF THE AMERICAN INDIAN,
HEYE FOUNDATION
Broadway at 155 St, New York, NY 10032
Tel: 212-283-2420
Head of Photography Dept: Carmelo Guadagno
Founded: 1922
Hours: Tues-Fri 10-4

CIRCULATION POLICY
Photographs: Public, fee service (appointment required)
Slides: Public, fee service (appointment required)
COLLECTIONS
Films: 14
Photographs: 41,000. Sculpture (Tribal American, Meso-
American, Andean); Decorative Arts (Tribal American,
Meso-American, Andean)
Slides: 4,500. Sculpture (Tribal American, Meso-
American, Andean); Decorative Arts (Tribal American,
Meso-American, Andean)
SPECIAL COLLECTIONS
American Indian Artifacts (negatives, slides)
SERVICES
Negatives: Prints available for purchase subject to copy-
right regulations and fees
Slides: Available for purchase

VR 431
THE MUSEUM OF MODERN ART
Audio-Visual Archive
11 W 53 St, New York, NY 10019
Tel: 212-956-2689
Archival Asst: Esther M Carpenter
Founded: 1966
Hours: Mon-Fri 11-5

CIRCULATION POLICY
Photographs: Public, fee service (appointment suggested)
Slides: Restricted, faculty/staff
Tapes: Public (appointment suggested)
COLLECTIONS
Photographs: 175,000. Sculpture (European, US); Painting
(European, US); Graphic Arts (European, US)
Slides: 2,500. Sculpture (European, US); Painting (Euro-
pean, US)

Tapes: 600
SPECIAL COLLECTIONS
Museum of Modern Art Collections
SERVICES
Negatives: Prints available for purchase; reproduction
subject to copyright regulations and regulations and
fees of museum; cover museum history, collections
and exhibitions
Slides: Available for purchase at Museum Bookstore

VR 432
THE MUSEUM OF MODERN ART
Department of Photography
21 W 53 St, New York, NY 10019
Tel: 212-956-2696
Dir of Dept of Photography: John Szarkowski
Staff: 5
Founded: 1940
Hours: Mon-Fri 9:30-5:30 (by appointment only)

CIRCULATION POLICY
Photographs: Restricted, students, researchers, faculty/
staff (appointment required)
COLLECTIONS
Photographs: 10,000 (by photographer's name)
SPECIAL COLLECTIONS
Museum of Modern Art Photography Collection
SERVICES
Negatives: Prints available for purchase, reproduction
rights and fees required
Slides: Available for purchase through the Education
Department illustrating museum's photography collection

VR 433
NIAGARA COUNTY COMMUNITY COLLEGE
LIBRARY*
430 Buffalo Ave, Niagara Falls, NY 14303
Tel: 716-731-4101; 3271

VR 434
NEW ROCHELLE PUBLIC LIBRARY
Fine Arts Department
662 Main St, New Rochelle, NY 11361
Tel: 914-576-2728
Dir: Eugene M Mittelgluck
Founded: 1892
Hours: Mon-Thurs 9-9
 Fri 9-6
 Sat 9-5

CIRCULATION POLICY
Pictures: Public, circulating
Prints: Public, circulating
Slides: Public, circulating
COLLECTIONS
Pictures: 439,659. Architecture (European, US); Painting
(European, US); Decorative Arts (European, US)
Slides: 5,155. Architecture (European, US); Sculpture
European, US); Painting (European, US); Decorative
Arts (European, US)

VR 435
NEW YORK CITY COMMUNITY COLLEGE
Namm Hall Audio Visual Center
300 Jay St, Brooklyn, NY 11201
Tel: 212-643-3803
Person in Charge: Prof Paul Sherman

Founded: 1967
Hours: Mon-Thurs 9-8
 Fri 9-5

CIRCULATION POLICY
Films: Students, faculty/staff
Microforms: Students, faculty/staff, fee service
Video-cassettes: Students, faculty/staff
COLLECTIONS
Films: 785
Microforms: 4,090
Video: 6

VR 436
THE NEW YORK PUBLIC LIBRARY/THE
RESEARCH LIBRARIES
Fifth Ave & 42 St, New York, NY 10018
Tel: 212-790-6254
Andrew W Mellon Dir: James W Henderson
Founded: 1895

CIRCULATION POLICY
Non-circulating
COLLECTIONS
Films: 2,721 NYPL
Microforms: 1,208,040 NYPL
Models: n.a. NYPL
Photographs: 2,581,509 NYPL. Architecture (Ancient, Islamic, Far East, African, Pacific, Tribal American, Meso-American, Andean, European, US, Canada); Sculpture (Ancient, Islamic, Far East, African, Pacific, Tribal American, Meso-American, Andean, European, US, Canada); Painting (Ancient, Islamic, Far East, African, Pacific, Tribal American, Meso-American, Andean, European, US, Canada); Graphic Arts (Ancient, Islamic, Far East, African, Pacific, Tribal American, Meso-American, Andean, European, US, Canada); Decorative Arts (Ancient, Islamic, Far East, African, Pacific, Tribal American, Meso-American, Andean, European, US, Canada)
Slides: n.a. NYPL. Sculpture (African); Painting (African)
Video: 370 NYPL
SPECIAL COLLECTIONS
Prints Division: Keeper of Prints, Elizabeth E Roth
 Collection Emphases: 19th Century French & American; Contemporary American & European
 Special Collections: American Views (Phelps Stokes Collection); New York City Views (Enco Collection); British & American Caricatures; George Washington Portraits (McAlpin Collection; Milton & Pope Portraits (Beverly Chew Bequest; Bookplates (including Radin Collection of Western European Bookplates); Japanese Prints (Smith Collection)
Theatre Collections Division: Curator, Paul Myers
 Special Collections: Photographs, Original Designs and Drawings, Scrapbooks (David Belasco Collection); History of Parisian State 17th-19th Centuries (Henin Collection); Clippings; Holograph Letters & Unmounted Photographs (Robinson Locke Collection)
Art Library, 20 W 53 St; Libn, Rebecca Siekevitz
Film Library, 20 W 53 St; Libn, William Sloan
Picture Collection, Fifth Ave & 42 St; Libn, Lenore Cowan

VR 437
NEW YORK UNIVERSITY, INSTITUTE OF
FINE ARTS
Slide Collection

One E 78 St, New York, NY 10021
Tel: 212-988-5550
Curator: Joan Abrams
Founded: 1940
Hours: Mon-Fri 9-5
 Wed 9-8 (office)

CIRCULATION POLICY
Slides: Restricted, students, researchers, faculty/staff
COLLECTIONS
Slides: 260,000 Institute of Fine Arts. Architecture (Ancient, Islamic, Far East, European, US); Sculpture (Ancient, Islamic, Far East, European, US); Painting (Ancient, Islamic, Far East, European, US); Graphic Arts (Far East, European, US); Decorative Arts (Ancient, Islamic, Far East, European)
SUBSCRIPTIONS
American Committee of South Asian Art (slides)
Carnegie Set (slides)
SERVICES
Negatives: Prints are available for purchase by special arrangement with curator and photographer from the collection of lantern slides

VR 438
ONONDAGA COUNTY PUBLIC LIBRARY
Art & Music Department
335 Montgomery Dr, Syracuse, NY 13202
Tel: 315-473-4492
Person in Charge: Beatrice N Maple
Founded: 1916
Hours: Mon, Wed, Fri 9-9
 Tues, Thurs 9-5:30
 Sat 9-5

CIRCULATION POLICY
Picture File: Public, circulating
COLLECTIONS
Picture File: 175,000

VR 439
PRATT INSTITUTE
Art & Architecture Department
Brooklyn, NY 11205
Tel: 212-636-3685
Slide & Circulation Asst: Liz Delgado

CIRCULATION POLICY
Slides: Students, faculty/staff
COLLECTIONS
Slides: 62,500. Architecture (Ancient, European, US); Sculpture (Ancient, European); Painting (Ancient, European, US); Graphic Arts (European); Design Arts (Ancient, European); Photography (European, US); Book Arts (European)

VR 440
QUEENS BOROUGH PUBLIC LIBRARY
Framed Picture Collection
89-11 Merrick Blvd, Jamaica, NY 11432
Tel: 212-739-1900
Art & Music Div Libn: Wendy Wiederhorn
Founded: 1965
Hours: Mon 10-9
 Tues-Fri 10-6
 Sat 10-5:30

CIRCULATION POLICY
Framed Picture Collection: Circulating
COLLECTIONS
Framed Picture Collection: 300

VR 441
**QUEENS COLLEGE OF THE UNIVERSITY OF
 NEW YORK**
Art Department Slide Collection
Kissena Blvd, Flushing, NY 11367
Tel: 212-520-7243
Slide Curator: Dorothy Berman

CIRCULATION POLICY
Slides: Restricted, art department faculty
COLLECTIONS
Slides: 100,000

VR 443
ROCHESTER INSTITUTE OF TECHNOLOGY
Media Resource Center
One Lomb Memorial Dr, Rochester, NY 14623
Tel: 716-464-2030
Dir of AV Services: Reno Antonietti
Staff: 3
Hours: Mon-Fri 8:30-4:30

CIRCULATION POLICY
Films: Restricted, public
Filmstrips: Restricted, public
Slides: Restricted, public
COLLECTIONS
Films: 430
Slides: 70,000 Santa Cruz. Architecture (Ancient, Euro-
 pean, US); Sculpture (Ancient); Painting (European,
 US); Graphic Arts (European); Decorative Arts (US)
Video: 100

VR 444
ROCHESTER MUSEUM & SCIENCE CENTER
657 East Ave, Rochester, NY 14603
Tel: 716-223-4780, Ext 30
Assoc Libn: Janice Taver Wass
Hours: Tues-Sat 9-12, 1-5

CIRCULATION POLICY
Photographs: Public (appointment suggested)
Slides: Public (appointment suggested)
TV News Film: Restricted (appointment suggested)
COLLECTIONS
Films: 500,000 ft.
Photographs: 15,000. Architecture (US); Decorative Arts
 (US)
Slides: 100
SPECIAL COLLECTIONS
Local Rochester (NY) History (negatives)
SERVICES
Negatives: Prints are available for purchase from the local
 history and museum collections subject to copyright
 and museum regulations and fees
Slides: Available for sale subject to copyright and museum
 regulations and fees

VR 445
ROCHESTER PUBLIC LIBRARY
Art Division
115 South Ave, Rochester, NY 14604
Tel: 716-428-7300; 7332

Div Head: Mary Lee Miller
Staff: 3
Founded: 1911

CIRCULATION POLICY
Picture File: Public, circulating
Slides: Public, circulating
COLLECTIONS
Picture File: 84 drawers Subject
Slides: 11,000 Dewey
SUBSCRIPTIONS
Carnegie Set (slides)

VR 446
ROCHESTER PUBLIC LIBRARY
Reynolds Audio Visual Department
115 South Ave, Rochester, NY 14604
Tel: 716-428-7333
Head: Robert Barnes
Staff: 1
Founded: 1948
Hours: Mon-Fri 9-9

CIRCULATION POLICY
Films: Public, fee service, circulating (appointment
 suggested)
Filmstrips: Public, fee service, circulating (appointment
 suggested)
Video: Public, fee service, circulating (appointment
 suggested)
COLLECTIONS
Films: 150
SUBSCRIPTIONS
Ascent of Man (video)
Civilization (video)

VR 446A
NICHOLAS ROERICH MUSEUM INC
319 W 107 St, New York, NY 10025
Tel: 212-UN 4-7752
Founded: 1923
Hours: Mon-Fri 2-5

CIRCULATION POLICY
Paintings: n.a.
Slides: Public (appointment suggested)
COLLECTIONS
Reproductions: n.a. Paintings
SERVICES
Negatives: Prints are available for purchase subject to
 copyright museum regulations and fees

VR 447
RUSSELL SAGE COLLEGE*
Art Department, Slide Library
28 First St, Troy, NY 12180
Tel: 518-270-2000

VR 448
SCHOOL OF VISUAL ARTS LIBRARY
380 Second Ave, New York, NY 10010
Tel: 212-679-7350, Ext 67; 68
Libn: Zuki Landau
Slide Curator: Cynthia Roberts

CIRCULATION POLICY
Slides: Restricted, faculty/staff only

Pictures: Students, faculty/staff
COLLECTIONS
Slides: 28,000 School of Visual Arts. Architecture (European, US); Sculpture (Far East, European, US); Painting (Far East, European, US); Graphic Arts (European, US); Decorative Arts (Far East, European, US)
Pictures: 20,000 Subject

VR 449
SKIDMORE COLLEGE*
Library, Art Reading Room, Slide Collection
Saratoga Springs, NY 12866
Tel: 518-584-5000
Founded: 1933

VR 450
HOBART & WILLIAM SMITH COLLEGES*
Slide Library
Geneva, NY 14456
Tel: 315-789-5500

VR 451
STATE UNIVERSITY OF NEW YORK AT ALBANY*
Department of Art, Slide Library
1400 Washington Ave, Albany, NY 12203
Tel: 518-457-3300

VR 452
STATE UNIVERSITY OF NEW YORK AT BINGHAMTON
Department of Art & Art History, Visual Resources
Vestal Pkwy E, Binghamton, NY 13901
Tel: 607-798-2215
Curator: Joyce C Henderson
Founded: 1960s
Hours: Mon-Fri 8:30-5

CIRCULATION POLICY
Photographs: Restricted
Slides: Students, researchers, faculty/staff
COLLECTIONS
Photographs: 50,000 Fogg. Architecture (Ancient, European); Sculpture (European); Painting (European)
Slides: 130,000 Fogg. Architecture (European, US); Sculpture (Ancient, European, US); Painting (Ancient, European, US)
SUBSCRIPTIONS
James Austin (photographs)
Bartsch (photographs)
Decimal Index of the Art of Low Countries (photographs)

VR 453
STATE UNIVERSITY OF NEW YORK AT BUFFALO
Art History Department Slide Collection
345 Richmond Quad, Ellicott Complex, Buffalo, NY 14261
Tel: 716-636-2437
Slide Curator: Dawn Donaldson
Hours: Mon-Fri 9-4:30

CIRCULATION POLICY
Photographs: Restricted (appointment suggested)
Slides: Restricted, faculty, circulating (appointment suggested)
COLLECTIONS
Lantern Slides: 22,000 Fogg

Photographs: 10,000 Fogg. Architecture (Ancient, European, US); Sculpture (Ancient, European, US); Painting (Ancient, European, US); Graphic Arts (European, US)
Slides: 85,000 Fogg. Architecture (Ancient, Far East, European, US); Sculpture (Ancient, Far East, African, Tribal American, European, US); Painting (Ancient, Far East, European, US); Graphic Arts (Far East, European, US); Decorative Arts (Ancient, Far East, African, Tribal American, European)
SUBSCRIPTIONS
James Austin (slides)
Carnegie Set (slides)

VR 454
STATE UNIVERSITY OF NEW YORK AT STONY BROOK*
Library, Art & Audiovisual Dept
Stony Brook, NY 11794
Tel: 516-246-5000
Art & AV Libn: Constance E Koppleman

VR 455
STATE UNIVERSITY OF NEW YORK COLLEGE AT BROCKPORT*
Art Department, Slide Resource Center
Brockport, NY 14420
Tel: 716-395-2209
Slide Curator: Katherine M Parker

VR 456
STATE UNIVERSITY OF NEW YORK COLLEGE AT CORTLAND
Art Department, Slide Lib
Cortland, NY 13045
Tel: 607-753-4318
Curator: Jo Schaffer
Founded: 1969
Hours: Mon-Fri 9-4 (by appointment)

CIRCULATION POLICY
Slides: Public, circulating (appointment suggested)
COLLECTIONS
Films: 10
Slides: 65,000 Minnesota. Architecture (Ancient, Meso-American, Andean, European, US); Sculpture (Ancient, Far East, African, Tribal American, Meso-American, European, US); Painting (Ancient, Far East, European, US); Graphic Arts (Far East, European, US); Decorative Arts (Ancient, Far East, African, Pacific, Tribal American, Meso-Amercian, Andean, European, US)
SUBSCRIPTIONS
James Austin (slides)
Carnegie Set (slides)
SPECIAL COLLECTIONS
American Pop Culture (slides)

VR 457
STATE UNIVERSITY OF NEW YORK COLLEGE AT NEW PALTZ
Slide Library
New Paltz, NY 12561
Tel: 914-257-2200
Person in Charge: Steven Martits
Hours: Mon-Fri 9-5

CIRCULATION POLICY
Slides: Faculty/staff
COLLECTIONS
Slides: 50,000. Architecture (Ancient, Islamic, Far East,
African, Meso-American, European, US); Sculpture
(Ancient, Far East, African, Meso-American, European,
US); Painting (Ancient, Islamic, Far East, African,
Meso-American, European, US); Graphic Arts (Euro-
pean, US); Decorative Arts (European, US)
SUBSCRIPTIONS
Carnegie Set (slides)

VR 458
**STATE UNIVERSITY OF NEW YORK COLLEGE
AT OSWEGO**
Art Department, Slide Library
Tyler Fine Arts Center, Rm 217, Oswego, NY 13126
Tel: 315-341-2177
Slide Curator: Marjorie H Panadero
Hours: Mon-Fri 9-12:30 (office)

CIRCULATION POLICY
Slides: Faculty/staff
COLLECTIONS
Slides: 25,000 Fogg. Architecture (European, US); Sculp-
ture (European); Painting (Far East, European, US);
Decorative Arts (Far East)

VR 459
**STATE UNIVERSITY OF NEW YORK COLLEGE
AT PURCHASE***
Library, Slide Department
Purchase, NY 12577
Tel: 914-253-5070
Slide Curator: Sally A Dalrymple

VR 460
SYRACUSE UNIVERSITY LIBRARIES
206 Bird Lib, Waverlyhue, Syracuse, NY 13210
Tel: 315-423-2916
Slide Curator: Romona Roters
Staff: 2½
Hours: Mon-Fri 8:30-5 (office)

CIRCULATION POLICY
Slides: Graduate students, faculty/staff
COLLECTIONS
Slides: 133,000 Fogg. Architecture (Ancient, Islamic, Far
East, Meso-American, European, US); Sculpture
(Ancient, African, Meso-American, European, US);
Painting (Ancient, Far East, Pacific, European, US);
Graphic Arts (US); Decorative Arts (Ancient, Euro-
pean, US)
SPECIAL COLLECTIONS
Cistercian Churches (slides)
Crusades (slides)
Theatre Series (slides)
Women Artists (slides)
Bernice M Wright Memorial Lecture by Bettye Caldwell
(slides)

VR 461
TIME-LIFE PICTURE COLLECTION*
Time-Life Bldg, Rockefeller Center, New York, NY 10021
Tel: 212-541-8041

VR 462
UNITED STATES MILITARY ACADEMY*
Library, Fine Arts Department
West Point, NY 10996
Tel: 914-938-2247
Fine Arts Libn/Sr Lecturer in Art: Elizabeth M Lewis

VR 463
THE UNIVERSITY OF ROCHESTER
Slide & Photograph Center
Art Library-Rush Rhees, Rochester, NY 14627
Tel: 716-275-4476
Slide & Photograph Curator: Shirley M Gray
Founded: 1920
Hours: Mon-Fri 9-5

CIRCULATION POLICY
Films: Students, researchers, faculty/staff, circulating
(appointment suggested)
Photographs: Students, researchers, faculty/staff,
circulating (appointment suggested)
Slides: Public, circulating (appointment suggested)
COLLECTIONS
Photographs: 15,000 Fogg. Architecture (Ancient, Euro-
pean, US); Sculpture (Ancient, Far East, European,
US); Painting (Far East, European, US); Graphic Arts
(European)
Slides: 70,000 Fogg. Architecture (Ancient, European,
US); Sculpture (Ancient, Far East, European, US);
Painting (Far East, European, US); Graphic Arts
(European); Decorative Arts (European)
SUBSCRIPTIONS
Asian Art Photographic Distribution (slides)
Carnegie Set (slides)
Chinese National Palace Museum Photo Archives (slides)
Civilisation Series-Kenneth Clark (films)
Decimal Index of the Art of Low Countries (photographs)

VR 464
VASSAR COLLEGE
Slide & Photograph Collection
Raymond Ave, Poughkeepsie, NY 12601
Tel: 914-452-7000, Ext 2655
Curator: Nicholas S DeMarco
Hours: Mon-Fri 8:30-5

CIRCULATION POLICY
Photographs: Students by permission, researchers,
faculty/staff (appointment suggested)
Slides: Students by permission, researchers, faculty/staff
(appointment suggested)
COLLECTIONS
Photographs: 30,000
Slides: 95,000 Fogg. Architecture (Ancient, European,
US); Sculpture (Ancient, Far East, European, US);
Painting (Ancient, Far East, European, US); Graphic
Arts (European); Decorative Arts (European, US)
SPECIAL COLLECTIONS
European & Modern Architecture, Sculpture, and Painting
(negatives)
SERVICES
Negatives: Prints available for purchase
Slides: Available for purchase and duplication on a limited
bases

VR 465
WHITNEY MUSEUM OF ART LIBRARY*
945 Madison Ave, New York, NY 10021
Tel: 212-794-0600

VR 466
YIVO INSTITUTE FOR JEWISH RESEARCH, INC
Slide Bank, Photo Collection
1048 Fifth Ave, New York, NY 10028
Tel: 212-LE 5-6700, Ext 32
Slides: Bernice Selden
Photographs: Marek Web
Staff: 2
Founded: 1925
Hours: Mon-Fri 9:30-5:30

CIRCULATION POLICY
Photographs: Public, fee service, circulating
Slides: Public, fee service, circulating (appointment
 required)
COLLECTIONS
Films: 50
Photographs: 100,000. Painting (European, US); Graphic
 Arts (European, US); Decorative Arts (European, US)
Slides: 2,000. Painting (European, US); Graphic Arts
 (European, US); Decorative Arts (European, US)
SPECIAL COLLECTIONS
Jewish History, Life & Art (art, photographs, slides)
SERVICES
Negatives: Prints available for purchase and use for repro-
 duction subject to copyright regulations and fees

VR 467
**YORK COLLEGE OF THE CITY UNIVERSITY OF
 NEW YORK***
Department of Fine Arts, Slide Library
Jamaica, NY 11451
Tel: 212-969-4040
Slide Curator: Agnes V Kelly

North Carolina

VR 468
BREVARD COLLEGE
J A Jones Library
Brevard, NC 28712
Tel: 919-883-8292, Ext 68
Person in Charge: Jane Wright
Staff: 1
Founded: 1853
Hours: Mon-Fri 8-6:30
 Mon-Fri 8-5 (office)

CIRCULATION POLICY
Slides: Restricted, students, faculty, Transylvania County
 residents
COLLECTIONS
Slides: 400

VR 469
DUKE UNIVERSITY
Art Department
East Duke Bldg, Durham, NC 27708
Tel: 919-684-2224
Slide Curator: Elizabeth M Mansell
Staff: 2

Founded: 1932
Hours: Mon-Fri 8-5

CIRCULATION POLICY
Photographs: Students, researchers, faculty/staff
Slides: Restricted, students, researchers, faculty/staff
COLLECTIONS
Photographs: 29,000 Metropolitan, Architecture (Ancient,
 Islamic, Far East, African, Pacific, Tribal American,
 Meso-American, European, US); Sculpture (Ancient,
 Islamic, Far East, African, Pacific, Tribal American,
 Meso-American, European, US); Painting (Ancient,
 Islamic, Far East, African, Pacific, Tribal American,
 European, US); Graphic Arts (Far East, European, US);
 Decorative Arts (Ancient, Islamic, European, US)
Slides: 117,000 Metropolitan. Architecture (Ancient,
 Islamic, Far East, African, Pacific, Tribal American,
 Meso-American, Andean, European, US); Sculpture
 (Ancient, Islamic, Far East, African, Pacific, Tribal
 American, Meso-American, Andean, European, US);
 Painting (Ancient, Islamic, Far East, African, Pacific,
 Tribal American, European, US); Graphic Arts (Far
 East, European, US); Decorative Arts (Ancient, Islamic,
 Tribal American, European, US)
SUBSCRIPTIONS
Wayne Andrews (photographs)
James Austin (photographs)
Carnegie Set (slides)
Decimal Index of the Art of Low Countries (photographs)

VR 470
EAST CAROLINA UNIVERSITY
School of Art, Library
Greenville, NC 27834
Tel: 919-757-6785
Libn: Nancy J Pistorius
Founded: 1967
Hours: Mon-Fri 8-12, 1-5 (office)

CIRCULATION POLICY
Slides: Faculty only
COLLECTIONS
Films: (small) LC
Slides: 50,000 Metropolitan. Architecture (Ancient, Euro-
 pean, US); Sculpture (Ancient, African, Pacific, Tribal
 American, Meso-American, Andean, European, US);
 Painting (Ancient, European, US); Graphic Arts (Euro-
 pean, US); Decorative Arts (Ancient, European, US)

VR 471
**MUSEUM OF EARLY SOUTHERN DECORATIVE
 ARTS**
Photographic Study Collection
924 S Main St, Winston-Salem, NC 27108
Tel: 919-722-6148
Dir: T Gray
Staff: 4
Founded: 1965

CIRCULATION POLICY
Photographs: Public (appointment suggested)
Slides: Public (appointment suggested)
COLLECTIONS
Photographs: 5,000. Architecture (US); Sculpture (US);
 Painting (US); Graphic Arts (US); Decorative Arts
 (US)

Slides: 5,000. Architecture (US); Sculpture (US); Painting
(US); Graphic Arts (US); Decorative Arts (US)

VR 472
NORTH CAROLINA MUSEUM OF ART
Art Reference Library, Cultural Resources Department
Raleigh, NC 27611
Tel: 919-733-7568
Libn: Cheryl Warren
Founded: 1956
Hours: Tues-Fri 10-5

CIRCULATION POLICY
Color Transparencies: Public
Negatives: Public, restricted circulation
Photographs: Public, restricted circulation
Slides: Public, circulating
COLLECTIONS
Photographs: 28 file drawers. Sculpture (European, US);
Painting (European, US); Graphic Arts (European, US);
Decorative Arts (African, European, US)
Slides: 2,000
SERVICES
Negatives: Available for purchase and reproduction use,
subject to museum and copyright regulations
Slides: Available for purchase of museum objects
Transparencies: Available for reproduction use subject to
museum and copyright regulations

VR 473
NORTH CAROLINA STATE UNIVERSITY
School of Design, Harrye Lyons Design Library
209 Brooks Hall, Raleigh, NC 27607
Tel: 919-737-2207
Libn: Maryellen LoPresti
Founded: 1945
Hours: Mon-Thurs 8:30-9
 Fri 8:30-5
 Sat 9-1
 Sun 1-5

CIRCULATION POLICY
Films: Public (with permit), students, researchers, faculty/
staff, circulating
Photographs: Restricted
Reproductions: Public (with permit), students, researchers,
faculty/staff, circulating
Slides: Public (with permit), students, researchers, faculty/
staff, circulating
COLLECTIONS
Films: 16. Architecture (US)
Microforms: 72
Photographs: 1,000. Architecture (US); Painting
(European)
Reproductions: 370
Slides: 34,496 AIA. Architecture (Ancient, Far East,
European, US); Sculpture (Ancient, European, US);
Painting (Ancient, European, US)
SUBSCRIPTIONS
AIA Products Council Collections (slides)
Environmental Communications (slides)
History of Photography (slides)
History of the Modern Movement (slides)
History of Art—Janson (slides)
Looking and Seeing (slides)
Measured Drawings of North Carolina Buildings
(photographs)
Spatial Developments in Man's Physical & Social
Environment—Weisse (slides)
SPECIAL COLLECTIONS
Industrial Design from Baerman Industries (slides)
Landscape Architecture (slides)
Transportation Problems on North Carolina State
University (slides)

VR 474
UNIVERSITY OF NORTH CAROLINA AT
CHAPEL HILL
Dept of Art, Slide and Photograph Division
Ackland Art Center, Columbia St, Chapel Hill, NC 27514
Tel: 919-933-3034
Curator of Slides & Photographs: Cecil McMath Gayle
Staff: 2
Founded: 1958
Hours: Mon-Fri 8-5

CIRCULATION POLICY
Photographs: Restricted, students, faculty/staff
Slides: Restricted, students, faculty/staff
COLLECTIONS
Photographs: 35,000
Slides: 150,000 Princeton, Architecture (Ancient, Islamic,
Far East, European, US); Sculpture (Ancient, African,
European, US); Painting (Ancient, Far East, European,
US); Graphic Arts (Far East, European, US); Decorative
Arts (Ancient, Islamic, Far East, European, US)
SUBSCRIPTIONS
Wayne Andrews (photographs)
James Austin (photographs)
Carnegie Set (photographs, slides)
Decimal Index of the Art of Low Countries (photographs)
Illustrated Bartsch (photographs)
SPECIAL COLLECTIONS
William Hayes Ackland Memorial Art Center
(photographs)
SERVICES
Photographs: Ackland Memorial Art Center collections
available for purchase

VR 475
WAKE FOREST UNIVERSITY
A Lewis Aycock Art Slide Library
Box 7232, Winston-Salem, NC 27109
Tel: 919-761-5310; 5303
Slide Libn: Susan Tamulonis
Hours: Mon-Fri 9-5 (closed August)

CIRCULATION POLICY
Films: Restricted, students, researchers, faculty/staff,
circulating
Slides: Restricted, public, circulating
COLLECTIONS
Films: 300
Slides: 90,000 Fogg. Architecture (Ancient, European,
US); Sculpture (Ancient); Painting (Ancient, European,
US); Decorative Arts (European, US)
SUBSCRIPTIONS
Carnegie Set (slides)
SPECIAL COLLECTIONS
Reynolda House of American Art (painting & prints)
(slides)

North Dakota

VR 476
NORTH DAKOTA STATE UNIVERSITY
North Dakota Institute for Regional Studies Library
Fargo, ND 58102
Tel: 701-237-8876
Assoc Curator: John E Rye
Founded: 1950
Hours: Mon-Fri 8-5

CIRCULATION POLICY
Photographs: Public
COLLECTIONS
Photographs: 25,000
SPECIAL COLLECTIONS
D F Barry Collection of late 19th Century Indians in
 Upper Great Plains (photographs)
Hulstrand 'History in Pictures' Collection of pioneer
 scenes in eastern North Dakota (photographs)
SERVICES
Negatives: Prints available for sale subject to copyright
 and Institute regulations and fees

Ohio

VR 477
BOWLING GREEN STATE UNIVERSITY
School of Art, Slide Library
Bowling Green, OH 43403
Tel: 419-372-2786

CIRCULATION POLICY
Slides: Restricted, faculty/staff (appointment suggested)
COLLECTIONS
Slides

VR 478
CASE WESTERN RESERVE UNIVERSITY
Dept of Art History, Slide Collection
Cleveland, OH 44106
Tel: 216-368-4118
Chairman: Walter S Gibson
Founded: 1875
Hours: By appointment

CIRCULATION POLICY
Slides: Students, faculty/staff, fee service, circulating
 (appointment suggested)
COLLECTIONS
Slides: 5,000. Architecture (European, US); Paintings
 (European, US)

VR 479
CINCINNATI ART MUSEUM
Dept of Slides & Photographs
Eden Park, Cincinnati, OH 45202
Tel: 513-721-5204
Curator: Christine Droll
Founded: 1977
Hours: Mon-Fri 9-5

CIRCULATION POLICY
Photographs: Researchers, faculty/staff, fee service
Slides: Researchers, faculty/staff, fee service

COLLECTIONS
Photographs: Sculpture (Ancient); Painting (Islamic, Far
 East, European, US); Decorative Arts (Far East, Euro-
 pean, US)
Slides: 16,000. Sculpture (Ancient); Painting (Islamic,
 Far East, European, US); Decorative Arts (Far East,
 European, US)
SERVICES
Negatives: Prints available for purchase and reproduction
 subject to copyright and museum regulations and fees
Slides: Available for duplication

VR 480
CLEVELAND INSTITUTE OF ART
Media Center
11141 East Blvd, Cleveland, OH 44106
Tel:: 216-421-4322, Ext 21; 22
Media Libn: Kim Kopatz
Founded: ca 1960s

CIRCULATION POLICY
Audio-cassette tapes: Students, researchers, faculty/staff,
 circulating
Slides: Students, researchers, faculty/staff, circulating
COLLECTIONS
Audio-cassette tapes: 750 Cutter Table
Slides: 37,500. Architecture (Ancient, Far East, Tribal
 American, Meso-American, European, US); Sculpture
 (Ancient, European, US); Painting (Far East, European,
 US); Graphic Arts (European, US); Decorative Arts
 (Far East, Tribal American, European, US)
SPECIAL COLLECTIONS
Photography (slides)
Photomicrography (slides)
Natural Design (slides)
20th Century Painting, Sculpture, & Crafts

VR 481
THE CLEVELAND MUSEUM OF ART
Dept of Prints & Drawings
11150 East Blvd, Cleveland, OH 44106
Tel: 216-421-7340, Ext 347
Curator: Louise S Richards
Staff: 1
Hours: Open to researchers by appointment

CIRCULATION POLICY
Photographs: Restricted, researchers, faculty/staff
 (appointment required)
COLLECTIONS
Photographs: 75,426 Gernsheim. Graphic Arts (European)
SUBSCRIPTIONS
Gernsheim Collection (photographs)

VR 482
THE CLEVELAND MUSEUM OF ART
Photograph & Slide Library
11150 East Blvd, Cleveland, OH 44106
Tel: 216-421-7340, Ext 216 (Photograph Library);
 Ext 281 (Slide Library)
Assoc Libn, Photographs & Slides: Stanley W Hess
Staff: 2
Founded: 1914
Hours: Tues-Fri 10-5 (Photograph Library)
 Tues-Fri 10-5:30 (Slide Library)
 Sat 9-4:30 (Slide Library)

CIRCULATION POLICY
Photographs: Students, researchers, faculty/staff
 (appointment suggested)
Slides: Public, fee service, circulating
COLLECTIONS
Illustrated Books: 4
Microforms: 206 fiches
Photographs: 201,948 Fogg/Frick. Architecture (Euro-
 pean); Sculpture (Ancient, Far East, European); Paint-
 ing (Far East, European, US); Graphic Arts (European);
 Decorative Arts (Far East, European)
Slides: 210,000 Cleveland. Architecture (Ancient, Far
 East, European, US); Sculpture (Ancient, Far East,
 European); Painting (Far East, European, US); Graphic
 Arts (Far East, European); Decorative Arts (Far East,
 European)
SUBSCRIPTIONS
American Committee of South Asian Art (photographs,
 slides)
Arndt (ancient sculpture) (photographs)
Asian Art Photographic Distribution (photographs, slides)
James Austin (slides)
Berenson Archives (photographs)
Carnegie Set (slides)
Chinese National Palace Museum Photo Archives
 (photographs, slides)
Courtauld Institute Illustration Archives (illustrated books)
Courtauld Institute Photo Survey of Private Collections
 (photographs)
Decimal Index of the Art of Low Countries (photographs)
Illustrated Bartsch (photographs)
Saskia (slides)
University Colour Slide Scheme (slides)
Victoria & Albert Museum Microfiche Collections (fiches)
SPECIAL COLLECTIONS
Both Photograph & Slide Library collections contain
 extensive coverage of the collections of the Cleveland
 Museum of Art. The Slide Library has extensive Far
 Eastern coverage.
SERVICES
Negatives: Photographs of objects in museum collection
 may be purchased for study, research or publication
Slides: Objects in museum collection may be purchased for
 study or research

VR 483
CLEVELAND PUBLIC LIBRARY
Fine Arts Department
325 Superior Ave, Cleveland, OH 44114
Tel: 216-623-2800; 2868 (Fine Arts)
Hours: Mon 9-8:30
 Tues-Sat 9-6

CIRCULATION POLICY
Films: Public, circulating
Photographs: Public
Slides: Public, circulating
COLLECTIONS
General subject areas

VR 484
CLEVELAND STATE UNIVERSITY
Art Services Area
1860 E 22 St, UT 400, Cleveland, OH 44115
Tel: 216-687-2492
Lib Asst: Cathy J Dottore
Hours: Mon-Fri 8-7
 Mon-Fri 8-5 (Summer Term)

CIRCULATION POLICY
Photographs: Public, circulating
Slides: Restricted, students with permission, faculty/staff
COLLECTIONS
Slides: 40,000 Santa Cruz. Architecture (Ancient, Far
 East, European, US); Sculpture (Ancient, Far East,
 African, European); Painting (European, US); Graphic
 Arts (US); Decorative Arts (African, Pacific, Tribal
 American)
SUBSCRIPTIONS
American Committee of South Asian Art (slides)
Carnegie Set (slides)
SPECIAL COLLECTIONS
Urban and Environmental Art (slides)

VR 485
COLLEGE OF MOUNT ST JOSEPH ON THE OHIO
Art Department
5701 Delhi Pike, Mount St Joseph, OH 45051
Tel: 513-244-4309
Chairman Art Dept: Sr Ann Austin Mooney
Hours: Mon-Fri 8:30-5

CIRCULATION POLICY
Films: Faculty/staff
Slides: Faculty/staff
COLLECTIONS
Films: 28
Slides: 45,100. Architecture (Ancient, African, Tribal
 American, Meso-American, European, US); Sculpture
 (Ancient, African, European, US); Painting (European,
 US); Decorative Arts (US)
SUBSCRIPTIONS
Carnegie Set (slides)

VR 486
COLUMUBUS COLLEGE OF ART & DESIGN
Packard Library
470 E Gray St, Columbus, OH 43215
Tel: 614-224-9101
Libn: Chilin Yu
Staff: 1
Founded: 1931
Hours: Mon & Fri 8:30-5
 Tues-Thurs 8:30-8

CIRCULATION POLICY
Photographs: Restricted, students, researchers, faculty/
 staff, in-house circulating
Records: Restricted, students, faculty/staff
Slides: Restricted, researchers, faculty/staff, in-house
 circulating
COLLECTIONS
Photographs: 21,000. Architecture (Ancient, Far East,
 European, US); Sculpture (Ancient, Far East, European,
 US); Painting (Ancient, Far East, European, US);
 Graphic Arts (Far East, European, US); Decorative
 Arts (Ancient, Far East, European, US)
Records: 357
Slides: 20,000. Architecture (Ancient, Islamic, Far East,
 European, US); Sculpture (Ancient, Far East, African,
 European, US); Painting (Ancient, Far East, European,
 US); Graphic Arts (Far East, European, US); Decorative
 Arts (Ancient, Far East, European, US)

VR 487
DAYTON ART INSTITUTE LIBRARY
405 W Riverview Ave, Box 941, Dayton, OH 45401
Tel: 513-223-5277, Exts 23; 24
Founded: 1922
Hours: Mon-Fri 9-5

CIRCULATION POLICY
Slides: Restricted, faculty/staff of Institute
COLLECTIONS
Slides: 23,700

VR 488
DENISON UNIVERSITY
Dept of Art, Slide Library
Granville, OH 43023
Tel: 614-587-0810, Ext 480
Person in Charge: Jacqueline O'Keeffe
Founded: 1930s
Hours: Mon-Fri 9-4 (office)

CIRCULATION POLICY
Slides: Restricted, students, faculty/staff
COLLECTIONS
Slides: 40,000 Metropolitan. Architecture (Ancient, Far
East, Far East, European, US); Sculpture (Ancient, Far East,
European, US); Painting (Far East, European, US);
Graphic Arts (European); Decorative Arts (European)
SUBSCRIPTIONS
American Committee of South Asian Art (slides)
Carnegie Set (slides)

VR 489
KENT STATE UNIVERSITY＊
College of Fine & Professional Arts, Slide Library
Kent, OH 44242
Tel: 216-672-2193

VR 490
MIAMI UNIVERSITY
Art Department, Slide Room
Maple St, Oxford, OH 45056
Tel: 513-529-6121
Prof of Art: J P George
Founded: 1970

CIRCULATION POLICY
Slides: Restricted, students, faculty/staff
COLLECTIONS
Slides: 15,000. Sculpture (African, European, US); Painting
(European, US); Graphic Arts (European, US)
SUBSCRIPTIONS
Carnegie Set (slides)

VR 491
OBERLIN COLLEGE
Art Department, Slide Collection
Allen Art Bldg, Oberlin, OH 44074
Tel: 216-775-8666
Slide Curator: Barbara Donley
Founded: 1917
Hours: Mon-Fri 8:30-5 (office)

CIRCULATION POLICY
Slides: Restricted, faculty/staff
COLLECTIONS
Films: 50
Slides: 200,000 Oberlin. Architecture (Ancient, Islamic,

Far East, European, US); Sculpture (Ancient, Islamic,
Far East, African, European, US); Painting (Ancient,
Islamic, Far East, European, US); Graphic Arts (Far
East, European, US); Decorative Arts (Ancient, Islamic,
Far East, African, European, US)
SPECIAL COLLECTIONS
Architecture of the turn of the Century (lantern slides)

VR 492
OBERLIN COLLEGE
Art Library, Photograph Collection
Allen Art Bldg, Oberlin, OH 44074
Tel: 216-775-3305
Libn: Christina Huerner
Founded: 1917
Hours: Mon-Fri 8:30-5 (office)

CIRCULATION POLICY
Photographs Public (appointment suggested)
COLLECTIONS
Photographs: (350 linear feet) Oberlin. Architecture
(Ancient, European, US); Sculpture (Ancient, Far East,
European); Painting (Far East, European, US); Graphic
Arts (Far East, European); Decorative Arts (Islamic,
Far East, European)
SUBSCRIPTIONS
Courtauld Institute Photograph Survey of Private Collec-
tions (photographs)
Decimal Index of the Art of Low Countries (photographs)
SPECIAL COLLECTIONS
Photograph collections strong in American Architecture
and Medieval Architecture (photographs)

VR 493
OHIO STATE UNIVERSITY＊
Div of the History of Art, Slide Library
126 N Oval Dr, Columbus, OH 43210
Tel: 614-422-5072
Founded: 1920s

VR 494
OHIO STATE UNIVERSITY
School of Architecture, Learning Resources Center
190 W 17 Ave, Columbus, OH 43210
Tel: 614-422-1012
Dir of Learning Resources: John P Marchion
Staff: 3
Founded: 1971
Hours: Mon-Fri 8-5 (office)

CIRCULATION POLICY
Slides: Restricted, researchers, faculty/staff, circulating
(appointment suggested)
COLLECTIONS
Slides: 25,000 (computerized). Architecture (Ancient, Far
East, European, US)

VR 495
OHIO UNIVERSITY
Fine Arts, Slide Library
Seigfred Hall, Athens, OH 45701
Tel: 614-594-6317
Slide Libn: Elizabeth Kortlander
Founded: 1966
Hours: Mon-Fri 8-5

CIRCULATION POLICY
Slides: Faculty/staff only

COLLECTIONS
Slides: 85,000 Santa Cruz. Architecture (Ancient, Far
East, European, US); Sculpture (Ancient, Far East,
African, Meso-American, European, US); Painting
(Ancient, Islamic, Far East, European, US); Graphic
Arts (European, US); Decorative Arts (European, US)

VR 496
PUBLIC LIBRARY OF CINCINATTI & HAMILTON
COUNTY
Films & Recordings Center
800 Vine St, Cincinnati, OH 45202
Tel: 513-369-6924
Person in Charge: Patrice Callighan
Staff: 3
Founded: 1947
Hours: Mon-Fri 9-9
 Sat 9-6

CIRCULATION POLICY
Films: Public, fee service, circulating
Slides: Public, circulating
COLLECTIONS
Films: 1,760
Slides: 17,316. Architecture (US)
SPECIAL COLLECTIONS
Cincinnati History (slides)
Illustration Art-Children's Literature (lantern slides)

VR 497
SALVADOR DALI MUSEUM LIBRARY
24050 Commerce Park Rd, Cleveland, OH 44122
Tel: 216-464-0372
Dir: Joan Kropf
Founded: 1956
Hours: By appointment

CIRCULATION POLICY
Photographs: Restricted (appointment required)
Slides: Restricted (appointment required)
COLLECTIONS
Photographs: 2,000
Slides: 250

VR 498
TOLEDO MUSEUM OF ART
Slide Library
Box 1013, Toledo, OH 43697
Tel: 419-255-8000, Ext 37
Libn: Anne O Reese
Hours: Mon 1-5
 Tues-Fri 9-5
 Tues, Thurs eve 6-8:30 (University session only)

CIRCULATION POLICY
Slides: Public, circulating
COLLECTIONS
Microforms: 48
Slides: 28,000
SUBSCRIPTIONS
Carnegie Set (slides)

VR 499
UNIVERSITY OF CINCINNATI
Art History Department, Slide Library
615-J Brodie A-1, Cincinnati, OH 45221
Tel: 513-475-5124

Lib Media Technical Asst: Stephen A Rapp
Hours: Mon-Fri 8-5

CIRCULATION POLICY
Photographs: Public
Slides: Public
COLLECTIONS
Photographs: 5,000. Architecture (European, US);
Sculpture (European, US); Painting (European, US);
Graphic Arts (European, US); Decorative Arts (Euro-
pean, US)
Slides: 200,000. Architecture (Ancient, Pacific, Tribal
American, Meso-American, European, US); Sculpture
(Ancient, African, Pacific, Tribal American, Meso-
American, European, US); Painting (Ancient, Pacific,
Tribal American, Meso-American, European, US);
Graphic Arts (Pacific, European, US); Decorative
Arts (Ancient, African, Pacific, Tribal American, Meso-
American, European, US)
SUBSCRIPTIONS
Courtauld Institute Illustration Archive (photographs)

VR 500
WRIGHT STATE UNIVERSITY
Art Department, Slide Library
Colonel Glenn Hwy, Dayton, OH 45435
Tel: 513-873-2896
Slide Libn: Sandra M Kaylor
Staff: 1
Founded: 1970
Hours: Mon-Fri 8:30-5

CIRCULATION POLICY
Slides: Public, circulating
COLLECTIONS
Slides: 35,000 Metropolitan. Architecture (Ancient, Euro-
pean, US); Sculpture (Ancient, European, US); Painting
(Ancient, European, US); Graphic Arts (US); Decorative
Arts (US)
SERVICES
Slides: Available for sale or duplication of works executed
by "Visiting Artists" subject to copyright and
university regulations and fees

Oklahoma

VR 501
MUSEUM OF THE GREAT PLAINS
Special Collections
Sixth St & Ferris, Lawton, OK 73502
Tel: 405-353-5675
Curator of Anthropology: Towana Spivey
Founded: 1961
Hours: Mon-Fri 8-5

CIRCULATION POLICY
Photographs: Restricted, researchers, faculty/staff
(appointment suggested)
Slides: Restricted, researchers, faculty/staff (appointment
suggested)
COLLECTIONS
Photographs: 5,000. Architecture (Tribal American);
Painting (Tribal American); Decorative Arts (Tribal
American)
SUBSCRIPTIONS
Smithsonian (photographs)

SPECIAL COLLECTIONS
Historic Views of Lawton by Geronimo & Quanah
 Parker (photographs)
SERVICES
Negatives: Prints available for purchase subject to
 copyright and museum regulations and fees

VR 502
OKLAHOMA STATE UNIVERSITY*
School of Architecture
Stillwater, OK 74074
Tel: 405-732-6211

VR 503
WILL ROGERS MEMORIAL
Box 157, Claremore, OK 74017
Tel: 918-341-0719
Curator: Dr Reba Collins
Staff: 1
Founded: 1938
Hours: Mon-Fri 8-5

CIRCULATION POLICY
Films: Restricted, researchers (appointment suggested)
Photographs: Restricted, researchers (appointment
 suggested)
Slides: Restricted, researchers (appointment suggested)
COLLECTIONS
Films
Photographs
Slides
SPECIAL COLLECTIONS
Will Rogers Memorial (material of or relating to)

VR 504
TULSA CITY-COUNTY LIBRARY SYSTEM*
Media Center, Fine Arts Department
400 Civic Center, Tulsa, OK 74103
Tel: 918-581-5171
Dir, Media Center: Keith M Edwards

VR 505
UNIVERSITY OF OKLAHOMA*
Art Library, Slide Library
School of Art, Rm 202 FJC, Norman, OK 73069
Tel: 405-325-0311
Founded: ca 1946

VR 506
UNIVERSITY OF OKLAHOMA*
School of Architecture
Norman, OK 73069
Tel: 405-325-2444

Oregon

VR 507
LIBRARY ASSOCIATION OF PORTLAND
Henry Failing Art & Music Department
801 SW Tenth Ave, Portland, OR 97205
Tel: 503-223-7201, Ext 55
Head of Dept: Barbara J Kern
Staff: 3
Hours: Mon-Thurs 9-9
 Fri-Sat 9-5:30
Circulation Policy

Framed Reproductions: Public, circulating
Pictures: Public, circulating
Slides: Public, circulating
COLLECTIONS
Slides: 12,000

VR 508
OREGON STATE UNIVERSITY*
Dept of Architecture, Slide Library
School of Humanities & Social Sciences, Gilman Hall,
 Corvallis, OR 97331
Tel: 503-754-0123

VR 509
OREGON STATE UNIVERSITY
Dept of Art, Slide Library
Fairbanks Hall, Corvallis, OR 97331
Tel: 503-754-4745
Slide Libn: Evelyn Bostwick
Founded: 1947
Hours: Mon-Fri 8-5

CIRCULATION POLICY
Slides: Restricted, students, researchers, faculty/staff
 (appointment suggested)
COLLECTIONS
Slides: 43,000. Architecture (Ancient, Islamic, Far East,
 Tribal American, Meso-American, European, US);
 Sculpture (Ancient, Far East, African, Pacific, Tribal
 American, Meso-American, European, US); Painting
 (Ancient, Far East, European, US); Graphic Arts (Far
 East, European, US); Decorative Arts (Ancient, Tribal
 American, European, US)
SUBSCRIPTIONS
Carnegie Set (slides)
SPECIAL COLLECTIONS
Gordon W Gilkey Graphic Arts Collection (graphic arts)

VR 510
PORTLAND ART MUSEUM*
Slide Library
SW Park & Madison, Potrland, OR 97205
Tel: 503-226-2811

VR 511
REED COLLEGE
Art Department, Slide Collection
Portland, OR 97202
Tel: 503-771-1112, Ext 215
Asst Prof: Peter Parshall
Founded: 1965

CIRCULATION POLICY
Slides: Restricted, students with permission, researchers
 with permission, faculty
COLLECTIONS
Microforms: (housed in main library)
Reproduction: 500
Slides: 40,000 LC. Architecture (Ancient, European, US);
 Sculpture (Ancient, Tribal American, European, US);
 Painting (Ancient, European, US); Graphic Arts
 (European, US); Decorative Arts (Tribal American,
 European, US)
SUBSCRIPTIONS
Carnegie Set (slides)
SPECIAL COLLECTIONS
Portland Center for the Visual Arts Exhibitions (slides)

VR 512
UNIVERSITY OF OREGON
School of Architecture & Allied Arts, Slide Library
Eugene, OR 97403
Tel: 503-686-3052
Slide Libn: Gail Wiemann
Hours: Mon-Fri 8-5

CIRCULATION POLICY
Pthotographs: Students, faculty/staff, circulating
Slides: Students, faculty/staff, circulating
COLLECTIONS
Photographs: 24,000. Architecture (European, US);
 Sculpture (European); Painting (Far East, European);
 Graphic Arts (European)
Slides: 130,000 Dewey. Architecture (Ancient, Far East,
 European, US); Sculpture (Ancient, Far East, Euro-
 pean); Painting (Far East, European, US); Graphic
 Arts (European)
SUBSCRIPTIONS
American Committee of South Asian Art (slides)
Wayne Andrews (photographs)
Asian Art Photographic Distribution (slides)
Chinese National Palace Museum Photo Archives
 (photographs, slides)

Pennsylvania

VR 513
ALLENTOWN ART MUSEUM
Art Reference Library
Box 117, Fifth & Court Sts, Allentown, PA 18105
Tel: 215-432-4333
Curator: Peter F Blume
Founded: 1959
Hours: Mon-Fri 9-5

CIRCULATION POLICY
Photographs: (appointment suggested)
Slides: (appointment suggested)
COLLECTIONS
Photographs: 1,000. Architecture (European, US)
Slides: 1,000. Architecture (European, US)

VR 514
BRYN MAWR COLLEGE
Depts of History of Art & Classical & Near Eastern
 Archaeology
Bryn Mawr, PA 19010
Tel: 215-LA 5-1000, Exts 250; 251
Curator of Slides & Photographs: Carol W Campbell
Staff: 1
Founded: 1897 (Photograph Collection); 1905-8 (Slide
 Library
Hours: Mon-Fri 9:30-5:30 (office, by appointment)
 Closed: Mid July-Mid August

CIRCULATION POLICY
Photographs Students, researchers, faculty/staff, in-house
 circulating (appointment required)
Slides: Students, researchers, faculty/staff, in-house
 circulating (appointment required)
COLLECTIONS
Photographs: 75,000 Metropolitan. Architecture (Ancient,
 Far East, European, US); Sculpture (Ancient, Far
 East, European, US); Painting (Ancient, Far East,

European, US); Graphic Arts (European, US);
 Decorative Arts (Ancient, Far East, European, US)
Slides: 146,200 Metropolitan. Architecture (Ancient,
 Far East, European, US); Sculpture (Ancient, Far
 East, European, US); Painting (Ancient, Far East,
 European, US); Graphic Arts (European, US);
 Decorative Arts (Ancient, Far East, European, US)
SUBSCRIPTIONS
Arndt (photographs)
Brunn (photographs)
Carnegie Set (slides)
University Colour Slide Scheme (slides)
SPECIAL COLLECTIONS
Greek Vase Painting by Beazley (photographs)
SERVICES
Negatives: Prints available for purchase to researchers
 subject to copyright and college regulations and fees

VR 515
BRYN MAWR COLLEGE
Thomas Library, Growth & Structure of Cities Program,
 Slide Library
Bryn Mawr, PA 19010
Tel: 215-LA 5-1000, Ext 437
Curator: Eileen J Andrews
Staff: 1
Founded: 1974
Hours: Mon-Fri 9-4:30

CIRCULATION POLICY
Photographs: Students, researchers, faculty/staff
Slides: Students, researchers, faculty/staff
COLLECTIONS
Photographs: 500
Slides: 15,000. Architecture (Ancient, European, US)
SERVICES
Slides: Available for duplication from original slides
 subject to copyright and library regulations

VR 516
CARNEGIE LIBRARY
Art Division, Slide Collection
4400 Forbes Ave, Pittsburgh, PA 15213
Tel: 412-622-3107
Libns: Katherine Kepes & A Catherine Tack
Founded: 1966

CIRCULATION POLICY
Slides: Public, circulating
COLLECTIONS
Slides: 100,000
SUBSCRIPTIONS
Carnegie Set (slides)

VR 517
CARNEGIE-MELLON UNIVERSITY*
Dept of Architecture
Schenley Park, Pittsburgh, PA 15213
Tel: 412-621-2600

VR 518
CARNEGIE-MELLON UNIVERSITY
Slide Room & Audio-Visual Services
Hunt Lib, Schenley Park, Pittsburgh, PA 15213
Tel: 412-621-2600, Exts 425 (Slide Rm); 480 (A-V)
Slide Curator: Mary Pardo
Dir of A-V Resources: Stephanie Evancho

Founded: ca 1961 (Slide Rm); before 1967 (A-V)
Hours: Mon-Fri 8-5

CIRCULATION POLICY
Pictures: Public
Prints: Public
Slides: Graduate students, researchers, faculty/staff
 (appointment suggested)
COLLECTIONS
Films: 221
Slides: 90,000. Architecture (Ancient, European, US);
 Sculpture (Ancient, Far East, African, European, US);
 Painting (Ancient, Far East, Andean, European, US);
 Graphic Arts (Far East, European, US); Decorative
 Arts (Tribal American, European, US)
Video: 167
SERVICES
Slides: Available for purchase or duplication subject to
 copyright and university regulations

VR 519
CLARION STATE COLLEGE*
Dept of Art, Slide Collection
Clarion, PA 16214
Tel: 814-226-6000

VR 520
DREXEL UNIVERSITY
Library, Non-Print Department
32 & Chestnut Sts, Philadelphia, PA 19104
Tel: 215-895-2764
Head, Non-Print Dept: Robert Rhein
Founded: 1973
Hours: Mon-Thurs 8-10
 Fri 8-8
 Sat 10-6
 Sun 2-10 (office)

CIRCULATION POLICY
Films: Students, researchers, faculty/staff
Slides: Students, researchers, faculty/staff, circulating
COLLECTIONS
Films: 15. Painting (US)
Filmstrips: 30
Slides: 22,000 Detroit Institute of Art. Architecture
 (Ancient, European, US); Sculpture (Ancient, Euro-
 pean, US); Painting (European, US); Decorative
 Arts (European, US)
SUBSCRIPTIONS
Carnegie Set (slides)

VR 521
THE FREE LIBRARY OF PHILADELPHIA
Logan Square, Philadelphia, PA 19103
Tel: 215-MN 6-5403
Admin Asst to Dir: J Randall Rosensteel
Founded: 1891

CIRCULATION POLICY
Films: Public, circulating
Microforms: Public
Photographs: Public
Prints: Public, circulation restricted
Slides: Public
Video: Public
Visual Media collections incorporated into general subject
 collections. For further information contact the

following departments:
Art Department, Head: Miriam Lesley
Films Department, Head: Steven Mayover
Print & Picture Department, Head: Robert F Looney
Theatre Collection, In-Charge: Geraldine Duclow

VR 522
THE LIBRARY COMPANY OF PHILADELPHIA
Dept of Prints & Drawings
1314 Locust St, Philadelphia, PA 19107
Tel: 215-KI 6-3181
Person in Charge: Edwin Wolf II
Staff: 6
Founded: 1731
Hours: Mon-Fri 9-4:30
 Mon-Fri 9-5 (office)

VR 523
MOORE COLLEGE OF ART LIBRARY*
20 & Race Sts, Philadelphia, PA 19103
Tel: 215-LO 8-4515

VR 524
MUHLENBERG COLLEGE*
Art Department, Slide Library
Allentown, PA 18104
Tel: 215-433-3191
Slide Libn: Veralee McClain

VR 525
THE PENNSYLVANIA STATE UNIVERSITY
Arts Library
E405 Pattee Library, University Park, PA 16802
Tel: 814-865-6481
Arts & Architecture Libn: Jean Smith
Staff: 1
Founded: 1957
Hours: Mon-Fri 8-12
 Sat 8-5
 Sun 1-12
 Summer closes at 10

CIRCULATION POLICY
Prints: Students, researchers, faculty/staff (appointment
 suggested)
COLLECTIONS
Prints: 492
SUBSCRIPTIONS
Decimal Index of the Art of Low Countries (photographs)

VR 526
THE PENNSYLVANIA STATE UNIVERSITY
Department of Art History, Slide & Photograph Collections
208-212 Arts II Building, University Park, PA 16802
Tel: 814-865-6236
Slide & Photograph Archivist: Carol A Bacon
Founded: 1930s
Hours: Mon-Fri 9-5 (office)

CIRCULATION POLICY
Photographs: Restricted, art history students, art history
 faculty/staff (appointment suggested)
Slides: Restricted, art history students, art history faculty/
 staff (appointment suggested)
COLLECTIONS
Photographs: 15,000. Architecture (European); Painting
 (European); Decorative Arts (Early Christian, Byzantine)

Slides: 150,000. Architecture (Ancient, Early Christian, Byzantine, European, US); Sculpture (Ancient, European); Painting (European, US); Decorative Arts (European, Early Christian, Byzantine)
SUBSCRIPTIONS
Carnegie Set (slides)
SPECIAL COLLECTIONS
Vatican Library Manuscripts-Codex Chigi PVII 9, PVII 10, PVII 12, PVII 13; Codex Spadavat Lat 11257, 11258 (photographs)

VR 527
PHILADELPHIA CITY PLANNING COMMISSION LIBRARY*
City Hall Annex, 13th Floor, SE Corner, Juniper & Filbert Sts, Philadelphia, PA 19107
Tel: 215-MU 6-4607

VR 528
PHILADELPHIA COLLEGE OF ART
Slide Library
Broad & Spruce Sts, Philadelphia, PA 19102
Tel: 215-893-3117
Supervisor: John M Caldwell
Staff: 1
Founded: ca 1960
Hours: Mon-Fri 9-5
 Mon-Fri 9-4 summer

CIRCULATION POLICY
Slides: Students, researchers, faculty/staff
COLLECTIONS
Slides: 140,000. Architecture (Ancient, Islamic, Far East, Meso-American, European, US); Sculpture (Ancient, Far East, African, Meso-American, European, US); Painting (Ancient, Islamic, Far East, European, US); Graphic Arts (European, US); Decorative Arts (Ancient, Far East, African, Meso-American, European, US)
SUBSCRIPTIONS
Art in America (slides)
Carnegie Set (slides)
George Eastman House (slides)
University Colour Slide Scheme (slides)
SPECIAL COLLECTIONS
Contemporary Crafts Exhibitions (slides)
European Street Furniture (slides)
Turkish Anthropology (slides)

VR 529
PHILADELPHIA MARITIME MUSEUM LIBRARY
321 Chestnut St, Philadelphia, PA 19106
Tel: 215-WA 5-5439
Curator: Richard K Page
Founded: 1960
Hours: Mon-Sat 10-5
 Sun 1-5

CIRCULATION POLICY
Photographs: Researchers, faculty/staff
COLLECTIONS
Microforms: 80 reels
Models: 200. Decorative Arts (US)
Photographs: 1,000. Painting (US); Graphic Arts (US); Decorative Arts (US)
SPECIAL COLLECTIONS
Thomas Birch, works by

Delaware River and Philadelphia area historical prints
Philadelphia Maritime Museum Marine Paintings Collection
SERVICES
Negatives: Prints available for purchase and publication, subject to copyright and museum regulations and fees

VR 530
PHILADELPHIA MUSEUM OF ART
26 St & Benjamin Franklin Pkwy, Philadelphia, PA 19101
Tel: 215- PO 3-8100, Ext 337
Slide Libn: Deborah Baker
Founded: 1953
Hours: Mon-Fri 9-1 (office)

CIRCULATION POLICY
Slides: Faculty/staff
COLLECTIONS
Slides: 100,000. Architecture (Far East, European, US); Sculpture (Far East, European, US); Painting (Far East, European, US); Graphic Arts (European, US); Decorative Arts (Far East, European, US)
SUBSCRIPTIONS
Decimal Index of the Art of Low Countries (photographs)
SERVICES
Slides: Available for purchase from the Dept of Rights and Reproduction of museum objects

VR 531
SWARTHMORE COLLEGE
Department of Art
Swarthmore, PA 19081
Tel: 215-KI 4-7900, Ext 315
Secretary: T Klingler
Hours: Mon-Fri 8:30-2:30 (office)

CIRCULATION POLICY
Photographs: Restricted, art major students, researchers, faculty/staff
Slides: Restricted, students, faculty/staff
COLLECTIONS
Films: 55
Photographs: 6,400. Architecture (European, US); Sculpture (Ancient, European, US); Painting (Ancient, European, US)
Slides: 70,000. Architecture (Ancient, Far East, European, US); Sculpture (Ancient, European, US); Painting (Ancient, European, US); Graphic Arts (European, US)
SPECIAL COLLECTIONS
Benjamin West Drawing & Painting Collection (college collection)
SERVICES
Negatives: Prints available for purchase subject to copyright and institutional regulations

VR 532
TEMPLE UNIVERSITY
Tyler School of Art, Slide Library
Beech & Penrose Aves, Elkins Park, PA 19126
Tel: 215-CA 4-7575, Ext 247
Slide Libn: Edith Zuckerman
Founded: 1939

CIRCULATION POLICY
Slides: Restricted, graduate students, researchers, faculty/staff

COLLECTIONS
Slides: 100,000. Architecture (Ancient, European, US);
Sculpture (Ancient, European, US); Painting (Ancient,
Far East, European, US); Graphic Arts (Ancient,
European, US); Decorative Arts (Ancient, European,
US)

VR 533
TYLER SCHOOL.OF ART, TEMPLE UNIVERSITY*
History of Art Department, Slide Collection
Beech & Penrose Aves, Philadelphia, PA 19126
Tel: 215-CA 4-7575
Founded: ca 1940

VR 534
UNIVERSITY OF PENNSYLVANIA
Fine Arts Library, Slide Room
Graduate School of Fine Arts/CJ, Philadelphia, PA 19174
Tel: 215-243-7086
Head of Slides: Concette G Leone
Staff: 1
Founded: ca 1930
Hours: Mon-Fri 9-5 (office)

CIRCULATION POLICY
Photographs: Students, researchers, faculty/staff
Slides: Researchers, faculty/staff, circulating
COLLECTIONS
Photographs: 54,000 Fogg
Slides: 165,000 Fogg. Architecture (Ancient, Islamic,
European, US); Sculpture (Ancient, Islamic, Euro-
pean, US); Painting (Ancient, Islamic, European, US);
Graphic Arts (Ancient, Islamic, European, US);
Decorative Arts (Ancient, Islamic, European, US)
SUBSCRIPTIONS
American Committee of South Asian Art (slides)
Wayne Andrews (photographs)
Berenson Archives (photographs)
Carnegie Set (slides)
University Colour Slide Scheme (slides)
SPECIAL COLLECTIONS
Art of Portugal (slides)
City Planning (slides)
Decorative Arts (photographs, slides)
Landscape Architecture (slides)
SERVICES
Slides: Available for duplication summer months
only—Special Collections

VR 535
UNIVERSITY OF PITTSBURGH
Frick Fine Arts Department, Collection of Slides &
Photographs
Schenery Park, Pittsburgh, PA 15260
Tel: 412-624-4121
Person in Charge: M Roper
Staff: 1
Founded: 1927-28
Hours: Mon-Fri 9-5

CIRCULATION POLICY
Photographs: Restricted, students, researchers, faculty/
staff
Slides: Restricted, students, researchers, faculty/staff
COLLECTIONS
Photographs: 75,000. Architecture (European); Sculpture
(European, US); Painting (European, US)

Slides: 200,000. Architecture (Ancient, Islamic, Meso-
American, European, US); Sculpture (Ancient, Meso-
American, European, US); Painting (Ancient, Euro-
pean, US); Graphic Arts (Ancient, Meso-American,
European); Decorative Arts (Ancient, European)
SUBSCRIPTIONS
Carnegie Set (slides)
SPECIAL COLLECTIONS
Carnegie International Exhibitions, prior to 1950 (lantern
slides)

VR 536
URSINUS COLLEGE
Myrin Library, Audiovisual Department
Collegeville, PA 19426
Tel: 215-489-4111, Ext 283
Person in Charge: Marilyn Quinn

CIRCULATION POLICY
Films: Students, faculty/staff, circulating
Filmstrips: Students, faculty/staff, circulating
Slides: Students, faculty/staff, circulating
COLLECTIONS
Films
Slides: 8,000. Architecture (Ancient, European, US);
Sculpture (Ancient, Pacific, European, US); Painting
(European, US); Graphic Arts (European, US);
Decorative Arts (Pacific)
SPECIAL COLLECTIONS
Pennsylvania-German Folk Life & Art (slides)

VR 537
VILLANOVA UNIVERSITY*
Department of Fine Arts, Slide Library
Villanova, PA 19085
Tel: 215-527-2100

VR 538
WASHINGTON & JEFFERSON COLLEGE*
Department of Art History, Slide Collection
Washington, PA 15301
Tel: 412-222-4400
Asst Prof: Hugh H Taylor

VR 539
WESTMORELAND COUNTY MUSEUM OF ART
Art Reference Library
221 N Main St, Greensburg, PA 15601
Tel: 412-837-1500
Person in Charge: Paul A Chin
Founded: 1958
Hours: Tues 1-9
Wed 10-5
Sat 2-6

CIRCULATION POLICY
Photographs: Restricted
Slides: Faculty/staff
COLLECTIONS
Photographs: 500
Slides: 7,500. Architecture (Ancient, Meso-American,
European, US); Sculpture (Ancient, Meso-American,
European, US); Painting (Ancient, European, US);
Graphic Arts (US); Decorative Arts (US)
SUBSCRIPTIONS
Carnegie Set (slides)
SERVICES
Negatives: Prints available for sale and for reproduction

subject to copyright and museum restrictions and fees
Slides: Available for duplication subject to copyright
 restrictions

Rhode Island

VR 540
BROWN UNIVERSITY
Art Department, Slide & Photograph Collections
Box 1861, 64 College St, Providence, RI 02912
Tel: 401-863-3218
Curator of Slides & Photographs: Norine Duncan Cashman
Staff: 1
Hours: Mon-Fri 8:30-5 (office)

CIRCULATION POLICY
Models: Restricted (appointment required)
Photographs: Faculty/staff (appointment required)
Slides: Students, researchers, faculty/staff (appointment
 required)
COLLECTIONS
Models: 25. Architecture (European, US)
Photographs: 17,000. Architecture (Ancient, European,
 US); Sculpture (Ancient, European); Painting
 (European)
Slides: 135,000. Architecture (Ancient, European, US);
 Sculpture (Ancient, European, US); Painting (Ancient,
 European, US); Graphic Arts (European, US);
 Decorative Arts (Ancient, European, US)
SUBSCRIPTIONS
Wayne Andrews (photographs, slides)
James Austin (photographs, slides)
Carnegie Set (slides)
Courtauld Institute Photo Survey of Private Collections
 (photographs)
Decimal Index of the Art of Low Countries (photographs)
SPECIAL COLLECTIONS
David Winton Bell Gallery, selected exhibition works
 (slides)

VR 541
MUSEUM OF ART, RHODE ISLAND SCHOOL OF
 DESIGN
Education Department, Slide Collection
224 Benefit St, Providence, RI 02903
Tel: 401-331-3512, Ext 279; 280
Asst Curator of Education: Jean S Fain
Staff: 2
Hours: Mon-Fri 11-5

CIRCULATION POLICY
Slides: Rhode Island Public School Teachers, fee service,
 circulating (appointment suggested)
COLLECTIONS
Slides: 14,000. Architecture (Ancient, European, US);
 Sculpture (Ancient, European, US); Painting (Euro-
 pean, US); Graphic Arts (European, US); Decorative
 Arts (European, US)
SPECIAL COLLECTIONS
Museum of Art Rhode Island School of Design Collection
 (slides)
SERVICES
Photographs: Available through Keeper of Photographs,
 Museum of Art, Rhode Island School of Design
Slides: Available for sale through Museum of Art,

Rhode Island School of Design
School Loan Program: Mounted color reproductions
 available for loan

VR 542
RHODE ISLAND SCHOOL OF DESIGN
Library, Slide & Photograph Department
2 College St, Providence, RI 02903
Tel: 401-331-3511, Ext 227
Head, Slides & Photographs: R B deLissovoy
Staff: 1
Hours: Mon-Fri 8:30-5 (clipping & photographs only)

CIRCULATION POLICY
Clippings: Restricted students, faculty/staff, circulating
Photographs: Restricted students, faculty/staff, circulating
Slides: Restricted, students, faculty, staff
COLLECTIONS
Clippings: 172,000. Architecture (Ancient, US); Sculpture
 (Ancient, US); Painting (Ancient, US)
Photographs: 30,000. Architecture (Ancient, Euro-
 pean, US); Sculpture (Ancient, European, US);
 Painting (Ancient, Far East, European, US); Decorative
 Arts (Ancient)
Slides: 81,000 Fogg. Architecture (Ancient, Far East,
 European, US); Sculpture (Ancient, African, Euro-
 pean, US); Painting (Ancient, Far East, European,
 US); Decorative Arts (Ancient, Meso-American,
 Andean, European, US)
SUBSCRIPTIONS
Chinese National Palace Museum Photo Archives
 (photographs)
SPECIAL COLLECTIONS
Contemporary Scene (slides)

VR 543
UNIVERSITY OF RHODE ISLAND*
Art Department, Slide Room
Kingston, RI 02881
Tel: 401-792-5822
Special Asst: Sylvia C Krausse

South Carolina

VR 544
BROOKGREEN GARDENS
Murrells Inlet, SC 29576
Tel: 803-237-4218
Dir: G L Tarbox, Jr
Staff: 1
Founded: 1931

CIRCULATION POLICY
Maps: Restricted, faculty/staff
Photographs: Restricted, faculty/staff, fee service
Slides: Faculty/staff, fee service, circulating
COLLECTIONS
Maps: 100 British Museum
Photographs: 1,600 British Museum. Sculpture (US)
Slides: 8,000 British Museum. Sculpture (US)
Slides: 8,000 British Museum. Sculpture (US)
SPECIAL COLLECTIONS
Brookgreen Gardens Collection of 19th & 20th Century
 American Sculpture
SERVICES
Negatives: Prints available for sale for publication, subject

to copyright and institutional regulations and fees
Slides: Available for sale and duplication, subject to
copyright and institutional regulations and fees

VR 545
CLEMSON UNIVERSITY
E A Gunnin Architectural Library, Slide Library
Lee Hall, Clemson, SC 29631
Tel: 803-656-3081
Slide Curator: Phyllis Pivorun
Hours: Mon-Fri 8:30-12, 1-5

CIRCULATION POLICY
Slides: Public, circulating
COLLECTIONS
Films: (very few)
Slides: 34,882. Architecture (Ancient, Far East, European, US); Sculpture (Ancient, Far East, European, US); Painting (European, US); Graphic Arts (European, US); Decorative Arts (Ancient, European, US)
SUBSCRIPTIONS
Civilisation Series (slides)
Rolf D Weisse Collection (slides)
SPECIAL COLLECTIONS
Charleston Collections (slides)

VR 546
FURMAN UNIVERSITY*
Dept of Art, Slide Collection
Greenville, SC 29613
Tel: 803-294-2000
Chairman: Thomas E Flowers

VR 547
GIBBES ART GALLERY/CAROLINA ART ASSOCIATION
135 Meeting St, Charleston, SC 29401
Tel: 803-722-2706
Founded: 1905
CIRCULATION POLICY
Photographs: Restricted, researchers (appointment suggested)
Slides: Restricted, researchers, circulating (appointment suggested)
COLLECTIONS
Photographs: 1,000 CAA. Architecture (US)
Slides: 1,500 CAA. Architecture (Ancient, European, US); Sculpture (Ancient, European, US); Painting (Ancient, European, US); Graphic Arts (US); Decorative Arts (US)
SPECIAL COLLECTIONS
Charleston & Vicinity 19th Century photographs (photographs)
SERVICES
Negatives: Prints available for purchase including special collections subject to copyright and museum regulations and fees
Slides: Available for duplication subject to copyright and museum regulations

VR 548
BOB JONES UNIVERSITY
Museum of Sacred Art & The Bowen Bible Lands Museum
Wade Hampton Blvd, Greenville, SC 29614
Tel: 803-242-5100, Ext 275
Person in Charge: Mrs Fred Davis
Staff: 6

Founded: 1951
Hours: Tues-Sun 2-5

SERVICES
Slides of museum collection available for sale

VR 549
PRESBYTERIAN COLLEGE
Fine Arts Department
Jacobs Hall, Clinton, SC 29325
Tel: 803-833-2820, Ext 296
Assoc Prof of Art: Robert Jolly
Founded: 1965
Hours: Mon-Fri 8-12, 2-5 (office)

CIRCULATION POLICY
Filmstrips: Restricted
Slides: Restricted, faculty/staff
COLLECTIONS
Filmstrips: 25
Slides: 3,000. Architecture (Ancient, European); Sculpture (Ancient, European); Painting (European)

VR 550
UNIVERSITY OF SOUTH CAROLINA
Dept of Art, Slide Library
Columbia, SC 29208
Tel: 803-777-2362
Slide Libn: Carol Molten
Staff: 1
Hours: Mon-Fri 8:30-5 (office)

CIRCULATION POLICY
Slides Students, researchers, faculty/staff, circulating
COLLECTIONS
Slides: 71,000. Architecture (Ancient, Far East, European, US); Sculpture (Ancient, Far East, European, US); Painting (Far East, European, US); Graphic Arts (European, US); Decorative Arts (European, US)
SERVICES
Slides: Non-copyrighted slides may be duplicated by borrower

South Dakota

VR 551
CIVIC FINE ARTS ASSOCIATION
235 W Tenth St, Sioux Falls, SD 57102
Tel: 605-336-1167
Dir: Raymond Shermoe
Staff: 2
Founded: 1961
Hours: Tues-Sat 11:30-5
 Sun 2-5

CIRCULATION POLICY
Slides: Students, researchers
COLLECTIONS
Films: Paintings (US)
Slides: Sculpture (US); Painting (US)
SERVICES
Negatives: Prints available for purchase, subject to copyright and association regulations and fees
Slides: Available for purchase

VR 552
MITCHELL PUBLIC LIBRARY
221 N Duff, Mitchell, SD 57301
Tel: 605-996-6693
Dir: James Olsen
Founded: 1903
Hours: Mon-Thurs 9:30-8:30
 Fri-Sat 9:30-6
 Sun 2-5 (winter)
 Mon-Sun 9-6 (summer)

CIRCULATION POLICY
Photographs Restricted, students, researchers
Slides: Restricted, students, researchers
COLLECTIONS
Art Reproductions: 7,500
Films: 100
Microforms: 2,000
Photographs: 500
Slides: 2,000
SPECIAL COLLECTIONS
Mitchell Area Views & History (photographs, postcards)

VR 553
SIOUX FALLS COLLEGE
Norman B Mears Library
Sioux Falls, SD 57101
Tel: 605-336-2850, Ext 121
Head Libn: Jane Kolbe
Staff: 1
Founded: 1883

CIRCULATION POLICY
Filmstrips: Students, faculty/staff, circulating
Slides: Faculty/staff
COLLECTIONS
Filmstrips: 350
Microforms: 4,000
Slides: 2,100. Painting (European, US)

VR 554
SIOUX FALLS PUBLIC LIBRARY
Audio-Visual Department
201 N Main Ave, Sioux Falls, SD 57101
Tel: 605-339-7081
Libn: Cynthia Winn
Founded: 1972
Hours: Mon-Fri 9:30-9
 Sat 9:30-6

CIRCULATION POLICY
Films: Public, circulating
Filmstrips: Public, circulating
Photographs: Public, circulating
Slides: Public, circulating
COLLECTIONS
Films: 148
Filmstrips: 18
Kits: 100
Microforms: 47
Pictures/photographs: 800
Slide Sets: 50

VR 555
SIOUXLAND HERITAGE MUSEUMS
Pettigrew Museum, Library
131 N Duluth, Sioux Falls, SD 57104

Tel: 605-336-6272
Registrar: Lee N McLaird
Founded: 1876
Hours: Mon-Fri 9-5

CIRCULATION POLICY
Photographs: Public
COLLECTIONS
Models: 20
Photographs: 1,000. Architecture (Tribal American, US)
Slides: 50
SPECIAL COLLECTIONS
D F Barry photographs of American Indians
 (photographs)
George Catlin (folio prints)
SERVICES
Photographs: Available for reproduction, advance
 permission required
Slides: Available for duplication, advance permission
 required

VR 556
THE UNIVERSITY OF SOUTH DAKOTA
W H Over Museum
Vermillion, SD 57069
Tel: 605-677-5228
Dir: June Sampson
Staff: 2
Founded: 1911
Hours: Mon-Fri 8-4:30
 Sat 10-4:30
 Sun 2-4:30

CIRCULATION POLICY
Photographs Restricted (appointment suggested)
Slides: Restricted (appointment suggested)
COLLECTIONS
Photographs: 700. Architecture (US); Decorative Arts
 (Tribal American)
Slides: 100. Decorative Arts (Tribal American)
SPECIAL COLLECTIONS
David W Clark Memorial Collection of Dakota
 Artifacts dating from 1872-1943 from Crow Creek,
 Lower Brule, and Rosebud Reservations
Stanley J Morrow Collection of Stereographs
SERVICES
Negatives: Prints available for purchase of above special
 collections subject to copyright and museum
 regulations and fees
Slides: Available for purchase and duplication subject to
 copyright and museum regulations and fees

VR 557
YANKTON COLLEGE LIBRARY
1016 Douglas, Yankton, SD 57078
Tel: 605-665-4662
Lib Dir: Patricia McDonald
Staff: 1
Founded: 1881

CIRCULATION POLICY
Slides: Public, circulating
COLLECTIONS
Films: 1
Slides: 209
Video: 25

Tennessee

VR 558
CHEEKWOOD FINE ARTS CENTER
Education Department
Cheek Rd, Nashville, TN 37205
Tel: 615-352-5310
Person in Charge: Roberta Mathews

CIRCULATION POLICY
Photographs: Restricted, faculty/staff
Slides: Restricted, faculty/staff
COLLECTIONS
Filmstrips
Slides: 1,000. Architecture (Ancient, European, US);
Sculpture (Ancient, European, US); Painting (European, US); Decorative Arts (European, US)

VR 559
FISK UNIVERSITY ART MUSEUM
18 & Jefferson Sts, Nashville, TN 37203
Tel: 615-329-8685
Dir: Earl J Hooks
Founded: 1949
Hours: Mon-Fri 9-5

CIRCULATION POLICY
Graphics: Restricted to schools & organizations, circulating
Paintings: Restricted to schools & organizations, circulating
Photographs: Restricted, students, researchers, faculty/staff
Slides: Students, researchers, faculty/staff, fee service
COLLECTIONS
Photographs: 103
Slides: 103
SPECIAL COLLECTIONS
Afro-American Art (photographs, slides)
Alfred Stieglitz Collection of American Art (slides)
SERVICES
Negatives: Prints are available for purchase and
publication subject to copyright and museum regulations
and fees
Slides: Available for sale of a general American art survey

VR 560
HUNTER MUSEUM OF ART LIBRARY
Bluff View, Chattanooga, TN 37403
Tel: 615-267-0968
Curator of Education: Carla M Michalove
Staff: 1
Founded 1973 (library)
Hours: Tues-Sat 10-4:30
 Sun 1-4:30

CIRCULATION POLICY
Photographs: Faculty/staff
Slides: Faculty/staff
COLLECTIONS
Photographs: 300
Slides: 2,000. Architecture (European, US); Sculpture
(European, US); Painting (European, US); Graphic
Arts (US)
SERVICES
Slides: Available for duplication subject to copyright and
museum regulations and fees of objects in the museum
collections

VR 561
MEMPHIS ACADEMY OF ARTS
G Pilon Lewis Memorial Library
Overton Park, Memphis, TN 38112
Tel: 901-226-4085
Asst Libn: Sandra C Wade
Founded: 1936

CIRCULATION POLICY
Slides: (appointment suggested)
COLLECTIONS
Prints: n. a.
Reproductions: n. a.
Slides: 23,000 Fogg

VR 562
MEMPHIS STATE UNIVERSITY
Art History Slide Library
Jones Hall, Rm 220, Memphis, TN 38152
Tel: 901-454-2071
Slide Curator: Georgianna H Ray
Founded: 1969
Hours: Mon-Fri 8-12, 1-4

CIRCULATION POLICY
Slides: Restricted, students & lecturers with approval,
faculty/staff, in-house circulating (appointment
suggested)
COLLECTIONS
Slides: 80,000 Fogg. Architecture (Ancient, European,
US); Sculpture (Ancient, Tribal American, European,
US); Painting (Ancient, Tribal American, European,
US); Decorative Arts (Tribal American, European,
US)

VR 563
AUSTIN PEAY STATE UNIVERSITY
Dept of Art
College Ave, Clarksville, TN 37040
Tel: 615-648-7333
Dir: Dr Charles T Young

CIRCULATION POLICY
Slides: Restricted, faculty/staff (appointment suggested)
COLLECTIONS
Films: 24
Slides: 15,000. Architecture (Ancient, Islamic, Far East,
Meso-American, European, US); Sculpture (Ancient,
Far East, African, Tribal American, Meso-American,
European, US); Painting (Ancient, Far East, European, US); Graphic Arts (Ancient, Far East, Tribal
American, European, US); Decorative Arts (Far East,
Tribal American, European, US)

VR 564
SOUTHWESTERN UNIVERSITY AT MEMPHIS
Art Department, Slide Library
2000 N Pkwy, Memphis, TN 38112
Tel: 901-274-1800, Ext 322
Prof of Art History: Anne Robbins
Staff: 1
Hours: By appointment

CIRCULATION POLICY
Slides: Restricted, faculty/staff (appointment required)
COLLECTIONS
Slides: 15,000 Fogg. Architecture (Ancient, Far East,

European, US); Sculpture (Ancient, Far East, European, US); Painting (Ancient, Far East, European, US); Graphic Arts (European, US); Decorative Arts (European, US)
SUBSCRIPTIONS
Carnegie Set (slides)

VR 565
TENNESSEE STATE PLANNING OFFICE LIBRARY
660 Capitol Hill Bldg, 301 Seventh Ave N, Nashville, TN 37219
Tel: 615-741-2363
Libn: Eleanor J Burt
Founded: 1971

CIRCULATION POLICY
Slides: Public
COLLECTIONS
Slides: 1,340. Planning (US)
SPECIAL COLLECTIONS
Community Planning & Playgrounds (slides)

VR 566
UNIVERSITY OF TENNESSEE
Art Department
101 McCluny Museum, Knoxville, TN 37916
Tel: 615-974-2591
Photographic Slide Compiler: Alice Marie Woody
Hours: Mon-Fri 8-5 (office)

CIRCULATION POLICY
Slides: Restricted, art dept faculty/staff
COLLECTIONS
Slides: 60,000 Art Institute of Chicago. Architecture (Ancient, Islamic, Far East, European, US); Sculpture (Ancient, Islamic, Far East, European, US); Painting Ancient, Islamic, Far East, European, US); Graphic Arts (European, US); Decorative Arts (Far East, European, US)

VR 567
VANDERBILT UNIVERSITY
Dept of Fine Arts, Slide Library
Box 1801, Station B, Nashville, TN 37235
Tel: 615-322-2831
Slide Libn: Linda Callahan
Photograph Archivist: Helen Baldwin
Staff: 1
Founded: 1949-50 (slides); 1969 (photographs)
Hours: Mon-Fri 9-5

CIRCULATION POLICY
Photographs: Restricted, Fine Arts graduate students, researchers, faculty/staff (appointment suggested)
Slides: Restricted, Fine Arts graduate students, faculty/staff
COLLECTIONS
Photographs: 60,000 New York University. Paintings (European)
Slides: 84,000 New York University. Architecture (Ancient, Far East, European, US); Sculpture (Ancient, Far East, European); Painting (Far East, European, US); Decorative Arts (Far East, European)
SPECIAL COLLECTIONS
Contini-Volterra Archive (photographs)
Vanderbilt University Fine Art Collection (photographs)

SERVICES
Negatives: Prints are available from Archivist of works in the Contini-Volterra Archive and the Vanderbilt University Fine Arts Collection

Texas

VR 568
ART MUSEUM OF SOUTH TEXAS LIBRARY
Box 1010, Corpus Christi, TX 78403
Tel: 512-884-3844
Asst Curator: Melinda Mayer
Hours: Mon-Fri 9-5

CIRCULATION POLICY
Slides: Restricted
COLLECTIONS
Slides: 6,500. Architecture (US); Sculpture (European, US); Painting (European, US)
SERVICES
Slides: Available for duplication subject to copyright and museum regulations and fees

VR 569
AUSTIN PUBLIC LIBRARY
Austin-Travis County Collection
401 W Ninth, Box 2287, Austin, TX 78767
Tel: 512-472-5433
Curator: Audray Bateman
Staff: 8
Founded: 1955
Hours: Mon-Thurs 9-9
 Fri 9-6
 Sat 9-1

CIRCULATION POLICY
Films: Public, non-circulating
Microforms: Public, non-circulating
Photographs: Public, non-circulating
Slides: Public, non-circulating
Video: Public, non-circulating
COLLECTIONS
Audiotapes: 117. Oral History
Microforms: (local)
Photographs: 28,000. Architecture (US)
Slides: 5,422. Architecture (US)
SPECIAL COLLECTIONS
Austin and Travis County (visual resources)
SERVICES
Negatives: Prints available for purchase and reproduction subject to copyright and library regulations and fees
Slides: Available for duplication subject to copyright regulations, by special arrangement with a commercial photographer

VR 570
AUSTIN PUBLIC LIBRARY
Prints & Recordings Collection
401 W Ninth St, Box 2287, Austin, TX 78767
Tel: 512-472-5433
Supervisor of Prints & Recordings Collection: Vicki Skinner
Founded: 1966
Hours: Mon-Thurs 9-9
 Fri-Sat 9-6
 Sun 2-6

CIRCULATION POLICY
Reproductions: Public, circulating
COLLECTIONS
Reproductions: 1,656 (alphabetically/artist). Painting
(European, US)

VR 571
BAYLOR UNIVERSITY
Visual Resources Collection
Waco, TX 76701
Tel: 817-755-1867
Lecturer: V Logan
Founded: 1970
Hours: Mon-Fri 8-5

CIRCULATION POLICY
Photographs: Restricted (appointment suggested)
Slides: Restricted (appointment suggested)
COLLECTIONS
Films: 25
Slides: 35,000. Architecture (Ancient, European, US);
Sculpture (Ancient, European, US); Painting (Euro-
pean, US)
SUBSCRIPTIONS
Carnegie Set (slides)

VR 572
BEAUMONT ART MUSEUM
Beaumont Art Museum Library
1111 Ninth St, Beaumont, TX 77702
Tel: 713-832-3432
Registrar: Yvonne Craig
Founded: 1950
Hours: Mon-Fri 9-5

CIRCULATION POLICY
Slides: Restricted, researchers, faculty/staff
COLLECTIONS
Slides: 7,096 Metropolitan. Architecture (Ancient, Euro-
pean, US); Sculpture (Ancient, African, European,
US); Painting (European, US); Graphic Arts (Euro-
pean, US); Decorative Arts (Ancient, African, Tribal
American, Meso-American, Andean, European, US)
SUBSCRIPTIONS
Carnegie Set (slides)

VR 573
AMON CARTER MUSEUM OF WESTERN ART
Photographic Collection
Box 2365, Fort Worth, TX 76101
Tel: 817-738-1933
Person in Charge: Marjorie A Morey
Founded: 1961
Hours: Mon-Fri 9-5

CIRCULATION POLICY
Photographs: Students, researchers, faculty/staff
(appointment suggested)
Slides: Students, researcheres, faculty/staff (appointment
suggested)
COLLECTIONS
Photographs: 225,000
Slides: 5,000
SUBSCRIPTIONS
Carnegie Set (slides)
SERVICES
Photographs: Available for sale of museum collection
Slides: Available for sale of museum collection

VR 574
CORPUS CHRISTI STATE UNIVERSITY
6300 Ocean Dr, Corpus Christi, TX 78411
Tel: 512-991-6810, Ext 242
Person in Charge: Carl Wrotenbery
Founded: 1972
Hours: Mon-Thurs 9-10
Fri 8-5
Sat 9-4
Sun 2-8
Mon-Fri 8-5 (office)

CIRCULATION POLICY
Films: Students, faculty/staff
Slides: Faculty/staff
COLLECTIONS
Films: 160
Microforms: 184,000
Slides: 5,000. Architecture (Ancient); Sculpture (Ancient,
Meso-American); Painting (European, US)
Video: 50

VR 575
DALLAS MUSEUM OF FINE ARTS
Slide Library
Box 26250, Dallas, TX 75226
Tel: 214-428-4187, Ext 48
Slide Libn-Education Asst: Mary Mills
Founded: 1970
Hours: Mon-Fri 9-5

CIRCULATION POLICY
Slides: Researchers, faculty/staff
COLLECTIONS
Slides: 18,000 Metropolitan. Architecture (Ancient, Far
East, Meso-American, European, US); Sculpture
(Ancient, Far East, African, Pacific, Meso-American,
Andean, European, US); Painting (Far East, European,
US)
SPECIAL COLLECTIONS
Dallas Museum of Fine Arts Collection (slides)

VR 576
SAM HOUSTON STATE UNIVERSITY*
Department of Art, Slide Collection
Huntsville, TX 77340
Tel: 713-295-6211
Inst: Darryl Patrick

COLLECTIONS
Lantern Slides: 500
Slides: 11,000

VR 577
INSTITUTE OF TEXAN CULTURES
University of Texas at San Antonio, Shuffler Memorial
Library
Box 1226, San Antonio, TX 78294
Tel: 512-226-7651, Ext 41
Dir of Lib Services: Laura Bullion
Staff: 1
Founded: 1968
Hours: Mon-Fri 8-5

CIRCULATION POLICY
Photographs: Restricted, public (appointment suggested)
Slides: Restricted, public (appointment suggested)

COLLECTIONS
Photographs: 35,000 Subject/Catalog. Architecture
 (Texas); Sculpture (Texas); Painting (Texas);
 Graphic Arts (Texas); Decorative Arts (Texas)
Slides: 5,000
SPECIAL COLLECTIONS
San Antonio Light Negatives, ca 1900-1940 (negatives)
SERVICES
Negatives: Prints available for purchase, subject to
 restrictions placed by lenders and donors
Slides: Available for purchase and duplication

VR 578
KIMBELL ART MUSEUM
Slide Library
Will Rogers Rd W, Box 9440, Ft Worth, TX 76107
Tel: 817-332-8451
Slide Libn: June van Cleef
Founded: 1968
Hours: Tues-Fri 10-5
 Tues-Fri 9-5 (office)

CIRCULATION POLICY
Films: Restricted, researchers, faculty/staff, circulating
 (appointment suggested)
Slides: Restricted, researchers, faculty/staff, circulating
 (appointment suggested)
COLLECTIONS
Films: 30
Slides: 25,332 Metropolitan. Painting (European);
 Decorative Arts (Meso-American)
Video: 1
SERVICES
Slides: Museum objects are available for purchase from
 Museum Bookstore

VR 579
MIDWESTERN STATE UNIVERSITY
George Moffett Library
3400 Taft, Wichita Falls, TX 76308
Tel: 817-692-6611, Ext 204
Dir of Libs: Melba S Harvill
Staff: 2
Founded: 1922

CIRCULATION POLICY
Filmstrips: Restricted, students, faculty/staff
Slides: Restricted, faculty/staff
COLLECTIONS
Microforms: 81,045
Slides: 712 LC
Video: 24 (unclassified)

VR 580
NORTH TEXAS STATE UNIVERSITY
Media Library
Denton, TX 76203
Tel: 817-788-2691; 2703
Dir: George Mitchell
Staff: 1
Founded: 1976 (formerly part of Special Materials
 Division of Library)

CIRCULATION POLICY
Films: Restricted use, public, in-house circulating
Slides: Restricted use, public

COLLECTIONS
Films: 49 Serial Classification
Filmstrips: Serial Classification
Slides: 606 Serial Classification
SUBSCRIPTIONS
Button/Sbarge History of Costume (slides)
Carnegie Set (slides)

VR 581
NORTH TEXAS STATE UNIVERSITY
Slide Library
NT Box 5098, Denton, TX 76203
Tel: 817-788-2398, Ext 32
Slide Libn: Karen M Olvera
Hours: Mon-Fri 7:45-9
 Mon-Fri 8-5 (office)

CIRCULATION POLICY
Films: Restricted, faculty/staff
Slides: Restricted, faculty/staff
COLLECTIONS
Films: 40. Architecture (US); Painting (European, US);
 Graphic Arts (European, US); Decorative Arts (Euro-
 pean, US)
Slides: 50,000. Architecture (Ancient, Far East, Meso-
 American, European, US); Sculpture (Ancient,
 Islamic, Far East, African, Pacific, Tribal American,
 Meso-American, Andean, European, US); Painting
 (European, US); Graphic Arts (European, US);
 Decorative Arts (European, US)

VR 582
OUR LADY OF THE LAKE UNIVERSITY
Media Learning Center
411 S W 24 St, San Antonio, TX 78285
Tel: 512-434-6711, Exts 280; 282
Dir: Anna Rose Kanning
Staff: 2
Founded: 1971
Hours: Mon-Thurs 8-9:30
 Fri 8-5
 Sat 8:30-12
 Mon-Fri 8-6 (summer)

CIRCULATION POLICY
Films: Public, limited circulating
Photographs: Public, limited circulating
Slides: Public, limited circulating
Video: Public, limited circulating
COLLECTIONS
Films: 287 Dewey. Sculpture (European, US); Painting
 (European, US); Graphic Arts (European, US)
Photographs: Dewey
Slides: 49,847 Dewey. Sculpture (European, US);
 Painting (European, US); Graphic Arts (European,
 US)
Microforms: 178,520 Dewey
Other: 16,455 Dewey
Video: 13 Dewey
SERVICES
Negatives: Prints available for purchase of non-
 copyrighted work
Slides: Available for purchase or duplication of non-
 copyrighted work

VR 583
RICE UNIVERSITY
Dept of Art & Art History, Slide Library

Box 1892, Houston, TX 77001
Tel: 713-537-4836
Curator of Slides & Photographs: Patricia Toomey
Founded: 1962
Hours: Mon-Fri 8:30-5 (office)

CIRCULATION POLICY
Photographs: Researchers, faculty/staff
Slides: Researchers, faculty/staff
COLLECTIONS
Photographs: 20,000. Architecture (Ancient, European, US); Sculpture (Ancient, European, US); Painting (Ancient, European, US)
Slides: 130,000. Architecture (Ancient, Far East, European, US); Sculpture (Ancient, Far East, African, Pacific, Tribal American, Meso-American, European, US); Painting (Ancient, Far East, European, US); Graphic Arts (European, US); Decorative Arts (Ancient, European, US)

VR 584
SAN ANTONIO COLLEGE
Audiovisual Service Center
1001 Harvard St, San Antonio, TX 78284
Tel: 512-734-7311, Ext 257
A-V Coordinator: Don Drummond
Staff: 2
Founded: 1967
Hours: Mon-Thurs 8-9
　　　 Fri 8-5
　　　 Mon-Fri 8-4 (office)

CIRCULATION POLICY
Films: Public
Filmstrips: Public
Slides: Public
COLLECTIONS
Films: 404 Accession Number
Filmstrips: 1,581 Dewey/Accession Number
Microforms: 39,360 Dewey/Accession Number
Slides: 66,215 Dewey. Architecture (Ancient, European, US); Sculpture (Ancient, European, US); Painting (European, US)
Video: 237 Dewey

VR 585
SAN ANTONIO MUSEUM ASSOCIATION
Ellen S Quillin Memorial Library
3801 Broadway, San Antonio, TX 78209
Tel: 512-826-0647, Ext 32
Libn: Billie Persons
Hours: Mon-Fri 9-5
　　　 Sat-Sun 10-6

CIRCULATION POLICY
Photographs: Students, researchers, faculty/staff, fee service (appointment suggested)
Slides: Students, researchers, faculty/staff, fee service (appointment suggested)
COLLECTIONS
Photographs: 2,000. Architecture (US)
Slides: 10,000. Architecture (Ancient, Meso-American, European, US); Sculpture (Ancient, Tribal American, Meso-American, European, US); Painting (Ancient, Tribal American, Meso-American, European, US); Graphic Arts (European, US); Decorative Arts (European, US)

SUBSCRIPTIONS
Carnegie Set (slides)
Eastman Collection (slides)
SERVICES
Negatives: Prints available for purchase subject to copyright and museum regulations
Slides: Available for purchase

VR 586
SAN ANTONIO PUBLIC LIBRARY
Art, Music & Films Department
203 S Saint Mary's, San Antonio, TX 78205
Tel: 512-223-6851
Libn: Frances S Smith
Founded: 1958
Hours: Mon-Fri 9-9
　　　 Sat 9-6

CIRCULATION POLICY
Slides: Public, circulating
COLLECTIONS
Films: 1,302
Microforms: 780
Slides: 2,418

VR 587
SAN JACINTO COLLEGE
Instructional Media Center
8060 Spencer Hwy, Pasadena, TX 77505
Tel: 713-479-1501, Ext 237
Dir: Monte Blue
Staff: 1
Hours: Mon-Fri 8-5

CIRCULATION POLICY
Audiotapes: Public, restricted circulating
Films: Faculty/staff, restricted circulating
Photographs: Faculty/staff, restricted circulating
Slides: Faculty/staff, restricted circulating
Video: Faculty/staff, restricted circulating
COLLECTIONS
Films: n. a.
Photographs: n. a.
Slides: 1,000
Video: 293

VR 588
SOUTHERN METHODIST UNIVERSITY
Division of Fine Arts, Slide Library
Dallas, TX 75275
Tel: 214-692-2796
Slide Curator: D J Quebe
Founded: 1968
Hours: Mon-Fri 9-5 (office)

CIRCULATION POLICY
Slides: Restricted, art students, researchers, faculty/staff, circulating
COLLECTIONS
Photographs: 700 Fogg
Slides: 90,000 Fogg. Architecture (Ancient, European, US); Sculpture (Ancient, African, Pacific, Tribal American, Meso-American, European); Painting (Ancient, Far East, European, US); Graphic Arts (US); Decorative Arts (Ancient, Far East, European)

VR 589
TEXAS CHRISTIAN UNIVERSITY
School of Fine Arts, Art Department Slide Library
Ed Landreth Hall, University & Cantey Sts, Fort Worth,
 TX 76129
Tel: 817-926-2461, Ext 591
Slide Libn: Judith S Cohen
Founded: 1973
Hours: Mon-Fri 10-2 (office)

CIRCULATION POLICY
Slides: Restricted, graduate students, researchers, faculty/
 staff (appointment suggested)
COLLECTIONS
Slides: 60,000 Metropolitan

VR 590
UNIVERSITY OF HOUSTON
Art Department, Slide Library
Fine Arts Bldg, Rm 354, Cullen Blvd, Houston, TX 77004
Tel: 713-749-1793
Slide Libn: Barbara Honig
Founded: ca 1970
Hours: Mon-Fri 8-4:30 (office)

CIRCULATION POLICY
Slides: Restricted, public, circulating
COLLECTIONS
Slides: 75,000. Architecture (Ancient, Andean, Euro-
 pean, US); Sculpture (Ancient, African, Pacific,
 Andean, European, US); Painting (European, US);
 Graphic Arts (European, US); Decorative Arts
 (Ancient, European, US)

VR 591
UNIVERSITY OF HOUSTON
Frenzheim Architecture Library
4800 Calhoun, Houston, TX 77027
Tel: 713-749-1193
Person in Charge: Jacqueline Dyer
Founded: 1970

CIRCULATION POLICY
Slides: Students, faculty/staff, circulating
COLLECTIONS
Slides: 29,000 Santa Cruz. Architecture (Ancient, Euro-
 pean, US)

VR 592
UNIVERSITY OF ST THOMAS*
Art Department, Slide & Photograph Curator
Houston, TX 77006
Tel: 713-522-7911

VR 593
UNIVERSITY OF TEXAS AT ARLINGTON
Art Department, Slide Library
Arlington, TX 76019
Tel: 817-273-2891, Ext 34
Professional Libn: Jan Meneley
Founded: 1974
Hours: Mon-Fri 8-12, 1-5 office)

CIRCULATION POLICY
Slides: Students, researchers, faculty/staff (appointment
 suggested)

COLLECTIONS
Slides: 35,000 Metropolitan. Architecture (Ancient, Far
 East, European, US); Sculpture (Ancient, Far East,
 African, Pacific, Tribal American, European, US);
 Painting (Ancient, Far East, African, Pacific, Tribal
 American, European, US); Graphic Arts (Far East,
 European, US); Decorative Arts (African, Pacific,
 Tribal American, US)

VR 594
THE UNIVERSITY OF TEXAS AT AUSTIN
Department of Art, Slide Collection & Photograph
 Archive
Art Bldg 1.202, Austin, TX 78712
Tel: 512-471-3365
Professional Libn: Nancy S Schuller
Founded: 1940
Hours: Mon-Fri 8-5 (office)

CIRCULATION POLICY
Photographs: Restricted, students, researchers, faculty/staff
 (appointment suggested)
Slides: Restricted, faculty/staff (appointment suggested)
COLLECTIONS
Filmstrips: 50
Photographs: 6,000. Architecture (Ancient, Meso-
 American, European); Sculpture (Ancient, Meso-
 American, European); Painting (European); Graphic
 Arts (European); Decorative Arts (Meso-American,
 European)
Slides: 200,000 Fogg. Architecture (Ancient, Meso-
 American, Andean, European, US); Sculpture (Ancient,
 African, Pacific, Meso-American, Andean, European,
 US); Painting (Ancient, European, US); Graphic Arts
 (European, US); Decorative Arts (Ancient, African,
 Tribal American, Meso-American, Andean, European,
 US)
SUBSCRIPTIONS
American Committee of South Asian Art (slides)
Carnegie Set (slides)
Courtauld Institute Photo Survey of Private Collections
 (slides)
SPECIAL COLLECTIONS
Pre-Columbian and Colonial Art & Architecture of
 Mexico and Central America (photographs, slides)

VR 595
THE UNIVERSITY OF TEXAS AT AUSTIN
Humanities Research Center, Photography Collection
Austin, TX 78712
Tel: 512-571-1833
Curator: Joe Coltharp
Staff: 3
Founded: 1964
Hours: Mon-Fri 8-5

CIRCULATION POLICY
Photographs: Public
Slides: Public
COLLECTIONS
Films: 400
Photographs: 200,000
Slides: 5,000
SUBSCRIPTIONS
Gernsheim Collection (photographs, slides)
SPECIAL COLLECTIONS
Goldbeck Collection, panoramic military views in the

United States and foreign countries (photographs)
Muller Collection, (photographs, cameras, and
memorabilia)
Smithers Collection, trans-Pecos area of documentation
since 1890 (photographs)
SERVICES
Negatives: Prints available for purchase and publication
subject to copyright and institutional regulations
Slides: (Produced by special request)

VR 596
THE UNIVERSITY OF TEXAS AT AUSTIN
School of Architecture, Slide Library
Austin, TX 78712
Tel: 512-471-1922
Slide Libn: Susan Hoover
Founded: 1969
Hours: Mon-Fri 8-5 (office)

CIRCULATION POLICY
Slides: Restricted, students, researchers, and professional
architects, faculty/staff
COLLECTIONS
Slides: 50,000. Architecture (Ancient, Islamic, Far East,
African, Pacific, Tribal American, Meso-American,
Andean, European, US); Decorative Arts (European)
SPECIAL COLLECTIONS
Urban Planning & Landscape Architecture (slides)

VR 597
UNIVERSITY OF TEXAS AT EL PASO
Department of Art, Slide Library
El Paso, TX 79968
Tel: 915-757-5181
Slide Libn: F Peterson
Founded: 1968
Hours: Mon-Fri 8-5 (office)

CIRCULATION POLICY
Films: Restricted, researchers, faculty/staff
Filmstrips: Restricted, researchers, faculty/staff
Photographs: Restricted, researchers, faculty/staff
Slides: Restricted, researchers, faculty/staff
COLLECTIONS
Films: 38
Models: 10. Architecture (Ancient)
Photographs: 1,500. Painting (European, US)
Slides: 20,000. Architecture (Ancient, Islamic, African,
Meso-American, Andean, European, US); Sculpture
(Ancient, Far East, African, Pacific, Tribal-American,
Meso-American, Andean, European, US); Painting
(Ancient, Meso-American, European, US); Graphic Arts
(Far East, European, US); Decorative Arts (Ancient,
Islamic, Far East, African, Pacific, Tribal American,
Meso-American, European, US)

VR 598
UNIVERSITY OF TEXAS AT SAN ANTONIO
Slide Library
6900 North FM 1604 West, San Antonio, TX 78285
Tel: 512-691-4303
VR Curator: Maurice Gonzales
Founded: 1973
Hours: Mon-Fri 8-5 (office)

CIRCULATION POLICY
Photographs: Researchers, faculty/staff

Slides: Researchers, faculty/staff
COLLECTIONS
Photographs: 1,000
Slides: 50,000. Architecture (Ancient, Islamic, Meso-
American, Andean, European, US); Sculpture (Ancient,
African, Meso-American, European, US); Painting
(Ancient, Islamic, Far East, Meso-American, European,
US); Graphic Arts (Far East, European, US)
SPECIAL COLLECTIONS
Pre-Columbian Art from Mexico & Guatemala (slides),
taken from the archives of the Foundation For Latin
American Anthropological Research

Utah

VR 599
SALT LAKE CITY PUBLIC LIBRARY
Fine Arts Department
209 E Fifth S, Salt Lake City, UT 84111
Tel: 801-363-5733, Ext 41
Head, Fine Arts Dept: Glenda Rhodes
Hours: Mon-Fri 9-9
Sat 9-6
Sun 1-5

CIRCULATION POLICY
Art Reproductions: Public, circulating
Picture File: Public, circulating
Slides: Public, circulating
COLLECTIONS
Art Reproductions: 5,504 Accession Number.
Painting (European, US)
Slides: 7,100 Accession Number. Architecture (European,
US); Sculpture (European, US); Painting (European,
US); Graphic Arts (US); Decorative Arts (Tribal
American, US)

VR 600
SPRINGVILLE MUSEUM OF ART
126 E 400 S, Box 258, Springville, UT 84663
Tel: 801-489-7305
Person in Charge: Ross Johnson

CIRCULATION POLICY
Photographs: Students, researchers, faculty/staff
(appointment suggested)
Slides: Students, researchers, faculty/staff (appointment
suggested)
COLLECTIONS
Photographs: 1,000. Sculpture (US); Painting (European,
US); Graphic Arts (US); Decorative Arts (US)
Slides: 2,000. Sculpture (US); Painting (European, US);
Graphic Arts (US); Decorative Arts (US)
SPECIAL COLLECTIONS
Edward Anderson, pioneer photographer (glass negatives)
SERVICES
Negatives: Prints available for purchase upon request

VR 601
UNIVERSITY OF UTAH*
Graduate School of Architecture
Salt Lake City, UT 84112
Tel: 801-581-8254

VR 602
UNIVERSITY OF UTAH
Marriott Library
Salt Lake City, UT 84112
Tel: 801-581-6283
Head, Non-Print Reference Services: Ruth A Frear
Hours: Mon-Thurs 7:30-11
 Fri 7:30-8
 Sat 9-8
 Sun 1-10 (during school year)

CIRCULATION POLICY
Films: Restricted
Filmstrips: Restricted
Slides: Restricted
Video: Restricted
COLLECTIONS
Films: 100 LC
Filmstrips: 420 LC
Microforms: 1,000,000 LC, ERIC, etc
Slides: 12,000. Architecture (Ancient, Meso-American,
 European); Sculpture (Ancient, Meso-American, Euro-
 pean); Painting (European, US)
Video: 1,300 LC

Vermont

VR 603
BENNINGTON COLLEGE
Crossett Library
Bennington, VT 05201
Tel: 802-442-5401, Exts 278; 279
Libn: Robert M Agard
Founded: 1928
Hours: Mon-Thurs 9-1
 Fri 9-10
 Sat 10-10
 Sun 10-1

CIRCULATION POLICY
Photographs: Students, researchers, faculty/staff
Slides: Students, researchers, faculty/staff
COLLECTIONS
Microforms: 4,151
Photographs: 90
Slides: 15,346. Architecture (European, US); Sculpture
 (European, US); Painting (European, US)
SPECIAL COLLECTIONS
Doerner Glass (3x3) Collection of European and Classical
 Art (large slides)

VR 604
CASTLETON STATE COLLEGE
Media Center
Castleton, VT 05735
Tel: 802-468-5611, Ext 248
Media Coordinator: Mary Giordano
Founded: 1971
Hours: Mon-Fri 8-11:30 am

CIRCULATION POLICY
Slides: Public, circulating (appointment suggested)
COLLECTIONS
Microforms: 10,275
Slides: 503
Video: 260

VR 605
MIDDLEBURY COLLEGE
Department of Art, Johnson Gallery
Middlebury, VT 05753
Tel: 802-388-2762
Curator of Slides & Photographs: Jane Fiske
Staff: 1
Founded: 1968
Hours: Mon-Fri 8:15-12:30, 1-5 (office)

CIRCULATION POLICY
 Slides: Researchers, faculty/staff
 (appointment suggested)
COLLECTIONS
Films: 5
Slides: 34,000. Architecture (Ancient, Far East, Euro-
 pean, US); Sculpture (Ancient, Far East, European,
 US); Painting (European, US); Graphic Arts (European,
 US); Decorative Arts (European, US)
SUBSCRIPTIONS
Carnegie Set (slides)

VR 606
UNIVERSITY OF VERMONT
Art History Slide/Photograph Collection
Art Dept, Fleming Museum, Burlington, VT 05401
Tel: 802-656-2092
Academic Program Specialist: Alice S Rydjeski
Founded: 1962

CIRCULATION POLICY
Photographs: Restricted, students, faculty/staff, circulating
Slides: Restricted, students, faculty/staff, circulating
COLLECTIONS
Photographs: 12,000. Architecture (Ancient, European,
 US); Sculpture (Ancient, Tribal American, European,
 US); Painting (Ancient, European, US); Graphic Arts
 (European, US); Decorative Arts (European, US)
Slides: 60,000. Architecture (Ancient, European, US);
 Sculpture (Ancient, African, Tribal American, Meso-
 American, European, US); Painting (Ancient, Euro-
 pean, US); Graphic Arts (European, US); Decorative
 Arts (European, US)

Virginia

VR 607
CHRYSLER MUSEUM AT NORFOLK
Onley Rd & Mowbray Arch, Norfolk, VA 23510
Tel: 804-622-1211
Libn: Jean O Chrysler
Founded: 1958
Hours Tues-Fri (by appointment)

CIRCULATION POLICY
Slides: Restricted
COLLECTIONS
Slides: 10,000

VR 608
COLONIAL WILLIAMSBURG*
Audiovisual Library
Drawer C, Williamsburg, VA 23185
Tel: 804-229-1000, Ext 2286
Head Audiovisual Library: Patricia G Maccubbin

VR 609
JAMES MADISON UNIVERSITY
Art Department, Visual Resource Center
Duke Fine Arts Bldg, Harrisonburg, VA 22801
Tel: 703-433-6588
Art Slide Curator: Christina B Updike
Founded: 1908
Hours: Mon-Fri 8-5 (office)

CIRCULATION POLICY
Films: Faculty/staff (appointment suggested)
Filmstrips: Faculty/staff (appointment suggested)
Prints: Faculty/staff (appointment suggested)
Slides: Faculty/staff (appointment suggested)
COLLECTIONS
Films: 30
Filmstrips: 120
Prints: 8,000 Minnesota. Architecture (Ancient, Far East,
 European, US); Sculpture (Ancient, Far East, Euro-
 pean, US); Painting (Ancient, Fart East, European, US);
 Graphic Arts (Ancient, European, US)
Slides: 15,000 Minnesota. Architecture (Ancient, Far East,
 Meso-American, European, US); Sculpture (Ancient,
 Far East, African, Meso-American, European, US);
 Painting (Ancient, Far East, European, US); Graphic
 Arts (Far East, European, US); Decorative Arts
 (Ancient, African, Meso-American, European, US)

VR 609A
**MOUNT VERNON LADIES ASSOCIATION OF
 THE UNION**
Mt Vernon, VA 22121
Tel: 703-780-2000
Libn: John A Castellani
Hours: Mon-Fri 9:30-4

COLLECTIONS
Photographs
Postcards

VR 610
NORFOLK PUBLIC LIBRARY
Feldman Department
301 E City Hall Ave, Norfolk, VA 23510
Tel: 804-441-2426
Dept Head: Audrey Hays
Staff: 2
Founded: 1972
Hours: Mon-Fri 9-9
 Sat 9-5

CIRCULATION POLICY
Films: Restricted, circulating
Reproductions: Public, limited circulating
Slides: Public, circulating
COLLECTIONS
Art Pictures: 551
Films: 15
Filmstrips: 30
Kits: 40
Sculptures: 60
Slides: 125 sets
SPECIAL COLLECTIONS
Circulating art collection (framed) by local artists

VR 611
NORTH VIRGINIA COMMUNITY COLLEGE*
Learning Resources Center
3443 S Carlyn Spring Rd, Baileys' Crossroads, VA 22041

VR 611A
OLD DOMINION UNIVERSITY*
Dept of Art, Slide Collection
Norfolk, VA 23508
Tel: 804-489-6000

VR 612
RANDOLPH-MACON WOMAN'S COLLEGE
Art Department, Slide Room
534 Leggett Bldg, Lynchburg, VA 24504
Tel: 804-846-7392
Asst Prof of Art: Nancy Mowell

CIRCULATION POLICY
Slides: Faculty/staff
COLLECTIONS
Slides: 18,000. Architecture (Ancient, Far East, European,
 US); Sculpture (Ancient, Far East, European, US);
 Painting (Ancient, Far East, European, US); Graphic
 Arts (US); Decorative Arts (US)

VR 613
ROANOKE PUBLIC LIBRARY
706 S Jefferson St, Roanoke, VA 24011
Tel: 703-981-2475
Manager: Nancy E Himes
Founded: 1921
Hours: Mon-Thurs 9-9
 Fri 9-6
 Sat 9-9

CIRCULATION POLICY
Slides: Public, circulating
COLLECTIONS
Films: 315
Microforms: 25,604
Slides: 2,745

VR 615
SOUTHWEST VIRGINIA MUSEUM
Big Stone Gap, VA 24219
Tel: 703-523-1322
Curator: William S Portlock
Staff: 2
Founded: 1946
Hours: Tues-Sat 9:30-5

SPECIAL COLLECTIONS
Historic Views of Southern Appalachians, 1900-1950
 (photographs)

VR 616
UNIVERSITY OF RICHMOND
Art Department, Art Library
Richmond, VA 23173
Tel: 804-285-6246
Person in Charge: Charles Johnson
Hours: Mon-Fri 8-5

CIRCULATION POLICY
Slides: Students, researchers, faculty/staff (appointment
 suggested)

COLLECTIONS
Slides: 20,000 Historical/chronological. Architecture
 (Ancient); Sculpture (Ancient, European, US); Painting
 (European, US); Graphic Arts (European)

VR 617
UNIVERSITY OF RICHMOND
Learning Resources Center
Richmond, VA 23173
Tel: 804-285-6314
Person in Charge: Terry Goldman
Hours: Mon-Fri 8-5

COLLECTIONS
Films: 100
Video: 100

VR 618
UNIVERSITY OF VIRGINIA
Cabell Hall, Slide Library
Language Laboratory, Charlottesville, VA 22903
Tel: 804-924-3807
Slide Libn: Patti Richards
Founded: 1975
Hours: Mon-Fri 10-12 (office)

CIRCULATION POLICY
Slides: Restricted (appointment required)
COLLECTIONS
Slides: 10,000. Architecture (Ancient, European, US);
 Sculpture (Ancient, European, US); Painting (European,
 US); Graphic Arts (European, US); Decorative Arts
 (European, US)

VR 619
UNIVERSITY OF VIRGINIA
Fiske Kimball Fine Arts Library, Slide Library
Bayly Dr, Charlottesville, VA 22903
Tel: 804-924-7024
Slide Libn: Marika Simms
Hours: Mon-Fri 8-5

CIRCULATION POLICY
Photographs: Public (appointment suggested)
Slides: Public (appointment suggested)
COLLECTIONS
Photographs: 1,800. Architecture (European, US)
Slides: 73,000. Architecture (Ancient, Islamic, Far East,
 European, US); Decorative Arts (European, US)
SPECIAL COLLECTIONS
Frances Benjamin Johnston Collection of Virginia
 Architecture (photographs)

VR 620
UNIVERSITY OF VIRGINIA
Fiske Kimball Fine Arts Library, Slide Room
Fayerweather Hall, Charlottesville, VA 22903
Tel: 804-924-3057
Slide Libn: Norman Rubenstein
Founded: 1967
Hours: Mon-Fri 8-4 (office)

CIRCULATION POLICY
Photographs: Restricted
Slides: Restricted
COLLECTIONS
Photographs: Architecture (European, US); Painting
 (European, US)
Slides: 125,000. Architecture (Ancient, Far East, Euro-
 pean, US); Sculpture (Ancient, Far East, European, US);
 Painting (Ancient, Far East, European, US); Graphic
 Arts (Ancient, Far East, European, US); Decorative
 Arts (Ancient, Far East, European, US)

VR 621
UNIVERSITY OF VIRGINIA*
McIntire Department of Art, Slide Library
Cocke Hall, Charlottesville, VA 22903
Tel: 804-924-0311

VR 622
UNIVERSITY OF VIRGINIA*
School of Architecture
Charlottesville, VA 22903
Tel: 804-924-0311

VR 623
VIRGINIA COMMONWEALTH UNIVERSITY
School of the Arts Library
901 W Franklin St, Richmond, VA 23284
Tel: 804-770-7120
Director: Joan L Muller
Staff: 1½
Founded: 1928
Hours: Mon & Tues 9-5
 Wed & Thurs 6-9
 Fri 9-4

CIRCULATION POLICY
Slides: Graduate students, faculty/staff
COLLECTIONS
Exhibition catalogs: 12,000
Slides: 200,000 Metropolitan. Architecture (Ancient, Far
 East, African, Tribal American, European, US); Sculp-
 ture (Ancient, Far East, African, Tribal American,
 European, US); Painting (Far East, European, US);
 Graphic Arts (European, US); Decorative Arts (Ancient,
 Far East, African, Tribal American, European, US)
SUBSCRIPTIONS
Carnegie Set (slides)
Chinese National Palace Museum Photo Archives (slides)
University Colour Slide Scheme (slides-discontinued)
SPECIAL COLLECTIONS
Communication Arts & Design (slides)
Contemporary Crafts & Painting (slides)
Interior Design (slides)
Twentieth Century Photography (slides)

VR 624
VIRGINIA MUSEUM OF FINE ARTS LIBRARY
Blvd & Grove Ave, Richmond, VA 23221
Tel: 804-786-6327
Libn: Betty A Stacy
Founded: 1962
Hours: Mon-Fri 9-5

CIRCULATION POLICY
Slides: (appointment suggested)
COLLECTIONS
Slides: 25,000. Architecture (US); Sculpture (US); Painting
(US); Graphic Arts (US); Decorative Arts (US)
SUBSCRIPTIONS
Carnegie Set (slides)

VR 625
VIRGINIA POLYTECHNIC INSTITUTE &
STATE UNIVERSITY*
College of Architecture & Urban Studies
Blacksburg, VA 24061
Tel: 703-951-6386

Washington

VR 626
EASTERN WASHINGTON STATE COLLEGE
Instructional Media Center
Cheney, WA 99004
Tel: 509-359-2265
AV Libn: Susan Wallace
Founded: 1965
Hours: Mon-Fri 8-5

CIRCULATION POLICY
Films: Restricted
Filmstrips: Public, circulating
Recordings: Public, circulating
Slides: Public, circulating
COLLECTIONS
Films: 300 Accession Number. Architecture (European);
Painting (European)
Recordings: 15,000 LC
Slides: 65,000 LC. Architecture (Ancient, Islamic, Meso-
American, Andean, European, US); Sculpture (Ancient,
Far East, African, Pacific, Tribal American, European,
US); Painting (Far East, European, US); Graphic Arts
(European, US); Decorative Arts (Far East, African,
Pacific, Tribal American, Meso-American, European,
US)
Video: 150 Accession Number
SUBSCRIPTIONS
American Committee of South Asian Art (slides)
University Colour Slide Scheme (slides)

VR 627
THE EVERGREEN STATE COLLEGE LIBRARY
Olympia, WA 98505
Tel: 206-866-6250
Dean of Lib Services: Jovana Brown
Staff: 6
Founded: 1970
Hours: Mon-Fri 8-5

CIRCULATION POLICY
Art Prints: Restricted (appointment suggested)
Films: Public, circulating
Slides: Students, faculty/staff, circulating (appointment
suggested)
COLLECTIONS
Art Prints: 749 LC

Films: 478 LC
Slides: 16,259 LC. Architecture (European, US); Painting
(European, US); Decorative Arts (Tribal American, US)
Video: 4 LC

VR 628
HENRY GALLERY, UNIVERSITY OF
WASHINGTON
Registry of Northwest Artists
Seattle, WA 98195
Tel: 206-543-2280
Registry Coordinator: Julia Talbott
Founded: 1968
Hours: Wed, Fri 12-4

CIRCULATION POLICY
Catalogs: Public (appointment suggested)
Clippings: Public (appointment suggested)
Periodicals: Public (appointment suggested)
Photographs: Public (appointment suggested)
Slides: Public (appointment suggested)
COLLECTIONS
Photographs: 500 Keysort. Architecture (US); Sculpture
(US); Painting (US); Graphic Arts (US); Decorative
Arts (US)
Slides: 15,000 Keysort. Sculpture (US); Painting (US);
Graphic Arts (US); Decorative Arts (US)
SPECIAL COLLECTIONS
Public Art Program (photographs, slides)
SERVICES
Negatives: Prints available for purchase from the files of
university employed photographers
Slides: Available for sale or duplication with permission
of artist or owner

VR 629
SEATTLE ART MUSEUM
Slide & Photograph Library
14 & Prospect, Seattle, WA 98112
Tel: 206-447-4710
Slide & Photograph Libn: Joan H Nilsson
Founded: 1933
Hours: Mon-Fri 9-5
CIRCULATION POLICY
Photographs: Restricted, researchers, faculty/staff
Slides: Public, circulating
COLLECTIONS
Films: 200
Photographs: 8,000. Sculpture (Ancient, African, Meso-
American); Painting (Islamic, European); Decorative
Arts (Islamic, European)
Slides: 53,000 Minnesota. Architecture (Ancient, Islamic,
Far East, Meso-American, European); Sculpture
(Ancient, Far East, African, Tribal American, Euro-
pean); Painting (Ancient, Far East, European); Graphic
Arts (European); Decorative Arts (Far East, European)
SERVICES
Negatives: Prints available for purchase and reproduction
of objects in collection
Slides: Available for purchase or duplication

VR 630
SEATTLE PUBLIC LIBRARY
Audio Collection & Media & Program Services
1000 Fourth, Seattle, WA 98104
Tel: 206-625-4980; 4989
Libn: Mary Carbray

CIRCULATION POLICY
Photographs: Public, circulating
Slides: Public, circulating
COLLECTIONS
Photographs
Slides

VR 631
SPOKANE PUBLIC LIBRARY
Fine Arts Department
W 906 Main Ave, Spokane, WA 99201
Tel: 509-838-3361, Ext 58
Libn: Janet Miller
Staff: 2
Hours: Mon-Sat 9-9

CIRCULATION POLICY
Photographs: Public
Slides: Public, circulating
COLLECTIONS
Art Reproductions: 600
Photographs: 400
Slides: (new collections)

VR 632
UNIVERSITY OF WASHINGTON
Art Library
101 Art Bldg, Rm 10, Seattle, WA 98195
Tel: 206-543-0648
Libn: Marietta Ward
Founded: 1950

CIRCULATION POLICY
Photographs: Restricted, students, researchers, faculty/
 staff
COLLECTIONS
Photographs: 15,000. Painting (Far East, European);
 Decorative Arts (African)
SUBSCRIPTIONS
Asian Art Photographic Distribution (photographs)
Chinese National Palace Museum Photograph Archives
 (photographs)
Decimal Index of the Art of Low Countries
 (photographs)

VR 633
UNIVERSITY OF WASHINGTON*
Department of Architecture
Seattle, WA 98195
Tel: 206-543-2100

VR 634
UNIVERSITY OF WASHINGTON
Library, Media Center DF-10
Seattle, WA 98195
Tel: 206-543-6051
Head, Media Center: Harriet D Marshall
Staff: 1
Hours: Mon-Fri 8-5

CIRCULATION POLICY
Audio cassettes: 6,000
Films: 217
Filmstrips: 471
Slides: 12,509
Video: 1,020

VR 635
UNIVERSITY OF WASHINGTON
School of Art, Slide Collection, DM-10
Seattle, WA 98195
Tel: 206-543-0649
Slide Curator: Mildred Ellquist Thorson
Staff: 1
Founded: 1958
Hours: Mon-Fri 7:30-5:30 (office)

CIRCULATION POLICY
Slides: Researchers, faculty/staff
COLLECTIONS
Slides: 160,000 Minnesota. Architecture (European);
 Sculpture (Far East, European, US); Painting (Far
 East, European, US); Graphic Arts (US); Decorative
 Arts (US)
SUBSCRIPTIONS
Asian Art Photographic Distribution (slides)
Carnegie Set (slides)
SPECIAL COLLECTIONS
Art in Public Places: State of Washington (slides)
Peter Paul Rubens (slides)

Wisconsin

VR 636
GATEWAY TECHNICAL INSTITUTE
Learning Resources Centers
3520 30 Ave, Kenosha, WI 53142
Tel: 414-552-9600, Exts 54; 55
Dist Coordinator of Instructional Resources:
 J Jerome Oehler
Staff: 4
Hours: Mon-Fri 8-4:30

CIRCULATION POLICY
Films: Restricted, public, circulating
Filmstrips: Public, circulating
Slides: Public, circulating
Video: Public, circulating
COLLECTIONS
Films: 825
Filmstrips: 1,825
Slides: 20,685. Architecture (Ancient, US); Painting
 (European); Decorative Arts (Ancient, European, US)
Video: 120
SPECIAL COLLECTIONS
A History of the Modern Movement (slides)
Art, Architecture, Design by Kurt Rowland (slides)

VR 637
GRAHAM PUBLIC LIBRARY
1215 Main St, Union Grove, WI 53182
Tel: 414-878-2910
Head Libn: Delores Saemisch
Staff: 1
Founded: 1932

CIRCULATION POLICY
Microfiche: Public
Picture File: Public, circulating
Slides: Public, circulating
COLLECTIONS
Microfiche

Picture File: 1,000
Slides: 2,000

VR 638
KENOSHA PUBLIC MUSEUM LIBRARY
Civic Center
Kenosha, WI 43140
Tel: 414-656-6034
Dir: Stephen H Schwartz
Staff: 2
Founded: 1933

CIRCULATION POLICY
Photographs: Public, circulating
Slides: Public, circulating
COLLECTIONS
Films: 200. Architecture (Canada); Decorative Arts
 (Canada)
Filmstrips: 2,000
Photographs: 50
Slides: 50
SPECIAL COLLECTIONS
Natural History Collection (slides)
SERVICES
Slides: Available for duplication subject to copyright and
 library regulations

VR 639
JOHN MICHAEL KOHLER ARTS CENTER
Slide Library
608 New York Ave, Sheboygan, WI 53081
Tel: 414-458-6144
Dir: Ruth DeYoung Kohler
Staff: 5
Founded: 1967
Hours: Mon-Fri 8-5
 Sat-Sun 1-5

CIRCULATION POLICY
Slides: Researchers, faculty/staff (appointment required)
COLLECTIONS
Slides: 15,000. Sculpture (European, US); Painting (Euro-
 pean, US); Graphic Arts (European, US); Decorative
 Arts (European, US)
SPECIAL COLLECTIONS
Kohler Arts Center Exhibitions Documentation (slides)
SERVICES
Slides: Available for sale or duplication with permission
 of artist or owner

VR 640
LA CROSSE PUBLIC LIBRARY
800 Main, La Crosse, WI 54601
Tel: 608-784-8623
Lib Dir: James W White
Staff: 10
Founded: 1881
Hours: Mon-Thurs 9-9
 Fri-Sat 9-6
 Sun 1-5 (Oct-May)

CIRCULATION POLICY
Microforms: Public
Slides: Public, circulating
COLLECTIONS
Films: 1,200

Microforms: 2,250
Slides: 1,200

VR 641
MADISON PUBLIC LIBRARY
Art & Music Division
201 W Mifflin St, Madison, WI 53703
Tel: 608-266-6311
Supervisor, Art & Music Div: Beverly Brager
Staff: 4
Founded: 1965 (Music & Art Division)
Hours: Mon-Fri 8:30-9
 Sat 9-5:30

CIRCULATION POLICY
Reproductions: Public, circulating
Films: Public, circulating
COLLECTIONS
Films: 600
Reproductions: 420
Video: 20

VR 642
MARATHON COUNTY PUBLIC LIBRARY
400 First St, Wausau, WI 54401
Tel: 715-845-7214
Dir: Wayne Bassett
Hours: Mon-Fri 8:30-9
 Sat 8:30-530

CIRCULATION POLICY
Original Art: Public, circulating
Photographs: Public, circulating
Reproductions: Public, circulating
Slides: Public, circulating
COLLECTIONS
Films: 900 Accession Number
Filmstrips: 2,000
Microforms: 3,056
Original Art: Paintings (US); Sculpture (US)
Photographs: (very few)
Slides: 120. Painting (European)
SERVICES
Slides: Available for duplication subject to copyright
 and library regulations and fees

VR 643
MILWAUKEE ART CENTER*
Slide Collection
750 N Lincoln Memorial Dr, Milwaukee, WI 53202
Tel: 414-271-9508
Founded: 1957

VR 644
MILWAUKEE PUBLIC MUSEUM
Audiovisual Center
800 W Wells St, Milwaukee, WI 53233
Tel: 414-278-2727
Person in Charge: Sharon K Chaplock
Hours: Mon-Fri 9-4

CIRCULATION POLICY
Films: Public
Realia: Faculty/staff
Slides: Faculty/staff
COLLECTIONS
Films: 7,500 (computerized)

Filmstrips: 3,800 (computerized)
Models: 1,100 (computerized)
Slides: 500 (computerized)
Video: 4 (computerized)
SPECIAL COLLECTIONS
Historical, fieldwork and book illustrations, handcolored
 (lantern slides)

VR 645
MILWAUKEE PUBLIC MUSEUM
Photo Department
800 W Wells St, Milwaukee, WI 53233
Tel: 414-278-2756
Chief Photographer: Leo Johanson
Hours: Mon-Fri 9-4

CIRCULATION POLICY
Photographs: Public
Slides: Public
COLLECTIONS
Films: 30
Photographs: 300,000
Slides: 1,000
SPECIAL COLLECTIONS
S W Matteson Photo Collection 1899-1920 of Early
 Americana (photographs)
Natural History Collections (photographs)
SERVICES
Negatives: Prints are available for purchase subject to
 copyright and museum regulations and fees of subjects
 including natural history, history, anthropology, etc.
Slides: Available for purchase and duplication of museum
 displays and collections

VR 646
MOUNT SENARIO COLLEGE
Library/Audiovisual Department
W College Ave, Ladysmith, WI 54848
Tel: 715-532-5511, Ext 277
AV Libn: Allan T Kohl
Founded: 1973

CIRCULATION POLICY
Films: Public, campus circulation
Filmstrips: Public, circulating
Slides: Public, circulating (appointment suggested)
COLLECTIONS
Films: 15 Modified LC
Slides: 8,000 Modified LC. Architecture (Ancient, Far
 East, Meso-American, European); Sculpture (Ancient,
 African, Meso-American, European, US); Painting
 (European, US); Graphic Arts (European, US);
 Decorative Arts (Far East, African, Tribal American,
 European, US)
SERVICES
Slides: Available for limited duplication upon application
 subject to copyright and library regulations

VR 647
OSHKOSH PUBLIC MUSEUM
1331 Algoma Blvd, Oshkosh, WI 54901
Tel: 414-424-0452
Person in Charge: Kitty A Hobson
Staff: 1
Founded: 1923
Hours: Tues-Sat 9-5
 Sun 1-5
 Mon-Fri 9-5 (office)

CIRCULATION POLICY
Photographs: Public (appointment suggested)
Slides: Public (appointment suggested)
COLLECTIONS
Photographs: 12 drawers. Architecture (US); Graphic
 Arts (US); Decorative Arts (US)
Slides: 300
SERVICES
Negatives: Prints available for publication and sale subject
 to copyright and library regulations and fees
Slides: Available for duplication subject to copyright and
 library regulations

VR 648
PAINE ART CENTER & ARBORETUM
Paine Art Center Reference Library
1410 Algoma Blvd, Oshkosh, WI 54901
Tel: 414-235-4530; 4531, Ext 7
Libn: Jennie L O'Leary
Founded: 1948
Hours: Tues-Sat 1-4:30 (summer)
 Tues-Thurs 1-4:30 (winter)
 Mon-Fri 8-5 (office)

CIRCULATION POLICY
Photographs: Restricted, researchers, faculty/staff
 (appointment suggested)
Slides: Restricted, researchers, faculty/staff (appointment
 suggested)
COLLECTIONS
Photographs: n.a. (alphabetical). Architecture (US);
 Painting (European, US); Horticulture (European, US);
 Decorative Arts (European, US)
Slides: Sculpture (Islamic, Far East, European, US);
 Painting (European, US); Horticulture (European, US);
 Decorative Arts (European, US)
SPECIAL COLLECTIONS
Paine Art Center Exhibitions (negatives)
SERVICES
Negatives: Prints available for purchase subject to copy-
 right and center regulations and fees
Slides: Available for duplication subject to copyright and
 center regulations

VR 649
THE ROHR WEST MUSEUM LIBRARY
Park St & N Eighth, Manitowoc, WI 54220
Tel: 414-684-4181
Dir: Joseph S Hutchison
Founded: 1942

SPECIAL COLLECTIONS
Manitowoc City & County regional history, 19th century
 photographs mostly by Herman Burke (photographs)
SERVICES
Negatives: Prints available for sale subject to copyright
 and museum regulations and fees

VR 650
STOUT STATE UNIVERSITY
Art Department, Slide Library
Menomonie, WI 54751
Tel: 715-232-1123

VR 651

**UNIVERSITY OF WISCONSIN CENTER—
MARSHFIELD/WOOD COUNTY CAMPUS**
Learning Resource Center
2000 W Fifth St, Marshfield, WI 54449
Tel: 715-387-1147, Ext 31
Person in Charge: Georgiane Bentzler
Staff: 1½
Founded: 1964
Hours: Mon-Fri 7:45-4:15 (office)

CIRCULATION POLICY
Slides: Public, fee service, circulating (appointment
 suggested)
COLLECTIONS
Original art & reproductions: 34
Slides: 8,000

VR 652

UNIVERSITY OF WISCONSIN—EAU CLAIRE
Art History Department, Slide Library
Hibbard Humanities Bldg, Eau Claire, WI 54701
Tel: 715-836-4374
Chairman, Art Dept: Charles Campbell
Founded: 1964
Hours: Mon-Fri 8-4:30 (office)

CIRCULATION POLICY
Slides: Restricted, students, researchers, faculty/staff
COLLECTIONS
Slides: 45,000. Architecture (Ancient, Tribal American,
 Meso-American, Andean, European, US); Sculpture
 (Ancient, African, Pacific, Tribal American, Meso-
 American, European, US); Painting (Ancient, African,
 Pacific, Tribal American, Meso-American, European,
 US); Graphic Arts (European, US); Decorative Arts
 (European)

VR 653

UNIVERSITY OF WISCONSIN—GREEN BAY∗
Instructional Services, Library
Green Bay, WI 54305
Tel: 414-465-2333

VR 654

UNIVERSITY OF WISCONSIN—MADISON
Department of Art History, Slide Collection
313 Elvehjem Art Center, Madison, WI 53706
Tel: 608-263-2288
Slide Curator: Christine L Sundt
Founded: 1923
Hours: Mon-Fri 8-4:30 (office)

CIRCULATION POLICY
Photographs: Restricted
Slides: Restricted
COLLECTIONS
Photographs: 10,000. Architecture (Far East, European,
 US); Sculpture (Far East, European); Painting (Far East,
 European); Decorative Arts (Far East)
Slides: 185,000. Architecture (Ancient, Far East, Meso-
 American, European, US); Sculpture (Ancient, Far East,
 Meso-American, European, US); Painting (Ancient, Far
 East, Meso-American, European, US); Graphic Arts
 (Ancient, Far East, European, US); Decorative Arts
 (Ancient, Far East, European, US)
SUBSCRIPTIONS
Wayne Andrews (photographs, slides)

James Austin (photographs)
Chinese National Palace Museum Photograph Archives
 (photographs)
University Colour Slide Scheme (slides)

VR 655

UNIVERSITY OF WISCONSIN—MADISON
Distribution Office, South Asian Area Center
1242 Van Hise Hall, Madison, WI 53706
Tel: 608-262-3012, Ext Distribution
Films Project Dir: Joseph Elder
Video Cassettes Dir: David M Knipe
Founded: 1974
Hours: Mon-Fri 8-12, 1-4:30

CIRCULATION POLICY
Films: Public (appointment suggested)
Video: Public
COLLECTIONS
Films: 9
Video: 15
SPECIAL COLLECTIONS
Contemporary South Asia (film series)
Exploring the Religions of South Asia (video series)
SERVICES
Films: Available for rental and sale dealing with the
 special collections listed above
Video Cassettes: Available for viewing or sale, dealing with
 the special collections listed above

VR 656

THE UNIVERSITY OF WISCONSIN—MILWAUKEE
Art History Department, Slide Library
Johnston Hall, Rm 179, Milwaukee, WI 53210
Tel: 414-963-4340
Curator: Mark Chepp
Hours: Mon-Fri 8:30-4:30

CIRCULATION POLICY
Photographs: Restricted, faculty/staff
Slides: Restricted, faculty/staff
COLLECTIONS
Photographs: 5,000. Architecture (Ancient, European, US);
 Sculpture (Ancient, European, US); Painting (Ancient,
 European, US); Graphic Arts (European, US); Decora-
 tive Arts (Ancient, European, US)
Slides: 152,000 Madison. Architecture (Ancient, African,
 Pacific, Meso-American, European, US); Sculpture
 (Ancient, African, Pacific, Meso-American, European,
 US); Painting (Ancient, African, Pacific, Meso-
 American, European, US); Graphic Arts (European,
 US); Decorative Arts (Ancient, African, Pacific, Meso-
 American, European, US)

VR 657

UNIVERSITY OF WISCONSIN—MILWAUKEE
School of Architecture & Urban Planning Information
 Center (SARUP)
Box 413, 2033 E Hartford, Milwaukee, WI 53201
Tel: 414-963-5239
Information Center Director: Thomas M Spellman
Staff: 1½
Founded: 1967
Hours: Mon-Fri 9-5 (office)

CIRCULATION POLICY
Slides: Students, researchers, faculty/staff, circulating

Videotape: Students, researchers, faculty/staff
COLLECTIONS
Slides: 11,000 SPIN. Architecture (Ancient, Far East, European, US)
Video: 40

VR 658
UNIVERSITY OF WISCONSIN—OSHKOSH
Forrest Polk Library
Oshkosh, WI 54901
Tel: 414-424-1234
Founded: 1869

CIRCULATION POLICY
Slides: Restricted, researchers, faculty/staff
COLLECTIONS
Slides: 27,000 Metropolitan. Sculpture (European, US); Painting (Far East, European, US); Graphic Arts (European, US)
SUBSCRIPTIONS
Carnegie Set (slides)
University Colour Slide Scheme (slides)
SERVICES
Slides: Available for duplication subject to copyright and library regulations and fees

VR 659
UNIVERSITY OF WISCONSIN—PARKSIDE
Fine Arts Division, Art Slide Department
Wood Rd, Kenosha, WI 53141
Tel: 414-553-2457
Art Slide Curator: Nancy S Gage
Founded: 1972
Hours: Mon-Thurs 9-12 noon (Sept-May)

CIRCULATION POLICY
Slides: Restricted, students, faculty/staff (appointment suggested)
COLLECTIONS
Slides

VR 660
UNIVERSITY OF WISCONSIN—PARKSIDE
Wyllie Library/Learning Center
Wood Rd, Kenosha, WI 53141
Tel: 414-553-2360
Media Libn: Linda Piele
Founded: 1968
Hours: Mon-Fri 7:45-12 midnight
 Mon-Fri 7:45-4:30 (office)

CIRCULATION POLICY
Films: Restricted, public, use limited to on-campus for all borrowers
Slides: Restricted, students, faculty/staff
Video: Restricted, public, use limited to on-campus for all borrowers
COLLECTIONS
Films: LC. Sculpture (European, US); Painting (European, US)
Microforms: LC
Slides: Architecture (Ancient, European, US); Sculpture (Ancient, European, US); Painting (European, US); Decorative Arts (US)
Video: LC. Sculpture (European, US); Painting (European, US)

VR 661
UNIVERSITY OF WISCONSIN—RIVER FALLS*
Art Department, Slide Library
River Falls, WI 54022
Tel: 715-425-3288
Slide Lib Asst: Lorelet Green

VR 662
UNIVERSITY OF WISCONSIN—STEVENS POINT
Art Department
Fine Arts Bldg, Stevens Point, WI 54481
Tel: 715-346-2839
Person in Charge: Robert Boyce
Staff: 1

CIRCULATION POLICY
Slides: Restricted, faculty/staff
COLLECTIONS
Slides: 40,000. Architecture (Ancient, African, Meso-American, Andean, European, US); Sculpture (Ancient, African, Meso-American, Andean, European, US); Painting (Ancient, European, US); Graphic Arts (European, US); Decorative Arts (European, US)

VR 663
UNIVERSITY OF WISCONSIN—WHITEWATER
Art Slide Library
800 W Main St, Whitewater, WI 53190
Tel: 414-472-1756
Slide Libn: Mary Jane Scherdin
Hours: Mon-Fri 9-5, 6-9

CIRCULATION POLICY
Slides: Public with permission, students, researchers, faculty/staff, circulating (appointment suggested)
COLLECTIONS
Slides: 55,000. Architecture (Ancient, Islamic, Far East, African, Pacific, Tribal American, European, US); Sculpture (Ancient, Islamic, Far East, African, Pacific, Tribal American, European, US); Painting (Ancient, Islamic, Far East, African, Pacific, Tribal American, European, US)

CANADA

Alberta

VR 664
ALBERTA COLLEGE OF ART*
Library, Slide Collection
Calgary, Alberta, Canada
Person in Charge: Mick Parkinson

VR 665
RED DEER COLLEGE*
Art Department, Art Resources
Red Deer, Alberta, Canada T4N 5H5
Tel: 403-346-3376
Instructor/Art Resources Coordinator: Edward Epp

British Columbia

VR 666
KOOTENAY SCHOOL OF ART, DIVISION OF SELKIRK COLLEGE
2001 Siwerking Rd, Nelson, British Columbia, Canada V1L 1C8
Tel: 604-352-6601, Ext 33
Curator/Instructor: E H Underhill
Staff: 1
Founded: 1960
Hours: Mon-Fri 8:30-4

CIRCULATION POLICY
Slides: Students, faculty/staff
COLLECTIONS
Filmstrips: 2,000
Slides: 25,000. Architecture (Ancient, Far East, European, US, Canadian); Sculpture (Ancient, Far East, African, Pacific, Tribal American, Meso-American, Andean, European, US, Canadian); Painting (Ancient, Islamic, Far East, African, Tribal American, European, US, Canadian); Graphic Arts (Far East, European, US, Canadian); Decorative Arts (Islamic, Far East, African, Pacific, Tribal American, Meso-American, Andean, European, US, Canadian)
SPECIAL COLLECTIONS
Eden Drawings of Pre-World War II Stained Glass (slides)
Victoria & Albert Museum Stained Glass (slides)

VR 667
MALASPINA COLLEGE
Learning Resources Centre
900 Fifth St, Nanaimo, British Columbia, Canada V9R 5S5
Tel: 604-753-3245, Ext 227
Dir, Learning Resources Centre: D Bridges
Staff: 3
Founded: 1969
Hours: Mon-Thurs 8-10:30
 Fri 8-4:30
 Sat 9-4

CIRCULATION POLICY
Kits: Public, circulating
Slides: Public, circulating
Tapes: Public, circulating
COLLECTIONS
Films: LC
Kits: LC
Microforms: LC
Slides: LC. Sculpture (Canadian); Painting (Canadian); Graphic Arts (Canadian); Decorative Arts (Canadian)
Video: LC. Painting (Canadian)

VR 668
SIMON FRASER UNIVERSITY
University Library
Burnaby, British Columbia, Canada V5A 1S6
Tel: 604-291-4351

VR 669
UNIVERSITY OF BRITISH COLUMBIA
Fine Arts Division Library, Slide Library, Fine Arts Department
2075 Wesbrook Place, Vancouver, British Columbia, Canada V6T 1W5
Tel: 604-228-4959

Head for Pictures: Melva J Dwyer
Slide Curator: Barbara Hopkins
Founded: 1948

CIRCULATION POLICY
Photographs: Restricted, students, researchers, faculty/staff
Slides: Restricted, faculty
COLLECTIONS
Photographs: 4,500 (unclassified)
SUBSCRIPTIONS
Alfieri (photographs, selected)
Asian Art Photographic Distribution (photographs)
Carnegie Set (photographs)
Chinese National Palace Museum Photograph Archives (photographs)
Courtauld Institute Photographic Survey of Private Collections (photographs)
SPECIAL COLLECTIONS
Mexican Art & Architecture Exhibition

Manitoba

VR 670
THE UNIVERSITY OF MANITOBA
Architecture Department, Slide Collection
Winnipeg, Manitoba, Canada R3T 2N2
Tel: 204-474-8757
Prof: Robert Madill
Founded: 1916
Hours: Mon-Fri 8:30-4:30

CIRCULATION POLICY
Slides: Public, circulating
COLLECTIONS
Slides: 110,000. Architecture (Ancient, Islamic, African, Andean, European, Canadian); Sculpture (Ancient, African, Pacific, Andean, European, Canadian); Painting (Ancient, Far East, African, Pacific, Tribal American, European, Canadian); Graphic Arts (African, European, Canadian); Decorative Arts (Islamic, African, Pacific, Tribal American, Andean, European, Canadian)
SPECIAL COLLECTIONS
Winnipeg Architecture (slides)
SERVICES
Slides: Available on limited basis for duplication subject to copyright and university regulations

VR 671
WINNIPEG ART GALLERY
Slide Library
300 Memorial Blvd, Winnipeg, Manitoba, Canada R3C 1N1
Tel: 204-786-6641, Ext 23
Slide Libn: Eileen Kelly
Staff: 1
Founded: 1970
Hours: Mon-Fri 11-5

CIRCULATION POLICY
Slides: Students, researchers, faculty/staff (appointment suggested)
COLLECTIONS
Slides: 7,000. Architecture (Tribal American, European, Canadian); Sculpture (Tribal American, European,

Canadian); Painting (European, Canadian); Graphic
Arts (Canadian); Decorative Arts (Canadian)
SERVICES
Negatives: Prints of gallery collections available for pur-
chase for publication and study purposes subject to
copyright and museum regulations and fees
Slides: Available for purchase and duplication of gallery
collections subject to copyright and gallery regulations
and fees

New Brunswick

VR 672
**MOUNT ALLISON UNIVERSITY—OWENS
ART GALLERY**
Sackville, New Brunswick, Canada E0A 3C0
Tel: 506-536-2040, Ext 270
Dir-Curator: T Keilor
Staff: 1
Hours: Mon-Fri 10-12, 1-5
 Thurs 7-10
 Sat-Sun 2-5

CIRCULATION POLICY
Slides: (appointment suggested)
COLLECTIONS
Slides: 1,500 Accession Number. Sculpture (Canadian);
Painting (Canadian); Graphic Arts (Canadian)
SPECIAL COLLECTIONS
Contemporary Canadian Art (graphics, oils, watercolors)
Pre-Raphaelites (paintings)
SERVICES
Negatives: Prints available for purchase of works in gallery
collection
Slides: Available for purchase or duplication subject to
copyright and gallery regulations

Nova Scotia

VR 673
ACADIA UNIVERSITY
Vaughan Memorial Library
Box D, Wolfville, Nova Scotia, Canada B0P 1X0
Tel: 902-542-2201, Ext 215
University Libn: Isobel Horton
Staff: 12
Hours: Mon-Fri 9-5

CIRCULATION POLICY
Slides: Public, circulating
COLLECTIONS
Slides: 600 LC. Architecture (European)
Video: 1,100 LC
SUBSCRIPTIONS
Inter Documentation Co, Emblem Book Collection
(microfiche)

VR 674
NOVA SCOTIA COLLEGE OF ART AND DESIGN
Library, Non-Print Services
5163 Duke St, Halifax, Nova Scotia, Canada B3J 3J6
Tel: 902-422-7381, Ext 182
Asst Lib Dir: Mary Snyder
Hours: Mon-Fri 9-5

CIRCULATION POLICY
Tapes: Public, circulating
Slides: Public, circulating
COLLECTIONS
Slides: 45,000 Fogg. Architecture (European, Canadian);
Sculpture (Far East, European, Canadian); Painting
(Far East, European, Canadian); Graphic Arts (Far
East, European, Canadian); Decorative Arts (Far East,
Tribal American, European, Canadian)
SUBSCRIPTIONS
University Colour Slide Scheme (slides)

VR 675
PUBLIC ARCHIVES OF NOVA SCOTIA
Coburg Rd, Halifax, Nova Scotia, Canada B3H 1Z9
Tel: 902-423-7030
Provincial Archivist: Dr C B Fergusson
Hours: Mon-Fri 8:30-10
 Sat 9-6
 Sun 1-10

CIRCULATION POLICY
Photographs (appointment suggested)
COLLECTIONS
Photographs: 3,000. Architecture (Canadian); Painting
(Canadian); Graphic Arts (Canadian); Decorative Arts
(Canadian)
SERVICES
Negatives & Prints: Available for reproduction subject to
copyright and archives regulations and fees

Ontario

VR 676
ART GALLERY OF ONTARIO
Audio-Visual Library
Grange Park, Toronto, Ontario, Canada M5T 1G4
Tel: 416-361-0414, Ext 260
AV Libn: Catherine Goldsmith
Staff: 4
Hours: Tues-Fri 10-5
 Thurs 10-9
 Mon-Fri 9-5 (office)

CIRCULATION POLICY
Audio Cassettes: Restricted (appointment suggested)
Films: Restricted
Photographs: Restricted (appointment suggested)
Slides: Restricted
Video: Restricted (appointment suggested)
COLLECTIONS
Audio Cassettes: 115 Anglo-American
Films: 70 Anglo-American
Slides: 40,000 Metropolitan. Architecture (Ancient,
European, Canadian); Sculpture (Ancient, European,
Canadian); Painting (Ancient, European, Canadian);
Graphic Arts (Ancient, European, Canadian)
Video: 60 Anglo-American
SPECIAL COLLECTIONS
Moore Collection (slides, video)
SERVICES
Photographs: Available for purchase from Photographic
Services Dept
Slides: Available for purchase

VR 677
CANADIAN INVENTORY OF HISTORIC BUILDING; PARKS CANADA
Indian and Northern Affairs Department, Federal Gov't
400 Laurier Ave, Rm 1124, Ottawa, Ontario, Canada
Tel: 613-996-4971
Slide Curator: Honor Weston
Hours: Mon-Fri 8-4

CIRCULATION POLICY
Slides: Faculty/staff
COLLECTIONS
Slides: 15,000 Geog/alpha. Architecture (Canadian)
SPECIAL COLLECTIONS
Canadian Architecture (slides) ". . . largest collection
 of Canadian architecture slides in country."

VR 678
CARLETON UNIVERSITY
Art History Department Slide Library
Rm 2203, Art History Department, Colonel By Dr,
 Ottawa, Ontario, Canada K1S 5B6
Tel: 613-231-7157
Slide Curator: Gillian M Scott
Founded: 1965
Hours: Mon-Fri 8:30-4:30

CIRCULATION POLICY
Slides: Restricted, art history students, researchers, faculty/
 staff, circulating (appointment suggested)
COLLECTIONS
Slides: 100,000. Architecture (Ancient, European, US,
 Canadian); Sculpture (Ancient, European, US,
 Canadian); Painting (Ancient, European, US,
 Canadian); Graphic Arts (European, US, Canadian);
 Decorative Arts (Ancient, European, US, Canadian)
SUBSCRIPTIONS
University Colour Slide Scheme (slides)

VR 679
SIR SANDFORD FLEMING COLLEGE OF APPLIED ARTS & TECHNOLOGY
526 McDonald St, Peterborough, Ontario, Canada
 K9J 7B1
Tel: 205-743-5620, Ext 34
Person in Charge: n.a.
Founded: 1968
Hours: Mon-Thurs 8:30-9
 Fri 8:30-5

CIRCULATION POLICY
Films: Public
Filmstrips: Public
Photographs: Public
Slides: Public
COLLECTIONS
Films: 20
Microforms: 30
Slides: 2,000. Painting (European, Canadian); Graphic
 Arts (Canadian); Decorative Arts (European, Canadian)
Video: 40
SERVICES
Slides: Available for duplication subject to copyright
 and institutional regulations

VR 680
METROPOLITAN TORONTO LIBRARY
Theatre Department
789 Yonge St, Toronto, Ontario, Canada M4W 2G8
Tel: 416-928-5230
Head: Heather McCallum
Staff: 2
Founded: 1961
Hours: Mon-Fri 9-9
 Sat 9-5
 Sun 1:30-5 (Oct-May)

CIRCULATION POLICY
Engravings: Public (appointment suggested)
Photographs: Public
Posters: Public (appointment suggested)
Slides: Public
Theatre Designs: Public (appointment suggested)
COLLECTIONS
Engravings, Posters, Theatre Designs: 5,970
Photographs: 43,506
Slides: 2,102

VR 681
NATIONAL GALLERY OF CANADA
Slide & Photograph Library
Ottawa, Ontario, Canada K1A 0M8
Tel: 613-996-6134
Research Asst/Slides & Photographs: S Giroux
Founded: 1930s
Hours: Mon-Fri 8:30-5

CIRCULATION POLICY
Photographs: Restricted, faculty/staff (appointment
 suggested)
Slides: Restricted, faculty/staff (appointment suggested)
COLLECTIONS
Films: Architecture (European, Canadian)
Photographs: 60,000. Architecture (Canadian); Sculpture
 (Canadian); Painting (European, Canadian); Decorative
 Arts (Canadian)
Slides: 70,000. Architecture (Canadian); Sculpture
 (Canadian); Painting (European, Canadian); Decorative
 Arts (Canadian)
SUBSCRIPTIONS
Carnegie Set (slides)
Courtauld Institute Photographic Survey of Private
 Collections (catalog)
Decimal Index of the Art of Low Countries (photographs)
University Colour Slide Scheme (slides)
SPECIAL COLLECTIONS
National Gallery of Canada, Canadian Art (photographs,
 slides)
SERVICES
Negatives: Prints available for purchase of works in
 National Gallery of Canada collections, subject to
 copyright and museum regulations and fees
Slides: Available for purchase of museum collections

VR 681A
ONTARIO CRAFTS COUNCIL
Craft Resource Centre
346 Dundas St W, Toronto, Ontario, Canada M5T 1G5
Tel: 416-366-3551
Coordinator, Libn: Irene Bolliger
Founded: 1976

Hours: Tues-Fri 12-5
 Sat 10-5

CIRCULATION POLICY
Audio-tapes: Public, circulating
Photographs: Public
Slides: Public, circulating
COLLECTIONS
Audio-tapes: 10
Photographs: 500
Slides: 3,000. Decorative Arts (Canadian)
SPECIAL COLLECTIONS
Ontario Crafts Council Gallery Exhibitions (slides)
SERVICES
Slides: Available for purchase in kit form from the
 gallery

VR 682
RICHMOND HILL PUBLIC LIBRARY
Audio-Visual Department
24 Wright St, Toronto, Ontario, Canada L4C 4A1
Tel: 416-884-0130
Head of AV Dept: Suzanne Buxton
Founded: 1959
Hours: Tues-Fri 9-9
 Sat 9-5

CIRCULATION POLICY
Cassettes: Public, circulating
Films: Public, fee service, circulating (appointment
 suggested)
COLLECTIONS
Films: 500 (alpha/title)

VR 683
ROTMANS ART GALLERY OF STRATFORD*
Slide Collection
54 Romeo St, Stratford, Ontario, Canada

VR 685
SCARBOROUGH COLLEGE, UNIVERSITY OF
TORONTO
Humanties Division, Slide Library
West Hill, Ontario, Canada M1C 1A4
Tel: 416-284-3146
Slide Curator: Carol D Lowrey
Founded: 1968

CIRCULATION POLICY
Slides: Students, researchers, faculty/staff, circulating
 (appointment suggested)
COLLECTIONS
Slides: 40,000 Yale/U of Toronto. Architecture (Ancient,
 Far East, Meso-American, European, US, Canadian);
 Sculpture (Ancient, Far East, Meso-American, Euro-
 pean, US, Canadian); Painting (Ancient, Islamic, Far
 East, Meso-American, European, US, Canadian);
 Graphic Arts (European, US, Canadian); Decorative
 Arts (Ancient, Islamic, European, US, Canadian)
SUBSCRIPTIONS
Wayne Andrews (slides)
Carnegie Set (slides)
Courtauld Institute Photographic Survey of Private
 Collections (slides)
Ian MacEachern (slides)
University Colour Slide Scheme (slides)

SPECIAL COLLECTIONS
Kommos, Crete excavations by J Shaw (slides)
Toronto Architecture, Yorkville Area (slides)

VR 686
SHERIDAN COLLEGE OF APPLIED ARTS &
TECHNOLOGY LIBRARY*
1430 Trafalgar Rd, Oakville, Ontario, Canada L6H 2L1
Tel: 416-362-5861, Ext 166
Chief Libn: Janet T Quance

VR 687
UNIVERSITY OF GUELPH
Slide Library
Guelph, Ontario, Canada N1G 2W1
Tel: 416-824-4120, Ext 2697
Slide Coordinator: Margaret Ashton
Staff: 1
Founded: 1968
Hours: Mon-Fri 8:30-4:30

CIRCULATION POLICY
Slides: Restricted, students, faculty/staff
COLLECTIONS
Slides: 90,000 Metropolitan. Architecture (Ancient,
 European, Canadian); Sculpture (Ancient, European,
 Canadian); Painting (Ancient, European, Canadian)
SUBSCRIPTIONS
James Austin (slides)
Boulerice (slides)
Rosenthal (slides)
Saskia (slides)

VR 688
UNIVERSITY OF OTTAWA*
Communications & Instructional Media Centre, Slide
 Library
100 Laurier East, Rm 106, Ottawa 2, Ontario, Canada
Tel: 613-231-3311

VR 689
UNIVERSITY OF OTTAWA*
Department of Visual Arts, Slide Library
600 Cumberland, Ottawa, Ontario, Canada K1N 6N5
Tel: 613-231-2915
Slide Libn: Helen Boivin-St-Onge

VR 690
UNIVERSITY OF TORONTO
School of Architecture
230 College St, Toronto, Ontario, Canada M5S 1A1
Tel: 416-978-2649
Libn: Pamela Manson-Smith

CIRCULATION POLICY
Slides: Restricted, faculty/staff
COLLECTIONS
Slides: 10,000. Architecture (Ancient, Islamic, Far East,
 European, Canadian, US)

VR 691
UNIVERSITY OF WESTERN ONTARIO
Visual Arts Department, Slide Library
London, Ontario, Canada N6A 5B7
Tel: 519-679-2418
Slide Curator: Brenda Messer
Staff: 1

Founded: 1967
Hours: Mon-Fri 8:30-4:30

CIRCULATION POLICY
Slides: Students, faculty/staff (appointment suggested)
COLLECTIONS
Slides: 60,000. Architecture (Ancient, European, Canadian); Sculpture (Ancient, European); Painting (Ancient, European, Canadian); Graphic Arts (European, Canadian); Decorative Arts (Ancient, European)
SUBSCRIPTIONS
Joint Library of Hellenic & Roman Societies (slides)

VR 692
YORK UNIVERSITY
Faculty of Fine Arts, Slide Library
4700 Keele St, Downsview, Ontario, Canada M3J 1P3
Tel: 416-667-3749
Slide Library Supervisor: Nancy Kirkpatrick
Founded: 1969
Hours: Mon-Thurs 8:30-6:30 (Sept-Apr)
 Fri 8:30-5 (Sept-Apr)
 Mon-Fri 8:30-4:30 (May-Aug)

CIRCULATION POLICY
Art Periodicals: Restricted, students, faculty/staff
Photographs: Restricted, faculty/staff, circulating
Slides: Restricted, students, faculty/staff, circulating
COLLECTIONS
Periodicals: 500
Photographs: 15,000. Architecture (European); Sculpture (Ancient, European); Painting (European); Graphic Arts (European)
Postcards: 15,000
Slides: 120,000 Metropolitan. Architecture (Ancient, European, US, Canadian); Sculpture (African, European, US, Canadian); Painting (Far East, European, US, Canadian); Graphic Arts (European, US, Canadian); Decorative Arts (African, Pacific, European)
SUBSCRIPTIONS
American Committee of South Asian Art (slides)
Anderson Photographs (photographs)
Carnegie Set (slides)
University Colour Slide Scheme (slides)
SPECIAL COLLECTIONS
German Bazin Collection (clippings, photographs, postcards)

Prince Edward Island

VR 693
CONFEDERATION CENTRE ART GALLERY & MUSEUM
Box 848, Charlottetown, Prince Edward Island, Canada C1A 7L9
Tel: 902-892-2464, Ext 139
Person in Charge: Mary Burke
Founded: 1964
Hours: Mon-Fri 9-5

CIRCULATION POLICY
Films: Faculty/staff
Slides: Public
COLLECTIONS
Films: 20. Painting (Canadian)
Slides: 5,000. Architecture (Ancient, European); Sculpture

(Ancient); Painting (European, Canadian); Graphic Arts (European, Canadian); Decorative Arts (Canadian)
Video: 4. Painting (Canadian)
SERVICES
Photographs: Available for purchase with permission of items in museum collections

Quebec

VR 694
BIBLIOTHEQUE DE LA VILLE DE MONTREAL
Cinematheque
2207 rue Montcalm, Montreal, Quebec, Canada H2L 3H8
Tel: 514-872-3680
Head of Film Lib: Lise Depatie-Bourassa
Staff: 6
Founded: 1947
Hours: Mon-Tues, Thurs-Fri 9-6
 Wed 12:30-6

CIRCULATION POLICY
Films: Public, fee service, circulating
Filmstrips: Public, fee service, circulating
Slides: Public, fee service, circulating
COLLECTIONS
Films: 4,566
Filmstrips: 1,480
Slides: 19,150. Architecture (European); Painting (European)

VR 695
DAWSON COLLEGE
Educational Resources Centre
1001 Sherbrooke E, Montreal, Quebec, Canada H2L 1L3
Tel: 514-525-2501, Ext 297
Dir of Educational Resources: Monique C Lavoie
Founded: 1969
Hours: Mon-Fri 8:30-9

CIRCULATION POLICY
Films: Public, circulating
Photographs: Public, circulating
Slides: Public, circulating
Video: Public, circulating
COLLECTIONS
Films: 136
Microforms: 9,395
Photographs: n.a.
Slides: 6,794
Video: 170

VR 696
DEPARTMENT OF INDIAN & NORTHERN AFFAIRS, NATIONAL HISTORIC PARKS & SITES BRANCH
Research Information Section, Records Archives
10 Wellington St, Hull, Quebec, Canada
Tel: 819-996-7241
Head, Research Information: Gary Durie
Hours: Mon-Fri 8:30-4:30

CIRCULATION POLICY
Maps: Restricted
Photographs: Restricted
COLLECTIONS
Maps: 5,000

Photographs: 10,000. Architecture (Canadian)
SPECIAL COLLECTIONS
Canadian National Historic Parks & Sites (maps,
 photographs)

VR 697
THE MONTREAL MUSEUM OF FINE ARTS/LE MUSEE DES BEAUX-ARTS DE MONTREAL
Archives
3400 avenue du Musee, Montreal, Quebec, Canada H3Z
 1J9
Tel: 514-285-1600, Ext 18
Registrar & Curator of Decorative Arts: Ruth Jackson
Staff: 3
Founded: 1950s
Hours: By appointment only

CIRCULATION POLICY
Photographs: By appointment only: Public, fee service
COLLECTIONS
Photographs: 6,000
SERVICES
Negatives: Prints are available for purchase subject to
 copyright and museum regulations and fees of the
 museum's collections

VR 698
MONTREAL MUSEUM OF FINE ARTS/LE MUSEE DES BEAUX-ARTS DE MONTREAL
The Slide Library/La Diatheque
3400 ave du Musee, Montreal, Quebec, Canada H3G 1K3
Tel: 514-285-1600, Ext 56
Slide Library Admin/La Diathecaire: Anne S Fenhagen
Founded: 1961
Hours: Tues-Fri 11-5
CIRCULATION POLICY
Slides: Public, fee service, circulating
COLLECTIONS
Slides: 29,000 Metropolitan. Architecture (Ancient,
 European, Canadian); Sculpture (Ancient, European,
 Canadian); Painting (European, Canadian); Graphic
 Arts (Canadian); Decorative Arts (African, Meso-
 American, European)
SPECIAL COLLECTIONS
Classic Mayan Vases of Guatemala (slides)
Museum special exhibitions (slides)
Quebec Domestic Architecture of 18th- early 19th
 century (slides)
John Ward Collection of Greek Coins (slides)
SERVICES
Slides: Available for purchase or duplication subject to
 museum and copyright regulations and fees; catalog of
 museum objects in slides pending

VR 699
MUSEE d'ART CONTEMPORAIN
Bibliothequqe du Musee d'art contemporain
Cite du Havre, Montreal, Quebec, Canada H3C 3R4
Tel: 514-873-2878
Libn: Isabelle Montplaisir
Founded: 1967
Hours: Tues-Fri 10-5
 Sat-Sun 12-6 (Sept-May)

CIRCULATION POLICY
Photographs: Restricted, public, circulating
Slides: Restricted, public, circulating

Video: Restricted, public, circulating (faculty/staff only)
COLLECTIONS
Films: 19. Sculpture (Canadian, US); Painting (Canadian,
 US)
Photographs: 8,000. Sculpture (European, US, Canadian);
 Painting (European, US, Canadian)
Slides: 14,325. Sculpture (European, US, Canadian);
 Painting (European, US, Canadian); Graphic Arts
 (European)
Tapes: 60
Video: 80

VR 700
UNIVERSITE DE MONTREAL
Section Histoire de l'art, Phototheque
Pavillon des Sciences Sociales,
3150 Jean Brillant, Montreal, Quebec, Canada
Tel: 514-343-6182
Photothecaire: Louise Thiabaudeau
Founded: 1967
Hours: Mon-Fri 9-5

CIRCULATION POLICY
Slides: Restricted, students, faculty/staff, circulating
 (appointment suggested)
COLLECTIONS
Slides: 100,000 Santa Cruz. Architecture (Ancient, Euro-
 pean, Canadian); Sculpture (Ancient, European,
 Canadian); Painting (Ancient, European, Canadian);
 Graphic Arts (Ancient, European, Canadian);
 Decorative Arts (Ancient, European, Canadian)
SUBSCRIPTIONS
Art in America (slides)
Courtauld Institute Photographic Survey of Private
 Collections (slides)
Light Impressions Corporation (slides)
Publivision (slides)
Scala (slides)
University Colour Slide Scheme (slides)
Visual Media (slides)

VR 701
UNIVERSITE DU QUEBEC A MONTREAL
Pavillons des Arts/Diapotheque
125 Ouest rue Sherbrooke, Montreal, Quebec, Canada
Tel: 514-282-4655
Slide Libn/Diapothecaire: Guy Sauuageau
Founded: 1969
Hours: Mon-Fri 9-5

CIRCULATION POLICY
Slides: Students, researchers
COLLECTIONS
Slides: 80,000. Architecture (Ancient, Islamic, Meso-
 American, Andean, European, US, Canadian); Sculp-
 ture (Ancient, Far East, African, Tribal American,
 European, US, Canadian); Painting (Ancient, Far
 East, European, US, Canadian); Graphic Arts (Ancient,
 European, US, Canadian); Decorative Arts (Ancient,
 Tribal American, European, US, Canadian)
SUBSCRIPTIONS
Boulerice Collection (slides)
Carnegie Set (slides)

VR 702
L'UNIVERSITE LAVAL
Bibliotheque Generale, Audiovideotheque

Cite Universitaire, Quebec, Quebec, Canada
Tel: 418-656-7025
Conseiller Arts & Architecture: Susanne Uinard
Hours: Mon-Fri 8-11
 Mon-Fri 8:30-5 (office)
CIRCULATION POLICY
Slides: Students, researchers, faculty/staff, circulating
 limited
COLLECTIONS
Slides: 15,000 Metropolitan. Architecture (Ancient,
 Islamic, African, Meso-American, European, Canadian);
 Sculpture (Ancient, African, Meso-American, European,
 Canadian); Painting (Ancient, Islamic, Meso-American,
 European, Canadian); Graphic Arts (European,
 Canadian)
SUBSCRIPTIONS
Wayne Andrews (slides)
James Austin (slides)
Carnegie Set (slides)
Courtauld Institute Photographic Survey of Private

Collections (slides)
Gernsheim Collection (slides)
SPECIAL COLLECTIONS
Quebec civil and religious architecture (slides)
SERVICES
Negatives: Prints available for purchase under restricted
 permit, subject to copyright and university regulations
Slides: Available for sale and duplication subject to copy-
 right and university regulations and fees

Saskatchewan

VR 703
SASKATOON PUBLIC LIBRARY*
Fine & Performing Arts Department
311-23 St E, Saskatoon, Saskatchewan, Canada S7K 0J6
Tel: 306-652-7313
Fine & Performing Arts Libn: Frances D Bergles

Index to Collection Emphases

*The parenthetical codes
following institutional names
indicate the media of specific
collections: Films (F);
Microforms (M);
Photographs (P);
Reproductions (R); Slides
(S); Video (V); Other (O).*

ARCHITECTURE-AFRICAN

United States

ARIZONA
Arizona State Univ (S) VR 8

CALIFORNIA
San Diego State Univ (S) VR 64
San Jose State Univ (S) VR 70

DISTRICT OF COLUMBIA
Howard Univ (S) VR 126
Museum of African Art (F, P,
 S) VR 128
The National Gallery of Art (S)
 VR 135

GEORGIA
Georgia State Univ (S) VR 164

HAWAII
Univ of Hawaii, Manoa (S)
 VR 173

ILLINOIS
Northern Illinois Univ (S) VR
 189
Northwestern Univ (P, S) VR
 190
Southern Illinois Univ at
 Edwardsville (S) VR 200

INDIANA
Indiana Univ (S) VR 215

IOWA
Sanford Museum and Planetarium
 (S) VR 227

KANSAS
Univ of Kansas (S) VR 234

KENTUCKY
Louisville Free Public Library
 (F) VR 239
J B Speed Art Museum (S) VR
 240

LOUISIANA
Louisiana State Univ (S) VR
 249

MARYLAND
Univ of Maryland (S) VR 273 &
 VR 274

MASSACHUSETTS
Boston Public Library (P) VR
 279
Brandeis Univ (S) VR 281
Harvard Univ (S) VR 288
Massachusetts Institute of
 Technology (S) VR 290

MICHIGAN
The Detroit Institute of Arts (S)
 VR 311

MINNESOTA
The Minneapolis Institute of Arts
 (S) VR 337

NEVADA
Joslyn Art Museum (S) VR 365

NEW JERSEY
New Jersey Institute of
 Technology (S) VR 374

NEW YORK
Columbia Univ (S) VR 406
Cooper-Hewitt Museum,
 Smithsonian Institution (P)
 VR 407
Metropolitan Museum of Art,
 Dept of Primitive Art (P)
 VR 426
Metropolitan Museum of Art,
 Photograph & Slide Library
 S) VR 427

The New York Public Library/
 The Research Libraries (P)
 VR 436
State Univ of New York
 College at New Paltz (S)
 VR 457

NORTH CAROLINA
Duke Univ (P, S) VR 469

OHIO
College of Mount St Joseph on
 the Ohio (S) VR 485

TEXAS
Univ of Texas at Austin (S)
 VR 596
Univ of Texas at El Paso (S)
 VR 597

VIRGINIA
Virginia Commonwealth Univ
 (S) VR 623

WISCONSIN
The Univ of Wisconsin at
 Milwaukee (S) VR 656 &
 VR 657
Univ of Wisconsin-Stevens Point
 (S) VR 662
Univ of Wisconsin-Whitewater
 (S) VR 663

ARCHITECTURE-ANCIENT

United States

ALABAMA
Univ of Alabama in Birmingham
 (S) VR 2

ARIZONA
Arizona State Univ (S) VR 8
Glendale Community College (S)
 VR 9
Univ of Arizona (P, S) VR 14

ARKANSAS
Univ of Arkansas (S) VR 19 &
 VR 20

CALIFORNIA
California College of Arts and
 Crafts (S) VR 28
California State College-
 Dominguez Hills (S) VR 31
California State Univ-Chico (S)
 VR 32
California State Univ-Fresno (S)
 VR 33
California State Univ-Hayward
 (S) VR 34
California State Univ-Los Angeles
 (S) VR 37
California State Univ-Northridge
 (S) VR 38
California State Univ-Sacramento
 (S) VR 39
Cosumnes River College (S) VR
 43
Hebrew Union College Skirball
 Museum (P, S)
Jr Arts Center in Barnsdall Park
 (S) VR 49
Los Angeles County Museum of
 Art (S) VR 52
Otis Art Institute (S) VR 58
Pomona College (S) VR 61
San Diego State Univ (R, S) VR
 64
San Francisco Art Institute (S)
 VR 65
San Jose City College (S) VR
 69
San Jose State Univ VR 70
Univ of California at Santa
 Barbara (S) VR 84
Univ of California-Berkeley (P,
 S) VR 74
Univ of California-Berkeley (S)
 VR 75
Univ of California-Irvine (S)
 VR 79
Univ of California-Riverside (P,
 S) VR 82
Univ of California-San Diego (S)
 VR 83

Univ of Southern California (S)
VR 87

COLORADO
Colorado College (S) VR 91
Univ of Denver (S) VR 99

CONNECTICUT
Connecticut College (S) VR 100
St Joseph College (S) VR 103
Trinity College (S) VR 104
Univ of Hartford (S) VR 106
Yale Univ (P, S) VR 111

DELAWARE
Univ of Delaware (S) VR 114

DISTRICT OF COLUMBIA
American Univ (S) VR 117
George Washington Univ (S)
VR 124 A
Howard Univ (S) VR 126
Museum of African Art (P, S)
VR 128
National Gallery of Art (P) VR
134
Trinity College (S) VR 139

FLORIDA
Lowie Art Museum, Univ of
Miami (S) VR 149
Museum of Fine Arts of St
Petersburgh (S) VR 150
Ringling School of Art (S) VR
153
Univ of South Florida (S) VR
157 & VR 158

GEORGIA
Atlanta College of Art (S) VR
160
Georgia Institute of Technology
(S) VR 163
Georgia State Univ (S) VR 164
Univ of Georgia (S) VR 166

HAWAII
Honolulu Academy of Arts (S)
VR 169
Univ of Hawaii, Manoa (S) VR
173

ILLINOIS
Chicago Public Library Cultural
Center (S) VR 177
Richard J Daley College (S) VR
179
Moraine Valley Community
College (S) VR 185
Northern Illinois Univ (S) VR
189
Northwestern Univ (P, S) VR
190
Quincy College (S) VR 194
Roosevelt Univ (S) VR 198
Southern Illinois Univ at
Edwardsville (S) VR 200
Univ of Illinois at Chicago Circle
(S) VR 204
Univ of Illinois at Urban-
Champaign (S) VR 205

INDIANA
Ball State Univ (S) VR 209
Indiana Univ (S) VR 215
Univ of Notre Dame (S) VR
219 & VR 220

IOWA
Davenport Municipal Art Gallery
(S) VR 222
Grinnell College (S) VR 223
Sanford Museum and Planetarium
(S) VR 227
Univ of Iowa (P, S) VR 228

KANSAS
Univ of Kansas (P, S) VR 234
Wichita State Univ (S) VR 237

KENTUCKY
Louisville Free Public Library
(F) VR 239
J B Speed Art Museum (S) VR
240
Univ of Kentucky (S) VR 241
Univ of Louisville (S) VR 242

LOUISIANA
Louisiana State Univ (S) VR 248
& VR 249
Loyola Univ (S) VR 249A
Southern Univ (S) VR 252
Tulane Univ (S) VR 254

MAINE
Bowdoin College (P, S) VR 257

MARYLAND
Goucher College (S) VR 266
Loyola-Notre Dame Library (S)
VR 268
Maryland Institute, College of Art
(S) VR 270
Univ of Maryland (O) VR 272
Univ of Maryland (S) VR 273
& VR 274
Univ of Maryland, Baltimore
County (P, S) VR 275

MASSACHUSETTS
Art Institute of Boston (S) VR
277
Boston Architecture Center (S)
VR 278
Boston Public Library (P) VR
279
Boston Univ (S) VR 280
Brandeis Univ (P, S) VR 281
Harvard Univ (S) VR 287
Harvard Univ (S) VR 288
Massachusetts College of Art (F,
S) VR 289
Massachusetts Institute of
Technology (P, S) VR 290
Mount Holyoke College (P, S)
VR 294
Smith College (S) VR 298
Smith College (P) VR 299
Tufts Univ (S) VR 300
Univ of Lowell (S) VR 301
Univ of Massachusetts (S) VR
303
Univ of Massachusetts in Boston
(S) VR 304
Wellesley College (P, S) VR 305
Wheaton College (S) VR 306
Worcester Art Museum (S) VR
308

MICHIGAN
The Detroit Institute of Arts (P,
S) VR 311
Eastern Michigan Univ (S) VR
312
Michigan State Univ (P, S) VR
318
Oakland Univ (S) VR 321
Univ of Michigan (P, S) VR 327
Univ of Michigan-Dearborn (S)
VR 328
Western Michigan Univ (F, S)
VR 330

MINNESOTA
Minneapolis College of Art &
Design (S) VR 335
The Minneapolis Institute of Arts
(S) VR 337

MISSOURI
Drury College (S) VR 345
Kansas City Art Institute (S)
VR 346
Kansas City Public Library (S)
VR 347
Southeast Missouri State Univ (S)
VR 353
Univ of Missouri-Columbia (P,
S) VR 355
Univ of Missouri-Kansas City (S)
VR 356
Univ of Missouri-St Louis (S)
VR 357
Washington Univ (S) VR 359

MONTANA
Montana State Univ (S) VR 361

NEVADA
Joslyn Art Museum (S) VR 365

NEW HAMPSHIRE
Dartmouth College (S) VR 367

NEW JERSEY
Caldwell College (S) VR 369
Montclair Art Museum (S) VR
372
New Jersey Institute of
Technology (S) VR 374
Newark Public Library (S) VR
376
Plymouth State College (S) VR
368
Princeton Univ (P, S) VR 380
Stockton State College (S) VR
383

NEW MEXICO
Univ of New Mexico (S) VR 387

NEW YORK
Adelphi Univ (S) VR 389
Brooklyn College of the City Univ
of New York (S) VR 396
Columbia Univ (S) VR 406
Cooper-Hewitt Museum,
Smithsonian Institution (P) VR
407
Cooper Union for the
Advancement of Science and
Art (S) VR 408
Cornell Univ (S) VR 409 &
VR 410
The Corning Museum of Glass
(S) VR 411
Metropolitan Museum of Art,
(P, S) VR 427
Munson-Williams-Proctor
Institute (S) VR 429
The New York Public Library/
The Research Libraries (P) VR
436
New York Univ, Institute of Fine
Arts (S) VR 437
Pratt Institute (S) VR 439
Rochester Institute of Technology
(S) VR 443
State Univ of New York,
Binghamton (P) VR 452
State Univ of New York at
Buffalo (P, S) VR 453
State Univ of New York College
at Cortland (S) VR 456
State Univ of New York College
at New Paltz (S) VR 457
Syracuse Univ Libraries (S) VR
460
The Univ of Rochester (P, S) VR
463
Vassar College (S) VR 464

NORTH CAROLINA
Duke Univ (P, S) VR 469
East Carolina Univ (S) VR 470
North Carolina State Univ (S)
VR 473
Univ of North Carolina, Chapel
Hill (S) VR 474
Wake Forest Univ (S) VR 475

OHIO
Cleveland Institute of Art (S)
VR 480
The Cleveland Museum of Art
(S) VR 482
Cleveland State Univ (S) VR 484
College of Mount St Joseph on
the Ohio (S) VR 485
Columbus College of Art &
Design (P, S) VR 486
Denison Univ (S) VR 488
Oberlin College (S) VR 491
Oberlin College (P) VR 492
The Ohio State Univ (S) VR 494
Ohio Univ (S) VR 495
Univ of Cincinnati (S) VR 499
Wright State Univ (S) VR 500

OREGON
Oregon State Univ (S) VR 508
Reed College (S) VR 511
Univ of Oregon (S) VR 512

PENNSYLVANIA
Bryn Mawr College (P, S) VR
514
Bryn Mawr College (S) VR 515
Thomas Library

Carnegie-Mellon Univ (S) VR
517
Drexel Univ (S) VR 520
The Pennsylvania State Univ (S)
VR 526
Philadelphia College of Art (S)
VR 528
Swarthmore Colllege (S) VR 531
Temple Univ (S) VR 532
Univ of Pennsylvania (S) VR
534
Univ of Pittsburgh (S) VR 535
Ursinus College (S) VR 536
Westmoreland County Museum of
Art (S) VR 539

RHODE ISLAND
Brown Univ (P, S) VR 540
Museum of Art, Rhode Island
School of Design (S) VR 541
Rhode Island School of Design
(P, S, O) VR 542

SOUTH CAROLINA
Clemson Univ (S) VR 545
Gibbes Art Gallery/Carolina Art
Association (S) VR 547
Presbyterian College (S) VR 549
Univ of South Carolina (S) VR
550

TENNESSEE
Cheekwood Fine Arts Center (S)
VR 558
Memphis State Univ (S) VR 562
Austin Peay State Univ (S) VR
563
Southwestern Univ at Memphis
(S) VR 564
Univ of Tennessee (S) VR 566
Vanderbilt Univ (S) VR 567

TEXAS
Baylor Univ (S) VR 571
Beaumont Art Museum (S) VR
572
Corpus Christi State Univ (S)
VR 574
Dallas Museum of Fine Arts (S)
VR 575
North Texas State Univ (S) VR
581
Rice Univ (P, S) VR 583
San Antonio College (S) VR 584
San Antonio Museum Association
(S) VR 585
Southern Methodist Univ (S)
VR 588
Univ of Houston (S) VR 590
& VR 591
Univ of Texas at Arlington (S)
VR 593
Univ of Texas at Austin (P, S)
VR 594
Univ of Texas at Austin (S)
VR 596
Univ of Texas at El Paso (O, S)
VR 597
Univ of Texas at San Antonio (S)
VR 598

UTAH
Univ of Utah (S) VR 601

VERMONT
Middlebury College (S) VR 605
Univ of Vermont (P, S) VR 606

VIRGINIA
James Madison Univ (P, S) VR
609
Randolph-Macon Woman's
College (S) VR 612
Univ of Richmond (S) VR 616
Univ of Virginia (S) VR 618 &
VR 620
Virginia Commonwealth Univ (S)
VR 623

WASHINGTON
Eastern Washington State College
(S) VR 626
Seattle Art Museum (S) VR 629

WISCONSIN
Gateway Technical Institute (S)
VR 636

Sandford Museum & Planetarium (S) VR 227
Univ of Iowa (P, S) VR 228

KANSAS

Topeka Public Library (S) VR 233
Univ of Kansas (P, S) VR 234
Wichita Art Museum (S) VR 236
Wichita State Univ (S) VR 237

KENTUCKY

Louisville Free Public Library (F) VR 239
J B Speed Art Museum (S) VR 240
Univ of Kentucky (S) VR 241
Univ of Louisville (S) VR 242

LOUISIANA

Louisiana State Univ (S) VR 248 & VR 249
Loyola Univ (S) VR 249A
Southern Univ (S) VR 252
Tulane Univ (S) VR 254

MAINE

Bowdoin College (P, S) VR 257

MARYLAND

Baltimore Museum of Art (S) VR 263
Goucher College (P, S) VR 266
Loyola-Notre Dame Library (S) VR 268
Maryland Institute, College of Art (S) VR 270
Univ of Maryland (O) VR 272
Univ of Maryland (S) VR 273
Univ of Maryland (F, S) VR 274
Univ of Maryland, Baltimore County (P, S) VR 275

MASSACHUSETTS

Art Institute of Boston (S) VR 277
Boston Architecture Center (S) VR 278
Boston Public Library (P) VR 279
Boston Univ (S) VR 280
Brandeis Univ (P, S) VR 281
Sterling & Francine Clark Art Institute (P) VR 284
Forbes Library (P) VR 286
Harvard Univ (P) VR 287
Harvard Univ (P, S) VR 288
Massachusetts College of Art (F, S) VR 289
Massachusetts Institute of Technology (P, S) VR 290
Mount Holyoke College (P, S) VR 294
Smith College (S) VR 298
Smith College (P) VR 299
Tufts Univ (S) VR 300
Univ of Lowell (S) VR 301
Univ of Massachusetts (S) VR 303
Univ of Massachusetts in Boston (S) VR 304
Wellesley College (P, S) VR 305
Wheaton College (P, S) VR 306
Worcester Art Museum (S) VR 308

MICHIGAN

Center for Creative Studies (S) VR 309
Detroit Institute of Arts (P, S) VR 311
Eastern Michigan Univ (S) VR 312
Michigan State Univ (P, S) VR 318
Oakland Univ (S) VR 321
Univ of Michigan (P, S) VR 327
Univ of Michigan-Dearborn (S) VR 328
Wayne State Univ (P) VR 329
Western Michigan Univ (F, S) VR 330

MINNESOTA

Minneapolis College of Art & Design (S) VR 335

Minneapolis Institute of Arts (S) VR 337
Walker Art Center (S) VR 343

MISSOURI

Drury College (S) VR 345
Kansas City Art Institute (S) VR 346
Kansas City Public Library (S) VR 347
St Louis Art Museum (S) VR 352
Southeast Missouri State Univ (S) VR 353
Univ of Missouri-Columbia (P, S) VR 355
Univ of Missouri-Kansas City (P, S) VR 356
Univ of Missouri-St Louis (S) VR 357
Washington Univ (S) VR 359

MONTANA

Montana State Univ (S) VR 361

NEVADA

Joslyn Art Museum (S) VR 365

NEW HAMPSHIRE

Dartmouth College (S) VR 367

NEW JERSEY

Caldwell College (S) VR 369
Montclair Art Museum (S) VR 372
New Jersey Institute of Technology (S) VR 374
Newark Public Library (S) VR 376
Princeton Univ (P, S) VR 380
Stockton State College (S) VR 383

NEW MEXICO

Univ of New Mexico (P, S) VR 387

NEW YORK

Adelphi Univ (S) VR 389 & VR 390
Brooklyn College of the City Univ of New York (S) VR 396
Columbia Univ (P) VR 404
Columbia Univ (S) VR 406
Cooper-Hewitt Museum, Smithsonian Institution (P) VR 407
Cooper Union for the Advancement of Science & Art (S) VR 408
Cornell Univ (S) VR 409
Cornell Univ (P, S) VR 410
Hispanic Society (P) VR 418
Metropolitan Museum of Art (P, S) VR 427
Munson-Williams-Proctor Institute (S) VR 429
New Rochelle Public Library (P, S) VR 434
New York Univ, Institute of Fine Arts (S) VR 437
Pratt Institute (S) VR 439
Rochester Institute of Technology (S) VR 443
State Univ of New York at Binghamton (P, S) VR 452
State Univ of New York at Buffalo (P, S) VR 453
State Univ of New York College at Cortland (S) VR 456
State Univ of New York College at New Paltz (S) VR 457
State Univ of New York College at Oswego (S) VR 458
Syracuse Univ Libraries (S) VR 460
Univ of Rochester (P, S) VR 463
Vassar College (S) VR 464

NORTH CAROLINA

East Carolina Univ (S) VR 470
North Carolina State Univ (S) VR 473

Univ of North Carolina at Chapel Hill (S) VR 474
Wake Forest Univ (S) VR 475

OHIO

Case Western Reserve Univ (S) VR 478
Cleveland Institute of Art (S) VR 480
Cleveland Museum of Art (P, S) VR 482
Cleveland State Univ (S) VR 484
College of Mount St Joseph on the Ohio (S) VR 485
Columbus College of Art & Design (P, S) VR 486
Denison Univ (S) VR 488
Oberlin College (S) VR 491
Oberlin College (P) VR 492
Ohio State Univ (S) VR 494
Ohio Univ (S) VR 495
Univ of Cincinnati (P, S) VR 499
Wright State Univ (S) VR 500

OREGON

Oregon State Univ (S) VR 508
Reed College (S) VR 511
Univ of Oregon (P, S) VR 512

PENNSYLVANIA

Allentown Art Museum (P, S) VR 513
Bryn Mawr College (S) VR 515
Carnegie-Mellon Univ (S) VR 517
Drexel Univ (S) VR 520
Pennsylvania State Univ (P, S) VR 526
Philadelphia College of Art (S) VR 528
Philadelphia Museum of Art (S) VR 530
Swarthmore College (P, S) VR 531
Temple Univ (S) VR 532
Univ of Pennsylvania (S) VR 534
Univ of Pittsburgh (P, S) VR 535
Ursinus College (S) VR 536
Westmoreland County Museum of Art (S) VR 539

RHODE ISLAND

Brown Univ (P, S, O) VR 540
Rhode Island School of Design (P, S) VR 541

SOUTH CAROLINA

Clemson Univ (S) VR 545
Gibbes Art Gallery/Carolina Art Association (S) VR 547
Presbyterian College (S) VR 549
Univ of South Carolina (S) VR 550

TENNESSEE

Cheekwood Fine Arts Center (S) VR 558
Hunter Museum of Art (S) VR 560
Memphis State Univ (S) VR 562
Austin Peay State Univ (S) VR 563
Southwestern Univ at Memphis (S) VR 564
Univ of Tennessee (S) VR 566

TEXAS

Baylor Univ (S) VR 571
Beaumont Art Museum (S) VR 572
Dallas Museum of Fine Arts (S) VR 575
North Texas State Univ (S) VR 581
Rice Univ (P, S) VR 583
San Antonio College (S) VR 584
San Antonio Museum Association (S) VR 585
Southern Methodist Univ (S) VR 588

Univ of Houston (S) VR 590 & VR 591
Univ of Texas at Arlington (S) VR 593
Univ of Texas at Austin (P, S) VR 594
Univ of Texas at Austin (S) VR 596
Univ of Texas at El Paso (S) VR 597
Univ of Texas at San Antonio (S) VR 598
Vanderbilt Univ (S) VR 567

UTAH

Salt Lake City Public Library (S) VR 599
Univ of Utah (S) VR 601

VERMONT

Bennington College (S) VR 603
Middlebury College (S) VR 605
Univ of Vermont (P, S) VR 606

VIRGINIA

James Madison Univ (P, S) VR 609
Randolph-Macon Woman's College (S) VR 612
Univ of Virginia (S) VR 618
Univ of Virginia (P, S) VR 619 & VR 620
Virginia Commonwealth Univ (S) VR 623

WASHINGTON

Eastern Washington State College (F, S) VR 626
Evergreen State College (S) VR 627
Seattle Art Museum (S) VR 629
Univ of Washington (S) VR 634

WISCONSIN

Mount Senario College (S) VR 646
Univ of Wisconsin-Eau Claire (S) VR 652
Univ of Wisconsin-Madison (P, S) VR 654
Univ of Wisconsin-Milwaukee (P, S) VR 656
Univ of Wisconsin-Milwaukee (S) VR 657
Univ of Wisconsin-Parkside (S) VR 659
Univ of Wisconsin-Stevens Point (S) VR 662
Univ of Wisconsin-Whitewater (S) VR 663

Canada

BRITISH COLUMBIA

Kootenay School of Art, Division of Selkirk College (S) VR 666

MANITOBA

The Univ of Manitoba (S) VR 670
Winnipeg Art Gallery (S) 671

NOVA SCOTIA

Acadia Univ (S) VR 673
Nova Scotia College of Art and Design (S) VR 674

ONTARIO

Art Gallery of Ontario (S) VR 676
Carleton Univ (S) VR 678
National Gallery of Canada (F) VR 681
Scarborough College, Univ of Toronto (S) VR 685
Univ of Guelph (S) VR 687
Univ of Toronto (S) VR 690
Univ of Western Ontario (S) VR 691
York Univ (P, S) VR 692

PRINCE EDWARD ISLAND

Confederation Centre Art Gallery & Museum (S) VR 693

QUEBEC
Bibliotheque de la Ville de Montreal (S) VR 694
Montreal Museum of Fine Arts (S) VR 698
Univ de Montreal (S) VR 700
Univ du Quebec a Montreal (S) VR 701
L'Univ Laval (S) VR 702

ARCHITECTURE-FAR EAST

United States

ARIZONA
Arizona State Univ (S) VR 8
Glendale Community College (S) (S) VR 9
Univ of Arizona (S) VR 14

ARKANSAS
Univ of Arkansas (S) VR 19 & VR 20

CALIFORNIA
California College of Arts & Crafts (S) VR 28
California State College-Dominguez Hills (S) VR 31
California State University-Chico (S) VR 32
California State Univ-Fresno (S) VR 33
California State Univ-Hayward (S) VR 34
California State Univ-Los Angeles (S) VR 37
California State Univ-Northridge (S) VR 38
Los Angeles County Museum of Art (S) VR 52
Mills College (S) VR 56
San Diego State Univ (S) VR 64
San Jose State Univ (S) VR 70
Univ of California-Berkeley (S) VR 75
Univ of California-Irvine (S) VR 79
Univ of California-Santa Barbara (S) VR 84
Univ of Southern California (S) VR 87

COLORADO
Colorado College (S) VR 91
Univ of Denver (S) VR 99

CONNECTICUT
Connecticut College (S) VR 100
Trinity College (S) VR 104
Yale Univ (P, S) VR 111

DISTRICT OF COLUMBIA
Freer Gallery of Art (P, S) VR 124

FLORIDA
Lowie Art Museum, Univ of Miami (S) VR 149
Univ of South Florida (S) VR 158

GEORGIA
Georgia Institute of Technology (S) VR 163
Georgia State Univ (S) VR 164
Univ of Georgia (S) VR 166

HAWAII
Honolulu Academy of Arts (S) VR 169
Univ of Hawaii, Manoa (S) VR 173

ILLINOIS
Northern Illinois Univ (S) VR 189
Northwestern Univ (P, S) VR 190
Quincy College (S) VR 194
Roosevelt Univ (S) VR 198
Univ of Illinois at Chicago Circle (S) VR 204

INDIANA
Indiana Univ (S) VR 215

IOWA
Univ of Iowa (S) VR 228

KANSAS
Topeka Public Library (F) VR 233
Univ of Kansas (P, S) VR 234

KENTUCKY
Louisville Free Public Library (F) VR 239
J B Speed Art Museum (S) VR 240
Univ of Kentucky (S) VR 241

LOUISIANA
Louisiana State Univ (S) VR 248
Tulane Univ (S) VR 254

MARYLAND
Goucher College (S) VR 266
Univ of Maryland (S) VR 273 & VR 274

MASSACHUSETTS
Boston Public Library (P) VR 279
Brandeis Univ (P, S) VR 281
Forbes Library (P) VR 286
Harvard Univ (P) VR 287
Harvard Univ (S) VR 288
Massachusetts College of Art (S) VR 289
Massachusetts Institute of Technology (P, S) VR 290
Mount Holyoke College (P, S) VR 294
Smith College (S) VR 298
University of Lowell (S) VR 301
Univ of Massachusetts (S) VR 303
Wellesley College (P, S) VR 305
Wheaton College (S) VR 306

MICHIGAN
Detroit Institute of Arts (S) VR 311
Univ of Michigan (P) VR 325
Univ of Michigan (P, S) VR 327
Univ of Michigan-Dearborn (S) VR 328
Western Michigan Univ (S) VR 330

MINNESOTA
Minneapolis College of Art & Design (S) VR 335
Minneapolis Institute of Arts (S) VR 337

MISSOURI
Drury College (S) VR 345
Kansas City Art Institute (S) VR 346
Univ of Missouri-Columbia (S) VR 355
Washington Univ (S) VR 359

MONTANA
Montana State Univ (S) VR 361

NEW JERSEY
New Jersey Institute of Technology (S) VR 374
Princeton Univ (P) VR 379
Princeton Univ (S) VR 380
Stockton State College (S) VR 383

NEW YORK
Adelphi Univ (S) VR 389
Columbia Univ (S) VR 406
Cooper-Hewitt Museum, Smithsonian Institution (P) VR 407
Cooper Union for the Advancement of Science & Art (S) VR 408
Cornell Univ (P, S) VR 410
Metropolitan Museum of Art (P, S) VR 427
The New York Public Library/ The Research Libraries (P) VR 436

New York Univ, Institute of Fine Arts (S) VR 437
State Univ of New York at Buffalo (S) VR 453
State Univ of New York College at New Paltz (S) VR 457
Syracuse Univ Libraries (S) VR 460

NORTH CAROLINA
Duke Univ (P, S) VR 469
North Carolina State Univ (S) VR 473
Univ of North Carolina at Chapel Hill (S) VR 474

OHIO
Cleveland Institute of Art (S) VR 480
Cleveland Museum of Art (S) VR 482
Cleveland State Univ (S) VR 484
Columbus College of Art & Design (P, S) VR 486
Denison Univ (S) VR 488
Oberlin College (S) VR 491
Ohio State Univ (S) VR 494
Ohio Univ (S) VR 495

OREGON
Oregon State Univ (S) VR 508
Univ of Oregon (S) VR 512

PENNSYLVANIA
Bryn Mawr College (P, S) VR 514
Philadelphia College of Art (S) VR 528
Philadelphia Museum of Art (S) VR 530
Swarthmore College (S) VR 531

RHODE ISLAND
Rhode Island School of Design (S) VR 541

SOUTH CAROLINA
Clemson Univ (S) VR 545
Univ of South Carolina (S) VR 550

TENNESSEE
Austin Peay State Univ (S) VR 563
Southwestern Univ at Memphis (S) VR 564
Univ of Tennessee (S) VR 566
Vanderbilt Univ (S) VR 567

TEXAS
Dallas Museum of Fine Arts (S) VR 575
North Texas State Univ (S) VR 581
Rice Univ (S) VR 583
Univ of Texas at Arlington (S) VR 593
Univ of Texas at Austin (S) VR 596

VERMONT
Middlebury College (S) VR 605

VIRGINIA
James Madison Univ (P, S) VR 609
Randolph-Macon Woman's College (S) VR 612
Univ of Virginia (S) VR 619 & VR 620
Virginia Commonwealth Univ (S) VR 623

WASHINGTON
Seattle Art Museum (S) VR 629

WISCONSIN
Mount Senario College (S) VR 646
Univ of Wisconsin-Madison (P, S) VR 654
Univ of Wisconsin-Milwaukee (S) VR 656
Univ of Wisconsin-Whitewater (S) VR 663

Canada

BRITISH COLUMBIA
Kootenay School of Art, Division of Selkirk College (S) VR 666

ONTARIO
Scarborough College, Univ of Toronto (S) VR 685
Univ of Toronto (S) VR 690

ARCHITECTURE-ISLAMIC

United States

ARIZONA
Arizona State Univ (S) VR 6 & VR 8
Glendale Community College (S) VR 9
Univ of Arizona (S) VR 14

ARKANSAS
Univ of Arkansas (S) V 20

CALIFORNIA
California Institute of the Arts (S) VR 29
California State Univ-Chico (S) VR 32
California State Univ-Fresno (S) VR 33
California State Univ-Los Angeles (S) VR 37
San Diego State Univ (S) VR 64
San Jose State Univ VR 70
Univ of California-Berkeley (P, S) VR 74
Univ of California-Berkeley (S) VR 75
Univ of California-San Diego (S) VR 83
Univ of California-Santa Barbara (S) VR 84
Univ of Southern California (S) VR 87

COLORADO
Colorado College (S) VR 91
Univ of Colorado (S) VR 98
Univ of Denver (S) VR 99

CONNECTICUT
Yale Univ (P, S) VR 111

DISTRICT OF COLUMBIA
Freer Gallery of Art (P, S) VR 124
Howard Univ (S) VR 126

GEORGIA
Georgia State Univ (S) VR 164

ILLINOIS
Richard J Daley College (S) VR 179
Northern Illinois Univ (S) VR 189
Northwestern Univ (P, S) VR 190
Quincy College (S) VR 194

IOWA
Univ of Iowa (S) VR 228

KENTUCKY
J B Speed Art Museum (S) VR 340

LOUISIANA
Louisiana State Univ (S) VR 249
Loyola Univ (S) VR 249A

MARYLAND
Univ of Maryland (S) VR 274

MASSACHUSETTS
Boston Architecture Center (S) VR 278
Boston Public Library (P) VR 279
Brandeis Univ (S) VR 281
Harvard Univ (P) VR 287
Harvard Univ (S) VR 288
Massachusetts College of Art (S) VR 289

Massachusetts Institute of Technology (P, S) VR 290
Mount Holyoke College (P, S) VR 294
Univ of Massachusetts (S) VR 303

MICHIGAN
Detroit Institute of Arts (S) VR 311
Eastern Michigan Univ (S) VR 312
Univ of Michigan (P, S) VR 327

MINNESOTA
Minneapolis College of Art & Design (S) VR 335

MISSOURI
Drury College (S) VR 345
Univ of Missouri-Columbia (S) VR 355

MONTANA
Montana State Univ (S) VR 361

NEW JERSEY
New Jersey Institute of Technology (S) VR 374

NEW MEXICO
Univ of New Mexico (S) VR 387

NEW YORK
Columbia Univ (S) VR 406
Cooper-Hewitt Museum, Smithsonian Institution (P) VR 407
Hispanic Society (P) VR 418
Metropolitan Museum of Art (S) VR 427
The New York Public Library/ The Research Libraries (P) VR 436
New York Univ, Institute of Fine Arts (S) VR 437
State Univ of New York College at New Paltz (S) VR 457
Syracuse Univ Libraries (S) VR 460

NORTH CAROLINA
Duke Univ (P, S) VR 469
Univ of North Carolina at Chapel Hill (S) VR 474

OHIO
Columbus College of Art & Design (S) VR 486
Oberlin College (S) VR 491
Oregon State Univ (S) VR 508

PENNSYLVANIA
Philadelphia College of Art (S) VR 528
Univ of Pennsylvania (S) VR 534
Univ of Pittsburgh (S) VR 535

TENNESSEE
Austin Peay State Univ (S) VR 563
Univ of Tennessee (S) VR 566

TEXAS
Univ of Texas at Austin (S) VR 596
Univ of Texas at El Paso (S) VR 597
Univ of Texas at San Antonio (S) VR 598

VIRGINIA
Univ of Virginia (S) VR 619

WASHINGTON
Eastern Washington State College (S) VR 626
Seattle Art Museum (S) VR 629

WISCONSIN
Univ of Wisconsin-Whitewater (S) VR 663

Canada

MANITOBA
Univ of Manitoba (S) VR 670

ONTARIO
Univ of Toronto (S) VR 690

QUEBEC
Univ du Quebec a Montreal (S) VR 701
L'Univ Laval (S) VR 702

ARCHITECTURE-MESO-AMERICAN

United States

ARIZONA
The Amerind Foundation, Inc (S) VR 5
Arizona State Univ (S) VR 8
Tucson Museum of Art (P, S) VR 12
Univ of Arizona (S) VR 14

ARKANSAS
Univ of Arkansas (S) VR 20

CALIFORNIA
California State Univ-Chico (S) VR 32
California State Univ-Los Angeles (S) VR 37
California State Univ-Sacramento (S) VR 39
San Diego State Univ (S) VR 64
San Jose State Univ (S) VR 70
Univ of California-Berkeley (P, S) VR 74
Univ of California-Irvine (S) VR 79
Univ of California-San Diego (S) VR 83
Univ of California-Santa Barbara (S) VR 84

COLORADO
Univ of Colorado (S) VR 98
Univ of Denver (S) VR 99

CONNECTICUT
Connecticut College (S) VR 100
Yale Univ (P, S) VR 111

DISTRICT OF COLUMBIA
Howard Univ (S) VR 126

FLORIDA
Lowie Art Museum, Univ of Miami (S) VR 149

GEORGIA
Atlanta College of Art (S) VR 160
Georgia Institute of Technology (S) VR 163
Georgia State Univ (S) VR 164

ILLINOIS
Art Institute of Chicago (S) VR 174
Richard J Daley College (S) VR 179
Northern Illinois Univ (S) VR 189
Northwestern Univ (P, S) VR 190
Quincy College (S) VR 194
Southern Illinois Univ at Edwardsville (S) VR 200

INDIANA
Ball State Univ (S) VR 209
Indiana Univ (S) VR 215

IOWA
Univ of Iowa (S) VR 228

LOUISIANA
Louisiana State Univ (S) VR 249
Newcomb College of Tulane Univ (S) VR 251
Tulane Univ (S) VR 254

MARYLAND
Loyola-Notre Dame Library (S) VR 268
Univ of Maryland VR 273 & VR 274

MASSACHUSETTS
Brandeis Univ (S) VR 281
Massachusetts Institute of Technology (S) VR 290
Univ of Massachusetts in Boston (S) VR 304

MICHIGAN
Western Michigan Univ (S) VR 330

MISSOURI
Drury College (S) VR 345
Southeast Missouri State Univ (S) VR 353

NEVADA
Joslyn Art Museum (S) VR 365

NEW JERSEY
Caldwell College (S) VR 369
Stockton State College (S) VR 383

NEW MEXICO
Univ of New Mexico (S) VR 387

NEW YORK
Adelphi Univ (S) VR 389
Columbia Univ (S) VR 406
Cooper-Hewitt Museum, Smithsonian Institution (P) VR 407
Metropolitan Museum of Art (P) VR 426
The New York Public Library/ The Research Libraries (P) VR 436
State Univ of New York College at Cortland (S) VR 456
State Univ of New York College at New Paltz (S) VR 457
Syracuse Univ Libraries (S) VR 460

NORTH CAROLINA
Duke Univ (P, S) VR 469

OHIO
Cleveland Institute of Art (S) VR 480
College of Mount St Joseph on the Ohio (S) VR 485
Univ of Cincinnati (S) VR 499

OREGON
Oregon State Univ (S) VR 508

PENNSYLVANIA
Philadelphia College of Art (S) VR 528
Univ of Pittsburgh (S) VR 535
Westmoreland County Museum of Art (S) VR 539

TENNESSEE
Austin Peay State Univ (S) VR 563

TEXAS
Dallas Museum of Fine Arts (S) VR 575
North Texas State Univ (S) VR 581
San Antonio Museum Association (S) VR 585
Univ of Texas at Austin (P, S) VR 594
Univ of Texas at Austin (S) VR 596
Univ of Texas at El Paso (S) VR 597
Univ of Texas at San Antonio (S) VR 598

UTAH
Univ of Utah (S) VR 601

VIRGINIA
James Madison Univ (S) VR 609

WASHINGTON
Eastern Washington State College (S) VR 626
Seattle Art Museum (S) VR 629

WISCONSIN
Mount Senario College (S) VR 646
Univ of Wisconsin-Eau Claire (S) VR 652
Univ of Wisconsin-Madison (S) VR 654
Univ of Wisconsin-Milwaukee (S) VR 656
Univ of Wisconsin-Stevens Point (S) VR 662

Canada

ONTARIO
Scarborough, Univ of Toronto (S) VR 685

QUEBEC
Univ du Quebec a Montreal (S) VR 701
L'Univ Laval (S) VR 702

ARCHITECTURE-PACIFIC

United States

DISTRICT OF COLUMBIA
Museum of African Art (P, S) VR 128

GEORGIA
Georgia State Univ (S) VR 164

HAWAII
Bishop Museum (P, S) VR 168
Univ of Hawaii, Manoa (S) VR 173

ILLINOIS
Northwestern Univ (P, S) VR 190
Southern Illinois Univ at Edwardsville (S) VR 200

INDIANA
Indiana Univ (S) VR 216

MARYLAND
Univ of Maryland (S) VR 274

MASSACHUSETTS
Massachusetts Institute of Technology (S) VR 290

NEVADA
Joslyn Art Museum (S) VR 365

NEW YORK
Columbia Univ (S) VR 406
Cooper-Hewitt Museum, Smithsonian Institution (P) VR 407
Metropolitan Museum of Art (P) VR 426
Metropolitan Museum of Art (S) VR 427
The New York Public Library/ The Research Libraries (P) VR 436

NORTH CAROLINA
Duke Univ (P, S) VR 469

OHIO
Univ of Cincinnati (S) VR 499

TEXAS
Univ of Texas at Austin (S) VR 596

WISCONSIN
Univ of Wisconsin-Milwaukee (S) VR 656
Univ of Wisconsin-Whitewater (S) VR 663

ARCHITECTURE-
TRIBAL AMERICAN

United States

ARIZONA
The Amerind Foundation, Inc
(S) VR 5
Arizona State Univ (S) VR 8

CALIFORNIA
San Diego State Univ (S) VR 64
San Jose State Univ (S) VR 70

COLORADO
Univ of Colorado (S) VR 98
Univ of Denver (S) VR 99

FLORIDA
Lowie Art Museum, Univ of
Miami (S) VR 149

GEORGIA
Georgia State Univ (S) VR 164

HAWAII
Univ of Hawaii, Manoa (S)
VR 173

ILLINOIS
Northern Illinois Univ (S)
VR 189
Northwestern Univ (P, S)
VR 190
Southern Illinois Univ at
Edwardsville (S) VR 200

INDIANA
Indiana Univ (S) VR 215

IOWA
Sandford Museum &
Planetarium (P, S) VR277

MARYLAND
Univ of Maryland (S) VR 274

MASSACHUSETTS
Massachusetts Institute of
Technology (S) VR 290
Mount Holyoke College (P, S)
VR 294

MISSOURI
Drury College (S) VR 345

MONTANA
Univ of Montana (S) VR 362

NEVADA
Joslyn Art Museum (S) VR 365

NEW JERSEY
Montclair Art Museum (S)
VR 372

NEW MEXICO
Univ of New Mexico (S)
VR 387

NEW YORK
Columbia Univ (S) VR 406
Cooper-Hewitt Museum,
Smithsonian Institution (P)
VR 407
Metropolitan Museum of Art (S)
VR 427
The New York Public Library/
The Research Libraries (P)
VR 436

NORTH CAROLINA
Duke Univ (P, S) VR 469

OHIO
Cleveland Institute of Art (S)
VR 480
College of Mount St Joseph on
the Ohio (S) VR 485
Univ of Cincinnati (S) VR 499

OKLAHOMA
Museum of the Great Plains (P)
VR 501

OREGON
Oregon State University (S)
VR 508

SOUTH DAKOTA
Siouxland Heritage Museums (P)
VR 555

TEXAS
Univ of Texas at Austin (S)
VR 596

VIRGINIA
Virginia Commonwealth Univ
(S) VR 623

WISCONSIN
Univ of Wisconsin-Eau Claire
(S) VR 652
Univ of Wisconsin-Whitewater
(S) VR 663

Canada

MANITOBA
Winnipeg Art Gallery (S)
VR 671

ARCHITECTURE-
UNITED STATES

United States

ALABAMA
Univ of Alabama in Birmingham
(S) VR 2
Univ of Alabama in Huntsville
(M, S) VR 3

ARIZONA
Arizona State University
(F, P, S, V) VR 7
Glendale Community College (S)
VR 9
Univ of Arizona (P, S) VR 14

ARKANSAS
Univ of Arkansas (S) VR 19 &
VR 20

CALIFORNIA
Brand Library (S) VR 26
California Institute of the Arts
(S) VR 29
California State College-
Dominguez Hills (S) VR 31
California State Univ-Chico (S)
VR 32
California State Univ-Fresno (S)
VR 33
California State Univ-Hayward
(S) VR 34
California State Univ-Los Angeles
(S) VR 37
California State Univ-Northridge
(S) VR 38
California State Univ-Sacramento
(S) VR 39
Greene & Greene Library of the
Gamble House (M, S) VR 45
Hebrew Union College Skirball
Museum (P, S) VR 46
Jr Arts Center in Barnsdall Park
(S) VR 49
Los Angeles County Museum of
Art (S) VR 52
Oakland Museum (P, S) VR 57
Otis Art Institute (S) VR 58
Pomona College (S) VR 61
Presidio of Monterey Museum
(F, P) VR 63
San Diego State Univ (S) VR 64
San Francisco Museum of
Modern Art (S) VR 67
San Jose City College (S) VR 69
San Jose State Univ (S) VR 70
Stanford Univ (S) VR 72
Univ of California-Berkeley
(P, S) VR 74
Univ of California-Berkeley (S)
VR 75
Univ of California-Davis (MR)
VR 77
Univ of California-Davis (S)
VR 78
Univ of California-Irvine (S)
VR 79
Univ of California-Riverside
(P, S) VR 82

Univ of California-San Diego (S)
VR 83
Univ of California-Santa Barbara
(S) VR 84
Univ of Southern California (S)
VR 87

COLORADO
Colorado College (S) VR 91
Denver Public Library (OP)
VR 93
Northeastern Junior College (V)
VR 95
Univ of Denver (S) VR 99

CONNECTICUT
Connecticut College (S) VR 100
St Joseph College (S) VR 103
Yale Univ (P, S) VR 111
Trinity College (S) VR 104
Univ of Hartford (S) VR 106

DELAWARE
Univ of Delaware (P, S) VR 114
H F duPont Winterthur Museum
Libraries (P) VR 115
H F du Pont Winterthur Museum
(S) VR 116

DISTRICT OF COLUMBIA
American University (S) VR 117
Archives of American Art (P, S)
VR 118
George Washington Univ (S)
VR 124A
Howard Univ (S) VR 126
The Library of Congress (P)
VR 127
National Collection of Fine Arts
(S) VR 132
National Gallery of Art (F, S)
VR 133
National Gallery of Art (P)
VR 134
National Gallery of Art (S)
VR 135
National Trust for Historic
Preservation (F, P, S, V)
VR 138
Trinity College (S) VR 139

FLORIDA
Florida International Univ (S)
VR 143
Lowie Art Museum, Univ of
Miami (S) VR 149
North Florida Junior College (S)
VR 151
Ringling School of Art (S)
VR 153
Univ of South Florida (S)
VR 158
Vizcaya Museum (P, S) VR 159

GEORGIA
Atlanta College of Art (S)
VR 160
Georgia Institute of Technology
(S) VR 163
Georgia State Univ (S) VR 164
Univ of Georgia (S) VR 166

HAWAII
Honolulu Academy of Arts (S)
VR 169
Univ of Hawaii, Manoa (S)
VR 173

ILLINOIS
Art Institute of Chicago (S)
VR 174
Chicago Public Library Cultural
Center (S) VR 117
Richard J Daley College (S)
VR 179
Northern Illinois Univ (S)
VR 189
Northwestern Univ (P, S)
VR 190
Quincy College (S) VR 194
Roosevelt University (S) VR 198
Southern Illinois University at
Edwardsville (S) VR 200
University of Illinois at Chicago
Circle (S) VR 204
Univ of Illinois at Urbana-
Champaign (S) VR 205

INDIANA
Ball State Univ (S) VR 209
Evansville Museum of Arts &
Science (P, S) VR 211
Herron School of Art (S) VR 213
Univ of Notre Dame (S) VR 219
& VR 220

IOWA
Davenport Municipal Art Gallery
(S) VR 222
Grinnell College (S) VR 223
Univ of Iowa (S) VR 228

KANSAS
Topeka Public Library (S)
VR 233
Univ of Kansas (P, S) VR 234
Wichita Art Museum (S)
VR 236
Wichita State Univ (S)
VR 237

KENTUCKY
Louisville Free Public Library
(F) VR 239
J B Speed Art Museum (S)
VR 240
Univ of Kentucky (S) VR 241
Univ of Louisville (S) VR 242

LOUISIANA
Historic New Orleans Collection
(P) VR 246
Louisiana State Univ (S)
VR 248 & VR 249
Loyola Univ (S) VR 249A
Newcomb College of Tulane
Univ (S) VR 251
Southern Univ (S) VR 252
Tulane Univ (S) VR 254

MAINE
Bowdoin College (S) VR 257
William A Farnsworth Art
Museum (S) VR 258
Shaker Library (P, S) VR 261

MARYLAND
Baltimore Museum of Art (S)
VR 263
Goucher College (P, S) VR 266
Loyola-Notre Dame Library
(S) VR 268
Maryland Institute, College of
Art (S) VR 270
Univ of Maryland (S) VR 273
Univ of Maryland (F, S)
VR 274
Univ of Maryland, Baltimore
County (P, S) VR 275

MASSACHUSETTS
Boston Architecture Center (S)
VR 278
Boston Public Library (P)
VR 279
Boston Univ (S) VR 280
Brandeis Univ (P, S) VR 281
Forbes Library (P) VR 286
Harvard Univ (P) VR 287
Harvard Univ (P, S) VR 288
Massachusets College of Art
(F, S) VR 289
Massachusetts Institute of
Technology (F, P, S, V)
VR 290
Merrimack Valley Textile
Museum (P, S) VR 293
Mount Holyoke College (P, S)
VR 294
Smith College (S) VR 298
Smith College (P) VR 299
Tufts Univ (S) VR 300
Univ of Massachusetts (S)
VR 303
Univ of Massachusetts in Boston
(S) VR 304
Wellesley College (P, S) VR 305
Wheaton College (P, S) VR 306
Worcester Art Museum (S)
VR 308

MICHIGAN
Center for Creative Studies (S)
VR 309

Detroit Institute of Arts (P, S)
VR 311
Eastern Michigan Univ (S)
VR 312
Michigan State Univ (P, S)
VR 318
Oakland Univ (S) VR 321
Univ of Michigan (P, S)
VR 327
Univ of Michigan-Dearborn (S)
VR 328
Wayne State Univ (P) VR 329
Western Michigan Univ (S)
VR 330

MINNESOTA
Minneapolis College of Art &
Design (S) VR 335
Minneapolis Institute of Arts (S)
VR 337
Walker Art Center (S) VR 343

MISSOURI
Drury College (S) VR 345
Kansas City Art Institute (S)
VR 346
Kansas City Public Library (S)
VR 347
St Louis Art Museum (S)
VR 352
Southeast Missouri State Univ
(S) VR 353
Univ of Missouri-Columbia (P,
S) VR 355
Univ of Missouri-Kansas City (S)
VR 356
Univ of Missouri-St Louis (S)
VR 357
Washington Univ (S) VR 359

MONTANA
Montana State Univ (S) VR 361

NEVADA
Joslyn Art Museum (S) VR 365

NEW HAMPSHIRE
Dartmouth College (S) VR 367

NEW JERSEY
Caldwell College (S) VR 369
Montclair Art Museum (S)
VR 372
New Jersey Institute of
Technology (S) VR 374
Newark Public Library (S)
VR 376
Princeton Univ (P, S) VR 380
Stockton State College (S)
VR 383

NEW MEXICO
Univ of New Mexico (S)
VR 387

NEW YORK
Adelphi Univ (S) VR 389 &
VR 390
Brooklyn College of the City
Univ of New York (S)
VR 396
Columbia Univ (S) VR 406
Cooper-Hewitt Museum,
Smithsonian Institution (P)
VR 407
Cooper Union for the
Advancement of Science &
Art (S) VR 408
Cornell Univ (S) VR 409 &
VR 410
Hall of Fame for Great
Americans (P) VR 417
Metropolitan Museum of Art
(P, S) VR 427
Munson-Williams-Proctor
Institute (S) VR 429
New Rochelle Public Library
(P, S) VR 434
New York Public Library/The
Research Libraries (P)
VR 436
New York Univ, Institute of Fine
Arts (S) VR 437
Pratt Institute (S) VR 439
Rochester Institute of Technology
(S) VR 443

Rochester Museum & Science
Center (P) VR 444
State Univ of New York at
Binghamton (S) VR 452
State Univ of New York at
Buffalo (P, S) VR 453
State Univ of New York College
at Cortland (S) VR 456
State Univ of New York College
at New Paltz (S) VR 457
State Univ of New York College
at Oswego (S) VR 458
Syracuse Univ Libraries (S)
VR 460
Univ of Rochester (P, S)
VR 463
Vassar College (S) VR 464

NORTH CAROLINA
Duke Univ (P, S) VR 469
East Carolina Univ (S) VR 470
Museum of Early Southern
Decorative Arts (P, S)
VR 471
North Carolina State Univ (F,
P, S) VR 473
Univ of North Carolina at Chapel
Hill (S) VR 474
Wake Forest Univ (S) VR 475

OHIO
Case Western Reserve Univ (S)
VR 478
Cleveland Institute of Art (S)
VR 480
Cleveland Museum of Art (S)
VR 482
Cleveland State Univ (S)
VR 484
College of Mount St Joseph on
the Ohio (S) VR 485
Columbus College of Art &
Design (P, S) VR 486
Denison Univ (S) VR 488
Oberlin College (S) VR 491
Oberlin College (P) VR 492
Ohio State Univ (S) VR 494
Ohio Univ (S) VR 495
Public Library of Cincinnati &
Hamilton County (S) VR 496
Univ of Cincinnati (P, S)
VR 499
Wright State Univ (S) VR 500

OREGON
Oregon State Univ (S) VR 508
Reed College (S) VR 511
Univ of Oregon (P, S) VR 512

PENNSYLVANIA
Allentown Art Museum (P, S)
VR 513
Bryn Mawr College (P, S)
VR 514
Bryn Mawr College (S)
VR 515
Carnegie-Mellon Univ (S)
VR 517
Drexel Univ (S) VR 520
Pennsylvania State Univ (S)
VR 526
Philadelphia College of Art (S)
VR 528
Philadelphia Museum of Art (S)
VR 530
Swarthmore College (P, S)
VR 531
Temple Univ (S) VR 532
Univ of Pennsylvania (S)
VR 534
Univ of Pittsburgh (S) VR 535
Ursinus College (S) VR 536
Westmoreland County Museum
of Art (S) VR 539

RHODE ISLAND
Brown Univ (P, S, O) VR 540
Rhode Island School of Design
(P, S, O) VR 541

SOUTH CAROLINA
Clemson Univ (S) VR 545
Gibbes Art Gallery/Carolina Art
Association (P, S) VR 547
Univ of South Carolina (S)
VR 550

SOUTH DAKOTA
Siouxland Heritage Museums
(P) VR 555
Univ of South Dakota (P)
VR 556

TENNESSEE
Cheekwood Fine Arts Center
(S) VR 558
Hunter Museum of Art (S)
VR 560
Memphis State Univ (S) VR 562
Austin Peay State Univ (S)
VR 563
Southwestern Univ at Memphis
(S) VR 564
Univ of Tennessee (S) VR 566
Vanderbilt Univ (S) VR 567

TEXAS
Art Museum of South Texas
(S) VR 568
Austin Public Library (P, S)
VR 569
Baylor Univ (S) VR 571
Beaumont Art Museum (S)
VR 572
Dallas Museum of Fine Arts
(S) VR 575
Institute of Texan Cultures (P)
VR 577
North Texas State Univ (F, S)
VR 581
Rice Univ (P, S) VR 583
San Antonio College (S)
VR 584
San Antonio Museum Association
(P, S) VR 585
Southern Methodist Univ (S)
VR 588
Univ of Houston (S) VR 590 &
VR 591
Univ of Texas at Arlington (S)
VR 593
Univ of Texas at Austin (S)
VR 594 & VR 596
Univ of Texas at El Paso (S)
VR 597
Univ of Texas at San Antonio
(S) VR 598

UTAH
Salt Lake City Public Library
(S) VR 599

VERMONT
Bennington College (S) VR 603
Middlebury College (S) VR 605
Univ of Vermont (P, S)
VR 606

VIRGINIA
James Madison Univ (P, S)
VR 609
Ranloph-Macon Woman's
College (S) VR 612
Univ of Virginia (S) VR 618
Univ of Virginia (P, S) VR 619
& VR 620
Virginia Commonwealth Univ (S)
VR 623
Virginia Museum of Fine Arts
(S) VR 624

WASHINGTON
Eastern Washington State College
(S) VR 626
Evergreen State Colllege (S)
VR 627
Henry Gallery, Univ of
Washington (P) VR 628

WISCONSIN
Gateway Technical Institute (S)
VR 636
Oshkosh Public Museum (P)
VR 647
Univ of Wisconsin-Eau Claire
(S) VR 652
University of Wisconsin-Madison
(P, S) VR 654
Univ of Wisconsin-Milwaukee
(P, S) VR 656
Univ of Wisconsin-Milwaukee
(S) VR 657

Univ of Wisconsin-Parkside (S)
VR 659
Univ of Wisconsin-Stevens Point
(S) VR 662
Univ of Wisconsin-Whitewater
(S) VR 663

Canada

BRITISH COLUMBIA
Kootenay School of Art, Division
of Selkirk College (S) VR 666

ONTARIO
Carleton Univ (S) VR 678
Scarborough College, Univ of
Toronto (S) VR 685
Univ of Toronto (S) VR 690
York Univ (S) VR 692

QUEBEC
Univ du Quebec a Montreal (S)
VR 701

DECORATIVE ARTS-AFRICAN

United States

ALABAMA
Univ of Alabama in Huntsville
(M, S) VR 3

ARIZONA
Glendale Community College (S)
Tucson Museum of Art (P, S)
VR 12

CALIFORNIA
California State Univ-Chico (S)
VR 32
California State Univ-Northridge
(S) VR 38
Jr Arts Center in Barnsdall Park
(S) VR 49
San Diego State Univ (S) VR 64
Univ of California-Irvine (S)
VR 79
Univ of California-Santa Barbara
(S) VR 84

CONNECTICUT
Yale Univ (P, S) VR 111

DISTRICT OF COLUMBIA
Museum of African Art (F, P, S)
VR 128

FLORIDA
Lowie Art Museum, Univ of
Miami (S) VR 149

GEORGIA
Georgia Institute of Technology
(S) VR 163
Georgia State Univ (S) VR 164
Univ of Georgia (S) VR 166

HAWAII
Univ of Hawaii, Manoa (S)
VR 173

ILLINOIS
Moraine Valley Community
College (S) VR 185
Northern Illinois Univ (S)
VR 189
Northwestern Univ (S) VR 190
Southern Illinois Univ at
Edwardsville (S) VR 200
Univ of Illinois at Urbana-
Champaign (S) VR 205

INDIANA
Indiana Univ (S) VR 215

IOWA
Grinnell College (S) VR 223
Sandford Museum & Planetarium
(S) VR 227
Univ of Iowa (S) VR 228

MARYLAND
Univ of Maryland (S) VR 273

MASSACHUSETTS
Boston Public Library (P)
VR 279

DECORATIVE ARTS-ANCIENT

United States

Canada

DECORATIVE ARTS-ANDEAN

United States

RHODE ISLAND

Rhode Island School of Design
(S) VR 541

TEXAS

Beaumont Art Museum (S)
VR 572
Univ of Texas at Austin (S)
VR 594

Canada

BRITISH COLUMBIA

Kootenay School of Art, Division
of Selkirk College (S) VR 666

MANITOBA

The Univ of Manitoba (S)
VR 670

DECORATIVE ARTS-CANADIAN

United States

NEW YORK

New York Public Library/The
Research Libraries (P) VR 436

WISCONSIN

Kenosha Public Library (F)
VR 638

Canada

BRITISH COLUMBIA

Kootenay School of Art, Division
of Selkirk College (S) VR 666
Malaspina College (S) VR 667

MANITOBA

The Univ of Manitoba (S)
VR 670
Winnipeg Art Gallery (S) VR 671

NOVA SCOTIA

Nova Scotia College of Art &
Design (S) VR 674
Public Archives of Nova Scotia
(P) VR 675

ONTARIO

Carleton Univ (S) VR 678
Sir Sandford Fleming College of
Applied Arts & Technology (S)
VR 679
National Gallery of Canada
(P, S) VR 681
Ontario Crafts Council (S)
VR 676
Scarborough College, Univ of
Toronto (S) VR 685

PRINCE EDWARD ISLAND

Confederation Centre Art Gallery
& Museum (S) VR 693

QUEBEC

Universite de Montreal (S)
VR 700
Univ du Quebec a Montreal (S)
VR 701

DECORATIVE ARTS-EUROPEAN

United States

ARIZONA

Arizona State Univ (S) VR 6
Univ of Arizona (S) VR 14

CALIFORNIA

California Institute of the Arts
(S) VR 29
California State College-
Dominguez Hills (S) VR 31
California State Univ-Chico (S)
VR 32
California State Univ-Hayward
(S) VR 34
California State Univ-Los Angeles
(S) VR 37
Henry E Huntington Library &
Art Gallery (P, S) VR 48

Los Angeles County Museum of
Art (S) VR 52
San Diego State Univ (S) VR 64
San Francisco Museum of
Modern Art (S) VR 67
San Jose State Univ (S) VR 70
Stanford Univ (S) VR 72
Univ of California-Berkeley (S)
VR 75
Univ of California-Irvine (S)
VR 79
Univ of California-Santa Barbara
(S) VR 84
Univ of Southern California (S)
VR 87

COLORADO

Colorado College (S) VR 91
Univ of Denver (S) VR 99

CONNECTICUT

Trinity College (S) VR 104
Univ of Hartford (S) VR 106
Yale Univ (P, S) VR 111

DELAWARE

Univ of Delaware (S) VR 114
H F duPont Winterthur Museum
(S) VR 116

DISTRICT OF COLUMBIA

American Univ (S) VR 117
George Washington Univ (S)
VR124A
National Gallery of Art (S)
VR 133
National Gallery of Art (P)
VR 134

FLORIDA

Cummer Gallery of Art (P)
VR141
Ringling School of Art (S)
VR 153
Vizcaya Museum (P, S) VR 159

GEORGIA

Atlanta College of Art (S)
VR 160
Georgia Institute of Technology
(S) VR 163
Georgia State Univ (S) VR 164
Univ of Georgia (S) VR 166

HAWAII

Honolulu Academy of Arts (S)
VR 169
Univ of Hawaii, Manoa (S)
VR 173

ILLINOIS

Art Institute of Chicago (S)
VR 174
Northern Illinois Univ (S)
VR 189
Northwestern Univ (S) VR 190
Public Art Workshop (S)
VR 193
Southern Illinois Univ at
Edwardsville (S) VR 200
Univ of Illinois at Urbana-
Champaign (S) VR 205

INDIANA

Evansville Museum of Arts &
Science (P, S) VR 211
Indiana Univ (S) VR 215

IOWA

Grinnell College (S) VR 223
Univ of Iowa (S) VR 228

KANSAS

Topeka Public Library (F, S)
VR 233
Univ of Kansas (P, S) VR 234
Wichita State Univ (S) VR 237

KENTUCKY

J B Speed Art Museum (S)
VR 240

LOUISIANA

Louisiana State Univ (S)
VR 249
Newcomb College of Tulane
Univ (S) VR 251
Tulane Univ (S) VR 254

MAINE

Bowdoin College (P, S) VR 257
William A Farnsworth Art
Museum (S) VR 258

MARYLAND

Baltimore Museum of Art (P, S)
VR 263
Goucher College (P, S) VR 266
Maryland Institute, College of
Art (S) VR 270
Univ of Maryland (S) VR 273

MASSACHUSETTS

Boston Public Library (P)
VR 279
Boston Univ (S) VR 280
Brandeis Univ (S) VR 281
Sterling & Francine Clark Art
Institute (P) VR 284
Forbes Library (P) VR 286
Harvard Univ (P) VR 287
Massachusetts College of Art
(F, S) VR 289
Massachusetts Institute of
Technology (S) VR 290
Mount Holyoke College (P, S)
VR 294
Museum of Fine Arts (P, S)
VR 295
Smith College (S) VR 298
Tufts Univ (S) VR 300
Univ of Massachusetts (S)
VR 303
Univ of Massachusetts in Boston
(S) VR 304
Wheaton College (S) VR 306
Worcester Art Museum (S)
VR 308

MICHIGAN

Detroit Institute of Arts (P, S)
VR 311
Univ of Michigan (P, S) VR 327
Western Michigan Univ (S)
VR 330

MINNESOTA

Minneapolis College of Art &
Design (S) VR 335
Minneapolis Institute of Arts
(S, V) VR 337

MISSOURI

Drury College (S) VR 345
St Louis Art Museum (S)
VR 352
Univ of Missouri-Columbia (P,
S) VR 355
Univ of Missouri-Kansas City
(S) VR 356

NEVADA

Joslyn Art Museum (S) VR 365

NEW HAMPSHIRE

Dartmouth College (S) VR 367

NEW JERSEY

New Jersey Institute of
Technology (S) VR 374
Newark Public Library (S)
VR 376
Princeton Univ (P, S) VR 380

NEW MEXICO

Univ of New Mexico (P, S)
VR 387

NEW YORK

Adelphi Univ (S) VR 389 &
VR 390
Columbia Univ (S) VR 406
Cooper-Hewitt Museum,
Smithsonian Institution (P)
VR 407
Corning Museum of Glass (P,
S) VR 411
Hispanic Society (P) VR 418
Metropolitan Museum of Art
(P, S) VR 427
Munson-Williams-Proctor
Institute (S) VR 429
New Rochelle Public Library
(P, S) VR 434
New York Public Library/The
Research Libraries (P)
VR 436

New York Univ, Institute of
Fine Arts (S) VR 437
State Univ of New York at
Buffalo (S) VR 453
State Univ of New York College
at Cortland (S) VR 456
State Univ of New York College
at New Paltz (S) VR 457
Univ of Rochester (S) VR 463
Vassar College (S) VR 464
YIVO Institute for Jewish
Research, Inc (P, S) VR 466

NORTH CAROLINA

Duke Univ (P, S) VR 469
East Carolina Univ (S) VR 470
North Carolina Museum of Art
(P) VR 472
Univ of North Carolina at Chapel
Hill (S) VR 474
Wake Forest Univ (S) VR 475

OHIO

Cincinnati Art Museum (P, S)
VR 479
Cleveland Institute of Art (S)
VR 480
Cleveland Museum of Art (P, S)
VR 482
Columbus College of Art &
Design (P, S) VR 486
Denison Univ (S) VR 488
Oberlin College (S) VR 491
Oberlin College (P) VR 492
Ohio Univ (S) VR 495
Univ of Cincinnati (P, S)
VR 499

OREGON

Oregon State Univ (S) VR 508
Reed College (S) VR 511

PENNSYLVANIA

Bryn Mawr College (P) VR 514
Carnegie-Mellon Univ (S) VR
517
Drexel Univ (S) VR 520
Pennsylvania State Univ (S)
VR 526
Philadelphia College of Art (S)
VR 528
Philadelphia Museum of Art (S)
VR 530
Temple Univ (S) VR 532
Univ of Pennsylvania (S)
VR 534
Univ of Pittsburgh (S) VR 535

RHODE ISLAND

Brown Univ (S) VR 540
Rhode Island School of Design
(S) VR 541

SOUTH CAROLINA

Clemson Univ (S) VR 545
Univ of South Carolina (S)
VR 550

TENNESSEE

Cheekwood Fine Arts Center
(S) VR 558
Memphis State Univ (S) VR 562
Austin Peay State Univ (S)
VR 563
Southwestern Univ at Memphis
(S) VR 564
Univ of Tennessee (S) VR 566
Vanderbilt Univ (S) VR 567

TEXAS

Beaumont Art Museum (S)
VR 572
North Texas State Univ (F, S)
VR 581
Rice Univ (S) VR 583
San Antonio Museum Association
(S) VR 585
Southern Methodist Univ (S)
VR 588
Univ of Houston (S) VR 590
Univ of Texas at Austin (P, S)
VR 594
Univ of Texas at Austin (S)
VR 596
Univ of Texas at El Paso (S)
VR 597

Canada

BRITISH COLUMBIA
Kootenay School of Art, Division
of Selkirk College (S) VR 666

MANITOBA
Univ of Manitoba (S) VR 670

ONTARIO
Scarborough College, Univ of
Toronto (S) VR 685

DECORATIVE ARTS-
MESO-AMERICAN

United States

ARIZONA
Amerind Foundation, Inc (S)
VR 5
Tucson Museum of Art (P, S)
VR 12
Univ of Arizona (S) VR 14

CALIFORNIA
California State Univ-Chico (S)
VR 32
California State Univ-Northridge
(S) VR 38
San Diego State Univ (S) VR 64
San Francisco Art Institute (S)
VR 65
San Francisco Museum of
Modern Art (S) VR 67
San Jose State Univ (S) VR 70

COLORADO
Univ of Denver (S) VR 99

CONNECTICUT
Yale Univ (P, S) VR 111

ILLINOIS
Art Institute of Chicago (S)
VR 174
Public Art Workshop (S)
VR 193
Southern Illinois Univ at
Edwardsville (S) VR 200

INDIANA
Indiana Univ (S) VR 215

IOWA
Univ of Iowa (S) VR 228

LOUISIANA
Newcomb College of Tulane
Univ (S) VR 251

MARYLAND
Goucher College (S) VR 266
Loyola-Notre Dame Library (S)
VR 268
Univ of Maryland (S) VR 273

MASSACHUSETTS
Massachusetts College of Art (S)
VR 289
Massachusetts Institute of
Technology (S) VR 290

MINNESOTA
Minneapolis College of Art &
Design (S) VR 335

MISSOURI
Drury College (S) VR 345
Southeast Missouri State Univ
(S) VR 353

NEW YORK
Adelphi Univ (S) VR 389
Columbia Univ (S) VR 406
Cooper-Hewitt Museum,
Smithsonian Institution (P)
VR 407
Herbert F Johnson Museum of
Art, Cornell Univ (S) VR 420
Metropolitan Museum of Art
(P) VR 426
Munson-Williams-Proctor
Institute (S) VR 429
Museum of the American Indian,
Heye Foundation (P, S)
VR 430

New York Public Library/The
Research Libraries (P) VR 436
State Univ of New York College
at Cortland (S) VR 456

OHIO
Univ of Cincinnati (S) VR 499

PENNSYLVANIA
Philadelphia College of Art (S)
VR 528

TEXAS
Beaumont Art Museum (S)
VR 572
Kimbell Art Museum (S)
VR 578
Univ of Texas at Austin (P, S)
VR 594
Univ of Texas at El Paso (S)
VR 597

VIRGINIA
James Madison Univ (S) VR 609

WASHINGTON
Eastern Washington State
College (S) VR 626

WISCONSIN
Univ of Wisconsin-Milwaukee
(S) VR 656

Canada

BRITISH COLUMBIA
Kootenay School of Art, Division
of Selkirk College (S) VR 666

QUEBEC
Montreal Museum of Fine Arts
(S) VR 698

DECORATIVE ARTS-
PACIFIC

United States

ARIZONA
Tucson Museum of Art (P, S)
VR 12

CALIFORNIA
California-State Univ-Northridge
(S) VR 38
San Diego State Univ (S) VR 64

DISTRICT OF COLUMBIA
Museum of African Art (P, S)
VR 128

GEORGIA
Univ of Georgia (S) VR 166

HAWAII
Honolulu Academy of Arts (S)
VR 169
Univ of Hawaii, Manoa (S)
VR 173

ILLINOIS
Richard J Daley College (S)
VR 179
Southern Illinois Univ at
Edwardsville (S) VR 200
Univ of Illinois at Urbana-
Champaign (S) VR 205

INDIANA
Indiana Univ (S) VR 215

IOWA
Univ of Iowa (S) VR 228

MASSACHUSETTS
Harvard Univ (P) VR 287
Massachusetts College of Art
(S) VR 289

NEBRASKA
Joslyn Art Museum (S) VR 365

NEW YORK
Columbia Univ (S) VR 406
Cooper-Hewitt Museum,
Smithsonian Institution (P)
VR 407

Metropolitan Museum of Art
(S) VR 427
New York Public Library/The
Research Libraries (P)
VR 436
State Univ of New York College
at Cortland (S) VR 456

OHIO
Cleveland State Univ (S)
VR 484
Univ of Cincinnati (S) VR 499

PENNSYLVANIA
Ursinus College (S) VR 536

TEXAS
Univ of Texas at Arlington (S)
VR 593
Univ of Texas at El Paso (S)
VR 597

WASHINGTON
Eastern Washington State
College (S) VR 626

WISCONSIN
Univ of Wisconsin-Milwaukee
(S) VR 656

Canada

BRITISH COLUMBIA
Kootenay School of Art, Division
of Selkirk College (S) VR 666

MANITOBA
Univ of Manitoba (S) VR 670

ONTARIO
York Univ (S) VR 692

DECORATIVE ARTS-
TRIBAL-AMERICAN

United States

ARIZONA
Amerind Foundation, Inc (S)
VR 5
Arizona State Univ (S) VR 6
Glendale Community College
(V) VR 9
Navajo Community College (P,
S) VR 10
Tucson Museum of Art (P, S)
VR 12
Univ of Arizona (S) VR 14

CALIFORNIA
California State Univ-Chico (S)
VR 32
California State Univ-Northridge
(S) VR 38
Jr Arts Center in Barnsdall Park
(S) VR 49
San Diego State Univ (S) VR 64
Univ of California-Santa Barbara
(S) VR 84

COLORADO
Univ of Denver (S) VR 99

DISTRICT OF COLUMBIA
National Gallery of Art (S)
VR 135

GEORGIA
Georgia State Univ (S) VR 164
Univ of Georgia (S) VR 166

HAWAII
Honolulu Academy of Arts (S)
VR 169
Univ of Hawaii, Manoa (S)
VR 173

ILLINOIS
Northwestern Univ (S) VR 190
Southern Illinois Univ at
Edwardsville (S) VR 200
Univ of Illinois at Urbana-
Champaign (S) VR 205

INDIANA
Indiana Univ (S) VR 215

IOWA
Sandford Museum &
Planetarium (P, S) VR 227
Univ of Iowa (S) VR 228

MASSACHUSETTS
Boston Public Library (P)
VR 279
Harvard Univ (P) VR 287
Massachusetts College of Art
(S) VR 289
Massachusetts Institute of
Technology (S) VR 290

MINNESOTA
Minneapolis College of Art &
Design (S) VR 335
Minneapolis Institute of Arts
(V) VR 337
Walker Art Center (S) VR 343

MISSOURI
Drury College (S) VR 345
Southeast Missouri State Univ
VR 353

MONTANA
Univ of Montana (S) VR 362

NEBRASKA
Joslyn Art Museum (S) VR 365

NEW JERSEY
Newark Museum Association
(P, S) VR 375

NEW YORK
Adelphi Univ (S) VR 389
Columbia Univ (S) VR 406
Cooper-Hewitt Museum,
Smithsonian Institution (P)
VR 407
Metropolitan Museum of Art
(P) VR 426
Munson-Williams-Proctor
Institute (S) VR 429
Museum of the American
Indian, Heye Foundation (P,
S) VR 430
Metropolitan Museum of Art
(S) VR 427
New York Public Library/The
Research Libraries (P) VR 436
State Univ of New York at
Buffalo (S) VR 453
State Univ of New York College
at Cortland (S) VR 456

NORTH CAROLINA
Duke Univ (S) VR 469

OHIO
Cleveland Institute of Art (S)
VR 480
Cleveland State Univ (S)
VR 484
Univ of Cincinnati (S) VR 499

OKLAHOMA
Museum of the Great Plains
(P) VR 501

OREGON
Oregon State Univ (S) VR 508
Reed College (S) VR 511

PENNSLVANIA
Carnegie-Mellon Univ (S)
VR 517

TENNESSEE
Memphis State Univ (S)
VR 562
Austin Peay State Univ (S)
VR 563

TEXAS
Beaumont Art Museum (S)
VR 572
Univ of Texas at Arlington (S)
VR 593
Univ of Texas at Austin (S)
VR 594
Univ of Texas at El Paso (S)
VR 597

UTAH
Salt Lake City Public Library
(S) VR 599

VIRGINIA
Virginia Commonwealth Univ (S) VR 623

WASHINGTON
Eastern Washington State College (S) VR 626
Evergreen State College (S) VR 627

WISCONSIN
Mount Senario College (S) VR 646

Canada

BRITISH COLUMBIA
Kootenay School of Art Division of Selkirk College (S) VR 666

MANITOBA
Univ of Manitoba (S) VR 670

NOVA SCOTIA
Nova Scotia College of Art & Design (S) VR 674

QUEBEC
Univ du Quebec a Montreal (S) VR 701

DECORATIVE ARTS-UNITED STATES

United States

ALABAMA
Univ of Alabama in Huntsville (M, S) VR 3

ARIZONA
Univ of Arizona (S) VR 14

ARKANSAS
Univ of Arkansas (S) VR 20

CALIFORNIA
Brand Library (S) VR 26
California Institute of the Arts (S) VR 29
California State College-Dominguez Hill (S) VR 31
California State Univ-Chico (S) VR 32
California State Univ-Hayward (S) VR 34
California State Univ-Los Angeles (S) VR 37
California State Univ-Sacramento (S) VR 39
Oakland Museum (P, S) VR 57
San Diego State Univ (S) VR 64
San Francisco Museum of Modern Art (S) VR 67
San Jose State Univ (S) VR 70
Univ of California-Berkeley (S) VR 75
Univ of California-Irvine (S) VR 79
Univ of California-Santa Barbara (S) VR 84
Univ of Southern California (S) VR 87

COLORADO
Denver Public Library (O, P) VR 93
Univ of Denver (S) VR 99

CONNECTICUT
Trinity College (S) VR 104
Yale Univ (P, S) VR 111
Univ of Hartford (S) VR 106

DELAWARE
Univ of Delaware (S) VR 114
H F duPont Winterthur Museum Libraries (P) VR 115
H F duPont Winterthur Museum (S) VR 116

DISTRICT OF COLUMBIA
American Univ (S) VR 117
Archives of American Art (P, S) VR 118

Daughters of the American Revolution Museum (S) VR 120
George Washington Univ (S) VR 124A
National Collection of Fine Arts (P, S) VR 132
National Gallery of Art (S) VR 133
National Gallery of Art (P) VR 134
National Trust for Historic Preservation (S) VR 138

FLORIDA
Cummer Gallery of Art (S) VR 141
Ringling School of Art (S) VR 153
Vizcaya Museum (P, S) VR 159

GEORGIA
Atlanta College of Art (S) VR 160
Georgia Institute of Technology (S) VR 163
Georgia State Univ (S) VR 164
Telfair Academy of Arts & Science, Inc (S) VR 165
Univ of Georgia (S) VR 166

HAWAII
Honolulu Academy of Arts (S) VR 169
Univ of Hawaii, Manoa (S) VR 173

ILLINOIS
Art Institute of Chicago (S) VR 174
Illinois State Museum (P, S) VR 183
Northern Illinois Univ (S) VR 189
Northwestern Univ (P, S) VR 190
Public Art Workshop (S) VR 193
Southern Illinois Univ at Edwardsville (S) VR 200
Univ of Illinois at Urbana-Champaign (F, S) VR 205

INDIANA
Evansville Museum of Arts & Science (P, S) VR 211

IOWA
Grinell College (S) VR 223
Sandford Museum & Planetarium (S) VR 227
Univ of Iowa (S) VR 228

KANSAS
Cultural Heritage & Arts Center (S) VR 231
Topeka Public Library (S) VR 233
Univ of Kansas (P, S) VR 234
Wichita State Univ (S) VR 237

KENTUCKY
J B Speed Art Museum (S) VR 240

LOUISIANA
Historic New Orleans Collection (P) VR 246
Louisiana State Univ (S) VR 249
Newcomb College of Tulane Univ (S) VR 251
Southern Univ (S) VR 252
Tulane Univ (S) VR 254

MAINE
Bowdoin College (P, S) VR 257
William A Farnsworth Art Museum (S) VR 258
Shaker Library (P, S) VR 261

MARYLAND
Baltimore Museum of Art (P, S) VR 263
Goucher College (P, S) VR 266
Maryland Institute, College of Art (S) VR 270
Univ of Maryland (S) VR 273

MASSACHUSETTS
Boston Public Library (P) VR 279
Boston Univ (S) VR 280
Brandeis Univ (S) VR 281
Brockton Art Center (S) VR 283
Sterling & Francine Clark Art Institute (S) VR 284
Forbes Library (P) VR 286
Harvard Univ (P) VR 287
Massachusetts College of Art (F, O, S, V) VR 289
Massachusetts Institute of Technology (S) VR 290
Merrimack Valley Textile Museum (P, S) VR 293
Mount Holyoke College (P, S) VR 294
Museum of Fine Arts (P, S) VR 295
Smith College (S) VR 298
Tufts Univ (S) VR 300
Univ of Massachusetts (S) VR 303
Univ of Massachusetts in Boston (S) VR 304
Wheaton College (S) VR 306

MICHIGAN
Detroit Institute of Arts (P, S) VR 311
Eastern Michigan Univ (S) VR 312
Univ of Michigan (P, S) VR 327
Western Michigan Univ (S) VR 330

MINNESOTA
Minneapolis College of Art & Design (S) VR 335
Minneapolis Institute of Arts (S) VR 337
Walker Art Center (S) VR 343

MISSOURI
Drury College (S) VR 345
St Louis Art Museum (S) VR 352
Southeast Missouri State Univ (S) VR 353
Univ of Missouri-Columbia (S) VR 355

NEBRASKA
Joslyn Art Museum (S) VR 365

NEW HAMPSHIRE
Dartmouth College (S) VR 367

NEW JERSEY
New Jersey Institute of Technology (S) VR 374
Newark Museum Association (P, S) VR 375

NEW MEXICO
Univ of New Mexico (S) VR 387

NEW YORK
Adelphi Univ (S) VR 389
Columbia Univ (S) VR 406
Cooper-Hewitt Museum, Smithsonian Institution (P) VR 407
Corning Museum of Glass (P, S) VR 411
Metropolitan Museum of Art (P, S) VR 427
Munson-Williams-Proctor Institute (S) VR 429
New Rochelle Public Library (P, S) VR 434
New York Public Library/The Research Libraries (P) VR 436
Rochester Institute of Technology (S) VR 443
Rochester Museum & Science Center (P) VR 444
State Univ of New York College at Cortland (S) VR 456
State Univ of New York College at New Paltz (S) VR 457
Syracuse Univ Libraries (S) VR 460
Vassar College (S) VR 464

YIVO Institute for Jewish Research, Inc (P, S) VR 466

NORTH CAROLINA
Duke Univ (P, S) VR 469
East Carolina Univ (S) VR 470
Museum of Early Southern Decorative Arts (P, S) VR 471
North Carolina Museum of Art (P) VR 472
Univ of North Carolina at Chapel Hill (S) VR 474
Wake Forest Univ (S) VR 475

OHIO
Cincinnati Art Museum (P, S) VR 479
Cleveland Institute of Art (S) VR 480
Columbus College of Art & Design (P, S) VR 486
Oberlin College (S) VR 491
Ohio Univ (S) VR 495
Univ of Cincinnati (P, S) VR 499
Wright State Univ (S) VR 500

OREGON
Oregon State Univ (S) VR 508
Reed College (S) VR 511

PENNSYLVANIA
Bryn Mawr College (P) VR 514
Carnegie-Mellon Univ (S) VR 517
Drexel Univ (S) VR 520
Philadelphia College of Art (S) VR 528
Philadelphia Maritime Museum (O, P) VR 529
Philadelphia Museum of Art (S) VR 530
Temple Univ (S) VR 532
Univ of Pennsylvania (S) VR 534
Westmoreland County Museum of Art (S) VR 539

RHODE ISLAND
Brown Univ (S) VR 540
Rhode Island School of Design (S) VR 541

SOUTH CAROLINA
Clemson Univ (S) VR 545
Gibbes Art Gallery/Carolina Art Association (S) VR 547
Univ of South Carolina (S) VR 550

SOUTH DAKOTA
Univ of South Dakota (P, S) VR 556

TENNESSEE
Cheekwood Fine Arts Center (S) VR 558
Memphis State Univ (S) VR 562
Austin Peay State Univ (S) VR 563
Southwestern Univ at Memphis (S) VR 564
Univ of Tennessee (S) VR 566

TEXAS
Beaumont Art Museum (S) VR 572
Institute of Texan Cultures (P) VR 577
North Texas State Univ (F, S) VR 581
Rice Univ (S) VR 583
San Antonio Museum Association (S) VR 585
Univ of Houston (S) VR 590
Univ of Texas at Arlington (S) VR 593
Univ of Texas at Austin (S) VR 594
Univ of Texas at El Paso (S) VR 597

UTAH
Salt Lake City Public Library (S) VR 599
Springville Museum of Art (P, S) VR 600

VERMONT
Middlebury College (S) VR 605
Univ of Vermont (P, S) VR 606

VIRGINIA
James Madison Univ (P, S)
 VR 609
Randolph-Macon Woman's
 College (S) VR 612
Univ of Virginia (S) VR 618,
 VR 619 & VR 620
Virginia Commonwealth Univ (S)
 VR 623
Virginia Museum of Fine Arts
 (S) VR 624

WASHINGTON
Eastern Washington State
 College (S) VR 626
Evergreen State College (S)
 VR 627
Henry Gallery, Univ of
 Washington (P, S) VR 628
Univ of Washington (S) VR 634

WISCONSIN
Gateway Technical Institute (S)
 VR 636
John Michael Kohler Arts Center
 (S) VR 639
Mount Senario College (S)
 VR 646
Oshkosh Public Museum (P)
 VR 647
Paine Art Center & Arboretum
 (P, S) VR 648
Univ of Wisconsin-Madison (S)
 VR 654
Univ of Wisconsin-Milwaukee (P,
 S) VR 656
Univ of Wisconsin-Parkside (S)
 VR 659
Univ of Wisconsin-Stevens Point
 (S) VR 662

Canada

BRITISH COLUMBIA
Kootenay School of Art, Division
 of Selkirk College (S) VR 666

ONTARIO
Carleton Univ (S) VR 678
Scarborough College, Univ of
 Toronto (S) VR 685

QUEBEC
Univ du Quebec a Montreal (S)
 VR 701

GRAPHIC ARTS-AFRICAN

United States

ALABAMA
Univ of Alabama in Huntsville
 (M ,S) VR 3

ARIZONA
Tucson Museum of Art (P, S)
 VR 12

HAWAII
Univ of Hawaii, Manoa (S)
 VR 173

ILLINOIS
Univ of Illinois at Urbana-
 Champaign (S) VR 205

INDIANA
Indiana Univ (S) VR 215

IOWA
Univ of Iowa (S) VR 28

MICHIGAN
Detroit Institute of Arts (S)
 VR 311

NEW YORK
Columbia Univ (S) VR 406
Metropolitan Museum of Art
 VR 426
New York Public Library/The
 Research Libraries (P) VR 436

Canada

MANITOBA
Univ of Manitoba (S) VR 670

GRAPHIC ARTS-ANCIENT

United States

ARIZONA
Arizona State Univ (S) VR 8

CALIFORNIA
California State Univ-Chico (S)
 VR 32
Hebrew Union College Skirball
 Museum (P, S) VR 46
San Jose City College (S) VR 69

CONNECTICUT
Univ of Hartford (S) VR 106
Yale Univ (P, S) VR 111

DELAWARE
Univ of Delaware (P, S) VR 114

DISTRICT OF COLUMBIA
American Univ (S) VR 117
George Washington Univ (S)
 VR 124A

FLORIDA
Lowie Art Museum, Univ of
 Miami (S) VR 149

ILLINOIS
Roosevelt Univ (S) VR 198
Univ of Illinois at Urbana-
 Champaign (S) VR 205

IOWA
Univ of Iowa (P, S) VR 228

KANSAS
Univ of Kansas (S) VR 234

LOUISIANA
Loyola Univ (S) VR 249A

MAINE
Bowdoin College (P, S) VR 257

MASSACHUSETTS
Art Institute of Boston (S)
 VR 277
Smith College (S) VR 298
Univ of Lowell (S) VR 301
Wheaton College (S) VR 306

MICHIGAN
Detroit Institute of Arts (P, S)
 VR 311
Oakland Univ (S) VR 321
Univ of Michigan (P, S)
 VR 327

NEW YORK
Columbia Univ (S) VR 406
New York Public Library/The
 Research Libraries (P)
 VR 436

PENNSYLVANIA
Temple Univ (S) VR 532
Univ of Pennsylvania (S)
 VR 534
Univ of Pittsburgh (S) VR 535

TENNNESSEE
Austin Peay State Univ (S)
 VR 563

VIRGINIA
Univ of Virginia (S) VR 620

WISCONSIN
Univ of Wisconsin-Madison (S)
 VR 654

Canada

ONTARIO
Art Gallery of Ontario (S)
 VR 676

QUEBEC
Univ de Montreal (S) VR 700
Univ du Quebec a Montreal (S)
 VR 701

GRAPHIC ARTS-ANDEAN

United States

ARIZONA
Tucson Museum of Art (P, S)
 VR 12

CALIFORNIA
California State Univ-Chico (S)
 VR 32

IOWA
Univ of Iowa (S) VR 228

NEW YORK
Columbia Univ (S) VR 406
Metropolitan Museum of Art
 (P) VR 426
New York Public Library/The
 Research Libraries (P)
 VR 436

**GRAPHIC ARTS-
CANADIAN**

United States

NEW YORK
New York Public Library/The
 Research Libraries (P)
 VR 436

Canada

BRITISH COLUMBIA
Kootenay School of Art, Division
 of Selkirk College (S) VR 666
Malaspina College (S) VR 667

MANITOBA
Univ of Manitoba (S) VR 670
Winnipeg Art Gallery (S)
 VR 671

NEW BRUNSWICK
Mount Allison Univ-Owens Art
 Gallery (S) VR 672

NOVA SCOTIA
Nova Scotia College of Art &
 Design (S) VR 674
Public Archives of Nova Scotia
 (P) VR 675

PRINCE EDWARD ISLAND
Confederation Centre Art Gallery
 & Museum (S) VR 693

ONTARIO
Art Gallery of Ontario (S)
 VR 676
Carleton Univ (S) VR 678
Sir Sandford Fleming College
 of Applied Arts & Technology
 (S) VR 679
Scarborough College, Univ of
 Toronto (S) VR 685
Univ of Western Ontario (S)
 VR 691
York Univ (S) VR 692

QUEBEC
Montreal Museum of Fine Arts
 (S) VR 698
Univ de Montreal (S) VR 700
Univ du Quebec a Montreal
 (S) VR 701
L'Univ Laval (S) VR 702

**GRAPHIC ARTS-
EUROPEAN**

United States

ARIZONA
Arizona State Univ (S) VR 6
Glendale Community College (S)
 VR 9
Univ of Arizona (P, S) VR 14

CALIFORNIA
California Institute of the Arts
 (S) VR 29
California State College-
 Dominguez Hills (S) VR 31
California State Univ-Chico (S)
 (S) VR 32
California State Univ-Hayward
 (S) VR 34
California State Univ-Los Angeles
 (S) VR 37
California State Univ-Northridge
 (S) VR 38
California State Univ-Sacramento
 (S) VR 39
Hebrew Union College Skirball
 Museum (P, S) VR 46
Humboldt State Univ (S) VR 47
Henry E Huntington Library &
 Art Gallery (P, S) VR 48
Jr Arts Center in Barnsdall Park
 (S) VR 49
Los Angeles County Museum of
 Art (S) VR 52
Pomona College (S) VR 61
San Diego State Univ (S)
 VR 64
San Francisco Museum of
 Modern Art (S) VR 67
San Jose City College (S)
 VR 69
San Jose State Univ (S) VR 70
Stanford Univ (S) VR 72
Univ of California-Berkeley (S)
 VR 75
Univ of California-Davis (S)
 VR 78
Univ of California-Irvine (S)
 VR 79
Univ of California-Riverside (P,
 S) VR 82
Univ of California-Santa Barbara
 (S) VR 84
Univ of Southern California (S)

COLORADO
Colorado College (S) VR 91
Univ of Denver (S) VR 99

CONNECTICUT
Connecticut College (S) VR 100
Trinity College (S) VR 104
Univ of Hartford (S) VR 106
Yale Univ (P, S) VR 111

DELAWARE
Univ of Delaware (S) VR 114
H F duPont Winterthur Museum
 (S) VR 116

DISTRICT OF COLUMBIA
American Univ (S) VR 117
George Washington Univ (S)
 VR 124A
Library of Congress (O, P)
 VR 127
National Collection of Fine Arts
 (P, S) VR 132
National Gallery of Art (F)
 VR 133
National Gallery of Art (P)
 VR 134
National Gallery of Art (S)
 VR 135

FLORIDA
Museum of Fine Arts of St
 Petersburg (S) VR 150
Ringling School of Art (S)
 VR 153
Univ of South Florida (S)
 VR 158

GEORGIA
Atlanta College of Art (S)
 VR 160
Georgia State Univ (S) VR 164
Univ of Georgia (S) VR 166

HAWAII
Honolulu Academy of Arts (S)
 VR 169
Univ of Hawaii, Manoa (S)
 VR 173

Western Michigan Univ (F, S)
VR 330

MINNESOTA
Minneapolis College of Art &
Design (S) VR 335

MISSOURI
Drury College (S) VR 345

NEW YORK
Columbia Univ (S) VR 406
Cornell Univ (P, S) VR 410
Munson-Williams-Proctor
Institute (S) VR 429
New York Public Library/The
Research Libraries (P)
New York Univ, Institute of Fine
Arts (S)
State Univ of New York at
Buffalo (S) VR 453
State Univ of New York College
at Cortland (S) VR 456

NORTH CAROLINA
Duke Univ (P, S) VR 469
Univ of North Carolina at Chapel
Hill (S)

OHIO
Cleveland Museum of Art (S)
VR 482
Columbus College of Art &
Design (P, S) VR 486
Oberlin College (S) VR 491
Oberlin College (P) VR 492

OREGON
Oregon State Univ (S) VR 508

PENNSYLVANIA
Carnegie-Mellon Univ (S)
VR 517

TENNESSEE
Austin Peay State Univ (S)
VR 563

TEXAS
Univ of Texas at Arlington (S)
VR 593
Univ of Texas at El Paso (S)
VR 597
Univ of Texas at San Antonio
(S) VR 598

VIRGINIA
James Madison Univ (P, S)
VR 609
Univ of Virginia (S) VR 620

WISCONSIN
Univ of Wisconsin-Madison (S)
VR 654

Canada

BRITISH COLUMBIA
Kootenay School of Art, Division
of Selkirk College (S) VR 666

NOVA SCOTIA
Nova Scotia College of Art &
Design (S) VR 674

GRAPHIC ARTS-ISLAMIC

United States

CALIFORNIA
San Jose State Univ (S) VR 70

COLORADO
Colorado College (S) VR 91

MICHIGAN
Detroit Institute of Arts (S)
VR 311
Univ of Michigan (P, S) VR 327

NEW YORK
Columbia University (S) VR 406
New York Public Library/The
Research Libraries (P) VR 436

PENNSYLVANIA
Univ of Pennsylvania (S) VR 534

GRAPHIC ARTS-
MESO-AMERICAN

United States

ARIZONA
Tucson Museum of Art (P, S)
VR 12

CALIFORNIA
California State Univ-Chico (S)
VR 32
San Francisco Museum of
Modern Art (S) VR 67

CONNECTICUT
Yale Univ (P, S) VR 111

IOWA
Univ of Iowa (S) VR 228

NEW YORK
Columbia Univ (S) VR 406
Metropolitan Museum of Art (P)
VR 426
New York Public Library/The
Research Libraries (P) VR 436

PENNSYLVANIA
Univ of Pittsburgh (S) VR 535

RHODE ISLAND
Rhode Island School of Design
(S) VR 541

GRAPHIC ARTS-PACIFIC

United States

ARIZONA
Tucson Museum of Art (P, S)
VR 12

HAWAII
Univ of Hawaii, Manoa (S)
VR 173

INDIANA
Indiana Univ (S) VR 215

IOWA
Univ of Iowa (S) VR 228

NEW YORK
Columbia Univ (S) VR 406
Metropolitan Museum of Art
(P) VR 426
New York Public Library/The
Research Libraries (P) VR 436

OHIO
Univ of Cincinnati (S) VR 499

GRAPHIC ARTS-
TRIBAL-AMERICAN

United States

ARIZONA
Amerind Foundation, Inc. VR 5

HAWAII
University of Hawaii, Manoa (S)
VR 173

INDIANA
Indiana Univ (S) VR 215

IOWA
Univ of Iowa (S) VR 228

MONTANA
University of Montana (S)
VR 362

NEW YORK
Columbia Univ (S) VR 406
Metropolitan Museum of Art (P)
VR 426
New York Public Library/The
Research Libraries (P) VR 436

TENNESSEE
Austin Peay State Univ (S)
VR 563

GRAPHIC ARTS-
UNITED STATES

United States

ALABAMA
Univ of Alabama in Huntsville
(M, S) VR 3

ARIZONA
Arizona State Univ (S) VR 6 &
VR 7
Glendale Community College (S)
VR 9
Univ of Arizona (P, S) VR 14

CALIFORNIA
Beverly Hills Public Library (S)
VR 25
California Institute of the Arts
(S) VR 29
California State College-
Dominguez Hills (S) VR 31
California State Univ-Chico (S)
VR 32
California State Univ-Fresno (S)
VR 33
California State Univ-Hayward
(S) VR 34
California State Univ-Los Angeles
(S) VR 37
California State University-
Northridge (S) VR 38
Hebrew Union College Skirball
Museum (P, S) VR 46
Humboldt State University (S)
VR 47
Jr Arts Center in Barnsdall Park
(S) VR 49
Los Angeles County Museum of
Art (S) VR 52
Oakland Museum (P, S) VR 57
Otis Art Institute (S) VR 58
Pomona College (S) VR 61
San Diego State University (S)
VR 64
San Francisco Museum of
Modern Art (S) VR 67
San Jose City College (S) VR 69
San Jose State Univ (S) VR 70
Univ of California-Berkeley (O)
VR 74
Univ of California-Berkeley (S)
VR 75
Univ of California-Irvine (S)
VR 79
Univ of California-Riverside
(P, S) VR 82
Univ of California-San Diego (S)
VR 83
Univ of California-Santa Barbara
(S) VR 84
Univ of Southern California (S)
VR 87

COLORADO
Colorado College (S) VR 91
Denver Public Library (OP)
VR 93
Univ of Denver (S) VR 99

CONNECTICUT
Connecticut College (S) VR 100
Trinity College (S) VR 104
Univ of Hartford (S) VR 106
Yale Univ (P, S) VR 111

DELAWARE
Univ of Delaware (S) VR 114
H F DuPont Winterthur Museum
Libraries (P) VR 115
H F duPont Winterthur Museum
(S) VR 116

DISTRICT OF COLUMBIA
American Univ (S) VR 117
Archives of American Art (P, S)
VR 118
George Washington Univ (S)
VR 124A
Howard Univ (S) VR 126
Library of Congress (O, P)
VR 127
National Collection of Fine Arts
(P, S) VR 132
National Gallery of Art (P)
VR 134

National Gallery of Art (S)
VR 135

FLORIDA
Museum of Fine Arts of St
Petersburg (S) VR 150
Ringling School of Art (S)
VR 153
Univ of South Florida (S)
VR 158

GEORGIA
Atlanta College of Art (S)
VR 160
Georgia State Univ (S) VR 164
Univ of Georgia (S) VR 166

HAWAII
Honolulu Academy of Arts (S)
VR 169
Univ of Hawaii, Manoa (S)
VR 173

ILLINOIS
Art Institute of Chicago (S)
VR 174
Moraine Valley Community
College (S) VR 185
Museum of Contemporary Art
(S) VR 186
Northern Illinois Univ (S)
VR 189
Quincy College (S) VR 194
Roosevelt Univ (S) VR 198
Southern Illinois Univ at
Edwardsville (S) VR 200
Univ of Illinois at Chicago Circle
(S) VR 204
University of Illinois at Urbana-
Champaign (S) VR 205

INDIANA
Evansville Museum of Arts &
Science (P ,S) VR 211
Indiana Univ (S) VR 215
Louis A Warren Lincoln Library
& Museum (O) VR 221
Univ of Notre Dame (S) VR 220

IOWA
Univ of Iowa (S) VR 228

KANSAS
Cultural Heritage & Arts Center
(S) VR 231
Univ of Kansas (P ,S) VR 234
Wichita Art Museum (S) VR 236
Wichita State Univ (S) VR 237

LOUISIANA
Historic New Orleans Collection
(P) VR 246
Louisiana State Univ (S) VR 249
Loyola Univ (S) VR 249A
Southern Univ (S) VR 252
Tulane Univ (S) VR 254

MAINE
Bowdoin College (P, S) VR 257
William A Farnsworth Art
Museum (S) VR 258
Shaker Library (P ,S) VR 261

MARYLAND
Baltimore Museum of Art (P, S)
VR 263
Goucher College (P, S) VR 266
Maryland College of Art &
Design (S) VR 269
Maryland Institute, College of
Art (S) VR 270
Univ of Maryland (S) VR 273
Univ of Maryland, Baltimore
County (S) VR 275

MASSACHUSETTS
Boston Public Library (P)
VR 279
Brandeis Univ (S) VR 281
Sterling & Francine Clark Art
Institute (S) VR 284
Massachusetts College of Art
(F, S) VR 289
Massachusetts Institute of
Technology (S) VR 290
Mount Holyoke College (P, S)
VR 294
Museum of Fine Arts (P, S)
VR 295

CONNECTICUT

Connecticut College (S) VR 100
St Joseph College (S) VR 103
Univ of Hartford (S) VR 106
Yale Univ (P, S) VR 111

DISTRICT OF COLUMBIA

George Washington Univ (S)
VR 124A
Museum of African Art (P, S)
VR 128
National Gallery of Art (P)
VR 134

DELAWARE

Univ of Delaware (S) VR 114

FLORIDA

Lowie Art Museum, Univ of
Miami (S) VR 149
Museum of Fine Arts of St
Petersburg (S) VR 150
Ringling School of Art (O, S)
VR 153
Univ of South Florida (S)
VR 158

GEORGIA

Atlanta College of Art (S)
VR 160
Georgia Institute of Technology
(S) VR 163
Georgia State Univ (S) VR 164
Univ of Georgia (S) VR 166

HAWAII

Honolulu Academy of Arts (S)
VR 169
Univ of Hawaii, Manoa (S)
VR 173

ILLINOIS

Richard J Daley College (S)
VR 179
Northern Illinois Univ (S)
VR 189
Northwestern Univ (P, S)
VR 190
Quincy College (S) VR 194
Roosevelt Univ (F, S) VR 198
Southern Illinois Univ at
Edwardsville (S) VR 200
Univ of Illinois at Urbana-
Champaign (S) VR 204

IOWA

Grinnell College (S) VR 223
Univ of Iowa (P, S) VR 228

KANSAS

Univ of Kansas (P, S) VR 234
Wichita State Univ (S) VR 237

KENTUCKY

Louisville Free Public Library
(F) VR 239
Univ of Kentucky (S) VR 241

LOUISIANA

Louisiana State Univ (S) VR 249
Loyola Univ (S) VR 249A
Tulane Univ (S) VR 254

MAINE

Bowdoin College (P, S) VR 257

MARYLAND

Univ of Maryland (O) VR 272
Univ of Maryland (S) VR 273
Univ of Maryland, Baltimore
County (S) VR 275

MASSACHUSETTS

Art Institute of Boston (S)
VR 277
Boston Univ (S) VR 280
Brandeis Univ (P, S) VR 281
Harvard Univ (P) VR 287
Massachusetts College of Art
(F, S) VR 289
Massachusetts Institute of
Technology (P, S) VR 290
Mount Holyoke College (P, S)
VR 294
Smith College (S) VR 298
Tufts Univ (S) VR 300
Univ of Lowell (S) VR 301

Univ of Massachusetts in Boston
(S) VR 304
Wellesley College (P, S) VR 305
Wheaton College (S) VR 306

MICHIGAN

Detroit Institute of Arts (P, S)
VR 311
Michigan State Univ (P, S)
VR 318
Oakland Univ (S) VR 321
Univ of Michigan (P, S) VR 327
Univ of Michigan-Dearborn (S)
VR 328
Western Michigan Univ (S)
VR 330

MINNESOTA

Minneapolis College of Art &
Design (S) VR 335
Minneapolis Institute of Arts (S)
VR 337

MISSOURI

Drury College (S) VR 345
Southeast Missouri State Univ
(S) VR 353
Univ of Missouri-Columbia (P,
S) VR 355
Univ of Missouri-St Louis (S)
VR 357
Washington Univ (S) 359

MONTANA

Montana State Univ (S) VR 361

NEBRASKA

Joslyn Art Museum (S) VR 365

NEW HAMPSHIRE

Dartmouth College (S) VR 367

NEW JERSEY

Montclair Art Museum (S)
VR 372
Newark Public Library (S)
VR 376
Stockton State College (S)
VR 383

NEW MEXICO

Univ of New Mexico (S)
VR 387

NEW YORK

Adelphi Univ (S) VR 389
Brooklyn College of the City
Univ of New York (S)
VR 396
Columbia Univ (S) VR 406 &
VR 410
Metropolitan Museum of Art
(P, S) VR 427
New York Public Library/The
Research Libraries (P) VR 436
New York Univ, Institute of Fine
Arts (S) VR 437
Pratt Institute (S) VR 439
State Univ of New York at
Binghamton (S) VR 452
State Univ of New York at
Buffalo (P, S) VR 453
State Univ of New York College
at Cortland (S) VR 456
State Univ of New York College
at New Paltz (S) VR 457
Syracuse Univ Libraries (S)
VR 460
Vassar College (S) VR 464

NORTH CAROLINA

Duke Univ (P, S) VR 469
East Carolina Univ (S) VR 470
North Carolina State Univ (S)
VR 473
Univ of North Carolina at Chapel
Hill (S) VR 474
Wake Forest Univ (S) VR 475

OHIO

Columbus College of Art &
Design (P, S) VR 486
Oberlin College (S) VR 491
Ohio Univ (S) VR 495
Univ of Cincinnati (S) VR 499
Wright State Univ (S) VR 500

OREGON

Oregon State Univ (S) VR 508
Reed College (S) VR 511

PENNSYLVANIA

Bryn Mawr College (P, S)
VR 515
Carnegie-Mellon Univ (S)
VR 517
Philadelphia College of Art (S)
VR 528
Swarthmore College (P, S)
VR 531
Temple Univ (S) VR 532
Univ of Pennsylvania (S)
VR 534
Univ of Pittsburgh (S) VR 535
Westmoreland County Museum
of Art (S) VR 539

RHODE ISLAND

Brown Univ (S) VR 540
Rhode Island School of Design
(P, S ,O) VR 541

SOUTH CAROLINA

Gibbes Art Gallery/Carolina Art
Association (S) VR 547

TENNESSEE

Memphis State Univ (S) VR 562
Austin Peay State Univ (S)
VR 563
Southwestern Univ at Memphis
(S) VR 564
Univ of Tennessee (S) VR 566

TEXAS

Rice Univ (P, S) VR 583
San Antonio Museum Association
(S) VR 585
Southern Methodist Univ (S)
VR 588
Univ of Texas at Arlington (S)
VR 593
Univ of Texas at Austin (S)
VR 594
Univ of Texas at El Paso (S)
VR 597
Univ of Texas at San Antonio
(S) VR 598

VERMONT

Univ of Vermont (P, S) VR 606

VIRGINIA

James Madison Univ (P, S)
VR 609
Randolph-Macon Woman's
College (S) VR 612
Univ of Virginia (S) VR 620

WASHINGTON

Seattle Art Museum (S) VR 629

WISCONSIN

Univ of Wisconsin-Eau Claire
(S) VR 652
Univ of Wisconsin-Madison (S)
VR 654
Univ of Wisconsin-Milwaukee
(P, S) VR 656
Univ of Wisconsin-Stevens Point
(S) VR 662
Univ of Wisconsin-Whitewater
(S) VR 663

Canada

BRITISH COLUMBIA

Kootenay School of Art, Division
of Selkirk College (S) VR 666

MANITOBA

Univ of Manitoba (S) VR 670

ONTARIO

Art Gallery of Ontario (S)
VR 676
Carleton Univ (S) VR 678
Scarborough College, Univ of
Toronto (S) VR 685
Univ of Guelph (S) VR 687
Univ of Western Ontario (S)
VR 691

QUEBEC

Univ de Montreal (S) VR 700
Univ du Quebec a Montreal (S)
VR 701
L'Univ Laval (S) VR 702

PAINTING-ANDEAN

United States

ARIZONA

Glendale Community College (S)
VR 9
Tucson Museum of Art (P, S)
VR 12

CALIFORNIA

California State Univ-Chico (S)
VR 32
San Diego State Univ (S)
VR 64

GEORGIA

Georgia State Univ (S) VR 164
Univ of Georgia (S) VR 166

MARYLAND

Univ of Maryland (S) VR 273

NEW YORK

Columbia Univ (S) VR 406
Metropolitan Museum of Art (P)
VR 426
New York Public Library/The
Research Libraries (P) VR 436

PENNSYLVANIA

Carnegie-Mellon Univ (S)
VR 517

PAINTING-CANADIAN

United States

NEW YORK

New York Public Library/The
Research Libraries (P) VR 436

Canada

BRITISH COLUMBIA

Kootenay School of Art, Division
of Selkirk College (S) VR 666
Malaspina College (S, V)
VR 667

MANITOBA

Winnipeg Art Gallery (S)
VR 671
Univ of Manitoba (S) VR 670

NEW BRUNSWICK

Mount Allison Univ-Owens Art
Gallery (S) VR 672

NOVA SCOTIA

Nova Scotia College of Art &
Design (S) VR 674
Public Archives of Nova Scotia
(P) VR 675

ONTARIO

Art Gallery of Ontario (S)
VR 676
Carleton Univ (S) VR 678
Sir Sandford Fleming College of
Applied Arts & Technology (S)
VR 679
National Gallery of Canada (P,
S) VR 681
Scarborough College, Univ of
Toronto (S) VR 685
Univ of Guelph (S) VR 687
Univ of Western Ontario (S)
VR 691
York Univ (S) VR 692

PRINCE EDWARD ISLAND

Confederation Centre Art Gallery
& Museum (S) VR 693

QUEBEC

Montreal Museum of Fine Arts
(S) VR 698
Musee d'Art Contemporain (F,
P, S) VR 699

State Univ of New York College at Cortland (S) VR 456
State Univ of New York College at New Paltz (S) VR 457
State Univ of New York College at Oswego (S) VR 458
Syracuse Univ Libraries (S) VR 460
Univ of Rochester (P ,S) VR 463
Vassar College (S) VR 464
YIVO Institute for Jewish Research, Inc (P, S) VR 466

NORTH CAROLINA
Duke Univ (P, S) VR 469
East Carolina Univ (S) VR 470
North Carolina Museum of Art (P) VR 472
North Carolina State Univ (P, S) VR 473
Univ of North Carolina at Chapel Hill (S) VR 474
Wake Forest Univ (S) VR 475

OHIO
Cincinnati Art Museum (P, S) VR 479
Cleveland Institute of Art (S) VR 480
Cleveland Museum of Art (P, S) VR 482
Cleveland State Univ (S) VR 484
College of Mount St Joseph on the Ohio (S) VR 485
Columbus College of Art & Design (P, S) VR 486
Denison Univ (S) VR 488
Miami Univ (S) VR 490
Oberlin College (S) VR 491
Oberlin College (P) VR 492
Ohio Univ (S) VR 495
Univ of Cincinnati (P, S) VR 499
Wright State Univ (S) VR 500

OREGON
Oregon State Univ (S) VR 508
Reed College (S) VR 511
Univ of Oregon (P, S) VR 512

PENNSYLVANIA
Bryn Mawr College (P, S) VR 514
Carnegie-Mellon Univ (S) VR 517
Drexel Univ (S) VR 520
Pennsylvania State Univ (P, S) VR 526
Philadelphia College of Art (S) VR 528
Philadelphia Museum of Art (S) VR 530
Swarthmore College (P, S) VR 531
Temple Univ (S) VR 532
Univ of Pennsylvania (S) VR 534
Univ of Pittsburgh (P, S) VR 535
Ursinus College (S) VR 536
Westmoreland County Museum of Art (S) VR 539

RHODE ISLAND
Brown Univ (P, S) VR 540
Rhode Island School of Design (P, S) VR 541

SOUTH CAROLINA
Clemson Univ (S) VR 545
Gibbes Art Gallery/Carolina Art Association (S) VR 547
Presbyterian College (S) VR 549
Univ of South Carolina (S) VR 550

SOUTH DAKOTA
Sioux Falls College (S) VR 553

TENNESSEE
Cheekwood Fine Arts Center (S) VR 558
Hunter Museum of Art (S) VR 560
Memphis State Univ (S) VR 562

Austin Peay State Univ (S) VR 563
Southwestern Univ at Memphis (S) VR 564
Univ of Tennessee (S) VR 566
Vanderbilt Univ (P, S) VR 567

TEXAS
Art Museum of South Texas (S) VR 568
Austin Public Library (O) VR 569
Baylor Univ (S) VR 571
Beaumont Art Museum (S) VR 572
Corpus Christi State Univ (S) VR 574
Dallas Museum of Fine Arts (S) VR 575
Kimbell Art Museum (S) VR 578
North Texas State Univ (S) VR 581
Our Lady of the Lake Univ (F, S) VR 582
Rice Univ (P, S) VR 583
San Antonio College (S) VR 584
San Antonio Museum Association (S) VR 585
Southern Methodist Univ (S) VR 588
Univ of Houston (S) VR 590
Univ of Texas at Arlington (S) VR 593
Univ of Texas at Austin (P, S) VR 594
Univ of Texas at El Paso (P, S) VR 597
Univ of Texas at San Antonio (S) VR 598

UTAH
Salt Lake City Public Library (O, S) VR 599
Springville Museum of Art (P, S) VR 600
Univ of Utah (S) VR 601

VERMONT
Bennington College (S) VR 603
Middlebury College (S) VR 605
Univ of Vermont (P, S) VR 606

VIRGINIA
James Madison Univ (P, S) VR 609
Randolph-Macon Woman's College (S) VR 612
Univ of Richmond (S) VR 463
Univ of Virginia (S) VR 618
Univ of Virginia (P, S) VR 620
Virginia Commonwealth Univ (S) VR 623

WASHINGTON
Eastern Washington State College (F, S) VR 626
Evergreen State College (S) VR 627
Seattle Art Museum (P, S) VR 629
Univ of Washington (P) VR 632
Univ of Washington (S) VR 634

WISCONSIN
Gateway Technical Institute (S) VR 636
John Michael Kohler Arts Center (S) VR 639
Mount Senario College (S) VR 646
Paine Art Center & Arboretum (S) VR 648
Univ of Wisconsin-Eau Claire (S) VR 652
Univ of Wisconsin-Madison (P, S) VR 654
Univ of Wisconsin-Milwaukee (P, S) V R656
Univ of Wisconsin-Oshkosh (S) VR 658
Univ of Wisconsin-Parkside (F, S, V) VR 659
Univ of Wisconsin-Stevens Point (S) VR 662
Univ of Wisconsin-Whitewater (S) VR 663

Canada

BRITISH COLUMBIA
Kootenay School of Art, Division of Selkirk College (S) VR 666

MANITOBA
Univ of Manitoba (S) VR 670
Winnipeg Art Gallery (S) VR 671

NOVA SCOTIA
Nova Scotia College of Art & Design (S) VR 674

ONTARIO
Art Gallery of Ontario (S) VR 676
Carleton Univ (S) VR 678
Sir Sandford Fleming College of Applied Arts & Technology (S) VR 679
National Gallery of Canada (P, S) VR 681
Scarborough College, Univ of Toronto (S) VR 685
Univ of Guelph (S) VR 687
Univ of Western Ontario (S) VR 691
York Univ (P, S) VR 692

PRINCE EDWARD ISLAND
Confederation Centre Art Gallery & Museum (F, S, V) VR 693

QUEBEC
Bibliotheque de la Ville de Montreal (S) VR 694
Montreal Museum of Fine Arts (S) VR 698
Musee d'Art Contemporain (P, S) VR 699
Univ de Montreal (S) VR 700
Univ du Quebec a Montreal (S) VR 701
L' Univ Laval (S) VR 702

PAINTING-FAR EAST

United States

ARIZONA
Arizona State Univ (S) VR 6
Glendale Community College (S) VR 9
Tucson Museum of Art (S) VR 12
Univ of Arizona (S) VR 14

ARKANSAS
Univ of Arkansas (S) VR 20

CALIFORNIA
California State College-Dominguez Hills (S) VR 31
California State Univ-Chico (S) VR 32
California State Univ-Fresno (S) VR 33
California State Univ-Los Angeles (S) VR 37
California State Univ-Northridge (S) VR 38
California State Univ-Sacramento (S) VR 39
Los Angeles County Museum of Art (S) VR 52
Mills College (S) VR 56
San Diego State Univ (S) VR 64
San Francisco Art Institute (S) VR 65
San Francisco Museum of Modern Art (S) VR 67
San Jose State Univ (S) VR 70
Stanford Univ (S) VR 72
Univ of California-Berkeley (P, S) VR 75
Univ of California-Davis (S) VR 78
Univ of California-Irvine (S) VR 79
Univ of California-San Diego (S) VR 83
Univ of California-Santa Barbara (S) VR 84
Univ of Southern California (S) VR 87

COLORADO
Colorado College (S) VR 91
Univ of Denver (S) VR 99

CONNECTICUT
Connecticut College (S) VR 100
Trinity College (S) VR 104
Yale Univ (P, S) VR 111

DISTRICT OF COLUMBIA
American Univ (S) VR 117
Freer Gallery of Art (P, S) VR 124

FLORIDA
Florida International Univ (S) VR 143
Univ of South Florida (S) VR 158

GEORGIA
Atlanta College of Art (S) VR 160
Georgia Institute of Technology (S) VR 163
Georgia State Univ (S) VR 164
Univ of Georgia (S) VR 166

HAWAII
Honolulu Academy of Arts (S) VR 169
Honolulu Academy of Arts (P, S) VR 170
Univ of Hawaii, Manoa (S) VR 173

ILLINOIS
Northwestern Univ (P ,S) VR 190
Roosevelt Univ (S) VR 198
Univ of Illinois at Chicago Circle (S) VR 204
Univ of Illinois at Urbana-Champaign (P, S) VR 205

INDIANA
Indiana Univ (S) VR 215

IOWA
Grinnell College (S) VR 223
Univ of Iowa (P S,) VR 228

KANSAS
Univ of Kansas (P, S) VR 234

KENTUCKY
Louisville Free Public Library (F) VR 239
J B Speed Art Museum (S) VR 240
Univ of Kentucky (S) VR 241

MARYLAND
Loyola-Notre Dame Library (S) VR 268
Maryland Institute, College of Art (S) VR 270
Univ of Maryland (S) VR 273

MASSACHUSETTS
Boston Public Library (P) VR 279
Brandeis Univ (S) VR 281
Harvard Univ (P) VR 287
Massachusetts College of Art (S) VR 289
Massachusetts Institute of Technology (S) VR 290
Mount Holyoke College (P, S) VR 294
Museum of Fine Arts (P, S) VR 295
Smith College (S) VR 298
Smith College (P) VR 299
Univ of Lowell (S) VR 301
Univ of Massachusetts (S) VR 303
Wellesley College (P, S) VR 305
Wheaton College (S) VR 306
Worcester Art Museum (S) VR 308

MICHIGAN
The Detroit Institute of Arts (S) VR 311
Univ of Michigan (P) VR 325
Univ of Michigan (P, S) VR 327
Univ of Michigan-Dearborn VR 328

ILLINOIS
Northwestern Univ (P, S) VR 190
INDIANA
Indiana Univ (S) VR 215
KENTUCKY
J B Speed Art Museum (S)
 VR 240
NEW YORK
Columbia Univ (S) VR 406
Metropolitan Museum of Art (P)
 VR 426
New York Public Library/The
 Research Libraries (P) VR 436
Syracuse Univ Libraries (S)
 VR 460
NORTH CAROLINA
Duke Univ (P, S) VR 469
OHIO
Univ of Cincinnati (S) VR 499
TEXAS
Univ of Texas at Arlington (S)
 VR 593
WISCONSIN
Univ of Wisconsin-Eau Claire (S)
 VR 652
Univ of Wisconsin-Milwaukee (S)
 VR 656
Univ of Wisconsin-Whitewater
 (S) VR 663

Canada

MANITOBA
Univ of Manitoba (S) VR 670
QUEBEC
L'Univ Laval (S) VR 702

PAINTING-
TRIBAL-AMERICAN

United States

ARIZONA
Amerind Foundation, Inc (S)
 VR 5
Navajo Community College (P,
 S) VR 10
CALIFORNIA
San Diego State Univ (S) VR 64
COLORADO
Northeastern Junior College
 (V) VR 95
DISTRICT OF COLUMBIA
National Portrait Gallery (P)
 VR 137
GEORGIA
Georgia State Univ (S) VR 164
Univ of Georgia (S) VR 166
HAWAII
Univ of Hawaii, Manoa (S)
 VR 173
ILLINOIS
Northwestern Univ (P, S)
 VR 190
INDIANA
Indiana Univ (S) VR 215
IOWA
Sandford Museum & Planetarium
 (P, S) VR 227
KENTUCKY
J B Speed Art Museum (S)
 VR 240
MASSACHUSETTS
Massachusetts College of Art
 (S) VR 289
Mount Holyoke College (P, S)
 VR 204
Univ of Massachusetts in Boston
 (S) VR 304

MISSOURI
Drury College (S) VR 345
Southeast Missouri State Univ
 (S) VR 353
MONTANA
Univ of Montana (S) VR 362
NEBRASKA
Joslyn Art Museum (S) VR 365
NEW JERSEY
Montclair Art Museum (S)
 VR 372
NEW MEXICO
Univ of New Mexico (S) VR 387
NEW YORK
Columbia Univ (S) VR 406
Metropolitan Museum of Art (P)
 VR 426
Munson-Williams-Proctor
 Institute (S) VR 429
New York Public Library/The
 Research Libraries (P)
NORTH CAROLINA
Duke Univ (P, S) VR 469
OHIO
Univ of Cincinnati (S) VR 499
OKLAHOMA
Museum of the Great Plains (P)
 VR 501
TENNESSEE
Memphis State Univ (S) VR 562
TEXAS
San Antonio Museum Association
 (S) VR 585
Univ of Texas at Arlington (S)
 VR 593
WISCONSIN
Univ of Wisconsin-Eau Claire
 (S) VR 652
Univ of Wisconsin-Whitewater
 (S) VR 663

Canada

BRITISH COLUMBIA
Kootenay School of Art, Division
 of Selkirk College (S) VR 666
MANITOBA
Univ of Manitoba (S) VR 670
ONTARIO
Scarborough College, Univ of
 Toronto (S) VR 685

PAINTING-UNITED STATES

United States

ALABAMA
Univ of Alabama in Birmingham
 (S) VR 2
Univ of Alabama in Huntsville
 (M, S) VR 3
ARIZONA
Arizona State Univ (S) VR 6
Glendale Community College (S)
Tucson Museum of Art (S)
 VR 12
Univ of Arizona (P, S) VR 14
ARKANSAS
Univ of Arkansas (S) VR 20
CALIFORNIA
Francis Bacon Foundation, Inc
 (P) VR 23
Beverly Hills Public Library (S)
 VR 25
Brand Library (S) VR 26
California College of Arts &
 Crafts (S) VR 28
California Institute of the Arts
 (S) VR 29
California State College-
 Dominguez Hills (S) VR 31

California State Univ-Chico (S)
 VR 32
California State Univ-Fresno (S)
 VR 33
California State Univ-Hayward
 (S) VR 34
California State Univ-Los Angeles
 (S) VR 37
California State Univ-Northridge
 (R ,S) VR 38
California State Univ-Sacramento
 (S) VR 39
Cosumnes River College (S)
 VR 43
Fine Arts Gallery of San Diego
 (S) VR 44
Hebrew Union College Skirball
 Museum (P, S) VR 46
Humboldt State Univ (S) VR 47
Jr Arts Center in Barnsdall Park
 (S) VR 49
La Jolla Museum of
 Contemporary Art (S) VR 50
Los Angeles County Museum of
 Art (S) VR 52
Mills College (S) VR 56
Oakland Museum (P, S) VR 57
Otis Art Institute (S) VR 58
Pomona College (S) VR 61
San Diego State Univ (S) VR 64
San Francisco Art Institute (S)
 VR 65
San Francisco Museum of
 Modern Art (S) VR 67
San Jose City College (S) VR 69
San Jose State Univ (S) VR 70
Stanford Univ (S) VR 72
Univ of California-Berkeley (O)
 VR 73
Univ of California-Berkeley (P,
 S) VR 75
Univ of California-Davis (S)
 VR 78
Univ of California-Irvine (S)
 VR 79
Univ of California-Riverside (P,
 S) VR 82
Univ of California-San Diego (S)
 VR 83
Univ of California-Santa Barbara
 (S) VR 84
Univ of Southern California (S)
 VR 87
COLORADO
Colorado College (S) VR 91
Denver Public Library (OP)
 VR 93
Northeastern Junior College
 (V) VR 95
Univ of Denver (S) VR 99
CONNECTICUT
Connecticut College (S) VR 100
St Joseph College (S) VR 103
Trinity College (S) VR 104
Univ of Hartford (S) VR 106
Yale Univ (P, S) VR 111
DELAWARE
Univ of Delaware (S) VR 114
H F duPont Winterthur Museum
 Museum Libraries (P) VR 115
H F duPont Winterthur Museum
 (S) VR 116
DISTRICT OF COLUMBIA
American Univ (S) VR 117
Archives of American Art (P,
 S) VR 118
Freer Gallery of Art (S) VR 124
George Washington Univ (S)
 VR 124A
National Collection of Fine Arts,
 Smithsonian Institution (O)
 VR 131
National Collection of Fine Arts
 (P, S) VR 132
National Gallery of Art (P)
 VR 134
National Gallery of Art (S)
 VR 135
National Portrait Gallery (P)
 VR 137
Trinity College (S) VR 139

FLORIDA
Cummer Gallery of Art (P)
 VR 141
Florida Gulf Coast Art Center
 (O, S) VR 142
Florida International Univ (S)
 VR 143
Museum of Fine Arts of St
 Petersburg (S) VR 150
Ringling School of Art (S)
 VR 153
Univ of South Florida (S)
 VR 158
GEORGIA
Atlanta College of Art (S)
 VR 160
Georgia Institute of Technology
 (S) VR 163
Georgia State Univ (S) VR 164
Telfair Academy of Arts &
 Sciences, Inc (S) VR 165
Univ of Georgia (S) VR 166
HAWAII
Honolulu Academy of Arts (S)
 VR 169
Univ of Hawaii, Manoa (S)
 VR 173
ILLINOIS
Art Institute of Chicago (S)
 VR 174
Chicago Public Library Cultural
 Center (S) VR 177
Richard J Daley College (S)
 VR 179
Illinois State Museum (P, S)
 VR 193
Moraine Valley Community
 College (S) VR 185
Museum of Contemporary Art
 (S) VR 186
Northern Illinois Univ (S)
 VR 189
Northwestern Univ (P, S)
 VR 190
Public Art Workshop (S)
 VR 193
Quincy College (S) VR 194
Rockford College (S) VR 195
Roosevelt Univ (S) VR 198
Southern Illinois Univ at
 Edwardsville (S) VR 200
Univ of Illinois at Chicago Circle
 (S) VR 204
Univ of Illinois at Urbana-
 Champaign (S) VR 205
INDIANA
Evansville Museum of Arts &
 Science (P, S) VR 211
Herron School of Art (S)
 VR 213
Indiana Univ (S) VR 215
Univ of Notre Dame (S)
 VR 220
IOWA
Davenport Municipal Art
 Gallery (S) VR 222
Grinnell College (S) VR 223
Univ of Iowa (S) VR 228
KANSAS
Cultural Heritage & Art Center
 (S) VR 231
Topeka Public Library (S)
 VR 233
Univ of Kansas (P, S) VR 234
Wichita Art Museum (S)
 VR 326
Wichita State Univ (S) VR 237
KENTUCKY
Louisville Free Public Library
 (F, S) VR 239
J B Speed Art Museum (S)
 VR 240
Univ of Kentucky (S) VR 241
Univ of Louisville (S) VR 242
LOUISIANA
Historic New Orleans Collection
 (P) VR 246

ONTARIO
Carleton Univ (S) VR 678
Scarborough College, Univ of
Toronto (S) VR 685
York Univ (S) VR 692

QUEBEC
Musee d'Art Contemporain (F,
P, S) VR 699
Univ du Quebec a Montreal
(S) VR 701

SCULPTURE-AFRICAN

United States

ALABAMA
Univ of Alabama in Huntsville
(M, S) VR 3

ARIZONA
Glendale Community College (S)
VR 9
Tucson Museum of Art (P, S)
VR 12
Univ of Arizona (S) VR 14

CALIFORNIA
California Institute of the Arts
(S) VR 29
California State Univ-Chico (S)
VR 32
California State Univ-Fresno (S)
VR 33
California State Univ-Los Angeles
(S) VR 37
California State Univ-Northridge
(S) VR 38
California State Univ-Sacramento
(S) VR 39
Jr Arts Center in Barnsdall Park
(S) VR 49
San Diego State Univ (S) VR 64
San Francisco Museum of
Modern Art (S) VR 67
San Jose State Univ (S) VR 70
Univ of California-Irvine (S)
VR 79
Univ of California-Santa Barbara
(S) VR 84
Univ of Southern California (S)
VR 87

COLORADO
Univ of Denver (S) VR 99

CONNECTICUT
Yale Univ (P ,S) VR 111

DISTRICT OF COLUMBIA
Museum of African Art (F, P,
S) VR 128
National Gallery of Art (S)
VR 135

GEORGIA
Georgia State Univ (S) VR 164
Univ of Georgia (S) VR 166

HAWAII
Honolulu Academy of Arts (S)
VR 169
Univ of Hawaii, Manoa (S)
VR 173

ILINOIS
Northern Illinois Univ (S)
VR 189
Northwestern Univ (P, S)
VR 190
Quincy College (S) VR 194
Roosevelt Univ (S) VR 198
Southern Illinois Univ at
Edwardsville (S) VR 200
Univ of Illinois at Urbana-
Champaign (S) VR 205

INDIANA
Indiana Univ (S) VR 215
Univ of Notre Dame (S) VR 220

IOWA
Univ of Iowa (S) VR 228

KANSAS
Topeka Public Library (S)
VR 233
Univ of Kansas (S) VR 234

MARYLAND
Baltimore Museum of Art (P, S)
VR 263
Univ of Maryland (S) VR 273

MASSACHUSETTS
Art Institute of Boston (S)
VR 277
Boston Public Library (P)
VR 279
Boston Univ (S) VR 280
Brandeis Univ (S) VR 281
Brockton Art Center (S)
Harvard Univ (P) VR 287
Massachusetts College of Art (S)
VR 289
Massachusetts Institute of
Technology (S) VR 290
Univ of Massachusetts (S)
VR 303
Univ of Massachusetts in Boston
(S) VR 304

MICHIGAN
Detroit Institute of Arts (S)
VR 311
Western Michigan Univ (F, S)
VR 330

MINNESOTA
Minneapolis College of Art &
Design (S) VR 335
Minneapolis Institute of Arts (S)
VR 337
Walker Art Center (S) VR 343

MISSOURI
Drury College (S) VR 345
Southeast Missouri State Univ
(S) VR 353
Univ of Missouri-St Louis (S)
VR 357

NEVADA
Joslyn Art Museum (S) VR 365

NEW HAMPSHIRE
Dartmouth College (S) VR 367

NEW JERSEY
Newark Museum Association (P,
S) VR 375
Newark Public Library (S)
VR 376
New Jersey Institute of
Technology (S) VR 374

NEW MEXICO
Univ of New Mexico (S)
VR 387

NEW YORK
Adelphi Univ (S) VR 389
Brooklyn College of the City
Univ of New York (S) VR 396
Columbia Univ (P) VR 404
Columbia Univ (S) VR 406
Herbert F Johnson Museum of
Art, Cornell Univ (S) VR 420
Metropolitan Museum of Art (P)
VR 426
Metropolitan Museum of Art (S)
VR 427
New York Public Library/The
Research Libraries (P, S)
VR 436
State Univ of New York at
Buffalo (S) VR 453
State Univ of New York College
at Cortland (S) VR 456
State Univ of New York College
at New Paltz (S) VR 457
Syracuse Univ Libraries (S)
VR 460

NORTH CAROLINA
Duke Univ (P, S) VR 469
East Carolina Univ (S) VR 470
Univ of North Carolina at Chapel
Hill (S) VR 474

OHIO
Cleveland State Univ (S)
VR 484
College of Mount St Joseph on
the Ohio (S) VR 485

Columbus College of Art &
Design (S) VR 486
Miami Univ (S) VR 490
Oberlin College (S) VR 491
Ohio Univ (S) VR 495
Univ of Cincinnati (S) VR 499

OREGON
Oregon State Univ (S) VR 508

PENNSYLVANIA
Carnegie-Mellon Univ (S)
VR 517
Philadelphia College of Art (S)
VR 528

RHODE ISLAND
Rhode Island School of Design
(S) VR 541

TENNESSEE
Austin Peay State Univ (S)
VR 563

TEXAS
Beaumont Art Museum (S)
VR 572
Dallas Museum of Fine Arts (S)
VR 575
North Texas State Univ (S)
VR 581
Rice Univ (S) VR 583
Southern Methodist Univ (S)
VR 588
Univ of Houston (S) VR 590
Univ of Texas at Arlington (S)
VR 593
Univ of Texas at Austin (S)
VR 594
Univ of Texas at El Paso (S)
VR 597
Univ of Texas at San Antonio
(S) VR 598

VERMONT
Univ of Vermont (S) VR 606

VIRGINIA
James Madison Univ (S)
VR 609
Randolph-Macon Woman's
College (S) VR 612
Virginia Commonwealth Univ (S)
VR 623

WASHINGTON
Eastern Washington State College
(S) VR 626
Seattle Art Museum (P, S)
VR 629

WISCONSIN
Mount Senario College (S)
VR 646
Univ of Wisconsin-Eau Claire
(S) VR 652
Univ of Wisconsin-Milwaukee
(S) VR 656
Univ of Wisconsin-Stevens Point
(S) VR 662
Univ of Wisconsin-Whitewater
(S) VR 663

Canada

BRITISH COLUMBIA
Kootenay School of Art, Division
of Selkirk College (S) VR 666

MANITOBA
Univ of Manitoba (S) VR 670

ONTARIO
York Univ (S) VR 692

QUEBEC
Univ du Quebec a Montreal
(S) VR 701
L'Univ Laval (S) VR 702

SCULPTURE-ANCIENT

United States

ARIZONA
Arizona State Univ (S) VR 6
& VR 8
Glendale Community College (S)
VR 9

Tucson Museum of Art (S)
VR 12
Univ of Arizona (P, S) VR 14

ARKANSAS
Univ of Arkansas (S) VR 19 &
VR 20

CALIFORNIA
Brand Library (S) VR 26
California College of Arts and
Crafts (S) VR 28
California State College-
Dominguez Hills (S) VR 31
California State Univ-Chico (S)
VR 32
California State Univ-Fresno
(S) VR 33
California State Univ-Hayward
(S) VR 34
California State Univ-Los Angeles
(S) VR 37
California State Univ-Northridge
(S) VR 38
California State Univ-Sacramento
VR 39
Cosumnes River College (S)
VR 43
Hebrew Union College, Skirball
Museum (P, S) VR 46
Humboldt State Univ (S) VR 47
Jr Arts Center in Barnsdall Park
(S) VR 49
Los Angeles County Museum of
Art (S) VR 52
Otis Art Institute (S) VR 58
Pomona College (S) VR 61
San Diego Univ (R, S) VR 64
San Francisco Art Institute (S)
VR 65
San Francisco Museum of
Modern Art (S) VR 67
San Jose City College (S) VR 69
San Jose State Univ (S) VR 70
Univ of California-Berkeley (S)
VR 75
Univ of California-Davis (MR)
VR 77
Univ of California-Irvine (S)
VR 79
Univ of California-Riverside (P,
S) VR 82
Univ of California-San Diego
(S) VR 83
Univ of California-Santa Barbara
(S) VR 84
Univ of Southern California (S)
VR 87

COLORADO
Colorado College (S) VR 91
Univ of Denver (S) VR 99

CONNECTICUT
Connecticut College (S) VR 100
St Joseph College (S) VR 103
Trinity College (S) VR 104
Univ of Hartford (S) VR 106
Yale Univ (P, S) VR 111

DELAWARE
Univ of Delaware (S) VR 114

DISTRICT OF COLUMBIA
American Univ (S) VR 117
George Washington Univ (S)
VR 124A
Museum of African Art (P, S)
VR 128
National Collection of Fine Arts
(P, S) VR 132
National Gallery of Art (P)
VR 134
National Gallery of Art (S)
VR 135
National Portrait Gallery (P)
VR 137
Trinity College (S) VR 139

FLORIDA
Florida International Univ (S)
VR 143
Lowie Art Museum, Univ of
Miami (S) VR 149
Museum of Fine Arts of St
Petersburg (S) VR 150
North Florida Junior College (F,
S) VR 151

ONTARIO

Art Gallery of Ontario (S)
VR 676
Carleton Univ (S) VR 678
Scarborough College, Univ of
Toronto (S) VR 685
Univ of Guelph (S) VR 687
Univ of Western Ontario (S)
VR 691
York Univ (P) VR 692

PRINCE EDWARD ISLAND

Confederation Centre Art Gallery
& Museum (S) VR 693

QUEBEC

Montreal Museum of Fine Arts
(S) VR 698
Univ de Montreal (S) VR 700
Univ du Quebec a Montreal (S)
VR 701
L'Univ Laval (S) VR 702

SCULPTURE-ANDEAN

United States

ARIZONA

Glendale Community College (S)
VR 9
Tucson Museum of Art (P, S)
VR 12

CALIFORNIA

California State Univ-Chico (S)
VR 32
California State Univ-Fresno (S)
VR 33
San Diego State Univ (S)
VR 64
San Francisco Museum of
Modern Art (S) VR 67
San Jose State Univ (S) VR 70
Univ of California-Santa Barbara
(S) VR 84

FLORIDA

Museum of Fine Arts of St
Petersburg (S) VR 150

GEORGIA

Georgia State Univ (S) VR 164
Univ of Georgia (S) VR 166

ILLINOIS

Roosevelt Univ (S) VR 198
Southern Illinois Univ at
Edwardsville (S) VR 200

IOWA

Univ of Iowa (S) VR 228

LOUISIANA

Louisiana State Univ (S)
VR 249
Tulane Univ (S) VR 254

MARYLAND

Univ of Maryland (S) VR 273

MASSACHUSETTS

Brandeis Univ (S) VR 281
Massachusetts College of Art (S)
VR 289
Massachusetts Institute of
Technology (S) VR 290

MISSOURI

Drury College (S) VR 345

NEVADA

Joslyn Art Museum (S) VR 365

NEW JERSEY

Stockton State College (S)
VR 383

NEW MEXICO

Univ of New Mexico (S)
VR 387

NEW YORK

Columbia Univ (S) VR 406
Metropolitan Museum of Art
(P) VR 426
Museum of the American Indian,
Heye Foundation (P, S)
VR 430

New York Public Library/The
Research Libraries (P) VR 436

NORTH CAROLINA

Duke Univ (S) VR 469
East Carolina Univ (S) VR 470

TEXAS

Dallas Museum of Fine Arts (S)
VR 469
North Texas State Univ (S)
VR 581
Univ of Houston (S) VR 590
Univ of Texas at Austin VR 594
Univ of Texas at El Paso (S)
VR 597

WISCONSIN

Univ of Wisconsin-Stevens Point
(S) VR 662

Canada

MANITOBA

Univ of Manitoba (S) VR 670

SCULPTURE-CANADIAN

United States

NEW YORK

New York Public Library/The
Research Libraries (P) VR 436

Canada

BRITISH COLUMBIA

Malaspine College (S) VR 667

MANITOBA

Univ of Manitoba (S) VR 670
Winnipeg Art Gallery (S) VR 671

NEW BRUNSWICK

Mount Allison Univ-Owens Art
Gallery (S) VR 672

NOVA SCOTIA

Nova Scotia College of Art &
Design (S) VR 674

ONTARIO

Art Gallery of Ontario (S)
VR 676
Carleton Univ (S) VR 678
National Gallery of Canada (P,
S) VR 681
Scarborough College, Univ of
Toronto (S) VR 685
Univ of Guelph (S) VR 697
York Univ (P, S) VR 692

QUEBEC

Montreal Museum of Fine Arts
(S) VR 698
Musee d'Art Contemporain (P,
S) VR 699
Univ de Montreal (S) VR 700
Univ du Quebec a Montreal (S)
VR 701
L'Univ Laval (S) VR 702

SCULPTURE-EUROPEAN

United States

ALABAMA

Univ of Alabama in Birmingham
(S) VR 2

ARIZONA

Arizona State Univ (S) VR 6
Glendale Community College (S)
VR 9
Univ of Arizona (P, S) VR 14

ARKANSAS

Univ of Arkansas (S) VR 19 &
VR 20

CALIFORNIA

Brand Library (S) VR 26
California College of Arts and
Crafts (S) VR 28
California Institute of the Arts
(S) VR 29
California State College-
Dominguez Hills (S) VR 31

California State Univ-Chico (S)
VR 32
California State Univ-Fresno (S)
VR 33
California State Univ-Hayward
(S) VR 34
California State Univ-Los Angeles
(S) VR 37
California State Univ-Northridge
(S) VR 38
California State Univ-Sacramento
(S) VR 39
Cosumnes River College (S)
VR 43
Hebrew Union College Skirball
Museum (P, S) VR 46
Humboldt State Univ (S) VR 47
Henry E Huntington Library &
Art Gallery (P, S) VR 48
Jr Arts Center in Barnsdall Park
(S) VR 49
La Jolla Museum of
Contemporary Art (S) VR 50
Los Angeles County Museum of
Art (S) VR 52
Mills College (S) VR 56
Otis Art Institute (S) VR 58
Pomona College (S) VR 61
San Diego State Univ (S)
VR 64
San Francisco Art Institute (S)
VR 65
San Francisco Museum of
Modern Art (S) VR 67
San Jose City College (S)
VR 69
San Jose State Univ (S) VR 70
Stanford Univ (S) VR 72
Univ of California-Berkeley
(P, S) VR 75
Univ of California-Davis (S)
VR 78
Univ of California-Irvine (S)
VR 79
Univ of California-Riverside (P,
S) VR 82
Univ of California-San Diego (S)
VR 83
Univ of California-Santa Barbara
(S) VR 84
Univ of Southern California (S)
VR 87

COLORADO

Colorado College (S) VR 91
Univ of Denver (S) VR 99

CONNECTICUT

Connecticut College (S) VR 100
St Joseph College (S) VR 103
Trinity College (S) VR 104
Univ of Hartford (S) VR 106
Yale Univ (P, S) V 111

DELAWARE

Univ of Delaware (S) VR 114
H F duPont Winterthur Museum
(S) VR 116

DISTRICT OF COLUMBIA

American Univ (S) VR 117
George Washington Univ (S)
VR 124A
National Gallery of Art (P)
VR 134
Trinity College (S) VR 139

FLORIDA

Lowie Art Museum, Univ of
Miami (S) VR 149
Museum of Fine Arts of St
Petersburg (S) VR 150
Ringling School of Art (S)
VR 153
Univ of South Florida (S)
VR 158

GEORGIA

Atlanta College of Art (S)
VR 160
Georgia State Univ (S)
VR 164
Univ of Georgia (S) VR 166

HAWAII

Honolulu Academy of Arts (S)
VR 169
Univ of Hawaii, Manoa (S)
VR 173

ILLINOIS

Richard J Daley College (S)
VR 179
Moraine Valley Community
College (F, S) VR 185
Northern Illinois Univ (S)
VR 189
Northwestern Univ (P, S)
VR 190
Quincy College (S) VR 194
Roosevelt Univ (F, S) VR 198
Southern Illinois Univ at
Edwardsville (S) VR 200
Univ of Illinois at Chicago Circle
(S) VR 204
Univ of Illinois at Urbana-
Champaign (S) VR 205

INDIANA

Indiana Univ (S) VR 215
Univ of Notre Dame (S) VR 220

IOWA

Davenport Municipal Art Gallery
(S) VR 222
Grinnell College (S) VR 223
Univ of Iowa (P, S) VR 228

KANSAS

Univ of Kansas (P, S) VR 234
Wichita State Univ (S) VR 237

KENTUCKY

Louisville Free Public Library
(S) VR 239
J B Speed Art Museum (S)
VR 240
Univ of Louisville (S) VR 242

LOUISIANA

Louisiana State Univ (S) VR 249
Loyola Univ (S) VR 249A
Tulane Univ (S) VR 254

MAINE

Bowdoin College (P, S) VR 257

MARYLAND

Goucher College (P, S)
Loyola-Notre Dame Library (S)
VR 268
Maryland Institute, College of
Art (S) VR 270
Univ of Maryland (O) VR 272
Univ of Maryland (S) VR 273
Univ of Maryland, Baltimore
County (S) VR 275

MASSACHUSETTS

Art Institute of Boston (S)
VR 277
Boston Public Library (P)
VR 279
Boston Univ (S) VR 280
Brandeis Univ (P, S) VR 281
Brockton Art Center (S) VR 283
Sterling & Francine Clark Art
Institute (P) VR 284
Harvard Univ (P) VR 287
Massachusetts College of Art (S)
VR 289
Massachusetts Institute of
Technology (P, S) VR 290
Mount Holyoke College (P, S)
VR 294
Museum of Fine Arts (P, S)
VR 295
Smith College (S) VR 298
Smith College (P) VR 299
Tufts Univ (S) VR 300
Univ of Lowell (S) VR 301
Univ of Massachusetts (S)
VR 303
Univ of Massachusetts in Boston
(S) VR 304
Wellesley College (P, S) VR 305
Wheaton College (S) VR 306
Worcester Art Museum (S)
VR 308

MICHIGAN

Center for Creative Studies (S)
VR 309
Detroit Institute of Arts (P, S)
VR 311
Eastern Michigan Univ (S)
VR 312

Univ of Illinois at Urbana-
Champaign (S) VR 205

INDIANA
Indiana Univ (S) VR 215

IOWA
Univ of Iowa (P, S) VR 228

KANSAS
Univ of Kansas (P ,S) VR 234

KENTUCKY
Louisville Free Public Library (S)
VR 239

MAINE
Bowdoin College (S) VR 257

MARYLAND
Loyola-Notre Dame Library (S)
VR 268
Univ of Maryland (S) VR 273

MASSACHUSETTS
Boston Public Library (P)
VR 279
Brandeis Univ (P, S) VR 281
Harvard Univ (P) VR 287
Massachusetts College of Art (S)
VR 289
Massachusetts Institute of
Technology (S) VR 290
Mount Holyoke College (P, S)
VR 294
Museum of Fine Arts (P, S)
VR 295
Smith College (S) VR 298
Smith College (P) VR 299
Univ of Lowell (S) VR 301
Univ of Massachusetts (S)
VR 303
Wellesley College (P, S) VR 305
Wheaton College (S) VR 306
Worcester Art Museum (S)
VR 308

MICHIGAN
Center for Creative Studies (S)
VR 309
Detroit Institute of Arts (S)
VR 311
Univ of Michigan (P) VR 325
Univ of Michigan (P, S) VR 327
Univ of Michigan-Dearborn (S)
VR 328
Western Michigan Univ (F, S)
VR 330

MINNESOTA
Minneapolis College of Art &
Design (S) VR 335
Minneapolis Institute of Arts
(S) VR 337

MISSOURI
Drury College (S) VR 345
Kansas City Art Institute (S)
VR 346
William Rockhill Nelson Gallery-
Atkins Museum (S) VR 349
Southeast Missouri State Univ
(S) VR 353
Washington Univ (S) VR 359

MONTANA
Montana State Univ (S) VR 361

NEVADA
Joslyn Art Museum (S) VR 365

NEW JERSEY
Newark Museum Association (P,
S) VR 375
Newark Public Library (S)
VR 376
Princeton Univ (P) VR 379
Princeton Univ (S) VR 380
Stockton State College (S)
VR 383

NEW YORK
Adelphi Univ (S) VR 389
Columbia Univ (S) VR 406
Cornell Univ (P, S) VR 410
Herbert F Johnson Museum of
Art, Cornell Univ (S) VR 420

Metropolitan Museum of Art (P,
S) VR 427
New York Public Library/The
Research Libraries (P) VR 436
New York Univ, Institute of Fine
Arts (S) VR 437
State Univ of New York at
Buffalo (S) VR 453
State Univ of New York College
at Cortland (S) VR 456
State Univ of New York College
at New Paltz (S) VR 457
Univ of Rochester (P, S) VR 463
Vassar College (S) VR 464

NORTH CAROLINA
Duke Univ (P, S) VR 469

OHIO
Cleveland Museum of Art (P, S)
VR 482
Cleveland State Univ (S) VR 484
Columbus College of Art &
Design (P, S) VR 486
Denison Univ (S) VR 488
Oberlin College (S) VR 491
Oberlin College (P) VR 492
Ohio Univ (S) VR 495

OREGON
Oregon State Univ (S) VR 508
Univ of Oregon (S) VR 512

PENNSYLVANIA
Bryn Mawr College (P, S)
VR 514
Carnegie-Mellon Univ (S)
VR 517
Philadelphia College of Art (S)
VR 528
Philadelphia Museum of Art (S)
VR 530

SOUTH CAROLINA
Clemson Univ (S) VR 545
Univ of South Carolina (S)
VR 550

TENNESSEE
Austin Peay State Univ (S)
VR 563
Southwestern Univ at Memphis
(S) VR 564
Univ of Tennessee (S) VR 566
Vanderbilt Univ (S) VR 567

TEXAS
Dallas Museum of Fine Arts (S)
VR 575
North Texas State Univ (S)
VR 581
Rice Univ (S) VR 583
Univ of Texas at Arlington (S)
VR 593
Univ of Texas at El Paso (S)
VR 597

VERMONT
Middlebury College (S) VR 605

VIRGINIA
James Madison Univ (P, S)
VR 609
Randolph-Macon Woman's
College (S) VR 612
Univ of Virginia (S) VR 620
Virginia Commonwealth Univ (S)
VR 623

WASHINGTON
Eastern Washington State College
(S) VR 626
Seattle Art Museum (S) VR 629
Univ of Washington (S) VR 634

WISCONSIN
Paine Art Center & Arboretum
(S) VR 648
Univ of Wisconsin-Madison (P,
S) VR 654
Univ of Wisconsin-Whitewater
(S) VR 663

Canada

BRITISH COLUMBIA
Kootenay School of Art, Division
of Selkirk College (S) VR 666

NOVA SCOTIA
Nova Scotia College of Art &
Design (S) VR 674

ONTARIO
Scarborough College, Univ of
Toronto (S) VR 685

QUEBEC
Univ du Quebec a Montreal (S)
VR 701

SCULPTURE-ISLAMIC

United States

ARIZONA
Arizona State Univ (S) VR 8
Glendale Community College (S)
VR 9

CALIFORNIA
California State Univ-Fresno (S)
VR 33
San Diego State Univ (S) VR 64
Univ of California-Irvine (S)
VR 79
Univ of Southern California (S)
VR 87

COLORADO
Colorado College (S) VR 91

CONNECTICUT
Yale Univ (S) VR 111

DISTRICT OF COLUMBIA
Freer Gallery of Art (P, S)
VR 124

FLORIDA
Museum of Fine Arts of St
Petersburg (S) VR 150

GEORGIA
Atlanta College of Art (S)
VR 160
Georgia State Univ (S) VR 164

MAINE
Bowdoin College (S) VR 257

MASSACHUSETTS
Boston Public Library (P)
VR 279
Brandeis Univ (S) VR 281
Massachusetts College of Art (S)
VR 289
Mount Holyoke College (P, S)
VR 294

MICHIGAN
Detroit Institute of Arts (S)
VR 311
Eastern Michigan Univ (S)
VR 312
Univ of Michigan (P, S) VR 327

MISSOURI
Drury College (S) VR 345

NEVADA
Joslyn Art Museum (S) VR 365

NEW MEXICO
Univ of New Mexico (S) VR 387

NEW YORK
Columbia Univ (S) VR 406
New York Public Library/The
Research Libraries (P) VR 436
New York Univ, Institute of Fine
Arts (S) VR 437

NORTH CAROLINA
Duke Univ (P, S) VR 469

OHIO
Oberlin College (S) VR 491

PENNSYLVANIA
Univ of Pennsylvania (S) VR 534

TENNESSEE
Univ of Tennessee (S) VR 566

TEXAS
North Texas State Univ (S)
VR 581

WISCONSIN
Paine Art Center & Arboretum
(P) VR 648
Univ of Wisconsin-Whitewater
(S) VR 663

SCULPTURE-
MESO-AMERICAN

United States

ARIZONA
Amerind Foundation, Inc VR 5
Tucson Museum of Art (P, S)
VR 12
Univ of Arizona (S) VR 14

CALIFORNIA
California State Univ-Chico (S)
VR 32
California State Univ-Fresno (S)
VR 33
California State Univ-Los Angeles
(S) VR 37
California State Univ-Northridge
(S) VR 38
San Diego State Univ (S) VR 64
San Francisco Art Institute (S)
VR 65
San Francisco Museum of
Modern Art (S) VR 67
San Jose State Univ (S) VR 70
Univ of California-Irvine (S)
VR 79
Univ of California-Santa Barbara
(S) VR 84

COLORADO
Univ of Denver (S) VR 99

CONNECTICUT
Connecticut College (S) VR 100

FLORIDA
Lowie Art Museum, Univ of
Miami (S) VR 149

GEORGIA
Georgia State Univ (S) VR 164
Univ of Georgia (S) VR 166

ILLINOIS
Northern Illinois Univ (S)
VR 189
Northwestern Univ (P, S)
VR 190
Roosevelt Univ (S) VR 198
Southern Illinois Univ at
Edwardsville (S) VR 200

INDIANA
Indiana Univ (S) VR 215
Univ of Notre Dame (S)
VR 20

IOWA
Univ of Iowa (S) VR 228

LOUISIANA
Louisiana State Univ (S) VR 249
Newcomb College of Tulane
Univ (S) VR 251
Tulane Univ (S) VR 254

MARYLAND
Univ of Maryland (S) VR 273

MASSACHUSETTS
Brandeis Univ (S) VR 281
Massachusetts College of Art (S)
VR 289
Massachusetts Institute of
Technology (S) VR 290
Univ of Massachusets in Boston
(S) VR 304

MICHIGAN
Western Michigan Univ (S)
VR 30

MISSOURI
Drury College (S) VR 345

NEVADA
Joslyn Art Museum (S) VR 365

Canada

BRITISH COLUMBIA
Kootenay School of Art, Division of Selkirk College (S) VR 666

MANITOBA
Winnipeg Art Gallery (S) VR 671

QUEBEC
Univ du Quebec a Montreal (S) VR 701

SCULPTURE- UNITED STATES

United States

ALABAMA
Univ of Alabama in Birmingham (S) VR 2
Univ of Alabama in Huntsville M, S) VR 3

ARIZONA
Arizona State Univ (F, P, S) VR 6
Glendale Community College (S) VR 9
Univ of Arizona (P, S) VR 14

ARKANSAS
Univ of Arkansas (S) VR 20

CALIFORNIA
Brand Library (S) VR 26
California Institute of the Arts (S) VR 29
California State College-Dominguez Hills (S) VR 31
California State Univ-Chico (S) VR 32
California State Univ-Fresno (S) VR 33
California State Univ-Hayward (S) VR 34
California State Univ-Los Angeles (S) VR 37
California State Univ-Northridge (S) VR 38
California State Univ-Sacramento (S, V) VR 39
Hebrew Union College Skirball Museum (P, S) VR 46
Humboldt State Univ (S) VR 47
Jr Arts Center in Barnsdall Park (S) VR 49
La Jolla Museum of Contemporary Art (S) VR 50
Oakland Museum (P, S) VR 57
Otis Art Institute (S) VR 58
Pomona College (S) VR 61
San Diego State Univ (S) VR 64
San Francisco Art Institute (S) VR 65
San Francisco Museum of Modern Art (S) VR 67
San Jose City College (S) VR 69
San Jose State Univ (S) VR 70
Stanford Univ (S) VR 72
Univ of California-Berkeley (S) VR 75
Univ of California-Irvine (S) VR 79
Univ of California-Riverside (P, S) VR 82
Univ of California-San Diego (S) VR 83
Univ of California-Santa Barbara (S) VR 84
Univ of Southern California (S) VR 87

COLORADO
Colorado College (S) VR 91
Denver Public Library (O) VR 93
Univ of Denver (S) VR 99

CONNECTICUT
Connecticut College (S) VR 100
St Joseph College (S) VR 103

Trinity College (S) VR 104
Univ of Hartford (S) VR 106
Yale Univ (P, S) VR 111

DELAWARE
Univ of Delaware (P, S) VR 114
H F duPont Winterthur Museum Libraries (P) VR 115
H F duPont Winterthur Museum (S) VR 116

DISTRICT OF COLUMBIA
American Univ (S) VR 117
Archives of American Art (P, S) VR 118
George Washington Univ (S) VR 124A
National Collection of Fine Arts (P, S) VR 132
National Gallery of Art (P) VR 134
National Gallery of Art (S) VR 135
Trinity College (S) VR 139

FLORIDA
Florida International Univ (S) VR 143
Lowie Art Museum, Univ of Miami (S) VR 149
Museum of Fine Arts of St Petersburg (S) VR 150
Ringling School of Art (S) VR 153
Univ of South Florida (S) VR 158

GEORGIA
Atlanta College of Art (S) VR 160
Georgia State Univ (S) VR 164
Univ of Georgia (S) VR 166

HAWAII
Honolulu Academy of Arts (S) VR 169
Univ of Hawaii, Manoa (S) VR 173

ILLINOIS
Art Institute of Chicago (S) VR 174
Chicago Public Cultural Center (S) VR 117
Richard J Daley College (S) VR 179
Moraine Valley Community College (S) VR 185
Northern Illinois Univ (S) VR 189
Northwestern Univ (P, S) VR 190
Roosevelt Univ (F, S) VR 198
Southern Illinois Univ at Edwardsville (S) VR 200
Univ of Illinois at Chicago Circle (S) VR 204
Univ of Illinois at Urbana-Champaign (S) VR 205

INDIANA
Evansville Museum of Arts & Science (P, S) VR 211
Herron School of Art (S) VR 213
Indiana Univ (S) VR 215
Univ of Notre Dame (S) VR 220

IOWA
Davenport Municipal Art Gallery (S) VR 222
Grinnell College (S) VR 223
Univ of Iowa (P, S) VR 228

KANSAS
Univ of Kansas (P, S) VR 234
Wichita Art Museum (S) VR 236
Wichita State Univ (S) VR 237

KENTUCKY
Louisville Free Public Library (F, S) VR 239
Univ of Louisville (S) VR 242

LOUISIANA
Louisiana State Univ (S) VR 249
Loyola Univ (S) VR 249A
Tulane Univ (S) VR 254

MAINE
Bowdoin College (P, S) VR 257

MARYLAND
Baltimore Museum of Art (P, S) VR 263
Goucher College (P, S) VR 266
Loyola-Notre Dame Library (S) VR 268
Maryland College of Art & Design (S) VR 269
Maryland Institute, College of Art (S) VR 270
Univ of Maryland (O) VR 272
Univ of Maryland, Baltimore County (S) VR 275

MASSACHUSETTS
Boston Public Library (P) VR 279
Boston Univ (S) VR 280
Brandeis Univ (P, S) VR 281
Brockton Art Center (S) VR 283
Sterling & Francine Clark Art Institute (P, S) VR 284
Forbes Library (P) VR 286
Harvard Univ (P) VR 287
Massachusetts College of Art F, S) VR 289
Massachusetts Institute of Technology (P, S) VR 290
Mount Holyoke College (P, S) VR 294
Museum of Fine Arts (P, S) VR 295
Smith College (S) VR 298
Smith College (P) VR 299
Tufts Univ (S) VR 300
Univ of Lowell (S) VR 301
Univ of Massachusetts (S) VR 303
Univ of Massachusetts in Boston (S) VR 304
Wellesley College (P, S) VR 305
Wheaton College (P, S) VR 306
Worcester Art Museum (S) VR 308

MICHIGAN
Center for Creative Studies (S) VR 309
Detroit Institute of Arts (P, S) VR 311
Eastern Michigan Univ (S) VR 312
Michigan State Univ (P, S) VR 318
Oakland Univ (S) VR 321
Univ of Michigan (P, S) VR 327
Univ of Michigan-Dearborn (S) VR 328
Western Michigan Univ (F, S) VR 330

MINNESOTA
Minneapolis College of Art & Design (S) VR 335
Minneapolis Institute of Arts (S) VR 337
Walker Art Center (S) VR 343

MISSOURI
Drury College (S) VR 345
Kansas City Art Institute (S) VR 346
Kansas City Public Library (S) VR 347
Southeast Missouri State Univ (S) VR 353
Southwest Missouri Univ (S) VR 354
Univ of Missouri-Columbia (P, S) VR 355
Univ of Missouri-Kansas City (P, S) VR 356
Univ of Missouri-St Louis (S) VR 357

Washington Univ (P) VR 358
Washington Univ (S) VR 359

MONTANA
Montana State Univ (S) VR 361

NEBRASKA
Joslyn Art Museum (S) VR 365

NEW HAMPSHIRE
Dartmouth College (S) VR 367

NEW JERSEY
Caldwell College (S) VR 369
Montclair Art Museum (S) VR 372
New Jersey Institute of Technology (S) VR 374
Newark Museum Association (P, S) VR 375
Newark Public Library (P) VR 376
Plymouth State College (S) VR 368
Princeton Univ (P, S) VR 380
Stockton State College (S) VR 383

NEW MEXICO
Univ of New Mexico (S) VR 387

NEW YORK
Adelphi Univ (S) VR 389 & VR 390
Brooklyn College of the City Univ of New York (S) VR 396
Columbia Univ (S) VR 406
Cornell Univ (S) VR 410
Hall of Fame for Great Americans (P) VR 417
Herbert F Johnson Museum of Art, Cornell Univ (S) VR 420
Metropolitan Museum of Art (P, S) VR 427
Munson-Williams-Proctor Institute (S) VR 429
Museum of Modern Art (P, S) VR 431
New Rochelle Public Library (S) VR 434
New York Public Library/The Research Libraries (P) VR 436
New York Univ, Institute of Fine Arts (S) VR 437
State Univ of New York at Binghamton (S) VR 452
State Univ of New York at Buffalo (P, S) VR 453
State Univ of New York College at Cortland (S) VR 456
State Univ of New York College at New Paltz (S) VR 457
Syracuse Univ Libraries (S) VR 460
Univ of Rochester (P, S) VR 463
Vassar College (S) VR 464

NORTH CAROLINA
Duke Univ (P, S) VR 469
East Carolina Univ (S) VR 470
Museum of Early Southern Decorative Arts (P, S) VR 471
North Carolina Museum of Art (P) VR 472
North Carolina State Univ (S) VR 473
Univ of North Carolina at Chapel Hill (S) VR 474

OHIO
Cleveland Institute of Art (S) VR 480
College of Mount St Joseph on the Ohio (S) VR 485
Columbus College of Art & Design (P, S) VR 486
Denison Univ (S) VR 488
Miami Univ (S) VR 490
Oberlin College (S) VR 491
Ohio Univ (S) VR 495

Index to Subscription Series

*The parenthetical codes
following institutional names
indicate the media of specific
collections: Films (F);
Microforms (M);
Photographs (P);
Reproductions (R); Slides
(S); Video (V); Other (O).*

CHINESE NATIONAL PALACE MUSEUM PHOTOGRAPH ARCHIVES

United States

COURTAULD INSTITUTE ILLUSTRATION ARCHIVES

COURTAULD INSTITUTE PHOTOGRAPHIC SURVEY OF PRIVATE COLLECTIONS

United States

EDWARD S CURTIS PHOTOGRAPH COLLECTION

DECIMAL INDEX OF THE ART OF LOW COUNTRIES

United States

DISTRICT OF COLUMBIA
National Gallery of Art (P)
VR 134

INDIANA
Indiana Univ (P) VR 215

IOWA
Univ of Iowa (P) VR 228

KANSAS
Univ of Kansas (P) VR 234

MASSACHUSETTS
Sterling & Francine Clark Art
Institute (P) VR 284
Harvard Univ (P) VR 287

MICHIGAN
Detroit Institute of Arts (P)
VR 311

NEW JERSEY
Princeton Univ (P) VR 380

NEW YORK
Columbia Univ (P) VR 404
Frick Art Reference Library
(P) VR 414
State Univ of New York at
Binghamton (P) VR 452
Univ of Rochester (P) VR 463

NORTH CAROLINA
Duke Univ (P) VR 469
Univ of North Carolina at Chapel
Hill (P) VR 474

OHIO
Cleveland Museum of Art (P)
VR 482
Oberlin College (P) VR 492

PENNSYLVANIA
Pennsylvania State Univ (P)
VR 525
Philadelphia Museum of Art (P)
VR 530

RHODE ISLAND
Brown Univ (P) VR 540

WASHINGTON
Univ of Washington (P)
VR 632

Canada

ONTARIO
National Gallery of Canada (P)
VR 681

**ENCYCLOPEDIA
BRITANNICA**

DISTRICT OF COLUMBIA
Museum of African Art (P, S)
VR 128

**ENVIRONMENTAL
COMMUNICATIONS**

ILLINOIS
Public Art Workshop (S)
VR 193

GERNSHEIM COLLECTION

United States

CONNECTICUT
Yale Center for British Art (P)
VR 110

DISTRICT OF COLUMBIA
National Gallery of Art (P)
VR 134

ILLINOIS
Northwestern Univ (S) VR 190

KENTUCKY
Univ of Louisville (S VR 242

MASSACHUSETTS
Harvard Univ (P) VR 287

NEW YORK
Frick Art Reference Library (P)
VR 414

OHIO
Cleveland Museum of Art (P)
VR 481

TEXAS
Univ of Texas at Austin (P, S)
VR 595

Canada

QUEBEC
L'Univ Laval (S) VR 702

ILLUSTRATED BARTSCH

CALIFORNIA
Univ of California-Berkeley (P)
VR 75

CONNECTICUT
Yale Univ (P) VR 111

DELAWARE
Univ of Delaware (P) VR 114

DISTRICT OF COLUMBIA
National Gallery of Art (P)
VR 134

IOWA
Univ of Iowa (P) VR 28

MASSACHUSETTS
Harvard Univ (P) VR 287
Sterling & Francine Clark Art
Institute (P) VR 284

NEW JERSEY
Princeton Univ (P) VR 380

NEW YORK
State Univ of New York at
Binghamton (P) VR 452

NORTH CAROLINA
Univ of North Carolina at Chapel
Hill (P) VR 474

OHIO
Cleveland Museum of Art (P)
VR 482

MARBURGER INDEX

CALIFORNIA
Univ of California-Berkeley (S)
VR 75

Univ of California-Davis (M)
VR 76

PRINCETON INDEX

NEW JERSEY
Princeton Univ (P) VR 380

ROSENTHAL

United States

ILLINOIS
Public Art Workshop (S) VR 193

Canada

ONTARIO
Univ of Guelph (S) VR 687

SASKIA

United States

CALIFORNIA
Stanford Univ (S) VR 72

KANSAS
Wichita State Univ (S) VR 237

MASSACHUSETTS
Smith College (S) VR 298

NEW YORK
Cornell Univ (S) VR 410

OHIO
Cleveland Museum of Art (S)
VR 482

Canada

ONTARIO
Univ of Guelph (S) VR 687

**TURNER WATERCOLORS
& SKETCHES-BRITISH
MUSEUM**

CALIFORNIA
Univ of California-Davis (M)
VR 76

**UNIVERSITY COLOUR
SLIDE SCHEME**

United States

CALIFORNIA
Stanford Univ (S) VR 72
Univ of California-Berkeley (P)
VR 75
Univ of California-Davis (S)
VR 78

CONNECTICUT
Yale Univ (S) VR 111

DISTRICT OF COLUMBIA
National Gallery of Art (S)
VR 135

ILLINOIS
Northwestern Univ (S) VR 190
Univ of Illinois at Urbana-
Champaign (S) VR 205

INDIANA
Indiana Univ (S) VR 215

IOWA
Univ of Iowa (S VR 228

OHIO
Cleveland Museum of Art (S)
VR 482

MARYLAND
Maryland Institute, College of
Art (S) VR 270

MASSACHUSETTS
Boston Univ (S) VR 280
Sterling & Francine Clark Art
Institute (S) VR 284
Harvard Univ (S) VR 287
Massachusetts Institute of
Technology (S) VR 290

MICHIGAN
Detroit Institute of Arts (S)
VR 311

NEW YORK
Columbia Univ (S) VR 406
Metropolitan Museum of Art
(S) VR 427

PENNSYLVANIA
Bryn Mawr College (S) VR 515
Philadelphia College of Art (S)
VR 528

VIRGINIA
Virginia Commonwealth Univ (S)
VR 623

WASHINGTON
Eastern Washington State
College (S) VR 626

WISCONSIN
Univ of Wisconsin-Madison (S)
VR 654
Univ of Wisconsin-Oshkosh (S)
VR 658

Canada

NOVA SCOTIA
Nova Scotia College of Art &
Design (S) VR 674

ONTARIO
Carleton Univ (S) VR 678
National Gallery of Canada (S)
VR 681
Scarborough College, Univ of
Toronto (S VR 685
York Univ (S) VR 692

QUEBEC
Univ de Montreal (S) VR 700

UNIVERSITY PRINTS

ARIZONA
Univ of Arizona (S) VR 14

ILLINOIS
Moraine Valley Community
College (O) VR 185

**VICTORIA & ALBERT
MUSEUM MICROFICHE
COLLECTION**

CALIFORNIA
Univ of California-Davis (M)
VR 76

OHIO
Cleveland Museum of Art (M)
VR 482

Subject Index to Special Collections

The parenthetical codes following institutional names indicate the media of specific collections: Films (F); Microforms (M); Photographs (P); Reproductions (R); Slides (S); Video (V); Other (O).

SPECIAL COLLECTIONS

Americana

Alaskan Historic Photographs (P) VR 4
East Orange, NJ Historical Society (P) VR 375
General Historical Collection (S) VR 412
Grand County, Colorado History (P) VR 94
Historic Elmira (O) VR 412
Historic Photographs of Oakland, 1870-1940 (P) VR 57
Historic Views of Greenwich (P) VR 101
Historic Views of Muscatine (O) VR 223
Historical Photographic Collection of Humboldt County (O) VR 47
Hulstrand 'History in Pictures' Collection of Pioneer Scenes in Eastern North Dakota (P) VR 476
Local Rochester (NY) History (O) VR 444
Will Rogers Memorial (O) VR 503
John Pitcher Spooner Collection of Californiana (P) VR 89
Views of California and the Southwest (P) VR 62
Western Americana Collections VR 93

Americana-Massachusetts

Concord Authors (P); Concord Flight Bicentennial (P, V); Concord History & Architecture (P) VR 285

Americana-New Orleans

Waud Collection of Drawings of New Orleans Views, 1871 (drawings produced to illustrate *Harper's Weekly* of the same years) VR 246

Americana-Ohio

Cincinnati History (S) VR 496

Americana-Oklahoma

Historic Views of Lawton (P) VR 501

Americana-Photography

L V Huber Collection of New Orleans & Louisiana History (O, P) VR 246

Archaeology & Ethnology-African

Peabody Museum of Archaeology & Ethnology VR 297

Archaeology & Ethnology-Andean

Peabody Museum of Archaeology & Ethnology VR 297

Archaeology & Ethnology-Central American

Carnegie Institute of Washington Central American Archaeological Expeditions 1929-1957 (O, P) VR 297

Archaeology & Ethnology-Meso-American

Peabody Museum of Archaeology & Ethnology VR 297

Archaeology & Ethnology-Pacific

Peabody Museum of Archaeology & Ethnology VR 297

Archaeology & Ethnology-Tribal American

Peabody Museum of Archaeology & Ethnology VR 297

Archaeology & Ethnology-United States

Peabody Museum of Archaeology & Ethnology VR 297

Architecture

AIA Products Council Collection (S) VR 473
Architectural Construction Techniques (S) VR 409
Architecture of the Turn of the Century (S) VR 491
Canadian Architecture (S) VR 677
Cistercian Churches (S) VR 460
Essex Company, Architectural & Engineering Drawings (O) VR 293
European & Modern Architecture, Sculpture & Painting (O) VR 464
Richard Koch Collection of World Architecture (S) VR 254
Rosenthal Architectural & Art Negative Collections (O) VR 190
Denise Scott Brown Wheaton Collection (S) VR 74
Winnipeg Architecture (S) VR 670

Architecture-African

Indigenous African Architecture (S) VR 126

Architecture-Alabama

Birmingham Architecture (S) VR 2

Architecture-Architects Collaborative

The Architects Collaborative (S) VR 276

Architecture-Boston

Boston Architecture (S) VR 278
Boston 1954, Urban & Social Documentation (P) VR 290

Architecture-Byzantine

Byzantine Architecture (S) VR 526

Architecture-California

Southern California Architectural Archives (O) VR 85

Architecture-Canadian

Canadian National Historic Park & Sites (O, P) VR 696
Quebec Civil & Religious Architecture (S) VR 702
Quebec Domestic Architecture of late 18th-early 19th Century (S) VR 698
Toronto Architecture, Yorkville Area (S) VR 685

Architecture-Collections

Frances Benjamin Johnston Collection of Virginia Architecture (P) VR 619

Architecture-Connecticut

Connecticut Architecture (P) VR 111

Architecture-Contemporary

Archives Colour Slides of Modern Architecture (S) VR 290
Art, Architecture, Design by Kurt Rowland (S) VR 636

Architecture-Domestic

William Keighley Color Slide Collection (S) VR 427

Architecture-Drawings

Archives of Architectural Drawings & Models in European & American Collections (P) VR 290

Architecture-Early Christian

Early Christian Architecture (S) VR 526

Architecture-Ecclesiastic

William Keighley Color Slide Collection (S VR 427

Architecture-Environment

Man-made Environment (S) VR 374

Architecture-European

Archive Colour Slides-Modern European Architecture 1779-1963 (S) VR 288

Architecture-Greene & Greene

Most Complete Collection of Drawings (O, P) VR 88

Architecture-Griffin

Walter Burley Griffin Architectural Plans Drawn by Marion Mahoney Griffin (O) VR 190

Architecture-Japanese

Japanese Architecture (S) VR 210

Architecture-Judaica

Architecture (P, S) VR 46

Architecture-Medieval

Photograph Collection (P) VR 492

Architecture-Mexican-Colonial

Judith De Sandoval Collection of Mexican Colonial Architecture (P) VR 287

Architecture-New York City

New York City/New Jersey Metropolitan Area (S) VR 374

Architecture-Planning

City Planning (S) VR 534
Community Planning & Playgrounds (S) VR 565

Architecture-Publications

American Architectural Books, Research Publications, Inc (M) VR 3

Architecture-Photography

Photography, European & US (S) VR 278

Architecture-Spanish

Anne de Egry Collection of Spanish Medieval Architecture (P) VR 287

Architecture-United States

California, Monterey History, Art & Architecture (O, P) VR 63
Charleston & Vicinity 19th Century Photographs (P) VR 547
Dunlap Society (M, S) VR 280
Dunlap Society (M, S) VR 292
Historic American Buildings Survey (P) VR 127
Historic Views of Southern Appalachians 1900-1950 (P) VR 615
Manitowoc City & County Regional History, 19th Century Photographs (P) VR 649
Measured Drawings of North Carolina Buildings (P) VR 473
Mitchell Area Views & History (O, P) VR 552
Photograph Collection (P) VR 492
Smithers Collection, Trans-Pecos Area Documentation Since 1890 (P) VR 595
Frank Lloyd Wright & Prairie School (S) VR 174

Art-Religions-South Asia

Exploring the Religions of South Asia (V) VR 655

Art-Renaissance-Collections

Morgenroth Collection of Renaissance Medals VR 85

Art-Renaissance-Italian

Chatsworth Collection (P) VR 406

Art-Romanesque

Romanesque Archive (P) VR 327
Zodiac (P) VR 134

Art-Science Fiction

Science Fiction Manuscripts VR 275

Art-Scotland

Scottish National Portrait Gallery (P) VR 134

Art-Techniques

Techniques-Painting, Sculpture, etc. VR 266

Art-Texas

San Antonio Light Negatives, ca 1900-1940 (O) VR 577

Art-Theater

Theatre Collections (O, P) VR 436
Theater History & Techniques (S) VR 266
Theatre History (S) VR 383

Art-Third World

Third World Cultures (S) VR 329

Art-Tibetan

Tibetan Art (P) VR 375

Art-Tribal American

Tribal American Art & Culture (P, S, O) VR 10

Art-United States

American Civilization (S) VR 383
Archives of American Art (M, O, P, S) VR 118
Arensberg Archives of Manuscripts, Correspondence with French & American Artists of the Century, (O) VR 23
Arts of the United States (S) VR 76
Thomas Birch, Works by (O) VR 529
Delaware River & Philadelphia Area Historical Prints (O) VR 529
History of American Art (S) VR 280
Peter Juley & Son Collection of American Artists of Past 80 Years VR 132
Reynolda House of American Art (S) VR 475
Benjamin West Collection & Painting Collection (O) VR 531

Art-Ukrainian

Ukrainian National Museum VR 206

Art-Urban & Environmental

Urban & Environmental Art (S) VR 484

Art-Video

Museum & Univ of Minnesota Produced Video Programs (V) VR 337

Art & Architecture

Budek Films & Slides (F, S) VR 298
Carnegie Foundation Photographs (P) VR 330
Historical, Fieldwork & Book Illustrations (S) VR 644
Marburger Index (M) VR 76
Picture Collection (P) VR 436
Theatre Series (S) VR 460

Art & Architecture-Asia

Contemporary South Asia (F) VR 655

Art & Architecture-European

Zodiac (P) VR 134

Art & Architecture-Hispanic

Hispanic Society Co-sponsored Expeditions (P) VR 418

Art & Architecture-Louisiana

Art & Architecture of Louisiana VR 251

Art & Architecture-Mexico

Mexican Art & Architecture Exhibition VR 669

Art & Architecture-Near Eastern

Turkish Anthropology (S) VR 528

Art & Architecture-Peru

Yale-Peruvian Expedition by Hiram Bingham (P) VR 418

Art & Architecture-Pre-Columbian

Abraham Guillen Collection of Pre-Columbian Art & Architecture (S) VR 254
Pre-Columbian & Colonial Art & Architecture of Mexico & Central American (P, S) VR 594
Pre-Columbian & Primitive Fieldwork Studies (S) VR 406

Art & Design

Communication Arts & Design (S) VR 623

Arts & Crafts-20th Century

20th Century Painting, Sculpture & Crafts VR 480

Book Arts

Pratt Institute (S) VR 439

Crafts

Contemporary Crafts & Painting (S) VR 263
Contemporary Crafts Exhibitions (S) VR 528

Crafts-Archives

Archives of the Museum of Contemporary Crafts VR 392

Crafts-Canadian

Ontario Crafts Council Gallery Exhibitions (S) VR 684

Crafts-Contemporary

Contemporary Crafts (F, P, S, V) VR 392

Crafts-United States

American Crafts Selected from Watercolors in the Index of American Design/National Gallery of Art VR 338

Decorative Arts

Therese Bonney Photographs of Art Deco, Decorative Arts (P) VR 407
DAPC/NEA-Funded Survey of Decorative & Folk Arts of the Delaware Valley (P) VR 115
Decorative Arts (P, S) VR 534
William Kieghley Color Slide Collection (S) VR 427
John Maximus Collection (O) VR 407
R W Symonds Collection of Photographs of British Furniture & Clocks (P) VR 115

Decorative Arts-Byzantine

Byzantine Decorative Arts (P, S) VR 526

Decorative Arts-Ceramics

Contemporary American Ceramics (S) VR 360

Decorative Arts-Collections

Nellie Gannon Memorial Collection of Ceramics VR 147

Decorative Arts-Early Christian

Early Christian Decorative Arts (P, S) VR 526

Decorative Arts-European

European Street Furniture (S) VR 528

Decorative Arts-Glass

Antique & Modern Glass Paperweights (S) VR 223

Decorative Arts-Jewelry

Burton Y Berry Ancient Jewelry Collection (S) VR 215

Decorative Arts-Louisiana

Decorative Arts of Louisiana VR 251

Decorative Arts-Shaker

Shaker Collections (S) VR 116

Decorative Arts-Textile Collection

Textile Study Collection VR 293

Decorative Arts-United States

American Antique Furniture & Decorative Arts (S) VR 223

Decorative Arts-United States Illinois

Decorative Arts (P, S) VR 183

Emblem Books

Emblem Book Collection, Inter Documentation Co VR 673

Folk Art-United States

Pennsylvania-German Folk Life & Art (S) VR 536

Folk Arts

DAPC/NEA-Funded Survey of Decorative & Folk Arts of the Delaware Valley (P) VR 115

Graphic Arts

Citrus Labels (O) VR 62
Graphic Arts, Advertising, Illustration, etc. (S) VR 153
Graphicstudio Collection (S) VR 158
Kubler Collection of 19th Century Woodcuts & Engravings (O) VR 407
Landfall Press (S) VR 329
Prints Division VR 436
Rose Collection of Woodcuts & Wood Engravings (O) VR 407
Windsor Castle Drawings (P) VR 406

Graphic Arts-Collections

Citrus Labels VR 62

Graphic Arts-Judaica

Graphic Arts (P, S) VR 46

Graphic Arts-Posters

Foreign Poster Collection of World Wars I & II (O) VR 130

Graphic Arts-United States

Gordon W Gilkey Graphic Arts Collection (O) VR 508

Horticulture-European

Horticulture (P, S) VR 648

Horticulture-United States

Horticulture (P, S) VR 648

Kommos, Crete

Kommos, Crete Excavations by J Shaw (S) VR 685

Landscape Architecture

Landscape Architecture (S) VR 534

Moore, Henry

Moore Collection (S, V) VR 676

Natural History

Natural History Collection (S) VR 638
Natural History Collections (P) VR 645

Natural History-United States

New Jersey Pine Barrens (S) VR 383

Painting

European & Modern Architecture, Sculpture & Painting (O) VR 464

Painting-British

British 18th Century Portraits (P) VR 134

Part Three
INDEX TO INSTITUTIONS